ENGAGING SYMBOLS

Engaging Symbols

GENDER, POLITICS, AND PUBLIC ART

IN FIFTEENTH-CENTURY FLORENCE

Adrian W.B. Randolph

YALE UNIVERSITY PRESS NEW HAVEN AND LONDON

Designed by Leslie Fitch
Set in Fournier and Futura type
by Leslie Fitch
Printed in Italy at Conti Tipocolor

LIBRARY OF CONGRESS CATALOGING-IN-
PUBLICATION DATA
Randolph, Adrian W. B., 1965–
 Engaging symbols: gender, politics, and
public art in fifteenth-century Florence/
Adrian W. B. Randolph.
 p. cm.
 Includes bibliographical references and
index.
 ISBN 0-300-09212-1
 1. Art, Italian—Italy—Florence—
15th century. 2. Gender identity in art.
1. Title.
 N6921.F7 R32 2002
 709'.45'5109024—dc21
 2001008174

A catalogue record for this book is available
from the British Library.
The paper in this book meets the guidelines
for permanence and durability of the
Committee on Production Guidelines for
Book Longevity of the Council on Library
Resources.
10 9 8 7 6 5 4 3 2 1

To Angela Rosenthal
and in memory of my friends
Half and Susanne Zantop

Contents

Acknowledgments

For a suggestive comment in class, for a word of encouragement or advice, or for their practical help, I would also like to thank those with whom I have had the opportunity to study: James Ackerman, Lina Bolzoni, Patricia Fortini Brown, Howard Burns, Ioli Kalavrezou, Joseph Koerner, John R. Martin, Gülru Necipoglu, Patricia Rubin, Irene Winter, and Henri Zerner. In this regard, I must offer special thanks to John Shearman, above all for giving me the freedom to develop in unexpected directions.

I would also like to thank the following individuals who have helped me in various ways over the last few years and in so doing nourished this project: Cristelle Baskins, Brian Bennett, Mario Carniani, Mark Hallett, Alexis Joachimides, Geraldine Johnson, Tore Kapstad, Marianne Koos, Jacqueline Musacchio, Patricia Simons, Stephan Wolohojian, and Alison Wright. At Dartmouth College, I have benefited from extraordinary colleagues and warm friends; I would especially like to thank Jane Carroll, Ada Cohen, Kathleen Corrigan, Stefano Cracolici, Jonathan Crewe, Mary Desjardins, Gerd Gemunden, Manuele Gragnolati, Marlene Heck, Jim Heffernan, Allen

Hockley, Amy Hollywood, Jim Jordan, Steven Kangas, Joy Kenseth, Agnes Lugo-Ortiz, Monika Otter, Amy Lawrence, Diane Miliotes, Graziella Parati, Barry Scherr, Silivia Spitta, Bart Thurber, Mark Williams, Half Zantop, Susanne Zantop, and Melissa Zeiger. For their support, I would also like to thank Betsy Alexander, administrative assistant of the Department of Art History, the staff of the Visual Resources Collection, and the Sherman Library at Dartmouth College. I am particularly indebted to Harvard University and to Dartmouth College, both of which supported me in practical ways while the ideas presented here evolved.

I shall be ever grateful to Patricia Fidler of Yale University Press for her acumen and good sense. She, along with her colleagues Jeff Schier and Leslie Fitch, have contributed fundamentally to this book. I thank them all.

My gratitude to my family knows no bounds: to Hermann and Mechtild Gabel, Kris Randolph, Peter Anneliese, and Felicia Rosenthal for their interest and companionship; to my mother and my aunt—Marie-José Affleck Randolph and Marie-Elizabeth Affleck—for fostering my interest in art and literature; and to my brother Dominic Randolph, with whom I first explored Italy and its art. Finally, I thank my colleague and partner Angela Rosenthal for her unwavering support. This book is dedicated to her, for without her it would never have been written.

Introduction

The political theorist Michael Walzer describes politics as "an art of unification; from many it makes one." Fundamentally aware of the power of symbolic activity, Walzer contends that "the union of men can only be symbolized, it has no palpable shape or substance. The state is invisible; it must be personified before it can be seen, symbolized before it can be loved, imagined before it can be conceived." Within Walzer's evocative metaphorics of the state, art can be seen as a dominant mode of symbolization and therefore to function not simply as a superstructural reflection of social life, nor only as a discursive elaboration of human relations, but as a quintessential operation of politics itself. To students of the Renaissance, Walzer's poetics of the state will echo Jacob Burckhardt's understanding of the "state as a work of art," by which the Swiss historian meant that during the period politics came to be the product of intentional, even aesthetic activity. Walzer, however, transforms Burckhardt's simile into a metaphoric proposition, positing representation not as

I

a *model* for understanding politics, but as a fundamental practice of politics. For if the state is rendered visible when personified, symbolized, and imagined, the visual arts have proved to be the most effective means of achieving this political visibility. Taking Walzer literally, this book sets out to examine the "*art* of unification" in fifteenth-century Florence.[1]

It is a central contention of this book that in fifteenth-century Florence politics became visual in a direct and distinctive manner. As Loren Partridge and Randolph Starn have formulated, during the Renaissance art became a work of state.[2] Following their Burckhardtian inversion, I argue that during the tumultuous period that witnessed the transition from an economic system characterized by feudal relations to one of marked capitalism, and from communal republicanism to absolutism, art can be seen to have participated in the formation of Florentine political life. Art did not *reflect* the broad changes I just mentioned, but rather it contributed to the practices that produced them.

Of signal importance is the differentiation between art that functioned politically or that can be interpreted politically, and "political art." My definition hinges on the difference between "civic art," which functioned indexically to re-present and mark the presence of authority, and "political art," which beyond its service as a label also functioned dialogically to engage spectators in symbolic activity in the public realm. In fifteenth-century Florence, I claim, politics became less a place for the staging of authoritarian monologues, and more the site for persuasion and the generation of consensus. Political art, engaging Florentines in symbolic exchange, played a fundamental role in manufacturing popular consent to authority.[3]

In this book I stress the importance of gender within these political dialogues concerning seduction, submission, and power. For if, in Walzer's powerful language, the embodied state materializes as an object of desire, it makes sense to ask: How was the state gendered and what form of desire did it call into being?

In coming to grips with this question, cultural historian Lauro Martines recently made the particularly useful proposal that Renaissance scholars recognize the political coding of love poetry. Within the courtly tropes of chivalric compliment and Petrarchan complaint, Martines sees in the powerful *donna* a figuration of authority and in the power relations encoded in amorous fealty and submission an allegorical figuration of political, consensual relations. What Martines's work calls most attention to is the fluid exchange between amatory and political language. Focusing on love poetry, Martines identifies the political within this distinctive and, for the age, characteristic discourse. It is evident, however, that political language also exhibits the same alloy of love and authority.[4] Amorous images litter the political poetry of the

Renaissance, encouraging readers and listeners to forge ties to authority in affectionate, even erotic terms. It is not, therefore, surprising that in personifying, symbolizing, and imagining their state in the visual arts, Florentines did so within poetic discourses of love. It is for this reason that gender is central to my project of envisioning the structures of political art in fifteenth-century Florence.

The Florentine State

In this book I seek to weave into my visual cultural analyses social and literary data traditionally used by historians. In so doing, I do not wish to promote a type of art history criticized by Mieke Bal and Norman Bryson as "contextual," setting art against an uncurtailable scrim of social, political, or cultural information.[5] To the contrary, I prefer to privilege the "interwovenness" of cultural phenomena within contextual analysis. Having said that, before turning to the visual culture at the center of my investigation, some preliminary words are in order concerning the structures and character of Florentine political life in the late Middle Ages and the Renaissance.

The struggles over representational power in Florence during the fifteenth century took place within a distinctive political and social context, characterized by the tension between, on the one hand, the operations of republican constitutional forms and, on the other, the growth of oligarchical and, under the Medici, lordly authority. Fifteenth-century Florence influenced both a nascent—and enormously influential—republican bureaucracy and the tendency toward a vertical arrangement of power relations that would mark the absolutist state in later centuries. It would be precipitous to see Florence, however, as the "root" of either.[6] Although my concerns and my language may be modern, I do not wish to see fifteenth-century Florence as a prelude to (or a "waning" of) monarchical or republican traditions. Having said that, it would be wrong not to understand fifteenth-century Florentine politics as operating both within the *longue durée* of institutional history and within the particular circumstances of its own time and place. Thus, I will proceed with an eye on history's glacial continuities *and* on the particular circumstances of Florentine fifteenth-century civic life.

The victory of Guelfic and republican ideology, along with the rise of a powerful mercantile class during the thirteenth century, precipitated the 1293 Ordinances of Justice, legislation that changed the picture of Florentine public life. With these laws, the aristocracy was excluded from open political engagement, and republican electoral instruments laid the groundwork for broader participation in a government characterized by its discrete branches and rapid turnover of elected officials. During the fourteenth century Flor-

entines came to depend upon a highly developed and independent governmental bureaucracy. The stability of the "Golden Age" of Florentine republicanism was shaken, if not shattered, by the Ciompi revolt of 1378. At this time workers and members of marginalized, so-called minor guilds overthrew the government and instituted electoral reforms that promised broader political participation. These reforms were fairly hastily repressed and, after this abortive revolution, an oligarchical government returned to power in 1382. Although an institutional failure, the Ciompi revolt irrevocably altered the way in which Florentines saw themselves in relation to their government. The self-evidence of communal structures vanished. Instead, as John Najemy has argued, the consensual nature of authority was acknowledged; in order to gain or maintain political power it was necessary not only to perform within governmental structures, but also to win the hearts and minds of individuals and groups through persuasion. In the trenchant expression of Riccardo Fubini, Florence moved "from social to political representation." By this Fubini intimates that in the radical shift from a guild-based commune to the elite regimes of the fifteenth century the realm of the political separated itself, institutionally and practically, from the social sphere. Politics, no longer only a matter of local affinities and networks, also became rhetorical, and thus entailed an engagement with public opinion.[7]

In the fifteenth century—first under the elite cadre of professional politicians who dominated the post-Ciompi oligarchical regime, and then, especially, under the Medici—politics became increasingly rhetorical. Power shifted from the esteemed electoral system and toward a politics of charisma and suasion. Much of this book is devoted to the Medici's ideological colonization of politics and the "public" through the visual arts. From 1434 to 1494, the Medici were the de facto rulers of Florence, cultivating republican appearances while controlling electoral politics from behind the scenes through the rigging of ballot boxes, through the construction of a strong patronage network, and through a careful management of cultural display. Although much work has been done to elucidate specific commissions and the activities of individual members of the Medici family, there is, to date, no systematic study of Medici patronage in the fifteenth century. While not a comprehensive account of their patronal activity, this book does attempt to take a broad view, following the intersection of Medici authority and visual culture through the three generations represented by Cosimo "il Vecchio," Piero "il Gotoso," and Lorenzo "il Magnifico." Thus, rather than presenting a history of patronage in the traditional sense, this book investigates, selectively, political life through some of the imagery the Medici cast about their authority. Operating within republican political forms, three generations of

Medici rulers acknowledged the importance of political appearances, crafting images of themselves, their city, and the consensual relation they imagined existing between the two. In much the same way that Lorenzo, in his carnival songs, appropriated a popular "voice," eviscerating it of its carnivalesque potential, the Medici diffused political publicness by making it their own.[8]

My approach to the visual politics of fifteenth-century Florence seeks to complement and provide a cultural dimension to the many studies addressing the emergence of the city as a state. Put simply, it seems to me that in the fifteenth century Florentines recognized the state as something worthy of visual discursive elaboration and therefore contributed pragmatically to its genesis as a working concept.

As Giorgio Chittolini has recently recognized, the term "state" when raised in discussions concerning premodernity is taken by some "in a strong sense to mean a nucleus of full sovereignty, unconditioned by external interference and internally centered entirely around the authority of the prince and his government, an authority capable of pervading and placing its stamp on the structures of the whole society—its groups, its individuals, its communities."[9] I agree with Chittolini that the omnipresent imaginary "state" of plenitude and power is a "straw man," erected by those who wish, simply, to do away with the concept altogether. I do believe that an ideal of statehood is recognizable in fifteenth-century Florence, but I do not feel bound by this belief to a teleology narrating the progressive evolution of "the" state. Instead, following Walzer, I would like to adopt a pragmatic definition of the term "state," and see it as an ideal, rather than a real, institutional, geographical, or social construction. The state is, as Ernst Cassirer put it, a "Myth."[10] For the "state" is not defined by frontiers, institutions, or bureaucratic relations; the state is an organizing principle within a cultural imaginary. It is easy to take potshots at Burckhardt, but his rubric picturing the state as a work of art, while flawed, does capture something of the manner in which a state unfolds as an image. What is more, it is precisely this political picturing that I would like to argue received sustained cultural attention in fifteenth-century Florence.

Few scholars of Florentine political history challenge the notion that in the period between 1300 and 1600 Florence surfaced as a state; controversy has clustered, instead, around the chronology of its emergence.[11] Traditionally collapsed into a biographical-narrative model describing Medici hegemony, or into a colonial-narrative model of territorial expansion after the Black Death, in recent years it has been generally accepted that something very distinctive occurred in the years following the Ciompi revolt that led to Florence's self-recognition as a state.[12]

Although not explicitly addressing Florence's statehood, it has been

Hans Baron's narrative of Civic Humanism that has been most influential among art historians seeking a political context for the revolutionary changes in Florentine art in the early part of the fifteenth century.[13] In Baron's account, humanism forged in the furnace of military crisis and by the threat of tyrannical oppression, became civic, investing traditional republican forms with an ideological vigor drawn from republican antiquity. Free-thinking humanists led the citizens of Florence toward liberty and enlightenment. Baron's rather convenient and dramatic history has been roundly criticized and reformulated.[14] Most tellingly, it has been avoided by a generation of scholars who, instead of seeking radical moments of transition, turned to the minutiae of institutional history and to an anthropology of social life. Thus, Nicolai Rubinstein, Gene Brucker, and those who have followed in their footsteps—including Dale Kent and John Najemy—have documented the constitutional structures of the Florentine state, describing a gradual process of bureaucratic intensification.[15] Another wing of Florentine historiography—represented in the work of Richard Trexler, Christiane Klapisch-Zuber, and F. W. Kent—turned to Florentine social life with methods tinged with anthropological terminology, scouring the archive for traces of broader, and largely unchanging, practices, patterns, and networks.[16] Both of these scholarly modes—the institutional and the anthropological—amply demonstrate the power of continuity, and with their sometimes overwhelming reproduction of the archive certainly provide a specificity that brings readers close to an experiential understanding of everyday life, but both suffer some strain when compelled to explain change. Although there are notable exceptions, art history has not, traditionally, contributed to the debates on the institutional or social-historical development of Florentine public life; to the contrary, it has been historians who have brought their knowledge of the archive to bear, fruitfully, on the history of Florentine urbanism, civic and domestic architecture, patronage, and the more performative aspects of visual culture.[17] With this book I hope to redress, partially, this lack. For it seems to me that describing the manners in which, to return to Walzer's formulation, Florentines personified, symbolized, and imagined their state might complement existing treatments of its emergence in the fifteenth century.[18]

From Civic to Political Symbols

Before 1400 Florentines had already assembled a rich assortment of civic symbols. It is not my intention to downplay their historical importance, nor their complexity; nonetheless, I do wish to claim that in the fifteenth century, Florentines were confronted by and came to expect very different things from a new set of political images.

After the imperial troubles of the mid thirteenth century Florence became an independent commune, albeit still owing allegiance to the emperor and pope. To mark this autonomy, Florentines crafted an array of visual symbols that served to gloss on the history and character of their city. Working within what Donald Weinstein aptly called "The Myth of Florence," these visualizations of the city and its authority gave the developing state palpable form.[19] Initially, this form was compound, growing out of local, parochial affinities. Like other communes, each administrative unit of the city possessed its unique civic signs, customarily flags and mascots. Similarly, the religious division of Florence generated quarters; these, too, yielded quasi-heraldic markers. But in the thirteenth century, and most insistently with the building of the city hall, later called the Palazzo Vecchio, a handful of civic signs came to represent the city as a whole to its inhabitants and to others.[20]

Writing in the early fifteenth century the Florentine Goro Dati identified and described six symbols (*segni*) of the Florentine Commune: the lion; the *giglio*, or heraldic flower of the city; the standard of justice (a red cross on a white background); the standard of liberty (marked with the word LIBERTAS); Hercules, who appeared on the city's official seal; and the gold florin, the city's famous coin, on the obverse of which one could find an image of Saint John the Baptist and on the reverse the Florentine *giglio*. These *segni* re-presented the city in a straightforward manner, marking a substitution: in various ways they stood for the state. Many possessed the allure and stability of great antiquity, and all called for civic allegiance. This cluster of civic imagery offers a glimpse into how Florentines visualized civic affection in the thirteenth and fourteenth centuries. Mimicking the representational strategies of traditional authorities—the papacy and the emperor—communes sought identification as the wards of saints or heroes (Saint John the Baptist, Hercules), as bearers of heraldic symbols (the *giglio*, the lion, or the flags), and through the material splendor of wealth generated through commerce (the florin).

The *segni* mentioned by Dati, whether representational or abstract, were used to mark power. Semiotically, they functioned like Peircean indices; set on, or near, the halls of power, or at charismatic sites in the city and surrounding territory, or embossed on civic correspondence, they signaled the presence of Florentine authority. These civic symbols did not, however, function politically, in the active, dialogic, and rhetorical sense on which I would like to insist.[21] At the end of the fifteenth century Dati's six symbols still held currency, but by 1500 these meta-heraldic markers had been joined by a new form of civic symbol, the purpose of which was to draw citizens into ideological exchange. I would like to call this special class of civic symbols political,

based on the communicative means by which they engaged spectators. It is this form of political, visual communication that I would like to describe as producing, within a public cultural imaginary, an image of the state.

Gender and the Public/Private Dialectic

If art contributed to the formation of the Florentine state, it did so above all in the public spaces of the city. Central to this project, therefore, is a workable definition of "public," and of its sibling "private." I would like to offer a few comments on how I am using these terms, and how, by introducing the third term "gender," we can perhaps avoid some of the weak and problematic transcendental binaries that plague discussions of these issues.[22]

In recent writing about the Renaissance, there has been a salutary and admirable turn toward the "private sphere." This turn is not unique to Renaissance studies, but rather reflects a broad shift in the historical disciplines toward particularist narratives and away from the broad narratives so incisively criticized by Hayden White in *Metahistory*. But the tendency of modern scholarship toward the study of the "private" has not only, or even predominantly, been carried out under the banner of postmodern skepticism. It has been driven, above all, by the twin forces of social history and women's history, the former seeking an embracing description of everyday life, and the latter pushing the male-dominated arenas of politics, warfare, and diplomacy to the margins, in favor of experiential accounts of the lives of women. Studies of "private" life in medieval and Renaissance Europe evolved as a separate and distinctive historiographical strain in the 1970s and continue today.[23]

The turn toward the domestic and private has yielded some of the most novel and challenging scholarship concerned with fifteenth-century Italian art. In one way or another scholars whose work has moved us into the private domain have had to address the theories of Richard Goldthwaite, who holds that the Renaissance in general and fifteenth-century Florence in particular witnessed the formation of conspicuous consumption and of the domestic sphere in a very forward-looking form. Goldthwaite's studies of domestic architecture, patronage networks, and patterns of consumption seem to elevate the "private sphere" as the invention of the Italian Renaissance and as the most telling characteristic of the age. Goldthwaite's interpretation of spending and consumption has won broad acceptance, but the conclusion that the economic historian draws concerning the mercantilist reduction of broad family ties in favor of a distilled, nuclear family unit have run into opposition from historians who stress noneconomic relations. Historians who base their researches on private letters and on public discourses tend to emphasize the constancies of clan affiliations and institutional structures. Thus, for example,

F. W. Kent openly contested Goldthwaite's claims that the fifteenth-century patrician palace represented the expansion of strong, intimate affections at expense of broader kinship ties, reminding us instead of the general, even characteristic sociability of fifteenth-century culture, which saw no opposition between private familial interest and broader civic participation.

The opposition between a privatizing account of Florentine history and accounts stressing continuity over change is a false one. The growing sense of privacy that Goldthwaite describes does not replace the publicity of traditional social and political groupings. Rather, it signals a particular coding of public and private action. There are many theorists who might help us to understand this dialectical relation between public and private, but it makes most sense to turn to Jürgen Habermas. It is often mistakenly thought that Habermas's theories posit an absolute point for the origin of the "public sphere" in eighteenth-century Europe. Both Habermas's claims and their repercussions spread, however, far wider. But it is not only because Habermas and his critics discuss late medieval and Renaissance culture that I turn to their texts. Habermas's writings on this subject are the most revealing and logical treatments of the problematic relation between public and private; what is more, it is in the wake of Habermas that feminist political theorists posed the questions that brought this book into being.

To understand Habermas's thinking on the public sphere, it is necessary to grasp his, at first glance, paradoxical terminology. For me, the central revelation in reading his foundational text on this subject, *The Structural Transformation of the Public Sphere*, is that the public sphere is, in fact, private, or possesses a distinctive form of privateness. What is more, this "private publicness" developed at the intersection between a medieval form of political representation and a modern form of discursive political publicness. This transition took place at different times and places in Europe, but certainly it was in the urban, capitalistic centers of northern Italy that Habermas and subsequent writers have recognized the earliest and most influential manifestations of a nascent public sphere.[24]

So what does it mean that the public sphere possesses a distinctive form of privateness? In an effort to identify different forms of publicness, Habermas rehearses the strange and paradoxical manners in which Europeans have used the word "public." On the one hand, the word implies governmental participation: public works, public schools (in the United States), public meetings, public service, public buildings, public interest, etc. In medieval Italy, we can think of the *res publica* of civic life, or of its concrete manifestation in the many town halls called "Palazzi Pubblici" as indicating precisely this form of collapse between the word public and the institutions of governance.

Habermas reminds us, however, that the contrary meaning also obtains and that the word public also connotes something precisely extragovernmental: *the* public, which, in its ideal form, Habermas labels the "public sphere of civil society," or "the bourgeois public sphere," meaning a corporate entity in which individuals rationally communicate outside of the pressures and strictures of public authority. As Habermas describes it: "The bourgeois public sphere may be conceived above all as the sphere of private people come together as a public; they soon claimed the public sphere regulated from above against the public authorities themselves, to engage them in a debate over the general rules governing relations in the basically privatized but publicly relevant sphere of commodity exchange and social labor."[25] Thus, for Habermas, the word public not only "betrays a multiplicity of concurrent meanings," but also exhibits a radical polarity, on the one hand indicating governmental power, and on the other hand representing the extragovernmental groupings that challenged centralized political control.[26]

Habermas was clear in seeing the "public sphere of civil society" coming fully into being in the eighteenth century, with the development of industrialization and mass communication; nonetheless, he is equally clear in recognizing that the "public sphere" arose with the breakdown of feudal relations. Put simply, the roots of his "public sphere" lie in the late medieval commune. Somewhat schematically and problematically, Habermas aligns medieval publicness with monarchical authority:

> Sociologically, that is to say by reference to institutional criteria, a public sphere in the sense of a separate realm distinguished from the private sphere cannot be shown to have existed in the feudal society of the High Middle Ages. Nevertheless, it was no accident that the attributes of lordship, such as the ducal seal, were called "public"; not by accident did the English king enjoy "publicness"—for lordship was something publicly represented. This *publicness* (or *publicity*) *of representation* was not constituted as a social realm, that is as a public sphere; rather, it was something like a status attribute.

Within feudal relations, representation—and Habermas is speaking here of political representation—issued from the figure of the lord.[27] Public representation followed the court and its sometimes visible, sometimes invisible, but always present center: the princely body. This type of publicness Habermas labeled "representative publicness." Unlike the dialogic public sphere of civil society, representative publicness was monologic: it represented itself from a particular place to a generalized spectatorship. It did not entail exchange; it did not address *a* public. For Habermas, the feudal

structure prohibited the evolution of politics per se. It was only when "representative publicness" was challenged by an "autonomous public," that is, a publicness not coterminous with governmental authority, that politics—in the modern sense—could evolve. I would like to make the case, via Habermas, that in the nonfeudal yet quasi-seigniorial environment of Florentine civic life, we can witness the formation of sustained political and visual discourses that can be called political in the modern sense.

This is not to claim that earlier art cannot be "political." Earlier art in similarly nonfeudal contexts might very well bear an analogous form of analysis. What is more, "representative publicness" did not vanish. Indeed, what Habermas identifies as "feudal" continued to exist in Europe until the nineteenth century, and it still continues to operate in many visual cultures. Nonetheless, it is striking that fifteenth-century Florence produced a critical mass of public art that sought not only to mark places of power and to signal the presence of authority, but also to engage a differentiated public dialectically. Thus, while previously there may have existed isolated examples of art that addressed a public politically, in Florence this type of communication grew into a coherent tradition, transforming the public spaces of the city.

I hope that my analyses make clear that in adopting Habermas's terminology I am by no means subscribing to a notion that the bourgeois public sphere developed progressively "from" Renaissance Florence. While I do believe that some of the political theoretical language that Habermas used to characterize the modern public sphere is well suited to describe what was transpiring in fifteenth-century Florence, that is not to say that I wish my work to operate within a genealogy of modern political art or, more broadly, within an evolutionary view of the formation of the modern state. In this book I recognize that the tensions between the bureaucratic, centralized instruments of the Florentine territorial state and an autonomous and informal sociability of citizens finds its best descriptive theorization via Habermas's vocabulary. In fifteenth-century Florence we see, in effect, a transition from feudal to capitalist modes of production and we see a struggle to control the public spaces of representation. This struggle was not coercive so much as rhetorical. The Florentine public, no longer passive receivers of monologic political emanations, engaged in the give-and-take of visual communication.

Feminist scholars have appropriated and reformulated Habermas's insights concerning the public/private dialectic. It has been, above all, the writings of Joan Landes that I have found most instructive. In *Women and the Public Sphere in the Age of the French Revolution* Landes recognizes how the structures and tensions Habermas describes as marking the transition from representative publicness to the bourgeois public sphere "invested public ac-

tion with a decidedly masculinist ethos."[28] In a move that mirrors Joan Kelly Gadol's inversion of the Burckhardtian model of Renaissance emancipation by questioning the position of women in the Renaissance, Landes questions the gendered biases of the Habermasian public sphere. In her analysis of the French Revolution, Landes demonstrates that women, rather than participating in the fruits of revolution, suffered in the new public sphere of "rational" communication. "It is of some consequence," she writes, "that modern republicanism—born of the Renaissance city-state, carried forward by aristocratic opponents of absolutism, and achieving its greatest heights in the bourgeois revolutions of the late eighteenth century—reinvents the classical world's commitment to civic virtue and inherits its affiliated prejudices for a gendered patterning of public and private life."[29] These words will, I am sure, strike a familiar note among students of Florentine Renaissance public life, since the practical and theoretical exclusion of women from participation in public affairs in this period and place was close to absolute. It is on this account that feminist scholars interested in women's history have called attention to the misogynism of public art, and/or to the potential liberties of the domestic sphere. Although building on these important insights, this book follows a slightly different approach, exemplified by the work of Patricia Simons and Cristelle Baskins.[30] Both scholars approach the public/private divide with a Foucauldian skepticism. Power in their writings transcends modern binaries and moves across the traditional seams of historical research, understanding the domestic as on a contiguous discursive plane with the public in terms of authority.

A Few Words on Method

It is the fundamental transdisciplinarity of the work of scholars like Simons and Baskins that made this project possible. Its form and scope derives precisely from their thematic and ideologically engaged writings. *Engaging Symbols* considers fifteenth-century Florentine public and political art without confining itself to one artist or patron. Nor does it restrict itself to one artistic medium or genre. Although I do wish to recognize the power of particular works, I acknowledge this only in order to understand how certain spectators were, literally, moved: persuaded and activated within a system of political relations. My individual analyses are not presented in a celebratory fashion and do not attempt to judge and therefore privilege individual works within an aesthetic hierarchy. In that sense, this book, like many other contemporary studies, seeks to test the boundaries that often are associated with art historical analysis, with its emphases on technique, style, attribution, and intrinsic worth.

Although this book does treat elite cultural production by artists like Botticelli and Donatello, whose work figures prominently in three chapters, ample space is also devoted to artifacts that lack conclusive attributions and to those often relegated to the "minor" arts: one chapter scrutinizes a pair of medals, while the final two chapters depend on the examination of rarely discussed engravings. Two chapters even address lost works, often slighted in traditional art historical analyses. My intention, however, has not been to be iconoclastic in choosing to move freely between paintings and sculptures with bibliographies longer than this book, and anonymously produced works that have received little or no scholarly attention. The materials of this study emerge, rather, from my desire to offer an inclusive, if far from comprehensive, vision of the Florentine visual sphere that accounts not only for a rarefied spectatorship of learned humanists and patrician merchants, but also for a broadly conceived public.

My decision to consider both popular and elite culture derives from an interest in contemporary, interdisciplinary cultural studies, as well as from my active engagement with the work of Aby Warburg. Warburg's writings have helped me to identify the cultural materials here analyzed and the methods I have used to make these materials speak. Opposed to the rather elitist iconographical method associated with Erwin Panofsky and dominant within art history, Warburg's cultural histories do more than simply ferret out textual, and often ancient, sources. In the Panofskian method, the image is figured as a version of the text; the hermeneutic goal of this method, often explicitly stated, is to recover artistic or patronal intention. Most troubling is the manner in which Panofskian iconographical analysis often posits an exceedingly narrow audience of learned men. As Margaret Iverson has expressly argued from a feminist perspective, the openness of Warburg's method offers itself up for appropriation by contemporary scholars pursuing more inclusive thematic agendas.[31] Although often adducing arcane texts, Warburg was never satisfied with the excavation of the textual foundations of images for its own sake. Instead, Warburg's iconology always aimed at characterizing the mentalities that produced, witnessed, and circulated imagery. That is to say, he never saw the iconographical method as an end in itself; it was, rather, a tool. What is more, Warburg anticipated contemporary approaches to artistic value in disregarding, almost entirely, questions of inherent quality. It would be misleading to state that Warburg took into account a broad audience in his analysis of Renaissance works of art, but his method does seem to permit a breadth of response that later, less creative minds seem to have restricted.

Following Warburg, I attempt not to present the textual "truth" behind

the symbols here studied, rather I have tried to plot some discursive trajectories that the gazes of contemporary, fifteenth-century Florentines might very well have followed. In this project, Michael Baxandall's critique of artistic influence and John Shearman's thinking about the structures of spectatorship have proved to be very useful. Rather than conceiving of an image as a point in the transmission of an ineffable "influence," Baxandall promotes a view of the image as an active response to past visual forms. Within this schema every image becomes a visual interpretation, not simply a reflection. I have used Baxandall's creative reformulation of the metaphors that dominate accounts of iconographic and stylistic dynamics as the foundation for investing formal variations with meaning and for the understanding of art as offering, itself, the grounds for reconstructing visual responses. Shearman's recapturing of an art historical tradition that bestowed as much attention on modes of viewing as on formal analysis informs my work from the inside out. His careful balancing of a positivist mode of historical reconstruction and the active role of the modern interpreter, especially in imagining culturally and temporally distant responses to art, has provided me with an important analytical model to emulate.[32]

The Structure of the Book

This book is arranged around six case studies; the project is selective and does not offer a "survey." Its structure reflects the material I seek to present, in that it follows distinct discursive traditions, treating them in depth but seeking not to subordinate them, deductively, to overarching teleological narratives. Practically, it also means that each chapter is semiautonomous and that the reader does not have to follow this text sequentially. Having said that, and despite significant temporal overlapping, the chapters are arranged, roughly, in chronological order.

The first chapter, "Common Wealth: Donatello's *Ninfa Fiorentina*," examines the striding embodiment of *Dovizia*, or Abundance, erected toward the end of the third decade of the fifteenth century in the busy Mercato Vecchio. Explicitly, the monument expressed a belief in and a desire for agricultural and economic well-being. Implicitly, presiding over the antique forum and economic heart of the city, the dynamic *Dovizia* was a type of *genius loci*, representing Florentia, the flourishing and flowering personification of the city. Seeing in Donatello's statue the origins of what Warburg called the *Nympha* or *ninfa fiorentina*, I seek to characterize the public and gendered politics that underwrote this distinctive evocation of antiquity by looking at the ways in which artists responded to Donatello's theme. Taking into account a variety of spectatorial positions, I attempt to understand the gendered politi-

cal logic of the statue within the turbulent events of the late 1420s and in light of the restructuring of the tax code that fundamentally altered the manner in which citizens perceived their relation to the state.

My second chapter, "*Florentia Figurata*," focuses on two medals—one portraying Cosimo de' Medici "il Vecchio," and the other his grandson, Lorenzo de' Medici "il Magnifico"—and describes the modes in which the Medici family reconstrued the traditional body politics of personification. On the reverses of both medals are representations of Florentia, the female embodiment of the state. The medals, usually consigned to the margins of art historical accounts, draw my attention for a number of reasons. They are the most explicit political images produced under the Medici during the fifteenth century. While other objects were used politically, or were provided with political glosses, these medals at their iconographic bases concern themselves with the difficult relationship between the Medici and their city. Moreover, this relationship is construed in a fashion that draws profoundly on then-current notions of gender-appropriate behavior. At once ancient and modern, reproducible and mobile, the medal also offers an especially telling insight into the authority of the Renaissance portrait as an instrument for the broadcasting of power.

Even more public was the preeminent sign of Medici presence in Renaissance Florence, the device of the diamond ring. In the third chapter, "Engaging Symbols: Legitimacy, Consent, and the Medici Diamond Ring," I regard this device not as a quasi-heraldic marker, but as an image. Traditional interpretations of this ring have catalogued its appearance on all manner of Medicean projects and objects, and have proposed elaborate hypotheses concerning its heraldic and humanistic sources. My analysis takes a different approach, attempting to gauge the ring's public significance by allowing for more common symbolic resonances to bear on its interpretation. For social-historical data reveal that the diamond ring was ineluctably associated with marriage. On the one hand, therefore, I see the ring device as quite literally representing to men and women the actual involvement of the Medici in controlling and manipulating the Florentine marriage market. On the other hand, I also propose to interpret the ring on a metaphorical level. Uniting the ring's social functions and its meta-heraldic meanings, I explore the hypothesis that the Medici, in deploying the ring as a family symbol, took advantage of its marital significance and thus toyed with notions of fidelity to, and subjugation of, the state personified as a woman/wife. Reconstructing the broad cultural significance of the ring as a symbol legitimizing marital relations, I seek to set the Medici's device within the widespread political trope describing the prince's marriage to the state.

Chapter Four, "Homosocial Desire and Donatello's Bronze *David*," returns to more familiar, political grounds, and to interpretative problems that have vexed art historical analysis of an icon of early Renaissance art. The political status of Donatello's bronze *David* has rarely been questioned; set at the center of the Medici palace courtyard and complemented by a patriotic inscription, the statue possesses a privileged position within a tradition of political art that leads directly to Michelangelo's giant marble *David*. Nonetheless, it has proved exceedingly difficult to square what many see as the statue's erotic, and specifically homoerotic, visual qualities with its public and political functions. This chapter attempts to resolve this apparent paradox, by considering Donatello's *David* within the social history of sexuality and by attending to the work's visual texture and narrative richness without reducing it to a mere illustration of its historical context. Building on Michael Rocke's extraordinary examination of male homosexual relations in Renaissance Florence, I seek to offer an explanation of the *David*'s ambivalent evocation and renunciation of a male desiring gaze that also makes sense given the statue's political sites and functions.[33] Operating within what Eve Kosofsky Sedgwick has called "homosocial desire," the *David* bound men together through unstated, but powerful, sexually inflected affection.[34]

Throughout this book I have ventured to frame visual culture within the boisterous performativity so comprehensively described by Richard Trexler.[35] Rather than seeking a stable and synchronic definition of particular meanings, *Engaging Symbols* strives to present political imagery at its points of reception, accounting for the mobile interface between lived experience and imagery in the performative culture of Renaissance Florence. The next chapter, "Spectacular Allegory: Botticelli's *Pallas Medicea* and the Joust of 1475," turns to these issues directly. Although lost, the allegorical standard painted by Botticelli and carried by Giuliano de' Medici into the famous tourney of 1475 has not been ignored by historians and art historians. Explanation of its iconography has, however, consistently been subordinated to the interpretation of other cultural artifacts—most often Poliziano's *Stanze* or Botticelli's other, mythological paintings. My analysis focuses on the pennant itself as a public and political expression. Reconstructing the appearance of the lost banner, and gauging its repercussions in contemporary texts and images, I read the painting as it appeared in public ritual as encoding a complex form of political embodiment. Understanding the iconography means engaging with esoteric literary culture, but I also seek to account for a broader set of responses by analyzing how the passive male body could function in fifteenth-century Florentine visual and political culture.

This vision of disempowered masculinity helps, in my last chapter, to

account for how Donatello's *Judith and Holofernes* was understood, both in what I take to be its original site in the garden of the Palazzo Medici, and outside the Palazzo Vecchio, where it was placed by the republican regime in 1495 after the Medici had been expelled from Florence. The subsequent removal of the *Judith and Holofernes* from its site before the city hall has elicited intriguing studies linking politics and gender. I trace the prehistory of this linkage by scrutinizing the theatrical sculptural performance of gender in the Medici palace garden. Judith's judicious and juridical execution of Holofernes was acted out for viewers in the presence of other statuary, especially two ancient figures of Marsyas and a statue of Priapus. I concentrate on the trope of the "woman-on-top," commonly found in Florentine culture on objects associated primarily with female viewers, in order to complicate traditional, moral-allegorical accounts of the statue. Seeing in Judith an image of both sexual emancipation and threat, I chart the gradual misprision of the iconography in fifteenth-century Florentine print culture and ceremonial performances. Construed within amorous discourses, the iconography was destabilized, its moral polarity between virtue and vice thrown into disarray. It was this multivalence that rendered the statue itself problematic as a symbol of the newly founded republic, a fact that becomes evident when one takes into account the fears concerning the feminization of political culture under the new regime, and the instability of the iconography of a woman armed with a sword.

The word public contains and suppresses an inherent struggle. Positing both a public authority and an autonomous publicness, the word is riven at its very core. This book seeks to interrogate, critically, the ways in which the visual arts, as modes of imagining, personifying, and symbolizing the state were deployed in order to close the very modern, and topical, rift in the word public. The political symbols I investigate did not only demarcate or announce authority, for they also sought to engage a public whose consent to authority could no longer be taken for granted. Not only about decoding static symbols, this book concerns itself with the mechanisms of power as they informed, and distorted, the social relations within which cultural production and reception took place.

The performative public and visual engagement on which I concentrate cannot be separated from gender. This coupling of gender and politics arises both from the means through which Florentines chose to visualize political discourse and from my own inclinations. The symbols I have chosen to analyze are personifications or, better put, embodiments: symbols that render the state in human form, visualizations engaged with and within the body politic. They are distinctively and influentially grounded in amorous discourses that

draw variously on metaphors of affection, desire, courtship, betrothal, marriage, homo- and hetero-eroticism, and procreation. The engaging symbols that I discuss body forth the state and seek to unify spectators within collective cultural and political gazes in a manner that both reflected and produced gender ideology. Thus the complicated ways in which public art presented and naturalized gendered bodies as models for political identification are interpreted as providing insight into widespread mentalities, and also, tellingly, as a component in a novel rhetoric of authority that attempted to bridge the widening gulf between the state and its citizens.

1

Common Wealth

DONATELLO'S *NINFA FIORENTINA*

Lo tesoro comincia,	(The Treasure begins,
Al tempo ke fiorença	At the time when Florence
Fioria efece frutto,	Flourished and bore fruit,
Si ch'elle'era del tutto	So that she was of all
La donna di Toscana.	The Lady of Tuscany.)
—Brunetto Latini	

Flos florum floret—Florentia crescit honore.
(The flourishing flower flowers—Florence grows with honor.)
　　　—Leonine couplet

The spectacle is capital to such a degree of accumulation that it becomes an image.
　　　—Guy Debord

In 1426 the Florentine Giovanni di Andrea Minerbetti wrote that "our weal consistently depends on money (*Salus nostra in ordine pecunie consistit*)."[1] His words were both truistic and truthful. Minerbetti restates a generic antique expression derived from Sallust to communicate something absolutely germane to his life and to the life of his city: the importance of money. It would be a mistake to read his recycled Roman quip as devoid of meaning, simply because its form is adopted; its content carries with it "modern" (and by this I mean fifteenth century) meanings which, to be understood, must be set in a context. Recognizing this dualism between antique form and "modern" meanings is essential to the interpretation of Renaissance culture.

Minerbetti's linking of *salus* and *pecunia*, communal well-being and money, certainly gestured toward antiquity, but it also possessed particular significance in the mid-1420s. As always, the survival of Florence's form of government depended on the amassing of money through taxation, but in the

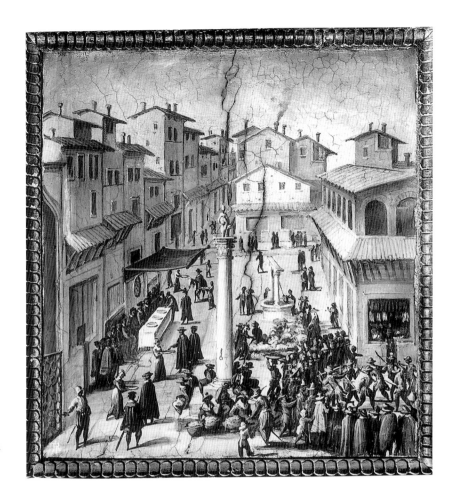

Figure 1.1

Joannes Stradanus, *Mercato Vecchio*, 1585–87. Fresco. Sala del Gualdrada, Palazzo Vecchio, Florence

Figure 1.2

Anonymous, *Mercato Vecchio*, late sixteenth–early seventeenth century. Oil on canvas. Berini Collection, Calenzano

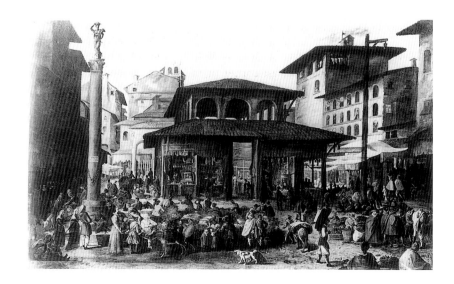

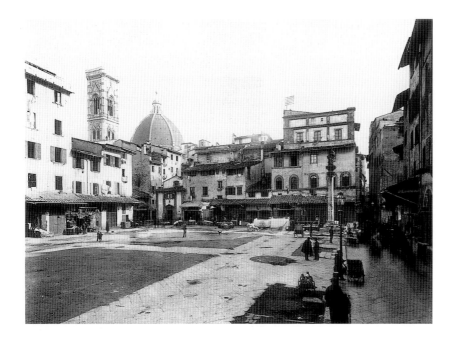

Figure 1.3
Anonymous, *Mercato Vecchio*
(late eighteenth century *Dovizia*
by Giovanni Battista Foggini
visible at right), before 1883.
Photograph. Alinari, Florence

first three decades of the fifteenth century the issue of government funding dominated public political discourse. Enervated by internal dissent and threatened by external attack, the oligarchic regime that had ruled Florence since 1382 oversaw a radical remaking of the relationship between individual and state, culminating in the introduction of a new tax code, the *catasto*, in 1427. Changing the fiscal image of the state, this new mode of taxation sought to equalize and regulate monetary relations to the central government. These relations were ordered and given visible economic and bureaucratic form.[2]

Within this broad context, it is hardly surprising that the oligarchy would have chosen, in the late 1420s, to permit the erection of a monument celebrating "wealth" in the bustling commercial heart of the city, the Mercato Vecchio (figs. 1.1–1.3).[3] An antique column, transferred from the cathedral works, was set in the southeast corner of the piazza, and on it was placed Donatello's statue of *Dovizia*. A corrupted form of the Latin *divitiae*, *Dovizia* meant "riches" or "wealth." The statue is no longer extant, but we know from visual and textual descriptions that it comprised a female figure in a loose, flowing gown, bearing a cornucopia in her left arm and, with her right, balancing a laden basket on her head. Iconographically the statue referred explicitly to abundance and plenty, and, allegorically and via antique visual precedents, to well-known personifications of these concepts such as Abundantia and Copia. Eaten away by the elements, Donatello's sandstone *Dovizia* crumbled to bits and was replaced in the late eighteenth century by a new version of the subject by Giovanni Battista Foggini (fig. 1.3).[4]

Given the importance of "wealth" to the republic, the decision to give this concept concrete form, seems, in retrospect, quite ordinary. But Donatello's statue, its column, and their site were all, in fact, extraordinary.[5] The *Dovizia* itself, as Sarah Blake McHam has underscored, can be seen as the first truly Renaissance statue in the sense set forth by Erwin Panofsky; that is, it combines ancient visual forms with ancient content.[6] This formal and iconographic novelty is compounded by the column, the *colonna d'Abbondanza* as it would later be called. Though not the first antique column to be raised in the city, this one, harking more insistently back to Roman monuments, was the first to receive monumental figural decoration. The formal innovation of the sculpture and its lofty pedestal combine to make the *Dovizia* one of the most important works of fifteenth-century Florentine art. It also, on account of its site and probable patronage, represents a watershed in Florentine political history.

It is my contention that the *Dovizia* made politics visual in a novel and striking manner, doing so in a particular spatial and ideological context. Under the oligarchic government of Florence, this monument was placed neither in a traditionally civic space, nor in front of a civic or communal structure. Rather, the *Dovizia* rose up in the thriving central market square of the city (fig. 1.2). The Mercato Vecchio was not circled by civic institutions, religious or secular. It was, instead, Florence's major produce market and banking center. Although other monumental public sculpture graced Florence's public spaces—especially the piazza del Duomo—I argue that the particular visual, spatial, and ideological context within which the *Dovizia* was produced and beheld defined a new, political role for public art. At stake was the definition of public space, and, more specifically, the way in which politics and art produced public space.

Since the late fourteenth century, Florentines had spent enormous sums decorating civic and, especially, religious structures, including the cathedral, the campanile, the baptistery, and the shrine of Orsanmichele. These decorative programs, which were certainly fueled by civic motivations and can be read as conveying certain ideologies, were not, I would like to claim, explicitly political. This is not an iconographical determination. Sculptures like Donatello's prophets for the campanile, Ghiberti's bronze doors for the baptistery, and the revolutionary patron saints on Orsanmichele, as well as other similar commissions of this period, were all continuations of earlier decorative projects, were all—fundamentally—funded through guild patronage, and all served, primarily, religious functions. If one wishes to contextualize these programs, one must look to the social, political, and religious circum-

stances of the early fourteenth, rather than the early fifteenth, century. It is, I confess, tempting to read the general trend toward an *all'antica* style in these works as reflecting a burgeoning sense of republican liberty in the writings of politically engaged humanists—that is, to what Hans Baron has called Civic Humanism. Nonetheless, this convenient sociological and political explanation for the works of Ghiberti, Nanni di Banco, and, above all, Donatello assumes a mechanistic interpretation of the relation between cultural products and political context. While historians are still perhaps reacting too extremely to Baron's cultural political theories, recent emphasis on the tenuousness of the connections between humanist culture and Florentine politics serves as a useful reminder to foreground the mediated relation between politics and artistic style. What is more, in the case of the early Renaissance sculpture that has most often attracted loosely "political" analysis, the stylistic affinities between the artists just mentioned are hardly so great as to warrant linking them in a global and politicized style. Rather than thinking of these works as political, therefore, I would suggest that their status might be better described as civic.[7]

In attempting to define political art in a focused manner, it is also necessary to take site into account. Before the appearance of the *Dovizia* in the Mercato Vecchio, little explicitly political imagery was to be seen in Florence's public spaces. By 1416, Donatello's marble *David* (fig. 4.10), supplemented by patriotic inscriptions, had been placed in the city hall, later called the Palazzo Vecchio.[8] Some, following Manfred Wundram, believe this statue to have been produced for this site, while others follow the broadly held opinion that Donatello's marble *David* was originally intended to adorn a buttress on the north tribune of the cathedral.[9] Even if the statue were made to serve a distinctly political function, it did not function to represent the city or its government to a wider public. It marked a political space, and perhaps proffered to the individuals making up the Florentine government a talismanic image presiding over political debate. Donatello's marble *David* falls within a well-established tradition of political imagery, hortatory pictures in city halls, relaying moral codes to the elected officials who passed through such buildings.[10] Thus, while the *David* can be seen as political both iconographically and intentionally, it did not operate within the public sphere, and therefore did not address a potentially wide spectrum of beholders in the manner I wish to focus on as essential to the novel political art of fifteenth-century Florence.

The only public sculpture predating the *Dovizia* monument that can perhaps be called political in the sense I seek to develop was a sandstone *Marzocco*, or Florentine Lion, set on the ceremonial platform outside the Palazzo

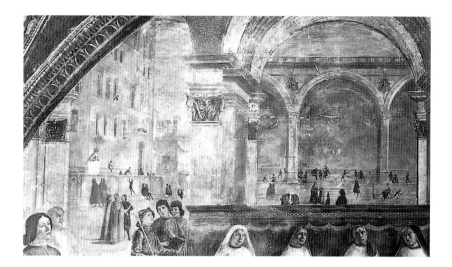

Figure 1.4
Domenico Ghirlandaio,
Confirmation of the Rule, 1479–85.
Fresco. Sassetti Chapel, Santa
Trinita, Florence, detail

Vecchio before 1377 (fig. 1.4).[11] This most important manifestation of the *Marzocco* possesses a pivotal position in the history of Florentine political symbolism. Presiding over civic ceremonies, the *leone di piazza* offered Florentines a composite and zoomorphic icon of their state, condensing into a quasi-heraldic mascot with Guelfic associations the qualities of courage, clemency, ferocity, and wisdom. Emerging from the practice of keeping live lions at civically sensitive areas of the city, the *Marzocchi* were in general, both within the city and without, intended to function as imperial markers, representing Florence's transition from a city to a state.

Beyond the *leone di piazza* very little sculpture visible in Florence during the first decades of the fifteenth century can claim to be political. While I do wish to establish a threshold defining and separating political art from art that can be interpreted politically, I do recognize that interpretation can and ought to traverse this boundary. A case in point is Mary Bergstein's fascinating study of a project that would have expressed a political message through a religious statue.[12] Bergstein draws attention to the plans to commission a statue of Santa Maria del Fiore, Florence's particular version of the Virgin Mary, to be set on the façade of the city's cathedral. Bergstein argues, convincingly, that the floral nomenclature, first developed in the late thirteenth century and reasserted in 1412, possessed civic implications. Mary, linguistically and theologically long associated with flowers and, especially, the lily of the Annunciation, was linked to the *giglio fiorentino* or Florentine "lily." Thus, the maternal Mary armed with her ambivalent flower could, metaphorically, be read as a religiously inflected personification of the state, a female Florentia. The Signoria's project was, so far as we know, never brought to comple-

tion, and Bergstein suggests how the patriotic fire driving this endeavor might have been quenched by Nanni di Banco's *Assumption of the Virgin* above the Porta della Mandorla on the north side of the cathedral, and, especially, by Brunelleschi's cupola, which Bergstein sees as signaling a Renaissance privileging of architectural magnificence as a means of political expression over a medieval mode of monumental sculptural personification. The compelling evidence compiled by Bergstein describing the oligarchy's desire to personify the state and its project to animate patriotic emotions through monumental sculpture does not, however, lead so insistently away from sculptural embodiments and so pointedly to the cathedral's dome. For if the quasi-governmental Arte della Lana never came to commission the statue of Santa Maria del Fiore for the cathedral's façade, the oligarchical regime of Florence did, albeit a decade and a half later, preside over Donatello's production of a monumental sculpture, the *Dovizia*, that fulfilled many of the political desires described so trenchantly by Bergstein.[13]

The *Dovizia* was not only the first monumental statue to have displayed the fusion of antique style and subject matter that would, to many, define the period called the Renaissance, but it also inaugurated a long and complex chapter in the history of Florentine civic statuary, some of which will be considered later in this study. More specifically, the statue was the only explicitly political, monumental, and public expression of the oligarchic government that ruled Florence between 1382 and 1434, at which time Cosimo de' Medici returned from exile, banished his opponents, and redefined the structure of political authority in the city. As such, the *Dovizia* is a natural point at which to initiate a discussion of fifteenth-century political art. What is more, by triggering a cultural dialogue within what can be defined, drawing on Jürgen Habermas, as an "autonomous" public space, developed outside of the traditional urban loci of civic authority, the monument produced a new and influential paradigm of political space. Finally, the *Dovizia* reminds us that at its inauguration in the Renaissance, Florentine political art set gender center stage. The concept "gender" ought not to be adduced simply because the statue represents a female personification; rather, the *Dovizia* uses the gender of this symbolic figure to further its message. It is therefore apt to begin this study—addressing the intersection of art, gender, and politics in the public sphere—with a closer look at Donatello's *Dovizia*.

The primary symbolic message of this prominent, ambitious, and freestanding statue is not difficult to decipher. The *Dovizia*'s plentiful burden was

clearly intended to reflect the commercial and agricultural abundance of the market below, but the statue also signified metaphorically, linking the sculpted harvest to the literal *divitiae* or riches of Florence (preeminently visible in the Mercato Vecchio, lined as it was by the "tables" of the major Florentine banks). The female figure bearing this bounty was similarly coded, both as an emblem of the labor and exchange that fueled the real economy of the city, and as a metaphoric personification of the city's assets, if not the city itself. For the statue represents the concepts of wealth and abundance while operating within what Donald Weinstein has called "The Myth of Florence."[14] The statue was a memorial, reminding Florentines not only of their city's ancient past, but also "the time when Florence / Flourished and bore fruit," as Latini referred to the city's late medieval "Golden Age."

The interpretation here presented seeks to complement the existing literature on the *Dovizia*, which has helped to reconstruct the lost sculpture and has offered political explanations of the statue's iconography. In his extraordinary 1934 monograph on Donatello, Hans Kauffmann established the general appearance of the lost work.[15] It was only in 1983, however, that David Wilkins produced a more thorough investigation of the *Dovizia*. In his comprehensive article, Wilkins offered not only a painstaking reconstruction of the sculpture, but also a persuasive interpretation of its meaning. Reviewing a number of painted views of the Mercato Vecchio and scrutinizing a handful of sculpted responses to the *Dovizia*, Wilkins managed to evoke a sharp image of how Donatello's statue would have appeared. His work was paralleled by that of Masahiko Mori, who, studying much of the same material, also contributed to the imaginative reconstruction of the sculpture and its physical context. The two analyses are, however, quite different. Whereas Mori carefully avoided a political reading of the *Dovizia*, Wilkins, while recognizing the polysemy of the statue, emphasized a political and humanistic reading. He suggested that Leonardo Bruni, the scholarly Chancellor of Florence, may have devised its iconography. Basing this claim and his wider political interpretation on the writings of Hans Baron, who had explored the shift between the exultation of poverty in the fourteenth century and the promotion of theories extolling wealth that developed, following ancient models, in the fifteenth century, Wilkins saw the statue as embodying the inseparable concepts of Civic Wealth and Civic Charity. In her 1986 article Sarah Blake McHam developed this aspect of Wilkins's interpretation. She set similar stress on Baron's description of the revaluation of wealth under humanism, but she linked Donatello's *Dovizia* more tightly to antique visual and cultural precedents, specifically focusing on the model of Trajan. To both Wilkins and McHam the *Dovizia* furnished fifteenth-century Florentines with an ideal

image of abundance and charity *all'antica*. On this view, the statue functioned to provide the state with ideological support at a moment of great need, while wars and financial crises threatened the stability and liberty of Florence.[16]

Building on the existing political interpretations of the statue, and following especially some paths suggested by Wilkins's rich article, this chapter addresses the manner in which the *Dovizia* rendered politics visual, producing an image of the state. My reading is, however, less concerned with understanding the monument in terms of contemporary Civic Humanism—Baron's concept describing the ideological engagement of humanist writers in promoting an active and participatory republicanism—than with exploring how the statue's recuperable visual characteristics may have operated within contemporary visual categories, cultural poetics, and political circumstances.[17] Like Minerbetti's Sallustian expression, the *Dovizia* must be seen as evoking antiquity, but in a very "modern" context. For I do not wish to imagine the rarefied cultural intentions driving the production of the monument independently of the work's operation within popular culture. Essential to constructing this bridge between the elite and popular meanings of the *Dovizia* is an understanding of the political circumstances in which the statue was produced, the significance and social consistency of the physical site in which it was displayed, and the manner in which its form rendered political ideals within a symbolic framework based on assumed definitions of gender-appropriate behavior. Studying the *Dovizia* one witnesses the complex intertwining of corporeal and political symbolism in the visual field.

A female figure bearing fruits and vegetables, the statue exemplifying abundance presented an image of Florence as the "flourishing flower that flowers" (to reformulate the civic leonine couplet cited at the head of this chapter). In so doing, it communicated to the public below not only abstract notions of plenitude, but also a concrete picture of the "common wealth." For in the *Dovizia*—I argue—money and politics collapsed together, yielding a prototypical Debordian accumulation, a spectacular image. The unified identity of citizens as *fiorentini* (Florentines) was guaranteed through the fruitful power of *fiorini* (florins), the coinage of the republic and, at this time, the most powerful currency in, and to some degree beyond, Europe. Donatello's powerful rendition of wealth sought to encourage civic unity by visualizing a common denomination understood and respected by all but a few Florentines. The dynamic figure of wealth bore fruit; it is worth recalling that to the medieval businessman, the Latin word *fructus* (literally, fruit) meant profit. The statue, rising amid the busy tables of Florence's international bankers, embodied in a particularly direct manner the dynamic nature of capital.

27

The need for this ideological unification around the concept of burgeoning capital derived from the factional strife that plagued Florence during the 1420s, and that, eventually, led to the domination of the Medici faction in 1434. In my analysis the statue parallels the increasing economic centralization of the Florentine state in the 1420s, leading to the institution of the *catasto*, the revolutionary tax code that aimed at redressing the fiscal imbalances resulting from Florence's long military struggles, especially against Milan. In a broader, sociological sense, the *catasto* sought to erode neighborhood relations and forge citywide sodalities wrought through class, rather than place.[18] The *catasto* and these new urban social geographies were ideals, rather than realities; the former did not effectively balance taxation, and the latter did not replace the familial, local, and cliental relations that survived in modified form. But these ideals did, nonetheless, effect a meaningful alteration in the ideological image of the city-state, which, rather than comprising a set of "corporate" subgroups, was increasingly perceived as a systemic whole. The *Dovizia* staked out the center of this integral image of the city-state and offered to all citizen-spectators a focus for their patriotic affections. It is my contention that the attraction of such attention was visually encoded in the statue itself, especially in its rendition of gender and in its evocation of an antique past. Visualizing the "common wealth" of Florence and its inhabitants, the *Dovizia* exhorted citizens to band together around an ancient and feminine image of their *res publica* and of its weal(th). In Minerbetti's terms Donatello's *Dovizia* represented the civic dialectic of *salus* and *pecunia*.

Because this argument rests on the appearance of the lost monument, I must first reconsider the existing representations of the statue, the public space in which it was displayed, and the column on which it rested. Having put forward some new interpretations of the statue's visual and spatial operations, I shall advance an account of how successive artists availed themselves of Donatello's model, in an attempt to anchor my interpretation of the statue's visual meaning in a set of extant Renaissance visual responses.

Reconstruction of the lost statue has always entailed considering how later artists responded to it. The corpus of fifteenth-century responses is relatively large, indicating the importance of the *Dovizia* both to later artists, and, perhaps, to Florentines in general. Moving away from a Panofskian analysis of sources, I would like instead to establish a particular link, between the *Dovizia* and the figure called by Aby Warburg the *Nympha*, or *ninfa fiorentina*, which he interpreted as revealing an essential dualism in the Renaissance's response to classical antiquity. Drawing on Warburg's discussion of the *Nympha* and on the visual trope associated with that figure, *bewegtes Beiwerk* or

"animated accessories," I recognize in the *Dovizia* a key inaugural moment in the history of Renaissance art. Subsequent artists turned to the statue often, adapting its "visual antiquity" to serve new goals. In so doing, they offered material interpretations of Donatello's statue that help us not only to imagine the sculpture's original appearance, but also to access the contextual and diachronic meanings attributed to the statue by those who beheld it; the responses also suggest how the gender of the *Dovizia* helped to amplify its evocations of fecundity and antiquity. Taking these interpretations into account, the placement of the statue at the heart of the commune, as well as contemporary political rhetoric and symbolism, I contend that the *Dovizia* can be read, on one level, as an embodiment of the city, as Florentia or as Donna Fiorenza. Evolving from the "female" iconographies of Salus, Abundantia, Alimenta, and Caritas, the *Dovizia*, in a manner analogous to ancient genii, as Kauffman suggests, and *tyches*, as Wilkins proposes, appears as an embodiment of Florence. This expressive personification in the Mercato Vecchio promoted a centralized image of the state, in which the inhabitants of Florence were granted equal visual access to a charismatic political body.[19]

To conclude, I contextualize my visual and iconographical analyses by turning to the political discourses that bracketed and, I would like to hypothesize, yielded the statue's production. Considering the lively political events of the 1420s and the rhetoric that characterized the debates about war, taxes, and factionalism, I venture to understand the collective motivations that led the government to undertake such a remarkable project. Finally, I also examine how these desires were registered in the subject matter and appearance of the statue itself.

The Statue, Its Column, and Their Site

In his *Panegyric to the City of Florence*, Leonardo Bruni imagined the Florentine state as a buckler or shield consisting of a series of concentric circles, defining both its scope and its center. Within these rings, Bruni writes that "Florence is first, similar to the central knob, the center of the whole orbit." This literary image of the city conformed to an emerging sense of Florence as a centralized state. The city's relationship to its colonial holdings, or *contado*, was no longer organic and flexible, but rather regimented and regulated. For in becoming the center of a state, the city itself came to be imagined as a discrete political entity.[20]

This novel autonomy—encapsulated in Bruni's target-like literary image—can be witnessed in fifteenth-century representations of the city. Especially informative are the manuscript illustrations of Jacopo d'Angiolo's

1406 translation of Ptolemy's *Geography* (fig. 1.5). The surviving copies, produced between 1469 and 1472, contain bird's-eye views of Florence from the north, showing only select buildings and sites. They specify, therefore, not so much a physical as a symbolic topography, constructing the fifteenth-century city in a hierarchical manner. Near the center of these illustrations, the column and the *Dovizia* mark the space labeled, explicitly, as the *vetus forum* (the old forum), or the Mercato Vecchio. The scale of the column is exaggerated in the Ptolemy manuscripts, emphasizing the monument's urban centrality and symbolic importance relative to other sites. This visual hyperbole also

characterizes the representation of the column on the so-called *Chain Map* (fig. 1.6). A view from the southwest, this late fifteenth-century woodcut, which reflects a lost engraving from the workshop of Francesco Rosselli, shows the *Dovizia* elevated well above the surrounding architecture and above the city over which she seems to preside.[21]

These panoramic views of the city render it as a discrete whole, and they draw attention to the key position of the *Dovizia* within this mental image. Both views—that found in Ptolemy's *Geography* and the *Chain Map*—emphasize the embracing and defining walls that separated the city from the surrounding countryside. These images stress a unified conception of the city and reflect, perhaps, the ideal of citywide, rather than local or neighborhood, affiliation.[22] In the woodcut, the visual field containing Florence is bounded by a chain. The represented links frame the image and produce a notion of the city as an autonomous and measurable whole. The inclusion of a prominent lock signals, perhaps, the viewer's power to possess the valuable city, albeit in representation. The figure of the draughtsman in the lower right captures the city optically, just as the chain signals the viewer's rights to visual control over the image of Florence that he or she had purchased. This visual economy also offers to every spectator a cohesive and circumscribed representation of Fiorenza (as Florence was often called throughout the period and as the city is labeled on the *Chain Map*).

The construction of the city as a single, integral form in these fifteenth-century views, although not mirroring actual circumstances, did serve to visualize actual cultural desires. The function of the *Dovizia* in these images, and in the imagined city, was centripetal. It served to highlight a charismatic center of Fiorenza, providing a locus of shared access and attention. It provides a figurated spatial center, balancing the architecturally dominated spaces embracing the cathedral and heralding the town hall. In order to understand the political dimensions of this imagined centralization we must first try to gauge what struck contemporary beholders as important about the

Dovizia's appearance while seeking to understand more precisely the symbolic, spatial, and social coding of its site.

The Mercato Vecchio (or Old Market) was adjectivally modified not only to distinguish it from the New Market, a few paces to the south, but also to signal its antiquity.[23] So much is apparent from the other name for the Mercato Vecchio, indicated on some of the contemporary maps and views: *vetus forum*. Nestled at the intersection of the *cardo maximus* and *decumanus maximus* of the Roman colony of Florentia, the Mercato Vecchio was a medieval redaction of the city's original forum.

As with many such Roman foundations, a column—a symbolic substitute for the surveyor's *groma*—marked the center of the plantation. Upon these columns were set *genii*, symbolically embodying the new foundation and, in some sense, operating as apotropaic charms to ensure communal good fortune. These talismanic sprites often took the form of winged, adolescent boys bearing a cornucopia or a cup of wine, although female versions are recorded.[24] Excavations undertaken in the nineteenth century, when the *colonna d'Abbondanza* was removed during the urban project that yielded the piazza della Repubblica, revealed the base of an older column below, suggesting that Romans in ancient Florentia likely had gathered around a columnar monument. What is more, this ancient column might very well have supported a *genius loci*, since a statue pedestal, now in the Museo Archeologico in Florence and said to have been found in the Mercato Vecchio, bears an inscription suggesting that it once carried the genius of Florentia: GENIO. COLONIAE / FLORENTIAE / (AT)T(I)DIVS / (MEDIC)VS.[25] That the *Dovizia* mon-

ument was set squarely over the site of an ancient, genius-bearing column provides curious, if insubstantial, evidence that Donatello's statue, as Kauffmann mentioned, functioned as a modern, female "genius": an auspicious representation of the city and its fortune.[26] In fact, Filarete, in his *Treatise on Architecture* from the 1460s, discusses the main piazza of his ideal city, advising that "a tall column twenty or twenty-two *braccia* tall should be raised . . . with a figure of the goddess Copia on top. . . . The goddess should have a basket full of fruits on her head and in her hand a horn full of fruits that spill out like the fruits in the basket."[27] Both Filarete's imaginary monument and the *Dovizia* reflect the desire to inscribe a civic relation to antiquity and to invest the column, statue, and market with some of the glory associated with Roman origins.

If the site contributed to the visual antiquity of the *Dovizia*, so too did the column on which Donatello's statue stood. Not only was the column itself antique, but the iconography of the figurated column was itself endowed with meanings that called up memories of ancient times.

The monument in the Mercato Vecchio was not the first column to have been erected in Florence's public spaces; nonetheless, its position and size did set it apart from its predecessors. In 1245 a small column capped by a cross was set up at the subsequently named Croce al Trebbio. This memorial, tucked into a small piazza just a few steps from the Dominican friary of Santa Maria Novella, recorded a victory against the Patarenes and possessed a distinctly religious significance. In 1381, not long before the *Dovizia* was set on its column, a similar monumental column was set in the piazza before Santa Felicita. It, however, only received figural decoration in the late fifteenth century, when a statue of Saint Peter Martyr was set upon it. Another column was, in fact, visible in the Mercato Vecchio before the *Dovizia*'s column was given by the Opera del Duomo to the Ufficiali della Torre. Shortly before 1426, however, it was moved to the piazza in front of San Felice in Oltrarno.[28]

Such columns—as well as those in other Italian cities—often supported Christian symbols and figures.[29] These columnar monuments all referred to antiquity, not only because they often were Roman *spolia*, but also, as Werner Haftmann in his exemplary study demonstrated, the iconography of the figurated columns—*Saülenmonumente*—came to represent, in a privileged fashion, ancient culture. The reception of this reference could differ dramatically. During the Middle Ages, the column with a statue referred to the pagan cults of the antique world. The toppling of the column, or the figure from the column, became a favored means of illustrating the triumph of Christianity over the idolatry of the ancients. Although this iconography remained popular, humanist promotion of *Romanitas* as a cultural ideal led to a re-evaluation

and revaluation of signs like the figured column. No longer only an evil sign of idolatry, the figured column also became a positive marker of civic virtue. In both interpretations, Christian and humanistic, the figured column implied antiquity. In Renaissance art, the presence of such a monument almost automatically suggested Roman presence (be it valued positively or negatively).[30]

The siting and the basic configuration of the *Dovizia* monument insist upon the *Romanitas* both of the Mercato Vecchio, and, synecdochically, of the city. This desire to assert Florentine antiquity fits easily into existing interpretations of early Renaissance art as visualizing the Civic Humanism theorized by Baron. On this view, the *Dovizia* served to remind citizens of their notional role as inheritors of Roman republican traditions. But if this visual ideology seems fixed when considering the column and its location, it becomes far more equivocal when one turns to the statue that capped the monument.

As of yet, no documents directly bearing upon the commission of Donatello's *Dovizia* have come to light. In 1984, however, Margaret Haines did rediscover three documents recording the transportation of the column upon which the statue would be placed. These reveal that on 12 May 1429, the Ufficiali della Torre received written confirmation that they, perhaps in response to a lost request, would indeed receive a roughly six-meter-long marble column from the Opera del Duomo and the Arte della Lana (the guild responsible for work on the cathedral). The documents further inform that the column was erected in the Mercato Vecchio in April of 1430. It is likely, but not written in stone, that Donatello was commissioned to produce the statue in 1429 and that it was set on the column before Donatello left for Lucca during spring of the following year.[31]

Most of the early sources for the Dovizia mention that the statue was sculpted in *pietra serena*. This local sandstone did not lend itself to detail and was not a particularly hardy medium. Nonetheless, quarried in Tuscany, it was materially tied to the Florentine state and was thus a fitting choice for civic statuary like the *Dovizia*.[32]

The decision to hire Donatello to sculpt the civic *Dovizia* is hardly surprising: by 1416 his explicitly civic marble *David* was to be seen inside the Palazzo Vecchio, before a blue backdrop spangled with silver Florentine flowers and with patriotic verses attached; in 1419, when the newly elected Pope Martin V began his long sojourn in Florence, it was Donatello who sculpted a *Marzocco*—again in civically coded sandstone—perched on a column decorating the stairs to the pope's apartments in Santa Maria Novella; and it was

Donatello who, in the 1420s, produced the politically charged representation of Saint Louis of Toulouse for the Parte Guelfa's niche on the east façade of Orsanmichele.[33] Already established as a sculptor of politically sensitive statues, Donatello was an obvious choice for the *Dovizia* commission. What is more, given the desire to highlight the antiquity of the Mercato Vecchio implicit in the choice of a columnar monument, it is likely that Donatello's facility in mimicking Roman forms in his sculpture would have appealed to those who controlled the project.

For whom Donatello worked is, however, unknown. The active role played by the Ufficiali della Torre does suggest direct governmental involvement.[34] Although other organizations often contributed to the decoration of civically coded buildings and spaces, such urban monuments and their spaces were more properly the responsibility of the central government. Without further evidence it is impossible to be more precise. What can be said is that, given the involvement of the Ufficiali della Torre and the prominent siting of the monument, the government must surely have approved of the *Dovizia*. If so, to what meanings were they subscribing in permitting this very direct expression of Florentine wealth and abundance to be erected in the city's major market? As I have suggested, the monument does, to my mind, reflect the development of the Florentine state as a centralized entity. But this is clearly not how Florentines would have reacted to the work. In order to imagine some possible fifteenth-century responses to the *Dovizia*, I will now turn to how other artists interpreted Donatello's striding female personification.

The Afterlife of Donatello's *Dovizia*

In his careful methodological treatise *Patterns of Intention*, Michael Baxandall bemoans the "wrong-headed grammatical prejudice about who is the agent and who is the patient" in art criticism. Rather than imbuing certain works of art with an illogical and ungraspable power to influence their successors, Baxandall entreats art historians to develop a broader vocabulary for discussing the appropriation and interpretation of models.[35] Traditional art historical language, he claims, tends to privilege the misleading concept of "influence," stressing the power of the prototype over its successors. In reconstructing the *Dovizia* by considering artistic responses to the monumental statue, Baxandall's observation helps us to discern a diachronic meaning based in a history of receptions. For meaning in this analysis is not equated with a numinous power emanating from patrons, artists, or forms, but rather with that which arises from subsequent readings, taking place within parameters established by patrons, artists, and forms.

Reconstructions of the *Dovizia* propose that Donatello's embodiment

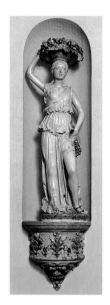

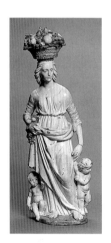

of wealth took the form of a young woman in a loose-fitting garment, stepping forth, as if into a breeze. In her left arm she bore a cornucopia, while with her right she supported a basket of fruit perched on her head. A mediated image of the lost statue emerges from a curious set of della Robbia statuettes, customarily dated between 1500 and 1520 (for example, figs. 1.7–1.11).[36] That they all refer to Donatello's statue is unmistakable. Although they all differ slightly from one another, and, apparently, from their source, they do possess enough shared features to classify them as renditions of "Dovizia" and as responses to Donatello's monumental version of the theme. Three of the statuettes even bear inscriptions identifying their subject as "Dovizia," albeit indirectly: GLORIA • ETDIVITIE / IN • DOMOTVA, that is, "Glory and riches be in your home."[37]

These works clearly refer to Donatello's *Dovizia*, providing a consistent image of a dynamic female figure, bearing fruit and dressed in agitated, classicizing robes. All but one of the terracotta statuettes show "Dovizia" with a basket on her head. This basket is filled with fruit: grapes, pears, apples, lemons, etc. Almost all of the figures raise a right arm to support this sometimes enormous load. These also reveal a slightly crooked left arm, in which most of the *Dovizie* cradle a cornucopia brimming with produce. The refracted image of Donatello's *Dovizia* projected by the statuettes can be fleshed out by considering some other versions of the iconography. Wilkins, McHam, and Mori all study details of paintings that can be associated with the *Dovizia*: the famous cityscape now in Baltimore in which one of the female personifications of the virtues perching on columns—bearing a basket and a cornucopia—calls to mind the iconography (fig. 1.13); the fresco of the Mercato Vecchio in the Sala del Gualdrada of the Palazzo Vecchio (fig. 1.1); Vasari's *Preaching of Saint Peter Martyr in the Mercato Vecchio* in the Vatican; and a couple of later, sixteenth- and seventeenth-century views of the market (for example, fig. 1.2). Other representations focus on the figure of *Dovizia* itself, outside of a monumental context. Striding women with baskets on their heads and possessing very similar iconographic coding appear repeatedly in Florentine art, in independent paintings (fig. 1.14), in engravings (fig. 1.15), and in drawings (fig. 1.19). None of these can, I think, claim to represent, faithfully, the *Dovizia*, but all respond to Donatello's work and confirm a basic iconographic reconstruction of the lost statue. Formally, the configuration of arms bearing cornucopia and basket constantly produces an elegant S-curve. The torsion of the upper body is matched by dynamic legs. These *Dovizie* all share an engaging motility; the figures are all shown stepping forward, their bodies caught in a series of balanced opposites: one leg forward, the other back, one arm raised, the other akimbo (or tugging at fabric, or a child). In

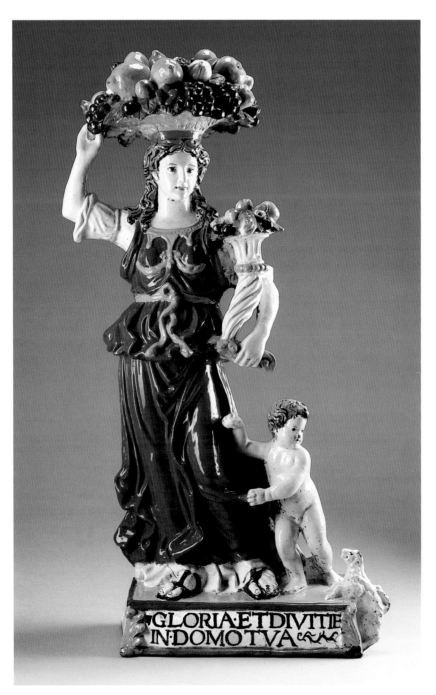

Figure 1.9
Giovanni della Robbia, *Dovizia*,
c. 1494–1513? Glazed terracotta. The
Minneapolis Institute of Arts, The
William Hood Dunwoody Fund

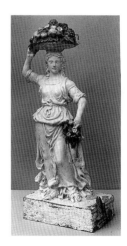

Figure 1.10
Workshop of Giovanni della
Robbia, *Dovizia*, c. 1494–1513?
Glazed terracotta. The
Metropolitan Museum of Art,
New York, from the Collection
of James Stillman, Gift of
Dr. Ernest G. Stillman, 1922
(22.16.6)

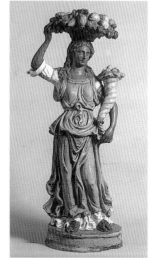

Figure 1.11
Workshop of Giovanni della
Robbia, *Dovizia*, c. 1494–1513?
Glazed terracotta. Museum of
Fine Arts, Boston, gift of Mrs.
Albert J. Beveridge in memory
of Delia Spencer Field
(Mrs. Marshall Field) (46.840)

Figure 1.12
Detail of 1.2

the della Robbia statuettes this pose is quite pronounced, suggesting not only imminent, but also immanent movement. The figures are implicitly dynamic, but their internal compositions also attract and occupy the viewer's eye.

This implied dynamism becomes even more evident in the painted views of the statue. In one (fig. 1.12) we see the left thigh of the *Dovizia* set forward; in others, the figure's dress flutters behind her, suggesting her pace (fig. 1.13). Although the statuettes lack some of this virtual motion, in most the treatment of drapery causes the beholder to attribute to them, and therefore to their lost model, ambulatory dynamism. Indeed, beyond the iconographic details, it is this aspect of the *Dovizia* that would appear to have most interested the artists who produced the terracotta statuettes and the painted renditions of the statue.

The type of garb on these sculpted and painted figures is also extraordinary. The represented clothing would have struck Florentines—both in the 1430s and at the turn of the sixteenth century—as remarkable. Rather than the stiff fabrics of contemporary fashion, these *Dovizie* wear loose-fitting garments with wide, revealing necklines (a comparison with the clothing visible in contemporary portraits bears this out). Particularly noteworthy are the high waistlines formed by fabric folded and bunched at the hips, producing a visual emphasis on breasts and midriff that would seem to have been intended to underscore the figure's symbolic fertility.[38] Although the treatment fabric differs from one work to the other, in general it is marked by its distinctive animation, suggesting the movement of the figure, or the gusting of wind. The garment swirls behind the figure and clings to its surface so as to permit the spectator a mediated view of the limbs beneath. In one of the terracotta figures (fig. 1.7), the *Dovizia*'s left leg emerges from beneath her "peplos" (which has also slipped from her right shoulder, revealing one breast).[39] All the known responses to the *Dovizia* seem to value the manner in which Donatello managed to suggest the corporeality of his figure through the representation of loose and fluttering fabric, at once revealing and hiding the feminine form beneath. Donatello had already experimented with this type of drapery

Figure 1.13
Anonymous, *Ideal Cityscape*,
c. 1470. Tempera on panel.
Walters Art Museum, Baltimore,
detail

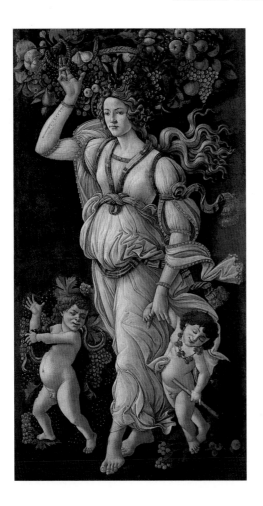

Figure 1.14
School of Botticelli, *Allegory of Drunkenness/Autumn*, c. 1490. Oil and tempera on canvas. Musée Condé, Chantilly

in his relief for the tabernacle of Saint George on Orsanmichele. It has long been recognized that the distinctive agitation of the drapery describing the figural form of damsel rescued by the hero was derived from ancient sculpture.[40] Given the similar qualities seen in the della Robbia terracotta statuettes, it seems likely that the drapery of the princess in the St. George relief and the *Dovizia* represent Donatello's attempts to explore the linear and expressive treatment of fabric he had seen in antique relief sculpture. It was especially to this feature of the *Dovizia* that artists would turn again and again, seeking to invest their figures with the "visual antiquity," and some of the iconographic significance, of the *Dovizia*.

The terracotta statuettes that clearly refer to Donatello's lost *Dovizia* do not reproduce it in a dogmatic fashion; rather, they imitate it creatively, each following and departing from the monumental statue's form. The undulation between imitation and invention reveals a process of artistic interpretation.

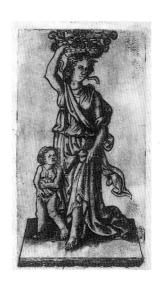

Figure 1.15
Anonymous, *Dovizia*, c. 1470. Engraving. Kupferstichkabinett, Berlin

The moments of fidelity to a model and decisions to depart from a model's form cannot simply be read in terms of serendipitous action or as technically determined; artistic production is a deliberate process and demands to be seen as such. In this instance, interpretation is made complex by the lack of an existing model. Taking the terracotta statuettes as a group, therefore, one must reconstruct through their shared features the dissolved prototype. This does yield a consistent if blurred image. But given their varied appearances, the terracotta statuettes, although resembling the *Dovizia*, certainly differed from it. Departing from their model, the artists who produced the statuettes offered a type of visual commentary on the *Dovizia*.

Comparing the statuettes to the painted images of Donatello's *Dovizia*, one iconographic detail leaps to one's attention. Half of the della Robbia statuettes include young children (for example, figs. 1.8 and 1.9) and three include a small animal—one a lizard (fig. 1.10), and two others a marten or a dog (for example, fig. 1.9). These details do not appear in the painted views, nor are they mentioned in any textual description of the monumental statue.[41] The inclusion of naked children has led commentators to read in these statuettes an iconographic hybrid, mixing Abundance/Dovizia with Charity; this, then, has been, implicitly, used to support an interpretation of the *Dovizia* as an embodiment of Charity.[42] While this certainly is an element running through the *Dovizia* and the subsequent visual responses to that sculpture by other artists, the reception of Donatello's statue, broadly conceived, reveals that it was also, if not preeminently, associated with fertility. For this reason, the children appearing in the terracotta statuettes may have referred more directly to female procreativity than to humanistic conceptions of Charity.[43]

In the case of the *Dovizia,* Baxandall's desired inversion has, in part, been fulfilled. In the terracotta copies, both Wilkins and McHam interpreted the appearance of children hanging on to the protagonist as revealing meanings inherent in their monumental prototype, emphasizing the theme of Charity. Nonetheless, the function of these terracottas and the broader manner in which artists drew on Donatello's statue have not been fully addressed. In order to bring to the fore the interpretative activity of artists who responded to the *Dovizia* as a model, a preliminary question must be posed: to what degree does significance migrate with visual form? To consider an extreme example, does a visual replica necessarily bear the same meaning as its model? The answer, in a post–Elaine Sturtevant and Sherry Levine world, is clearly no. The sign's context will affect its significance and interpretation. Having said this, some meaning *will* inhere to the visual sign. How much depends upon the fidelity of the copy and on how it is "recontextualized." In the case of the statuettes, consistencies between them speak of a certain mimetic

fidelity to the *Dovizia*, but it is clear that they operated within a context radically dissimilar from that occupied by Donatello's public monument. Their size, and the surviving inscriptions, inform us that they were destined for private consumption and therefore functioned very differently from Donatello's statue. However, in calling into existence an image based on the *Dovizia* artists and patrons furnished a commentary on that monumental work and an insight as to what it might have meant to them. An analysis of the reception of the *Dovizia*, therefore, must account for the function and context of the objects considered as artistic responses to the original, and balance this against the inherent meanings that model and interpretation share.

In addressing these problems in relation to the *Dovizia*, Aby Warburg's comments on *bewegtes Beiwerk* (animated accessories) and the figure he dubbed the *Nympha* are essential. Warburg did not refer to Donatello's lost *Dovizia* in his discussions of these themes, perhaps because the statue's appearance was not well known before the publication of Kauffmann's monograph in 1934, half a decade after Warburg's death. Kauffmann, although not citing Warburg, saw in the *Dovizia* the first example of what, in essence, was Warburg's *ninfa fiorentina*. Kauffmann, in passing, called the figures "Floras": "These figures, the rushing basket-bearers with blown dress, whose attributes (basket, cornucopia, and slipped chiton) and contrast between covered and uncovered leg, were favored by fifteenth-century artists from Fra Filippo Lippi to Ghirlandaio and Botticelli."[44] This perceptive remark leads me to see in the *Dovizia* the origins of Warburg's "Florentine nymph," the striding, breeze-encountering female figure that he viewed as a particularly telling moment in the Renaissance's cultural evocation of antiquity.[45] It also follows, in my analysis, that the visual and meaningful imitation of Donatello's statue by later artists helps us to reconstruct a consistent interpretative strain. This enables contextualized readings of both the responses and their prototype.

Warburg's comments on the *Nympha* are fragmentary. His concern with this figure and the "animated accessories" that defined it appears throughout his written works. He first became fascinated with the swirling fabric, suggesting movement, visible in Tuscan art, in the 1880s. This treatment of drapery attracted Warburg because it did not sit easily within the dominant notion of Renaissance realism, based on Winckelmann's evocation of the "noble simplicity and quiet grandeur" of antiquity and on Lessing's musings on the expressive limits of the visual arts in his *Laocöon*.[46] The activated and expressive representation of frenetic movement seemed to Warburg to correspond to "another antiquity," and its appearance in fifteenth-century Florence reflected hidden tensions in that culture.

Warburg developed these thoughts above all in three projects: his dis-

sertation on Botticelli's *Primavera* and *Birth of Venus* from the early 1890s; his jocular and contrived correspondence with his friend André Jolles at the turn of the century; and in his *Mnemosyne* project, a "picture atlas" announced in 1927 and left incomplete at his death in 1929.[47]

In his dissertation addressing the cultural sources and context of Botticelli's two mythological paintings, Warburg was drawn to the figures on the right-hand side of each painting, that is, to the Hora greeting Venus in the *Birth* (fig. 1.16) and, in the *Primavera*, to the figure he called the Goddess of Spring (usually identified as Flora) (fig. 5.9).[48] Warburg suggested that the dynamic treatment of drapery and hair in these paintings not only derived from ancient art and poetry, but also emerged within contemporary fifteenth-century conceptions of antiquity as expressed by Leon Battista Alberti, Angelo Poliziano, Zanobio Acciaiuoli, and others.[49] Warburg saw the neo-Attic drapery style as it appeared in the fifteenth century as formally underwriting the antique reference in Renaissance art. "It may be one-sided, but not unjustified," Warburg wrote, "to make the treatment of accessories in motion the touchstone of the 'influence of antiquity.'"[50] Nonetheless, his point was not only to suggest sources for Botticelli's details, but also to imagine the milieu within which the reconstrual of such sources made sense.

Figure 1.16
Sandro Botticelli, *Birth of Venus*, c. 1485. Oil and tempera on canvas. Galleria degli Uffizi, Florence

In their art theoretical writings, both Alberti and Leonardo promote the depiction of wind-blown drapery as a means of producing pleasing effects. Alberti recommends that painters include "the face of the West or the South wind blowing" in the corner of the picture (an idea Botticelli developed in his *Primavera* and *Birth of Venus*). "The pleasing result," Alberti continues, "will be that those sides of the bodies the wind strikes will appear under the covering of clothes almost as if they were naked, since the clothes are made to adhere to the body by the force of the wind; on the other sides the clothing blown about by the wind will wave appropriately in the air."[51] Leonardo expresses a similar desire: "As much as you can, imitate the Greeks and Latins in the way in which the limbs are revealed when the wind presses the draperies over them."[52]

In his dissertation, Warburg recognized in the wind-encountering "nymph" the most characteristic and frequent manifestation of this visual and textual trope. The theories of Alberti and Leonardo were, therefore, not only abstract formulations, but also tied to a central form in Florentine fifteenth-century art and culture.[53] In his philologically sensitive analysis of a mosaic of texts and images, Warburg linked this stylistic predilection for *bewegtes Beiwerk* to a broad, cultural engagement with an ecstatic, "Dionysian" antiquity.

After his dissertation, Warburg returned sporadically to the *ninfa fiorentina* in his notes until the end of his life. It also gave rise to one of the more curious texts in Renaissance art historiography: his "fictitious" correspondence with André Jolles.[54] Within an apparently lighthearted epistolary conceit, Warburg and Jolles discuss, among other things, the *Nympha*. Jolles pretends to have fallen in love with the *Nympha*, embodied in Ghirlandaio's stepping maid, seen in the *Birth of Saint John the Baptist* in the Tornabuoni Chapel, Santa Maria Novella, Florence (fig. 1.17):

> I lost my heart to her and in the days of preoccupation which followed I saw her everywhere. . . . In many of the works of art I had always liked, I discovered something of my Nymph. . . . Sometimes she was Salome dancing with her death-dealing charm in front of the licentious tetrarch; sometimes she was Judith carrying proudly and triumphantly with a gay step the head of the murdered commander; and then again she appeared to hide in the boy-like grace of little Tobias. . . . Sometimes I saw her in a seraph flying towards God in adoration and then again in a Gabriel announcing the good tidings. I saw her as a bridesmaid expressing innocent joy at the Sposalizio and again as a fleeing mother, the terror of death in her face, at the Massacre of the Innocents.[55]

Jolles's humorous tone ought not to obviate the validity of his observations. His remarks stress the ubiquity of the dynamic *Nympha* and the figure's apparent iconographic versatility. The attractive *Nympha* appears repeatedly, in different guises, throughout fifteenth-century Florentine art. Within this frame, Warburg sketches out the antique heritage of the *ninfa fiorentina,* and the meaning of this expressive form within the *mentalité* of Ghirlandaio's patron, Giovanni Tornabuoni. In Warburg's notes we read:

> Exuberant vitality, the awareness of a germinating, creative will-to-life, and an unspoken, maybe an unconscious opposition to the strict discipline of the Church . . . demand an outlet for their accumulated pent-up energy in the form of expressive movement. And thus a diligent search begins in the permitted sacred story for a pretext; after which the classical past must lend its protective, indisputable authority as a precedent to allow the search for freedom of expression, if not in words then at least in pictorial form.[56]

Caught up in the frenetic details of hair and drapery, Warburg contends, is the cultural stuff of an antiquity free from the social and religious strictures of fifteenth-century Florentine society. Moreover, although Warburg does not explicitly frame it in these terms, the liberation of the female body from the stiff, heavy fabric of late-medieval fashion signaled a momentous cultural shift. The flowing and sometimes transparent garments express for him the subconscious bourgeois desire for the freedom of an ideal antiquity.

Warburg's final project, the "picture atlas" called *Mnemosyne,* was a compilation of groups of images that shared, internally, a theme, and between one another a certain powerful and exemplary effect on European collective memory. One wall of this project was devoted to the *Nympha*. Here, photographs of striding, basket-bearing Renaissance nymphs were juxtaposed to ancient and medieval representations of similar figures. Text has fallen away, and the thick visual relations are left to speak for themselves.

Warburg did not systematically study the appearance of the *ninfa fiorentina;* his approach, as the *Mnemosyne* screen reveals, was altogether more impressionistic and suggestive. In one note, he called his enterprise "The Fairy Tale of Miss Hurrybring," indicating, perhaps, his interest in the broad historical narrative, even folkloric, significance of such a "pathos formula." I, too, do not wish to present a history of the *Nympha;* rather, I would like to consider how artists attended to and transformed the most important and public exemplar of this figural type, Donatello's *Dovizia*. Imitating the *Dovizia*, artists such as Filippo Lippi, Sandro Botticelli, and Domenico

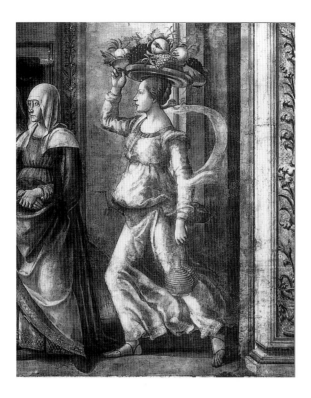

Figure 1.17
Domenico Ghirlandaio, *Birth of Saint John the Baptist*, 1485–90.
Fresco. Tornabuoni Chapel, Santa Maria Novella, Florence, detail

Ghirlandaio signaled their desire not only to emulate neo-antique form, but also to draw on Donatello's rich rendition of dynamic fertility.

Many of the earliest and most characteristic appearances of the *Nympha* appear in scenes narrating births. For example, the first basket-carrying "nymph" mentioned by Warburg appears in Filippo Lippi's Bartolini *tondo*, now in the Palazzo Pitti, Florence.[57] In the left background of this painting, behind the divine protagonists, we witness the birth of Mary; to the right of the Madonna and Child appears a woman clad in light, billowing fabric, which seems to swirl around her body as she steps forward (fig. 1.18). She supports the burden on her head—a covered basket—with her right arm.[58] A very similar figure appears in Antonio del Pollaiuolo's *Birth of the Baptist*, a relief sculpture for the silver altar of San Giovanni. These "nymphs" resemble closely the terracotta versions of *Dovizia* and the object of Jolles's feigned desire, Ghirlandaio's figure in the Tornabuoni Chapel, painted some decades later than the examples of Lippi and Pollaiuolo. In Ghirlandaio's scene representing the *Birth of Saint John the Baptist* the basket brought to Elizabeth, who has just given birth, is filled with fruit (fig. 1.17).[59] Here, the symbolic status of the "nymph" is underscored by the patent coding of dress. The armorlike robes of the contemporary figures in the visual field stand in stark contrast to

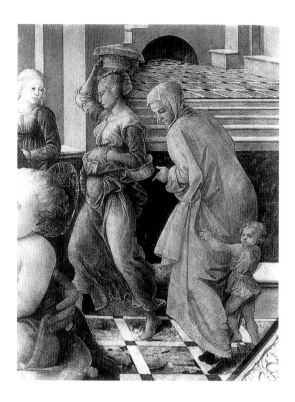

the flowing, revealing garment of the dynamic *Nympha*. This contrast serves to remind us of both the restrictive nature of fifteenth-century patrician clothing for women, and of the symbolic function of the basket- bearing maid.

The inclusion of these figures in birthing scenes might very well function, as Warburg would have it, to introduce an energetic and dynamic antique reference. But the figures also function more prosaically, providing symbolic depth to scenes of birth. Activating the pictorial space, the mobility implied by their suggestive drapery produces an atmosphere of potential action. The figures bear fruit or baskets that we assume contain comestibles. While we do know that it was customary in Florence for patrician mothers to receive special food before and after parturition, these "nymphs" cannot simply reflect social habit.[60] These mobile figures also functioned symbolically, serving to echo the representations of parturition and, in Lippi's *tondo*, Mary's status as the fruitful tabernacle of Christ. In Pollaiuolo's relief, the *ninfa fiorentina* has become the prime connotational bearer of meaning. In all these works, the emphasis on the body beneath the represented clothing serves to emphasize the procreative potential of the *Nympha*. Warburg's own notes on this figural type serve to underscore this interpretation: "Exuberant vitality, the awareness of a germinating, creative will-to-life . . ."[61]

The appearance of the "nymph" in Botticelli's two mythologies studied by Warburg—the Birth of Venus and the Primavera—also emphasizes the association of this dynamic figure with fertility.62 The Birth of Venus is again a scene of parturition, this time mythological. Without a basket and in a significantly different pose from that of the reconstructed Dovizia, the Hora to the right of Venus nonetheless serves a function similar to that fulfilled by the "nymphs" in the religious works by Lippi, Pollaiuolo, and Ghirlandaio: she brackets and amplifies a scene of birth. Here, however, the billowing garment, itself bursting with floral decoration, is sufficient to signal a continuance of the theme. If the basket and fruit are explicitly analogous to procreation, bewegtes Beiwerk becomes an implicit bearer of such meaning, its "vivification" of inanimate material suggesting germination.

This can be seen, too, in Botticelli's *Primavera*. On the right-hand side of the painting, we witness the transformation of Chloris by Zephyr, the West Wind, into Flora (fig. 5.9). Striding forth—her left leg appearing through a slit in her dress in a manner not unlike that seen in the Casa Buonarroti terracotta statuette (fig. 1.7)—Flora appears to strew the flowers that she holds in the folds of her dress. The rosebuds cascade from her lap, literally envisioning the birth of spring. Flora is the flourishing embodiment of this season. Her gown, despite Zephyrus's appearance behind her, twists and flutters against his breezy attack, responding not to wind, but instead to her rapid movement and the iconographic imperatives of the "Florentine nymph."

In all of these paintings—Lippi's, Ghirlandaio's, and Botticelli's—the dynamic female figure appears to bolster the symbolism of birth, the activated drapery operating visually to support this meaning. I would like to suggest that these figures, although perhaps indirectly deriving from antique sources, responded also to Donatello's *Dovizia* both in their adoption of *bewegtes Beiwerk* and in their reference to fertility.

It is in this light that a drawing by Botticelli, now in the British Museum, and customarily entitled *Abbondanza* or *Abundance* ought to be seen (fig. 1.19).[63] The drawing describes a figure very similar to that one rendered in the terracotta statuettes. A woman clothed in a diaphanous and shifting gown appears to have been caught in mid-step, her right foot firmly planted, and her left raised. Her body presents an elegant S-curve; it is accentuated by the clinging drapery through which her body emerges and is rendered legible. Dress and hair swirl and flutter; all accessories are here animated in exemplary fashion. In her right hand she supports a massive cornucopia, its gyration echoing hers. To either side are small children, at least one holding grapes. This drawing helps us to understand the iconography of the terracotta statuettes. Hanging from a chain around the main figure's neck we can

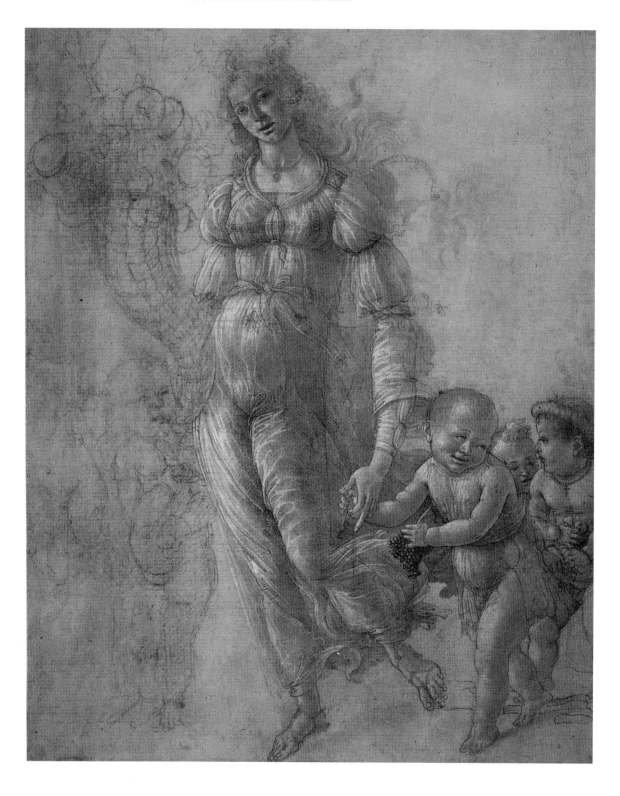

make out a pendant with three pearls. Contemporaries would have associated this piece of jewelry with marriage; they would have recognized this body as betrothed.[64] In this marital context, the presence of spry, grape-bearing children and the stuffed horn of plenty plainly refer to desired female fertility. The dress that decorously covers the body also reveals it explicitly, drawing particular attention to her wide hips and scarcely veiled genitals. This visual emphasis is significant.

The figure of *Abundance* drawn by Botticelli helps explain how the terracotta figures functioned. They were clearly domestic items, intended as talismanic *lares*. Curious descendants of Roman household gods, these *Dovizie* sought generally to ensure the economic well-being, and specifically the procreative success, of a particular family. That the sculptors of these figures and artists such as Botticelli turned to the *Dovizia* for this type of symbolic form tells us not only something about contemporary correlations between money and offspring, but also about the way in which Donatello's statue was perceived. Put simply, in the public and artistic imagination, the *Dovizia* came to be associated with human, as well as agricultural and economic, fertility.[65] Visually, these meanings inhere to the implied motility of the sculpted shift worn by the figure. The liveliness of fabric, possessing, as it were, a life of its own, redounds with the generative potential of the fruit and vegetables borne by the *Dovizia*. Moreover, as the reception of this iconography reveals, notions of agricultural plenty and female procreativity are seen to merge on this bountiful body. The fluttering fabric expresses this germination visually. Florentine wealth derived, above all, from the manufacture and trade of cloth. In a very concrete manner, therefore, Donatello's dynamic rendition of fabric served to picture the economy and fecundity of the city. It might also have been invested with more specific political values.

Warburg posited *bewegtes Beiwerk* as revealing a moment of rebellion against the hierarchical norms of late medieval society. For him, the dynamic accessories symbolized the Dionysian aspect of antiquity, which in his thinking served as a model for an ecstatic and liberating mode of comportment. Although not entirely concurring with Warburg's presentation of this Nietzschean dialectic, I would like to suggest that the *Dovizia*'s loose gown might serve not only to emphasize the agricultural, economic, and biologic potential of the Florentine state, but also, perhaps, to manifest that most revered concept of Florentine republicanism, *Libertas*.[66] The truth-revealing gown, assuring the decorousness and visibility of the body beneath, permits the *Dovizia* liberty of movement, free from the customary constraints of contemporary fashion. In a manner similar to Delacroix's monumental Marianne

Figure 1.19
Sandro Botticelli, *Abundance*, c. 1480. Drawing in pen, wash, and chalk on pink paper. British Museum, London

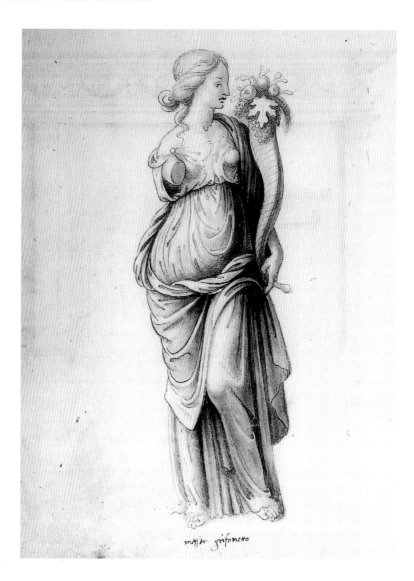

leading the charge over the barricade, the liberated female body served in the *Dovizia* to encode political ideas and to embody the republic, freed from conventional and institutional shackles. Donatello's statue, on this view, becomes a purposeful evocation of that age described by Latini as "when Florence / Flourished and bore fruit, / So that she was of all / The Lady of Tuscany."

That a statue of a female figure should possess such civic meaning is not surprising. For this form of civic personification was not unknown in Italy, although it was customarily antique sculptures that served to represent the state visually. This helps to explain the remarkable "stylistic antiquity" of Donatello's statue, for in some ways, the *Dovizia* can be considered a modern *spolium*, a metaphorical relic of Florence's Roman past, its antiquity inherent

in the age of its form, which, as all commentators have indicated, derived from Roman sculpture. Formally and iconographically, Donatello may very well have been consulting Roman remains. He may also have studied reliefs with personifications of Abundance, like the one now found in the Louvre and recorded in the early sixteenth century in the Codex Escurialensis (fig. 1.20).[67] Nonetheless, if the *Dovizia* is to be read, stylistically, as an ancient statue, it is not to be interpreted solely as a humanistic and archeological gesture toward Florence's Roman foundation. The placement of a female personification with venerable "stylistic antiquity" in the main market of the city emerged, also, from a very different and modern cultural *mentalité*.

There were precedents for displaying antique "female" statues in civic spaces. There is the famous example of the so-called Siena Venus, which the republican regime of the Nine in Siena had placed in the *Campo*, the city's main civic space, in the early 1340s. After the devastation of the Black Death, and the consequent fall of the patrician and humanistically inclined Nine in 1355, the new government, popular and religious in sentiment, decided at a meeting on 7 November 1357 to remove—although probably not destroy, as Ghiberti would report a century later—the statue.[68]

The animus against pagan statuary that motivated the Sienese government to oust the antique statue from the *Campo* was by no means universal. In 1368 Cansignorio della Scala had an antique statue of a woman dating to the second century C.E. placed above a fountain in Verona's flower, vegetable, and fruit market, the piazza dell'Erbe, a space that, like the Mercato Vecchio, had once served as the Roman colony's forum (fig. 1.20).[69] When this statue was erected, a new head and arms were added, as was a bronze banderole with a leonine couplet, drawn from the communal seal: EST IUSTI LATRIX URBS HAEC ET LAUDIS AMATRIX ("This city is the bearer of justice and the lover of fame").[70] Fully integrated into Veronese civic symbolism, the statue came to embody, metaphorically, the city itself.

Before the statue was set in the piazza dell'Erbe, Fazio degli Uberti, poet at the Scaliger court, apostrophized the city as Madonna Verona in his encyclopedic *Dittamondo* (1345–67):

Figure 1.21
Anonymous, *Madonna Verona*.
Marble. Piazza dell'Erbe, Verona

> Ah, Verona, noble and rich city
> Lady and queen of the Italian lands,
> Formed above the Adige
> Where virtue and valor breed . . .
> Not among the Germans, nor the Gallic peoples,
> Searching through all Europe, I do not believe
> That you will find a more angelic Lady. . . .[71]

Fazio degli Uberti, scion of a Florentine family, found it quite natural to embody Verona in this fashion and to consider all the cities of Europe as ladies in a conceptual beauty pageant. Shortly after the poet penned these lines, the antique fragment set in the piazza dell'Erbe slipped into this apostrophizing discourse, becoming Madonna Verona. Already in the fourteenth century Marzagaia called the statue "simulacrum Veronae."[72] And in 1477 Francesco Corna da Soncino, describing the statue as "completely gilded," referred to it as the "symbol of Verona."[73]

The Madonna Verona bears no cornucopia and carries no basket, nor does fabric twist behind the figure in response to wind or pace. Be that as it may, the dynamic treatment of drapery is reminiscent of the lost *Dovizia*. The contrapposto of the Madonna Verona leaves a right leg trailing; beholding this statue from the left, one perceives a sense of thrust and implied forward movement (while from the right-hand side, the statue appears static). This visual connection prompts one to imagine that Donatello may have visited Verona before 1428. More important to my argument, however, is the significance of the Madonna Verona as a monumental antique statue of a woman in a market, which had originally been a forum. The antique statue, moreover, either was intended as, or quickly became, an embodiment of the state. The statue, presiding over economic exchange and acting as a patroness of Verona, surely tendered a corporate and ideal image of the city, above all to Cansignorio della Scala.

The Madonna Verona reflects a poetic norm, through which cities were apostrophized and, in this case, visualized and memorialized.[74] The *Dovizia*, though not functioning in the same manner, did operate similarly. No other contemporary work possessed the *all'antica* purity of the *Dovizia*. The antique appearance of the statue—her chiton-like dress and its neo-Attic style—asserts Florence's claim to her cultural inheritance, giving visual form to this distinctive ideological relation. This formal appropriation was compounded by the statue's iconography, its columnar base, and its site at the founding intersection of the Roman *castrum*. All signal Florence's identity as a new Rome, or, as Dante had put it, Florence was the "bellissima e famosissima figlia di Roma."[75]

Madonna Verona bound modern Verona to her ancient origins. Nonetheless, the fealty and patriotism accorded to Lady Verona was infused with a pseudocourtly and very "modern" pathos. Similarly, the *Dovizia*, set on an antique column in the ancient forum of Florentia, was invested with the power of an antique genius loci; it also operated as a modern embodiment of the state, as, if you will, Madonna Fiorenza. This linking of modern Fiorenza

to antique Florentia would have been particularly topical in the early fifteenth century. At this time humanists were discussing at length the details of Florence's Roman foundation, specifically whether it was founded under the Roman republic or empire.[76] But if the *Dovizia* purposefully instantiated and fabricated collective memories of ancient glory, it did so in very modern spatial and political contexts.

Reproducing the Mercato Vecchio

Daughter of ancient Roma,
I am the noble lady Fiorenza,
Who through divine and sovereign grace
They have multiplied my race.
My progeny from that flower growing in my garden
Spreads throughout the world:
The time has come and awakes the light.
Those whom you see in my presence,
Each well-formed by nature,

So that they are unequaled in this world,
Whether in arms or in learning
So highly are they held by all
That my Comune is always honored by them,
But such are born only rarely in this world.
I advise all who appear,
Who desire fame, take as an example those
Who surpass the richness of every treasure.[77]

There seems no doubt that one of the prime motivations for the government's decision to allow a monument to be raised in the Mercato Vecchio was to reconfigure the space ideologically, to recast the eminently "modern" space of trade as a type of Roman forum. This humanistic and rhetorical gesture is akin to the clothing of all manner of contemporary forms—textual, visual, political—in antique garb. But this revestment of late medieval culture was pure fiction. The *Romanitas* of Florentine Civic Humanism cannot be taken at face value. In order to see through the propagandistic intentions of the *Dovizia* monument, it is necessary to return to the Mercato Vecchio and to consider the social production of this sensitive space.

The views of the city considered above—the illustrations of Ptolemy's *Geografica* and the *Chain Map*—are too panoramic to sustain a visual analysis of the Old Market itself. The only fifteenth-century view to provide an idea

Figure 1.22

Anonymous, *View of Florence*,
c. 1447. From the "Codex Rustici"
(Marco di Bartolommeo Rustici,
*Dell'andata o viaggio al S. Sepolcro
e al monte Sina*), f. 29v. Biblioteca
del Seminario Archivescovile
Florence

of the monument's relationship to its immediate surroundings is an illustration in the so-called Codex Rustici (fig. 1.22). In this picture we can just make out the *Dovizia,* set in the southeast corner of the piazza, fixing her stony attention toward the east, that is, down the via degli Speziali to the via dei Calzaiuoli, the north–south artery linking the city's most important political and religious spaces, the piazza della Signoria and the piazza di San Giovanni. In this manner the *Dovizia* forged a visual link between the commercial, political, and religious spaces that defined the ancient core of the medieval city.

The Rustici illustration, adhering to a convention visible throughout the manuscript, eliminates all traces of social activity in this eminently busy space. Thus, the empty piazza seen in this view helps only to reconstruct physical topography; it does not aid us in re-imagining the social activities that produced the space of the market. More useful in this regard are the views captured in the late sixteenth or early seventeenth centuries (figs. 1.1 and

1.2), for despite their late date they do provide us with some idea of how Donatello's statue related to the hectic life that took place immediately below and around it during the fifteenth century.[78] In these paintings we see the *Dovizia* perched on a Corinthian capital set on a column, itself elevated above the piazza on a stepped pedestal. The figure of *Dovizia* was, in fact, raised some six meters above the heads of the public below.[79] Even at this height, the sweeping curves produced by arms and legs, and the suggested and suggestive movement of the almost eight-foot-tall statue would have been quite legible to most spectators.[80] Gazing at the statue from the piazza below, the sense of movement would have even been heightened by the sharply foreshortened view. The contrast between the static rigidity of the column and the impossible flux of the statue would have produced an attractive visual oxymoron, underlining the figure's virtual mobility.

The Mercato Vecchio, destroyed in the nineteenth-century urban transformation of the area into the present piazza della Repubblica, was the mercantile center of the medieval commune. Set off from the axis connecting the political and religious centers of the city, the town hall and the cathedral, respectively, the Mercato Vecchio typified another type of public space. Neither explicitly political nor religious, the Mercato Vecchio was the major arena for the buying and selling of agricultural produce; it was the economic heart of the city.[81] The 1422 *Annales Cerretani* record that "in the streets round the Mercato Vecchio were seventy-two 'banchi di tavolello e tappeto'" (fig. 1.1). These included the banking tables of the most important merchants of the city, including the Medici.[82] (In fact, the area around the church of San Tommaso [see fig. 1.22], in the Mercato Vecchio, was also the traditional center of the Medici clan in Florence, before they moved north to their palaces on the via Larga.)[83] The *Dovizia* loomed over a shrine open to the street and dedicated to Santa Maria della Tromba. Also nearby were a number of major guild halls. A few steps away, to the east, was Orsanmichele, home to one of Florence's most important miracle-working paintings and the focus of so much guild patronage in the early years of the fifteenth century.

The poet Antonio Pucci, writing in the late fourteenth century, left a remarkably vivid description of daily life in the Mercato Vecchio. Here street gamblers rubbed shoulders with gentlemen, and women from the country sold their produce to city-dwellers. The most striking aspect of the Old Market, as described by Pucci and irrevocably lost to us, was the concentration of agricultural abundance that filled the space daily. Although Pucci does mention the wares one could purchase—linens, utensils, glasses—his focus falls squarely on the comestibles purveyed in this market, which was, he states,

"supplied by the world." All kinds of meats were to be had, including hare, wild boar, pheasant, venison, partridge, and capons. One could also find fruits and vegetables of all sorts: figs, dried figs, grapes, pears, peaches, apples, garlic, onions, and various fresh greens. The market was itself a cornucopia, which, when filled, was a tangible sign of Florence's prosperity. Pucci's nationalistic pride bursts forth from his verses:

> Never was there so noble a garden
> Such as the Mercato Vecchio was then,
> That fed both the sight and taste of every Florentine.[84]

The rich offerings of the market, satisfying both visual and gustatory senses, attracted a broad spectrum of Florentine society, and united them in capitalistic action. Naturally, buying and selling took place elsewhere in the city, and other spaces were coded as "economic." Nonetheless, in Florence no space could typify economic space so thoroughly as the Mercato Vecchio. For Pucci, and I take his text as representing a broader swathe of opinion, the Old Market exemplified the type of space produced by the social activity of economic transaction. What set this piazza apart from most other contemporary spaces was its yielding of random social mingling that blurred customary distinctions based on gender, class, and geography. In Pucci's Mercato Vecchio, men and women, the mercantile elite and the abject poor, assembled, drawn together by what was surely the great unifying principle of Florence's proto-capitalistic society, economic exchange.

> Every morning the street is jammed
> With packhorses and carts in the Market,
> There is a great press and many stand looking on,
> Gentlemen accompanying their wives,
> Who come to bargain with the market women.
> There are gamblers who have been playing,
> Prostitutes and idlers,
> Highwaymen are there too, porters and dolts,
> Misers, ruffians, and beggars.[85]

The edibles attracted consumers like flies, making the market a space for the type of interactions not circumscribed by gender, class, or local affinities. Writing in the fifteenth century, the patrician Francesco Alberti (Leon Battista's older brother), offered a similarly chaotic, albeit less picturesque, poetic vision of the space:

> Enveloped within the Mercato Vecchio
> Between baskets, and cages, birds, thighs and torsos.

In the piazza we are pressed by kicks and bites,

Then, those who have trodden on me, thank me . . . [86]

The Mercato Vecchio, as an economic magnet, pulled Florentines to-
gether across class and gender divides, bringing about the unusual bodily
proximity, which appears to have struck Alberti.

The acquisitive and corporeal energies that activated the public space of
the piazza were matched by a certain libidinal investment in the area. To the
north one found the municipal brothels, and leading to the south was the via
de' Pellicciai, the street of the Furriers, well known as a place to arrange
sodomitical trysts.[87] In his wicked compilation of sexual encounters, the *Her-
maphroditus*, Antonio Beccadelli—il Panormita—calls attention, especially,
to the market's erotic character:

Arriving there, take a right; proceeding a little,

Stop and ask, oh [my] tired book, for the Mercato Vecchio.

Near it is the obelisk, the genial bordello is right there, the place betrays

itself by its odor.[88]

Busy with barter and trade, the space of Mercato Vecchio was a product
of the secular, nongovernmental, mercantile element of fifteenth-century
Florentine society so easily undervalued in art historical analyses plying
Civic Humanism or Christianity as hermeneutic keys. It is in this piazza that
we can imagine the disorganized, serendipitous world of social, economic,
and sexual exchange. The Mercato Vecchio was, in many ways, a "city-wide
neighborhood," a spatially public arena in that it afforded forms of uncon-
trolled social interactions to all comers. As such, it can perhaps be seen as one
of the most sensitive points in Florence's social body.

I would like to suggest that the Mercato Vecchio resembles what Jürgen
Habermas, in his paradigmatic study of the development of civic publicness,
The Structural Transformation of the Public Sphere, would call "a new form of
representative publicness."[89] This type of social space formed the nucleus of
what for Habermas would become the hallmark of modernity, the public
sphere, an arena characterized by the incidental passage of information and
goods and by class ambiguities that fall well outside the spatial hegemony of
the state or the Church. While certainly not wishing to figure fifteenth-cen-
tury Florence as fully modern, I would like to claim for the Mercato Vecchio
some of the characteristics of Habermasian modernity. I do this not to posit
modernity as the telos toward which Florentine culture was pointing, but
rather to adopt Habermas's dialectical structure positing a form of autono-
mous, collective publicness, exerting itself against a centralized, governmen-

tal publicness, the latter representing the co-option and structuring of untrammeled, dialogic communication. For the imposing *Dovizia* monument represents an imposition: a desire to redefine the space of the Mercato Vecchio and control, or at least channel, the types of actions that produced it.

Although it was the center of the Roman foundation and the heart of the medieval city's economic life before the erection of the *Dovizia*, the Mercato Vecchio was not a civic or governmental space per se (following Henri Lefebvre, it makes more sense to label it an "economic space").[90] Donatello's charged statue changed this, defining the market as not only civic, but also public and political. On this view, the erection of the *Dovizia* in the Mercato Vecchio reflects a tension around the definitions of "public" and "public space." For if one agrees that this preeminently economic space represented a challenge to governmental notions of publicness, then the transformation of this market might be seen to signal an attempt by the government to harness the economic power of this space and tame the potentially dangerous autonomy it exemplified. Regardless of patronage and intention, ideologically the monument brought the space under the government's symbolic control. Florentines would have recognized that the massive monolithic column was not new, but rather that it came from a Roman building. Later it was even thought that the column had originally stood at the center of the baptistery—the very core of Florentine civic consciousness—and had supported the ancient equestrian statue of Mars, which also evoked civic sentiments; to some, therefore, the column was already invested with civic meanings.[91] The siting of this enormous column, with its attendant symbolic freighting and in what was the Roman forum of Florentia, recast the thriving medieval market as a civic space of great antiquity. This spatial reformulation was compounded by the appearance of the statue itself, the iconography and pose of which also served to elevate the activity of the market onto an ideal level. This becomes evident when one considers the visual relation between the figure and its local context.

Eternally stepping forth, the *Dovizia* certainly symbolized the passage of goods through the Mercato Vecchio. The "dynamic" but stony form produced a play between the female allegory of abundance and the real, working bodies inhabiting and defining the space of the market below. For while she was a personification of abundance, on another level she was also an actor in a quotidian narrative with local import: she carried agricultural goods. On this level, the *Dovizia* becomes the elevated, ideal epitome of the practical bodies milling around the Mercato Vecchio. The *Dovizia*'s action, therefore, stands for Florentine economic activity not only in a symbolic manner, but also in an immediate visual way.

If the dynamic commercialism of the market was projected through the *Dovizia*'s suggested movement, this reflection of life was captured in stone and elevated both physically and symbolically above the realm of the everyday. The column, with its flourishing and vegetal Corinthian capital, would have perhaps supported a reading of the statue as embodying the produce and production below, but its antiquity would also have served to remind viewers of the *Dovizia*'s symbolic status. Thus, if the virtual dynamism of the *Dovizia*'s sandstone body echoed the real bodies below, the monumental stasis of the statue and the esteemed antiquity of the column on which it stood guaranteed that it could not be seen solely as a direct rendition of contemporary bodies.[92] In fact, the statue sets forth an intriguing mixture of antique and modern, operating symbolically as a personification, and as a socially entwined rendition of the real labor, the real exchange, and the real wealth found below in the Mercato Vecchio. Presiding over the old forum of the Roman colony of Florentia, the *Dovizia* refigured the economic world of late medieval Florence in the garb of ancient Rome. The economic space of the Mercato Vecchio became a monumental space.

"Monumental space," writes the philosopher Henri Lefebvre, "offered each member of a society an image of that membership, an image of his or her social visage. It thus constituted a collective mirror more faithful than any personal one."[93] With the erection of the *Dovizia* and the reproduction of the space of the Mercato Vecchio as "monumental" in Lefebvre's terms, the social and monetary wealth of the piazza did not vanish, but it was put, ideologically, at the service of the state. The *Dovizia* did not blot out the emergent publicness of the socially heterogeneous Mercato Vecchio. The statue, rather, redefined the actions that took place within the Old Market, setting an idealizing mirror of urban membership before the eyes of Florentines. In the *Dovizia* they could recognize the body politic of which they themselves were members. Representing that Florentine *corpus politicum,* the *Dovizia* simplified the complex social composition of the city and especially of the Mercato Vecchio, condensing complex notions of wealth and fertility into a charismatic image of a woman, toward which Florentines could train their patriotic gazes.

Political Unity and the Common Wealth

In May 1429, when the Arte della Lana and Opera del Duomo signaled their cooperation with the Ufficiali della Torre concerning the transport of the column on which the *Dovizia* would stand, what might have motivated the government to oversee the erection of a civic monument of this scale and

importance? The Officers of the Tower were, as Goro Dati put it in the early years of the fifteenth century, responsible "for maintaining and improving the bridges and the walls of the city and the *contado* and to repair the paving of the roads when they are in poor condition."[94] They did turn their attention to the Mercato Vecchio on other occasions. In 1415, they threatened to fine the butchers if they did not repair the roof of their loggia, and in 1436 we hear of the Signoria urging the Officials of the Tower to work to improve roads near the Mercato Vecchio.[95] Nonetheless, the erection of a statue, and one with such patent civic symbolism, cannot be attributed simply to the Ufficiali fulfilling their brief to maintain walls and roads. They were, rather, instruments in a broader program.

Without direct evidence concerning the planning and commissioning of the monument, it is possible only to offer hypotheses regarding the discussions and desires that yielded the *Dovizia*. Customarily, endeavors of this type often seek causation in political discourses, attempting to link a work of art to a particular, inaugural political event. While not dispensing altogether with concepts of causation, in describing a political context for the *Dovizia*. I wish to emphasize the reciprocal interaction between art and politics. Specifically, I would like to examine how the formal characteristics and iconography of Donatello's *Dovizia*, in conjunction with its location and means of presentation, make sense when bracketed by contemporary debates concerning war, taxes, and gender.

In portraying the oligarchical government that guided Florence through so much turmoil from 1382 to 1434, Gene Brucker described its two most visible faces. On the one hand, he recognized that "[m]ost obvious to the modern observer is the coercive and exploitative character of this patrician régime; it governed for the benefit of the rich and the powerful, and often to the disadvantage of the poor and the lowly."[96] On the other hand, Brucker notes that the oligarchy was able to maintain among even the most disadvantaged groups of the populace a loyalty and devotion for the republic.[97] Personal well-being was subordinated to a corporate ideology of the state as a type of family, writ large. Rinaldo Gianfigliazzi went so far as to set devotion to the state above that owed to the family: "The *patria* is more important than our children and everything should be done for its protection, so that we bequeath to our posterity what we have inherited from our ancestors."[98]

The *Dovizia* bears traces of these two aspects of oligarchical rule: the exploitative and the patriotic. Placed in the Mercato Vecchio, the monument staked out this public space and projected the city's growing colonial hegemony over the expanding Tuscan state to the citizens of Florence. But if the

Dovizia can be read as signaling the robust colonialism that, literally, fed the city of Florence, the monument also reflects a less monologic characteristic of the oligarchy: the patriotic fervor it generated. For the *Dovizia* also possessed a centripetal force. Drawing patriotic gazes into its symbolic vortex, the *Dovizia* invited citizens into a visual dialogue. In producing a monument glorifying wealth, the government and Donatello tapped into a truly unifying civic emotion. For, as implied at the head of this chapter by the words of Giovanni di Andrea Minerbetti, if there was one concept that could draw Florentines of all stripes together, it was money.[99]

The decision to elevate the statue and the concept of wealth above the economic nucleus of the city took into account the revised notion of personal riches described by the humanists. As Wilkins and McHam have argued, following the theses of Hans Baron, the *Dovizia* signals a departure from the mendicant promotion of *paupertas* subscribed to by many cultural leaders of the fourteenth century. Fifteenth-century humanists advocated, instead, the necessity of capital as an instrument, if not precondition, of virtue. Money, this argument goes, enables the individual to engage in worthy acts. This valuation of wealth bears not only upon the iconography of the *Dovizia*, but also upon the commune's promotion of civic adornment. External splendor, it was thought, rendered manifest the virtue of the city and its citizens. Promoting urban magnificence and economic weal, humanists turned to ancient texts: in 1421 Bruni translated an economic treatise he thought to be by Aristotle, and Aurispa introduced Xenophon's *Oeconomicus* in 1427. Wilkins and McHam, given the pseudomorphosis that links the figure of *Dovizia* in some of the terracotta versions with the iconography of Charity, read this humanistic promotion of worldly gain as lauding the prosperity and beneficence of the Florentine state. I find this intellectual context for the *Dovizia* strong. There is room, however, for an interpretation that seeks to contextualize the statue more directly within the sociopolitical circumstances precipitating the commission. It is my contention that the statue—symbolizing iconographically and formally the agricultural, economic, and political potential of the state—functioned as a visual analog to the numerous appeals for unity from the leaders of the regime that ruled Florence. As such, the *Dovizia*'s promulgation of an ideal, shared abundance relates directly—if not necessarily causally—to the passage of a new tax code, the *catasto*, in May 1427, which called for citizens to reveal their personal possessions and to contribute a fixed amount thereof to the "common wealth."[100] Seen in this fashion, the *Dovizia* represented, generally, a charismatic center of the expanded and unified Florentine state, and, specifically, the goals of the "progressive" taxation promoted by Rinaldo degli Albizzi and his statist allies. It is, moreover, meaningful that

this imagined fiscal unity was communicated through a dynamic female body. The ideological pull that underwrote the *catasto* was aligned with desiring cultural gazes, trained on the *Dovizia*. To make these points, we must turn to the intricate political circumstances preceding the spring of 1429 when we first hear of plans regarding the column for the *Dovizia*.

Although the oligarchical rulers of Florence oversaw the aggressive and progressive expansion of the Florentine territorial state in the early fifteenth century, they were nonetheless haunted by the past. Two memories, especially, appear to have borne upon the policy making of this elite cadre of quasi-professional politicians: the Ciompi revolt and the threat of external invasion. The former was an uprising of the lower orders, who seized control of the government and, for a few months in 1378, attempted to reform Florence's rigid guild-based republicanism that excluded members of the lesser guilds from political participation. Led by the wool workers—derisively labeled "Ciompi"—this abortive rebellion was countered by an alliance between patrician and wealthy mercantile families, forming the oligarchical caste that was to rule the city for the next four decades. Recognizing the threat posed by the "revolting" Ciompi, patrician Florentines and members of the major guilds drew together, suppressing the rebellion and solidifying their constitutional control of the government. Subsequently, fear of another uprising fueled the oligarchical policies that restricted participation in the government and promoted a form of authority based on tradition, bureaucratic expansion, and a politics of personality.[101]

The second factor bearing upon the policy making of the oligarchical regime with particular urgency was the threat of invasion by "foreign" foes. Like other independent states, Florence, a free commune, passionately valued its liberty. Traditionally a city with Guelfic and pro-papal leanings, since waging the War of the Eight Saints (1375–78) against the papacy Florence had enjoyed a singular ideological independence. What is more, its economic might enabled it to protect this freedom in concrete ways. Put simply, when Florentines pooled their enormous financial resources, they had the ability to purchase the services of the very best mercenaries. To understand the fervent political tenets of the Florentine ruling class in the late 1420s, one must grasp the almost religious civic faith held and promoted by some of the oligarchy's most important members. Between 1400 and 1429 Florentines survived, against all odds, a number of very serious foreign assaults. The first, and perhaps the most traumatic, was the threat posed by the Milanese and Giangaleazzo Visconti in 1402. Only Visconti's sudden death while besieging the city preserved Florentine *libertas*. Slightly more than a decade later King

Ladislaus of Naples suffered an oddly analogous fate while threatening Florence, and the city withstood invasion yet again.

While these internal and external crises informed Florentine social and political life, their most profound impact might have been upon the collective mentality of the ruling oligarchy and, therefore, upon its management style.[102] In response to the uncertainty caused by such disturbances, the oligarchy pursued a politically conservative agenda, stabilizing their authority by multiplying the instruments of power at their disposal and by bolstering the fiscal might of the state by increasing tax revenues. Strengthening the offices and procedures of the republic—brought out most clearly in the new constitution of 1415—the oligarchy also limited its own direct access to power. In so doing, they erected an administrative structure through which they, and later the Medici, would have to steer. Often circumvented in reality, the procedural shape of Florentine political life was, nonetheless, important, so important that much energy was expended in maintaining the appearance of its efficacy.

Although increasingly bureaucratic, Florentine governance was still very much a personal matter. The offices and instruments of the republic proliferated, but the elaborate institutional structure still relied on a handful of individuals. These men came to see themselves not as elected officials, but as professional politicians, whose lives were devoted to the state. In 1466, casting a rueful eye back to the heyday of the Florentine oligarchy, Luca della Robbia remarked in his life of Bartolomeo Valori that "[a]lthough she always flourished, she thrived most between 1390 and 1433 . . . less by the aid of good fortune than through the counsel of the worthy citizens then at the head of the ruling group, whose abilities were marvelously demonstrated, to the extent that they need not be considered inferior to those wisest Romans so celebrated from antiquity."[103]

By 1420 the senatorial cadre of great merchants leading Florence had been shaped by both experience and great fortune. On the one hand, they had recognized that Florence was vulnerable to internal and external attack; on the other hand, the almost divine interventions that had brought the city back from the brink of tyranny suffused the elite with the confidence that good fortune brings. Armed with this optimism, the more hawkish and militarist elements within the oligarchy set Florence on a course of territorial expansion. During the late thirteenth and fourteenth centuries, Florence had emerged as an international power. Not simply a city, it had become a state. The militarily aggressive oligarchy had managed to reassert Florence's claims, annexing Arezzo (1384), Montepulciano (1390), Pisa (1406), Cortona (1411), and Livorno (1421). Florence was, however, troubled by its success. Rather than con-

solidating its control over Tuscany, militarist elements in the government urged further expansion.[104]

In the 1420s, understanding that Florence would remain susceptible to the incursions of Milan, Naples, or other of the peninsula's major powers, the hawkish party, led by Rinaldo degli Albizzi, counseled and promoted active colonial development based on military strength. Others within the *reggimento*'s core of statesmen were less sanguine. They envisioned Florence's participation in external affairs as consisting more in strategic and flexible alliances than in military interventions. Giovanni di Bicci de' Medici, his son Cosimo, and his nephew Averardo de' Medici were among those who tended toward favoring diplomacy over war.

It was during the debates concerning the renewal of hostilities with Milan in 1423–24 that Rinaldo degli Albizzi emerged as the most eloquent and impassioned proponent of the expansionist position. After Genoa surrendered to Milan in 1421, the conservative and militaristic groups in the Florentine government urged that Florence take the first step in what they saw as an inevitable conflict with the Visconti. "I wish we were real men," Rinaldo exclaimed, "and would beat the Duke [of Milan] to the draw; it would be greater glory than the Romans ever achieved!"[105] Heeding this advice, appealing to Florentine masculinity and *Romanitas,* Florence engaged Milan. In so doing the city entered a dangerous, economically debilitating military engagement.

The war began badly for Florence. Having attacked Forlì, the mercenary troops hired by the Florentine Signoria lost a series of battles to the Milanese. Between 1423 and 1426 sentiment for the war waned in Florence. From 1424 to 1426 losses at Zagonara, Val di Lamone, Anghiari, and Faggiola engendered pessimism among the populace. Despite widespread dissatisfaction, a conspiracy led by the Pagnini against the government in 1425 was unsuccessful. Heedless of internal opposition, the government continued to levy extraordinary taxes in order to pay for a campaign that seemed destined to fail. This situation led, inevitably, to internal divisions within the *reggimento,* especially regarding the issue of taxation. The perceived and real injustices of the existing system, based on neighborhood assessments of property, split the ruling elite and speeded its atomization into smaller factions. Secret societies and religious confraternities were seen as harboring the types of unregulated congregation that led to such sectarianism. It was for this reason that they had been suppressed by legislation in 1419; this was apparently unsuccessful, as renewed strictures were passed in 1429.[106] Thus in the years preceding 1429 it was the perceived disunity of Florentine society, the roots of this disunity in fiscal inequity, and the consequent spawning of secret societies that dominated governmental discussions.

64

In response to the proliferation of factional sects, or *sette*, the government actively promoted civil concord and unity. Especially important in this regard is Giovanni Cavalcanti's description of a gathering in Santo Stefano al Ponte in August of 1426. At this meeting, the leaders of the war party assembled and heard, according to Cavalcanti, Rinaldo degli Albizzi upbraid those who opposed tax reform (i.e., the *catasto*). Referring to his opponents as *gente nuova*, or upstarts, and identifying them with those who led the Ciompi uprising, Rinaldo stirred up patrician fear and proposed radical changes to the Florentine constitution that would have restricted political participation.[107] What is more, he argued that these changes ought to be imposed by force.[108]

Rinaldo's speech, as recorded by Cavalcanti, accurately reflects the view held by the war-mongering, high-oligarchical faction. Although meetings such as that held in Santo Stefano were precisely the type of congregation seen as dangerous and leading to factionalism, Rinaldo and his partisans presently began a concerted campaign, calling for civic unity through tax reform and, what they considered to be its necessary correlate, the suppression of groups they perceived as promoting disunity. According to Cavalcanti it was, ironically, the meeting in Santo Stefano itself that galvanized the opponents of Rinaldo about Giovanni de' Medici and that ultimately led to the events of 1433–34.[109]

As Gene Brucker noted, the polar characterization of Florentine politics set forth by Cavalcanti belies the actual welter of opinions within the *reggimento*.[110] What is clear is that while many if not all of the ruling male elite belonged to factions or secret societies, there was a growing ideal of a unified, centralized state. Publicly, therefore, the legislation that followed the Santo Stefano meeting renewing the 1419 ban on confraternities and suppressing clandestine meetings of all sorts passed with relative ease.

> Officials should be sent to every church and monastery where these groups met, to collect and burn their records. The entrances to the meeting-places should be sealed; the rectors of the churches should be warned that they would be punished severely if they permitted the disbanded societies to meet on their premises. . . . The recommendations received the support of every counselor who participated in the debates. No one dared to defend the societies.[111]

The factionalism precipitated by the war with Milan and by taxation brought about, paradoxically, the public promulgation of unity. In the years before the erection of the *Dovizia* in the Mercato Vecchio, no issue was discussed more often in governmental meetings. But unity was hardly a unified concept itself; it meant very different things for different groups and individ-

uals. For the Albizzeschi, calls for unity were intended for the ears of mercantile patricians, while for the chancellor, Leonardo Bruni, and other professional rhetoricians active in Florentine public life, civic solidarity was a goal to be promoted among the citizenry, broadly conceived.[112]

At the center of these discussions concerning unity, even if not always openly enunciated, was taxation. The war with Milan had brought with it massive expenditures. After nearly a decade of discussions concerning tax reform aimed at equalizing the economic burden among citizens, finally, in May 1427, the Council of the People, and then the Council of the Commune, passed legislation enacting the *catasto*.[113] The *catasto*, which demanded that heads of households submit returns (*portate*) listing taxable possessions, was introduced explicitly to combat factionalism and to promote unity.[114] Jacopo Gianfigliazzi had hoped that this new tax code would help the city achieve unity "so that the citizens would tend to their affairs, conventicles would dissolve, and money would always be on hand."[115] The *catasto* aimed at making transparent personal wealth and equalizing citizens' contributions to the fisc. It opposed the personalized system of local assessments and the cellular sodalities that accompanied it. The new tax code represented the victory of an image of the state as a single, unified, and centralized system. "It will reveal [everyone's] property," stated Niccolò Barbadori, "it will bring unity to the *popolo* and eliminate discord; it will encourage citizens to speak freely in debates and provide for the commune's necessities."[116] In March 1427 Francesco Machiavelli had voiced similar hopes. The *catasto*, he foresaw, would put an end to the factions that had enervated civic unity: "The societies will disband; there will be an end to [tax] evasion, and to the power of the cliques, and to the complaints of the multitude who are constantly clamoring at the doors [of the Signoria's palace]."[117] Machiavelli's and Barbadori's optimistic views were not, however, to be realized immediately, for the *catasto* was a long-term project. It was widely acknowledged that in order to implement the new tax code a census of sorts was demanded; this would take at least two years to organize and conduct. It is perhaps owing to this delay that the legislative call for future fiscal unity embodied by the *catasto* was accompanied by a spectacular and centralized "orgy of celebration," as Gene Brucker called it, promoting patriotism and civic unity via festivals, orations, and jousts.[118] Between the summer of 1426 and the spring of 1429 the government suppressed local groups, traditionally in charge of organizing such celebrations on feast days and secular holidays, and replaced them with state-controlled institutions. Celebrations, which had emerged from local affections, became a truly civic enterprise. This visual activation of the public sphere by the government sought to render visible to Florentines the state which they sustained through

their tax contributions. The ideology of unification mirrored the fiscal unifi-
cation set forth in the *catasto*.

But if these celebrations reflected a new conception of the state, they
also signaled an up-swing in Florentine military fortunes. In these years, Flo-
rentines had much to celebrate. After the nadir of 1426, the Milanese cam-
paign improved, from a Florentine perspective. The alliance with Venice,
agreed upon in 1427, led to the First Treaty of Ferrara in 1428 and to the for-
mal cessation of hostilities.

The third decade of the fifteenth century had been a difficult one for
Florence. By the spring of 1429 there were, however, many reasons for hope.
Not only had the long war with Milan, which had raged since 1423, finally
cooled, but the fiscally sensitive issue of how to fund such military enterprises
appeared to have been resolved through the introduction of the *catasto* in
1427. Nonetheless, in hindsight, the optimism that might have been felt dur-
ing the spring of 1429 was badly founded. The peace with Filippo Maria Vis-
conti was to break down and lead to the resumption of full hostilities in 1430.
Already in late 1429 the unwise militaristic policy of the Florentines would
embroil them in armed conflict against Volterra and, subsequently, Lucca.
The latter engagement changed, radically, the course of Florentine politics by
setting the stage for the exile of Cosimo de' Medici in 1433, and his subse-
quent triumphant return in 1434.

Also, despite the introduction of the *catasto* and the apparent end of the
Milanese conflict in 1428, factionalism continued to plague the *reggimento*. For
that reason, the discussions of unity not only continued, but became more
urgent.[119] Lorenzo Ridolfi, who took the lead in an important *pratica* of 25
January 1429, noted that participation in factious assemblies was akin to idol-
atry: "As we should adore one God, so you, Lord Priors, are to be venerated
above all citizens, and those who look to others are setting up idols, and are to
be condemned."[120] Ridolfi's suggestion that sectarians were idolaters implies
that the veneration accorded to the Priors ought to be akin to the respectful
gazes directed toward Christian images. Ridolfi's sentiments, clearly respond-
ing to the actual lack of such respect accorded to the Priors by the *popolo*,
were echoed by many speakers, and as a result four days later citizens were
asked to take the following oath, sworn on the Bible:

> To forgive those both present and absent their wrongs. To abandon
> all hatreds. To divest ourselves completely of partisanship and loy-
> alty to factions. To consider only the welfare and honor and great-
> ness of the Republic and of the Parte Guelfa and of the Signoria. To

forget every injury received up to this day on account of partisan or factional passions, or for any other reason.[121]

In February a new magistracy was appointed. The Conservatori delle Leggi were directed to "prevent any citizen who belonged to a society which might give rise to a *setta* from assuming any of the major offices of the commune."[122]

Both Gene Brucker and Dale Kent, the scholars who have read and painstakingly described the government discussions that took place at this time, stress the problem of disunity, and the fiscal and cultural governmental programs promoting solidarity among Florentines. The concept of unity was variously coded but usually operated as a means for calling for a more equitable tax code. The resulting *catasto* was both this and an expression of a new, dominant image of the centralized state, led by a few professional politicians, but institutionalized as an anonymous bureaucracy. In this mechanistic state every citizen's access to authority was, after a fashion, equidistant. This new state also marshaled its power behind representation, erecting in the Mercato Vecchio a monument to the unifying concept of wealth.[123]

The *Dovizia*, an extraordinary monument on account of its iconography, site, and prominence, speaks with the voice of the oligarchical regime that governed Florence from 1382 to 1434. The image of wealth addressed a broad spectrum of the city's populace. The allegory of plenty could capture the imagination and eye of both the acquisitive merchant and the humanist familiar with the most progressive strains of thinking concerning virtue and magnificence. The *Dovizia*, at the economic nucleus of the greater Florentine territory, supplied Florentines with a focused image of the state, emphasizing the plenitude and abundance it guaranteed. This promotion of a notion of Florence as well-nourished and wealthy corresponds to a radical change in civic perceptions. In 1426, Rinaldo degli Albizzi complained that "we have no more money, and what never happened before in any of our previous wars is now occurring: robberies and extortions, the flight of our subjects from the territory, many acts of treason."[124] In the spring of 1428, delivering an important funeral oration in honor of the general Nanni Strozzi, Leonardo Bruni painted an altogether different picture: "As for resources and wealth, I am afraid that it might inspire envy if I were to report our apparently inexhaustible supply of money. Evidence of it is this long Milanese war which has been waged at incredible cost, in which we are spending over thirty-five hundred thousand [florins], and nevertheless men are prompter in paying their levy now when the war is drawing to a close than they were at its beginning,

so that there seems to be a kind of monetary force in our economy which sends up new shoots every day as if by some divine power."[125]

"The function of money," wrote Georg Simmel, "is to facilitate motion."[126] It was precisely the dynamism of capital that the *Dovizia* captured. But the statue not only reflected economic and sociopolitical weal, it also functioned as propaganda. The statue addressed a citywide audience, demanding their consensual financial support of the government on account of the prosperity and safety it vouchsafed. "Dovizia" could well replace "pecunie" in Sallust's tag, cited by Minerbetti in 1426 and at the beginning of this chapter, "Salus nostra in ordine pecunie consistit." For this was literally the case. Producing a monumental space in the Mercato Vecchio, the column and figure functioned to bolster the centripetal ideological pull that sought to unite the *reggimento*. Its message was broadcast across the city, not only free of the traditional ties of neighborhood, relatives, and family, but in conscious opposition to such personal, private, and intimate relations. But if the monument addressed a public, constituting its audience as a civic body, the statue, paradoxically, privatized public discourse by capitalizing on gender.

Gendering Plenty

Since the early fourteenth century, Florentines repeatedly personified their city as Fiorenza or Florentia. Again and again, she was framed as a woman loving, loved, or abused by her citizens or the Signoria.[127] Like many cities, Florence was apostrophized by poets.[128] Another figurative layer was added to this trope, when writers represented the personified Florence as caught up in an amorous relation.[129] This type of social commentary was based upon the ubiquitous metaphors casting political control, or lack of it, in amorous terms.[130] In September 1378, for example, Franco Sacchetti described the government as having "the republic in its arms."[131] Most explicit, however, is the remarkable song, composed toward the end of the fourteenth century, in which the Florentine oligarchical government is figured, simultaneously, as the fathers, sons, and lovers of a very Marian Fiorenza:

> Excellent lords and glorious
> Fathers and governors of this woman,
> Full of virtue and excellence,
> Upright guides at your rest
> And the queen and lady of freedom
> For whom Italy bears reverence,
> You are the fruit of her seed.[132]

Addressing the council, the song takes the metaphor further, casting Florence as a bride and repeating Sacchetti's metaphor: "this your bride, this your Fiorenza dear and worthy who trusts [you] and sleeps in your arms."[133]

This recasting of the political within the personal can, perhaps, be understood if we return to a poem found attached to the doors of the Palazzo Vecchio in the summer of 1426 and attributed to Niccolò da Uzzano, leader of the conservative group before the ascendancy of Rinaldo degli Albizzi.[134] The political poem was composed before the *catasto* was voted into effect and probably before the decision to erect the monument in the Mercato Vecchio was taken. Nonetheless, it provides another contextual frame through which to understand the *Dovizia*.

The verses were cast within the long tradition of personifying the state as a woman. Moreover, they were composed in the conservative spirit defining the relationship between the old families in the oligarchy and Fiorenza as one marked by loyalty and entailing certain responsibilities. The highest priority was protecting Florence from the advances of the *gente nuova*. The poem begins by recalling how much the "old lovers"—*antichi amanti*—of Florence had spent on her adornment, asking these political suitors to desist from forming factions among themselves:

> Old lovers of the good and the beautiful [Lady],
> Made magnificent with your contributions,
> So that all the world marvels at her.
> Let now pass your quarrels,
> That you have pursued so as to make yourselves greater
> Than her court and than her beautiful land.[135]

Should the *antichi amanti* of Florence not quell the disturbances among themselves, the outcome threatened in these verses was exile:

> If you do not [stop quarreling], soon with grief
> You shall be cast out from her chamber
> By those "new men," who owe you everything.[136]

The factionalism that threatened the internal stability of the *reggimento* was fashioned, here, in amorous terms—taxes sublimated as gifts to a beautiful woman and the patrician men of Florence cast as jealous lovers, protecting their mistress from the advances of socially unsuitable suitors. Appealing to their chivalric fealty to their Lady and state, the author demands that patricians unite against the dangerous heirs of the Ciompi, the wealthy *gente nuova*. He continues:

Therefore, ancient and courageous people,

Put aside all strife,

And immediately make peace amongst yourselves.

No longer permit to rise up

The pride of the ungrateful and new people,

Who want to do over [*trasmutare*] your Lady.[137]

The verb *trasmutare* means "to transform" but it also possesses here a more earthy significance. The author warns the *reggimento* that the upstarts wish to have their way with Donna Fiorenza, forcing her to do their will. Political coercion is set in a sexual allegory. Further on in the poem, if one follows the analysis recently proposed by Alan Smith, the activities of the *gente nuova* are equated with sodomy, implying, according to the morals of the age, a sinful, unnatural, and fraudulent relationship between the state and the opponents of the Uzzeschi and Albizzeschi.[138] Having compared Fiorenza to "quella donna Veneziana," the verses draw to a close with a telling metaphor: "Make every law, never in vain . . . so that this pious Lady shall not be kissed by vile people."[139]

I adduce this poem since it provides a possible means of access to the mentalities of those who commissioned the *Dovizia*. It is not accidental that the *Dovizia* is a female allegory, nor is it to my mind pure chance that commentators have been struck by the sensual, if not erotic, nature of the closest copies after the lost work.[140] In the harangue that Cavalcanti reports Rinaldo degli Albizzi having delivered in Santo Stefano in 1426, the *antichi amanti* are purposefully contrasted to the *meccanici cittadini* or *venticci*, the laboring citizens or newcomers. Rinaldo urges his patrician oligarchs not to succumb to the lower orders, for in doing so, he states, "You are like a man who cuts off his balls to spite his wife."[141] Calling his audience's intelligence and virility into question, Rinaldo also sets political relations within a sexual allegory, equating self-emasculation with the oligarchs' failure to oppose the *venticci*, represented by the Medici. The not-so-hidden object of desire in this oration too is *lo stato*, the masculine authority to govern the city.

The *Dovizia* was erected at a moment when patriotic sentiments were often set in an amorous and allegorical register and when Florence was quite often figured as the poetic paramour of the ideal citizen. The reference to Donna Veneziana in the political poem attributed to Niccolò da Uzzano reminds us of the currency of such ideas, and their realization in the visual arts. Donatello's *Dovizia* emerges from this form of civic poetics, rendering the *corpus politicum* of Florence visible as a fertile and desirable woman.

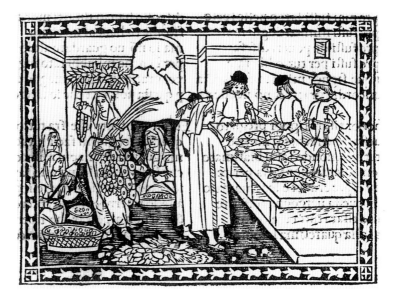

Although civic embodiments were very often female, based on long traditions of personifying cities as women, the rendition of the gender of this statue opened it up for readings that naturalized a political message of unity and prosperity in an assumed biology. For the iconographic references to plenitude, abundance, and procreation inherent in the statue's name and in the agricultural wealth that she bears establish an analogy between the productive potential of the land and woman's procreative potential. Symbolically, the harvest of Tuscany, conveyed by a youthful and fertile woman, enters the Mercato Vecchio, just as the actual foodstuffs were brought to the market, and set into motion the capitalistic cycle supporting the city's economy.

This direct embodiment is manifest in a fascinating woodcut, containing yet another artistic response to Donatello's statue (fig. 1.23). An illustration in an incunabulum containing popular songs contrasting, antithetically, carnival to Lent—*Contrasto di Carnesciale e la Quaresima*—the print describes what appears to be a quotidian urban scene: on the right, we see fishmongers purveying their catch to a group of Florentine men, while on the left, we see a group of women selling their goods.[142] The most prominent of the women, standing in the left foreground, derives from Donatello's *Dovizia*. Balancing an enormous basket on her head, and bearing, instead of a cornucopia, a large sheaf of wheat, the figure brings Donatello's metaphoric statue down into the streets. Departing from its model, this figure appears to carry traditional *ciamballe* (doughnuts) suspended from her left arm. But the artist has retained a trace of the *bewegtes Beiwerk* of the sandstone sculpture. The woman's dress appears to billow around her legs, and a small wisp of fabric

twists behind her left foot, echoing the dynamism of the *Dovizia*'s lilting contrapposto. This translation of the *Dovizia* into a secondary level of personification realizes visually one aspect of the monumental statue's meaning: its allegorical reference to the actual work that went on in the Mercato Vecchio.

In light of Antonio Pucci's vivid verses, the economic cycle of production and trade appears to have drawn Florentines into its vortical pull most visibly in the Mercato Vecchio. This economic gravity was compounded symbolically by Donatello's *Dovizia*. The statue's mingling of agricultural, economic, and human fertility aligned economic and sentimental desire into a powerful cultural gaze. Donatello's *all'antica* civic embodiment became, if not explicitly, then implicitly, a representation of the expanding territorial state. This personification of Florentia and its wealth promoted a conception of the state as unified. The fractious and traumatic politics of the 1420s called for such ideological interventions, and the statue can be seen as a visual echo of the introduction of the *catasto* in 1427. Just as the *Dovizia* represents the "common wealth" of Florentines, so the *catasto* represented the shared economic responsibility for municipal structures and their concomitant freedoms, rationalizing each household's fiscal relation to the state. The statue is on one level an allegory of the *catasto*, a restatement of its ideals and aims in visual form.

This urban embodiment was produced by capitalizing on the rich intersection linking biological fertility to civic health; it would, therefore, have addressed male and female contemporaries in quite different manners, corresponding to the structuring of public gazes. To women, the statue might have suggested that their highest civic duty was linked to their biological procreativity. In his *Vita civile*, for example, Matteo Palmieri argued that "the principal service that is expected from a woman is [the production of] children and the generation of families. The wife is like fecund land, which having received the seed, nourishes and multiplies [it, yielding] abundant and good fruit." Turning their eyes to the *Dovizia*, women, who were taught to value their roles as mothers, might see their service to family and state set in an allegorical register. Palmieri goes on to speak of how a farmer ought to choose his land: "If, therefore, experience proves to good farmers always to choose the best land from which to receive the best fruit, is it not even more important for a man to choose the best wife from which to receive the best children?"[143] Palmieri's civic-minded advice indicates what was surely an important aspect of Florentine notions of female beauty. Leon Battista Alberti, in his dialogue on the family, renders this connection even more explicit. He has one of his characters declare that "I opine that one cannot judge the beauties of a woman solely by the charms and gentleness of her face, but more by

the form of her body and her suitability for bearing and producing for you the most beautiful children in quantity."[144] A metaphoric and visual embodiment of fertility, the *Dovizia* would have satisfied a particular criterion of contemporary Florentine aesthetics, which prized female bodies that appeared to ensure progeny.[145]

Aligning patriotic affection, visual attraction, female plenitude, and lucre, the statue also acted as a symbolic target for the patriotic heterosexual gazes of male citizens.[146] Put differently, Fiorenza/*Dovizia*, on this view, would become that desirable woman whom the oligarchical patriciate felt duty-bound to protect, constructing—in a manner analogous to the political poetry cited above—citizen-viewers from this caste as heterosexual lovers of the state. This striding *ninfa fiorentina*, clothed in liberating loose and revealing *all'antica* garb, broke with the rather more restrictive contemporary norms of female clothing; patriotic and capitalistic gazes cast upon the symbolic visualization of wealth—the republic's salvation—were structured by a scaffold of heterosexual desire. From her male guardians, Fiorenza demanded the protection guaranteed by the oligarchy's familial political compact; the statue interpellated female viewers as living representatives of Florentine agricultural and economic fecundity. This econo-libidinal visuality assumed and called into being certain ideal, cultural gazes, emerged within a charismatic politics that construed the ties between state and individual as corresponding to the "natural" roles encoded in gender relations. This centrist and heterosexual ideology—legible in poetry and visualized by Donatello's *Dovizia*—aimed at decompartmentalizing Florentine political life by dissolving the secret or patent factionalism that plagued the city and divided man from man.

In electing to state the case for political and fiscal unity by promoting Florentine economic growth through an image of human fertility, the government was, I believe, responding not only to the development of *sette* and to the institution of the *catasto*, but also to the perceived evil of sodomy: sexuality that bore no fruit. Fears concerning this "unspeakable vice" flared up, ferociously, in the 1420s. Thinking that the population of the city was declining, the government actively supported marriage by excluding single men from political participation, by establishing the Monte delle doti, an investment scheme for dowries, and by promoting civic prostitution.[147] Later, in 1432, the government instituted the Ufficiali di Notte (Officers of the Night) whose prime function was to prosecute sodomites.[148] A year later, a governmental proclamation exhorted women not to demand so many goods at marriage, since the costs for men were becoming insupportable; the document also reminded women that their duty to the state consisted of their service as

"seed-sacks" for "replenishing this free city."[149] Clearly fearing depopulation and attributing it to sodomy, which was indeed very widespread, the government of Florence pursued policies supporting marriage and procreation. Symptomatic of this social policy was the invitation extended to San Bernardino da Siena by the government to deliver the Lenten sermons in 1425. In these sermons Bernardino upbraided Florentines for permitting all manner of lasciviousness to wrack their society. With particular fury, however, he exhorted his enormous audiences to prosecute the most heinous of all "vices," sodomy.

It was in this terrifying environment—where illicit associations, factional and sexual, were seen as threatening the very fiber of Florentine republicanism—that the *Dovizia* was deployed. The Mercato Vecchio was known as a privileged site for political congregation; it was, after all, the clandom of what was to prove the most dangerous of the many *sette*, the Medici faction. What is more, it was also reputed to be a place associated with sodomitical relations. It is, perhaps, for this reason that the government used the *Dovizia* monument as a site for the punishment of sodomites. In the sixteenth- and seventeenth-century views of the Old Market the shackles at the foot of the *colonna d'Abbondanza* are clearly visible (figs. 1.1 and 1.2). These, we know, were there before the close of the fifteenth century. In 1488 the Ufficiali di Notte prosecuted four men who had sodomized a ten-year-old boy. Convicted of the crime, the four men, before they were banished from the city, were mitered and affixed to the *colonna d'Abbondanza,* where they were given "multiple lashes on their nude buttocks."[150] That the commune would chose to punish sodomites beneath Donatello's *Dovizia* supports reading the statue as exhorting Florentines to abandon nonprocreative sex and to replenish the city.

Florentines saw their salvation in the fertility of their city, the "flourishing flower." When thinking of what fruit their city bore, citizens might very well think of agricultural produce, capital investment, and human progeny. Donatello gave the multiple associations of growth and prosperity visual form in his statue celebrating wealth, the *Dovizia*. This statue, the symbolic axis around which the Florentine state could revolve, represented a desire to live up to the era described by Brunetto Latini and cited at the head of this chapter, "when Florence / Flourished and bore fruit, / So that she was of all / The Lady of Tuscany."[151] The *Dovizia,* laden with metaphoric and allegorical meaning, became a surrogate for Lady Florence, giving corporeal form to the personified Donna Fiorenza, and to the complex cluster of social and political ideals promoted by the oligarchic *reggimento* during the years just prior to the regime of Cosimo de' Medici.

2

Florentia Figurata

*Erano . . . due cittadini potentissimi, Cosimo de' Medici e Neri Capponi,
dei quali Neri era un di quelli che avevano acquistato la sua riputazione per
vie pubbliche, in modo che egli aveva assai amici e pochi partigiani.
Cosimo, dall'altra, avendosi alla sua potenza la pubblica e la privata via
aperta, aveva amici e partigiani assai.*

(There were two most powerful citizens, Cosimo de' Medici and Neri
Capponi, of whom Neri was one of those who had acquired his reputa-
tion through public paths, so that he had many friends, but few followers.
Cosimo, on the other hand, having his power from the open roads of
public and private life, had enough friends and partisans.)
 —Niccolò Machiavelli

That Florentines would have thought of their city, and state, in corporeal
terms is hardly surprising. Medieval political theory abounds with such
metaphors of the state, of which the "body politic"—a central metaphor,
from which a vast array of political imagery emerged—is only the most in-
clusive and well-known.[1] Of the political tropes emerging from the organic
metaphor of the state as a body few were more congenial to visual represen-
tation than personification: the translation of an abstract idea into human
form.[2] Indeed, in 1470 a legislative text spoke of the city, quite passionately, in
just these terms. This official document describes the Monte (the governmen-
tal investment fund) as "the heart of this, our body, that which is called a city
. . . each member, large and small, contributes all that is possible toward the
conservation of the body."[3]

I would like to reconsider the question of Florentine civic personifica-
tion raised in the previous chapter but shift attention away from the oligarchy

and toward the Medici regime, which dominated civic politics between 1434 and the death of Lorenzo de' Medici in 1492. I do so because the political erotics that precipitated the poetry framing participatory politics of the 1382–1434 oligarchy in terms of love and affection became a central myth of Medici authority. To understand the context in which the trope of civic personification appeared after the ascendancy of the Medici as the dominant force in Florentine politics in 1434, a few general comments regarding Medici cultural patronage are in order.

From Vasari on, patronage has been a central concern of art history.[4] During the last three decades, however, the study of patronage has emerged as a cross-disciplinary sector of all manner of historical studies addressing the Renaissance.[5] In fact, the patron-client interaction has, for many, become pivotal in characterizing premodern or early modern social relations. In studies devoted to the Italian Middle Ages and early modernity, historians with a sociological bent and sociologists mining historical data have used patronage to develop an ethnographic picture of premodern Mediterranean cultures characterized by close social interdependence founded on economic reciprocation.[6] The term "patronage" has proven remarkably flexible, helping to elucidate the quasi-feudal relations that bound *contadino* and worker to territorial princes as well as the liquidation of traditional corporate ties in city-states in favor of the more personal connections between leader and partisan. Within this anthropologically inflected historiographical paradigm, art history's agenda has tended to cede its traditional explanatory goal in favor of more limited, positivistic ends. Thus, Michael Baxandall's ambitious *Painting and Experience*, which sought to present a "social history of pictorial style" by examining patronal expectations and the emerging discourses communicating them, although it found a readership across the disciplines, bore no immediate academic progeny.[7] Instead, patronage studies in art history have tended to adopt the biographic and ethnographic imperatives of social history, largely jettisoning visual and material analyses linking mentalities to formal appearances.

Art history can make a fuller contribution to patronage studies by complementing the quantitative and positivistic methods of social historians with visual analyses attending to the elaboration and instantiation of social relations visually and materially. There are, of course, many methods for traversing the rift between form and context.[8] When dealing with political imagery, however, many run the risk of instrumentalizing the work of art, pressing it into the service of a larger thesis or structure. As Daniel Arasse indicated in a recent discussion of early modern European political art, historians and art historians alike have tended to use works of art to illustrate, that is, to explain

other, extra-artistic givens.[9] Arasse proposes that we reconstrue the word "illustrate" by returning to its etymological foundations. Instead of considering material culture as "illustrating" power (in the conventional sense of "explaining" a text), we should instead seek to understand how art provides power with "luster"; that is, political art offers more than an iconic re-presentation or reflection of the textual historical record and/or a certain political ideology. Political art—at once both autonomous from and integral to authority—grants power a glittering, changeable, and seductive visual surface. Citing Francastel's underappreciated yet apposite notion of "la pensée figurative," Arasse offers a welcome challenge to interpret not only the iconography of political art, but also its appearance and the manner in which political meaning surfaces as a visual quality.[10] This is to say that a social history of art aiming at decoding the cultural elaboration of power, while eschewing a formalism that finds satisfaction in the teleology of the eye, must adopt a formalism that seeks to understand how objects operate visually and materially to sustain political relations.

This chapter attempts to grasp one segment of the lustrous superficie of Medicean power by concentrating on the trope of civic personification: *Florentia Figurata*, Florence figured.[11] It considers works of art that, owing to the blatant manner in which they manifest the relations between the Medici and Florence, can claim to be the most explicit political images produced under the so-called early Medici. These objects are two portrait medals, one showing Cosimo "il Vecchio" (fig. 1.1–2) and the other Lorenzo "il Magnifico" (fig. 1.8–9). On the reverses of each of these medals are found personifications of Florentia. Examining these medals, I hope to elucidate how civic allegory operated to produce an assumed relationship between the Medici and the state, imag(in)ed as a woman. I also wish to discuss the particular manner in which the Medici, capitalizing on the tiered structure of allegorical communication, seem to have blurred the lines between "public" and "private," presenting political issues in personal, even intimate terms.

Making the Medici

Retrospectively, peering through the heavy papal and ducal curtains drawn in the sixteenth century, the authority of the early Medici over Florentine civic life seems preordained, irrefragable, and fixed. Nothing, however, could be further from the truth. Lurching between the republican and the monarchical, and without a constitutionally legitimate claim to rule, the early Medici felt with particular urgency the necessity of manufacturing popular consent to their power.

Around 1400, the Medici thought of themselves as a family in decline.[12]

Since 1378 the clan had been associated with populist politics. At that time Salvestro de' Medici supported the Ciompi revolt. Salvestro's position during the tumult gave birth to the widespread notion that the Medici favored the *popolo minuto*, laborers and lower guildsmen.[13] Francesco Guicciardini, writing in the sixteenth century, has Bernardo del Nero describe Medici authority succinctly as "founded upon the policy favoring the lower classes."[14] In the early fifteenth century, this association, perhaps more apparent than actual, nonetheless led to the political and social marginalization of the Medici within the ruling oligarchy, which as a general rule despised and feared the lower orders as the harbingers of revolt and instability.

Despite apparent ties to the lower classes, the Medici were not social *arrivistes*. What is more, they ranked among the wealthiest of Florentines, deriving their riches largely from banking and especially from their business with the papacy. With the Ricci, the Spini, and the Alberti, the Medici dominated the financial operations of the Apostolic Camera—the largest and most complex bureaucratic system in Europe, but one which was compelled to keep some distance between itself and the usurious practices of institutional banking. It was, above all, in the service of the papacy that the Medici built their fabled financial empire.

During the first two decades of the fifteenth century the papacy fractured into competing obediences, each supporting its own pontiff. The fortunes of the Medici clan escalated rapidly in the second decade of the fifteenth century when Baldassare Cossa, a friend of Giovanni di Bicci de' Medici, ascended to one of the three papal thrones as John XXIII.[15] Of the "Pisan Obedience," John was later deposed at the council of Constance and subsequently labeled an antipope. Nonetheless, in 1410, when John granted the Medici bank a dominant position in the finances of his curia (and with the sudden bankruptcy of their Spini competitors), Giovanni di Bicci de' Medici and his sons, Cosimo and Lorenzo, became enormously wealthy, amassing vast personal fortunes that would in the course of two decades help elevate their family from its relative political obscurity. In 1427, two years before he died and only seven before his son, Cosimo, became Florence's unofficial *signore*, Giovanni di Bicci de' Medici was the second wealthiest man in Florence.[16]

Money alone, however, cannot explain *how* Medici hegemony evolved. Recent scholarship has highlighted the structure and nature of Medici patronage—broadly conceived—as the key to their political rehabilitation and success. It was above all Christiane Klapisch-Zuber, Dale Kent, and F. W. Kent, drawing on a formula found in all nature of contemporary documents, who identified, analyzed, and introduced three paradigmatic social relations—those between "friends, relatives, and neighbors"—with Dale Kent recogniz-

ing in this triad of affiliations the network within which Medici partisanship developed.[17] Building on Dale Kent's research, and on Samuel Cohn's study of class and marriage patterns, the sociologists John Padgett and Christopher Ansell have used quantitative analysis to argue that these forms of sociability can also be charted specifically on the axes of geography and class.[18] During the first three decades of the fifteenth century the Medici exploited their economic power by marrying into a citywide patrician network.[19] In a world where marriage was very much a business, the patricians were attracted, no doubt, to Medicean wealth. The Medici, on the other hand, produced *parentadi* (agnatic relations) with the mercantile elite of the city and thereby secured the social status of their clan. Simultaneously, Padgett and Ansell have argued, Cosimo developed close economic cliental relations with the *novi cives* in his own quarter of San Giovanni, forging "friendships" predominantly with his "neighbors." Generating personal ties with the social elite and mercantile upstarts, Medici social and economic patronage yielded a well-balanced constituency of partisans, producing, by the late 1420s, the so-called Medici faction.

After the death of his father, Giovanni, in February of 1429, Cosimo became the undisputed head of this faction. Supported by his brother Lorenzo and his cousin Averardo, Cosimo also emerged from the debacle of the Milanese and Luccan wars of the 1420s and early 1430s as the representative of those who opposed the oligarchical status quo. His perceived opposition to the expansionist policies championed by Rinaldo degli Albizzi only further increased Cosimo's authority in the city. Despite his canny social strategy, it seems unlikely that Cosimo de' Medici intentionally plotted to gain a position of political preeminence, nor did he purposefully develop a faction; nonetheless, while seeking to secure the economic and social position of his clan, Cosimo came to represent a set of values behind which political support materialized. Notwithstanding his open political moderation, Cosimo's enormous wealth and his family's apparent sympathy with the *popolo* rendered him suspect to his fellow oligarchs, who perceived him as a threat. At the instigation of Rinaldo degli Albizzi, therefore, Cosimo was arrested for sedition and imprisoned in the Palazzo Vecchio late in the summer of 1433. At this pivotal moment, it was the loyalty of Cosimo's socially diverse supporters that stayed his execution; instead, the oligarchy, led by Rinaldo degli Albizzi, declared the Medici *magnates*—that is, nobles, and consequently banned from political participation—and banished Cosimo and his circle from Florence.[20] The first decree, proving that the political affiliations of 1378 had not been forgotten, recalled the supposed Medici support for the Ciompi rebellion. It went on to exile Cosimo to Padua, calling him and his closest relatives "per-

tubators of the fatherland, most truculent and most cruel enemies of the present state of Florence."[21]

Exile did not, however, ruin Cosimo as it did so many others (like his cousin, Averardo, for example).[22] As papal bankers, the Medici possessed an international financial network, with branches throughout northern and southern Europe as well as in the Middle East. This broad economic base enabled Cosimo to keep his wealth safely away from Florence and to survive exile in Venice. He did not, however, have to survive for long. By the autumn of 1434 he had already been recalled by the Signoria to Florence.

In the end, the bureaucratic instruments of power produced by the professional politicians of the oligarchic regime proved to be that elite's downfall. Elections during the summer of 1434 brought enough Medici partisans into the Signoria to rescind Cosimo's punishment. This bizarre election was the result of the bureaucratic momentum of the statist structures put in place by the oligarchs. Ironically, in unifying the city and its government, they precipitated their own overthrow.

After 1434 Cosimo's role as unofficial leader of Florence was by no means secure. Although his position was considerably enhanced with the expulsion of his major enemies after his return, Cosimo still required widespread consent in order to control the city.[23] In a fundamental study devoted to electoral practices, Nicolai Rubinstein elucidated the means by which the Medici sought to clothe their authority within the guise of constitutional legitimacy.[24] Ensuring that his partisans filled the electoral rolls, Cosimo, although he rarely held public office himself, could dominate governmental decision making through his growing circle of influence, composed of his "relatives, friends, and neighbors." The mechanics of Medici power, therefore, are relatively clear. The documents permit us to see both the apparent republicanism of Florentine governmental forms, and the actual circumvention of these institutions in practice. The study of cultural documents has proved to be less straightforward.

In this regard, Machiavelli's comparison between Cosimo de' Medici and Neri Capponi cited at the beginning of this chapter is instructive. Both Neri and Cosimo were "most powerful." The former, a solid oligarch, acquired his reputation through public means, that is, through public offices and, especially, through his military services. In so doing, Capponi developed "friends." Cosimo, on the other hand, managed to awake not only friendship, but also partisanship, Machiavelli suggests, by *public and private* means. Scholars of Cosimo's accrual of power have endorsed Machiavelli's analysis. The Medici sought to secure their *public* position through apparently *private* means—most explicitly through marriage and business dealings. Privately

they assembled a consortium of partisans on whose support they could depend when it came to public business. This mingling of public and private was, retrospectively, recognized by Guicciardini, when he wrote, perceptively, that "the Medici had always more their private advantage at heart than the general good. But as they had neither any position nor Signoria abroad, their interest was generally one with that of the commonwealth, whose glory and fame were likewise theirs."[25]

I contend that this sociopolitical blending of private and public interests also found expression in the visual arts. Producing engaging symbols, the Medici framed their *public* relation to the state, and to the people of Florence, in *personal* terms, and in ways akin to widespread medieval monarchical symbolism, but tempered so they would not be vulnerable to the accusation of despotism. Understanding the complex balance that they struck between broadcasting their power and carefully masking their might requires recognizing how politics inflected Medici cultural patronage.[26]

In literature, this tension between expression and reticence is comparatively easy to identify, if not to interpret. For example, it is not difficult to remain skeptical regarding the republicanism of the chancellors who served under the Medici, like Leonardo Bruni, Carlo Marsuppini, Poggio Bracciolini, and Bartolomeo Scala; the laudatory praise of these and other clients does not always ring true. The tension between compliance and resistance legible in these authors' works is one of the more intriguing areas of contemporary literary history of the period.[27] Interpreters have scrutinized the literary voices of the so-called Civic Humanists and have attempted to square this textual function with the individual and political circumstances of the author.

Such analyses, however, are not easily applicable to other cultural products—like painting, sculpture, and music—where at this time authorial voices seldom surfaced openly, especially when it came to politics. For this reason, the literary model of seeking to discern variances between authorial and personal voices does not usually suit analysis of the visual arts. Instead, when considering the political investment of visual signs in this period, interpretations have turned, insistently, to the patron and to what might be called the "patronal voice."

In the case of the early Medici, the direction of patronage studies has been determined by Ernst Gombrich's essay, "The Early Medici as Patrons of Art." Gombrich, as his subtitle announces, presents a "survey of early sources." His goal seems, therefore, to be an assessment of the tools at one's disposal for writing a history of Medici patronage in the fifteenth century. His thesis, however, is broader. For in the article, Gombrich, expanding on a the-

ory already suggested by Kurt Gutkind in his biography of Cosimo de'
Medici, seeks to differentiate between the patronage proclivities of Cosimo,
Piero, and Lorenzo.[28] The picture resulting from this approach to "patronal
style" presents Cosimo as a pious, if guilty, builder, Piero as one fascinated by
material splendor and a collector of objets d'art, and Lorenzo as a multifac-
eted if less productive patron, concentrating on literature and antiquities.
This sketch cannot possibly do justice to Gombrich's rich article, nor to the
range of Medici patronage, nonetheless it does help us understand the task
that art history set for itself: to describe the "patronal styles" of individual
members of the family. These styles did not, however, emerge purely from
the data, instead they follow patterns of interpretation already visible in the
sixteenth century (and earlier, in Cosimo's case).[29]

If the patronal styles of Cosimo, Piero, and Lorenzo can be said to share
anything, it is a common concern with making their patronage serve to glo-
rify the state, and to have it shine splendid, if reflected, light on their own
house. Cultural patronage supported the Medici regime in an oblique man-
ner.[30] Most obviously Cosimo and his successors funded popular religious
and corporate projects, linking their largesse to traditional groups and goals.[31]
Taking into account what Günter Bandmann has called "material iconology,"
the physical magnificence of Medici patronage might very well stand as proof
of their wealth, virtue, and commitment to public welfare.[32] Giovanni Pon-
tano recognized as much when discussing the patronage of Cosimo the elder
in his treatise on the social virtues: "In our days Cosimo the Florentine imi-
tated the magnificence of the Ancients through constructing temples and vil-
las and through founding libraries. He was not content, it seems to me, to
imitate them, but he was the first to revive the custom of dedicating private
wealth to the public welfare and to the embellishment of the fatherland."[33]
Only rarely, however, did the Medici, and Cosimo in particular, commission
works of art with an explicitly political content in which they refer directly
to themselves.[34] This can perhaps best be demonstrated with a handful of
examples.

What we might call the careful patronage style of the Medici is already
visible in Giovanni di Bicci's support for the erection of an extraordinary
monument to the antipope John XXIII in the Florentine baptistery in the
early 1420s.[35] Produced by Donatello and Michelozzo in the antique style, the
tomb stuns one not only through its lavish materials—marble, bronze, and
gold—but also by its position: the most sensitive place in the Florentine civic
consciousness, the baptistery dedicated to the city's patron saint. The tomb
was not explicitly commissioned by the Medici; it was paid for with funds set
aside by the deceased in his testament, of which Giovanni di Bicci was an ex-

ecutor. A monument to the unlucky antipope, the tomb also memorializes the personal and economic relationship between Cossa and the Medici. What is more, given the pivotal role played by Cossa in securing for Giovanni di Bicci and Cosimo access to papal banking, the tomb records, albeit obliquely, the reciprocity and fealty underpinning Medici economic success.[36]

Benozzo Gozzoli's frescoes in the Medici palatine chapel provide another example of cautious Medici patronage. The murals represent the journey of the Magi. Rab Hatfield's researches have prompted numerous interpreters to see these paintings in light of the Medici involvement with the Compagnia de' Magi, a group responsible for staging elaborate Epiphany celebrations.[37] The Medici, who sporadically performed in these processions, could very easily be seen to embody the regal trinity of Balthasar, Caspar, and Melchior. In 1459, when the frescoes were completed, father, son, and grandson— Cosimo, Piero, and Lorenzo—possessed a Magus-like aura. In fact, as Richard Trexler has shown, rulers both before and after the Medici found in the traveling trio of biblical Magi an attractive model for self-identification. In Florence, citizens were certainly aware of the biblical analogy between Medici and Magi.[38] Despite this symbolic aptness, the Medici did not have Gozzoli paint them *as* the Magi; instead, Cosimo, Piero, Lorenzo, and his brother Giuliano appear with other contemporaries in the retinue of the biblical kings.[39] Even in their own chapel, hardly a public space per se, the Medici demonstrated great reticence when it came to elaborating their political position through the arts, as if the mixture of material magnificence and iconographies of authority might prove too heady a draught for a Florentine audience.

It is on this account that so many commissions stemming from the Medici seem to emerge within a liminal space between the public and private spheres, their palace being the most obvious case in point. The magnificent Palazzo Medici was, as Pius II commented in the 1460s, "fit for a king."[40] But, by clever reference to civic architectural forms, and by framing it as a public space, the Medici managed to put the self-evident magnificence of the edifice at the service of the state. Although the building did arouse some negative responses, in general its visual allusions to the Palazzo Vecchio and the civic functions it was given served to protect the Medici against the accusation of tyranny.[41]

The patronal style of the Medici in the fifteenth century was largely inexplicit. The direct light cast by their magnificent projects fell on the state, or on religious icons and institutions; their authority shone in the reflected, but fulgent glow of material splendor. The Medici never really masked their political intentions through their cultural patronage. Rather, they sought to

couple their rule to existing charismatic political and religious forms. Drawing civic and religious spaces into a form of "public privateness," the Medici marshaled their cultural patronage behind a statist banner. As Guicciardini remarked, "their interest was generally one with that of the commonwealth, whose glory and fame were likewise theirs."[42]

Given the structure and character of Medici patronal style, the portrait medals I now wish to discuss are both exemplary and extraordinary. They are exemplary in that as objects and iconographically they operate between the concepts and spaces implied by the words "public" and "private." They are, however, extraordinary, in that they represent the most blatant extant political expression made by the early Medici through the visual arts. For these reasons, they demand our attention.

Medallic Portraits and the Luster of Authority

The medals in question represent, on their obverses, Cosimo de' Medici and his grandson, Lorenzo (fig. 2.1 and fig. 2.8). On the reverse of each is a representation of Florence personified (fig. 2.2 and fig. 2.9). At first glance, these medals seem to lack the perquisite monumentality and canonical centrality for political interpretation. Nonetheless, taking into account the rather laconic and circumspect manner in which the fifteenth-century Medici framed their authority, these two medals stand out as possessing a remarkably clear mode of political address.

Although there is no evidence concerning the patronage of the two medals in question, without more detailed information it seems best to assume that the commission came from the Medici.[43] If this is the case, they are the only manifestly political works of art produced for the early Medici in which specific individuals were portrayed.

In Renaissance culture, the publicity afforded by the reproducible portrait medal was unparalleled in scope and structure. Like Roman coins, Renaissance medals could secure and transmit an individual's likeness and status across time and space. Filarete, writing in the 1460s, praised the medallic arts for precisely these capabilities: "To prove that this is so every day we recognize by means of this skill Caesar, Octavian, Vespasian, Tiberius, Hadrian, Trajan, Domitian, Nero, Antoninus Pius, and all the others. What a noble thing it is, for through it we know of those who died a thousand or two thousand or more years ago. We could not have such an accurate record of them through writing. We could know about their deeds but not the appearances of their faces. It cannot be shown as well by writing as this."[44]

A portrait medal, however, served to inscribe the sitter not only into history, but also into the social hierarchies of his or her own time. Many

Renaissance medals help, therefore, to reveal a distinctive layer of the developing publicness of the arena into which political imagery was increasingly deployed. In this light the portrait medals of Cosimo and Lorenzo, customarily marginal within art historical discussions, become central icons of the Medici appropriation of civic myths. For these small objects possessed a potentially broad communicative address lacked by many objects—especially paintings (which, despite their singularity and quite often their "privateness," are frequently the subject of politically inflected interpretations).

Medals were expensive objects and, despite existing in multiple casts, cannot be seen as belonging to a popular culture. But like the emerging print culture that developed in the second half of the fifteenth century, medals offered a means of communicating with a public not defined by geographical confines. Mobile, the Renaissance medal represents an early mass medium, not because it could be reproduced in quantities for a mass audience, but rather because multiple versions of a single image could address a spatially fragmented spectatorship, unified only by their act of apprehension. The individuals that composed this public did not necessarily see one another, nor communicate among themselves. They were related, rather, obliquely and tangentially through the circulating medal, and through the identity of the person portrayed. In diagrammatic terms, the reception of the portrait medal produces a star-shaped network with the sitter as its central node. Spatially, and perhaps socially, separated viewers assemble around this hub, joined only through the sitter at the center of the network and through their collective act of reception. If, however, the discrete manner in which these medals were circulated served to fracture forms of group reception, this rupture fostered a particularly intimate relationship between the represented and the "be-holder."

I introduce the awkward hyphen into "beholder" to make a point. Despite contemporary affection for the term "visual culture," it can be misleading when it comes to dealing with material objects. The medal highlights this problem. The medallic art is a medium grounded in a particular form of tactile reception; to be grasped, a medal literally must be held. To limit the apprehension of medals to the optical is to drain these objects of their communicative power and significance. Although medals might be stored and displayed in a number of ways, beholding medals demands a certain type of activity. The metal disc is made for the palm of a hand, its gravitational force serving to remind one of the substance of its content. The metal itself—often silver or gold—speaks similarly to the beholder, exhorting him or her to weigh up the person represented.[45] Materially, through its physical composition and heft, the medal communicates that the person portrayed is someone

of substance: the patron's wealth is therefore not only alluded to, but is in-dexically present in material form. The metal disc also begs to be turned over. Customarily, the Renaissance medal privileges the obverse. Here we see (and perhaps feel) the protagonist of the medallic event, for the image on the re-verse serves to comment on the portrayed, and possesses few independent functions.[46] Medal reverses most often contain symbolic images that seek to describe the character or achievements of the figure portrayed on the obverse.

This "duplicity" leads me to another important characteristic of the Re-naissance portrait medal: its complex internal structure that links not only two images, but also two, or more, sets of texts. Words are a fundamental compo-nent of the Renaissance medal. Usually in Latin, majuscule inscriptions on the obverse link the likeness to a particular name and sometimes to a particu-lar social rank or role. Inscriptions on medal reverses explaining or comple-menting the symbolic figure expand upon the virtues of the person portrayed on the obverse, and sometimes include a date and, occasionally, a signature. Filled with visual and verbal signs, the medal exhorts the viewer not only to behold, but also to read. The medal demands close inspection and to be spun around so that the text can be deciphered. There is no preordained sequence to one's apprehension, the medal encourages instead a fragmented and im-pressionistic reception in which image interacts with image, text with text, and image with text. This "un-diegetic" activity is, however, directed. The telos of the medallic event is not narrative closure, but the individual whose name is spelled out, whose face is described, and whose internal qualities are suggested through symbolic words and images.

The portrait medals of Cosimo and Lorenzo are superficially very sim-ilar: the profile portraits of the two Medici are complemented by a seated personification of Florence (fig. 2.2 and fig. 2.9). Using comparable visual strategies, the medals demonstrate how the Medici attempted to weave their identities into the sentimental patriotism of their subjects and to produce an ideological link between themselves and their subjects, incorporated as Florentia. The structural similarities they share underline the continuity in Medicean symbolism, not to mention Lorenzo's purposeful emulation of his grandfather. Nonetheless, the two medals also differ substantially, drawing attention to each sitter's virtue and framing his relation to Florentia in distinct manners. Thus, while the similarities permit the identification of a central trope in Medici cultural politics, the differences help us to understand the particular management styles exhibited by the two men.

~∿§∾~

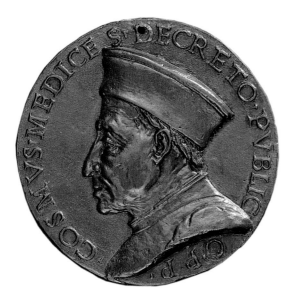

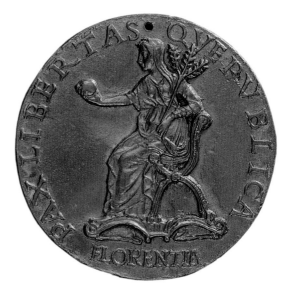

Figure 2.1

Anonymous, *Cosimo de' Medici, Pater Patriae*, c. 1465–92. Obverse of bronze medal. National Gallery of Art, Washington, D.C., Samuel H. Kress Collection

Figure 2.2

Anonymous, *Florentia Holding an Orb and Triple Olive-branch*, c. 1465–92. Reverse of bronze medal. National Gallery of Art, Washington, D.C., Samuel H. Kress Collection

The first medal (of which there are at least two versions that can claim to reflect an original) represents, as the inscription informs, Cosimo de' Medici (fig. 2.1).[47] Since the inscription refers to the honorific title *pater patriae*, conferred on Cosimo posthumously, it seems probable that the medal was a memorial, produced after the sitter's death in 1464, perhaps at the instigation of his son, Piero. What is more, the original medal was certainly produced before Antonio del Chierico included a painted version of it in a manuscript dedicated to Piero de' Medici, who died in 1469.[48]

From two sources we know that at least one version of the medal was cast in gold. The 1492 inventory of the Palazzo Medici records "[u]na medaglia sciolta, d'oro, schulto la testa di Cosimo," and in a mysterious portrait, to which I shall return, Sandro Botticelli depicts a sitter pointedly displaying a golden impression of the medal (fig. 2.6).[49]

For the purposes of this analysis, I shall refer to an extant example now in the National Gallery of Art, Washington, D.C. The profile portrait on this medal conveys an enormous amount of information with remarkable economy. Indeed, the sensitivity of the portrait has even led some to attribute a related medal to Donatello.[50]

Facing left, Cosimo's features appear to have been rendered with careful attention to veristic details. An artery meanders beneath subtly suggested skin across the left temple. The topography of the face suggests a cranial solidity: cheek- and jawbones project, providing a credible armature from which Cosimo's flesh seems to hang, palpably obeying the laws of gravity. Conforming to the conventions of medallic portraits, which do not often en-

courage a psychological link with the viewer, Cosimo's mouth is represented as resolutely shut, while his heavy-lidded gaze turns purposively away from the viewer. The *gravitas* bestowed on Cosimo lends him a Roman, senatorial air; his clothing, however, reminds us of his modernity. His neck and shoulder are described by a plain garment, which appears stiff. The relative lack of surface relief on the robe contrasts, and thereby emphasizes, the pellicular complexity of Cosimo's face. The same can be said of Cosimo's distinctive hat. This clearly modern accoutrement would seem to confer a certain status on Cosimo. The closest comparative examples of such headgear of which I am aware are not Florentine, but can be found, rather, in court portraits. In the *Camera Picta* of the Palazzo Ducale in Mantua (1465–74), Mantegna depicts Lodovico Gonzaga with a very similar hat, while in his famous diptych in the Uffizi (of about 1472) Piero della Francesca paints Federico da Montefeltro in a costume that closely resembles Cosimo's. Given its roughly contemporary aptness for a marquis and a duke, the hat would appear to confer on Cosimo a quasi-princely status that his monarchical peers—who themselves represent a possible be-holdership for this medal—would recognize.

The relief portrait emerges from a flat field. The artist has carefully separated the likeness from the edge of the medal and from the inscription that rings Cosimo's profile, meticulously avoiding compositional overlapping or awkward mergers between forms. This compositional clarity is most evident in the treatment of Cosimo's torso. Early medallists had essayed a number of solutions to the compositional problem of how to treat the relation between the edge of the medal and the body of the portrait. Two basic answers emerged. The artist could either have the torso run down to the edge of the medal, or he could truncate the torso before the edge, presenting the portrait as a bust. The latter course, taken insistently by Pisanello, whom some consider to be the father of the medallic portrait, leads to a couple of secondary problems (fig. 2.3). First, in order to give the shoulder three-dimensionality, it must project from the surface of the medal. But the artist must suggest this protrusion without having the shoulder jut out too far, producing an awkward break from the planar surface of the medal. A related problem is the two-dimensional line defining the amputation. Pisanello chose, most often, to have the base of his bust-length portraits run parallel to the arc defined by the edge of the medal (although he also essayed other solutions). Finally, the artist must decide how to treat the space beneath the bust. This was a natural place to continue the inscription identifying the sitter. The medallic form encourages the use of a continuous inscription running around the outer edge of the medal to be read as the spectator rotates the disc in his or her hand. The bust-form, however, tends to arrest the eye and produce an insistent vertical-

Figure 2.3
Pisanello, *Leonello d'Este*, c. 1440.
Obverse of bronze medal.
Collection of Roger Arvid
Anderson

ity; for this reason, Pisanello and later medallists often "reversed" inscriptions in the exergue (the area below the bust), producing a more stable viewing configuration and a unified textual pattern. In this system, the words lose their independence and become ancillary to the compositional imperatives of the image.

The maker of Cosimo's medal presents a very satisfying solution to these compositional quandaries.[51] Rather than have the portrait conform and echo the round shape of the medal—Pisanello's preferred solution—the artist establishes an antagonistic relation between the two constituent elements: the portrait and its circular visual field. Although slightly curved, Cosimo's hat follows its own steeply tangential trajectory, conceding little to the arc of the medal or its inscription. The subtle autonomy of the portrait relative to the medal's shape is best witnessed by considering how the artist treats the problem of the bust. The line defining the base of the bust does not convexly mimic the medal's edge, rather it possesses a gentle S-curve, lending to the shoulder a skeletal solidity and to the vestigial chest that visually supports the likeness above a satisfying weight, and producing a pleasing choreography between linear forms.

The bust solution might suggest to the viewer that the medallic portrait was not taken from life, but rather from a preexisting sculptural likeness. In general, it alludes to the ancient genre of sculpted portrait busts and to the renewed interest in this form in fifteenth-century Florence.[52] The medallic portrait of Cosimo is related, in fact, to an *all'antica* marble bust-length relief portrait of Cosimo in Berlin often attributed to Andrea del Verrocchio.[53] On

the medal, Cosimo appears removed from us not only on account of his averted gaze and closed lips, but also since he appears *as* an image. For the credible mimesis suggested by the detailed physiognomy serves not to provide us with direct access to the sitter, but rather to emphasize the antiquity of the medallic format and the *Romanitas* of Cosimo himself.

Despite Cosimo's distinctively modern haberdashery, the visual antiquity of the stoic and somber profile portrait seems to emphasize the sitter's Ciceronian and senatorial qualities.[54] This republican *Romanitas* is underscored by the inscription that brackets the portrait: COSMVS MEDICES DECRETO. PVBLIC O P P ("Cosimo de' Medici by Public Decree P[ater] P[atriae]"). These words do not run beneath the portrait, nor do they circumscribe it.[55] They are rather scrupulously arranged around the head and shoulders of the figure. The trajectory of their course around the medal is interrupted by the pinnacle of Cosimo's hat and the extensions of his torso. Not occluding the letters themselves, this visual intrusion of the image into the space of the text generates a curious play between the portrait and the frame produced by the words. The result of this play is an increased sense of monumentality granted to Cosimo's head, which appears to fill out the visual field, expanding beyond the enframing text.

The Latin rendition of his name compounds the aura of Roman dignity projected by the portrait. The "P"s following the name are certainly linked to the epithet *pater patriae*. As Alison Brown has shown, since the 1440s writers, like Antonio Paccini and Francesco Filelfo, desiring to curry the good favor of Cosimo, had repeatedly appended the republican tag to his name.[56] It was, however, only on 16 March 1465 that the government officially bestowed this title on the deceased statesman.[57] The epithet *pater patriae* was associated with Cicero and Cato, and both ancient politicians were adduced in panegyrics addressed to Cosimo. Likened to ancient orators, Cosimo was seen to embody virtues associated with antique, republican politics. Seen as the "Father of Florence," Cosimo was regarded in paternal terms.[58]

Despite the Latin inscription and the intentionally antique format, the medal is not simply a playful archeological exercise. For the medal comments, meaningfully, on Cosimo's political appearance. This becomes clearer when we look at the medal's reverse.

The two-sided medal provides the viewer with both the sitter's "body" (the portrait proper) and his or her "spirit" (a symbolic rendition of or commentary on the sitter); in this it is similar to an *impresa*.[59] Although in cataloguing and referring to such medals, we tend to lend priority to what is known as the obverse, that is, the portrait, in an experiential sense the medal exhorts its beholder to grant equal weight to the reverse and to animate the

portrayed body through reference to its allusive spirit. How then did the artist commissioned to commemorate Cosimo elaborate the corporeal portrait of his paternal sitter? Or, taking into account the probable intervention by Piero, how was the artist directed to re-animate Cosimo?

Turning the medal over, one finds a seated, female figure facing left. An inscription in the exergue identifies her as FLORENTIA. She wears a long gown, and a veil decorously covers her head. In her right hand Florentia holds out a sphere the size of a grapefruit or a small melon; it might, as John Paoletti has suggested, be read as a heraldic Medicean *palla*.[60] In her left she supports the base of a vegetal branch that is propped against her shoulder like a rifle. She sits on a faldstool, supported, in turn, by what would appear to be a yoke.[61]

Under later Medici luminaries—and especially Giovanni de' Medici—the yoke became a central family *impresa* and was hitched to the verbal tag *suave*, or "easy." This would appear to refer to Matthew 11.28–30: "Come unto me, all ye that labour and are heavy laden, and I will give you rest. Take my yoke upon you, and learn of me; for I am meek and lowly in heart: and ye shall find rest unto souls. For my yoke is easy, and my burden is light." If the yoke on the medal does refer to this biblical passage, the allusion is particularly apt for Cosimo, whose meekness and lowliness were proverbial—in Gozzoli's frescoes in the Medici palace chapel Cosimo appears mounted on a donkey.[62]

The major inscription circling Florentia reads: PAX LIBERTAS QVE PVBLICA ("Peace and Liberty for the Public"). In conjunction with this inscription, it seems likely that the branch held by Florentia is an olive branch, signifying peace. Lending Florentia a Minervan air, this arboreal symbol refers generally to Cosimo's efforts to ensure Florentine security; the medal might have reminded contemporaries specifically of Cosimo's central role in bringing about the Peace of Lodi in 1454, a pact that ensured that relative peace reigned in central Italy for more than a decade. The orb in Florentia's other hand is a more generic symbol. Usually associated with universality and authority, and a mainstay of imperial and Christian iconography, the orb also possessed a particular reference to Cosimo's name; in poetry and the visual arts, Cosimo was often associated with the "cosmos" (both "Cosimo" and the Italian *cosmo* were "Latinized" in the fifteenth century as *cosmus*).[63] The globe in Florentia's hand, therefore, was both a punning reference to Cosimo and a symbol of his authority. On the medal, Florentia makes a pointed gesture with the orb: she retains, and yet offers, her sphere of influence. The intended recipient cannot but have been Cosimo. The woman is the embodiment of the *patria* of which Cosimo was the *pater*.

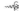

The only direct visual antecedent for the representation of Florentia on Cosimo's medal can be found in manuscript illustrations of the so-called *Panegyric to Robert of Anjou of Naples*. Probably composed in the 1330s, this text exists in a number of versions, the most important of which is in the British Library.[64] A female figure, wearing a red and white cloak beneath which we see a blue undergarment with gold neckline and cuffs, dominates folio 13r of this manuscript; a diaphanous veil encloses her plaited hair (fig. 2.4). The figure appears to kneel, having moved from the wooden seat seen behind her. Arms crossed over her chest, she gazes in three-quarter profile to her right, her lips slightly parted. She resembles the Virgin Annunciate.

As with other similar figures in the manuscript, this is a personification. A few folios earlier a vexed and distraught Italia implores Robert of Anjou (equipped with gown, scepter, and orb) to aid her in her quest to regain her ancient glory (the text was composed during the so-called Babylonian Captivity, while the papal court was in Avignon); Roma, rending her robes and weeping, also makes an appearance. The figure on folio 13r is also a civic personification. Visually this is announced by the multicolored flower that sprouts from the throne to her right. The distinctive triform flower contains an adaptation of a common civic leonine couplet cited at the head of the previous chapter; the revised lines read: "Flos florum, flore Florentia crescit honore, / me qua virtutis rego, rex, frenoque salutis" (Flower of flowers Florentia grows from flowers with honor, because I am governed, O King, with the reins of virtue and of safety). We also learn that this is Florentia from the text on folios 12v and 13r. The words are spoken by the female personification; her open lips remind us of her grammatical position in the text as subject. She gives three flowers—a white, a gold, and a red lily—to Robert of Anjou, and urges him to help her mother Roma. She ends her discourse by affirming her family ties: "I am the daughter of Roma; I speak for her as if for myself, and it is thought that I have the name Florentia for a reason. Originally it was the flowers of the Romans who founded me and girded me with new and beautiful walls: now I lament for the disasters [that have befallen] my unlucky mother."

Visually, the personification of Florentia in the *Panegyric to Robert of Anjou* shares little with that seen on Cosimo's medal. Nonetheless, the manuscript does help us to reconstruct the fundamental assumptions that made the medal reverse possible. The literary trope of personifying Florence as the daughter of Rome was widespread;[65] the manuscript illumination demonstrates how easily Florentia could become an image. Moreover, the grammatical position of Florence as the subject of the text establishes a dialectical relationship with an assumed, privileged reader: in this case, Robert of Anjou.

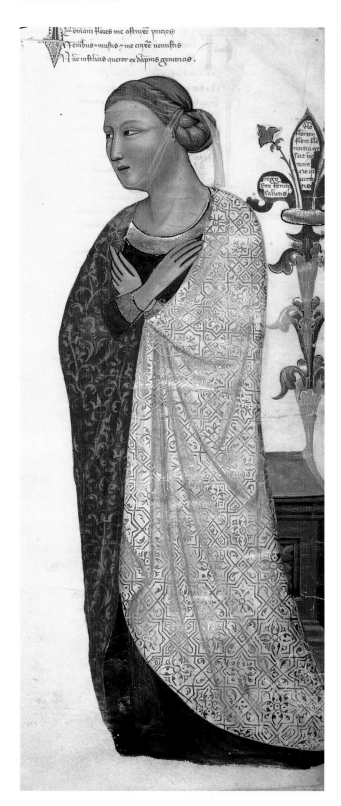

Figure 2.4
Anonymous (follower of Taddeo
Gaddi), *Florentia*, 1330s. From the
*Panegyric to Robert of Anjou of
Naples.* British Library,
London

This connection between a prince and a civic personification was a customary one, a staple of monarchical symbolism. The medal reveals a similar structure, emphasizing the relation between Cosimo and Florentia.

Iconographically, the manuscript illumination figures Florentia as Mary. This association still possessed great power in the fifteenth century, and, as Mary Bergstein has demonstrated, fueled the rededication of the Florentine Duomo as Santa Maria del Fiore.[66] While the Florentia of the *Panegyric* derives from a lively literary tradition of civic allegory, and from Marian imagery, the Florentia on Cosimo's medal possesses antique visual roots.

Tyches

The impression of naturalness projected by personification is deepened by the trope's antiquity. The idea of giving personality to an inanimate object or to a concept reaches so far back into our cultural origins that it resists defamiliarization. It is, of course, at the heart of most religious systems. But more specifically, medieval Europe inherited an extensive iconography of civic personifications from the Graeco-Roman pantheon. I am thinking here especially of *tyches*, female personifications of cities or states, particularly popular in the Hellenistic world. The antique *tyche* was not simply a convenient politi-cal naturalization, it was also a magical figure, protecting the state and tinged with divine might.[67] The most famous and prototypical exemplar of this genre was the *tyche* of Antioch, cast in bronze by Eutychides of Sicyion, a pupil of Lysippus, in about 300 B.C.E. This statue represented a seated female figure in a long robe, her knees crossed, and bearing, in her right hand, a sheaf of wheat. Seated on a rock, symbolizing Mount Silpius, at her feet was a figure personifying the Orontes River. The most striking attribute of this *tyche* was her headgear: a crenellated crown referring to the walls of Antioch. She was a "map" of Antioch, her body a mystical and unified symbol of the state.[68]

Linked to the figure of *tyche*-Fortuna, the personification of Chance, the city-*tyche* produced a symbolic connection between the worldly concerns of quotidian politics and the celestial sphere. Minor deities, city-*tyches* possessed symbolic regalia and became the focus of cultic worship, but they did not receive the extensive narrative elaboration bestowed upon the major gods in the Greek pantheon.[69]

The *tyche* of Antioch spawned a legion of similar personifications. The attributes, naturally, changed, but the basic format of a seated, crowned figure embodying a city remained constant. Moreover, the *tyche* was both a realization of the city in a single body, and the representation of a presiding spirit, guiding and protecting her charge.

The most important descendant of the *tyche* of Antioch was the goddess Roma.[70] On the so-called *Gemma Augustea*, a carved sardonyx cameo from the first century C.E. (fig. 2.5), one finds an exemplary rendition of this civic personification.[71] In the late Middle Ages, the *Gemma Augustea* was housed in Toulouse and its appearance was well known in Italy. In 1464 Filarete referred to it in his treatise on architecture, and a cast of the *Gemma* could even be found in the collection of Pius II, Aeneas Silvius Piccolomini.[72] Although the imagery of the *Gemma* is an encomium dedicated to Augustus and his heirs, the central figure of the upper register is a seated representation of the *tyche* Roma. She displays in this context two important aspects. The first is military. A Minervan helmet has replaced the crenellated crown, and Roma rests her feet on symbolic booty: on the *Gemma Augustea*, Roma represents the military might of the Augustan city. Beneath, in the lower register of the *Gemma*, one sees the vanquished barbarians of the Illyrian campaign. But Roma has another aspect: she accompanies the seminude and heroic Augustus. She appears as his ideal consort. Supporting this notion, Roma appears to hold a *thrysus*, and not a spear. The *thrysus*, a Bacchic wand with a pinecone on the end, was a staple of amorous and marital iconography. Throughout the empire, in fact, Augustus and Roma were the focus of joint cultic worship, implying the former's union with a semidivine bride.[73]

Feminist scholarship has provided convincing explanations why Western artists have chosen more often than not to represent ideal and allegorical figures as women, and real and historical figures as men. Marina Warner and Sigrid Weigel, for example, have demonstrated how this separation reflects and reinforces the dominant patterns of the division of labor and the elaborate definitions of ideal femininity, which dislocated women's achievements from the worldly, promoting them into a celestial, ideal zone.[74] It is not, therefore, surprising that men in the *polis*, or in the city-state, chose to represent themselves corporately as a female figure. But this did have consequences. Given the symbolically martial aims of the crenellated *tyche*—to represent the polis as strong and well-armed—the female personification became a figure of compound attributes. Feminine and motherly, the Hellenistic *tyche*, with her walled crown, and Roma, with her magnificent helmet, came to be amazonic ideal hybrids of feminine and masculine virtues.

The *tyche* is also liminally positioned between allegory and deity. As a goddess, she presides over her city, but citizens could also develop narratives around this distant personification. By embedding the personification in stories, particular social relations were described and developed. As the relation between Augustus and Roma the *Gemma Augustea* suggested, the personifica-

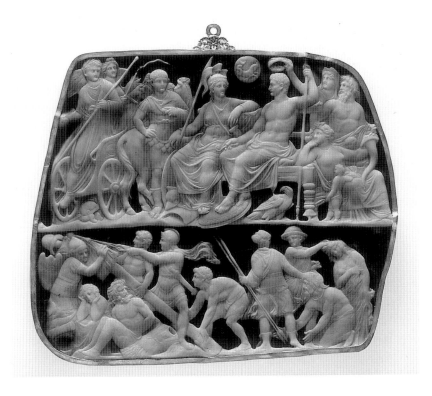

Figure 2.5
Anonymous, *Gemma Augustea*,
1st c. C.E. Sardonyx cameo.
Kunsthistorisches Museum,
Vienna

tion of the state as a woman bore consequences for the types of martial and marital relations that might be elaborated between her and the ruler.

That the representation of Florentia on Cosimo's medal could be seen as a modernized rendition of the goddess Roma is demonstrated by a sixteenth-century medal attributed to Domenico di Polo and representing Cosimo I. There can be no doubt that this medal, although it is based on a Roman coin, refers pointedly to that of Cosimo "il Vecchio."[75] On its reverse a helmeted and lance-bearing figure resembles closely that of Roma as she appears on innumerable Roman coins and, as we have seen, on the *Gemma Augustea*. The seated personification, identified in the exergue as FLORENT[IA], mimics the gesture of Florentia on the medal of Cosimo "il Vecchio." Here, however, she proffers a more pointedly political gift, a palladium. While the inscription—SALVS PVBLICA—refers to Lorenzo de' Medici, the seated Roma-Athena as Florentia harks back to Cosimo's medal and to the *tyche* tradition within which it operated.[76]

Domenico di Polo's medal of Cosimo I renders visible the extensive symbolic genealogy linking Florence and Rome. Dante claimed, in a creationist flourish, that Rome made Florence "ad imaginem suam atque similitudinem."[77] This reflects the symbolic relation manifest in the *Panegyric to*

Robert of Anjou considered above: Florentia as the daughter of Roma.[78] On the medal reverse of Cosimo I this genealogical metaphor is iconographically expressed; Florentia descends, literally, from representations of Roma.

Domenico di Polo recognized and made archeologically explicit the identity of Florentia on the medal reverse of Cosimo "il Vecchio." Wrapped in a classicizing mantle, this figure bodies forth a Roman Florentia. The medal reverse promotes the idea that under Cosimo's paternal rule, Florentia became Roma, or, put another way, Florence became a New Rome.

Paternal and Filial Politics

If Florence was the daughter of Rome, she was also Cosimo's daughter. The medal reverse aligns Cosimo's senatorial *Romanitas* with his "daughter's" Roman heritage, producing a distinguished paternity for Florentia (fig. 2.2). A late medieval version of an ancient *tyche*, Cosimo's Florentia resembles a Roman matron, her hair veiled and bearing symbolic attributes like the figures on so many Roman coins. But this daughter of Roma demonstrates her filial devotion not only to her eternal mother, but also to Cosimo. His character is, thereby, metaphorically marked by paternal Roman *virtus*. The medal offers a distinctly political message, but one crafted in a carefully inoffensive manner. The conjunction of Cosimo's *pater patriae* appellation with the free and peaceful rendition of Florentia suggests a natural and familial relation.[79]

Florentia's gesture is also eloquent. She engages actively with Cosimo, of her own volition placing herself under paternal control. This filial submission, though metaphoric, was far from being cryptic or esoteric. In praising the virtues of the deceased statesman, Angelo Ambrogini, or Poliziano, the Medici unofficial court poet of the Laurentian era, asked rhetorically: "Who is not aware of the ancient glory and renowned honor of the Medici family, and of great Cosimo, the splendor of Italy, whose city calls herself his daughter?"[80] While tinged with hyperbole, Poliziano's encomiastic query does contain a kernel of truth. The metaphor of Cosimo as the protective father of Florentia was both readily understood and broadly disseminated.

This medal, obviously commemorative and political, projects an image of Cosimo to the public whose peace and liberty he guaranteed. Thus despite its relatively small size and the indeterminate breadth of its reception, the medal is a public statement, putting Cosimo on an open political stage and casting him as a patriarchal figure of estimable authority.

We do not know who owned, or be-held, Cosimo's medal. Sources concerning the passage of medals among the courts of northern Italy would suggest that they were circulated as diplomatic gifts, and records of the melting

down of medals in later periods indicate that they were collected in enormous quantities.[81] One extraordinary visual document—the portrait painting by Botticelli of a young man mentioned above—does, however, raise some issues concerning the medal's reception in a Florentine context (fig. 2.6). The panel is remarkable for its inclusion of a gilded gesso impression of Cosimo's portrait medal.[82] The youth, wearing a rich dark-green robe and a red cap, is presented before a deep landscape and a wan, sparsely clouded sky. The artist has defined the sitter's robust features—a strong, broad nose, full lips, and cleft chin—by rendering the complex reflection of light from the different planes of the face with exceptional sensitivity. This highly complex visage is set off against a mane of thick hair that falls to the sitter's shoulders. Most exceptional are the hands. Some have seen these as awkward, but they appear to me to be a very satisfactory response to a difficult artistic problem.[83] The hands bear and display a representation of Cosimo's medal that defies the boundary between represented and actual space. For this version of the medal is not simply painted, but rises from the surface of the painting. The maker of the panel allowed a raised section of wood to remain as a base onto which the gesso impression was attached and then later gilded. It is obvious that the rendition of the medal was obtained either by taking a gesso impression from the original matrix, or from a plaster impression taken from a medal, for the portrait and inscription are not reversed. Attention, therefore, was taken to ensure that the feigned medal in the portrait would appear as more than simply a visual representation; instead, Botticelli worked to emphasize the materiality of Cosimo's presence in the painting.

Cosimo's face, in fact, competes with that of the sitter for spectatorial attention. Botticelli, setting both heads slightly off-center, produces a gentle rhythm between the two protagonists. This compositional movement is heightened by the rotation of the young man's head and the corollary sharpening of his impassive gaze. This honed glance normally provides a basis for the attentive presentation of the sitter, who, rather than simply the passive object for the viewer, appears conscious of the meta-social encounter that portraiture can produce. In this instance, however, the sitter's gaze—along with the elegant and consciously demonstrative bearing of the hands—seems to shift attention subtly away from the youth and toward the medal he presents.

On account of this visual emphasis, some art historians have suggested that the painting portrays the medallist—variously identified as Niccolò Fiorentino, Cristoforo di Geremia, and Bertoldo di Giovanni—proudly presenting his work.[84] Other interpreters have proposed that the Medicean medal was included so as to indicate that the sitter was a member of the family, a descendant of Cosimo "il Vecchio." On stylistic grounds, the portrait was al-

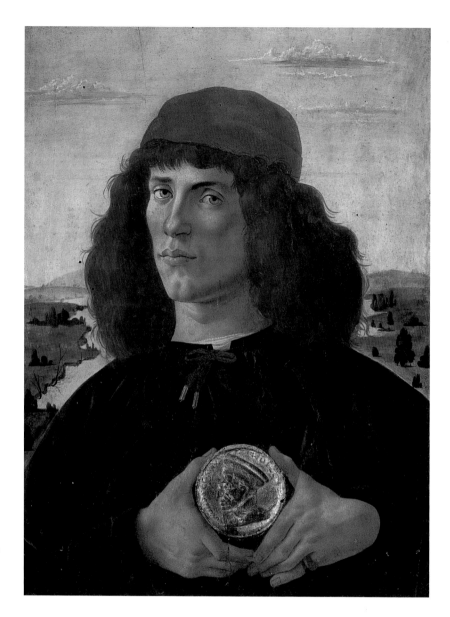

Figure 2.6
Sandro Botticelli, *Young Man with
a Medal of Cosimo de' Medici*,
c. 1475. Galleria degli Uffizi,
Florence

most certainly painted in the mid-1470s; in this analysis the medal would have
been, therefore, a record of posthumous veneration and affiliation. But for
whom? Apt candidates from the Medici clan have not been forthcoming. The
sons of Cosimo were too old, while the grandsons either too young or bear-
ing little resemblance to the man in the painting.[85] A similar, and in my opin-
ion stronger theory proposes that the sitter might be Cosimo's godson, of
which there were many.[86]

Lacking stronger evidence, it seems best to consider this young man as
related to Cosimo by the ties characterized by social historians as linking

"friends, relatives, and neighbors"; in this sense, the sitter can be counted among Medici partisans. Given his apparent youth, it also makes sense to see the sitter as bridging a generational divide. Perhaps he is the son of a partisan connected directly to Cosimo. Certainly the purposeful presentation of the medal seems to suggest a desire to affirm the sitter's long-standing relation to the Medici family and, in particular, to its deceased patriarch.

If we suppose that the gold medal, either in physical reality or simply in the representational reality of the painting, belongs to the youth, it speaks of his well-being and gratitude. Holding this gleaming eucharistic shield over and near to his heart, the sitter also signals his allegiance to Florentia on the reverse: his patriotic affiliation guaranteed through the patronage of Cosimo.[87] Were this a representation of a direct relative, the inclusion of the medal and pointed thematization of a Medicean "relation" would probably have been superfluous. The young man appears rather to be emphasizing the role of Cosimo as his metaphoric father, signaling his membership in a broad, quasi-familial political network. I would like to suggest that the medal, distributed perhaps to Medici partisans, would have helped to constitute this network, reminding be-holders of the complex relations that bound them to the Medici and, through the paternal Cosimo, to the maternal state.

"E tu, ben nato Laur . . ."

Paternal symbolism functioned effectively given the memory of Cosimo in the late 1460s as an elderly statesman. When, however, Lorenzo de' Medici found himself the de facto *paterfamilias* of the Medici and of Florence, paternal symbolism was less appropriate. The symbolic elaboration of Lorenzo's authority followed a very different path and exhibits a very different visual logic.

When Piero de' Medici died in 1469, his eldest son, Lorenzo, was twenty years old. The Medici family had unofficially ruled Florence for thirty-five years, first under Cosimo "il Vecchio," and then for five years under Piero, his gouty eldest son. Unlike his father and grandfather, Lorenzo spent his entire life in preparation to take over the family business of banking and politics. During his subsequent twenty-three years in power, he was to demonstrate more talent for the latter than for the former, but in 1469 his political authority was far from secure. The five years of Piero's guardianship of Florence had demonstrated the fragility of Medicean consensus. In 1466 Dietisalvi Neroni and Luca Pitti initiated a coup that surely could have succeeded but for the indecision of the latter.[88] With his father's death, Lorenzo inherited an unstable position; it was unclear whether the youth would automatically be granted the civic role played by his father and grandfather. However,

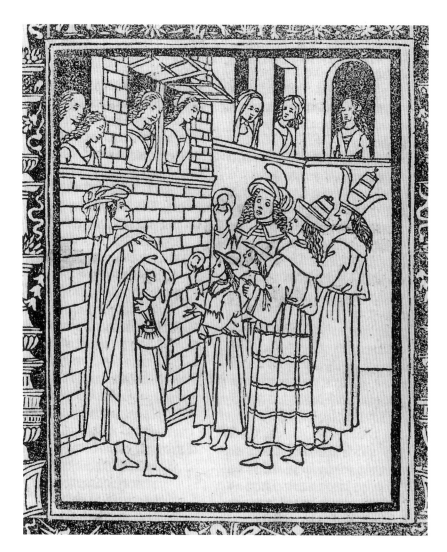

Figure 2.7
Anonymous, *Lorenzo de' Medici*,
c. 1500. Woodcut frontispiece of
Lorenzo de' Medici, Angelo
Poliziano, and Bernardo
Giambullari, *Canzone per andare in
maschera per carnesciale* (Florence,
n.d. [c. 1500]). British Library,
London

because of the unwavering support of a handful of loyal counselors and
the persuasive rhetoric of Tommaso Soderini, a broad sector of Florentine
citizens endorsed the status quo by backing Lorenzo.[89] At this uncertain
moment, Lorenzo naturally turned to the example of his grandfather, who
had so successfully "managed" Florence. Constantly advised to take Cosimo
as his model, Lorenzo fashioned his rule on that of his grandfather's. No sin-
gle factor bore upon Lorenzo's political style more significantly than this con-
stant reminder. Nonetheless, Lorenzo's public persona was very different
from that projected by his paternal grandfather. This can be ascribed partly to
their age in the public and historical consciousness. Lorenzo died in 1492
when he was forty-three years old; Cosimo—literally "il Vecchio"—became
the most dominant force in Florentine politics at age forty-five, exercising a

controlling interest over the city until his death in 1464 at age seventy-five. During his years in power, Lorenzo was always a relatively young man.

Even late in his life, Lorenzo presented Florentines with a youthful image of authority. A woodcut frontispiece to a collection of carnival songs composed by Lorenzo, Angelo Poliziano, and Bernardo Giambullari and published around 1500 impresses this fact upon us (fig. 2.7).[90] Lorenzo stands at the corner of a palace, possibly his family's on the via Larga. Standing before a group of masked performers, Lorenzo seems to take part in their fanciful and carnivalesque celebrations. He, and the players, attract the attention of a host of young women, assembled at the windows above. Although clearly an august personage, Lorenzo appears as a man satisfying a broad popular taste; not a Roman senator, Lorenzo becomes a courteous bard with, if not of, the people. This visualization of Lorenzo's public persona is matched by his flexible literary identity. Lorenzo composed numerous carnival songs, *canti carnascialeschi*. In these he adopts the voices of street vendors, calling out to customers. This social ventriloquism represents a telling moment in the history of literature; it also reveals a certain pattern in Lorenzo's public self-presentation. Although he could appear to Cristoforo Landino and the elite readers of the *Disputationes Camuldanenses* as the philosophical defender of the contemplative life, Lorenzo also set stock in a popular image of himself as the poetic *troubadour* who could speak directly to the *popolo* and in the traditional Florentine *volgare* respected by oligarchic and patriotic patricians.

The woodcut and Lorenzo's vocal flexibility help to contextualize the second portrait medal I would like to discuss (figs. 2.8–2.9).[91] On the obverse of this medal we see Lorenzo. This face shares with the portrait of his grand-

Figure 2.8

Niccolò Fiorentino, *Lorenzo de' Medici*, c. 1485–92. Obverse of bronze medal. National Gallery of Art, Washington, D.C., gift of The Circle of the National Gallery of Art

Figure 2.9

Niccolò Fiorentino, *Florentia Under a Laurel Tree*, c. 1485–92. Reverse of bronze medal. National Gallery of Art, Washington, D.C., gift of The Circle of the National Gallery of Art

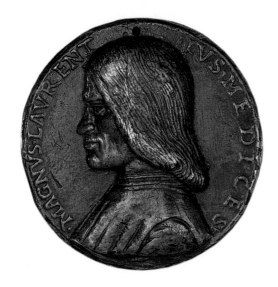
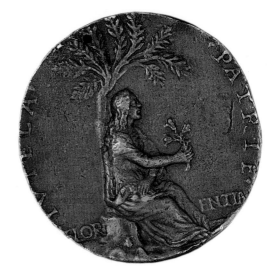

father a certain appropriately serious air. But Lorenzo is represented not as a Roman statesman, but as a gallant man. His thick, flowing hair dominates the face of the medal. Moreover, Lorenzo's likeness is presented to the viewer in a more immediate manner than that of his grandfather. Here the sitter's torso is cropped by the edge of the medal. The likeness does not emphasize its similarity to an antique bust; rather, the portrait offers what appears to be a more direct relationship with the sitter. Compositionally, the inscription serves to reinforce the edge of the medal. This boundary produces a limited sense of space, emphasized by Lorenzo's massive head occluding, just slightly, the inscription.

The inscription suggests that this medal was cast with a direct relationship between it and Cosimo's medal in mind. Lorenzo, physically and adjectivally, is figured as "great"—MAGNVS LAVRENTIVS MEDICES—but no longer "father of his fatherland." Not only would the inclusion of such an honor (bestowed upon Cosimo by governmental decree) have been inappropriate during Lorenzo's lifetime, but the title was inapt.[92] In a Florence feigning republicanism, Lorenzo could not simply appropriate the title, nor the symbolic paternalism attributed to Cosimo. The reverse of this medal hints how Lorenzo responded to this apparent lack of space within the existing symbolic language.[93]

On the reverse we again find Florentia, identified by the inscription that brackets her body (fig. 2.9). Here, however, the personified city is presented in a manner radically different from that seen on Cosimo's medal (fig. 2.2). Although again in vaguely antique garb, Florentia on this medal is pictured with hair flowing freely down her back. Unlike Cosimo's Florentia, who was seated in an abstract and blank visual field, Lorenzo's Florentia resides in a landscape, albeit a sparsely indicated one: one sees the suggestion of a ground plane, and, most strikingly, behind the seated figure rises a tree with distinctive, broad leaves. Facing to the right, her left hand rests across her lap while in her other hand she holds what appear to be three flowers. This Florentia seems to mimic the gesture found on Cosimo's medal, but instead of the mystical and empowering "cosmic" orb, she—in a manner reminiscent of Florentia in the *Panegyric to Robert of Anjou*—appears to proffer flowers. Again, I would suggest, the intended recipient is the present, yet absent, sitter on the obverse.

The major inscription on the reverse helps us clarify another aspect of Lorenzo's presence on this side of the medal. It reads TVTELA PATRI[A]E. Not the father, Lorenzo figures as the guardian or protector of his female ward, Florentia. The artist has made this protective relation visible, probably intending the thick-leafed tree under which Florentia sits to represent a laurel.

This is a recurrent Medicean symbol and one that plays a major role in the poetic invention of Lorenzo, who often appears as *Laurentius* or *Lauro* (the latter meaning "Laurel" in Italian).[94] In fact, both Bernardo Bellincioni and Angelo Poliziano produced memorable literary images of Lorenzo/Lauro protecting Florence.

Shortly after Lorenzo's death in 1492, Bellincioni writes how "he sees another beautiful lady with flowers in her lap, of whom the world sings as a new Athena [clearly Fiorenza/Florentia]. I see her resting happily in the shade of that plant which I so loved in its living form."[95] The "new Athena" refers to the deity Florentia, while the plant Bellincioni reveres and under whose protective canopy the personification rests is, of course, the laurel—a component in Lorenzo's poetic *senhal,* the textual intersection that joins Lorenzo-Lauro-*lauro.* The literary image was not new, and the coincidence with the iconography of Lorenzo's medal reverse, probably produced a few years before, might even suggest that Bellincioni's verses are a creative ekphrasis, describing and transforming the allegory on the medal's reverse.

Earlier, Angelo Poliziano, friend and collaborator of Lorenzo, had also made use of this imagery: "And you, well-born Laurel, under whose shelter, happy Florence rests in peace, fearing neither winds nor threats of heaven, nor irate Jove in his angriest countenance: receive my humble voice, trembling and fearful, under the shade of your sacred trunk; o cause, o goal of all my desires, which draw life only from the fragrance of your sacred leaves."[96] This text might be seen as the source for the allegory on the reverse of Lorenzo's medal, but, given the absence of specific proof, a more tempered interpretation would simply see these and Bellincioni's lines as operating within the same symbolic register as the medal: image and word are traces of a complex lost oral and visual culture that likened Lorenzo to the laurel tree and Florence to a deified woman who could find safety under its limbs. But if Lorenzo is the laurel tree, he is also the courteous and gallant lover offering succor to the public of Florence, incorporated as a woman.

Responding to Lorenzo, Florentia, set in a vestigial garden, offers flowers. It is possible that the three buds on a single stalk were intended to represent lilies or irises, and thus refer to the omnipresent floral communal symbol of Florence: the *giglio fiorito,* as Goro Dati called it.[97] In some accounts, this quasi-heraldic device was thought to derive from the legend that Florence was founded upon a field filled with flowers.[98] On the medal reverse, therefore, we might interpret Florentia's gesture as acknowledging Lorenzo's seigneurial relation to the state. But the setting and Florentia's gesture also imply that the flowers might have been drawn from poetic, rather than explicitly political, iconography.

In 1465, at the marriage of his friend Braccio Martelli to Costanza de' Pazzi, Lorenzo bestowed a clutch of violets to Lucrezia Donati, the recipient of his public and amorous affections.[99] This gift figures prominently in Lorenzo's poetic self-image and, as Charles Dempsey has pointed out, in his poem *Ambra* Lorenzo himself called the city "il gentil fior."[100] By representing Florentia as bearing flowers—both her attribute and, albeit perhaps only through a false etymology, eponymous sign—the medal also sets the personification in a courtly narrative with Lorenzo. Within a poetic world of gardens and gifts, the relationship between the two, Florentia and Lorenzo, is amorous. But it is also political. For if Lorenzo offers Florentia shade from the sun, and protection from the lightning of "irate Jove," she returns the favor by proffering civic flora: *gigli fioriti*. On another famous medal—that commemorating the Pazzi Conspiracy of 1478—Lorenzo is called SALVS PVBLICA, the "salvation of the public."[101] The flowers bestowed on Lorenzo by his willing consort, Florentia, suggest that in exchange for his guaranteeing peace (something Lorenzo did indeed do), the people of Florence would consent to his authority and legitimize his rule.

What is more, Lorenzo de' Medici's identity as the lover of Florence on the medal here examined was based on the widespread metaphoric topos, reviewed in Chapter One, of allegorizing the state as a female object of desire.[102] It is within this context that the reverse of Lorenzo's portrait medal ought to be understood. Florentia "rests in peace" beneath the shade cast by the laurel/Lorenzo. The vision of Florence, personified, and framed within discourses of love, figures Lorenzo as her protective, arboreal lover.

Despite the iconographic tradition of the *tyche*, throughout antiquity and the Middle Ages, the *corpus politicum* was consistently theorized as male. When this political science met with the iconography of personification, which more often than not incorporated the state as a female figure, the metaphoric system was thrown into disarray. Or, put more generously, the confluence of theoretical and visual bodies politic offered fertile ground for the production of new notions of statehood and, particularly, rulership. Particularly ripe for exploitation was the relationship between the charismatic ruler and his female state. It is my contention that the figure of Florentia on Lorenzo's medal offers one example of the way in which the Medici, and especially Lorenzo, managed to insert themselves into a poetic political narrative, "naturalizing" an otherwise "unnatural" form of authority. Establishing what Niccolò Machiavelli would later call a *principato civile*, a civil principality.[103]

Medici rule was not based on electoral tricks and financial might alone. The Medici, in order to maintain their rather precarious position at the top of the Florentine political hierarchy, had to ensure popular consent to their rule. Broadcasting, however, their intentions openly would have meant the risk of appearing tyrannical. Instead, Cosimo and his descendants depended heavily on cultivating support among their adherents within the *reggimento*. The Medici faction, sometimes called the *Palleschi,* was concentrated in the *gonfalone* of the Gold Lion, and in the adjacent areas near San Lorenzo, but its tentacles, especially later in the fifteenth century, spread citywide. Each adherent brought with him a chain of clients, bound to their patron, and therefore to the Medici, by personal allegiance. In this system, it was the link joining the Medici to their friends and partisans in the *reggimento* that bore the most stress. And it was, therefore, above all to this audience that the Medici addressed their political imagery.

The star-shaped pattern that marks the structural reception of the Renaissance portrait medal in general, and these two Medici medals in particular, corresponds well to the patronal patterns identified by the sociologists Padgett and Ansell. The Medici linked themselves to a citywide patrician network through marriage, producing partisans whose connection to broader sociopolitical groups passed through Cosimo, Piero, and, later, Lorenzo. The medals operated similarly. Discrete objects possessed, I speculate, by Medici partisans, these portrait medals served to reinforce the social and political centrality of their sitters.

Pursuing a pointed and successful marriage strategy, the Medici managed to secure their position on the social ladder that structured Florentine political participation. In this light the imagery of amorous attraction and consent embodied in Lorenzo's medal reverse was particularly fortuitous, for it would have reminded the Medici's clients of the unquestionable nature of the bond between themselves (as Florentia) and their patrons. The Medici cast themselves as the fathers and lovers of Florentia; proper cliental relations demanded that Florentia return the favor.

3

Engaging Symbols

*Said Neri di Gino [Capponi] to Cosimo: I would like for you to say things
clearly to me, so that I can understand you. Cosimo replied: Learn my
language!*
—Angelo Poliziano

The biography of Cosimo de' Medici emerges from a legion of such quips.[1]
These sibylline utterances spring forth from the fertile oral tradition of Tus-
cany and from biographical conventions, but they also contain seeds of truth.
In this instance, Cosimo exhorts those who wish to understand him to try
harder. This, naturally, inscribes a power relation—it is not Cosimo's duty
to make his words clear, rather such toil belongs to those around him. But Co-
simo's language was also, perhaps, intentionally obscure. Like other wealthy
families in republican political contexts, the Medici, as this and other studies
stress, were at great pains to promote themselves while not overstepping the
cultural norms that circumscribed permissible public display by individuals,
families, and factions. Nonetheless, given Cosimo's particularly pivotal posi-
tion in Florentine public life, his linguistic ambiguity, as recorded by Poli-
ziano, Vespasiano da Bisticci, Niccolò Machiavelli, and others, might be seen

to express a deeper and purposeful political ambiguity, what two recent commentators have called Cosimo's "multivocality."[2]

Within the republican structures of Florence, Medici political authority was illegitimate, founded not on constitutional approval, but on networks of personal, patronal, and familial relations. Consciously playing factions against one another and forging ties with different sectors of Florentine society, Cosimo clearly projected a variety of images to a differentiated public. Medici authority meant different things to different individuals and constituencies. It is perhaps the breadth and variety of the consensus the Medici generated that has left us with a prismatic and multifaceted image of Cosimo and his words.

The polysemic nature of Medici power bears, fundamentally, on the manner in which the family produced and sustained their authority visually. It is in this light that I would like now to turn to one of the most prominent visual signs of Medici legitimacy and authority: the family device of the diamond ring.[3]

In the fifteenth century the symbol of the ring was the most widespread family device of the Medici, appearing in various forms on all nature of commissions; its origins and significance, however, remain very murky. The Medici possessed and deployed many different devices and *imprese* during the fifteenth and sixteenth centuries. Obsessively inserting arcane family symbols into new contexts, twisting meanings via puns and anagrams, and switching between esoteric and popular registers of meaning, the Medici cast a dense web of visual and textual metaphors about their crypto-sovereignty. Taking every opportunity to capitalize upon obscure references to the nature of their rule as they saw it, the Medici elaborated on their coat of arms and their heraldic *palle;* the cult of the Magi; on themes of renewal suggested by the *broncone* and later by GLOVIS (*si volg[e]*, meaning "it turns," backwards); on their family name (Medici—*medicus*, by choosing the medicinal saints Cosmas and Damian as their patrons and, playing upon their "doctoring" of the public, Lorenzo adopted the epithet *Salus Publica*); as well as on their forenames (for example, Cosimo/*cosmo*, Piero/*pietra*, Lorenzo/*lauro*).[4] The nature, breadth, and details of this language of authority has attracted considerable scholarly attention. Curiously, the ring, though surely the most widely applied Medici device, has received relatively little consideration.

I wish to explore the significance of this important device by arguing that the Medici ring makes sense within the tropes of embodiment introduced in the last two chapters. I claim that the meaning of the ring's use by the

Medici as a family symbol cannot be lodged only in instances of its prior use by other families, nor exclusively in the symbolic *anime* provided by six-teenth-century reference books; rather, I would like to present a possible social and visual logic of the ring as a Medici symbol by connecting it to the material object it represents: a diamond ring.

During the fifteenth century, the diamond ring was the preeminent symbol of marital alliance. Seeing the Medici ring as a nuptial band does not exhaust the possibilities of its significance, nor does it exclude other, more commonly adduced meanings. To the contrary, I hope that my approach to the Medici ring does not reduce this symbol to a single set of meanings, but rather I aim to restore to the device some of the rich polyvalence it possessed in its original contexts. Having said that, I do believe that to do justice to the Medici ring requires approaching it not only as a badge or heraldic marker, but also as a representation. By considering it not only as an abstract index of Medici presence in the city, I wish to see the ring as a deep and engaging symbol. My analysis attempts to give a voice to the Medici ring's original audience—the Florentine public—by reconstructing a broad "horizon of ex-pectations" for what a diamond-set ring might have meant. For the Medici diamond ring pictured to a broad and differentiated Florentine public a mate-rial object with a long and complex history. To the inhabitants of fifteenth-century Florence, I claim, the ring's significance as a sign of marital relations would have been inescapable.

The wedding ring in general was the most visible sign of legitimate, consensual matrimony, and the diamond ring in particular was a prominent component of patrician marriage in fifteenth-century Florence.[5] The words that describe the diamond ring's functions in the ceremonies of marriage in the fifteenth century—"legal," "legitimate," "consensual"—help us to gauge its appropriateness as a sign of Medicean rule, a fundamentally despotic form of authority operating within republican electoral structures. Add to these so-cial functions the symbolic layers derived from the ring's poetic and religious codings, and the power of the ring as a "symbol of rule"—what German scholar Percy Ernst Schramm labeled a *Herrschaftszeichen*—emerges. Taking to heart Cosimo de' Medici's reputed exhortation to Neri Capponi to "learn his language," I attempt to apprehend the particular visual dialect material-ized in the diamond-ring device.

When pictured as a marriage ring, the device becomes a particularly strong form of symbol, engaged, as it were, through its dense referential sig-nification to social practice and life. This analysis cannot therefore be foun-ded in hermeneutics of intention (either artistic or patronal), or the circuit of

a *Wirkungsgeschichte* (a history of discrete receptions). It requires, rather, an interpretative shift. I do not, for the most part, pose questions seeking answers in the data banks of heraldry, or the symbolic networks of *imprese*. Rather, I explore how contemporaries might have understood a wedding ring as a social and symbolic material object and then relate this to common political tropes defining gendered power and submission through the metaphor of marriage. In doing so, I hope to show how the diamond ring could become a gendered "symbol of rule" reinforcing a politically and poetically marital relationship between the Medici and the embodied bridal state, lending an appearance of legitimacy to a fundamentally illegitimate form of authority, and representing to Florentines an ideal image of their consent to Medici rule.

Il diamante: The Ring of Authority

I cannot do any better than [mention] the three diamond [rings] that the great Cosimo ["il Vecchio"] used, those you see sculpted in the room where I slept and studied. But, to tell you the truth, despite seeking with great diligence, I was never able to find out precisely what they were supposed to mean . . .

—Paolo Giovio[6]

Lorenzo de' Medici's birth in 1449 was heralded by a ring. As was not unusual in Florence, when she gave birth to Lorenzo, Lucrezia Tornabuoni de' Medici received a *desco da parto*, a birth salver, the symbolic and functional significances of which are still far from clear.[7] It would appear that, later, Lorenzo kept the distinctively round panel in his private chamber in the Palazzo Medici.[8] It was possibly Masaccio's brother, the artist Giovanni di Ser Giovanni, called Lo Scheggia, who painted on the front of this panel a Petrarchan *Triumph of Fame* (fig. 3.1) and on its reverse a ring (fig. 3.2).[9] The originally golden ring—the gilding has flaked off—is set against a blue ground; the arms of Lorenzo's father, Piero, and his mother, Lucrezia Tornabuoni, float above the ring, within which are arranged three ostrich feathers and a banderole bearing the inscription SEMPER. Set in the ring is a large, pyramidically cut gem.[10]

That this device was associated with the Medici has long been recognized.[11] A Medicean manuscript now in Florence's Biblioteca Nazionale lists the devices thought to have been used by Lorenzo de' Medici, including the following entry: "a diamond set in a ring with three feathers, white, red, and royal blue. Semper."[12] Sixteenth-century commentators—the most important of whom were Paolo Giovio, Gabriel Simeoni, and Alessandro Segni—already noted that the ring was a Medicean device, or *impresa* (as it was later

Figure 3.1

Giovanni di Ser Giovanni, called Lo Scheggia, *Triumph of Fame*, 1449. Tempera on panel. Metropolitan Museum of Art, New York, purchase in memory of Sir John Pope-Hennessy: Rogers Fund, the Annenberg Foundation, Drue Heinze Foundation, Annette de la Renta, Mr. and Mrs. Frank E. Richardson, and The Vincent Astor Foundation Gifts, Wrightsman and Gwynne Andrews Funds, special funds, and Gift of the children of Mrs. Harry Payne Whitney, Gift of Mr. and Mrs. Joshua Logan, and other gifts and bequests by exchange, 1995 (1995.7)

Figure 3.2

Giovanni di Ser Giovanni, called Lo Scheggia, *Medici Ring*, 1449. Tempera on panel. Metropolitan Museum of Art, New York, purchase in memory of Sir John Pope-Hennessy: Rogers Fund, the Annenberg Foundation, Drue Heinze Foundation, Annette de la Renta, Mr. and Mrs. Frank E. Richardson, and The Vincent Astor Foundation Gifts, Wrightsman and Gwynne Andrews Funds, special funds, and Gift of the children of Mrs. Harry Payne Whitney, Gift of Mr. and Mrs. Joshua Logan, and other gifts and bequests by exchange, 1995 (1995.7)

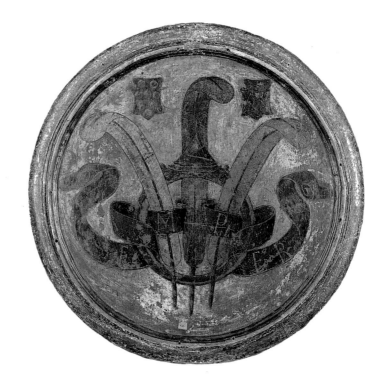

called).[13] These writers, moreover, affirm that the gem set in the Medici ring was held to be a diamond. Indeed, although I shall refer to the device in question as the "Medici ring," in Italian it was known simply as *il diamante*.[14]

Without a beginning or an end, the ring was, and is, a generic symbol of eternity. The crystalline strength of the diamond certainly reinforced this meaning. It is customarily assumed that the three feathers, which Giovio falsely believed were used first by Lorenzo, symbolized the three theological virtues, the colors green, white, and red referring to Faith, Hope, and Charity, respectively.[15] Furthermore, as Giorgio Vasari confirms, the feathered ring signaled the eternal virtue of its referent, adding that the ring was also a rebus, the diamond meaning "Di amando," a variation of "Deo amante," meaning, roughly, "loved by God."[16] Nonetheless, as Giovio's exasperation demonstrates, although the general symbolic content of the ring was well known, the specific meaning of the Medici ring as a device was not at all clear to the sixteenth-century compilers despite the ring's appearance on all manner of Medici commissions.

Beginning in the 1440s, the Medici marked a vast array of their artistic undertakings with this device, or variations of it. Most publicly, the diamond ring was put on architectural projects. It appears prominently in the windows of the family palace on the via Larga, constructed during the late 1440s and early 1450s (fig. 3.3). The device also marked Medici patronage on other architectural projects, including the important shrines of the Cappella del Crocifisso in San Miniato, and the Cappella dell'Annunziata in Santissima Annunziata.[17] Naturally, coats of arms had long dotted Florence's religious sites, proclaiming traditional patronal rights, but the inclusion of personal devices served to "privatize" ecclesiastical space and to offer the Medici a privileged relation to centers of extraordinary religious and civic significance, particularly San Giovanni Gualberto's speaking crucifix and the cultic icon of the Annunciation. Devices could carry out this symbolic co-option of space in a manner more direct and intimate than familial heraldry could achieve.[18] The Medici ring also appears on other buildings, including the Badia Fiesolana and, later, Michelangelo's Laurentian Library. Indeed throughout San Lorenzo, the Medici made their patronal presence manifest through their diamond ring; it can be seen on marble lavabos, on iron gates, and on wood intarsia decorations. Given its public currency, it is not surprising that the diamond ring device should also appear in Medici commissions of a more private nature: Filippo Lippi's overdoor *Annunciation* in the National Gallery, London (fig. 3.4); Botticelli's so-called *Pallas and the Centaur* (fig. 3.5); the birth salver mentioned above (fig. 3.2); and Gozzoli's frescoes in the Medici

Figure 3.3
Anonymous, *Medici Ring*,
c. 1455. Medici palace, Florence,
detail of window

Figure 3.4
Filippo Lippi, *Annunciation*,
1448–50. Tempera on panel.
National Gallery, London, detail

Figure 3.5
Sandro Botticelli, *"Pallas and the Centaur"*, c. 1482. Tempera and oil on panel. Galleria degli Uffizi, Florence, detail

Figure 3.6
Benozzo Gozzoli, *Procession of the Magi*, c. 1459. Fresco. Chapel, Medici palace, Florence, detail

Figure 3.7
Anonymous, *Antique Cup
Belonging to Lorenzo de' Medici.
Museo degli Argenti*, Palazzo
Pitti, Florence, detail

palace chapel (fig. 3.6). Later the Medici ring would appear frequently in murals and tapestries commissioned by Leo X and Clement VII.[19] The diamond ring appears on a variety of objects associated with the Medici: sculptures, maiolica plates, antique crystal vases (fig. 3.7), chests, and numerous manuscript margins, as well as incunabula (fig. 3.8). The Medici even had door knockers made in the form of diamond rings.[20]

This list cannot claim to be exhaustive, but it does give an idea of the range of visual fields within which this symbol was deployed.[21] At a basic level, the Medici ring functioned as a family badge, marking patronal presence. In the scope and density of its application, the meta-heraldic image of the diamond ring vied for preeminence with the heraldic *palle* or balls of the Medici coat of arms.[22] These symbols were essential in broadcasting familial presence in an urban environment where visual cues such as these produced notions of place, ownership, and power.[23] In this instance, however, the ring is, to my thinking, also a representation of an existing symbol—the nuptial ring—functioning therefore not only as a marker, but also bearing with it representational meaning and producing an image of the relation between the Medici and their public. Before turning directly to such representational functions, we must confront some problems concerning the more basic meanings of the ring as a badge.

Figure 3.8
Anonymous, *Medici Ring*, 1490.
Woodcut, frontispiece from
Lorenzo de' Medici, *La rappresentatione di San Giovanni et
Paulo* (Florence, 1490), detail

The examples of the diamond-ring device enumerated above also bring to the fore two difficulties faced when interpreting the ring as a trace of Medici patronage. First, the diamond ring does not appear in a consistent form on Medici commissions. And second, the ring does not appear only on works commissioned by a single member of the family, but rather surfaces on works commissioned by different individuals within the core of the Medici clan (especially, if perhaps not exclusively, by the descendants of Cosimo and Lorenzo di Giovanni di Bicci). These two issues have led commentators to align certain configurations of the device with the patronage of *particular* Medici scions. Giovio, for example, associates the device of three interlocking rings with Cosimo "il Vecchio," the image of a falcon holding a ring in its talons with Piero "il Gottoso," and the ring with three feathers with Lorenzo "il Magnifico."[24] Nonetheless, divvying up particular forms to particular members of the clan leads, inevitably, to confusion, for particular presentations of the ring are but weak evidence in differentiating the patronage of Cosimo from that of his sons Piero and Giovanni, his grandsons Lorenzo and Giuliano, and his grandnephew Lorenzo di Pierfrancesco de' Medici.[25] For example, while the ring-bearing falcon does appear to point more insistently to Piero than to his father or son, the Medici seem to have been rather liberal in sharing their devices with one another. How else can one understand the appearance of both a ring-bearing falcon and feather-laced interlocking rings on the Cappella del Crocifisso in San Miniato? What are we to make of the multiple ring configurations on the dress of the figure of a woman taming the centaur in Botticelli's mythological painting produced, in all likelihood, for Lorenzo di Pierfrancesco (fig. 3.5)? While there are fifteenth-century examples of particular devices referring to specific individuals, the desire to address all devices in this manner and produce a "science" of *imprese* was first felt in full force in the sixteenth century. The broad use of the ring and its manifold appearances from 1440 to 1500 speak of its function as a family or consortorial marker, particular not to individuals, but shared by the descendants of Giovanni di Bicci de' Medici.[26]

Although the diamond ring could refer to different members of the Medici clan, it seems clear that it was first and foremost the *impresa* of Piero di Cosimo. The ring appears initially on commissions closely connected with his patronage. Moreover, the diamond-ring device playfully alludes to Piero himself, a fact that modern scholarship has not recognized.[27] In the 1440s, observant Florentines would have readily understood the diamond embedded in this symbol as a pun on Piero's "stony" name. Such connotations were not lost on the literati of the Medici circle.

Niccolò Risorboli, a friend of Bernardo Pulci and a Medici intimate, availed himself of this pun, having Donna Fiorenza utter the following Christ-like lines to Piero de' Medici after the perils of 1466: "You are my Piero [*Petro*] and on this rock [*petra*] I have renovated the temple dedicated to liberty."[28] Writing in the aftermath of the peace accord of 1468, Bernardo di Piero Cambini, another pro-Medici poet, hopes that "if God produced the external peace, he founded it on strong stone [*pietra*], o Pietro, of diamond and not of fragile glass."[29] Bernardo Pulci, writing at the same time, explicitly likens Piero, whom he calls "viva petra," to a diamond worn by Fiorenza.[30] Later, Poliziano, linking the durability of the diamond with the ring's traditional signification of eternity, writes in praise of Piero:

> O Motherland, that stone which remains in the earth
> In eternal memory of the triumph, fame, honor, superiority, and glory
> Of your great relative [Piero di Cosimo de' Medici].
> This is the diamond.[31]

Although these literary examples appear later than the first uses of the diamond ring as a Medici device, it seems likely that the Medici ring sprang in part from such poetic punning and initially bore a particular relation to Piero di Cosimo de' Medici. The ring, however, soon came to signify in a broader fashion. Thus, from 1440 to 1469, while the male core of the Medici regime numbered four or five individuals, the diamond ring indicated Medici presence in a sweeping manner. It is in this capacity, for example, that the feather-and ribbon-laced rings appear on the windows of the Medici palace. Such sharing of devices among the male Medici was not uncommon. When, in 1459, Lorenzo wore the device of his father—a falcon—for the festivities accompanying the visit of Galeazzo Maria Sforza and Pius II, the significance of the symbol was commuted to the son. With the deaths of Cosimo in 1464, Piero in 1469, and, especially, Giuliano in 1478, the diamond ring that had appeared on Lorenzo's *desco da parto* celebrating his birth in 1449 came to be associated with him again, this time in a more restricted sense.

Without a doubt the ring was indeed a Medici device and would have been recognized as such by contemporary viewers. Nonetheless, it would be wrong to see the ring symbol as the unique property of the Medici. Like many meta-heraldic signs, the ring was used by other families in Italy and even in Florence. Most attention has been given to the insistent use of the ring on the architectural projects of Giovanni Rucellai and his son, Bernardo, in the quarter of Santa Maria Novella. It is inviting to link these rings to the Medici–Rucellai match contracted in 1461 and consummated in 1466; Brenda Preyer,

however, has argued that Giovanni Rucellai paid, among others, Marco del Buono to paint a *tondo* bearing a diamond ring for the family loggia as early as 1452.[32] Borgia and Cambi Gado circumvent this problem by relating the Rucellai use of the ring to the early plans for the match between their offspring in 1438.[33] Preyer had already offered an alternate theory, hypothesizing that the Rucellai ring had nothing to do with the Medici, but was "given" to Giovanni by the Este of Ferrara, who are also known to have used this device.[34] Following a similar line of reasoning, Francis Ames-Lewis also proposes a Ferrarese origin for the Medici ring.[35] Recently, Lorenz Böninger set forth an analogous hypothesis, arguing that the Medici ring was in fact derived from a Sforza device.[36] While the donation of such devices is not unheard of, in this case there exists no documentary evidence for such gifts.[37]

Studied as a diplomatic gift, interpretation of the Medici diamond ring has remained at a fairly esoteric level. Its status as a meta-heraldic sign cannot, however, have meant much to the average Florentine, whose familiarity with courtly symbolic networks, though not to be dismissed, must nevertheless have been quite limited. Thus, in arguing for a Ferrarese or a Milanese connection as essential to the ring's meaning, interpreters tacitly posit a circumscribed audience: those literate in the elaborate sign system of court life. I would like to try and recognize a geographically narrower, but socially broader, audience for the Medici ring.[38]

By positing a broad spectatorship, I am consciously traversing boundaries—particularly of class and gender—that are often assumed in the study of Renaissance art. For Brunelleschi's monocular fantasy of linear perspective so dear to students of Renaissance Florence has, ironically, been reproduced methodologically in Baxandall's "period eye": visuality distilled into a singular cultural oculus, composed from a broad array of materials, but leading seemingly ineluctably to an educated male viewer. The notion of a unique point of reception is, to some degree, a necessary stage in interpretation (especially in Baxandall's social historical explanation of stylistic change), but modern scholars typically have recreated an ideal bourgeois male viewer, conversant with ancient literature, while ignoring other spectators, especially women and the working classes. Throughout this book I seek to expand the pool of beholders taken into analytical account. In the case of the Medici ring, this produces a radically new reading. For the power of this symbol resides precisely in its ability to signify on a number of different levels and to different types of beholders. In this analysis, the viewer is not posited as someone versed in the cryptic symbolism of *imprese* or familiar with the emblems and devices of other courts; the viewer, rather, is imagined as someone equipped to recognize the Medici ring as a representation of a wedding ring (that is,

most if not all adult viewers). I would now like to examine viewers' under-
standing of a "wedding ring," in other words the associations that might have
accrued to this object on account of its social and cultural functions.[39]

Ring Theories

In modern Western culture, two rings are customarily given to the bride: an
engagement ring and a wedding ring.[40] The former is a troth, the second is
legally binding or symbolic of a legal bond. Although rings could and did
mean different things, fifteenth-century Florentines would have shared with
modern viewers an immediate and powerful association of a ring with be-
trothal and marriage. The cultural stuff of their association, however, would
have been both richer and broader than ours, owing partly to the symbolic
and economic centrality of jewelry to the exchanges defining marriage, and
partly to the ring's juridical function and history.[41]

Medieval Europeans, although they often placed the ring on the right
instead of the left hand, continued the ancient Roman practice of giving to the
bride a betrothal ring (*anulus sponsalitius* or *anulus pronubus*).[42] Rather than
being associated with the betrothal, however, the ring emerged in the Middle
Ages as the high point of the marriage ceremonies. Civil law defined marriage
as comprising four stages: the declaration of the volition of the spouses; the
desponsatio, concluded between the groom and the *mundualdus* (guardian) of
the bride; the *traditio per manum,* the handing over of the bride; and the *sub-
arrhatio cum anulo,* the "subarrhation" with the ring. The *arrha* can be defined
as a *defensive* gift from the bridegroom to the bride's father. The gift was of-
fered so as to place the father in obligation. If the father of the bride did not
pay the dowry, he was held *in duplum* and in a legal bind. When the groom
handed over the gift, he said "arrha"; the bride, then, was *subarrhata* (under
contract). Since it became custom for the father to give his daughter this
token gift, it came to be accepted that the groom ought to supply an *arrha* con-
sisting of feminine adornments; finally, the ring emerged as the condensed
token of this gift which returned (at least symbolically) to the bridegroom
upon the hand of his bride. The ring, as *arrha,* marked the bride's body as
debiting; the ring represents the money owed to the bridegroom and is there-
fore immediately related to the dowry.

The marriage ring was a very powerful symbol in late medieval and Re-
naissance Italy. Used as a means of making public the consummated marriage
bond, the ring was an object with enormous legal power. The bestowal of a
ring, even without the other customary legal and social rites, could—and
sometimes did—comprise a legally binding promise of marriage.[43] In Italy,
the bridegroom gave a ring, which in patrician circles was customarily set

with a diamond. The hard stone exemplified the adamantine fidelity of its wearer and thus the permanence of the bond contracted between man and wife. This ring, rather than the many rings that brides received from their new relatives, possessed particular legal force and symbolic depth.[44] The social symbolism of the ring is most evident in the records patrician Florentines left concerning marriage.[45]

In their family *ricordanze,* Uguccione and, after his death, his son, Recco Capponi, recorded eleven family marriages between 1433 and 1475. The formula of marriage was recorded consistently. For example, in 1437 Uguccione wrote about the marriage of his daughter, Chosa:

> I record how on 26 August 1437, I gave the faith to Sandro di Giovanni Biliotti to give as legitimate wife Chosa, my daughter, to Bartolomeo di Lorenzo Lenzi. And the above mentioned Sandro gave the faith to me in the name of the above mentioned Bartolomeo that he will be the legitimate husband of the above mentioned Chosa, my daughter.
>
> And on 27 August the above mentioned Chosa, my daughter, gave her promise in Santa Maria sopra Porta [San Biagio] to the above mentioned Bartolomeo Lenzi. And on 2 September it was sworn in Santa Maria sopra Porta; it was administered by Ser Uberto di Martino, notary of the guild of Porta Santa Maria with the dowry and declared dowry of 900 florins . . . between money and gifts.
>
> And on 1 November 1438 [more than a year later] she had the ring and it was administered by Uberto di Martino, notary of the guild of Porta Santa Maria and after we went to eat, and they went to marry [i.e., to consummate the marriage].
>
> And on 31 May 1443, Bartolomeo Lenzi in his name and in my gonfalon confessed to have had the dowry of the above mentioned Chosa, consisting of 900 florins; this was administered by Uberto di Martino in his inventory book. . . .
>
> And on 27 January [1444] Lorenzo Lenzi agreed to the above mentioned dowry, as appears in the book of Uberto, notary of the guild of Porta Santa Maria. . . .
>
> And on 1 February, Francesco, son of the above mentioned Lorenzo Lenzi agreed to the said dowry, as appears in the said book of Uberto.[46]

I cite these entries at length because they can stand for countless other notations in *ricordanʒe*, and they help us to embed the ring in the complex dealings that produced marriage in fifteenth-century Florence. The giving of the ring—in Florence called the *anellamento*—is bracketed by the giving of words between families and the handing over of money and gifts that formed the dowry. The long period between the *giuramento* (or exchange of oaths) and the *anellamento* (the equivalent of the *subarrhatio cum anulo*), though not extraordinary, is not customary; usually the ring was given shortly after the oath. What *is* customary is the coupling of the ring day with the *noʒʒe* (the wedding celebrations) and with the consummation of the marriage (often indicated by the verb *menare*, but here by *andare a marito*).

The ring is almost always mentioned in such records. Recording its exchange was as important as noting the handshakes and monetary transactions. The ring served to make visible the legal and economic pledges between the families.[47]

A report similar to that written by Uguccione Capponi, this time by Marco Parenti—son-in-law of Alessandra Macinghi Strozzi, and brother-in-law of Filippo Strozzi—records the marriage of his daughter Costanza:

> I record that this day, 15 March 1472, I married Costanza, my daughter, to Filippo di Lorenzo di Messer Andrea di Messer Lorenzo Bondelmonti and it was sworn on the said day in Orto San Michele in the presence of many family members. And the arbitrators were on their part Messer Luigi di Piero di Messer Luigi Guicciardini and for our part Lorenzo di Piero di Cosimo de' Medici with a dowry of 1400 sealed florins and it was administered by Ser Lionardo di Giovanni di Lionardo da Colle. And on 7 March, at 2 in the night, this parentado was concluded via the mediation of Piero di Neri di Messer Donato Acciaiuoli together with Lorenzo Carducci. And after, on 13 March, the handshakes were exchanged at [the palace] of the above mentioned Lorenzo de' Medici. Give thanks to the Lord whence all good things come.
>
> On 30 May 1472, the above mentioned Filippo gave the ring to the above mentioned Costanza in a sign of legitimate matrimony, and it was administered by Ser Francesco di Domenico di Bartolo, who was then notary at the Torre and after. On 1 June, Costanza "went to marry" in the house of the above mentioned Filippo, and they consummated the matrimony and then the dowry, placed in the Monte (which appears in this book on page 39), was secured.

Like Capponi, Parenti considered the giving of the ring pivotal to the marriage ceremony. It is not without meaning that the *anellamento* is here again coupled with the consummation of the marriage. As an open symbol of the contract the ring was, in fifteenth-century Florence, of more *public* import than the consummation. Similarly to the writing in the notary's book, the ring inscribed upon the bride's body the legitimacy of the sexual act that was to occur.

The secular ring that figured in marriage ceremonies in fifteenth-century Florence functioned above all as a juridical and personal troth, symbolically linked to the legitimate marriage pact. But if the ring made visual the legality of marriage, by the fifteenth century this visualization was fortified by religious discourses on marriage and fidelity. Christiane Klapisch-Zuber addressed one aspect of this fortification in her study of Tuscan marriage ceremonies and the iconography of the *Spozalizio,* or betrothal of the Virgin, arguing specifically that the late medieval Church supported a sacralization of the ring and the marriage ceremony in an attempt to stress the consensual nature of marriage and the symbolic relation between the conjugal pair.[48] In so doing, Klapisch-Zuber argues that the Church pursued a cohesive strategy aimed at supplanting broader kinship groupings with the couple, a more pliable social configuration.[49]

Fifteenth-century preachers went further in developing the symbolic power of the ring, lending Christian significance to the popular physiological notion that the ring, banding the ring finger, controlled the heart of its wearer.

Authorities have never completely agreed on which finger the wedding band ought to be worn. In antiquity, marital rings were often worn on the middle finger; during the Middle Ages, wedding rings were commonly worn on the fourth finger of the left or the right hand (that is, on what is today often called the ring finger).[50] The reason for this derives, above all, from a creative piece of anatomical theory. In the *Attic Nights,* Aulus Gellius wrote that "it is said that there is a certain very thin vein that goes from this particular finger [on the left hand] . . . proceeding to and arriving at the human heart."[51] The *digitus medicinalis,* as this finger came to be called, was discussed by, inter alia, Apion, Pliny, Galen, and Macrobius.[52] This piece of physiological lore was received in the medieval West and disseminated effectively by Isidore of Seville's influential *Etymologium* and by Gratian, who integrated Isidore's reading into the *Decretals.*[53]

The popular fifteenth-century preacher Bernardino da Siena was certainly aware that the wedding ring should be placed on the *digitus medicinalis.* Discussing matrimony, he states unequivocally that "the ring is put on that

[finger] with the vein which goes to the heart."[54] Through a rather complex and confusing tripartite division of the bride's finger, Bernardino extracted a Pauline reading of the ring, interpreting it as symbolizing "that fidelity which is promised to have power over the body of the other."[55] Cherubino da Spoleto in his *Regole della vita matrimoniale* elaborated upon Bernardino's rather elliptically described moral anatomy:

> As a sign, in the ceremony of the Holy Church, the husband places on the finger of his wife a ring which is called faith. Whereby it is intended that the faith, or the ring of that faith, is a bond, in order to let you know that it is not permitted to you, man, to have another wife, while your first one is alive; and it is not permitted to you to have another wife or concubine. . . . Moreover, note that the ring, called faith, is placed on the finger that is next to the little finger, where there is a vein which has its root in the heart; that is so as to let you know that you, who are in matrimony, ought to love cordially, and by loving cordially you ought to content each other without searching for another person.[56]

Fleshed out by religious commentators, the ring became a divinely invested exhortation to sexual probity and spousal loyalty. Its mystical, hematological connection to the heart guaranteed its effectiveness in curbing illicit passions and promoting "cordial love."

Despite Bernardino's and Cherubino's emphases upon the mutual workings of the wedding ring on both bride and bridegroom, the anatomic reading of the ring bears upon the former's fidelity to a greater degree than upon that of her husband. It is her body that serves as the cultural site of the contract. The *anellamento* referred to the bride's reception of the ring; customarily performed shortly before the bride and groom "went to marry," the *anellamento* became, in effect, the symbolic performance of the increasingly private, yet legally essential consummation.

In his etiquette manual for women, Francesco da Barberino describes in detail the stages of marriage, including how the bride ought to accept the ring:

> But I will not leave out for you the day of the
> When the words are spoken that
> Make the whole marriage between you.
> It becomes her then to be tremulous
> And humble with the eyes lowered,
> The members still, and with a fearful countenance.

The hands ought not to be given freely to him who holds them
When the ring is given to her.
But first wait, so that the hand is taken
Almost forcefully; and after it has been taken,
It does not become her to offer any resistance. . . .
Thus, when she is asked:
"Do you agree to take him?"
Or such words,
Wait—one, two, three—
And make your response, gently and softly.[57]

The ideal temerity of the bride, who must be given the ring "quasi sforzata," speaks of a sublimated version of consummation; indeed, it is very likely that the connection between the ring and consummation was symbolically close, for in poetic language the passage of the finger through the ring had an unambiguous and sexual meaning.

In poetic and, one can presume, popular language, the ring was associated with the female genitals. Both Ariosto and Poggio (telling a story ostensibly about the Francesco Filelfo) use the ring as a metaphor for the vagina and suggest that husbands wear it to ensure their wives' fidelity.[58] This play on the religious interpretation of "fidelity" capitalized upon the existing play between the *anellamento* and sexual intercourse.[59]

At this popular level the ring maintains its significance as a marker of fidelity and legitimacy. These concepts run through the ring's codings in poetry, legal texts, Christian imagery, and religious sermons. As a bearer of such meanings, the ring was an apt sign for the Medici to adopt, for it provided ideological buttressing at precisely those points where the edifice of their authority was most rickety. The ring, therefore, could possess many meanings, but I would like to stress its marital associations, which underscored the concepts of legitimacy and consent, and represented Medici authority through a marital metaphor.

The most robust of political imagery often does not reflect actual strength, but is, rather, of necessity so impressive, masking actual weaknesses.[60] Illegitimate authority—without deep roots, or without popular mandate—clearly profits most from sustained cultural programs promoting its legitimacy. The Medicean crypto-monarchy felt acutely the dangers of its illegitimacy. Unlike a monarchical *signore*—for instance his ally Francesco Sforza—Cosimo de' Medici did not base his power on overt claims to authority. Under Cosimo, Florence's system of government resembled Machi-

avelli's "civil principality," for despite his dominant position in Florentine politics Cosimo basically worked within the constitutional structures established by the pre-1434 regime.[61] Medici authority was particularly weak at those moments when it came closest to appearing monarchical, that is, when power passed to Cosimo's son, and then grandson. Eager to downplay the automatic succession of heirs, the Medici required symbols like the diamond ring, which, through its legal, religious, and popular encryptions, sustained an appearance of continuity and legitimacy.

Also symbolically apt were the ring's suggestions of consensual fidelity. The Medici regime's ability to stretch constitutional forms—extending the terms of extraordinary councils (*balìe*) and controlling whose name found its way into the election bags—depended upon maintaining the sway they held over their partisans. Money and favors, though the primary means of effecting this, could not perform the public functions of providing visual evidence of a charismatic center, about which to form allegiances. Using the ring to represent themselves, the Medici might very well have suggested to their friends and supporters the deep loyalty that they could expect from their patrons, and the fidelity they requested in return. The unending ring and the motto SEMPER often included in a banderole looped through or swathed around the Medici ring would have made this reference more profound, implying the stability, durability, and dependability of the ruling clan. The ring might reinforce the notion that the political relations keeping the Medici in power were mutual and consensual; within such political metaphors, Medici authority appeared less as an imposition from above and more as something akin to reciprocal love, binding client to patron in a network of mutual interdependence. The significance of the diamond ring might be seen as thematizing this type of patronal relation even more directly.

Modern historians have come to understand the fundamental role that marriage played in late medieval and early modern civic politics, serving to engender the partisan networks on which authority could be founded.[62] The studies of Dale Kent and of John Padgett and Christopher Ansell have shown how, between 1400 and 1434, the Medici managed to recoup their social position by tactical marital affiliation.[63] What is more, once a factional power, the Medici actively arranged strategically advantageous matches, by serving as *mezzani*, or marriage negotiators. The Medici strove, therefore, not only to link themselves to important families throughout the city, but also to link together certain elements within the ruling classes of Florence, the so-called *reggimento*, and thus to consolidate their network of support. Numerous *giuramenti* (like that of Marco Parenti discussed above) took place in the

Palazzo Medici.[64] In this sense, too, the diamond ring device would have suited the Medici, by referring obliquely to their strategic investments in the Florentine marriage market.

In a general sense, then, the symbolic meanings that can be recognized as defining the ring as a social object—legitimacy, consensual fidelity, as well as a cluster of affections associated with marriage—would have been quite apt attributes of Medicean authority. Is it, however, possible that a representation so innocuous as a wedding ring could function meaningfully as a political symbol? One way of assessing this is to take a slightly broader view and turn to the symbolism of late medieval and Renaissance lordship.

Engaging Symbols

When taking the veil, nuns participated in a symbolic marriage ceremony, with the ring serving to mark their metaphysical espousal to God. During the Middle Ages and Renaissance, the celebrant would pass the ring onto the nun's thumb, index, and middle finger—uttering trinitarian formulae—and finally place it on the ring finger of her right hand. At this point the bishop would pronounce: "Accipe annulum fidei, signaculum Spiritus sancti, ut sponsa Dei voceris, se ei fideliter serveris." That is, "Accept the ring of faith, a sign of the Holy Ghost, so that you might be called the bride of God, [and] that you might serve him faithfully." Returning to their seats, the nuns would then raise their right hands and sing: "Anulo suo subarravit me dominus" (with his ring the lord "subarrhates" me).[65]

At their investiture, bishops also received a ring; symbolically, they married the Church and Christ.[66] The fourth-century bishop and saint Ambrose, combining Lombard law and mysticism, wrote that "with the ring of his faith the Lord places me under *arrha*."[67] In Florence, at his consecration the archbishop symbolically married the abbess of San Pier Maggiore, bestowing upon her a golden ring and sleeping one night at the convent so as to signify his "conjugal" fidelity to the city and to the Church.[68] In the twelfth century, Honorius of Autun elaborated upon the religio-amorous relationship of the episcopal ring. Citing Pliny and Aulus Gellius on the "anular vein," Honorius discussed the diamond ring as a symbol of love. Because "just as the diamond is unbreakable," he wrote, "love is insuperable. Therefore the priest wears a ring, so that he be recognized as the husband of the Church, and that if it should be necessary he would, like Christ, sacrifice himself for that cause."[69]

Episcopal rings possessed twofold functions, both mystical and worldly. For if the clerics' rings suggested their marriage to the Church, they also connoted their dominion over their sees. In a ceremony that mingles sacred and

secular, at his elevation a pope receives, beyond his episcopal and signet rings, a gold ring engraved with the image of Saint Peter in a boat: the *anulus pisca-toris* or the Ring of the Fisherman. Linked to the temporal, rather than to the institutional, role of pope, at the pontiff's death the *camerlengo* symbolically defaces the ring.[70] Given the currency of the ring as a symbol of authority, carrying with it a double-edged message of submission and dominion, it is hardly surprising that the allegorical ring also left its mark on secular, royal ceremonial.

The secular version of this ceremonial investiture *per annulum* had a long history. In the late Middle Ages it was a broadly accepted ritual, repre-senting the bestowal of monarchical rights.[71] In France, for example, Charles, the rebellious brother of Louis XI, had himself married to the duchy of Nor-mandy by the Bishop of Liseux. When Charles lost control of the duchy in 1469, Louis had the ring that symbolized the illegitimate match destroyed on an anvil at the exchequer of Rouen.[72] Bestowed upon a ruler, secular or sacred, the ring referred to the symbolic union between the donee and his constituency.

In the sixteenth century monarchical marriage symbolism flourished in France, where the ritual joining of the king to the realm, via a marriage ring, became the focus of intricate ceremonial rites. Writing in the early seven-teenth century, Thomas Godefroy described the accession of Henry II to the throne in 1547. In the most explicit description of the ring's function in early modern ceremonies of investiture, Godefroy commented upon the marital qualities of the ceremony and the symbolism of the ring the king received:

> Royal ring: because on the day of consecration, the King solemnly weds his realm, and is, via the sweet, gracious and amiable connec-tion of marriage, inseparably united with his subjects, for the mutual benefit of those who are the spouses, he is presented by the . . . Bishop of Chartres a ring, in order to mark this reciprocal conjunc-tion . . . he places the said ring, with which the King marries his realm, on the fourth finger of the right hand, from which proceeds a certain vein which touches the heart.[73]

Referring to the well-known vein (although here claiming that it runs between the heart and a finger in the *right* hand), Godefroy's description of the French ceremony draws together the disparate strands of the ring as a po-litical symbol. Set on the king's finger, the ring joins his heart to his subjects; married to the realm, a metaphysical bond joins the prince to his state via a physical metaphor.

This type of symbolism can also be seen to have operated in late me-

dieval and Renaissance Italy. Florentines would have most likely been familiar with this symbolism through the well-known feast of the Sensa, celebrated in Venice each feast of the Ascension, forty days after Easter.[74] This annual event centered on the doge's "marriage to the sea," consummated when he threw a gold ring into the lagoon. The sexual symbolics of the state were well understood by contemporary viewers. The first records of this ceremony date from the thirteenth century. "By 1267," the historian Edward Muir writes, "when Martin da Canal described the ceremony, a *desponsatio*, or marital covenant, between the doge and the sea had been grafted onto the *benedictio*, creating a composite rite and establishing the rudiments for the marriage of the sea, or the Sensa festival." The chronicler describes how the bishop presided over the symbolic matrimony, and how the bridegroom/doge bestowed a gold ring upon his bride the sea, throwing the symbolic object into the waves.[75] Writing in 1285, Salimbene de Adam expanded upon this description:

> On the day of the Ascension of the Lord, the doge of the Venetians with his Venice betroths the sea with a gold ring, partly in order to demonstrate fidelity and to lead the bride home, and partly motivated by a certain idolatrous custom, whereby the Venetians sacrifice to Neptune, [and] partly in order to show that the Venetians have dominion over the sea. Afterwards, those fishermen who want (who are not otherwise engaged) take off their clothes and, taking deep breaths that they later let out, dive into the deep sea to search for the ring. And whoever can find it can possess it without any challenge.[76]

In marrying the sea, was the Venetian doge acting out a part defined by classical and pagan precedent as Salimbene de Adam seemed to think? Certainly the casting of the ring into the sea was not an uncommon topos in the ancient world, but it was only in the Middle Ages, with the development of the legal and ceremonial discourses describing the espousal of prince and state, that the ring was invested with sufficient symbolic power to indicate, independently, the wedding of the ruler to the realm.[77]

Significantly, before his return from exile in September of 1434, Cosimo de' Medici had been living in Venice. Although there is no record that he participated in the ceremonies surrounding the Sensa that summer, he must have been aware of the doge's ring, and his symbolic marriage.

These symbolic uses of the ring—by the papacy, Louis XI, Innocent III, and Venetian doges, and in French ceremonial—prove that the ring could and did fulfill the functions of a *Herrschaftszeichen*. In all likelihood the secular use of the ring in royal ceremonial evolved from the ring's episcopal significance.

There is, however, a startling difference between the ring's mystical and practical meanings in both episcopal and secular investitures. The bishop's ring was initially a sign of his mystical union with Christ and the Church, representing its wearer's bride-like submission. Collaterally, it implied the bishop's fidelity to his flock. The secular manifestation of this ritual reversed this polarity. The ring on the hand of a monarchical lord—episcopal or secular— came less to signify his submission to a greater power than it did his dominion over his subjects. Given this ground of significance, the ring as a political symbol was a pledge of fidelity offered to the state by the prince, in exchange for its support of, or rather submission to, his rule.[78]

This use of the ring assumed the political trope of princely marriage to the state.[79] Derived from the theological interpretation of clerical marriage that had figured powerfully in canon law, civil jurists applied the metaphor to secular rule. Most important among the early commentators were Cino da Pistoia and Luca de Penna. Cino conceived of the emperor's political role as analogous to that of a husband. As a man protects his wife, so the emperor protects the *respublicae:* "Because following the election of the emperor and the acceptance of the election then proposed by the republic, law follows it, just like mutual consent makes a marriage. . . . And the comparison between the corporeal matrimony and the intellectual one is good: for just as the husband is called the defender of his wife . . . so is the emperor the defender of that *respublica*."[80]

The marital-political metaphor was also important to Luca de Penna, an important Tuscan jurist of the early fourteenth century. Discussing Lucan's description of Cato as "father" and "husband" of the city, Luca de Penna touches upon the symbolic nexus linking secular and religious notions of mystical marriage: "There is contracted a moral and political marriage between the prince and the *respublica*. Also, just as there is contracted a spiritual and divine marriage between a Church and its prelate, so is there contracted a temporal and terrestrial marriage between the prince and the state. And just as the Church is in the prelate, and the prelate in the Church . . . so is the prince in the state and the state in the prince."[81]

Luca's conception of the prince and the state cohabiting within the body politic operates within the moral and theologically prescribed principles defining marriage during the late Middle Ages as consensual.[82] His text brings to the fore the analogy between secular and ecclesiastical marriage, and grants us access to what is certainly a widespread metaphor for conceptualizing lordship. Against this legal, mystical, and ceremonial background the ring emerges as a key object in late medieval and Renaissance symbology of the state.

The *Comento*

Specifically under Lorenzo "il Magnifico," who dominated Florentine politics from 1469 to 1492, the argument regarding the allegorical union of prince and state can be made with more confidence. This is so owing to the unique document Lorenzo himself composed, his *Comento de' miei sonetti*.[83]

Written in the vernacular, the *Comento* comprises forty-one sonnets with accompanying commentaries. The text was composed over a number of years and was left unfinished at the time of Lorenzo's death in 1492. The genre of commentary was popular, two texts by friends of Lorenzo being particularly relevant to the *Comento:* Ficino's commentary on Plato's *Symposium*, and Pico della Mirandola's *Commento alla canzione d'amore del Benivieni*.[84] But the structure and content of Lorenzo's text derives most explicitly from Lorenzo's reading of Dante's *Vita nova*. Lorenzo emulates Dante's autobiographic voice and raids the treasury of the *stilnovisti* for his imagery while relying, especially in the sonnets themselves, upon a Petrarchan vocabulary and pathos.

I do not want to represent the *Comento* as an autobiographical master text through which the political imagery of the marriage to the state, and by extension the Medici ring, can be explained; rather, the text offers an interesting parallel discourse describing a relation between Lorenzo and Florence.

As Mario Fubini demonstrated, reconstructing a cohesive narrative from the *Comento* is not possible.[85] Rather, the sonnets present a loosely connected set of scenes tracing the progress of love. These vignettes are bound together via the commentaries, which at certain moments suggest a close connection between the events described in verse and "real" events, while at others give the impression that the poems are merely vehicles for Lorenzo's Neoplatonic musings. To some degree this lack of unity can be ascribed to the fact that the sonnets and commentaries were written over the span of Lorenzo's adult life: sonnets I–IV and VII–IX between 1474–75 and 1477, X between 1478 and 1479, and the rest between 1480 and 1483; the commentaries were begun in 1473, continued in the 1480s (after the Pazzi and Frescobaldi conspiracies and Lorenzo's "sacrificial" voyage to Naples), and were returned to, with particular energy in 1490 and 1491, until the author's death in 1492.[86] It has long been recognized that to fail to take into account the political significance of Lorenzo's writings is to deny them their full historical import.[87] Moreover, in the *Comento* Lorenzo refers to his political fortunes directly (see, especially, the commentary to sonnet X). The text itself does not contain a hidden political message, but, taking into consideration the author's

political position, the work is impoverished if not read within the political context of its production and probable reception.[88]

Given the structure and language of the *Comento*, its readers have been characterized as elite, as opposed to the popular audience said to have been intended by Lorenzo for *La Nencia da Barberino*, the *Canzoni a ballo*, the *Canti carnascialeschi*, and the *Uccellagione*. Indeed, as Mario Martelli has argued, Lorenzo de' Medici's poetry can be seen as bridging the meritocratic Latinate culture of the humanists traditionally supported by the Medici, and the Italianate literary culture associated with the Florentine oligarchy.[89] The *Comento*, with its blend of lyric and Neoplatonic commentary, might be read as synthesizing these two discursive strains. The key to this synthesis is Lorenzo, and specifically his profound and complex love.

At the core of the *Comento* is the popular amorous image of the narrator's heart. In its central cycle, between sonnets XI and XV, Lorenzo's heart is "made noble" by the eyes of his Lady and then extracted. Formed and "made noble" a second time, *now* by the "Candida, bella e dilicata mano," the heart is replaced with an image of his loved one engraved on it. Later, the anatomy of the narrator is rewritten: the heart within him is said to be that of his Lady.

The somatic imagery of love is a common and recurrent trope in Italian fourteenth- and fifteenth-century poetry. A broad audience would immediately understand Lorenzo's self-figuration as a Petrarchan lover, at the mercy of Love and his *donna*. To elite readers, or auditors, the structural progression of the narrator's love in the *Comento* would have also raised other issues. Lorenzo couches the "making noble" of the heart, explicitly, in the Aristotelian language of reproduction. Falling in love, the man falls under the spell of his Lady: she removes his heart and forms the matter of his heart. Petrarchan love, however, is the reversal of peripatetic embryology. Man-heart is matter formed by woman-hand. Understanding this reversal is essential to discerning the political logic of Lorenzo's *Comento*.[90]

Having had his heart once "made noble" via ocular power, the narrator turns to the hands of his Lady in sonnet XIII:

> O pure white, delicate and lovely hand,
> Where love and nature placed those graceful sweets,
> So noble and so lovely that it seems
> That all their other works are made in vain,
> You gently drew my heart forth from my breast,
> Out through the wound the lovely stars had made

When Love made them so pious and so sweet;
You entered in behind them, bit by bit,
And with a thousand knots you bound my heart.
You formed it new; and when you afterward
Had made it noble, it won't do
To longer seek to bind it with new knots,
Or ever think it pleased by something else.[91]

The commentary signals the difference between the nobility achieved by ocular and manual fashioning: "And for this it was made noble, that is, to understand, to contemplate and to enjoy that beauty only by means of the eyes. But after that whitest of hands entered into my breast and drew the heart from it, it seemed that it would be elevated to a very worthy office, because this demonstrates the jurisdiction that my lady exercised over my heart, and it expressly clarifies that she already considered it hers."[92]

Moreover, while the narrator fixes on the beauty of the hand, in a manner congruent with both poetic tradition (*la bianca mano*) and social custom, he also calls attention to the fact that it is the left hand of his Lady that performs the amorous surgery:

And therefore, as for a new office and end, it needed to be made noble again, because it not only had her beauty as its object, but also the love of my lady—a thing as much more worthy as it was more spiritual and less corporeal, and her beauty was not less wanting nor less desirable to my heart than were her eyes to mine. It was then necessary, as has been said, to make my heart noble again and to shape it for this new object, and for this function nothing seemed better suited than the hand of my lady. This must be understood to have been the left hand, which, in departing from my lady's heart, [appeared] like a more certain messenger and witness of its intention. For it is said that in the ring finger, that is the one next to the finger that in the vernacular we call "the little finger," is a vein that comes directly from the heart, almost a messenger of the heart's intention. Of necessity we see then that my heart again had to be reformed and made noble to this new and worthier end, and that the true officer of this effect was her left hand for the reasons stated above.[93]

Sonnet XIV continues along these lines, explaining that *Amore* gave to the narrator this hand as a pledge (*pegno*)—the hand that gilds the arrows, which both wound and heal like Achilles' lance. The giving of the hand refers to some sort of legal pact. In the commentary this is made evident, with ref-

erence to social custom: "It is a common and ancient custom among men in every contract and transaction, to touch, as a more efficacious sign of our heart and will, with our own right hands the right hand of him with whom the pact is made, and commonly it is done when peace is restored after some war and related injury. Similarly, when in such cases or in others someone takes an oath, the right hand is its instrument and officer."[94]

This reference to shaking hands and giving oaths is, within this context and taking into account quotidian usage, full of marital overtones, reminiscent of the *impalmamento*. The final sonnet I shall cite, XV, closes this minicycle.

> O how I envy you, my blessed heart,
> Because that the charming hand now presses, now
> Caresses you, expunging every hardness low,
> And you are thereby made so noble that
> The name to which Love consecrated you,
> That finger white portrays in you, and now
> Imprints her face angelic, represents
> It joyful now, now troubled tenderly.
> Now one by one her amorous, winsome thoughts
> The lovely hand sets down, now it records
> Her blessed and sagacious words so sweet.
> O my fine heart, what more then can you hope?
> Only that those divine lights have the power
> To change you to unyielding diamond.[95]

The narrator's heart is apostrophized and envied. The narrator says that his Lady wrote upon his heart and formed her angelic face upon his coronary material. Finally, this organ is poetically transformed into a diamond—hard, his heart will retain that which his Lady there inscribed. The commentary expands: "As soon as my heart became noble matter, as long as the matter could be without noble form, the longer the matter could be without form. And because Love joins matter and form together, that is a natural desire that the one has for the other, so Love, who moved that hand to ennoble my heart, also moved it again to give my heart a very noble impression."[96]

Amore goes on to inscribe the Lady's name on the softened material. Consecrated like a temple or church, the narrator's heart bears the name and image of its patron. Lorenzo, then, digresses, offering his famous explanation of what makes a good painting—good materials, a good master, and things that are "in their own nature, attractive and pleasant to the eyes."[97] Finally, the commentary turns to the transformation of the heart:

Neither was there ever a hand so noble and expert in [forming] such a picture as that of my lady, nor could a thing more pleasing be expressed in my heart than the sweetest sayings and the face and name of my lady. And therefore, in the judgment of my heart this picture was very perfect, for my heart wanted it to be perpetuated and thus be preserved in it eternally. And this is a very natural desire and follows from the principles already mentioned, since one goes on the way of perfection, which is very hard and laborious, to reach beatitude. And, there remains for whoever has the grace to be led there, no other desire than achieving [beatitude] and abiding in it, as my heart still desires to do. And, believing that this was the way to be able to perpetuate itself in such good, it desired that the eyes of my lady might have that power and virtue that one reads about, indeed that the face of Medusa possessed, and that, just as the sight of her turned men into stone, so the eyes of my lady thus painted in my heart and so lovely might change it into a hard diamond. One must understand then the picture of such great beauty and of the sweetest things in my heart to be the thoughts that were in it and the imagination of such things as those. Since those might be preserved in it and that they might endure in the fashion of the hardness of a diamond, and that new and troubled thoughts would not succeed them and drive away those that were sweet, as many times occurs with lovers, who ordinarily are preserved in the same condition but for a brief time.[98]

Medusa-like, the Lady turns the narrator's heart to stone, in this case a diamond. This petrified image of the heart is thus a monument to the narrator's love, preserving it, unchanged. The diamond, like the ring, symbolizes the adamantine fidelity of the lover, and the eternity of his devotion.

The *Comento* suggests a number of possible levels of reading. One can attend to the voice of the sonnets or to that of the narrator. The poet's references to Simonetta Catteneo Vespucci in the first sonnets and to Lucrezia Donati in the body of the text make an anecdotal reading tempting—the sonnets XIII–XV here discussed represent themselves as excerpts from his relationship with Lucrezia, while the commentaries offer interpretations of this relationship, inflected by the political events of the late 1470s and the philosophical turn of Florentine thought.[99] But the references to Lucrezia Donati are not to be taken for granted. The "affair" cannot be seen as simply that; rather it was a public and princely staging of love.[100] Similarly, the *Comento* fashions a role for the political Lorenzo. As the passive, effeminized Petrar-

chan lover, the narrator places himself under the control of his Lady. To Florentines, the text might have invited the speculation that this also characterized Lorenzo's relation to another Lady: Fiorenza. In the commentary to sonnet X, it is suggested that the lover's suffering be equated with the political fortunes of the author (a key moment where the narrative discourse reaches out beyond its frame). Surely, Florentine readers or auditors of Lorenzo's *Comento* would have understood the amorous woes of the narrator as being related to the conspiracies of 1478 and 1479, and his adoption of a self-sacrificial Petrarchan role as being connected to the diplomatic voyage to Naples, whereby Lorenzo offered himself as prisoner in exchange for the freedom of Florence. And finally, given the literary personification of Florence as Fiorenza-Florentia and suggesting an amatory or marital connection between her and the Medici, can the position of the Lady in the *Comento* as a representation of Florence be granted a prominent place among those interpretations most likely to have struck a chord among its readers?

Although, as many have pointed out, Lorenzo's language is insistently Petrarchan, a possible source for Lorenzo's imagery is Boccaccio. In the *Amorosa visione,* the narrator describes the following, by now familiar, series of events:

> And thus, standing there, it seemed that I saw
> This noble lady come towards me
> And open my breast and write within,
> There in my heart, placed so as to suffer,
> Her beautiful name in letters of gold,
> So that it might never escape.
> She, after a short pause,
> Placed upon my little finger a ring
> Taken from her great treasure [her breast];
> To which, it seemed to me, if my intellect was able to understand,
> Was linked a small chain
> Which descended from the lovely lady's breast,
> Passed into her and held her with its hooks
> As firmly as an anchor grips a rock.[101]

The significances of the Medici ring as a symbol, I suggest, are enriched when considered within the poetic tropes that personify Florence. Lorenzo's clearly ironic representation of himself as the disempowered lover, and the playful equation of his heart with a diamond, provide a possible frame for the consideration of the Medici ring, within which it becomes not only an esoteric family device, but a politically active image of the gendered relation of the Medici to the state they governed.[102]

With this in mind, I would like to turn to a final poem, a panegyric by Bernardo Pulci.[103] Writing to Lorenzo de' Medici in the aftermath of the dangerous Pitti-Neroni conspiracy of 1466, Pulci's poem addresses Fiorenza. Referring to the renewal of her ancient glories, Pulci pictures Fiorenza with jewels, reminiscent of those received by brides at marriage:

> I see, lofty lady, your beautiful breast
> Decorated with precious gems and with gold,
> And the ancient treasure,
> That was lost in oblivion, recuperated.

The poet then recalls the manner in which Camillus restored his spouse, Roma, to peace. Next Pulci recounts the trials of other ancient statesmen and heroes who, like Piero de' Medici, faced conspiracies bravely.[104] Toward the end of the poem, its imagery becomes less historical and more allegorical and mystical.

> O fortunate and gracious lady [Fiorenza],
> You have joined so noble and glorious a spouse . . .
> Is he not the one who alone dared
> To re-adorn you in so rich a dress,
> The living stone [*petra*] and column,
> Where all our hopes are founded?
> Beautiful lady, rest on and with welcome
> Virtue serve so firm and beautiful a diamond [Piero] . . . [105]

The patent marital and lithic symbolism of such verses could not have been lost on the impressionable Lorenzo de' Medici.

Medicean symbolism of rule under Lorenzo did possess a social and visual logic. The cultural expressions embodied in the ring were in dialog with political circumstances. In his love poetry, Lorenzo figured himself in strongly Petrarchan tones, as a gallant lover beset by the travails of love.[106] This position of apparent weakness produces a lack, fulfilled only by the absent object of desire: the narrator's *donna*. But this lack is poetically inscribed so as to explain the crystalline and powerful devotion of the narrator/lover. Thus, even within the poetic register, the expressions of weakness belie an actual empowerment. In his poetry, Lorenzo blurs the interplay between the actual and the fictional. In his poetic romp through the Florentine suburbs, *I beoni*, Lorenzo calls the city "la mia Fiorenza."[107] As underscored in the discussion of the medal in Chapter Two, at the intersection of the poetic and the

politic Lorenzo was pictured as the supple yet strong laurel—impervious, as Poliziano informs, to Jupiter's lightning—protecting his *donna,* his beloved Fiorenza.

It is within such rhetorical imagery—embodying the city as the desirable Lady Fiorenza and protecting her beneath a metaphorical mantle—that the ring, I believe, becomes more than only an inert marker of Medici presence. That is not to say that the pictorial metaphor—first developed for Piero, or perhaps Cosimo—was from its inception so framed. But given the ring's currency as a symbol of rule, as part of episcopal and papal regalia, and as a quotidian symbol of marital loyalty, it would be willfully ahistorical to set the Medici use of the ring as a family device outside of such sign systems. Moreover, the metaphoric reading of the ring, connecting marital and political fidelity and domination, is one available both to literate and illiterate audiences.

The diamond ring, therefore, was well suited to its function if not pushed, metaphorically, too far. It could, on the one hand, imply that form of mystical bond between prince and state that the mercantile, crypto-monarchical Medici needed to promote, both abroad and domestically (especially among the *reggimento*). This symbolic tie was natural, irrefragable, and religiously sanctioned. On the other hand, given the theoretically consensual nature of marriage, the Medicean diamond ring could subtly, cryptically, and absolutely falsely suggest that the Medici *primi* were indeed only *inter pares.*

The horizon of expectations—for both elite and popular audiences—was such that a diamond ring necessarily possessed a marital and sexual significance. This does not mean that the ring referred exclusively to marriage, but it does suggest that this meaning presents a fundamental symbolic layer that other interpretations must take into account. There can be no doubt that other readings are possible and relevant.

The social coding of the ring as ensuring legitimacy and fidelity made the object a desirable symbol for Medicean rule. What is more, the ring's role in the ceremonies and theories of political espousal offer a telling context for the Medici device, one suggesting a variety of relations. With the ring, the Medici may be signaling their betrothal to Florence and its people, underlining their subjugation to a greater, quasi-divine entity. Simultaneously, the marital associations of the ring might imply the consensual subordination of spouses. If the Medici implied with their ring a certain submission, they expected a similar response from their civic spouse. The ring, put simply, fortified the legitimacy of the bond between the Medici and Florence personified as Florentia, and therefore the legitimacy of Medici rule.

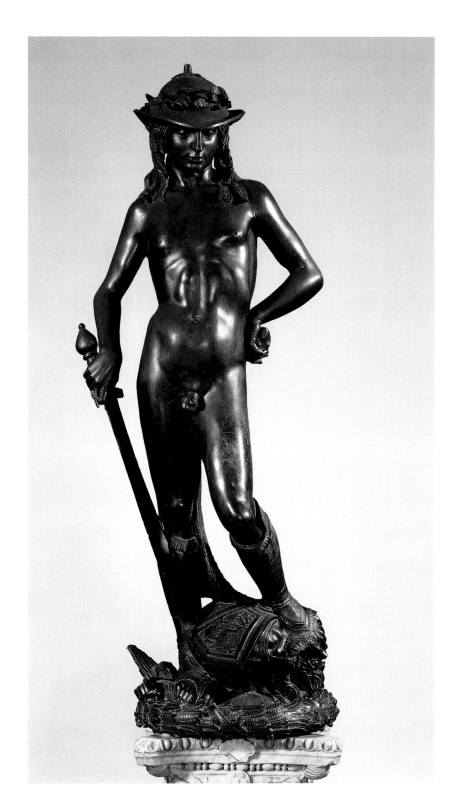

Figure 4.1
Donatello, *David*, c. 1450.
Bronze. Museo Nazionale del
Bargello, Florence, frontal view

4

Homosocial Desire and Donatello's Bronze *David*

El Davit della corte è una figura et non è perfecta, perchè la gamba sua di drieto è schiocha.

(The David of the court is an imperfect figure, because from behind his leg is silly.)

—Francesco Filarete

In 1466 Medici hegemony was seriously threatened by the so-called Pitti-Neroni conspiracy.[1] Nonetheless, with political mettle and a considerable amount of luck, Piero de' Medici emerged unscathed, and, in the fall of 1466, Medici authority appeared unassailable. Seeking to ingratiate himself with Piero de' Medici, Niccolò Risorboli, a friend of Bernardo Pulci, penned an exorbitant *canzone* in praise of Piero and celebrating the political triumph of the Medici line. The *canzone* adopts the voice of Fiorenza, who, likening Piero to Roman statesmen who had similarly overcome conspiracies and intrigues, showers the gouty banker with hyperbole. Fiorenza addresses Piero as "O splendor rilucente, o santo raggio," emphasizing the unimpeachable good of Medici rule by recalling Piero's father, "Cosimo santo e felice," whom the female narrator calls "padre mio." Then, toward the end of the poem, Fiorenza utters the following lines:

I [Fiorenza] see to your [Piero's] left and right sides
Two green little laurel branches rise,
And it appears that each desires
To shade my hair with its fronds,
On a column is an armed one,
Who appears to give grief to your enemies,
So that you fear and love
That which is done by him to overcome Goliath.
This was that unjust and ill-spirited faction,
That wanted to take from me those who were born with me,
Just like the sun pleases the sky
So it [the faction] turned in flight and its great iniquity
Fell to reason and to justice.[2]

If, as seems likely, this poem was indeed composed shortly after the failed Pitti-Neroni conspiracy of 1466, it represents the earliest known textual response to Donatello's bronze *David* (fig. 4.1).[3] Its imagery and wording are striking. Operating within the political tropes described and discussed in the previous chapters, the personification of Fiorenza "speaking" Risorboli's lines presents a particularly intimate, familiar, and familial relation between the Medici and their city. The two green branches Fiorenza sees refer, unequivocally, to Lorenzo and Giuliano, Piero's sons. As discussed in Chapter Two, the image of laurel shading Fiorenza's hair operates within a well-known political and poetic trope. But Risorboli moves from textual imagery to the material, when he has Fiorenza focus on the "armed one on a column," who "overcomes Goliath." Risorboli, I submit, offers an interpretation of Donatello's bronze *David*, a political statue that was, at that time, in the middle of the courtyard of the Medici palace on the via Larga. David's victory over Goliath, Risorboli comments, resembles Piero's victory over his enemies. It is, however, intriguing that in the poem, Risorboli distances Piero from the violence done by David; Piero is seen to "fear and love" the violence done to Goliath. While the Medici profited from the suppression of the Pitti-Neroni conspiracy, they did not wish to be associated with the punishment of their opponents. It was better to have the abstraction "justice" and David take care of the "unjust and ill-spirited sect" that threatened Medici rule.

Although scholars agree about very little concerning Donatello's bronze *David*, there is, I believe, general consensus that it was a political statue.[4] Regardless of the doubts surrounding its original function and location, with the construction of the new Medici palace on the via Larga, the

David seems to have become the centerpiece of its first courtyard; Risorboli's *canzone* tells us that it had probably gained this preeminent position by the autumn of 1466.

Perched on a column in the main courtyard of the Palazzo Medici, the *David* produced a new coordinate on the political visual grid of Florence; what is more, it thereby produced a triangular form, linking the new Medici palace to the Palazzo Vecchio and to the Mercato Vecchio. The notional lines connecting these charismatic centers were reinforced by the name Donatello. For in placing that artist's bronze rendition of *David* in their courtyard, the Medici drew an unavoidable analogy between that space and the space of government, where Donatello's marble version of the Old Testament hero had been placed in 1416. Furthermore, in setting the bronze *David* on a column, the Medici echoed the columnar monument to Wealth in the Old Market, the traditional center of the Medici family in Florence and, as discussed in Chapter One, a space rendered political through the *Dovizia* monument. The symbolic nexus binding these sites was reinforced by Donatello's authorship of these public icons.[5]

The bronze *David* remained in the Palazzo Medici until 1495 when, following the flight of Piero di Lorenzo de' Medici, the republican Signoria confiscated it, along with many other Medicean statues and objets d'art.[6] The *David* was moved from the Palazzo Medici to the Palazzo Vecchio, where, ironically mimicking its former position, it was placed in the main courtyard of the city hall.[7]

In both these palaces the *David*, on a columnar base with juridical connotations, stands triumphant, having judged, condemned, and executed his people's enemy, Goliath. Held up to the apostrophized citizenry of Florence as a moral and political *exemplum*, this *David* is, however, an unlikely hero. That this naked ephebe should be allotted political iconicity is *visually* odd. This oddity has vexed twentieth-century writing about the *David*, rendering the *David* "enigmatic."[8] Political explanations attempting to cover up the brazen nudity and youthfulness of the boy by piling on contextual data have not succeeded in taming the object.

While Donatello's unprecedented decision to represent David without clothes is curious, it is not the nudity of the *David* per se that has baffled modern scholars; rather, it is the distinctive presentation of adolescent nudity set forth in the bronze that has presented analysts with troubles. For if the bronze *David* proffered to citizens an allegory celebrating the triumph of intelligence over physical might, it set this pointedly political moral within an apparently eroticized frame. It is the seeming incompatibility between the erotic and the political that has troubled art historical analysis of this work. Nonetheless, as

this book attempts to prove, during the fifteenth century, these two categories were not only close, they were also functionally related. Here, I would like to contend that, like the *Dovizia*, which attempted to galvanize the *reggimento* in a shared amorous and patriotic gaze, the *David* developed its political message within discourses of love.

Figuring the state as a beautiful adolescent boy, the statue offered to fifteenth-century viewers a body defined as possessing paradigmatic representational clarity; simultaneously, the statue invoked (and revoked) a desiring cultural gaze. In this instance, however, the cultural material of this visuality is no longer to be found in the public traditions of heterosexual political personification, but rather in the social and visual structures of what Eve Kosofsky Sedgwick has usefully called "homosocial desire."[9] Sedgwick's phrase helps circumvent the deadlock reached between historians of premodern sexuality concerning the nature of male-male relations, between "Boswellian" essentialists, who promote a transhistorical and transcultural gay identity, and "Foucauldian" relativists, who argue for the historical singularity and cultural contingency of sexual identities.[10] Akin to similar debates in feminist scholarship, the dichotomy between so-called essentialists and so-called social constructivists derives from the very different political motivations and strategies of their proponents.[11] Sedgwick's concept of "homosocial desire" alleviates the most acute problems faced when dealing with the disparate approaches to the history of male, same-sex relations.[12] By "homosocial desire" she intends to draw together two seemingly incompatible social phenomena: male-male sex and the social bonding of men defining masculinity. Rather than separating intermale social and sexual relations, Sedgwick seeks to understand them on a single, contiguous analytical plane. By so doing, she manages to reveal the manner in which apparently opposing visions of masculinity are, in fact, mutually supporting.

In coming to grips with such issues in representation, I draw specifically on Whitney Davis's recent reformulation of the concept of gender, about which a few preliminary remarks are in order.[13] Davis argues for a radically depolarized theory of gender *in* and *of* representation. Moving away from theories of gender *difference*, Davis sees gender operating according to quasi-grammatical rules, making sense only in terms of *agreement*, which I take to mean, in the first instance, the formal concordance of elements in representation. It is, in the second instance, into this gendered representational logic that the viewer enters, bringing a second set of gendered inflections to bear. Seeking agreement, although often finding disagreement, viewers struggle to make sense of the various elements that gender the image.

Davis's argument offers a powerful model for reconsidering gender and

material representation. I have found two aspects of his thinking particularly useful. First, despite being an extended *linguistic* metaphor, Davis's proposal frees the analyst from some of language's more troublesome confines, which reinscribe polar gender differences at every turn.[14] In his paradigm, the language of sexual difference can be dismantled by unhitching gender from biological determinism and from absolute cultural contingency, by examining the gender in and of representation instead in terms of formal and contextual agreements. Second, Davis's use of grammar as a pattern for giving order to the multiplicity of possible genderings in and of representation furnishes the analyst with a useful tool for elucidating the materialization of gender and its concordance with social acts of apprehension.

Davis's concept of gender and Sedgwick's theorization of homosocial desire will here be brought to bear on the bronze *David* in such a way as to help explain the statue's intricate and powerful intertwining of politics and sexuality. I begin my analysis by looking at the statue and its first known spatial and ideological context, the Medici palace on the via Larga. Reimagining the statue in this place, I present a fusion between my own responses to the work and those I construe it as eliciting between the late 1450s and 1495. Using Davis's concept of (dis)agreement, I argue that the statue's meaning is enhanced by decentering the problem of "sexing" the statue and turning instead to its mobile "gendering." Then, focusing on the novel nudity of the statue and reviewing some of the major analytical frames through which the *David* has been interpreted—humanism and antique culture, eroticism and politics—I turn to the social history of sodomy in fifteenth-century Florence. This frame of reference can, I believe, help us to understand the realization of political power within the homosocial desire both visually activated and chastised by Donatello's bronze *David*.

Narrative, Form, Place

There can be no question that the statue commonly known as the bronze *David* (fig. 4.1) does in fact represent the youthful biblical hero.[15] Recognizing the youth of the victorious protagonist, the scale of the sword he bears in his right hand, and the stone he clutches in his left, as well as the large, helmeted and disconnected head at his feet, the viewer familiar with the Old Testament, and particularly with the Book of Samuel, quickly surmises what is depicted: David standing triumphant on the head of his defeated Philistine foe, Goliath. Beholding the statue, one finds it difficult not to envisage the battle, to recall the skillfully slung stone that brought down the gigantic Goliath, and to remember how the shepherd boy David, taking up his enemy's sword, beheaded the fallen Philistine.[16] David, the chosen one, ancestor of

Figure 4.2
Donatello, *David*, c. 1450. Bronze.
Museo Nazionale del Bargello,
Florence, detail of Goliath's head

Christ, defeated a giant foe against all odds and thereby saved his people. His victory was based on his aptitude with a sling and, more importantly, the support of divinity.[17]

Despite this undammable narrative torrent, casual and intent viewers alike see more than simply the retelling of a textual narrative. For as with other images of "David Triumphant," this does not represent a diegetic *moment* so much as a condensed representation of the struggle and the issues at stake in the story of threat, combat, and victory. To reduce Donatello's *David* to a renarration of the biblical text would be similar to considering Shakespeare's *Hamlet* as a historical treatment of the Danish monarchy. David stands with his right foot on one of the enormous feathers adorning the Philistine's helmet, and his left resting on the dead giant's face (fig. 4.2). It is difficult, if not impossible, to imagine this as an episode within a narrative.[18] In stark contrast, for example, with the vivid representation of the dénouement in his *Judith and Holofernes* (fig. 6.1), Donatello does not refer to a discernible moment in a story. While it is apparent that the battle has in some sense already taken place—Goliath is dead—David, nevertheless, holds a stone in one hand, suggesting a temporal collapse, a prolepsis, rather than a succession of events. The helmet also unsettles a simple narrative reading. How could a stone have penetrated such formidable and apparently impregnable headgear?[19] Indeed, the undamaged and serene face of Goliath suggests sleep, rather than death. These antinarrative details compel the viewer to see in the statue a compilation of suggestive signs, packed together, condensing

time. Are we encouraged by the statue to imagine that David took a moment, after downing the monstrous warrior (and picking up a stone), to stand on Goliath's head? No, the basic configuration of the statue exhorts the viewer to engage in acts of recollection and synthesis. We are asked to unpack the details and to test them against the familiar Old Testament story and against other images—physical and mental—of David and his famous battle.

This statue, like other images, cannot be seen solely as an illustration, or reflection of a text or a textual tradition.[20] If one cannot but feel the force of biblical fabulation emitted through and by the statue, joining that textual pressure are pictorial and imagistic impressions.[21] Not "behind" the image, pressing through it, these nontextual qualities link the work, synchronically, to its immediate social and cultural context.[22] In this instance, the most telling, antinarrative feature of the *David* is the expressive and somewhat confounding nudity of the boy-hero. For while the biblical text does have David cast off Saul's heavy armor, the representation of the boy warrior naked but for his knee-high boots and jaunty hat finds no substantial basis in the biblical text, nor does it correspond to previous images of the Old Testament hero. To understand this daring subversion of the textual narrative, we must take a closer look at the statue's physical context and visual qualities.

Beyond the inscription on the pedestal of the statue (to which I shall return) and Risorboli's undated *canzone,* the earliest textual reference to the *David* appears in Marco Parenti's 1469 description of the festivities held in honor of Lorenzo de' Medici's marriage to the Roman aristocrat Clarice Orsini: "There were no pantry tables for the silverware," it reads, "only tall counters covered by tablecloths in the middle of the courtyard around the beautiful column on which stands the bronze *David,* and in the four corners four bronze basins."[23] From this description we learn that the statue was in the "middle" of the courtyard, that the author considered it necessary to mention that the pedestal was "beautiful" (without adjectivally modifying the bronze *David*), and that both the pedestal and statue were clearly visible above the tables arranged around them. I shall return to the first and last points later, but the second ought to give us pause. The pedestal, probably sculpted (and, in part, cast) by Desiderio da Settignano, perhaps after a design by, or developed in coordination with, Donatello in the late 1450s, presented viewers with what was in all likelihood a stupendous piece of craftsmanship.[24]

Despite the apparent beauty of this pedestal, in focusing on the base of the statue, Parenti was, inadvertently, shedding light on the bronze *David.* His failure to do more than simply mention the striking, revolutionary, and technically superb work does not, I think, indicate that Parenti was more attracted to Desiderio's base; his omission, rather, reflects his familiarity with

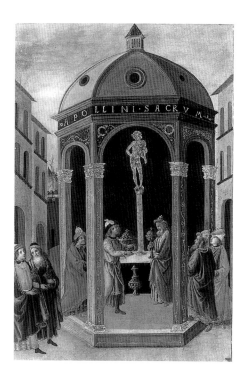

Figure 4.3

Master of Marradi, *The Treasure of the Temple at Jerusalem Brought by Nebuchadnezzar to the House of God*, c. 1490. Tempera on panel. High Museum of Art, Atlanta, gift of the Samuel H. Kress Foundation (58.47)

Figure 4.4

Matteo de' Pasti, *Fountain Surmounted by a Nude Male Figure*, c. 1445. Bronze medal. National Gallery of Art, Washington, D.C., Samuel H. Kress Collection

Donatello's work. The bronze *David*, preceded in Parenti's text by the definite article, was so public that it did not require description, or modification of any kind. Indeed, the courtyard of the palace, although owned by the Medici, was not a "private" space. To the contrary, with portals giving onto both the via Larga, and, via the garden courtyard to the west, the via de' Ginori, the courtyard appears to have functioned as a semipublic space.[25]

A number of fifteenth-century representations of male figures on columnar pedestals help us to envisage how the *David* may have appeared in the Medici palace, although none can claim to be a representation of the statue. A *spalliera* panel now in the High Museum of Art in Atlanta is a representative example, showing a naked male figure, probably Apollo, playing a violin of sorts atop a skinny Corinthian column (fig. 4.3). Another example can be found on the reverse of a medallic portrait of Guarino Veronese by Matteo de' Pasti (fig. 4.4). Here we see a nude male warrior set atop a fountain. Although this pedestal does not appear "columnar" (it may, in fact, resemble the original base for Donatello's *Judith and Holofernes*), the configuration provides us, perhaps, with a notion of how high the *David* might have been set in the Medici palace courtyard.[26] Most interesting in this regard is a panel representing the *Marriage of Antiochus and Stratonice*, now in the Huntington Art Galleries in San Marino (fig. 4.5). The painting contains a prominent grisaille rendition of a statue of David Triumphant. The fictive statue is

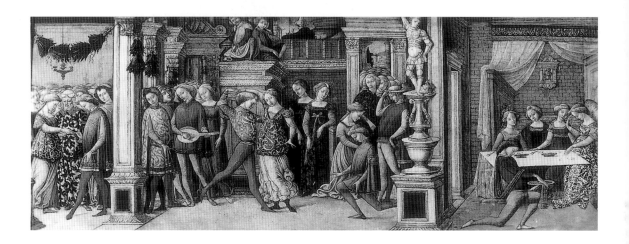

proportionally smaller than the "real" figures celebrating below. On an elaborate pedestal, reminiscent of Desiderio's multilevel decoration at the apex of the Marsuppini tomb in Santa Croce (fig. 4.6), the painted David stands not only above the head of Goliath, but also above the heads of the figures courting and dancing in the courtyard below. Through the portal behind the David sculpture, the young men enter into the amorous choreography of the wedding, "losing their heads," as it were, to the damsels who greet them.

These indirect representations remind us of Parenti's description of the pedestal, visible above the tables arranged around it. The 158-cm statue stood on a base that measured about 210 cm in height; that is, the figure rose above the real bodies milling around in the space below. As John Pope-Hennessy, exhorting museum visitors to sit down before the statue in the Bargello, pointed out, the statue is transformed when considered from *di sotto in su*. Whether one agrees with the seemingly arbitrary conclusions he draws from this experiment—that the wing rising between the *David*'s legs is deeroticized, that from the front and the back the proportions of the body "take on a more vigorous, more masculine presence," and that the face "would no longer appear introverted and withdrawn, but would look out with an expression of confident nobility"—Pope-Hennessy does remind us of the manner in which many fifteenth-century spectators would have visually and spatially apprehended the statue on its column: from below.[27] It should be

Figure 4.5
Master of Stratonice, *Marriage of Stratonice*, c. 1470. Tempera on panel. The Huntington Library, Art Galleries, and Botanical Gardens, San Marino

Figure 4.6
Desiderio da Settignano, *Tomb of Carlo Marsuppini*, 1450s. Marble. Santa Croce, Florence

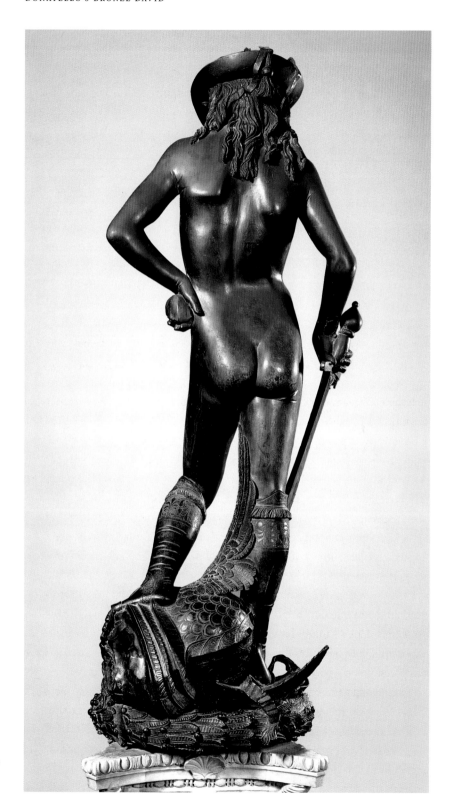

Figure 4.7
Donatello, *David*, c. 1450. Bronze.
Museo Nazionale del Bargello,
Florence, rear view

noted, however, that the height of the *David* would have also established a more private set of viewing points, through the windows of the first-story rooms giving onto the court.[28] Indeed, although it is quite right to imagine certain optical trajectories produced by the sculpture in concert with its locations, it would be a mistake to reduce the viewing of the bronze *David* to a set of particular coordinates. Even if photography can mimic the *di sotto in su* view that a spectator standing at the foot of the statue's base would have experienced, it would be wrong to forget the infinite other approaches to the statue. Any casual spectator of sculpture soon discovers what a difference a step—especially a step away or toward a work—can do. In this instance, the proximate viewing point that Pope-Hennessy seems to suggest as determinant evolves less from an account of fifteenth-century practices than from the intimacy and scrutiny of the modern spectatorial norms of the museum.[29]

Gazes emitted from the windows of the *piano nobile*, from the atrium below, or, for that matter, from the via Larga met with a statue remarkable for its compliance, even encouragement of multiple points of view. Parenti's description tells us that the statue was set in the "middle" of the courtyard, and, without claiming this was its original location, I feel strongly that the statue was produced to be seen from all sides. For the bronze *David* permits the beholder all manner of visual and spatial freedoms. The space around the statue bristles with possible approaches. Transforming a "classical," Polykleitan contrapposto, Donatello produced a pose that heightens the contrast between figural stasis and compositional dynamism. That is, the bronze figure's lack of implied action is underscored by a visual kinesis of subtle torsion and compositional intricacy. The balanced gaze and relaxed musculature of the boy, with his protruding belly and deep navel, suggest a body in repose. As such, there is no suggestion of past or future movement. On the other hand, the body pulses with compositional paths along which mobile eyes are invited to traverse.

The lithe body appears as a controlled calligraphic flourish. From behind (fig. 4.7), the double arc of the boy's left leg and the parabolic wing between the *David*'s thighs balances the curve of the spinal cord. This curvature waxes and ebbs as one follows its passage through space. The angular arms reinforce this corporeal plasticity: the left arm, so fragilely supported on a slight hip; and the torqued right arm, accentuated by the distinctive manner in which the youth is seen to hold the sword (fig. 4.8), with his index finger hooked over the hilt.

The object's material characteristics compound the dynamism of the composition, if not the pose. Light picks out gleaming projecting details against the rich metallic surface of browns, grays, and greens (figs. 4.1

Figure 4.8
Donatello, *David*, c. 1450. Bronze.
Museo Nazionale del Bargello,
Florence, detail of David's hand

and 4.7). The remains of gilding—especially in the hair (figs. 4.9 and 4.2)—urge us to imagine the statue's original splendor and still produce a highly charged visual experience. The chased and polished "skin" is set off against the textured boots and against the boy's heavy curls of hair, which, from the front, frame the youth's face and, from behind, cascade over his shoulders.

I have already proposed how, iconographically, the *David* distances itself from its foundational biblical text. Visually and materially, the object also begs us to see it as more than only a textual rendition. As Vasari rightly recognized, it possesses some of the physical characteristics of a real body, in that its fullness and tactility seem to emerge from within and to project outward to the viewer. "This figure is so natural in its lifelike pose (*vivacità*) and its rendering of the soft texture of flesh (*morbidezza*)," wrote Vasari, "that it seems incredible to artists that it was not formed from the mold of an actual body."[30]

Any large, three-dimensional rendering of the human body possesses a special tangibility; the robust materiality of sculpture itself appeals for the viewer's empathetic response. The very physical property of sculpture posits a particularly corporeal relationship between the beholder and the work. It is for this reason that we tend to attribute notions of autonomy and identity to large-scale figurative sculptures. It is not, therefore, without grounds that iconoclasts have always attacked this genre with the most passion.[31] Donatello, more than any other artist of his century, managed to harness this might and set it to work in his sculpture. What is perhaps most extraordinary about his figures is the manner in which their *physical* independence sustains, supplements, and reinforces their striking projection of *psychological* independence. More often than not, his large-scale figures seem internally riven, caught on the horns of a secret dilemma, which viewers are exhorted to divine. This moral complexity enlivens, also, his bronze *David* (despite the passivity of its countenance). The serene and tender visage of the boy (fig. 4.9) contrasts with the drama suggested by the head at his feet. The carefree pose of this *garzone* emphasizes the terrific gap between what we see, and what we know to have taken place. The viewer struggles to reconcile the apparent grace and ease of David and the turmoil and violence of the implied past action.

We do not mistake the *David* for a human being, but, responding to an inescapable sense of physical presence, the engaged spectator almost automatically does attempt to plumb the mysteries of the *David*'s psychic state. Does "he" triumph or reflect? Is "he" self-questioning or arrogant? These questions are, rightly, unanswerable. But that such questions seem to be possible reflects the formidable mimetic power of the work. Represented on the

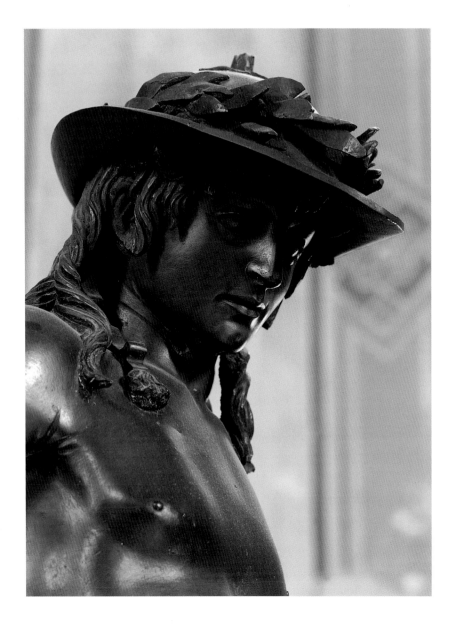

Figure 4.9
Donatello, *David*, c. 1450. Bronze.
Museo Nazionale del Bargello,
Florence, detail of David's head

cusp of so many internal states, the *David* is a receptacle for the beholder's imaginative concerns.

The enlivening S-curve of the form, visible from all angles, is heightened when beheld from before or from behind the bronze. Although the viewer, perhaps in response to deep psychological imperatives, does tend to privilege the frontal view, there is no preprogrammed point of view, which exists for some of Donatello's works.[32] In the center of the Medici palace courtyard, the frontal view would have possessed another privilege: that of publicity. For, assuming that the statue was indeed erected facing the portal

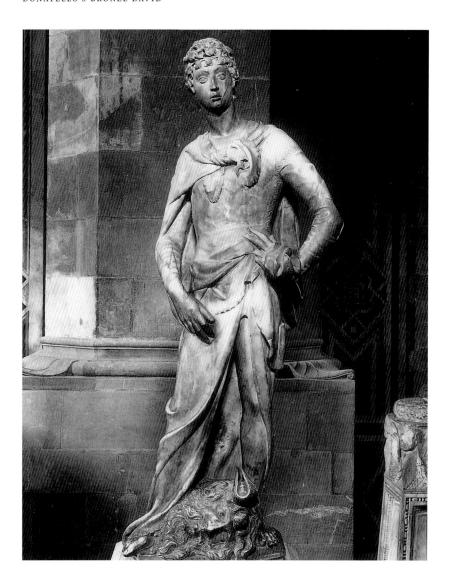

giving onto the via Larga, it was this view of the statue that would have made
its mark on the consciousness of Florentines. Within the courtyard, those
more intimate with the Medici would enjoy a closer and less regimented view.
For example, the "family" (taken in the broad sense of the Renaissance
famiglia) could experience the statue from a position of domination, from
the windows of the *piano nobile* giving onto the courtyard. Thus, the various
views afforded by the statue's location chart the power relations that pro-
duced the space of the courtyard.

The compositional, figural, material, visual, and spatial characteristics
of the bronze *David* complement, if not produce, the psychic complexity we

attribute to the statue. The *vivacità* and *morbidezza* that so struck Vasari cannot be overlooked when considering the bronze's meaning. Any reading of Donatello's bronze *David* that wishes to propose a political account of its significance must address the statue's emphatic and extraordinary presentation of an unclothed, male, adolescent body.

Nudity and Meaning

To Renaissance viewers the notion of representing David without clothes would have been novel. The iconographic models to which Donatello probably turned, including his own marble version, all represented David clothed.

Donatello probably sculpted his marble *David* in 1408–9 (fig. 4.10). When, in 1416, the city government bought the statue from the Opera del Duomo, he reworked the statue.[33] Erected in what is now the Sala dei Gigli in the Palazzo Vecchio, the marble *David* signaled a profound shift in Florentine civic symbolism. There can be little doubt that the choice of David as a political persona representing the republic sprang from the daunting challenges faced by Florence during the first two decades of the fifteenth century.[34] By 1416, the Goliath-like figures of Gian Galeazzo Visconti and Ladislaus of Durazzo had been felled by fortune and by Florentine mettle. The miraculous victory over the Philistine suited well Florence's self-conception as a vulnerable, yet victorious, entity.

Departing from the traditional iconography of David as a prophet and poet, Donatello's marble version follows instead the precedents laid out in the existing frescoes of the biblical hero painted by Taddeo Gaddi in the Baroncelli chapel in Santa Croce (fig. 4.11) and by Ambrogio Baldese and/or Spinello Aretino, in the vaults of Orsanmichele.[35] Donatello has the hero stand triumphant, his cape thrown over his right shoulder and armed with his sling. But rather than holding Goliath's head—as is the case in the frescoes—it appears at his feet. In this, the marble *David* stands firmly within the lively visual tradition of the psychomachia.[36] In literary terms, a psychomachia is the representation of internal qualities in combat; in the visual arts, however, this allegorical battle was distilled into the image of one figure atop another. Thus, while the dimensions and palpable psychological expressivity of the statue tend to implicate the figure in the spectator's time and space, it is invested with narrative content only by implication, via the iconographic accoutrements suggesting the defeat of Goliath, notably the juxtaposition of the rock in Goliath's forehead with the rock in David's hand. Another narrative level leads to the allegorical, and to the Manichaean political context of early Renaissance Florence.

The distinctive stance of the marble *David* also developed within an

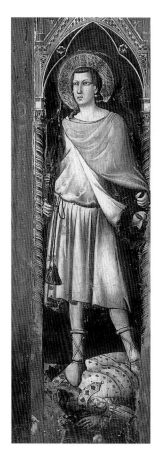

Figure 4.11
Taddeo Gaddi, *David*, c. 1328–34. Fresco. Baroncelli Chapel, Santa Croce, Florence

existing political and visual context. While the contrapposto of both of Donatello's *David* statues remains to our eyes quite different from antique models, the lilt of the figures' bodies and the arm resting on the hip would have reminded the visually literate viewer of another of Florence's traditional avatars, Hercules, as he was represented both on the Campanile (fig. 4.12), and on the Porta della Mandorla (fig. 4.13).[37] The heroic and antique reverberations suit Donatello's subject matter. Hercules had appeared on the Florentine seal since the thirteenth century, and the virtues embodied by the antique hero melded with notions of Christian fortitude.[38] Donatello's Herculean *Davids* offered a new, Christianized embodiment of the republic, one aligned with the Civic Humanist discourses developed by Coluccio Salutati and, later, Leonardo Bruni.[39]

The iconographic paths subsequently blazed by Renaissance depictions of Hercules and of David bear out this thematic, and political, connection. Not only did Donatello's bronze *David* become the model for many subsequent representations of Hercules—I am thinking here especially of the bronze statuettes attributed to Francesco di Giorgio, Antonio del Pollaiuolo, and Adriano Fiorentino—but the Medici harped on the two figures, drawing visual parallels between their feats.

The bronze *David* (fig. 4.1) resembles its marble predecessor (fig. 4.10) fundamentally: Donatello retained the contrapposto, but radically reworked

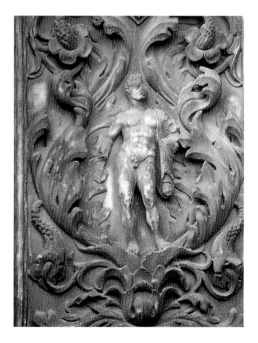

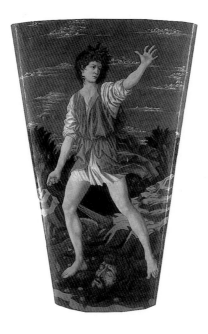

Figure 4.14
Andrea del Castagno, *David*,
c. 1450. Tempera on leather
mounted on wood. National
Gallery of Art, Washington, D.C.,
Widener Collection

it so as to make a more convincing antique reference; Goliath's head still rests beneath David's left foot; the left arms of both *Davids* are supported in a similar fashion, on the hip. Donatello's bronze *David* also makes Herculean visual reference, in part by its marble antecedent and also directly. In fact, Donatello adopted the pose of the civically invested earlier Hercules sculptures with greater precision in his second *David*. The angles of the shoulders, the left profiles of the figures' torsos, and the relations between the left arms and their respective bodies all speak of Donatello's active engagement with the Porta della Mandorla *Hercules* (fig. 4.13), while his reintroduction of the sword reminds one of the position of Hercules' club in the Campanile relief panel (fig. 4.12). Finally, the nudity of the bronze *David* can also, in part, be seen as deriving from these models and as lending the representation of the biblical warrior a Herculean and antique dimension. It is also on this nudity that the differences between the two *Davids* hinge.

Beginning in the 1450s, Florentine artists produced a steady stream of *Davids*, which must be seen as responses to Donatello's paradigmatic marble and bronze versions. Curiously, however, neither of Donatello's statues can be said to have established a firm iconographical tradition. For if artists responded to Donatello's *Davids*, they did not necessarily answer in the affirmative.

Castagno's painted leather shield in the National Gallery, Washington (fig. 4.14), offers a dynamic *David*, in the process of hurling a stone with his

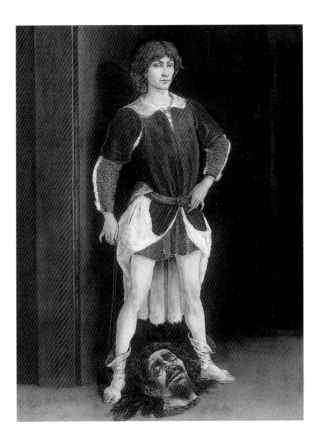

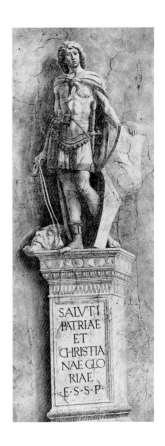

Figure 4.15
Antonio del Pollaiuolo, *David*,
c. 1470. Tempera on panel.
Formerly in the Gemäldegalerie,
Berlin

Figure 4.16
Domenico Ghirlandaio, *David*,
1485. Fresco. Sassetti Chapel,
Santa Trinita, Florence

sling and, proleptically, including at the hero's feet the head of Goliath, complete with a large rock lodged in its forehead. Traditionally dated to mid-century, this painting contains little to demonstrate Castango's familiarity with either of Donatello's statues. Antonio del Pollaiuolo's Berlin panel of circa 1472, on the other hand, seems clearly to have adapted the pose, sling, and clothes of Donatello's marble version (fig. 4.15). Another fifteenth-century Florentine painting, Domenico Ghirlandaio's frescoed *David* over the entrance to the Sassetti Chapel in Santa Trinita (fig. 4.16), demonstrates the profound shift that took place after Andrea del Verrocchio produced his bronze *David*, probably in the 1460s (fig. 4.17).[40] Ghirlandaio, following Verrocchio's model, represented the boy warrior in a tightly fitting jerkin and a short skirt. Indeed, it was Verrocchio's statue, perhaps commissioned by the Medici for a villa or house and certainly sold by Lorenzo and Giuliano de' Medici to the government in 1476, that became the preeminent model for Florentine artists wishing to represent David in the last quarter of the fifteenth century.

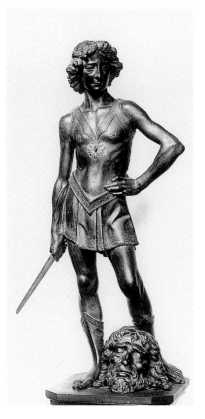
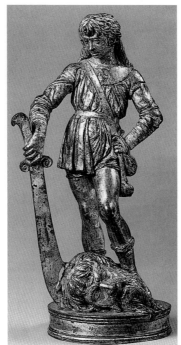
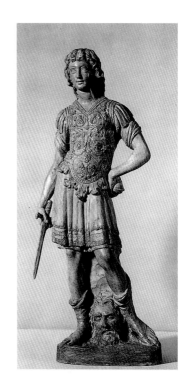

The government placed Verrocchio's bronze *David* at the entrance to the Sala dei Gigli in the Palazzo Vecchio. Although it was, therefore, positioned not far from Donatello's marble *David*, it was to his predecessor's bronze version that Verrocchio turned for inspiration. But Verrocchio eradicated precisely those elements of Donatello's work that might be called subversive, or troubling. No stray helmet feathers caress the inner thighs of Verrocchio's clothed *David*, the lad's hair is cropped short, and the large sword carried by Donatello's boy is here replaced by a shorter and decidedly nonthreatening weapon. It is this blunted and theatrical version of David that we see repeated by other artists. The versions by Bartolomeo Bellano (fig. 4.18),[41] Antonio (or Bernardo) Rossellino, and Maso di Bartolomeo, as well as the small terracottas of the boy-hero (fig. 4.19) and the anonymous drawing in the so-called Florentine Picture-Chronicle all shy away from the problematic aspects of Donatello's bronze prototype, drawing instead on Verrocchio's docile, clothed rendition of the Old Testament hero.[42]

Figure 4.17
Andrea del Verrocchio, *David*, c. 1465. Bronze. Museo Nazionale del Bargello, Florence

Figure 4.18
Bartolomeo Bellano, *David*, c. 1470–80. Bronze. Metropolitan Museum of Art, New York

Figure 4.19.
Master of the David and Saint John Statuettes, *David*, c. 1490. Terracotta. National Gallery of Art, Washington, D.C., Samuel H. Kress Collection

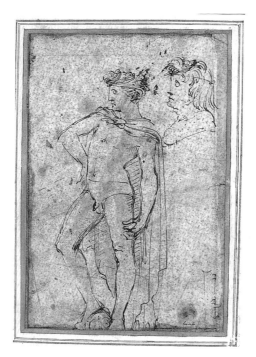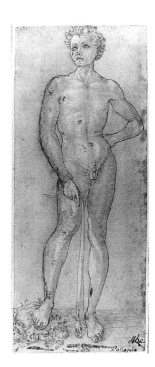

Figure 4.20

Anonymous (Donatello?), *David*, c. 1440. Drawing in pen and ink. Musée des Beaux-Arts de Rennes

Figure 4.21

Tommaso di Antonio?, *David*, c. 1450. Drawing in brown pen and white heightening on prepared red paper. Nationalmuseum, Stockholm

A handful of artists did follow Donatello in representing David naked. A drawing of David in Rennes, sometimes attributed to Donatello (fig. 4.20), and another in Stockholm, often given to Antonio del Pollaiuolo or his follower Tommaso di Antonio (fig. 4.21), do not, however, seem to offer an "iconographic" nudity; rather, they have all the appearance of being studies from the nude, like so many contemporary drawings of partially clad or naked *garzoni*.[43] There were later representations of David that do derive immediate inspiration from the nudity of Donatello's bronze *David:* Michelangelo's colossal marble *David* (fig. 4.22); Fra Bartolomeo's distinctive drawing of the hero in an enormous hat, which adapts Donatello's pose and transforms the puerile form into a Michelangesque muscular man while retaining the distinctive "reversed" contrapposto; Giovanni Francesco Rustici's bronze *bozzetto* of David—which Francesco Caglioti has convincingly linked to plans for the redecoration of the Medici palace after the fall of the "first republic" in the second decade of the sixteenth century; and Marcantonio Raimondi's engraved version of David heroically naked.[44]

Considering the bronze *David* against this array of images, the statue's distinctive, if not quite unique, pairing of nudity and adolescent youthfulness emerges powerfully. This is not to say that the bronze *David* was not imitated. Many of the *Davids* mentioned, although they were clothed, did appropriate and modulate the basic pose of Donatello's *David:* Bellano's bronze (fig. 4.18)

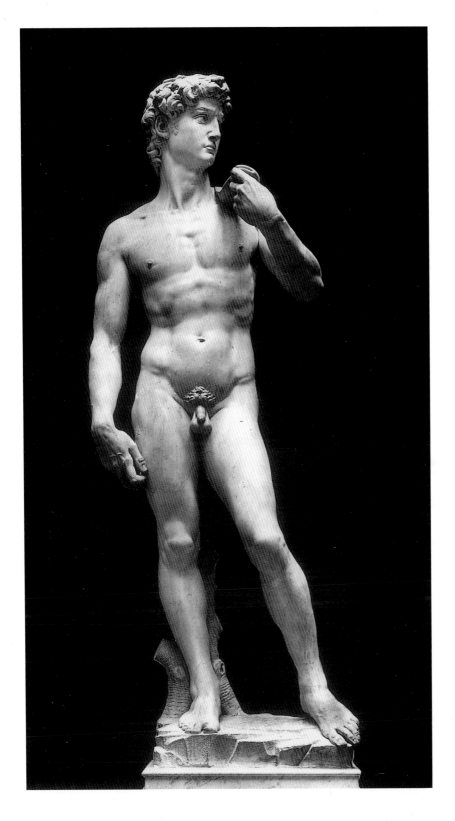

Figure 4.22
Michelangelo Buonarroti, *David*,
1504. Marble. Galleria
dell'Accademia, Florence

and the terracotta statuettes (fig. 4.19) bear this out forcefully. What is more, the adolescent nudity of the bronze *David* is apparent in representations of Hercules and in many striking images of Saint Sebastian. Nonetheless, the conscious clothing of Donatello's bronze in the work of his immediate followers highlights the work's iconographic singularity. The nudity, which has troubled twentieth-century art historians, must surely have appeared very odd to fifteenth-century viewers.

Permitting the artist some license, spectators well versed in the Old Testament tale might see the nudity as a form of visual hyperbole, aimed at providing a latent reference to the youth's casting off of Saul's armor before he took the field.[45] Others might interpret David's lack of clothing as symbolizing his humility, or his later prophetic abilities.[46] Or one might take a step further and recognize the nudity as a sign of David's heroic virtue, his beautiful body a somatic expression of internal qualities.[47] But surely most contemporary viewers would have seen the youth's divestment within the norms of ancient statuary and as a conscious imitation of Roman art.

Probably by the autumn of 1466 and certainly by the spring of 1469, the nude *David*, commanding the space around it, stood on a column like a pagan idol. It is therefore not surprising that the *David* has come to represent the characteristic syncretism of Renaissance culture, binding Christian content to antique form. Akin, for example, to the adolescent nudity of one of the most famous statues visible in Rome throughout the Middle Ages, the *Spinario*, the *David* might be seen as eliding biblical and antique heroism in a humanistic typology.

The Humanistic *David*

To many modern commentators, the bronze *David* embodies the "rebirth" of interest in antiquity in the visual arts that characterizes Renaissance culture. These claims are supported by visual analyses arguing for particular antique sources for the statue's pose. Some scholars, including Jeno Lànyi, Alessandro Parronchi, and John Pope-Hennessy, have even read the iconographic accoutrements as supporting an identification of the statue as an antique persona, Mercury.[48] On the other end of the scale, others have downplayed such influences, seeing very little antique about the statue.[49] The nudity alternatively authorizes and deconstructs reference to the antique. The conjunction of nudity in sculpture was, in the minds of contemporaries, unavoidably antique. On the other hand, schematic and fleshy, the body of the *David* is too insistently realistic to be categorized only as *all'antica*.[50]

Donatello did not copy antique sculpture slavishly, as later genera-

Figure 4.23
Arch of Constantine, 4th century
C.E. Marble. Rome, detail

tions of artists would attempt to do. His use of antique forms is, rather, analogous to that of his contemporary and, in all likelihood, friend, Filippo Brunelleschi.[51] While it may be true that one can find no example of Brunelleschi adopting particular ancient architectural motifs and that his dependence on Tuscan Romanesque forms has been underplayed in the literature, it does not necessarily follow that the architect did not intend to bestow on his buildings a certain *Romanitas*.[52] Like the early humanists whose Latin would be condemned as hopelessly un-antique by their successors, and like the painters of domestic furnishings who envisioned antiquity through the eyes of chivalric romance, Brunelleschi perceived antique forms through late medieval Tuscan eyes. So, too, did his peer Donatello.

The emphatic and quadratic thrust of the hip of the bronze *David* derives, whether directly or indirectly, from antique sources.[53] Despite, however, turning to the antique for the "profile" of the pose, Donatello has willfully inverted the logic of the contrapposto: supporting his figure's arm on the hip of the relaxed and trailing leg, rather than on the side of the weight-bearing, straight leg.[54] This rather unclassical pose stresses the lithe and serpentine qualities of the *David*.

Monumental statuary dominates modern visions of Roman antiquity, much of which was not visible in the early fifteenth century. To Donatello and his contemporaries, the art and culture of antiquity came alive most readily in smaller works of art.[55] Donatello would certainly have been familiar, for example, with the roundels on the Arch of Constantine, one of the most visible of the ancient remains to have been known throughout the Middle Ages.[56] One relief in particular, showing a naked male figure on a pedestal, might have served as a prototype for Donatello's adolescent figure on a columnar base (fig. 4.23).[57] Less easy to assess is the potential influence of small bronze

Figure 4.24
Anonymous, *Hercules*, Roman
bronze. Museo Archeologico,
Florence

Etruscan and Roman statuettes (for example, fig. 4.24).[58] But surely the most
compelling antique source for Donatello's *David* is the remarkable sardonyx
gem owned by Alvise Trevisan and reset by Ghiberti in 1428 (fig. 4.25).[59]
While the gem appears to have been in Rome during the 1430s and 1440s,
there is every reason to believe that the iconography was very well known
and widely disseminated. Not only did Trevisan have extended stays in Flor-
ence in the 1430s, but numerous casts in plaster and bronze have survived.
The languid and flamboyantly posed naked figure of Apollo on the gem calls
to mind the similarly serpentine bronze *David,* and one wonders whether this
visual affinity derives from direct acquaintance.

The visual evocation of antiquity of the bronze *David* has resulted in
determined attempts to interpret the statue as bodying forth particular an-
tique ideas. It is hardly surprising that the first extant freestanding nude statue
to have been produced in Europe since antiquity should have attracted inter-
pretations setting it within the rebirth of interest in ancient texts, social life,
and, to some extent, morals. Considerable confusion, however, has arisen
from the desire to link the statue to *particular* texts, and to use these connec-
tions to bolster arguments concerning the date of the statue's facture. The
interpretations stressing an answer to the statue's riddle in humanism have

Figure 4.25
Dioskourides, *Apollo, Olympos, and Marsyas* 1st c. C.E. Engraved sardonyx. Museo Archeologico Nazionale, Naples

usually opted for an early dating (about 1430), contextualizing the *David* within the Epicureanism of Antonio Beccadelli and/or Lorenzo Valla.[60]

The Sicilian humanist Beccadelli, called il Panormita, dedicated his polished pornographic *Hermaphroditus,* a bimorphic poem composed of "male" and "female" parts—the first dealing with homosexual and the second with heterosexual sex—to Cosimo de' Medici. To some, this dedication casts *David* as an *all'antica*, Epicurean ephebe, and suggests that the statue played a modern Antinoüs to Cosimo's Hadrian.[61] Another Epicurean explanation for the *David* finds "con-textual" support in Lorenzo Valla's *De voluptate* of 1427. This dialogue brings together, fictionally, Leonardo Bruni, the Aretine chancellor of Florence, Niccolò Niccoli, his bibliophilic friend, and a pre-*Hermaphroditus* Panormita. Together with Valla and some papal secretaries, they discuss the virtues of the stoic versus the Epicurean life, with Panormita, not surprisingly, expounding a very positive view of the latter. Bruni is the apologist for the former, while Niccoli argues that both philosophies fail. Nonetheless, the Epicurean system wins more praise from Niccoli and can thus be seen to triumph in the dialogue. Proposing a Judeo-Christian appropriation of the insights of the ancients, Valla defends the humanistic enterprise, emphasizing the example of David. Taking this text as the source for

Donatello's statue, one might see in the bronze *David* a representative of the Christian tradition overcoming the pagan hierarchy by using its own weapons.[62]

These humanistic interpretations differ, strongly, from those that instead bring Neoplatonic textual sources to the fore and attempt to date the statue significantly later. The Neoplatonic revolution in Florentine thought is usually believed to have occurred in the 1450s.[63] Those wishing to see the victory of *amor caelestis* over *amor vulgaris* in Donatello's statue feel compelled to argue that the *David* was produced after this date. This notion was first strongly set forth by Hans Kauffmann; it was later adopted and expanded by Laurie Schneider and Francis Ames-Lewis.[64] The virtue of this interpretation lies in its perception of a Neoplatonic program driving the adornment of the Palazzo Medici courtyard and its interpretation of the *David* in light of the complex themes set forth in the Donatellian roundels set above the atrium's arcade.[65] In identifying a decorative system, however, proponents of this theory have found it necessary to claim that the *David* was made specifically for that system.[66]

Another possible humanistic context for the *David* might be found more directly in art theory. Kauffmann, while arguing that the statue was made for the courtyard of the Medici Palace, also promoted the idea that it conformed to the proportional canon found in Alberti's *De statua* (a treatise he thought had been written in the 1460s).[67] Recent commentators have reaffirmed the proportional affinity between Donatello's work and Alberti's schema, although the treatise is now thought to have been composed much earlier, taking with it, collaterally, the statue.[68] Unresolved is the direction of the influence (did Alberti influence Donatello or vice versa) and the date of Alberti's ideas about proportions (could he have developed, and discussed, the system before it was concretized in his tractate).[69]

These humanistic interpretative strains—the Epicurean, the Neoplatonic, and the proportional—all bear discussion and seem to possess varying degrees of contextual validity. Set against particular texts, the *David* does read as Epicurean, Neoplatonic, or reflecting certain art theories. What is more, I do not dispute that one or all of these cultural phenomena might very well have affected the production and reception of the statue, and particularly its nudity. But if a preliminary interpretation of the statue's nudity leads one to biblical and antique symbolic paths, it should also lead to less arcane symbolic byways.

Motivated by desires similar to those that have led Aby Warburg, Pierre Francastel, and Charles Dempsey to see Botticelli's *Primavera* not only as the

rendition of antique texts and distant mythologies, but also as functioning within a network of contemporary meanings, linked to public and popular rituals and language, I would like to embed the *David* within its culture, as well as within ancient culture (or its esoteric restitution by notaries and secretaries in the fifteenth century). What is more, I would like to contend that not only does the bronze *David by necessity* refer to its physical, social, political, and artistic contexts contiguously, but in addition there are aspects of the appearance of the statue that produce temporally "horizontal" references to popular culture—some of which, I argue later, are in turn linked to contemporary political culture. Some years ago Hans Kauffmann, for example, argued to the satisfaction of almost all later commentators that David's hat was not an ancient *petasus*, but rather a representation of a fourteenth- and fifteenth-century cap particularly favored by shepherds.[70] The implications of this suggestion have not been considered fully. We can, of course, try to understand the antique genealogy of the *David*'s pose and plumb the intricacies of its rendition of a text, but the distinctive hat Donatello placed on his figure's head ought to remind us that the artist also used "modern" signs that contemporaries would immediately comprehend.

In particular, I would like to suggest that the nudity of the *David* be read not only as "antique" (or indicating an arcane symbolism), but also as representative of and signifying within a fifteenth-century context. It has been above all at the insistence of feminist analysis that nudity, and especially female nudity, in the visual arts has come to be understood in more than aesthetic terms.[71] All represented nudity, whether derived from antique precedents or not, must be considered within the social norms of dress and undress prevalent when the representation was made and then displayed. Thus, while certainly not entirely eschewing interpretations based on biblical and antique texts, I do wish to shift focus away from iconological interpretations that seek closure in humanistic (or religious) literary sources. Instead, I propose to coordinate my own visual responses to the statue with certain fifteenth-century social and visual culture phenomena within which the *David* was originally apprehended. One aspect of that culture, the erotic, has particularly vexed modern scholarship.

The Erotic *David*

Like Joseph in his form,
Like Adoniah his hair.
Lovely of eyes like David
He has slain me like Uriah.
 —Yishaq ben Mar-Saul[72]

Art historical writing about the eroticism of the bronze *David* has, unfortunately, fallen into simplifying and ahistorical binaries, which have drained the statue of both its visual and political potency.[73] Libidinal interpretations of the *David* have been problematized by the unrecognized historical and cultural specificity of gender. Since 1957, when Janson described the statue as "androgynous" and suggested that Donatello was "homosexual," the debate about the "sexuality" of the image, its author, and its patron has roiled beneath the surface of scholarship addressing the bronze *David*. Janson, departing from Hugo von Tschudi's Vasarian opinion that the biblical hero was rendered nude on artistic grounds, claimed that the statue was plainly homoerotic in its sensual depiction of the nude male body.[74] Janson reinforced this claim with subsidiary suggestions: that its author engaged in homosexual relations, and that its patron was tolerant of such behavior and indeed might very well have found pleasure in its representation.

Before proceeding, the question must be asked, what is homoerotic? It is far from presenting us with a firm foundation for analysis. To the contrary, like (hetero)erotic (the norm it seems to posit), it is, as Foucault so trenchantly described in the first volume of his *History of Sexuality*, historically mobile.[75] Foucault's negative history, tracing prohibitions and policing, demonstrates how culture delimits and therefore defines identities. This has quite often led to an analytical separation between sex and gender, the former thought to refer to a biological base, and the latter to a cultural superstructure.[76] But, as Thomas Laqueur and other cultural theorists and critics, especially those dealing with "homosexual" identity, have demonstrated, the biological is as fabricated as any social construct.[77] Without transhistorical foundation, sex and gender prove very difficult to ply as analytical tools; instead, they appear as vessels, waiting to be filled by data from particular historical contexts. Given this vexed linguistic field, the term homoerotic possesses a distinct lack of critical edge. In the scholarship addressing the *David*, most problematic has been the absence of precision about where in the sender-message-receiver trinity "eroticism" comes into play. Is it the artist and/or patron who invest(s) a particular object with erotic content or form? Is it the work, independent of production and reception, that appears erotic? Or is it the desiring and culturally produced gaze of the viewer that sanctions the label "erotic"? In the case of the *David*, all these configurations have been adduced or implied by commentators claiming that the statue is homoerotic.

Most attention has fallen on Donatello's sexual proclivities. In his monograph, Janson cited a group of well-known gossipy tales, collected in the late fifteenth century, that characterized Donatello, albeit obliquely, as a sodomite and pederast.[78] Although it would be an error to read these *novelle*

as mimetic documentation, it is equally absurd to dismiss the idea that they possess some referential value. Like the story of Brunelleschi and the *grasso legnaiuolo,* the tales about Donatello tell us much about how he, and perhaps artists in general, were understood in Florentine culture. These texts *cannot,* however, inform us about Donatello's "sexual identity." Nonetheless, Janson's fragmentary musings on the homoeroticism of the *David* and the sexual preferences of its author were taken up and reasserted in a Freudian vein by Laurie Schneider, who developed a thesis founded on identifying Donatello as "a homosexual." On this basis, she exposed the apparent libidinal freighting of his works with Freudian anxieties.[79] Her hypotheses drew criticism, some simply prudish balking at any reference to homosexuality, others taking issue with her ahistorical conception of sexuality *tout court.*[80] Pope-Hennessy, writing of the analyses of Schneider (and the related critique of John Dixon), aired an extreme view when he bemoaned that even the "cautious, devout figure Cosimo il Vecchio was tarred with 'an interest in, if not an inclination towards, homosexual practices.'" Pope-Hennessy concluded that the "unhistorical nature of this thinking could be more readily forgiven if it had not, through undergraduate teaching, left a little trail of slime on a great work of art."[81] Pope-Hennessy was, to a degree, correct in charging studies arguing for the "homosexual" content of the *David* with ahistoricism. Be that as it may, his own intemperate rejection of what he considered to be insulting interpretations is, in its own rights, ahistorical. Moreover, despite the existence of much evidence to the contrary, Pope-Hennessy's rejection of any interpretation that takes the male homoerotic gaze into account continues.[82]

As Pope-Hennessy's remarks reveal, those who have argued for Donatello's "homosexuality" have bolstered their arguments by training their gazes also on the patronal homoerotic gaze. Recently, Andreas Sternweiler has comprehensively described the evidence for an Epicurean pedophilic culture at the Medici court.[83] Given the enormous controversy Panormita's racy *Hermaphroditus* occasioned—San Bernardino burnt the book and effigies of its author—it *is* telling that the Sicilian humanist chose to address this text to Cosimo de' Medici. As Michael Rocke points out, it seems unlikely that Beccadelli, who was openly seeking a patron, would have presented the transgressive *Hermaphroditus* to the Medici *paterfamilias* without some idea that Cosimo would have appreciated it.[84] At the same time that Cosimo owned the *Hermaphroditus* tells us very little about Cosimo's sexual identity, both because the text covers a vast range of possible sexual acts and combinations, and since it is not at all convincing that the possession of a book necessitates that its owner conform to an "identity," sexual or not, described therein. What is more, given the outrage that accompanied the publication of the *Her-*

maphroditus, it seems unlikely that Cosimo, or Piero, would have chosen to decorate their family's courtyard with a statue sharing symbolic ground with Panormita's text. Finally, it is also worth recalling that although we know that the statue was later erected in the courtyard of the Palazzo Medici, there is no firm evidence indicating that Donatello made the statue for Cosimo.[85] Without knowing more about who the patron of the statue was, or a deeper understanding of homoeroticism in Florentine life, the evidence of Cosimo's immediate participation in a culture in which homoerotic literature was accepted and enjoyed possesses little direct relevance to the production or reception of the *David*.[86]

Turning away from arguments delving into the patron's and artist's sexual preferences and into the assumed homoeroticism of the statue, Cristelle Baskins theorized a "hetero-erotic" reception for the *David*, positing an implicit female viewer and a marital context for the statue's creation.[87] Akin to E. Ann Kaplan's poignant critique of Mulveyan visuality, Baskins, too, asks, "Is the Gaze Male?"[88] Taking the 1469 text describing Lorenzo de' Medici's wedding to Clarice Orsini as a point of departure, Baskins questions whether the statue implies a male viewer and a culturally male gaze. Problematizing the assumed male viewer, she asks why the eroticism of the *David* might not be expanded to include the heterosexual responses from women, and particularly brides like Clarice. Although I wish to restate the case for the homoeroticism of the *David*, Baskins reminds all interpreters to guard against any simple correlations between what one imagines the artist's sexual preference to be and the intended audience's reaction to a work of art.[89]

Looking afresh at the statue, what is it that has encouraged art historians of diverse disciplinary persuasions to label the bronze *David* erotic? Are there grounds for the use of such an adjective? Clearly, many twentieth-century viewers seem to think so. But, given recent and convincing feminist and queer theory, the categories defining sexuality (if not sex itself) cannot be understood as fixed and unchanging.[90] That the statue appears erotic *to us* does not tell us if it was perceived in that manner in the fifteenth century; we cannot assume a fusion of twenty-first- and fifteenth-century gazes. Indeed, as many commentators who vigorously deny any libidinal interpretations of the *David* aver, it would have been highly inappropriate to display an erotic statue, let alone a homoerotic one, in a public space. Such responses, though sometimes motivated by methodological caution, are often laced with misunderstandings concerning premodern sexuality and its representation. While it is true that we ought not to assume "genetic" links between modern and premodern sexual categories (i.e., homosexuality and sodomy, nudity and eroticism), it is not therefore correct to conclude that the behaviors grouped in

such categories are entirely disassociated.[91] Put simply, although the terms "heterosexuality" and "homosexuality" did not exist prior to the nineteenth century, alternate, similarly signifying categories did. Like the ancient *kinaidos* (effeminate man) or medieval *bardassa* (male prostitute), many premodern cultures did assign linguistic—and visual—parameters outside of an assumed "compulsory heterosexuality."[92] The identities forged within such boundaries produced cultural gazes that do not necessarily conform to the assumed heterosexual male gaze upon which so much art historical analysis is based.

What is it that initiated the discussion of homoeroticism in relation to the *David*? Surely it could not only have been the tales about Donatello's sexual orientation? No, art historians have discussed the *David* as homoerotic based on transhistorical and transcultural assumptions concerning visual desire.

Without arguing for the statue's transhistorical and transcultural erotic coding, all spectators ought to acknowledge that the bronze *David* does seem to thematize *homosocial* relations. The extraordinary youth of the protagonist—emphasized by his nudity, juvenile features, and compact genitals—establishes a dialogue between the triumphant boy and the older, defeated head at his feet. The narrative relation between the two figures is antagonistic as is the placement of David atop his foe; nonetheless, in a sensitive essay, Albert Czogalla recognized the ways in which Donatello visually elaborated on the relationship between the two figures so as to complicate such a polar reading. Czogalla drew attention to two details in particular. First, he focused on the intertwining of the hair of Goliath's beard with David's toes (fig. 4.26). This detail—similar, as John Shearman noted, to the ivy "growing" on the tomb of Giovanni di Bicci de' Medici and Piccarda de' Bueri in the Old Sacristy of San Lorenzo—imparts to the hair an apparent volition. It also draws the attentive viewer into a speculative dialogue with the statue; this nonnarrative detail asks us to question the relation between the two figures.[93] The second detail that Czogalla studies is the large feathered wing that rises from the right temple of Goliath's helmet between David's legs. Clearly sensuous, the suggestion of feather on flesh brings to life the inert metal, helping to produce that sense of "liveliness" so admired by Vasari. Given this visual embellishment of the relation between the two represented figures, Czogalla and Shearman have proposed that we recall the original meaning of David's name—the "beloved." In this manner we can see how Donatello might have amplified David's role as the loved one by encoding the physical relation between victor and foe as sensual.[94]

Figure 4.26
Donatello, *David*, c. 1450. Bronze. Museo Nazionale del Bargello, Florence, detail of Goliath's head

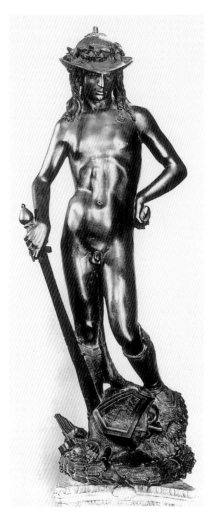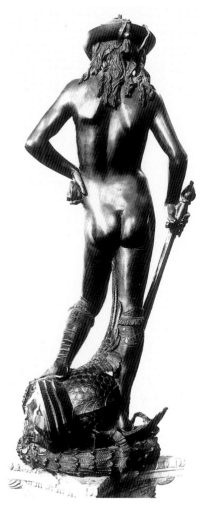

Figure 4.27
Donatello, *David*, c. 1450. Bronze.
Museo Nazionale del Bargello,
Florence, frontal view

Figure 4.28
Donatello, *David*, c. 1450. Bronze.
Museo Nazionale del Bargello,
Florence, rear view

Above all it is the nudity of the statue that fuels the interpretative transformation of this patent sensuality into sexuality. In the fifteenth century, as today, nudity itself was not necessarily erotic. But in the case of the *David*, it is not the nudity itself that invokes a desiring gaze, but rather the particular *type* of nudity bodied forth by the statue. Unlike the heroic and mighty message emitted by the public representations of Hercules mentioned above, or indeed other representations of David, Donatello's bronze presents an ambivalent conception of gender.[95] This ambivalence registers differently with different viewers and ought not to be contracted into a meaningless polarity of "masculine" and "effeminate" attributes, which actually reinforces a static notion of gender difference.[96] More helpful is thinking in terms of Davis's agreements, how the visual characteristics of the statue accord among one another and with their physical context.

Although the statue was, I believe, intended to account for any number of viewing points, its front and back were privileged in architectural and psychological terms.[97] From the front (fig. 4.27), that is, the "public" view, the *David* seems to offer the most narrative information. Similar to the paintings of *David Triumphant*, the boy warrior is framed as victorious. Unclothed but for his hat and boots, David appears like an ancient athlete, "clothed" in the glory of his patriotic achievement. It is, moreover, likely that the civic-spirited inscription on the base of the monument (about which I shall say more presently) would have been read from in front.

The view opposed to this public, frontal perspective, reveals, to my thinking, a radically different reading, especially concerning the gender of the figure (fig. 4.28). From in front the *David* is readily sexed; his visible, if small, genitalia fixing him in a "biologic" category. From behind, this fixity is undone. This is not to say that the statue appears to represent a woman or a girl, but rather that the iconographic and formal agreement (in Davis's terms) that stabilizes the frontal view of the David *as* a boy, from behind, falls apart. From behind, we have to start all over again. The formal play of limbs, sword, and helmet in space continues, but certain features receive different emphasis.

Commentators have certainly mentioned the purported androgyny communicated by the luxuriant shoulder-length tresses and by the *David*'s plump buttocks. The word "androgynous" suggests, however, an organic hybridity that papers over the actual synthetic construction of gender in artistic representation. The statue is not a body, but a compound of elements in which we often seek a coherent and gendered pattern, an agreement between parts.

From behind, the narrative of victory and defeat is subordinated. From behind it is especially the feathery caress of the wing that commands attention. Splayed like a giant yet delicate hand against the right leg of the *David*, the wing seems to initiate the play of pressures producing the vertical undulation that activates the composition from behind. Scholars have avoided the most curious feature of this wing: its uppermost fingerlike pinions are lost in the "flesh" of the boy's inner thighs. When he crouched down in the Bargello to study the *David* from behind, Pope-Hennessy thought that the "first factor to diminish in significance [was] the wing of the helmet of Goliath stroking against David's thigh." From below, Pope-Hennessy confidently opines, the wing "would have read as what it was, a highly ingenious solution to the structural problem of giving necessary additional support to the weight-bearing leg."[98] My reaction to this sculptural passage is quite different from Pope-Hennessy's. While the structural function of the wing is not in doubt, from below, the visual track of the feathery buttress seems even more emphatic: it

leads one's eye to the boy's rear, pointing a feathery finger toward a hidden vanishing point. The left leg, drawn forward and raised, opens up this visual trajectory to a viewer approaching the statue, as it were, *a tergo*. Similarly, the right arm of the *David* twists so as to reveal the sword's provocatively bulbous hilt, which seems undeniably to carry with it phallic under- if not overtones. The surpassing artistic sensibility of the artist—representing in hard, cold metal the soft touch of feather on skin—heightens spectatorial pleasure; but this tactile passage also may possess alternate, social iconographic meaning. As Frederick Hartt pointed out, in Italian the word for "bird"—*uccello*—is a colloquial euphemism for penis.[99] Nonetheless, the juxtaposition of feather and flesh is striking enough visually to speak for itself.

While the courtyard provided innumerable points of view from which one could behold the statue, certain positions were privileged. Indeed, each of the bays in the arcades defining the space emphasized a particular ocular path to the centrally placed statue. But the major portals, from the front and from behind, surely produced the most favored of viewing axes.[100] The public view, aligned with the entrance from the via Larga, yielded a vision of male adolescent power that, despite the boy's distinctive lack of clothes, could be seen to agree with the Old Testament story of David and Goliath, and its medieval, allegorical interpretation. From behind, a more private view, this textual concordance evaporates. What is more, from this angle the formal agreement gendering the frontal view of the statue collapses. Lacking narrative cohesion, suggesting a less conclusive visual agreement concerning gender, and focusing on a phallic hilt and obscured anus, from behind the *David* posits a very different set of questions and a very different array of ideal viewers.

I would now like to attempt to tie these observations more closely to the statue's historical context. The *David* was a political statue. In focusing on the very different visual qualities of the front and back of the statue, I have aimed to highlight not only a binary opposition between a public and normative view and its opposite, but rather a fundamental tension that marks the statue from all points of view. Gendering an inert metallic alloy requires the spectator's often unconscious activity. In this instance, simple narrative and biologic closure is denied by carefully constructed interference. The statue defies homogeneous constructions of a homoerotic or hetero-erotic gaze, permitting instead an ungendered gaze that in time and space can adopt a number of different physical, metaphysical, and erotic positions. Be that as it may, in the Medici palace, the statue operated within a visual field shot through with considerable power, and focusing on the visual characteristics of the statue alone

does not account for the manner in which external interference also determined its meaning. The most important of these forces was political. I would now like to suggest how an erotic reading of the *David* and its mobile configuration of gender can be squared with its political and public functions. In order to do this, I would like to examine two social frames through which spectators might have gendered this complex rendition of an ephebic body in a manner that can be read in both erotic and political terms: the representative value of the male adolescent body in Florentine popular culture and the social norms of male-male sexuality. Both offer insights into the broader workings of homosociality in Renaissance Florence, the male culture of public and private, fraternal, filial, and sexual affections that drew Florentine men together and determined Florentine political culture. Before turning to these two contextual frames, however, it is necessary to consider how art historians have described the statue's political function.

The Political *David*

Although the philosophical, theoretical, and libidinal contexts proposed as elucidating the statue's original meaning have drawn much scholarly attention, the major contextual arguments for dating and interpreting the bronze *David* have emphasized politics. To Hartt the iconography of *David* represented a visual embodiment of the *virtù* that he considered typical of Civic Humanism. Finding textual analogies in the writings of Salutati and his followers, and subscribing fully to Hans Baron's theory that the military crises suffered by Florence in the early fifteenth century forged a political antipathy for monarchy and a love of liberty, Hartt proposes that images of *David* be seen as a political psychomachia, trumpeting the virtues of republicanism.[101] Hartt's broad thesis has been widely accepted.[102] While Baron's learned text is an attractive foundation for analysis, subsequent historical investigations have provided a more nuanced and less clear-cut version of the Florentine political climate and particularly the effect of the political crises on the early fifteenth-century development of Civic Humanism.[103] This undermines the power of Hartt's thesis. More troubling, however, is the osmotic relation between politics and artistic style that he posits. Although seemingly deeply skeptical about mechanistic theories linking style to ideological contexts (i.e., Frederick Antal's Marxism), Hartt seems to do just that, aligning particular representational modes with particular political trends.[104]

Hartt does not dwell on the bronze *David*. His text is important, however, in that it enunciates the assumptions underlying the dominant tradition of interpreting works of art and artistic style in light of politics. Political interpretations of the bronze *David* have, perhaps in response to the sweeping

nature of Hartt's hypothesis, attempted to tie the production of the statue to specific political events.

In his magisterial study of the bronze *David*, Volker Herzner recognized in the statue the victory of virtue over vice and, following Margrit Lisner and Saul Levine, affirmed a direct political reading of the work as an icon of the Medici triumph.[105] Dating the sculpture, basically on stylistic grounds, to after 1435 and before 1444, Herzner drew the conclusion that the statue might have been an image celebrating the Medicean triumph at Anghiari over the foreign troops led by those Florentines exiled after Cosimo's return to Florence in 1434.

Janson, in an article of 1978, returned to the bronze *David* and offered an even more specific political context for the statue. Convinced that the *David* demonstrated affinity to Donatello's work in the late 1420s and early 1430s, and deducing that the wings on Goliath's helmet referred to Visconti devices, Janson argued that the statue was a communal commission, celebrating Florence's apparent victory over Milan.[106]

Recently, Christine Sperling has refined this reading, arguing that the statue was made to commemorate the 1428 Treaty of Ferrara, which brought, albeit temporarily, war with Milan to an end.[107] Supporting this interpretation, she adduced a transcription, from a manuscript in the Biblioteca Laurenziana, of an inscription said to be found "In domo magnifici Pieri Medicis sub Davide eneo" (In the home of Piero de' Medici the magnificent under the bronze David).[108] What is more, the Sapphic verse transcribed was set next to another that is known, from other sources, to have been visible beneath Donatello's *Judith and Holofernes*, a statue that probably decorated the garden court of the Medici Palace.[109] The inscription reported by Sperling as on the bronze *David* reads:

> The victor is whoever defends the
> Fatherland. God crushes the wrath of an
> Enormous foe. Behold! a boy overcame a
> Great tyrant. Triumph, o citizens![110]

The manuscript from which this transcription was taken dates, according to Sperling, to between 1466 and 1469. But she argues that the inscription was actually composed three decades earlier, since it served as the model for Francesco Filelfo's poem of the early 1430s featuring the refrain: "Vincite fortes." Nonetheless, the dating of texts on formal grounds has proven as tenuous as chronologies founded in the eye, for Francesco Caglioti has shown that the inscription could very well date to the mid 1450s.[111]

Caglioti demonstrated that in 1973 Cecil Grayson had already published the Davidian inscription cited by Sperling. It passed, however, unnoticed by art historians.[112] Caglioti's researches have transformed study of Donatello's *David* (and the *Judith and Holofernes*), since they have brought to light several more manuscript transcriptions of the inscription. Caglioti persuasively attributes the authorship of the verse to Gentile de' Becchi, tutor of Piero de' Medici's children. The inscription was composed, it would appear, soon after 1454, when Becchi entered the Medici household.

Armed with this information, Roger Crum, following the historians who have criticized Baron for not taking municipal politics fully into account, has taken issue with the overwhelming emphasis placed on foreign affairs in the political interpretations of the *David*. Crum argues instead that the statue be regarded, also, as addressing internal, domestic issues. Specifically, he reads the statue as decrying "domestic tyranny."[113] Following the injunctions of Francis Ames-Lewis not to trust stylistic datings of the *David*, Crum does not attempt to draw from this conclusion a firm date for the bronze. Rather, following Caglioti's recent revelations about the manuscript evidence concerning the inscription once found beneath the statue, Crum opts for a later but loose dating to the 1450s or 1460s.

It is salutary to set Crum's conclusions next to those presented, almost simultaneously, by Andrew Butterfield.[114] The latter, deeply skeptical of "hidden" political meanings, seeks the primary meaning of the statue in contemporary thinking about its protagonist, David. Rather than proposing a political interpretation of the bronze through "analogy," Butterfield urges that we look more directly at the identity of the figure represented and attempt to reconstruct the "political significance of Davidian imagery" through texts immediately related to the iconography. Following Czogalla's lead, Butterfield lays special emphasis on Psalm 143, *Benedictus Dominus,* and subsequent exegeses of its symbolic content.[115] The psalm stresses the divine succor granted to the boy warrior and his theocratic rights to rule the people of Israel. "[I]n the fifteenth century," Butterfield opines, "David was widely understood as an *exemplum* worthy of imitation, especially by political leaders."[116] Butterfield then turns to Platina's *De optimo cive* of 1474, in which the author has Cosimo de' Medici extol the divine right of David to rule: "[o]n account of his amiable disposition, David, although young, was chosen to rule by universal consent, to such an extent that parents preferred him to their children, and children to their parents, since he was seen to have taken hold of the realm to be of use to men rather than out of a desire for power."[117] The analogy to Lorenzo de' Medici's political ascendancy after the death of his fa-

ther in 1469 is unquestionable. But what relevance does this text from the mid 1470s have for the interpretation of the bronze *David*, which, even if one opts for a late dating, was produced at least twenty years previously? Butterfield argues for a continuity in political and theological significance. Not especially republican, the *David* referred to a matrix of political goods. Unstated is that those goods were traditionally monarchical, emphasizing David's eventual kingly status.

Now, it is remarkable to compare this conclusion to Crum's. Both seem well founded, and both, rhetorically, leave some room for other interpretations to share in explaining the multivalent statue. Regardless, they are, it would appear, at odds with one another. How can a political meaning of republican triumph over tyranny (domestic or otherwise) be squared with a political meaning emphasizing the quasi-monarchical rights of David and, we must assume, of the Medici? What is more, both characterizations of the intentions driving the statue's production seem out of step with the probable political strategies of the Medici. Despite attempts to figure an antityrannical David into Cosimo's "constitutionalism," it seems a rather dangerous symbolism to stress, given the quasi-tyrannical role the *pater patriae* played in communal affairs. On the other hand, the breadth of knowledge necessary to understand the monarchical virtue of David—by way of Nicholas of Lyra, Augustine, and other commentators—would seem to narrow the possible political audience for Donatello's statue to a handful of bookish and pious amateur political theorists.

A political paragon or a political memorial, the *David*, to my knowledge, has not yet been interpreted as *visually* political. While iconographical parsing has offered clues for political readings, visual analysis has served almost exclusively as a tool to date the work, rather than as a means to understand its content. I do not wish to undermine interpretations founded on the biblical narrative, nor do I wish to arrest contextual speculation concerning the intentions driving the production and/or display of the statue. However, it seems to me that as much energy must be put into understanding how this bronze image of an almost naked boy, set atop a deracinated head and upon a base, might have signified to a wider Florentine public, and how this communicative pattern might correspond to the statue's political function.

The strongest textual sources for statues are the inscriptions often carved into them or set on their bases. Although the manuscript evidence presented by Caglioti does not help to date the *David* (as it does the *Judith and Holofernes*), it does offer the earliest textual source for the statue. Its content puts to rest theories that the primary subject of the bronze is not David. It of-

fers no suggestion of even a possible secondary identification with Mercury, Ganymede, or other ancient personages.[118] Nor in its language does it hint at an Epicurean or Neoplatonic reading. It denotes directly a political interpretation. It complements the statue by stressing the defense of the fatherland (a much beloved topic in Renaissance Florence), the divine aid the boy received, the remarkable feat accomplished by David in defeating a gigantic "tyrant," and, finally, the analogy between David and the apostrophized citizens (of Florence). The inscription, therefore, offered to the Latinate beholder in the courtyard of the new Palazzo Medici a clarification and amplification of the themes expressed visually in bronze. Taking the emphases backward, the Florentine (male) citizen-viewer is encouraged to see himself as David, to share in the glory of the boy warrior who defeated a large and tyrannical foe, to recognize the hand of God in this victory, and to wonder at the good that evolves from patriotism. Clearly politicizing the biblical hero, the inscription does not provide the basis for a contextual dating by reference to a particular occurrence. A creative interpreter, therefore, could make the compound of text and image apply to any number of political events that mark fifteenth-century Florentine public life. The inscription did, however, operate in a particular physical context: the "atrium" of the Palazzo Medici. Given its location, one can recognize the attempt to align Medicean victory to a broader sense of civic triumph. Thus, while it spatially implies the authority of the Medici family and their unofficial grip on political power, the statue of *David*, read through its inscription, offers a monument to the citizenry of Florence and to their collective might. The body of *David*, therefore, becomes the site of a double identification: on the one hand, it embodies the Medici family; on the other hand, it is a corporate image of Florence.

But what sort of image? How were the Medici and Florence bodied forth? Beyond the narrative and contextual readings reviewed above, what can this naked boy have meant to the men and women of Florence? How should the statue have registered at the level of popular street culture?

Positing, again, a broadly defined audience for public art means accommodating for multiple, overlapping readings. In the case of the *David*, this is not only a hermeneutic problem, but also an absolute necessity. For the statue operated visually and politically precisely at the level of contradiction. Depending on one's point of view, the work could be read as an expression of princely virtue or of antityrannical political sentiment. We have also seen the bifurcation of gender arising from the statue's physical circumstances: approaching the statue from the via Larga, the viewer engages visually and through recollection, setting information into a pattern of agreement, reaffirmed in the largely unambiguous rendition of gender; from behind, such

consensus is skewed and problematized. Pursuing this mingling of visual and topographical analysis of an empirical viewer, I would like to turn to the ideal "public" for the statue, the citizens of Florence, and identify an analogous split dividing the field of vision into two overlapping segments.[119] The first gives an account of the special representational power of the male adolescent body in fifteenth-century culture. The second, based on the social history of male sodomy, redescribes the spectatorial availability of the statue in terms of its evocation and dismissal of a conflicted erotic gaze. Controlling this gaze, the *David* served to reproduce (both passively and actively) the structure of Medicean authority.

Representing Adolescence

Ante annos animumque gerens curamque virilem
(before the years of manhood demonstrating the courage
and care of a man).
 —Virgil

Thanks to the studies of Grayson, Sperling, and especially Caglioti, we are now equipped with four textual transcriptions of the inscriptions borne by the *David* while it was in the main courtyard of the Medici palace. Despite slight differences, the inscription itself appears in relatively consistent form in all four manuscript sources. There are, however, curious and meaningful differences in the way in which the location of the inscription was recorded. For example, at the head of the manuscript tradition outlined by Caglioti stands Gentile de' Becchi's rendition of what is, in all likelihood, the epigraph he himself authored. As might be expected from one so intimately familiar with the statue and its site, de' Becchi's description of the inscription's location is succinct: "Sub statua David ceso Gulia in area Cosmiana ad animandos pro patria cives" (Beneath the statue of David, who has killed Goliath, in the courtyard of Cosimo in order to excite the hearts of the citizens for their fatherland).[120] The anonymous collector of inscriptions, who recorded his findings in a manuscript now in the Biblioteca Riccardiana in Florence, offers the most succinct rubric: "In domo magnifici Pieri Medicis sub Davide eneo" (In the house of the magnificent Piero de' Medici under the bronze David).[121] Lorenzo Guidetti, the probable author of the two other manuscript sources discovered by Caglioti, is a little more expansive. The labels accompanying his transcriptions run thus:

Sub imagine enea David puer super columna in medio aree domus
Laurentii Petri de Medicis (Under the image of the bronze boy

David on the column in the middle of the courtyard of the house of Lorenzo di Piero de' Medici).[122]

and

Epigramma sub imagine enea David pueri funda adversus Godiam gigantem pugnantis posita super columna marmorea in area Magne domus Laurentii Petri Cosmi de' Medici, Florentie (Epigram placed under the bronze image of the boy David, who fought with his sling against the giant Goliath, it stands on the marble column in the courtyard of the great house of Lorenzo di Piero di Cosimo de' Medici, in Florence).[123]

These labels, obeying the rhetoric of such florilegia, emphasize the location and ownership of the statue. What is more, they all, in good Baxandallian fashion, record the material from which the statue was made.[124] Bronze, extraordinarily expensive, was worth mentioning. Gentile de' Becchi, a member of the Medici household, even gives a hint concerning the explicit political purpose of the statue to excite patriotism among the citizens of Florence. In his transcriptions Guidetti, another Medici intimate, lays particular stress on the *age* of the protagonist. The inscription he transcribes is to be found, so he states, under "the bronze image of the *boy* David." Given the textual void within which the bronze statue stands, this designation ought to be taken seriously and we ought to consider looking, again, at the *David* as a boy. This might seem a banal point, but given how remarkably young Donatello's bronze *David* appears in relation to its forerunners and followers in the visual arts, Guidetti's emphasis on the representation's "youthfulness" takes on added weight.

Although boyhood was seen as volatile and giddy by most medieval commentators, there were also literary tropes defining a different type of boyishness. I am referring to the topos of the "old boy." By juxtaposing senectitude and puerility, commentators garnered power from the apparently oxymoronic image. Ernst Curtius traced this trope back to Virgil's description of Iulus cited above.[125] Curtius, moreover, follows the tradition of praising the *puer senilis* or *puer senex* into the late Middle Ages. The crushing seriousness of the *David* might be seen as a visual equivalent of this trope, exaggerating the figure's youth so as to make his heroic and very adult action, and internal life, appear in deeper contrast.

A related visual context for the representative adolescent body can be found in Florentine popular culture. Richard Trexler has described in some detail the revolutionary changes in Florentine ritual celebrations during the

first half of the fifteenth century, underscoring the contributions made by male youths. At this time, the adolescent male body transformed the notion of corporeal representation at civic and religious spectacles. The processions and festivities that defined time, place, and affiliation through order and ritualized disorder became, in the fifteenth century, less a diagrammatic presentation of social relations than a programmatic re-presentation of societal values. Public life became, more insistently, a form of art—elaborate, conscious, and directed. It was through the politically nonrepresentational bodies of Florentine adolescents—who were not permitted to participate in Florentine governmental life—that public life became an artificial performance. Through the prism of the male youth's body, Florentine society interpreted itself.

The most striking aspect of this "ritual revolution" was the boys' confraternity.[126] Following the suppression of many of the confraternal groups for older youths and men, youth lay groups swelled.[127] Boys belonging to such organizations would receive religious guidance, listen to edifying religious orations, and, most importantly in visual cultural terms, take part in processions and perform sacred plays. Indeed, the boys' confraternity played a fundamental role in the development of the revolutionary performative genre of the *sacra rappresentazione*, or sacred drama. These plays revealed, immediately, the potential of the adolescent male body as a representative form.[128] Because boys were more pliant and, perhaps, less self-conscious than adults, the adolescent male body's dramatic potential was both recognized and realized in the boys' religious companies. As Trexler puts it, "[t]he boys' confraternities moved onto the stages already established by adult groups, and charged them with a new force, and a new message."[129] By mid century the adolescent male body transmitted moral information in a privileged fashion. It was an accepted bearer of significant gestural and performative meaning.[130]

As the titles of early *sacre rappresentazioni* attest, the subjects performed by the boys' groups were predominantly drawn from the Old Testament. Reversing and restating political power relations, the boys acted out

> the biblical stories, visualizing for their elders the meaning of fraternity . . . slowly becoming a new fetish of a deeply religious society, a salvational instrument that could either supplement or supplant both their fathers' and the clergy's ritual position in the city. The essentially new aspect of this realignment of sacrality was that the new cult object was a purer and more direct reflection of societal values and personages—a direct affirmation of the present, but at the same time a generational guarantee of the future.[131]

The new fetish of the adolescent male body acted out dramas stressing famil-

ial order, patriarchal power, and physical might. The morality was Judaic in its blunt confrontation of good with evil, necessarily presenting the two. The introduction to one sacred play bears this point out with particular force:

> And we will perform those representations
> That are said to be done on the said day,
> With certain competitions between the good and the bad
> Which will make this act more devout and more ornate.
> And by the said questions
> One will be able to understand who will profit from
> The joy that comes from doing good
> And how much vices are the cause of punishment.[132]

The boys, through the purity and innocence guaranteed by confraternal affiliation, possessed a moral power as dramatic transmitters. "When the bourgeois of Florence saw their everyday concerns and ideals represented in theater," Trexler rightly claims, "it was an adolescent voice and face which reflected those values."[133]

Following Trexler's suggestive lead, Christopher Fulton has described the many representations of well-behaved children and adolescents in Florentine art against both fifteenth-century didactic practices and against the public functions that adolescent male bodies were asked to perform in contemporary rituals. Like Fulton, I would like to interpret Donatello's bronze *David* within the reformulation of street life described by Trexler, emphasizing the manner in which performativity can be read in the statue itself.[134]

The *David*'s patently youthful body, at the head of a veritable flood of dependent, if different, subsequent representations, operates at an explicitly dramatic level. Thus, the bronze statue can be seen as a contemporary *reenactment* of a biblical story, in much the same way a *sacra rappresentazione* set life-sized adolescents before an audience of adults. It is worth recalling that in 1429 the boys of the *Compagnia de' Magi*—an organization with well-established ties to the Medici—actually enacted the story of David and Goliath.[135] Both bodies, bronze and fleshy, possessed a representative power owing to their perceived purity and their potential to communicate in an unmediated fashion.

It is not unimportant that the story of David is, in essence, the tale of a young shepherd who, through celestial aid and courage, rises to lead his people. The biblical David was indeed young. The youngest son of Jesse, unexpectedly anointed by Samuel, rose quickly in Saul's favor, having dispensed with the threatening, gigantic Goliath. This battle, in which God granted the boy strength and precision, presaged David's kingship. The Medici might

surely have seen their own familial trajectory as paralleling that of the biblical hero. Under Piero, and then especially under his adolescent heirs, the message emitted by a representation of a heroic boy warrior could not but have struck a strong political chord. The reproduction of David seems to reflect a secular, political, and patriotic cult, in which the biblical hero, originally a communal civic form, bodied forth the city of Florence under the aegis of the Medici family. If, however, the iconography of David Triumphant came to link the Medici to an existing civic visual discourse on freedom and divine aid, Donatello's version offered a very particular reading of this widespread political topos. Why might the Medici emphasize the unsteady and potentially weak aspects of political puerility through the *David?* And why would the Medici display in their palace, and therefore align themselves with, such a feeble and effete image of the biblical hero?

Until the sixteenth century, Medici rule always conceived of itself as youthful, striving, and in need of support and advice. We must also recall that for most of the century the Medici were, in a very *real* sense, young. This is especially true from about 1460 on (that is, from about the time when the *David* was to be seen in the Palazzo Medici courtyard). Although Cosimo, since his return from exile in 1434, was a mature man, the birth of his grandchildren, Lorenzo and Giuliano, in 1449 and 1453 respectively, led to the juvenation of the ruling line. Unlike Cosimo and Piero (who was already eighteen when his father gained his preeminent position in Florentine political life), these boys were raised as heirs. In 1469, moreover, when Piero died, Lorenzo was a scant twenty and Giuliano only sixteen years of age. Lorenzo, in fact, died before attaining the minimum age of forty-four to become the standard bearer of justice, the commune's highest elected office, while his brother Giuliano never even turned thirty, the minimum age for holding any elected office.[136] The youthfulness of the Medici boys did occasion some handwringing by their opponents. The anti-Medicean Alamanno Rinuccini complained that the city was being "led around here and there at the will of one adolescent . . . a *giovane* whose opinions and wishes prevailed over those of the elders."[137]

Despite such feelings, the youthful bodies did serve to present a vigorous conception of the state and its policies. For both boys bodied forth in their limbs, comportment, speech, and actions a conception of Florence. From an early age, they were political actors, Lorenzo making his diplomatic debut at age five.[138] They embodied in exemplary fashion the dictum recorded by the humanist educator Vergerio, who wrote that "[a] well-behaved youth is of the highest importance to the commonweal."[139] Their adolescent bodies represented the health and splendor of the republic.

The conjunction of the boyish *David* in the courtyard of the Palazzo Medici and the ephebic masculinity of Cosimo's grandsons in the 1460s can be seen within the larger revolution in Florentine public life promoting a representative adolescence. Although the Medici distrusted autonomous ritual groups, the boys' confraternities flourished under their rule. The Medici urged a cultic appreciation of boyishness and, thereby, their youngest scions. It is in this light that Platina's discussion of David in the 1470s, cited above, ought to be read. David despite his youth was elected to rule owing to his "amiable disposition . . . by universal consent."[140] Like Platina's David, Lorenzo and Giuliano asked citizens to think of them as both children and parents, seeking in their public appearance to be useful, rather than simply powerful.[141] The dramatic *David* in the Medici palace operated as a performative representation of good against evil, akin to the *sacra rappresentazione*'s pointed moral binarism.

Seeing the *David* within the context of a "representational adolescence" one can even recognize something stagy in its appearance. Is this a representation of *David?* Or is it rather the representation of a boy "playing" *David?* The modern shepherd's hat combined with the clinging stocking-boots give the impression of artificiality, of a *tableau vivant*. Though interwoven with models of all stripes, one might indeed see in the statue a posing *garzone*, a fifteenth-century apprentice-model, lurking underneath the biblical narrative and antique visual references.[142] The sensuality and corporeal realism of the represented body, noted so accurately by Vasari, leads to another contemporary social frame: the erotic gaze and the social norms which produced it.

Sodomy and Sodality

But at the bottom, he [Bernardino da Siena] had come to believe, Florentine factions were held together by boys: The love of boys was what bound the men of Florence together!
 —Richard C. Trexler[143]

Setting aside homophobic ahistoricism, all evidence indicates that sexual relations between men were not only widespread in fifteenth-century Florence, but also absolutely central to the sociopolitical structuring of family and class sodalities. Instead of stressing the "homosexuality" of the artist and/or patron (that is, their own sexual preferences), or a globalizing category of the homoerotic, I would like to put more emphasis on the term homosocial as a cultural and visual category spanning the erotic and the political. I base my reconstruction of a "queered" period eye, therefore, not on a particular identity and/or subculture, but rather on a broader conception of male homoso-

ciality, which implicates the desiring male gaze within both the exchanges of male-male sexuality, and within the public discourses of political life.[144] In order to do so, we must first grasp how central male-male sex, or, to adopt the term current at that time, sodomy, was to the lived experiences of fifteenth-century Florentines.

Given its breadth, the ramifications of male sodomitical practices touched all Florentines in one way or another.[145] So famous was the city on the Arno for promoting it, that in Germany, homosexual sex was described by the verb *florenzen,* and in France it was called "the Florentine vice."[146] The most fervent recorded critic of Florentine sodomy was the Franciscan firebrand San Bernardino da Siena. In public and in well-attended sermons, Bernardino railed against the "unmentionable vice," seeing it as one of the fundamental reasons for the enervation of all that made society good. Most grievous, in Bernardino's opinion, was that by avoiding marriage sodomites did not procreate and therefore hindered population growth.[147] He even accused sodomites of filicide, extinguishing the lives of potential offspring through their "unnatural" proclivities. While Bernardino's attacks were misguided, they were not without foundation in social realities. Marriage had become an expensive business, and demographic analysis has shown that as a result Florentine males were indeed marrying less often and later in life.[148] A general result of this trend was the elaboration of male homosocial relations, including sexual relations. This state of affairs did not concern only moral crusaders like Bernardino; the municipal government also considered sex between men to be problematic. In response to the perceived spread of male-male sex, the government took action by sponsoring a state-subsidized dowry investment scheme, the Monte delle Doti, aimed at supplying fathers with the necessary funds to marry off their daughters; by promoting certain youth confraternities where licit homosocial behavior could be inculcated; and by establishing state-run brothels and thereby encouraging heterosexual relations.[149]

By far the most dramatic step taken by the government against sodomy, however, was the institution in 1432 of the Ufficiali di Notte, the Officers of the Night. This special judicial task force was charged with identifying and prosecuting suspected sodomites. It was, above all, from the documents drawn up for this tribunal that Michael Rocke has been able to describe via quantitative analysis the shape and scale of sodomitical relations in Renaissance Florence. Rocke estimates that during the seventy years between 1432 to 1502, there were on average four hundred trials a year for sodomy. Of these four hundred defendants, between fifty-five and sixty were condemned.

Extrapolating from these estimates, Rocke concludes that, in a city of roughly forty thousand inhabitants, over the course of three generations about seventeen thousand men were accused of sodomy, with three thousand being convicted.[150] So great are the numbers of those implicated in the hearings of the Ufficiali di Notte that homosexual relations bore—to a greater or lesser extent—upon the lives of all Florentines: as defendants, witnesses, or prosecutors (or relatives of any of these individuals).

In a phrase destined to become one of the more renowned in Renaissance studies, Rocke describes the omnipresence of sodomy in fifteenth-century Florentine culture: "In the later fifteenth century, the majority of local males at least once during their lifetimes were officially incriminated for engaging in homosexual relations."[151] In this simple and carefully worded statement lies the basis for a radical reappraisal of sexuality in early Renaissance Florence. Sodomy, rather than representing a dusty and esoteric corner of historical analysis, moves to center stage. No longer can modern binaries emphasizing heterosexual relations be taken as an unquestioned given. We must realign our sights on the past, taking into account the cultural *norm* produced by homosexual relations in early modernity. Another of Rocke's conclusions follows from this. Male-male sexual relations were not eccentric, but they were in fact important constituent elements in the production of Renaissance masculinity and therefore contributed fundamentally to the shape of public life in a broad sense. For the condemnation of homosexual relations did more than yield interest for dowries and build communal brothels, it also structured social relations, and most importantly, relations between men.

It would, as Rocke indicated, be misleading to speak of a "homosexual subculture" in fifteenth-century Florence. Homosexual relations, although proscribed and circumscribed, were nonetheless a pervasive and "centric" mode of behavior, linking individuals normally separated by class and by neighborhood affiliations. Sodomy's publicness is borne out not only by the scope of its prosecution, but also by its strong physical presence in the public spaces of the city. Although most sodomitical meetings took place in private residences, there were a number of public locales known for the frequency of such relations, for example the tavern *Vinegia*, near San Remigio, the public baths at San Michele Berteldi, the via de' Pelliciai (the street of the furriers, just south of the Mercato Vecchio), and the Ponte Vecchio.[152] Sodomy was a public affair. Indeed, many men, rather than returning to a domestic setting or a tavern, acted on their urges literally in the streets or, somewhat surprisingly, in churches. The cathedral appears to have been privileged in this regard. We hear, for example, of Salvi Panuzzi fondling a boy's genitals in the choir, and Jacopo di Matteo del Campana sodomizing a boy in the Church.

What is more, court documents reveal that both Giotto's campanile and Brunelleschi's dome served as sites for male-male coupling.[153]

The picture painted by Rocke of male-male sex is panoramic. It occurred throughout the city, involving men from all walks of life. Its publicness, even though it is recorded fundamentally through its prosecution, emerges clearly. In fifteenth-century Florence, although defined as "unmentionable" by social critics and theologians, sodomy possessed an irrepressible life of its own. Not only was it practiced widely and publicly by Florentines, but it produced particular categories of masculinity, structuring "homosocial" relations. The language of prosecution—derived directly from theology—provides the basis for describing particular male roles within homosexual relations. In an overwhelming majority of cases, such relations involved an older, active partner and an adolescent, passive partner. Adult males only rarely pursued other adult males; indeed, Rocke asserts that ninety percent of the "passive" partners recorded in court proceedings were eighteen years old or younger, concluding that the "focus of men's homoerotic desire was on what Florentines called 'fanciulli,' or boys, and we would tend to call adolescents."[154] Most passive adolescents were not prosecuted for their "crimes." Active male sodomy was, on the other hand, perceived of as punishable: the penetrator was the perpetrator. Having said that, active sodomy did not represent a threat to a man's masculine identity. His virility, if anything, was enhanced by his subjection of another man. Sodomy, if unpunished, represented a reinscription of male sexual power. The passive partner was quite differently defined. He was seen as "effeminized" and altered by the act. But even this redefinition did not substantially threaten masculinity, for the passive role was seen as a temporary phase, one the adolescent would quickly shed with maturity. The cultural gaze produced by the adult and active masculine desire for the passive adolescent male body constituted one important aspect of Florentine homosociality.

On the streets of Florence, the male adolescent body was both a compromised site for homoerotic gazing and also an expressive sign, guaranteed effective via its potential innocence and purity. In early Renaissance Florence a "boy" was himself a sexual drama. To understand how the *David* embodied this dialectic between desire and its repression, one must take the culture of fifteenth-century Florentine sodomy into account.

In Donatello's version of *David Triumphant*, although large, Goliath's head is not gigantic. The bearded head bears a realistic proportional relation to the boy warrior. The lavishly naked, long-tressed boy has arrested his opponent and rendered him powerless. Read in terms of the sodomitical rela-

tions discussed above, the sculpture provocatively thematizes a reversal of the social norm. At least one Renaissance commentator outspokenly commented on the perhaps "subversive" potential of this sculpture.

None other than the herald of the Florentine Signoria, Francesco Filarete, signaled his displeasure with the back of the statue after it had been placed in the courtyard of the Palazzo Vecchio: "El Davit della corte è una figura et non è perfecta, perchè la gamba sua di drieto è schiocha."[155] These words, cited at the head of this chapter, can be translated in a number of ways. Most literally they mean: "The David of the court is an imperfect figure, because his back leg is silly."[156] But one could also construe a different meaning for the last clause, reading instead: " . . . because the leg *from behind* is silly."

This comment could simply be dismissed as a subjective response to a work of art, indicating that Filarete thought that Donatello's statue was not well done, that the boy was literally "lame." This, however, seems unlikely, given the opinion, expressed later in the century in Giovanni Battista Gelli's *Vite d'artisti*, that "Donatello made . . . the youthful bronze David in the courtyard of the Palazzo Vecchio, a marvelous work; according to the bronze sculptors, there is nothing more perfect and without fault than this."[157] Indeed, Filarete's ambiguous wording does not clarify precisely what he found wrong with the statue. There is nothing obviously problematic with either of the statue's legs in technical terms, nor does the pose seem illogical from the rear. His words, rather, appear to express his dislike of the view of the lower part of the bronze from behind. Could it be that Filarete, like modern viewers, found perplexing the wing, which does, in formal terms, lead the eye to *David*'s buttocks? Filarete likewise would have enjoyed the *di sotto in su* view afforded by Desiderio's lost pedestal, on which the *David* was also placed when set in the Palazzo Vecchio.[158] Above his head, the ocular trajectory suggested by the feather would have been an even more obvious path for the eye than today. Could it have been this visual emphasis on the boy's rump that disturbed the herald of the Florentine Signoria?

Filarete's language might be seen to betray him in this regard. The Tuscan *schiocha* (elsewhere *sciocca*) is not a word one finds often in descriptions of works of art. It means "dumb," "silly," "lame," or in some way lacking (soup needing salt is called *sciocca*). Within the equivocal tradition of burlesque poetry, however, *schiocha* appears as an adjective describing the passive male object of desire.[159] The herald, one ought to recall, was the poet laureate of the Signoria. It was his duty to compose political poems and to improvise entertaining verses for the officeholders while they temporarily lived in the Palazzo Vecchio. The poet Filarete, who held his position as *araldo* for over

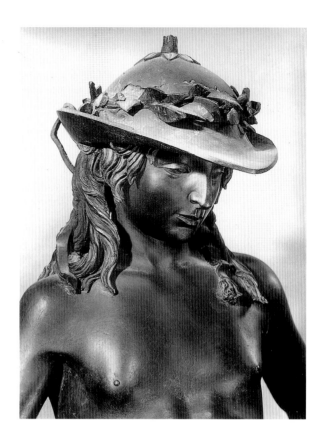

Figure 4.29
Donatello, *David*, c. 1450. Bronze.
Museo Nazionale del Bargello,
Florence, detail of David's head

forty years, was well acquainted with the powerful Burchiellesque language of inversion that runs through the poetry of his day.

In calling the statue or, to be more precise, its leg *schiocha*, Filarete might have been condemning the manner in which the statue's content shifted when the work was seen from behind; or to use Whitney Davis's terms, from behind the spectatorial and formal agreement that held together the gendering of the work seems, in Filarete's mind, to have come undone. No longer an image of David the boy warrior, the bronze, attracting a male active and homoerotic gaze, becomes a rendition of a passive adolescent object of desire.

The *David* is not entirely naked. His large hat, perhaps originally adorned with a feather, draws as much attention to his nudity, as his naked body emphasizes the striking presence of this contemporary headdress (fig. 4.29). The inclusion of a hat was an iconographic novelty. Although David was sometimes represented with a garland, the distinctive hat in Donatello's bronze *David* is remarkable.[160] That it is a modern hat would have brought to the fore the performative aspect of the statue, which is today somewhat obscured by historical distance. The hat reminds us that the *David* represents a quotidian drama, which contemporaries would have recognized. It is curious, and to

my mind very suggestive, that within popular sodomitical culture, the hat, too, signifies prominently.

Rocke describes in detail the "game" of hat stealing, which he calls "a sort of ritual extortion for sex."[161] Men seeking sodomitical sex would swipe the hats off the boys who attracted them and refuse to hand the caps back unless the adolescents succumbed to their advances. "I won't ever give it back to you unless you service me," cried Piero d'Antonio Rucellai, according to his victim, the fifteen-year-old Carlo di Guglielmo Cortigiani, testifying in a trial of 1469. After submitting to sex in an alley, Cortigiani got back his hat. On the street a hat on an attractive boy would have drawn attention. It was a signal of potential gratification. The retention of a hat, conversely, transmitted the conservation or reassertion of corporeal and sexual authority.[162]

The hat atop the head of the bronze *David* can be seen to reproduce this ambivalence. It amplified the "boy's" seductive beauty by coding the adolescent body as desirable. On the other hand, David's garlanded hat, so firmly on his head and beyond the reach of the beholders below, simultaneously functioned to underscore the boy's victory. If one sees the *David* as embodying the victory of an adolescent boy over the homoerotic gaze, his otherwise iconographically inexplicable hat takes on new significance, symbolizing the boy's retention of honor and dismissal of sexual "attack." While still, perhaps, attracting stolen homoerotic gazes, *David*'s atemporal and predestined victory over any such spectatorial thievery is cast in bronze. The hat, therefore, might elicit a desirous visuality, but, from the front, David's serious innocence conjoined with his brazen nudity simultaneously would have undermined all lasciviousness. Like the boy-saint Pelagius, who, when fondled by the Caliph of Cordoba, threw off his clothes taunting his persecutor with that which was unattainable, the *David* seems both to elicit and to dismiss attraction precisely through its nudity.[163]

Paradoxically enticing and dismissive, the boy warrior rose above all heads in the courtyard of the Medici palace. The unplaced adult male gazes rising up to meet the *David* were aligned, therefore, with the remnant of male power at the boy's feet: Goliath's head. There is an automatic analogy between Goliath and the viewer. At the feet of the boy, the beholder calibrates his gaze with that of the felled Philistine; like Goliath, the viewer is to be punished, struck by the power of the reflected and blunted homoerotic gaze.

In both its representation and reception the statue ignites the homoerotic gaze only to extinguish it. The statue does not leave the homoerotic gaze unpunished. Goliath is beheaded, and the active and desiring eyes of the viewer are—morally—shut with the Philistine's. It is precisely this moral trumping that makes the homoeroticism of the *David* both licit and effective. It does

not glorify sodomy, it operates within the paradoxical and self-policing norms of "homosocial desire" to produce an emotionally and visually powerful message.

The body represented in the bronze *David* is not simply the passive receiving body of the *bardassa,* or male prostitute. While the statue generates an ideal homoerotic gaze, through which beholders are encouraged to view the bronze, this potential attraction is cut off, literally, by the boy warrior, who, rather than acting as a passive object of desire, can be seen to have taken action. The potential disorder implied by the daring wing and the Bacchanalian revels on Goliath's helmet are arrested by that virtue guaranteed by David's beauty.

In this manner, David's body is ambivalent, while the moral content of the work need not be. On the one hand, David's victory over Goliath is a victory of the citizen over erotic impulses coded as vile; on the other hand, David stands an ideal embodiment of proper homosocial relations.

The Medici and Homosocial Desire

Susan McKillop has long urged that we understand Medicean symbolism as positing an analogy between their house and the house of David, focusing her attention on the family's heraldic *palle*.[164] The bronze *David,* although embodying the state in an image of political triumphalism, also called upon viewers to identify the victorious ephebe with the Medici.

After Lorenzo de' Medici died, a death mask was taken to record his features. On this mask were inscribed some lines of poetry composed by Lorenzo's friend, Angelo Poliziano: "Cruel death came to this body, and in so doing turned the world up-side-down. While you lived, you held all [the world] in peace."[165] This epitaph speaks volumes. Like the *David,* Lorenzo was seen by his intimates as having stopped dangerous inversions. Like the *David,* he held peril at bay. A rarely discussed portrait medal of Lorenzo visualizes this in exemplary fashion.[166]

On the obverse we see Lorenzo's familiar profile and his distinctive long, flowing hair. The artist has, moreover, suggested Lorenzo's heroic nudity, since his neck and shoulder are left uncovered. On the reverse (fig. 4.30), an armed warrior with a spear in one hand and a sword in the other rises above threeprone figures. The configuration was adapted from a brass *sestertius* of Trajan, recording that emperor's campaigns against Armenia and Mesopotamia.[167] The inscriptions reveal that the Renaissance medal, perhaps cast after the Pazzi conspiracy, records Lorenzo's service to the state and triumph over his enemies. In the exergue we read AGITIS IN FATVM, referring to the vanquished who "rush to their fate." The major inscription records in-

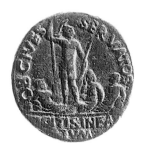

Figure 4.30
Anonymous, *Warrior,* c. 1490. Reverse of a bronze portrait medal of Lorenzo de' Medici. British Museum, London

stead Lorenzo's service to Florence: OB CIVES SERVATOS ("In Order to Save the Citizens"). On the medal, Lorenzo as guardian of the citizens rises above and controls his enemies, halting political inversion. Like the bronze *David*, the medal presents a political psychomachia.

Lorenzo was, as Platina indicated, the youthful David of his people. Presenting himself as such, Lorenzo tapped into the existing visual structure produced by Donatello's bronze statue. Approaching the statue on the privileged central axis from the via Larga, the male viewer apprehended its narrative value and the political analogy set forth in Gentile de' Becchi's inscription. But the statue demanded more from the viewer. The revolutionary free-standing statue cajoled the spectator to approach it mobilely, to grasp it visually from all angles. This visual "touching" was, however, simultaneously cut short. Homoerotic visuality was arrested in the blinded desire of Goliath's closed eyes and violently severed neck. The troubled male gaze—libidinally invested and internally repressed—was both drawn to the "soft" and "vivacious" body of the boy in the Medici courtyard and rejected synchronically. How could this ambivalent (dis)engagement of the homoerotic gaze square with the statue's political function?

Throughout the fifteenth century, the Medici displayed an ambivalent policy toward sodomy. In general, under their rule the penalties against the "unmentionable vice" were lessened. But, with lighter punishment came a broader prosecution of the "crime." Thus, while individual sodomites suffered less under the Medici, the number of convictions increased under their regime, especially in the 1460s.[168] This double-edged policy tallies well with what we know about the Medici leaders themselves. As mentioned above, it was to Cosimo that Panormita dedicated his infamous *Hermaphroditus* and Lorenzo's court was known to have harbored a number of suspected sodomites, most famously Luigi Pulci, Braccio Martelli, and Angelo Poliziano.[169]

Beyond the sexual forbearance or orientation of individual family members, there is reason to believe that the Medici were, already in the 1420s, associated with a lenient attitude toward homosexual relations. In 1425 San Bernardino da Siena demanded action against sodomites in a manner that has been interpreted as possessing a subtextual anti-Medicean barb. "Do justice quickly," he exclaimed, "with this sin [sodomy], so that the doctors [*medici*] don't run to cure the wicked!" Do not, he says, permit the Medici to interfere in the suppression of sodomy.[170]

The *David* neatly parallels the Medici's public policies on sodomy. Plumbing the deep and complex homosociality that both produced male-male sex and repudiated it, the Medici implicated themselves in the public intimacy that bound men to one another.

In the Medici palace courtyard the *David* functioned, I conclude, ambivalently, mingling power with weakness, and inviting while rejecting desiring male gazes. The ambivalence emerges most clearly by reimagining the statue within its original physical context, which both opened up the statue to multiple spectatorial approaches and structured certain axes as dominant. Diachronic and "diaspatial" viewing cannot, however, be distilled to such ideal trajectories. The ambivalence of the statue, while clarified by examining its front and its back, cannot be reduced to this bifurcated viewing. The ambivalence runs deeper. I think that Risorboli's *canzone* reveals, obliquely, this visual and ideological paradox. Referring to the "fear and love" which Piero de' Medici felt toward the stern statue, Risorboli captured the dialectic of affection and rejection that rendered the erotic *David* politically viable. In the main courtyard of the palace, masculinity was enticed, condemned, and praised. Seduced into an illicit visual discourse, chastened for its presumption, and then lauded as triumphant over vice, a multifaceted masculinity was put on trial but ultimately acquitted and placed at the service of a political agenda.

During his exile, Niccolò Machiavelli advised the Medici that "it is much safer to be feared than loved."[171] In the cultural arena at least, Machiavelli's advice went unheeded. When the sons of Lorenzo and Giuliano de' Medici returned to rule Florence in the second decade of the sixteenth century, they faced the problem of redecorating the courtyard of their palace. They explicitly rejected Giovanfrancesco Rustici's model for a new *David*, claiming that it would be inappropriate: "non parendogli tempo di fare allore il Davitte."[172] Instead, Cardinal Giulio, acting for his brother, Giovanni de' Medici (then Leo X), commissioned Bandinelli to sculpt a harp-bearing Orpheus, the ancient hero, who, following his disastrous relationship with Eurydice, renounced all intimate relations with women (inducing the Bacchante to bludgeon the musician to death in retaliation). Bandinelli's naked and ephebic misogynist curiously draws on and reverses the sexual mores of the bronze *David*, in a manner perhaps appropriate to the new papal Medicean regime.

5

Spectacular Allegory

BOTTICELLI'S *PALLAS MEDICEA* AND
THE JOUST OF 1475

*Aurelio to the magnificent orator, Bernardo Bembo. You ask me, Bembo,
why it is that on the sign of [Giuliano de'] Medici. Love should be painted
with his hands tied behind his back, his bow and quiver at his feet having
been broken, and why it is that no feathers hang from his shoulders, and
why he holds his eyes fixed, motionless, on the ground, as if undergoing an
undeserved torture. Terrible Pallas, tremendous on account of her helmet
and the cruel Medusa, overcomes him with her spear. Some give one
explanation, and others, another: no one is of the same opinion, so that
it is the most beautiful of painted images.*
—Giovanni Aurelio Augurelli to Bernardo Bembo, 1475

Augurelli was describing to his friend Bernardo Bembo "Giuliano's sign,"
that is, the banner painted by Sandro Botticelli and carried by Giuliano de'
Medici during a joust held in January of 1475. Augurelli's partial reading of
the imagery and his admission that no one interpretation had emerged as
definitive remind us both that such ephemeral paintings had a profound and
immediate effect on a broad spectatorship, who perceived these banners as
worthy of interpretative efforts, and also that simple, univocal readings can-
not do justice to the complexity of opinions that bubbled up in the wake of
these spectacular allegories.

In fifteenth-century Florence, paintings, and especially secular paint-
ings, rarely addressed the city's population as a corporate body directly. Even
large-scale frescoes were normally the objects of discrete beholding by indi-
viduals or circumscribed social groups. Speaking of a "public" or "audience"
for paintings in fifteenth-century Florence, therefore, we must imagine most

readily spectatorial assemblies of cloistered religious, pious confraternal or local congregations. Lay spectators might huddle around public sculptures in civic spaces, but secular paintings, for the most part, posited and produced more private, restricted beholding groups: families, friends, and, in certain public buildings, elected officials. There are exceptions, notably the political paintings of *condottieri* in the cathedral, and the frescoes "defaming" traitors and renegades on the façades of civic buildings, including the Palazzo del Popolo (the Bargello), and the Stinche, the city's largest prison.[1] These are, however, exceptions. Very few paintings possessed a broad public address, and very few of these can sustain a political interpretation. Given this paucity, the banners carried at the Medicean jousts of 1469 and 1475 represent particularly important moments in the history of Florentine public political imagery.[2] Moreover, these eminently public paintings produced complexly gendered relations between the Medici and their subjects.

The banners seem to offer us a privileged glance into the amorous neo-chivalric spectacular culture of early Laurentian Florence.[3] Since Jacob Burckhardt and, especially, Aby Warburg, this aspect of fifteenth-century Florentine culture has received sustained historical attention; nonetheless, it still sits uneasily within interpretations of the Renaissance that stress the revival of antique forms. The evocation of medieval literary, festive, and visual culture appears in linear histories of the period as a regression, to be explained away as a frivolous, pretentious, and nostalgic pursuit of mock-feudal pleasure.

Recent scholarship has taken Florentine jousts in general, and the famous Medicean tourneys of 1469 and 1475 in particular, seriously, studying them within, and not just against, Renaissance culture.[4] Plumbing the meaning of these performed battles as social and political events, geared to framing authority via a creative synthesis of antique and courtly images, historians, literary critics, and art historians have opened up the jousts for detailed cultural analysis.[5] This chapter seeks to build on this body of work by looking in detail at the iconography of the banner carried by Giuliano into the piazza di Santa Croce on 28 January 1475 and the contemporary visual and political culture within which it operated. Produced by Sandro Botticelli, this work was one of the most important public paintings of the fifteenth century. Despite this fact, it has rarely received significant scholarly attention itself. If it is mentioned, it is usually to explain other, apparently more important cultural artifacts: Botticelli's *Primavera* or so-called *Pallas and the Centaur*, or Poliziano's *Stanze per la giostra di Giuliano de' Medici*. Since the banner in question no longer exists—as is the case with almost all such ephemeral paintings of this period—it is necessary to return to literary sources that per-

mit a partial reconstruction of its appearance. I aim, however, to remain focused on the banner, on its political context, and on the complex allegory rendered on it by Botticelli.

Augurelli's admission that no single meaning emerged from Giuliano's banner cautions us that analysis of the banner ought not aim at recovering a unitary meaning. Indeed, the ephemeral imagery of the joust demands acknowledging, with particular insistence, the contingency, mobility, and fragile materiality of pictorial significance. I would like to highlight two concerns in this regard. The first is iconographic, the second revolves around the representational and political status of the image on the banner.

Iconographically, the banner introduced ancient mythological personages into the political field of vision. The protagonists of the painting were Pallas Athena/Minerva and Eros/Cupid.[6] Although in the 1470s the representation of antique figures was not novel, their inclusion lent Giuliano's joust a distinctly "classical" air. What is more, the image of Pallas and Eros was borne by the spectacular princely body of Giuliano. Implicated in the painted symbolism (and, as we shall see, its iconographic web), Giuliano became an image and simultaneously invited his mythological peers into the material and political spheres.

In thinking about this reciprocity, I have found particularly useful Gordon Teskey's thoughts on allegory. Teskey proposes that "the prominence of the gods in the art of the Renaissance reflects their role in the conjoining of political authority to spiritually resonant cultural forms. It was around the revival of classical antiquity that the modern category of the aesthetic was formed; and it was in the more dangerously spiritual forces of antiquity, embodied in the gods, that the political force of the classical was revealed. In the relatively secularized culture of the Renaissance, the classical gods were politically sacred, conferring an aura of mysterious power on the symbols of the state, the most important of which was the body of the prince."[7] The suture seen by Teskey as effected by the "Renaissance gods" links the abstract code of explicit narrative and the material "truth" of inherent meaning across the "rift" of allegory.

The structure of the allegorical and ephemeral image demands the constant deferral and reconstruction of meaning. The "logico-magical" appropriation of the sacred power of images in early modernity served to inflate the status accorded to embodiments of the state, most obviously the princely *corpus politicum*. Giuliano's body is politically and magnificently invested, so that "a mysterious power is bound to the body of the prince through the mediation of Olympian forms."[8] Teskey's conceptualization of the function of

the "classical" gods in early modern political imagery helps to defamiliarize such antique references and to place traditional iconographic analysis in the service of broader sociopolitical history. Particularly useful to the present study is the central role accorded to the body and embodiment in effecting the allegorical suture Teskey describes.

The affinity between Teskey's and Warburg's thinking is remarkable, and it leads me to the second issue mentioned above, the "representational and political status" of Botticelli's painting. The spectacularization of urban space by the Medici in their tourneys offered to citizens a material image of authority. The boundaries of this image are not, however, circumscribed by a physical frame. The definition between image and ground dissolves in a participatory spectacle. I shall concentrate on Botticelli's painting, considering the banner as a component of a larger visualization of political relations activating the public sphere and defined by the joust. The parameters of representation vanish in this expanded communicative field. Here the embodiment of the state takes place both within and outside the actual field of representation. While I have consistently tried to understand works of art as functioning *with* their viewers, in this case, the viewer/participant/subject of representation (Giuliano) stands in an undesignatable zone in and of representation. By the compound phrase "spectacular allegory," I hope to register this expanded political field where the point of enunciation is embedded within a hybrid representation comprising both lived action and reproduced imagination.

The Medicean jousts, although nostalgic evocations of a mythic chivalric past, invested public space visually, materially, and politically in a very new way. This is not to say that jousts were a novel occurrence in Florence; on the contrary, such tourneys were a staple of Florentine public life since at least the fourteenth century. What is more, jousts were often linked to political events (military successes, foreign policy triumphs, etc.). Nonetheless, performing their *res gestae* as and in representation, the Medici could harness the enormous visual and material power of the joust to galvanize public attention and draw it toward themselves.

Jockeying for Position

The Medici tournaments of 1469 and 1475 supplanted the traditional jousts organized annually by the Parte Guelfa, which by this time was in precipitous decline as a vital political body.[9] Like their predecessors, the Medici jousts took place in the ample space of the piazza di Santa Croce, which is roughly 125 feet long and 60 feet wide.[10] This urban space was relatively new, lying outside the *cerchia antica* of the early medieval commune. And although the piazza also lay well beyond the Roman walls of Florentia, the Roman am-

phitheater—the site of more grisly games—lay just to the southwest of where medieval Florentines most often jousted.

Outside of the congested city center, the piazza di Santa Croce offered enough room for both the mounted combatants and spectators. The martial and spectatorial parameters of such events are revealed in a Florentine great-chest panel that shows a joust taking place in the piazza before the mendicant basilica of Santa Croce (fig. 5.1). The painting probably dates to the 1470s, by which time Donatello's statue of St. Louis of Toulouse, originally made for the niche of the Parte Guelfa at Orsanmichele, had been placed over the main portal of the Franciscan church; the statue is visible in the upper left corner of the painting.[11] In this work we see a condensed version of the melee. Striking is the painting's representation of the disposition of the audience. Distinguished spectators can be seen at the center of the panel, raised on a dais above the fighting. Clustering at the windows of the palace in the background, men and women (carefully separated) gaze out onto the spectacle and offer themselves up as images for the audience below. In front of the partition in the foreground of the painting, male spectators stand on benches and stools, securing a view of the battle behind the fence, while boys squint through holes in the same temporary wall.

A confoundingly complex spectacle takes place before these virtual viewers: armor-encased knights on richly caparisoned horses engage one another, while attendants in livery supply their masters with weapons. In the right background a female allegorical figure armed with a bow perches atop a triumphal car. The artist has bracketed the joust with two large, allegorical banners, that on the left with an image of Father Time, while to the right we see a pennant with a seated female figure.

The great-chest panel, although clearly not to be read as a transparent document of how jousts actually appeared, does help us to visualize some salient aspects of these spectacular battles. Most intriguing is the insistence on the audience and on the act of looking. Although one cannot identify specifically lower-class spectators, who almost certainly also attended such events, the hierarchy of viewers, rehearsed above, does indicate a breadth of spectatorial positions: on the ceremonial platform, at palace windows, and in the street. What is more, the attention granted to the joust is complemented by gestures and poses implying conversation and exchange. Nowhere is the social act of viewing, including its stringent separation of the sexes, more clearly represented in fifteenth-century Italian painting. The publicness of this arena is exemplary: a broad audience witnesses and discusses the spectacle of individual prowess and familial prestige. These viewers also, we cannot doubt, would have considered and discussed the large banners the

Figure 5.1

Shop of Apollonio di Giovanni,
Joust in the Piazza Santa Croce,
c. 1470. Tempera on panel. Yale
University Art Gallery, New
Haven, Yale University purchase
from James Jackson Jarves

"knights" carried into the piazza. It was within such an attentive and public
visual field that Lorenzo and Giuliano de' Medici performed at their jousts of
1469 and 1475.

At these jousts, the princely bodies of Lorenzo and Giuliano were also
representational, encased in armor and in the mythical symbolism of Burgun-
dian chivalry. Both jousts were allegories, speaking obliquely of the right of
Lorenzo and Giuliano to retain the power that Cosimo and, in turn, Piero had
possessed. This public and political statement was not set forth directly, but
hidden within impenetrable armor and dense symbolism. Therefore, before
even considering the standards the young men carried into the arena, we must
turn to their appearance and the roles they enacted before their public.[12]

During the years that the Medici youths presided over Florentine pub-
lic life (especially between 1469 and 1478), their authority was envisioned
within an amorous frame. The courtly ethos of their public liaisons—
with Lucrezia Donati Ardinghelli and Simonetta Cattaneo Vespucci, respec-
tively—encrypted their rule in chivalric code. Producing a spectacular cul-
ture of lavish display, the Medici and their cohorts danced, sang, and jousted
themselves into the popular consciousness. Of the public festivities that pic-
tured Lorenzo and Giuliano as figures of authority, none were more impor-
tant than the jousts held in 1469 and 1475.[13]

The origins of Lorenzo's and Giuliano's jousts were twofold. On the
one hand, like other jousts, these were held to commemorate political suc-
cesses: Lorenzo's feted the 1468 league between Florence, Milan, Naples, and
Venice; Giuliano's celebrated the renewal of peace among these partners

in 1474.[14] On the other hand, the tourneys were envisaged by their protago-
nists and by their cronies as courtly offerings. In his personal record book,
Lorenzo noted laconically that he "jousted in the piazza di Santa Croce in
order to follow and do as the others, and, although the armed combat and
blows were not strenuous, I was judged the winner, [and] therefore [was
given] a silver helmet with a Mars as its crest."[15] Lorenzo's claim that he was
only keeping up with his peers papers over the very real perception that, de-
spite their participation within a mercantile elite, the Medici were *venticci,* or
social "arrivistes." Thus, in staging a magnificent joust showcasing his mar-
tial skill, Lorenzo also demonstrated his cultural affinity with the patrician
class of Florence, from which he, on his mother's side, was descended. What
is more, in aping the traditional celebration of arms, Lorenzo purposefully
outdid others; he notes in his *Ricordi* that he spent about ten thousand florins
on the joust.

Lorenzo's joust emerged, as did that of Giuliano, from a distinct per-
sonal mythology.[16] Both Lorenzo and Giuliano were seen to put their lives at
risk and their physical prowess on display for the sake of their mistresses.[17]
For while the jousts arose from the public matters of international diplomacy
and familial propaganda, they also sprang from the "private" myths cast by
the Medici around their amorous relationships with married women. In Feb-
ruary 1469, despite his planned marriage to Clarice Orsini in June of the same
year, Lorenzo went to battle for his poetic paramour, Lucrezia Donati, the
wife of Niccolò Ardinghelli.[18] Similarly, Giuliano entered the tourney for the
sake of Simonetta Cattaneo Vespucci, wife of Marco Vespucci.[19] Playing gal-

lant knights, these banker's sons sought to encase their rather prosaic lives in the shiny magnificence of courtly display. Just as these private mythologies—of love, sacrifice, and battle—ought not to obscure the function of the jousts in shoring up support for the Medici regime in the wake of its foreign policy triumphs, our eyes cannot be caught only on the surface of the glittering splendor of these spectacles at the expense of a penetrating and critical view into the manner in which they framed Medici domestic relations.

In his record book Benedetto Dei noted that "on the day of 28 January [1475] a beautiful joust was made in the piazza di Santa Croce; there were twenty-two combatants, very rich in jewels and pearls: Giuliano di Piero de' Medici captured the highest honors, and Iacopo Pitti came second."[20] Thus, like his brother, Lorenzo, who six years earlier had carried the day in a similar tourney, Giuliano emerged the "victor" in January 1475. Although it is difficult to gauge the seriousness of the performed combat, the results of both jousts were surely prescribed; that Lorenzo and then, in turn, Giuliano would emerge victorious from these mock battles was a foregone conclusion.[21] The tourneys served, therefore, to present the Medici youths to their public in a sumptuous and quasi-monarchical frame. The bodies of the youths became symbols of Medici wealth and authority.

Augurelli, describing the joust of 1475, recorded Giuliano's appearance in the piazza di Santa Croce, focusing on the valuable exoskeleton worn by the youth: "You were·the last to enter the field, o my Giulio, but the first in beauty, strength, and wealth. It is impossible to describe the quantity of jewels and pearls that glittered on your person, on your company, and on your mounts: I cannot do justice to the lines of horsemen, footmen, and heralds, since, poor me, half out of my mind, I could not wrench my eyes from your divine form, covered in gems and diamonds: Mars in arms and Love in visage."[22]

This Heepish paean offers a concrete example of the magnificent image the Medici desired to broadcast.[23] Wealth frames Giuliano not only as a princely combatant, but also as divine: he appears as a hybrid, combining the courage and fortitude of the pagan god of war, while retaining the beauty and charisma of Lord Love. An anonymous report, submitting an inventory of the boy's sumptuous garb, provides us with an even closer look at Giuliano and his apparel:

> Giuliano had in his company two men of arms, and nine trumpeters on horseback with pennants of fringed blue silk, which had in the middle a compass within which were the arms of the Medici with a gold falcon with open wings for their crest. And these pennants were filled with branches of olive and flames of fire. The trumpeters were

dressed in skirts of blue silk with their sleeves all painted in silver with branches of olive and flames of fire. And on their heads they had caps of blue silk made in the French style. And now a few words about the mount and garb of the young Medici. He rode a piebald steed called Orso, covered in armor, with a cuirass covered with white silk embroidered with pearls; the surface of his shield was filled by a Medusa-head. There were about eleven ounces of pearls; and they were all lost during the joust. And on top of this he wore another, red cape with a three-finger-broad gold fringe, to which were attached big pearls, diamonds, balases, rubies, and sapphires of enormous value. On his head he wore a silk garland on which were two white feathers, and at the base of one was a balas, and of the other was a diamond and three pearls of great value.[24]

These responses to Giuliano's appearance remind us what contemporary viewers thought most essential to record. In this case, the jewel-encrusted body of the "prince" riveted spectators' attention. The reasons for these military games were clearly propagandistic, bolstering the youthful "reign" of the Medici brothers, but the enormous wealth poured onto Giuliano's representative body was not only a matter of magnificent display for its own sake. Indeed, that so many pearls were "lost" during the tourney was surely intentional; after the celebrations, eager Florentines would harvest the treasure, which served, therefore, as a tangible sign of Medicean largesse.

This and other jousts were a form of Renaissance potlatch. The other participants, some unwilling, had to disburse enormous sums to equip themselves with mounts, armor, livery, trumpets, not to mention the men and boys who formed their entourages. Benedetto Salutati recorded the purchase not only of armor and a steed, but also of thirty pounds of pearls, fifty-two pounds of pure gold, and one hundred and seventy pounds of fine silver, some of the latter used to decorate his horse's bridle, having been crafted in low relief and enameled by Antonio del Pollaiuolo.[25] Compelling patrician *amici* into an economic as well as a physical battle, the Medici demonstrated their wealth, dignity, and prowess on a broad public stage and thus cemented their social and cultural superiority among the mercantile *reggimento*.

Setting Standards: The Ephemeral Allegories of Verrocchio and Botticelli

The tournaments of 1469 and 1475 were pivotal moments in Florentine visual culture and in the history of Medicean political symbolism. The most complex and visually intriguing aspects of these performances were the banners carried

by the participants into "battle." The extant written descriptions of these banners, which offer some of the most exhaustive and comprehensive textual responses to Italian fifteenth-century paintings, are an index of their immediate importance to contemporary beholders. What is more, the Medici clearly considered their banners important enough to demand the services of Andrea del Verrocchio and Sandro Botticelli, artists of great skill and imagination.[26]

The standards carried by Lorenzo and Giuliano, although important, were also components in a larger visual field that made up the broader spectacle of the joust. In particular, they were linked thematically and formally to the pennants carried by the other competitors, and to the already representational bodies of the Medici youths. Their allegorical themes, therefore, cannot be decoded as univocal; rather, the banners must be seen as functioning within the dialogic and multivocal context of the jousts themselves.

After the death of Andrea del Verrocchio, his brother Tommaso inventoried works that Andrea had produced for the Medici. Having noted the portrait panel of Lucrezia Donati that Verrocchio created for Lorenzo de' Medici, Tommaso recorded "the standard for the joust of Lorenzo."[27] Indeed, it is not surprising that Lorenzo, seeking an artist to produce so important a painting, would have turned to Verrocchio, who, since the mid 1460s, had been working extensively for the Medici.[28]

These banners were in all likelihood triangular pennants, similar to those that appear on the great-chest panel representing a joust in the piazza di Santa Croce and discussed above (fig. 5.1).[29] Two written descriptions in particular help us reconstruct in more detail the appearance of Verrocchio's lost banner. The first, by an anonymous diarist, records the names of the sixteen participants and their steeds, paying special attention also to the iconographies of the standards. The imagery painted on these, while clustering around a few pseudomythological themes, does not appear to possess a clear narrative unity. Braccio di Carlo de' Medici carried a banner emblazoned with a naked woman holding a sail, a common symbol for fortune. Luca Pitti and Piero Antonio di Luigi Pitti followed. On their shared banner could be seen a woman in a red damask dress who, having seized the bow and arrows of Eros, had bound his hands behind his back with a golden chain and then plucked the helpless god.[30] The next standard, belonging to two mercenaries in the service of Bernardino da Todi, displayed a woman in black, breaking a golden yoke against her knee. On other banners, the allegorical women continue to appear, accompanied often by quasi-antique mythological figures, especially Cupid.

The anonymous diarist also described Lorenzo's triangular standard, painted by Andrea del Verrocchio for the joust of 1469: "And on his beautiful pennant one sees a sun at the top and below it a rainbow. In the middle of the said standard in a field, there was an upright lady dressed in rich blue cloth embroidered with flowers of gold and silver. She moved on an intense red field [toward] a laurel bush with many dry branches, and in the middle a green branch that extended up into the white field; the said lady collected the said laurel and made from it garlands, sowing the whole white field, and the red field is sown with shoots of dry laurel."[31]

The standard and its protagonist are obviously allegorical. The flower-strewn field of red and white alludes to Florence, for the colors are those of the city's heraldic arms—the red *giglio fiorentino* against a white field.[32] What is more, Verrocchio visualized the floral mythology of the *città dei fiori* literally, in the flowers that adorned both the "field" and the female figure's blue dress, decorated "with flowers of gold and silver."[33] The dress is, perhaps, a visualization of the French fleur-de-lis (gold on blue), bestowed on the Medici by Louis XI in 1465. Coloristically and heraldically, therefore, the banner proffers a distinctly civic and Medicean statement.

The mostly desiccated but partially sprouting laurel bush represents, symbolically, Lorenzo/Lauro/laurel. The resurgent life visible in the apparently dry shrub serves to embody the idea of eternal renewal, a central theme of Medici symbolism.[34] This message of rebirth emphasized an allegorical continuity that, given Piero de' Medici's imminent death, must surely be read as referring to the power of the Medici dynasty to retain its authority, despite adversity.

The anonymous chronicler describes the woman as weaving garlands from the laurel leaves; she then casts garlands and leaves about the red and white field of the standard. Allegorically, we can extrapolate: this splendid allegorical woman will spread Lorenzo's fame and glory (his name *lauro*), which will become one with that of Florence (the red and white field).

But who is this woman? Certainly, adorned with flowers, the allegorical woman does serve to body forth the city. Nonetheless, this civic symbolism must be seen as percolating up through another allegorical layer. Understanding this banner requires recalling the origins of the joust in the personal mythology of Lorenzo, produced largely, but not exclusively, by Luigi Pulci's poetic rendition of the joust and the events leading to it, *La giostra di Lorenzo de' Medici*.[35] Composed between 1469 and 1475, the poem sees the roots of the joust neither in foreign policy nor in domestic propaganda, but rather in a personal promise made by Lorenzo some years before. At the wedding feast

of his friend Braccio Martelli in 1466, the gallant Lorenzo gave a posy of violets to Lucrezia Donati in exchange for a garland, which she had bestowed upon Lorenzo; he then pledged to hold a tournament in her honor.[36] Pulci describes how, since Piero did not immediately consent to let his son joust, Lorenzo remained true to Lucrezia, waiting until he could fulfill his oath. Lorenzo, we hear from Pulci, "grieved" that he could not make good on his promise, whiling away the time with, among other things, "horses, fantasies, costumes, devices, and emblems."[37]

> But certainly that Lauro of mine, always constant,
> Did not wish to be ungrateful to his Lord;
> And therefore he [Lorenzo] has it written in diamond
> That act worthy of celestial honor,
> Recalling, like a genteel lover,
> An old expression: Love desires loyalty [*Amor vuol fe*],
> And he already prepared those gracious arms
> But without the consent of his renowned father.[38]

These lines, written in all probability after the death of Piero de' Medici on 2 December 1469, attempt to highlight Lorenzo's independence from his father (an important issue during the tricky months following Piero's death).[39] In the poem, Lorenzo follows Lord Love, vowing to joust in Lucrezia's honor, stressing his loyalty through the "old expression," derived from Boccaccio, *Amore vuol fe*.[40]

When the political situation was ripe, Pulci's narrative continues, Piero permitted Lorenzo to fulfill his oath and demonstrate his constancy to Lucrezia at a joust held on 7 February 1469. The spectacle of magnificently clad chargers, the unfurling of large and complex banners, and the actual mock combat itself, rivaling contemporary religious displays in richness and intricacy, constructed an elaborate stage for Lorenzo's triumph. Describing and mythologizing this spectacular performance of authority, Pulci also describes the hero's pennant, offering some germane details regarding its appearance and meaning:

> . . . and on his beautiful standard one sees
> in the upper part a sun and then a rainbow
> where, in golden letters, one reads:
> *Le tems revient*, by which one can interpret
> That time turns and the century renews itself.
> One half of the field was red
> And the other white, and nearby [there was] a laurel

With she whom the heavens sent as an example
Of the beauties of the eternal choir
Who had woven a garland,
Clothed wholly in blue and beautiful flowers of gold
And this laurel being partly green
And partly dry, having already lost its value.[41]

Because it mirrors in such detail the previously cited anonymous description, Pulci's poetic ekphrasis seems to be a credible source for the iconography of the pennant, reinforcing the symbolic reading outlined above. Pulci's account, however, also leads to another level of interpretation. Within his poem, the angelic woman "whom the heavens sent as an example" is clearly intended to be, at some level, a representation of Lucrezia Donati ("who had woven a garland" for Lorenzo at Braccio Martelli's *nozze*). Pulci also relates the French motto that appeared on the banner: "Le tems revient." Literally, this means "the time returns," but figuratively it refers to the renewal of a Golden Age. On one level this is a paradigmatic expression of the renascent interest in emulating Roman antiquity. But, reflecting contemporary fashion for Burgundian culture that swept Florence in the third quarter of the fifteenth century, this desire for *Romanitas* is expressed in the language of courtly romance, French. The neo-chivalric motto joins Florentine pride in its recent economic and colonial success with the nostalgic evocation of antiquity. Lorenzo de' Medici ratifies these glorious versions of the past through the valor and merit he enacts at the joust. Although performing for Florence in a very real sense, within the narrative of the tourney, Lorenzo's actions were intended for the hybrid embodiment that materialized between his mistress and the allegorical woman on the banner.

The identity of the protagonist on Lorenzo's banner cannot be fixed absolutely. Although there is surely something in her of Lucrezia Donati, this woman is also a "goddess" of sorts (the anonymous chronicler uses "dama" and "Iddea" interchangeably in his text). This "upright" *donna/dea*, apparently heaven sent, appears in a visual field ripe with civic symbolism. The allegorical woman, set against heraldic red and white, seems also to represent Florentia, in this case better seen as Donna Fiorenza. Gazing toward the sun, Lucrezia/Fiorenza stares also at Lorenzo's Apollonian splendor, the natural refulgence that also produced the luminous promise of renewal inherent in the rainbow.[42] In wooing Lucrezia, and battling for her in the piazza di Santa Croce, Lorenzo simultaneously paid tribute to his civic *donna*, proving his fealty and worth to Florentines, incorporated as an allegorical mistress.

The structure of Giuliano's joust in 1475 was similar to that of Lorenzo's held six years earlier.[43] Although thematically similar, the imagery on the banners carried by the contestants in 1475 was, however, both more complex and more unified.[44] Indeed, at Giuliano's tourney viewers witnessed a quasi-programmatic succession of images on the banners carried into combat. Again, the pennants themselves are lost, but the iconography of Giuliano's banner, painted by Botticelli, is known through a number of descriptions.

An anonymous description of the festivities describes Giuliano's banner thus:

> At the top was a sun, and in the middle of this standard was a large figure resembling Pallas [Athena], clothed in a calf-length dress of fine gold. And under this dress was a white shift, highlighted with ground gold, and on her legs she had a pair of blue boots. This figure held under her feet two flames of fire, and from the said fire shot flames that ignited olive branches that were on the bottom of the banner, so that from the middle up there were branches without fire. She had on her head a crestless helmet in the antique manner and her braided hair fluttered in the wind. This said Pallas had a lance in her right hand and in her left the shield of Medusa. And near the said figure [there was] a field adorned with flowers of varied colors, from which emerged an olive bush with one big branch, to which was tied a god of love, with the hands tied behind him with a cord of gold. At his feet were his bow, quiver, and broken arrows. On a branch of the olive, where the god of love was tied, was a short inscription in French that read: *La sans par*. The above mentioned Pallas looked fixedly into the sun that was above her.[45]

Another eyewitness, the humanist Naldo Naldi, recorded the appearance of the banner in the following manner: "And if you want to know which of the signs of these youths will be victorious direct your eyes toward Minerva who contemplates the sun, and who holds in one hand a spear, and in the other her large shield with the snake-haired Gorgon. The chaste goddess opens a way, stepping with her modest feet on some flickering flames. There you will see nothing tender nor soft, but the son of Venus, his hands behind his back, tied, if I am not mistaken, to the pollarded trunk of an olive tree, all of his virile power destroyed by the victorious goddess."[46]

These descriptions are more than adequate for determining the basic appearance of the banner and its simplest meanings. It seems apparent that Botticelli's standard for Giuliano was based upon Verrocchio's banner of 1469. They shared certain features, especially the allegorical female figure,

who gazes at the sun in the upper corner of the standard, and the symbolic shrubs. Nonetheless, Giuliano's was a little more intricate.

The female figure in Botticelli's painting is described as "resembling" or being Pallas Athena. She is represented bearing a helmet and a medusan shield, the traditional accoutrements of the goddess. Buttressing this straightforward iconographic reading, instead of Lorenzo's eponymous laurel, Giuliano's flag featured an olive tree, that is, Pallas's sacred plant and the symbolic harbinger of peace. Not only did this tree appear behind this Pallas, but beneath her feet viewers could descry two branches of olive, the lower reaches of which were consumed by flames. These burning branches—speaking, perhaps, of Giuliano's ardor and the inviolate body of Pallas—emphasized the allegorical and immortal identity of the female figure as the virgin warrior.

Details of Giuliano's armor produced a thematic consistency between the Pallas on the banner and the princely body. The youth bore into the piazza di Santa Croce a shield decorated with a Gorgon's head. This yielded a visual analogy between the two figures, synchronically bestowing on Giuliano some of the goddess's moral power, and diegetically forging a subsidiary identification of Giuliano with Perseus. A discrepancy between the two descriptions cited above brings to the fore a second detail that weaves together the figures of Giuliano and Pallas. While Naldi describes the Pallas as carrying a spear (*hasta*), the anonymous diarist records that she held a jousting lance (*lancia da giostra*). Because a lance would have been an odd weapon for Pallas, and given that both observers did not hesitate in identifying the figure with the goddess, there is good reason to think that the anonymous witness recorded a distinctive iconographic detail. At a very simple level, therefore, the Pallas with her jousting lance became a special goddess, presiding over Giuliano's Perseus-like mock-heroism at the tourney of 1475.

A similar analogy between Giuliano's body and the banner he bore emerges from another anonymous report that describes Giuliano as wearing a helmet decorated with "a god of love sitting on an olive stump and with his hands tied behind an olive branch."[47] The famous Medici inventory of 1492 records the presence of this helmet in the family palace on the via Larga.[48] Giuliano, in his morally coded armor, fought under the auspices of chaste Pallas *and* Love, his own ambivalent body teeming with symbolism and potential for open-ended allegoresis.

Botticelli's banner departed most strikingly from Verrocchio's precedent in its more expansive narrative. Like the figure of Lucrezia on the 1469 banner, the Pallas of 1475 stared directly at the sun in the upper corner of the triangular standard. Not only was this woman given a mythological identity,

but the descriptions cited above also attributed to her a narrative role: she walked back toward a figure of Cupid, tied to a pruned olive tree (no longer Lorenzo's Petrarchan evergreen). Giuliano's banner, therefore, seemed to offer a synthesis of his brother's standard and that carried by the Pitti in 1469, which featured the chastisement of Cupid.

The French motto emblazoned across the banner (*La sans par*) indicated that "she [presumably Pallas] is without equal." Visually, beholders were presented with a mythological psychomachia in which Pallas represented Chastity triumphant, and Cupid, Lust vanquished. The eloquent ensign, therefore, commented on the goddess's and, by extension, Giuliano's virtue. The burning olive branches under Pallas's feet—which also appeared on Giuliano's livery—were a variation on a traditional Medicean device, the *broncone*.[49] The flames, representing Giuliano's burning love, do not consume the green olive branches: the amorous youth continues to burn, eternally (they do not, however, manage to hinder Pallas/Chastity in her antierotic quest). This basic reading of the banner is sustained and transformed by a further text, Poliziano's famous mythological and allegorical version of the joust, *Stanze per la giostra di Giuliano de' Medici*.

The *Stanze* relate an amorous tale, in which Cupid arranges for the young hunter Iulio (that is, Giuliano), who was scornful of love, to fall in love with a nameless nymph. At one prosaic level, this nymph can be identified with Simonetta Vespucci, Giuliano's mistress. Venus and Cupid decide that in order to broadcast the unquestionable might of love, Iulio must offer a public display of arms for the nymph. They therefore conspire to produce the circumstances for the tourney. The poem reaches its acme, and ends, with a dream Iulio has the night before the joust. In his sleep, Iulio sees images related to the banner of 1475.

Some claim that the poem was left a fragment, unfinished owing to the death of Simonetta on 26 April 1476, or on account of the death of Giuliano, two years later to the day, during the Pazzi Conspiracy. Recently, Charles Dempsey, reviewing such theories, has argued that the poem, offering a nostalgic evocation of life's lost promise, was written after the death of Giuliano.[50] Since Poliziano may very well have had a hand in devising the elaborate imagery for the tournament, one cannot, however, read the poem simply as a response to the chivalric spectacle. Nor, for that matter, can one read it as the source for the imagery of the joust. The production of such poetry cannot easily be dated. Interwoven with contemporary oral and performative culture, and given the uncertainties concerning the dating of the origins, themes, and composition of the poem, it is best to see the *Stanze* as a literary phenom-

BOTTICELLI'S *PALLAS MEDICEA*

enon running parallel and tangentially connected to actual events, but is not determined by them.[51]

In Poliziano's "dream-sequence," Iulio/Giuliano sees "his lady," that is, Simonetta, dressed in armor and tying Cupid to an olive tree ("[la] felice pianta di Minerva"); having done this she breaks his weapons and plucks the feathers from his wings. Cupid cries out for help, but Iulio declines to do combat with Simonetta. Cupid responds to Iulio

> Raise, raise your eyes Iulio, to that flame
> Which, like a sun, dazzles you with its brightness:
> There is she who inflames lofty minds
> And removes all baseness from the heart.

The god of love refers to the descent of Glory, "flashing about a fierce splendor," and accompanied by Poetry and History. Glory manages to strip Simonetta of her armor and then give it to Iulio.

Reading the banner through the *Stanze,* the identity of "Pallas" seems to split and multiply. In light of Poliziano's text the already hybrid figure of Pallas/Chastity must also be seen as Simonetta, masquerading as a goddess. Like Poliziano's nymph, Botticelli's female protagonist can be seen as an ideal portrait of the material Simonetta Vespucci merging with the mythological Pallas and the allegorical Chastity. Identification must be found within, yet suspended between these categories. Poliziano himself paved the way for such a multivalent reading of the nymph of his *Stanze* when he wrote of her that "she would resemble Thalia if she took lyre in hand, Minerva, if she held a spear; if she had a bow in hand and quiver at her side, you would swear she was chaste Diana."[52] Florentine spectators at the joust did not see on Giuliano's banner "Simonetta *as* Pallas" or "Simonetta *as* Chastity," rather they saw a compound figure, Pallas/Chastity/Simonetta.

The matter, however, is even more complex. For on the banner it is this composite character that, adopting Iulio's heliotropic gaze in the *Stanze,* turns her eyes toward the light of Glory.[53] On the standard, the Pallas/Chastity figure *is* Simonetta, but she *is also* Giuliano, the embodiment of his prowess, and the guarantor of his preordained victory.

The cycle of identification within social-historical, poetic, mythographic, and moral-allegorical frames, akin to what Dempsey describes as "masking," cannot be arrested. The identity of the woman on the banner is constantly deferred, leading to an amalgam of meanings linking Simonetta to Pallas Athena, to Poliziano's nymph, and to Chastity. The dynamism of signification, ceaselessly moving on, also functioned to define Giuliano's

princely body in a similar fashion. The body, bearing symbolic armor, also could bear multiple identifications: as the historical son of Piero de' Medici, as Mars, as Amor, and even as Pallas herself. The mobile princely body waged war on and for Chastity, proving its burning desire and its impenetrable virtue.

Although there can be no full closure concerning the identity of the female protagonist of Botticelli's banner, her multiple personalities can be embraced within the broad tropics of civic embodiment. Related to Lorenzo's florid Lucrezia as Fiorenza, Giuliano's multifaceted *dama* also bodied forth Florence, obliquely. As Dempsey astutely observed regarding Lucrezia, Lorenzo "virtually identified her with his fortune and the city's, seamlessly expanding a private and poetic love that had been shared with the members of his *brigata* into a public myth of Florentine peace and renewal."[54] Similarly, the visual trajectory of fealty and adulation commanded by Giuliano's magnificent princely body was given focus and power when it fell on Botticelli's painted allegorical woman, the object of Giuliano/Iulio's poetic affection, his patroness and his guardian. The unparalleled Simonetta/Pallas on Giuliano's banner functioned as both a private talisman and a public symbol. But I would also like to suggest that the hybrid embodiment on Giuliano's banner possessed more direct civic connotations, caught up in the visual characteristics of the figure. In this instance, however, the visual reference was guaranteed not by strewn flowers, as was the case on Verrocchio's banner for Lorenzo, but by Botticelli's derivation of his Simonetta/Pallas from the most important civic embodiment of the early fifteenth century, Donatello's *Dovizia*. This appropriation operated within a broad pattern of such co-optations, some of which were considered in Chapter One. Here I would like to trace a different, if related, set of responses to Donatello's civic statue, seeking to understand how the Medici mingled their private mythologies and public imagery within a particular mythological rendition of the *ninfa fiorentina*.

"Pallas Medicea"

As was the case with the lost *Dovizia*, reconstruction of the appearance of the female figure on Botticelli's standard means turning to artistic responses, and describing a history of reception.[55] This complex process must begin by noting the existence of yet another lost work. The inventory taken of Lorenzo de' Medici's possessions after his death in 1492 records the presence of a canvas painting in the *camera* of Piero de' Medici (that is, the son of Lorenzo "il Magnifico"). The painting was about four *braccia* high and on it was painted "a figure of Pallas with a shield and a 'langia d'archo' by Sandro di Botticello."[56] It is impossible to know if, in fact, this painting was based on the ban-

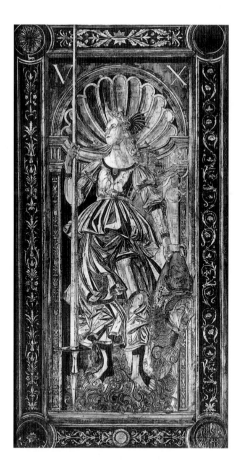

Figure 5.2
Anonymous (designed by
Botticelli?), *Pallas Athena*,
c. 1472–76. Wood marquetry.
Palazzo Ducale, Urbino

ner or vice versa. Some scholars, following the early lead of Giovanni Poggi, identify this painting with the banner for the 1475 joust.[57]

In his *Life* of the artist, Vasari mentions the work in Piero's *camera*, adding a key detail: "He [Botticelli] made many works in the house of the Medici for the elder Lorenzo, particularly a Pallas on a device of great branches, which spouted forth fire: this he painted of the size of life, as he did a St. Sebastian."[58] The flaming branches on which Pallas treads remind one of the flaming olive sprouts upon which the Pallas/Simonetta from Giuliano's battle banner trod. That Botticelli appears to have produced both paintings strengthens the notion that they are intimately connected. The painting mentioned in the inventory, and by Vasari, is lost, but four surviving images, on account of their iconographies, seem to reflect how the banner and/or the painting from Piero's study might have appeared.

The first is an *intarsia* wood panel in the Palazzo Ducale, Urbino (fig. 5.2).[59] Here we see a female figure holding a lance in her right hand and supporting a Gorgon-bearing shield with her left. She stands in a niche and stares

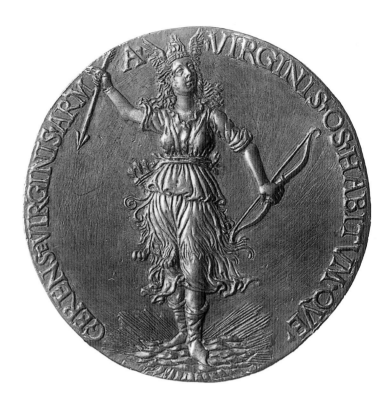

Figure 5.3

Niccolò Fiorentino, *Venus as Diana*, c. 1486. Reverse of a bronze portrait medal of Giovanna degli Albizzi Tornabuoni. National Gallery of Art, Washington, D.C., Samuel H. Kress Collection

resolutely upward and to her right. It is especially this directed gaze that leads one to believe that this figure resembles the figure of Pallas on the banner, which "looked fixedly into the sun that was above her." The Urbino *Pallas* also stands on a pile of curly flames. These seem to signify similarly to the burning *bronconi*, the quasi-heraldic olive branches, on Giuliano's standard; they are not, however, obviously appropriate for a Montefeltro commission.[60] Most significant, perhaps, is the appearance of the jousting lance, instead of a spear, in Pallas's right hand. This rather odd detail would seem to suggest that Botticelli based his design for the *intarsia* panel directly on the 1475 banner, in which Pallas was recorded as clenching a *lancia da giostra*.

The Urbino *intarsia*, in turn, seems related—formally and iconographically—to two other Florentine images. The first is a representation of Venus as Diana on the reverse of a portrait medal of Giovanna degli Albizzi Tornabuoni (fig. 5.3). The medal, dating to the late 1480s, shares a number of features with the Montefeltro panel. The inscription on the medal reverse— VIRGINIS OS HABITVMQVE GERENS ET VIRGINIS ARMA—clearly refers to that moment in Virgil's *Aeneid* when Venus appears in the guise of Diana.[61] Thus we see the representative of love, masked as the chaste huntress, producing a curious synthesis of opposites. Certain details remind us of the Urbino *Pallas*,

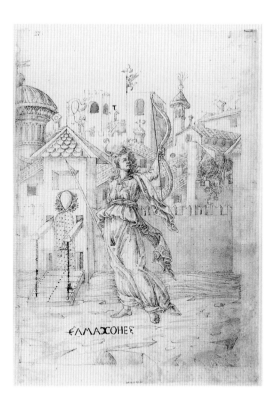

Figure 5.4
Anonymous (Florentine),
Amazon, c. 1460–80. Drawing in
pen and ink. From the so-called
Florentine Picture-Chronicle.
British Museum, London

most notably the gaze, directed upward and to the side. The similarity between the two purposefully turned heads is underscored by the headgear of each figure: wings adorn both. The cloud and light-feigning striations on which *Venus as Diana* stands call to mind, moreover, the tongues of flame licking Pallas's feet in the Urbino panel. Finally, although the style in which the artists represent drapery in each of these works differs considerably, both figures share the aggravated and dynamic appearance that Warburg labeled *bewegtes Beiwerk*, or animated accessories. This last point is brought forth with even more force in a drawing that may in fact be the direct source for Giovanna degli Albizzi Tornabuoni's medal reverse.

Among the drawings that make up what has come to be known as the *Florentine Picture-Chronicle* is a representation labeled "Amaxone" (fig. 5.4).[62] This *Amazon* again possesses the distinct averted and upturned gaze (here, as on the medal reverse, to the right). She holds aloft a bow in her left hand and in her right, somewhat incongruously, a spear. The drapery of this figure is bunched up around the waist, and its legs seem clearly related to the Urbino panel. Without attempting to discern a clear filiation between these three objects, I do think that the *Venus as Diana* and the *Amazon* preserve both formal (*bewegtes Beiwerk*, averted gaze, weapons) and thematic (the armed

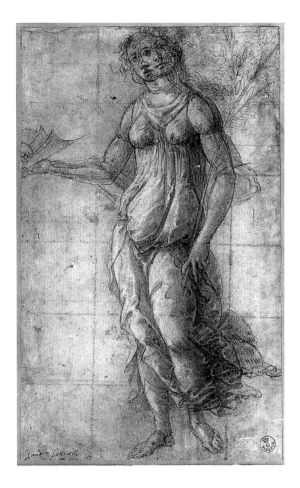

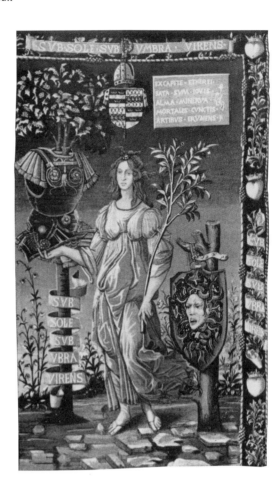

Figure 5.5
Sandro Botticelli, *Pallas Athena*,
c. 1475. Drawing in pen and ink
on prepared paper. Galleria degli
Uffizi, Florence

Figure 5.6
Anonymous (after Botticelli),
Minerva, c. 1491. Tapestry for
Comte Guy de Baudreuil.
Collection of the vicomte de
Baudreuil, Favelles

woman, Chastity) details that speak of an ancestry shared with the Urbino *Pallas.* That is, they all derive, perhaps indirectly, from Botticelli's Medicean allegory.

Two other images, related to the standard, can be considered together. The first is a drawing, now in the Uffizi and attributed to Botticelli (fig. 5.5). Here we see a female figure in a long, gauzy gown. She steps forward not unlike Flora in the *Primavera* (fig. 5.9), but here the figure bears in her right hand a helmet (we see only its visor, which looks quite similar to that worn by the Urbino *Pallas*). In her left hand is a long reed or stalk. A remarkably similar figure appears on a tapestry made for Comte Guy de Baudreuil in 1491 (fig. 5.6).[63] The female figure, carrying a helmet and a long olive branch, is here surrounded by pieces of armor: on a tree stump—perhaps an olive—to her left, a shield with the head of Medusa; and to her right, a cuirass hangs on a holly-sprouting tree. The tapestry seems closely related to the drawing by

Botticelli, although it seems unlikely that the drawing was made as a preparatory study for the tapestry.

The final picture that helps us imagine how the figure of Simonetta/ Pallas on Botticelli's standard may have appeared is a small woodcut from the 1494 edition of Poliziano's *Stanze* (fig. 5.7). As Salvatore Settis argued in an essay of extraordinary erudition, this woodcut cannot be taken as an illustration of Poliziano's text; rather, it is itself a creative interpretation of the imagery in the poem. Within a vaguely ecclesiastical setting we see a man kneeling before an altar, on which there is a small pile of burning wood. Behind the altar and in a niche is a female figure—a statue we imagine— bearing a spear in her left hand, while her right rests upon her hip. One is tempted to identify this figure as Pallas Athena, but the inscription on the altar reads CITAREA, that is, Cythera, the sacred island of Aphrodite/Venus. Settis concludes that Iulio/Giuliano is shown devoting his device, the *bronconi,* to Venus as Pallas (or Pallas as Venus).[64] The woman/icon on the altar is also Simonetta, whom Bernardo Pulci described, after her death, as having been given "the body of Citarea," and "the ingenuity of Pallas."[65]

No one of these images—the Urbino *intarsia,* the drawing in the *Picture Chronicle,* the Botticelli drawing, the Baudreuil tapestry, or the woodcut—is a direct reflection of Botticelli's standard. Nonetheless, this iconographic cluster does help to establish a set of parameters defining the most important visual characteristics of the lost paintings (the banner and/or the Pallas in Piero's *camera*).

Figure 5.7
Anonymous (after Botticelli?), *Man at the Altar of Citarea.* Woodcut from Angelo Poliziano, *Stanze per la giostra* (Florence, 1513). British Library, London

Figure 5.8
Agostino di Duccio, *Temple of Minerva*, c. 1460. Marble. Tempio Malatestiano, Rimini

All of the personae represented in the works I have adduced as related to the female protagonist on Botticelli's standard—Pallas Athena, Venus as Diana, the Amazon, inter alia—share a thematic concern with the "master allegory" of Chastity, visualized as an armed woman, vanquishing lust. This iconographic motif finds visual strength in the pose of the figures—all variations on a dynamic contrapposto, and many sharing the averted gaze that would seem to derive from Botticelli's Simonetta/Pallas staring toward the Sun/Glory. Finally, and to my mind most tellingly, all the figures possess animated drapery, especially the activated hem, which twists as if of its own volition.

Based on this shared visual characteristic, it seems likely that Giuliano's banner presented Simonetta/Pallas in a similar fashion (the anonymous description of Giuliano's banner did mention that "her [Pallas's] braided hair fluttered in the wind"). The *Pallas*, inflected as Simonetta, as Venus, and, in the *Stanze*, as a nymph, can also be considered as a Warburgian *Nympha*. This

active and allegorical rendition of the female body descended, as I argued in Chapter One, from Donatello's lost statue of *Dovizia* in the Mercato Vecchio. But, if one accepts the derivation of this type from Donatello's monument, Botticelli's *Pallas,* carried into the piazza di Santa Croce, offered an inverted interpretation of the civic statue. The Florentine goddess of the Mercato Vecchio, divested of her bounty, could be seen to appear as the chaste and ferocious Pallas.

That Donatello's *Dovizia* could be interpreted as a goddess is apparent in Agostino di Duccio's so-called *Temple of Minerva,* a relief sculpture in the Tempio Malatestiano, Rimini (fig. 5.8).[66] Unlike the running nymphs in the paintings by Lippi, Ghirlandaio, and Botticelli, the link with Donatello's lost statue is not immediately apparent. The figure in question stands on a pedestal, in front of an antique barrel-vaulted arcade. She can be read as a statue, and the male figures who surround her as "worshippers" in her temple. The statue stands in sharp contrapposto, right arm raised and holding a spear, the other lowered and supporting a shield. Although these weapons suggest identifying the figure as Minerva or Pallas Athena, without a Gorgon on her shield, a helmet, cuirass, greaves, or even a nearby olive tree, the beholder is left uncertain. All that can be ascertained is that this is intended to represent an armed pagan goddess. Below the statue of this powerful woman, an august assembly of wise and brave men from all eras mill around in the suggestively public space defined by the monument.

The goddess holds a spear and shield, and not the accessories associated with the *Dovizia.* What is more, the linear and "spheric" drapery style used by Agostino here and elsewhere has little in common with the treatment of fabric in images we think of as representing the *Dovizia.* The distinctive pose, however, does stem from the *Dovizia.* Comparing Agostino's *Minerva* to the statue, as it appears in the painted views (fig. 1.1 and fig. 1.2) and in the terracotta version now in the Casa Buonarroti (fig. 1.7), the relation is evident. The distinctive crook in the figure's left arm, the raised right arm, and the clinging quality of the dress all would appear to derive from Donatello's lost original. As does, moreover, the dynamism of the drapery, if not its specific form. Agostino, moreover, was in all probability trained in Donatello's workshop; that he would imitate his master's most public work is, as a consequence, hardly surprising. I would like to see this emulation as bearing meaning. Using Donatello's *Dovizia* as a model for his armed goddess, Agostino responded to the Roman appearance and forumlike siting of the statue, reading Donatello's work as a pagan, civic goddess.

It is not without significance that Florence itself was addressed as a Roman goddess in civic poetry. Poliziano, in a poem apostrophizing *Gloriosa*

Fiorenẓa, produces this pagan typology, suggesting that she is honored by the goddess Minerva.[67] The monumental *Doviẓia* appears as an ancient genius or presiding deity, pictured in a mode that emphasized her antiquity and divinity. Similarly, Botticelli, in availing himself of the forms and meanings that accrued to the *Doviẓia,* and transforming this civic *tyche* into a chaste and armed goddess on the banner of 1475, produced a novel confection of aggression and submission, invoking both virtuous admiration and undying devotion.

The aftereffects of Botticelli's allegorical woman are felt in two paintings that the artist, in all likelihood, produced for the Medici: the *Primavera* and the *"Pallas and the Centaur,"* both certainly painted within a decade of Giuliano's joust.

Warburg thought that the figure of Flora, or the Goddess of Spring, in the *Primavera* (fig. 5.9) was a portrait of Simonetta Vespucci. Given the similarities between this figure and that on the Baudreuil tapestry (fig. 5.6) and the Urbino panel (fig. 5.2), his deduction is not without merit. Although Nicolai Rubinstein has recently offered a re-identification of Flora, proposing that the figure represents, primarily, Iuventus, the goddess of youth, concerns about a "hidden" portrait seem likely to continue.[68] Charles Dempsey has most eloquently and sensitively restated the case for identifying Flora as Simonetta; this against an array of scholars who prefer to see the iconography of the painting as emerging more directly from the marriage between Lorenzo di Pierfrancesco de' Medici and Semiramide d'Appiani, concluded in the summer of 1482.[69] These analyses, either explicitly or implicitly, would seem to read the figure of Flora/Iuventus as an ideal portrait of the bride Semiramide, rather than Simonetta.

Without fundamentally reformulating the word "portrait," it is extraordinarily difficult to sustain a claim that Flora (or Iuventus) represents in any straightforward manner Simonetta, Semiramide, or any other fifteenth-century person; in general, Botticelli's rather generalized female faces hinder such precise identifications, especially in his mythological paintings. If one were to argue that the *Primavera* represents, in some manner, the relations between Giuliano and Simonetta, it ought to be noted that the figures in the Baudreuil tapestry and in the related drawing in the Uffizi possess visual affinities not with Flora/Iuventus, but rather with the central figure in Botticelli's *Primavera,* Venus. Having said this, one distinctive feature of Botticelli's Flora draws her into the circle of images reflecting Giuliano's banner. As she steps forth, strewing her flowers, her dress flutters behind. This dynamic detail speaks of a shared heritage. But what of the hypothesis that the *Primavera* concerns itself iconographically with the marriage between Lorenzo di Pierfrancesco and Semiramide d'Appiani?

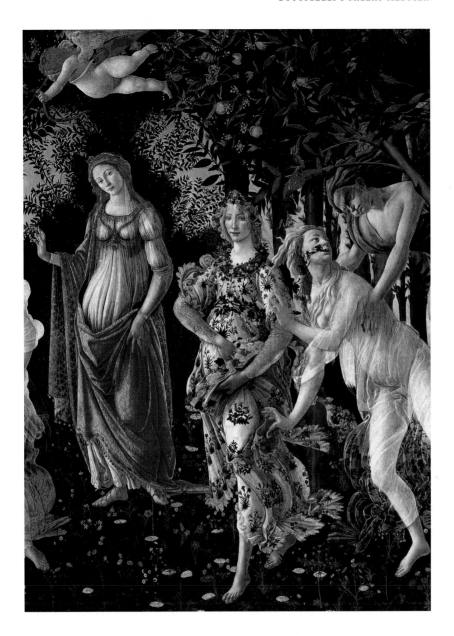

Figure 5.9
Botticelli, *Primavera*, c. 1478.
Tempera and oil on panel.
Galleria degli Uffizi, Florence,
detail

This interpretation emerged from the discovery that in 1498 the *Primavera* could be found in the *casa vecchia* of the Medici, that is, in the residence of the cadet branch of the family: the descendants of Cosimo de' Medici's brother Lorenzo.[70] This discovery put to rest the earlier assumption—based on Vasari—that the painting was produced for the Medici villa at Careggi, owned by the main branch of the family. But as John Shearman warned when he published the inventory data, the document of 1498 tells us only where the painting was then, and not where it was originally placed.[71] It

seems unwise to assume that paintings—even those integrated into the furnishings of a *camera*—did not move, especially in the heady days following the expulsion of Piero de' Medici in 1494. What is more, the 1498 inventory reveals that the *Primavera* and the *"Pallas and the Centaur"* were displayed together in the *casa vecchia*, suggesting the possibility that they were painted as pendants, or were conceived within a unified artistic program.[72] Given this likelihood, I think that it is telling that the figure of "Pallas" wears a robe decorated with three interlocked diamond rings, which, as we have seen, were a symbol associated with the main branch of the Medici dynasty. This detail suggests to me that we ought, along with Charles Dempsey, to reflect long and hard before abandoning the notion that the paintings were originally intended for the main Medici branch. What is more, even if produced for Lorenzo di Pierfrancesco, it could be that they have more iconographic links to his politically enfranchised cousins, Lorenzo and Giuliano.

Thus, without leaping to assumptions concerning the patronage and original location of the *Primavera*, it is, I believe, still possible to conceive of it within the framework of political symbolism. For I agree wholeheartedly with Janet Cox-Rearick's keen and persuasive observation that Flora is an idealized version of Florentia/Fiorenza.[73] Further, I propose that Botticelli chose as a model for this figure Donatello's *Dovizia*, responding not only to the statue's explicit symbolic embodiment of fertility, but also to its political significance.

That Flora *could* stand for Florentia becomes more likely when one considers the etymological assumptions of the artist's contemporaries. It was assumed that the word Florence or Firenze, derivatives of the Latin Florentia, emerged from the tradition that the city was founded in a field of flowers. The floral site, it is thought, gave rise to the florid name. Although Florentines perpetuated this mythology, calling Florence *La città dei fiori*, addressing their tutelary version of the Virgin as Santa Maria del Fiore (St. Mary of the Flower), and electing to adorn all nature of civic objects with their heraldic lilies and/or irises and, later, their Guelfic and French fleur-de-lis, the word Florence bears only a loose semantic connection to "flower."[74] Yet Florence still saw itself as *florens* and, in its optimistic moments, associated itself with the fecundity of nature and, especially, springtime.[75] In adopting Donatello's breezy *Dovizia* for his representation of Flora, Botticelli was responding to a blurring of the symbolic lines between Donatello's fertile and antiquarian representation of wealth, and the very rich constellation of symbols producing the flowery figuration of Florence.

Substantiation for the identification of Flora as Florentia can be found in the painting itself. The right edge of the *Primavera* is dominated by two

large laurel trees. A branch from the larger arches over Zephyrus and Chloris and disappears behind the head of Flora. The resulting configuration reminds one of the material and literary images, examined in Chapter Two, that picture Florentia beneath a laurel tree. On the reverse of a portrait medal of Lorenzo de' Medici (fig. 2.4) and in Poliziano's verses we find Florentia resting beneath the protective canopy of Lauro/Lorenzo, while Bernardo Bellincioni paints Florence as a beautiful woman, even calling her a "new Athena" with "flowers in her lap" and "resting in the happy shade" of the laurel.[76] Botticelli, astutely recognizing the *Dovizia* as a personification of fertility and Florence, modeled his Flor(enti)a on Donatello's creative personification, drawing also, perhaps, on the *Pallas* he produced for the joust of 1475.

Another painting by Botticelli, the above-mentioned *"Pallas and the Centaur"* (fig. 5.10), can also be seen to respond to the artist's lost 1475 banner. The *"Pallas and the Centaur"* is usually dated to the early 1480s, although some critics have opted for an earlier date of about 1478—that is, before Lorenzo de' Medici sent Botticelli with other Tuscan artists (and the Umbrian Perugino) to Rome to decorate Sixtus IV's palatine chapel.[77] Early interpretations of the painting, based on the assumed patronage of Lorenzo de' Medici, set forth political readings.[78] A later wave of iconologists, beguiled by Florentine Neoplatonism, preferred to see in the *"Pallas and the Centaur"* an allegory pitting Chastity against Reason, linking the work to the marriage of Lorenzo di Pierfrancesco de' Medici and his contacts with Marsilio Ficino.[79] More recently, following a theory outlined by Ronald Lightbown, some scholars have emphasized the private, marital content of the painting, seeing in the figures a record of the uneasy relations between Lorenzo di Pierfrancesco and Semiramide.[80] As with the *Primavera*, in the absence of stronger evidence, it seems somewhat hazardous to construct such detailed iconographic readings of the *"Pallas and the Centaur"* on the hypothesis that the painting was made for a specific event. Analysis is better founded on the painting itself.

The painting shows two figures. To the right of center, a woman armed with an ornate halberd grasps the forelock of a centaur to her right. Again we appear to see an allegory of Chastity curbing Lust. Recognizing this fundamental meaning, most commentators identify the female figure as Pallas; Shearman, however, noting the lack of obvious iconographic cues, proposed that the woman be seen as Camilla.[81] Shearman's proposal reminds us of the iconographic indeterminacy of the figure. Similar to the *Pallas* of 1475, it seems wise in this instance as well to suspend unitary identifications. In fact, the woman represented next to the centaur resembles the previously dis-

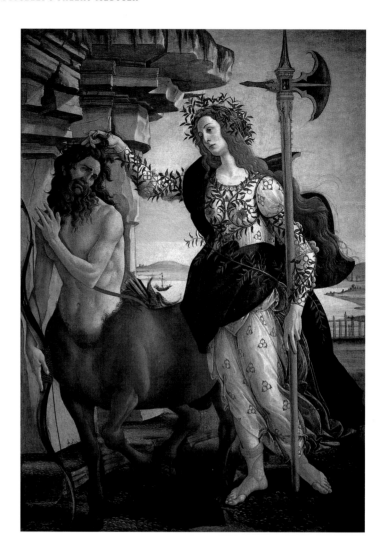

Figure 5.10
Botticelli, *"Pallas and the Centaur,"* c. 1480. Tempera on panel. Galleria degli Uffizi, Florence

cussed images that relate directly to Botticelli's 1475 banner. Comparing the centaur-tamer to the drawing of *Pallas* discussed above (fig. 5.5), we can see the many characteristics they have in common, especially the pose and treatment of drapery around the legs. Perhaps more important than a fixed identity for this figure is her status as an armed woman, representing Chastity, who is clearly associated with the Medici. This latter connection is stated unequivocally by Botticelli, who, as mentioned above, included on the white dress of the figure numerous interlocking diamond rings. Be this a representation of Pallas or Camilla, this allegorical woman is Medicean. Like the multivalent and complex *palla Medicea,* the heraldic ball of the family, which seems to offer so many different possibilities for interpretation, Botticelli's goddess—the *Pallas Medicea*—is ripe with irreducible meaning and identi-

ties. At once Florentia and Medicean, the allegorical woman daintily grasping and controlling Lust (backing up her authority with a rather menacing weapon), represents the same ambivalence concerning undying love and decorous chastity defining the public significance of Botticelli's *Pallas Medicea* on the standard of 1475.

Cupid Crucified [82]

That first ancient sage who painted Amor
[As a] nude youth with delicate wings,
And with such marvelous hands,
And with those beautiful eyes bound by a veil;
Certainly he who makes Love too well,
Who seems to love, is never able to hide
His fervent and amorous desires,
So that the flame in him is never quenched by reason.
He is given arrows and torches and a bow in hand,
With which he wounds both from near and from afar,
With sweet wounds and to the eternal memory of the heart.
Propelling him who flees, and nourishing him who succumbs
With uncertain hope, and never releasing him who suffers
From infinite suspicions and new scorn.

—Leon Battista Alberti[83]

If the figure I call the *Pallas Medicea* on Giuliano's banner is ambivalently charged, its mobile moral position is defined in part by the representation of Cupid tied to the olive tree. This iconography had appeared at Lorenzo's joust, on the standard carried by the Pitti. Perhaps recognized as apt, it was integrated into Giuliano's allegory, even appearing as the crest on the ceremonial helmet he wore. The essential meaning of this image is simple: Cupid restrained signifies Lust reined in. The god of love—representative of earthly passion—somewhat paradoxically comes, like the leashed unicorn, to indicate Chastity. Although this meaning cannot be ignored, the bound male body could and did mean more in contemporary culture. Understanding the figure of Cupid on Giuliano's pennant means, therefore, considering not only the textual tradition from which the iconography sprang, but also the visual context within which it operated.

Two early Florentine engravings, which represent Shakespeare's "wimpled, whining, purblind, wayward boy" bound to a tree and punished by

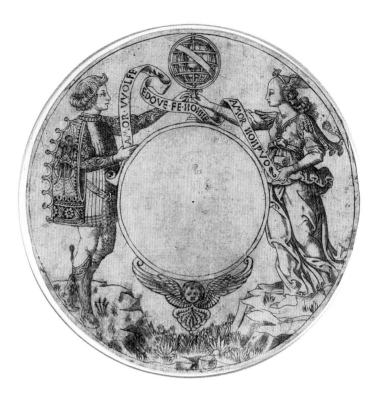

Figure 5.11
Anonymous (Florentine), *Youth and a Nymph (Lorenzo de' Medici and Lucrezia Donati)*, c. 1469–78. Engraving (Hind A. IV. 11). Bibliothèque Nationale de France, Paris

a group of women (fig. 5.12 and fig. 5.13), aid in reconstructing the iconography of *Cupido cruciatur,* or Cupid tortured, as it appeared on Botticelli's allegorical banner. These images belong to a series of engravings, collectively known as the Otto prints.[84] Among the first known Italian engravings, dating to about 1465–78, these round and oval prints were probably intended to decorate small courtship boxes. It seems likely that the prints, cut to shape, were affixed to either the inside or the outside of these boxes' covers.[85] Four pieces of evidence suggest this. First, a handful of boxes with amorous imagery similar to that seen in the Otto prints painted or embossed on them have survived.[86] Second, the distinctive round and oval shapes of the prints match the forms of these extant boxes. Third, on some of the prints spaces or shields have been left blank, leaving room for heraldic devices to be inserted;[87] in some cases family arms have indeed been added in pen and ink.[88] This would seem to suggest a marital function. And fourth, documents inform us that brides did receive small gifts in decorated boxes before marriage.[89]

The subjects represented on the forty-two Otto prints offer a glimpse behind that rational and humanistic curtain that often hinders art historical study of the Renaissance. Running the gamut from biblical to pagan, from erotic to grotesque, the prints reveal a Renaissance voice husky from revel-

Figure 5.12
Anonymous (Florentine), *Cupid
Chastised*, c. 1469–78. Engraving
(Hind A. IV. 7). Graphische
Sammlung Albertina, Vienna

ing. They are not by one artist, nor, in my opinion, necessarily from a single workshop.[90] Indeed, the manner of figural rendition varies considerably between the prints. While it is possible to group them according to stylistic categories, the recognition of many hands leads one to the conclusion that these prints are but a fraction of the many that must have been produced. I shall concentrate on a handful of the Otto prints, those representing the punishment of Cupid, and, in the next chapter, two prints apparently representing Judith triumphantly holding the head of Holofernes. If the subject matter of the Otto prints is broad, it is also consistent: a woman taming a unicorn, a bacchic procession of putti, hunting scenes, reclining lovers, grotesque couples, images of musical merrymaking, and, perhaps most disconcertingly, a leering male face, ring-clad fingers pulling at the corners of his mouth and below his eyes, poking fun, it appears, at the viewer. The most common subject represented shows a male and a female figure reaching, with their glances or their hands, over a central "oculus" containing either a small scene, or reserved for the insertion of family arms (fig. 5.11). Various, the prints share a certain thematic consistency found at the intersection between popular songs, pseudochivalric patrician culture, and love. They consequently provide an invaluable insight into the visual culture linked to the street life that charac-

Figure 5.13
Anonymous (Florentine), *Cupid Chastised*, c. 1469–78. Engraving (Hind A. IV. 8). British Museum, London

terized Medicean Florence before the violence and turbulence of the late 1470s and early 1480s. They offer, however, a little more. Not only a reflection of carnival themes, the Otto prints also present a refraction of Medicean symbolism.

Since Aby Warburg, few scholars have taken these prints (not to mention the boxes) seriously. Warburg, although he never completed a systematic study of their imagery, understood that the Otto prints were a unique visual manifestation of the chivalric and spectacular culture of late fifteenth-century Florence.[91] It was he who recognized the "diamond ring and three feathers device" on the clothing of one of the figures in the Otto prints (fig. 5.11). Based on this information, Warburg identified this young man as Lorenzo de' Medici and his companion as Lucrezia Donati. The consequences of this revelation have never been fully acknowledged. What is the connection linking the Medici to the Otto prints? Why would Lorenzo and Lucrezia be an appropriate subject for the decoration of a courtship box? Were the prints made for the Medici?

I would like to suggest some ways these questions might be answered by examining the Otto prints within the context of the chivalric spectacles

orchestrated by the Medici. I wish now to take the iconography of "Dan Cupid" punished as a point of departure for a discussion concerning the imagery of the bound male body and its position within the symbolic universe of late fifteenth-century Florence.[92]

It is my claim that the two Otto prints representing *Cupido cruciatur* respond to Botticelli's banner of 1475, and offer us the closest reflection of how Cupid may have appeared on this important painting. On the first of these prints (fig. 5.12), one sees a naked, adolescent male figure with wings on his shoulders and ankles. The boy is blindfold and tied to a severely pruned tree, perhaps, but not obviously, an olive. The youth, we can safely assume, is Cupid, Eros, or Amor, the god of love. His bow is visible just to the right of his left knee, while the contents of his quiver have been emptied on the ground before him. He is surrounded by women clothed in fifteenth-century garb. The woman in the right background holding on to one end of Cupid's fractured bow has picked up a couple of the disgorged arrows and appears to be beating the god with his own weapons. Next to her a companion, while holding on to the now-useless bowstring, prepares to strike the bound god with what appears to be a shoe. Opposite these assailants, in the left background, a woman carries a knife in her right hand and with her left grasps Cupid's right wing; she seems to be preparing to perform some rather brutal form of plucking. Finally, a woman dressed in an elaborate cape and a French-style, "horned" headdress, is poised ready to strike Cupid with a distaff.

The second Otto print representing this subject (fig. 5.13) fundamentally resembles the first (fig. 5.12). The prints share specific figural dispositions. In each three women are shown in full profile, and one in three-quarter profile. Moreover, the women in the foreground of each print resemble one another in that each has her right arm raised, ready to strike the god. Despite such similarities, comparison between the two engravings reveals some differences. Most notably, in the first (fig. 5.12) Cupid's wrists are tied together above his head (like one of the antique statues of Marsyas in the courtyard of the Medici palace), while in the second (fig. 5.13) his arms are bound behind his back (resembling numerous contemporary paintings and sculptures of Saint Sebastian).[93] Also, the assailants in the two prints bear different weapons: in the second version a sword replaces the wool-winder, and a pair of scissors, the knife. Compositionally, the figures in the second print are relatively larger; Cupid's wings, for example, are cropped by the round frame defining the visual field. The prints also vary stylistically: in the second (fig. 5.13), the modeling is cruder, the clothing of the women more rudimentary, and the faces less expressive.

Both the probable function of the prints—decorating "courtship" boxes—and their iconographies (the punishment of Cupid) lead one to believe that the subject of these engravings is love. Why do the women punish Cupid? Two hypothetical and preliminary narratives spring to mind: perhaps these women have been unhappy in love and vent their anger against its representative; or, one could imagine that these are chaste women, chastising Cupid and thus allegorically opposing lust.

The presence of Cupid suggests that we are dealing with a narrative drawn from antique sources. But if so, little in the prints suggests an antique setting; on the contrary, the only datable item in the prints is the attire of the women, which is conspicuously modern. This should not bother us too much. The transposition of classical stories into contemporary settings was common practice among Florentine artists of the second half of the fifteenth century. Innumerable panels for wedding chests (or *cassoni*) show ancient heroes and heroines in distinctively modern clothing. There is, however, something more specifically contemporary about the garb of Cupid's antagonists. On the sleeves of one of the figures in each print are "embroidered" inscriptions. One reads DROIT MANT ("uphold the right"), and another reads AMOR VUOL FE ("love desires loyalty"). The first, in French, expresses the ineffable moral rectitude of the courtly ethos suffusing Florentine public life in the 1470s. The second is actually a fragment of a longer saying, "Amor vuol fe[de] e dove fe[de] non è amor non può [essere]" (Love desires loyalty, and where there is no loyalty, there can be no love). It is also an expression mentioned by Pulci in his poetic reformulation of Lorenzo's tourney of 1469. It is not, therefore, surprising that this inscription is also to be found on what is the most famous of the Otto prints (fig. 5.11), which Warburg argued represented Lorenzo and Lucrezia supporting an armillary sphere (*sfera* = *spera* or hope) between them and locked in a clearly amorous visual exchange.[94] The inclusion of a contracted version of this inscription in the print of Cupid chastised tells us two things: the iconography of Cupid punished would appear to have more to do with "chastity" or fidelity than with lovelorn women; and, if one accepts Warburg's identification of the figure with the ring device as an ideal avatar of Lorenzo de' Medici, the reappearance of *Amor vuol fe* in the other print showing Cupid's chastisement suggests that it too ought to be considered within the broader framework of Medicean iconography.

Affixed to a *scatolina* or *goffanuccio,* the iconography of Chastity would appear to function similarly to the exempla painted on marriage chests and *spalliera* panels exhorting brides to emulate Lucrezia, Eurydice, Virginia, and other heroines.[95] The inscriptions on the sleeves of Cupid's tormentors— *Amor vuol fe* and *Droit mant*—reinforce this reading. But there is something

else operating in these prints, another layer of significance brought out by a contextual interpretation of their imagery. To understand the valence of the body of Cupid on the two prints and on Giuliano's banner, it is useful to review the literary and visual traditions that yielded this iconography.

The image of Cupid bound by Pallas to a tree that appeared on Botticelli's 1475 banner for Giuliano developed directly from the rich mythographic tradition in Italian vernacular poetry.[96] In his ranging *Triumphi*, Petrarch describes the "Triumph of Chastity" in which appear, along with the protagonist, the Seven Muses, Judith, and other classical and biblical characters "among whom to the right the first was Lucrezia and the other Penelope." The poet tells how these female figures, all examples of heroic chastity, "had broken the arrows and the quiver at the side of that arrogant one [that is, Cupid] and plucked his feathers."[97]

In describing this scene of vendetta, Petrarch assumes his readers will understand its allegorical intent. That the Old Testament heroine Judith is included in the band torturing Cupid, though chronologically and apparently thematically incongruous, is actually quite normal. Christian commentators had long seen the Old Testament widow Judith as a representative of heroic chastity, and the melding of antique and Christian themes in the service of a greater allegorical narrative was a familiar rhetorical flourish since late antiquity.

In his *Genealogia deorum* Boccaccio supplements Petrarch's ekphrastic evocation with the following entry describing one aspect of Cupid: "We know that he was affixed to the cross, which is an example of how we can overcome our weakness by which man's spirit is recalled to laudable activity and we see with open eyes that which draws us into vice."[98] Boccaccio, it will be noted, explicitly describes Cupid as fixed to a *cross* and implicitly as blindfold.

Both Petrarch and Boccaccio were elaborating on an iconography well known in antiquity. On many antique engraved gems one finds the little boy Eros, hands tied behind his back and bound to a pillar or tree. Often a butterfly represents Psyche, referring to Eros's own amorous misfortunes.[99] The conceit of Cupid tied up and beaten surfaced repeatedly in epigrams from the Hellenistic *Greek Anthology*, describing a "Statue of Eros in Bonds." Crinagoras, for example, writes: "Weep and groan, schemer, the sinews of your arms bound fast; such are your deserts. There is not one to untie you. Let us have no more piteous glances up. You, Eros, were the one to squeeze tears from others' eyes; you fixed your bitter arrows in the heart, and instilled the poison of passions inescapable. The agonies of mortals are your mirth. What is done to you is what you did; justice is an excellent thing."[100]

Antipater of Thessalonica adds that the statue he saw, or imagined, was tied to a pillar. There is every reason to believe that the images described by Crinagoras and Antipater of Thessalonica were very different from medieval conceptions of the adolescent Lord Love. Antiquity pictured Eros as a young, winged child. Greek and Roman representations of Eros reflect this. Moreover, the epigrams do not refer, explicitly, to those who actually captured and restrained the god—certainly, the epigramists refer to no women torturing Eros.[101]

It was, however, the writings of the fourth-century poet Ausonius—who had composed free translations of epigrams from the *Greek Anthology*—that fleshed out the iconography of *Cupido cruciatur*. In an ekphrastic essay, Ausonius describes in a letter to Gregorius Proculus a mural in the house of his friend Zoïlus in Trier, showing Cupid crucified: "Cupid is being nailed to the cross by certain lovelorn women—not those lovers of our own day, who fall into sin of their own free-will, but those heroic lovers who excuse themselves and blame the gods."[102]

The poet imagines a painted scene of crucifixion taking place in "the aerial fields, told of in Virgil's verse, where groves of myrtle o'ershade lovers lorn," that is, in the underworld.[103] His protagonists, therefore, are the souls of women who had died owing to amorous misadventures. "Into the midst of these," Ausonius describes, "Love rashly broke scattering the darkness of that murky gloom with rustling wings. All recognized the boy, and as their thoughts leapt back, they knew him for the one transgressor against them all, though the damp clouds obscured the sheen of his golden-studded belt, his quiver, and the flame of his glowing torch."[104] Surrounding the intruder, they capture and restrain the god.

> On the tall trunk of [a myrtle tree] Love was hung up, his hands bound behind his back, his feet tied fast; and though he weeps, they lay on him no milder punishment. Love is found guilty without charge, condemned without a judge. . . . All upbraid him, and prepare to use on him the tokens of the death they once endured. . . . One holds a halter ready, another advances the unreal phantom of a sword, another displays yawning rivers, jagged rocks, the horrors of the raging sea, and a deep that has no waves. Some shake firebrands, and in frenzy menace him with torches which crackle without fire. Myrrha, with glistening tears, rends open her ripe womb and hurls at the trembling boy the drops of amber which trickle from her stem.[105]

Petrarch and Boccaccio drew on Ausonius's imagery, but their rendi-

tions differed considerably from the late-antique allegory. Concentrating, for a moment, on descriptive particulars, we recall that Petrarch mentions neither the cross nor the myrtle tree described by Ausonius. Boccaccio does, while making no reference to Cupid's female tormentors. Beyond these particulars, however, it will be noticed that Boccaccio and, especially, Petrarch, in transforming the Ausonian imagery, altered its mood considerably.

The tenor of Ausonius's ekphrasis is decidedly dark compared to Petrarch's triumph. The late-antique poet has his ghostly women take revenge for their deaths upon the bound and helpless god. The mural represents for Ausonius an opportunity to offer an extension of Virgil's underworld, and to draw together Greek and Roman mythology through the themes of love and death. Petrarch's description of Cupid chastised in the *Triumph of Chastity* is allegorical and differs sharply from Ausonius's tragic scene. Here the women, who beat Cupid, no longer represent unhappy love. His assailants are, rather, a mythographic and Christianized array of chaste women. Thus, although the literary image remains somewhat stable, its meaning has completely changed. Rather than an image of unhappy love, Petrarch's chastised Cupid symbolizes the triumph of Chastity.

Turning from the literary evolution of Cupid's chastisement to the development of the iconography in visual culture, an obvious point of departure is Erwin Panofsky's fundamental essay on "Blind Cupid."[106] Panofsky traces the evolution and transformations of the personification of Love. Pointing out that in the classical world Eros was never depicted blindfold, Panofsky describes the medieval development of two distinct Cupids: one puerile, the other adolescent. The former, derived from classical sources, was figured within moralizing mythographies as the representation of worldly love, or lust. The *puer alatus*, therefore, came to be represented with talons, referring to his tenacity, and a blindfold, symbolizing the serendipity and irrationality of his actions. The adolescent, on the other hand, was a poetic and chivalric exaltation of "Lord Love" and represented celestial and incorporeal affection. What Panofsky calls the "pseudomorphosis" of Cupid was completed in the fourteenth and fifteenth centuries in Italy, where the two versions of Cupid melted into one: "Cupid, his sex unchanged, shrank in size, was deprived of his garments and thus developed into the popular *garzone* or *putto* of Renaissance and Baroque art, who—except for his newly acquired blindness—resumed the appearance of the classical *puer alatus*."[107] The significance of the blindfold, Panofsky concludes, was so precise and determinate that Cupid's "image could be changed from a personification of Divine Love to a personification of illicit Sensuality, and vice versa, by simply adding, or removing, the bandage."[108]

Renaissance culture, Panofsky argued, inherited this duality hinging on the presence or absence of the blindfold. And although the dividing line between Panofsky's two Cupids was sometimes blurred, the blindfold always implied the negative moral status of the god as a representative of worldly love. According to Panofsky, the blindness of Cupid puts him definitely on the wrong side of the moral world.[109] Nonetheless, during the Renaissance the stark difference between the evil mythographic Cupid and his poetic, Lordly twin, diminished. The duality between puerile and adolescent Cupids became, instead, a "rivalry between *Amor sacro* and *Amor profano*," in which the combatants were to be recognized by the absence or presence of the blindfold.[110]

Within Panofsky's model, the meaning of Cupid's punishment on the Otto prints (fig. 5.12 and fig. 5.13) is fairly clear: the women (contemporary Florentine women) berate Cupid, the representative of carnal love recognizable by the blindfold. The inscriptions described above—"love demands loyalty" and "uphold the right"—reinforce the notion that the women chastise the infidelity and impropriety of their own lovers, led astray by erotic desire. Thus the scene shows Chastity versus Lust. It is in this sense, also, a psychomachia: the representation of internal qualities, personified, in combat. Only the maturity of this Cupid gives reason for us to pause. If this Cupid is indeed the representative of an irrational and problematic Love, why is he represented as the adolescent Lord Love? And why (to anticipate a later argument) is Cupid's body represented with such sympathy? It is necessary, I believe, to question Panofsky's somewhat rigid interpretative structure (which aims, it should be said, to explain sixteenth-century, northern Italian representations of Cupid). To account for fifteenth-century Tuscan images of Cupid, Panofsky's stark moral binary must be modified.[111]

The moral relativity of Cupid, when punished by women, is emphasized in visual renditions of Petrarch's *Triumphs*. In this extended allegorical and ekphrastic poem, Petrarch drew on antique imagery, on descriptions of Roman military triumphal entries, and on the late-antique literary rhetoric of personification—practiced by Prudentius, but also by Statius, Claudian, and, above all, Boethius. Petrarch wrote of four triumphs: Love, Chastity, Death, and Fame. Later visual reworkings of his thematic expanded this repertoire, figuring triumphs of Religion, Time, and Divine Providence. In the fifteenth century the imagery of triumph came to be accepted as a particularly apt motif for the decoration of objects associated with marriage and the bridal bedroom, especially great chest panels and *spalliera* panels.[112] It is clear that the triumphs of Love and Chastity referred in a privileged manner within a

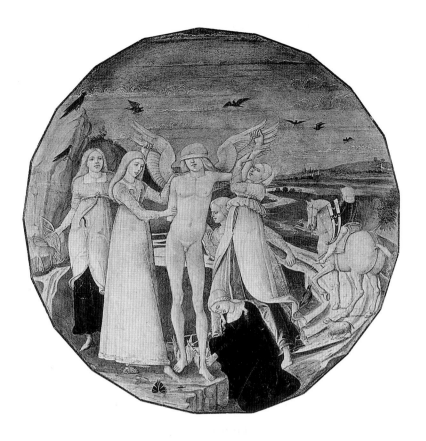

Figure 5.14
Girolamo di Benvenuto, *Cupid Chastised*, c. 1490–1500. Tempera and oil on panel. Yale University Art Gallery, New Haven

marital context. Drawing on Petrarchan imagery, artists imagined the triumph of Chastity as a procession: the vanquished Cupid paraded as a trophy.

On a Sienese *desco da parto* one finds an image of Cupid punished not unlike that seen in the engravings (fig. 5.14). The similarity is underscored by the panel's almost round form. The *desco* represents Cupid, naked but for his blindfold, being tied up and taken to task by five women. The large wings sprouting from his shoulders and the broken bow confiscated by the woman on the far left identify this figure unambiguously as Cupid. The women, like some of those in the Otto prints, focus their attention on plucking feathers from his wings.[113] They seem intent on grounding the god—his inability to fly juxtaposed to the birds that are shown in flight in the background. The woman to the left of Cupid seems less eager to disempower the god. While her right hand appears, at least nominally, to hold Cupid's arm, her left hand simply rests on his shoulder. This, together with the incline of her head, seems to signal a certain degree of melancholy and regret. This rendition of Cupid's punishment contains traces of empathy for the captured immortal.

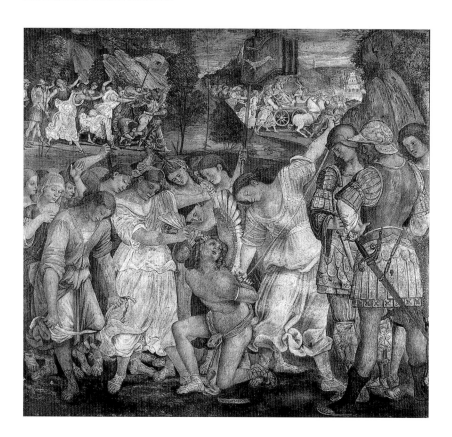

The iconography, it would appear, enjoyed some currency in Siena. For Luca Signorelli, in a very important commission for the ruler of the city Pandolfo Petrucci, painted a mural of the scene in the Palazzo Magnifico behind the city's cathedral (the work has been detached and is now in London's National Gallery). In this painting (fig. 5.15), the binding of Cupid is set in a narrative. In fact, it is a rendition of Petrarch's *Triumph of Chastity*, with narrative details lifted from Ausonius. A small scene in the left background recounts how, before Cupid was caught and bound, he was first pursued by the female representatives of Chastity; then, in a scene in the right background, we see how Cupid was set on a triumphal car. In the center foreground we witness Cupid being tied up.

In order to understand these representations of Cupid chastised, one must make the connection set out by Panofsky. The blindfold tells us that we are witnessing the symbolic curbing of lust. In these images, women are exhorted through exempla to defend their chastity, or, better conceived, their honor. The subject represents one strand of a broad iconographic tradition describing the struggle between Chastity and its opposite.[114]

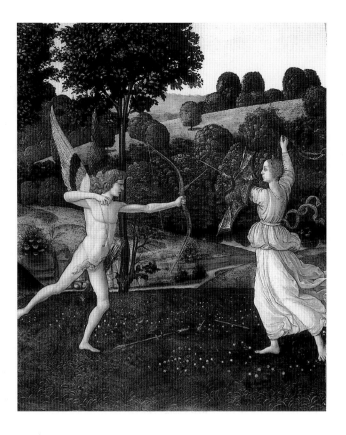

Figure 5.16
Gherardo di Giovanni del Fora,
Chastity Battling Cupid,
c. 1475–85. Tempera on panel.
National Gallery, London

Isabella d'Este, in a famous letter of 1503, ordered a painting including "a battle of Chastity and Lasciviousness, that is Pallas and Diana combating vigorously against Venus and Cupid" for her *studiolo* from the artist Pietro Perugino.[115] The scene shows Diana and Aphrodite battling in the center foreground. To the left, Athena has already subdued Eros. His eyes are blindfold.

In a similar Florentine painting (fig. 5.16), a naked adolescent engages a white-clad woman armed with a medusan shield.[116] With his wings and bow, the male figure is clearly Cupid. The woman, the shield implies, is Athena-Minerva-Chastity. The broken arrows in the foreground—as well as the arrow in the process of shattering against her shield—suggest her imminent victory. In this image we witness combat similar to that described by Prudentius in his fourth-century text, the *Psychomachia*. In a section called the "Fight for Mansoul," Prudentius has Chastity (*Pudicitia*) defeat Lust the Sodomite (*Libidinis*) with a sword.[117] In the fourteenth century Boccaccio picks up on this imagery in his *Teseida*, in which the Amazons, led by Hippolyte, attack Cupid.[118] But, more importantly, Petrarch transposed Prudentius's battle into a less allegorical and less violent register, describing Laura as an oddly real

personification of Chastity, engaging Cupid in combat. Details suggest that the panel is, in fact, a visualization of Petrarch's scene.

> She wore, that day, a white gown
> The shield in hand that hardly saw Medusa.
> There was a column of beautiful gem,
> To which with a diamond and topaz chain
> (Infused in the middle of the river Lethe)
> That women used to use, but use no longer today,
> I saw her tie him up and exact that punishment
> That was sufficient for a thousand other vendettas;
> And I for one was content and satisfied.[119]

These images—the Girolamo da Benvenuto, the Signorelli, the Perugino, and the panel in the National Gallery—all share a basic symbolic language. Moreover, each Cupid is symbolically represented as Lust and set firmly at the negative end of the moral scale, while not being visually reviled. They share an explicit and ambivalent intention to condemn Lust and to exalt worldly love. This makes sense when one considers how these images functioned. For example, Girolamo da Benvenuto's painting is a *desco da parto*, a birth salver, operating, in some fashion, within the rites surrounding parturition, while Signorelli's *Triumph* was commissioned for the camera of Pandolfo Petrucci, probably to celebrate his marriage.[120] Despite their rather obvious, explicit message—exhorting female viewers to be faithful—these representations contain an implicit ambivalence coded in Cupid's body. While the Italian fourteenth-century psychomachiata of Petrarch and Boccaccio adopted the trappings of Prudentius's moral allegory, the valence of Cupid's restrained body is very different in their work. In Boccaccio's tale, the Amazons eventually regret the violence they wrought upon the representatives of love. Even Petrarch's Laura, praised for her chastity, is considered hard in her opposition to the narrator.

I already touched on the tender manner of one of Cupid's torturers in the Sienese *desco da parto* (fig. 5.14), but a visual ambivalence analogous to that registered by Petrarch and Boccaccio can best be demonstrated by a panel attributed to Gherardo di Giovanni del Fora that represents *Chastity Battling Cupid* (fig. 5.16). There is no getting around the fact that in this painting Cupid represents worldly love. But within the Petrarchan reinterpretation of the classical world, the moral judgment suggested to the viewer is not simple. Nothing makes this clearer than the conspicuous absence of the blindfold in this scene. Cupid's heroic body and sightedness indicate his hybrid moral status. No longer simply the representative of Lust or of a chivalric concep-

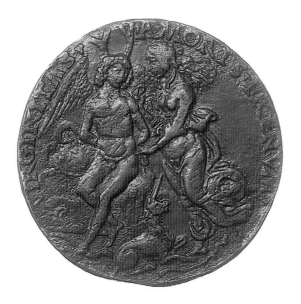

Figure 5.17
Niccolò Fiorentino?, *Cupid Chastised*, c. 1485–90. Reverse of a bronze portrait medal of Costanza Rucellai. National Gallery of Art, Washington, D.C., Samuel H. Kress Collection

tion of celestial love, Cupid here represents the heroic, if misguided, struggle of terrestrial love against chastity. One is not to support Cupid, but one can pity him.

Panofsky's analysis is very useful and his arguments are well founded, but his fairly rigid analytical system does not account, in general, for fluctuations in meaning and, more specifically, for the sway held by Petrarchan sentiment in the Renaissance and its effect on the interpretation of amorous symbolism. What I hope to have demonstrated is that the adolescent Cupid did not, in the fifteenth century, automatically signify as Lord Love. Nor can one immediately identify the blindfold Cupid with *Amor profano*. The Cupidian body bound and punished surely was meant to suggest lust, curbed. But this did not mean that worldly love was to be disdained as in the early-Christian moralizing allegories. The reason for this ambivalence toward Cupid/Love can, I believe, be seen most clearly within the poetry of Petrarch. Cupid, it would appear, became a substitute for the forlorn Petrarchan lover.[121] Cupid, still godlike, nonetheless begins to resemble the mortal male lover.

A fifteenth-century Florentine medal portraying on its obverse a certain Costanza Rucellai displays on its reverse a by now familiar configuration: a woman in contemporary dress tying Cupid's hands behind his back and to a tree; a unicorn, symbol of conquered lust (and, by implication, chastity), nestles between the two figures (fig. 5.17). An inscription supplements the image: VIRGINITAS AMORIS FRENVM ("Virginity, the bridle of Love"). Here the psy-

chomachia is set out in no uncertain terms. The inscription and the image are flattering references to the chastity and propriety of Costanza Rucellai: she controls Cupid, that is, Lust. On the medal the moral charge of the female figure is unequivocally positive. It is curious, however, that in this image Cupid's eyes are not blindfold.

Comparison with a *niello* print, now in the Louvre (fig. 5.18), helps clarify how this omission transforms the represented male body.[122] *Niello* prints were drawn from small metal decorative buckles and plaquettes often used to adorn belts and other fashionable accoutrements of patrician women (and sometimes men). Given the centrality of clothing and body decoration to the ritual exchanges constituting matrimony, it is not surprising that many *niello* prints also refer to amorous themes. Artists applied a sooty-black substance (*niello*) to these objects, pressing it into excavated crevices. Subsequent polishing made the shiny metal stand out, brilliantly, against the dark design. Drawing prints from these *nielli* was probably a formative stage in the development of Florentine intaglio printmaking.

The *niello* print under discussion shows a scene not unlike that one seen on the reverse of Costanza Rucellai's medal. Again we see a woman tying the hands of a male figure behind his back and to a vestigial tree. The streaming hair of the women and the poses of the male figures in both images are superficially related to one another. Nonetheless, there are considerable differences between the image on the medal and the *niello* print. In the latter, the man is no longer Cupid: he has no wings. Moreover, there is no unicorn and the woman is naked. Is this an image of virginity controlling lust? I think not. There is a tantalizing and ambivalent inscription on a banderole to the right of the figures on the print which reads: VA · MORI. It can signify "go die," indicating the rather bleak plight of the bound male body. Read another, non-imperative way, the inscription can also mean "there is love." The inscription, therefore, underscores the odd mingling of violence and love expressed in the image.

The *niello* print does not belong to the tradition of punishing Cupid. It falls, rather, into another thematic category. Visually, the violence done by the woman to the man makes sense in a broader context of the Petrarchan male lover's disempowerment by his female beloved.[123] The moral charge of the male body in this imagery differs from that seen in the Cupidian body. Cupid, though beginning in the fifteenth century to elicit sympathy from the viewer, was always negatively charged in the narrative: in representing Lust, Cupid negatively defines the Chastity of his female assailants. The Petrarchan male body, in contrast, possesses a positive moral charge. At the mercy of his beloved, the moping and doomed man wishes to enlist our support. His *donna*

Figure 5.18
Anonymous (Florentine), *Woman Tying the Hands of a Man*, c. 1470. Niello print. Musée du Louvre, Paris

is hard and unforgiving. He is a servant to a fate beyond his control. The Amazonic *belle dame sans merci* possesses an ambivalent role in this moral configuration. Despite her animosity toward her admirer, whom she rejects and torments, we are meant to share in the "narrator's" belief in her ultimate, if not incomparable, worthiness. The Petrarchan body is a partisan construction. It is understood that the reader should interpret the vulnerable body of the narrator/lover as a reflection of his emotions, and not as a literal reflection of events. Pitying his plight, but nonetheless distancing ourselves from the biased version that body represents, we as readers do not condemn the powerful, and aggressive mental construction of the *belle dame sans merci*.

On the banner of 1475, Cupid and his female tormenter must be read with and against one another. Given the information we have, it is impossible at this point to visualize the appearance of Cupid. Having said that, given the array of meanings that could accrue to the bound male body, and given the appearance of the god on the two Otto prints—the works that have the strongest claim to thematic and visual proximity to Botticelli's standard— some conclusions may be drawn regarding the spectacular allegory of 1475.

Like the adolescent body of Donatello's *David*, the Cupid on Botticelli's painting served to suggest and undo masculine power. The iconography of Cupid chastised carried with it the clear meaning of Lust constrained. On the banner, therefore, Pallas/Simonetta becomes the morally positive representative of Chastity and Cupid her vice-inspiring opponent. The moral ambiguity of Cupid and the nymph in Poliziano's *Stanze* urges us to abandon any such monochromatic reading, for the banner is awash with a broad spectrum of moral hues.

It has been noted that the pose of the protagonist in one of the two prints of *Cupid Chastised* (fig. 5.12) was drawn from Martin Schongauer's engraving of the attempted execution of Saint Sebastian.[124] Moreover, the Cupid from the other Otto print of the same subject bears a strong relation to Florentine images of Sebastian by Antonio del Pollaiuolo, Sandro Botticelli, and Antonio Rossellino.[125] What is more, the Christlike appearance of Cupid cannot be ignored. To an audience acquainted with Florentine artistic conventions, these visual allusions might have positively tinged the normally negatively coded body of Cupid. Like Poliziano's god of love, Cupid on the Otto prints does not conform to the traditional, negative iconography described by Panofsky. Could it be that Botticelli's Cupid of 1475 aimed at evoking pity? In his *Comento*, Lorenzo de' Medici devotes a few lines to the meaning of Cupid's blindfold, likening it not to the folly and serendipity of love, but rather to the lover's uncertainty: "I saw Love entwined in the rays of

those beautiful eyes, and these rays showed the path by which he had been able to flee from me into the eyes of my lady. This path one might call blind, because the heart did not then have any certainty save for the words of Love, and it then walked in uncertainty and self-doubt, so much the more so because Love, who was the guide on this journey, is also painted blind."[126] Love's lack of sight, Lorenzo implies, corresponds to the lover's blindness, his "uncertainty and self-doubt." Cupid, not the unheeding tormentor, is instead seen as an allegorical twin for the lover, deserving to be pitied, not upbraided.

Given the extraordinarily open arena in which it was displayed, and the manner in which civic affection and the public amorous mythology of the Medici seem imbricated in its complex iconography, the crucifixion of the god of love on Botticelli's 1475 banner was political. The mixing of politics and the discourses of love was hardly a novelty for the Medici. I argue, in fact, that it was a central strategy in their crafting of a symbolics of power and in their manipulation of the Florentine political unconscious. Representing their love of the state, figured as the multivalent Pallas/Simonetta, the Medici represented themselves as Petrarchan lovers, disempowered and self-sacrificial. In so doing, the Medici produced a deceptive image of themselves and of their relationship to Fiorenza, blurring the image of actual social relations.

The ambivalence of Cupid on Botticelli's banner of 1475 is borne out in a letter written by Marchese Rodolfo Gonzaga to his mother, Barbara of Brandenburg. In it, Rodolfo reports that after Giuliano's joust on Friday, 28 January, Lorenzo de' Medici called for another, smaller tourney between two teams to be held the following Monday. Lorenzo would fight for a squad "defending Amor," while Giuliano would, perhaps carrying Botticelli's standard to the event, contribute to the team "that wants to condemn Amor."[127] The battle, which probably did not take place, pitted Lorenzo/Lauro against Giuliano/Iulio, their mythical identities defined around the body of Cupid. The Medici boys were seen to contend for and against love, their loving fealty and decorous probity guaranteed by the multivalent bodies of the woman as Pallas and of Cupid crucified.

Botticelli's standard, which ought to be considered one of the most important public artistic expressions of Medicean authority in the fifteenth century, presented a tiered allegory, positing multiple but vaguely consistent identities for the Medici and their Florentine subjects. An allegory presents a fictional fabula, which parallels the unsaid yet unavoidable "truth." Botticelli's allegory represents the fabula of Pallas Athena punishing Cupid, signaling a hidden truth: Chastity vanquishes Lust. In this instance, therefore, the mythographic allegory leads not to the unenunciated "truth," but to an-

other allegorical level, confusing the usually stark division between the two registers of narrative (what Gordon Teskey calls a rift). Rather than leading from an ideal to a material level of meaning, the banner resists closure in physical bodies and terms. Were we to interpret the woman on the standard as the historical individual Simonetta Vespucci, and Cupid, perhaps, as Giuliano, this would provide only an apparent fixity; for these admittedly fleshy beings were also allegorical and the love affair played out between them, whether or not it was actual, was, above all, a performance. Lorenzo and, in turn, Giuliano acted the chivalric roles of Lauro and Iulio, commanding attention and respect, while conveying their ultimate obedience and fealty to their civic *donne*.

6

O Puella Furax

DONATELLO'S *JUDITH AND HOLOFERNES* AND
THE POLITICS OF MISPRISION

*On headhunting: Judith, Salome, maenad, via the Nymph as a bringer of
fruit, Fortuna, the Hora of Autumn, to the server of water at the well, Rachel
at the well, the fire-fighter at the Borgo fire. . . .*
—Aby Warburg

*Armed with these evils [capriciousness, irascibility, avarice, intemperance,
deceit, etc.] woman subverts the world; woman the sweet evil, compound of
honeycomb and poison, spreading honey on her sword to transfix the hearts of
the wise. Who persuaded the first parent to taste what was forbidden? Woman.
Who compelled a father to corrupt his daughters? Woman. Who drained a
man's strength by shearing off his hair? Woman. Who cut off the sacred head
of a good man with a sword? A woman who piled crime on the crime of her
mother and marked offensive incest with yet more offensive murder.*
—Marbod of Rennes

Who, indeed, lopped off the sacred head of a righteous man with a sword?
The implied answer, surely, is Salome. But unlike the other exempla that the
twelfth-century theologian Marbod of Rennes invokes—Eve, Lot's wife, and
Delilah—that of Salome is less than straightforward. In the Gospel she does
not cut off Saint John the Baptist's head.[1] Rather, she dances for her uncle and
stepfather, Herod Antipas, gains a wish, and, at the behest of her mother
Herodias, she asks for the head of the Baptist. The execution takes place de-
spite Herod's misgivings; his illicit visual pleasure precipitates his loss of con-
trol. By omitting the names of the characters he describes, Marbod subsumes
them under the rubric "woman." His anti-exempla share only their sex. By re-
ducing narrative details, and giving a woman a sword, Marbod brands her as
dangerous and evil, representing the inverted order of a world turned upside
down. Thus armed, Marbod's Salome also begins to resemble another bibli-
cal "headhuntress," the heroine Judith.

In his notes on the *ninfa fiorentina*, Aby Warburg performed a similar act of condensation, dissolving narrative boundaries while considering a recurrent trope in Florentine visual culture. Drawing Judith and Salome together, Warburg touched upon an ambivalence encoded in images of these figures within Florentine artistic traditions. This ambivalence—hinging on the iconography of a woman dominating and decapitating a man—was of particular political import in Florence. For the central myth of civic identity revolved around the baptistery of San Giovanni and the city's patron saint, Saint John the Baptist. The city's beheaded hero represented a crucial image in the symbolic structure within which Florentines perceived themselves and their position in a Christian universe. To Florentines, Salome appeared as the personification of all evil, mingling the taboos of murder, incest, and luxury. She appears as such in Florentine art, most famously perhaps in Giotto's frescoes in the Peruzzi chapel of Santa Croce, and, in the baptistery itself, on the encyclopedic thirteenth-century ceiling mosaics, on Andrea Pisano's succinct narratives on the bronze doors presently in the structure's south portal, and on the magnificent silver altar dedicated to the Baptist. These retellings of the Baptist's story share certain iconographic emphases. The juxtaposition of Salome's seductive dance and the laden banqueting table, set with precious plate and beakers of wine, might have reminded parsimonious Florentines of the twinned perils of gluttony and luxury. This hybrid vice becomes particularly clear when John the Baptist's head appears on its charger, like the final course of a corrupt feast. It is the prominence of Saint John the Baptist and his decapitation by this demonic antiheroine within the Florentine symbolic cosmology that makes Warburg's recognition of an iconographical affinity between the "headhuntresses" Salome and Judith, and the emergence of the latter as a civic heroine in the late fifteenth century, curious.

Featuring the virtuous heroine Judith at the moment when she beheaded the Assyrian general, Donatello's *Judith and Holofernes* (fig. 6.1) became the most important political statue in fifteenth-century Florence, overshadowing the artist's earlier, overtly political works: the *Marzocco*, the *Dovizia*, the marble *David*, and even the bronze *David*.[2] The statue was probably produced in the late 1450s and then erected in the garden of the new Medici palace on the via Larga. During the subsequent three decades Donatello's bronze surely became a spectacle of interest to the Florentine public. For the work was extraordinary not only for its expense, subject matter, scale, style, and location, but also for its technical, compositional, and psychological virtuosity. It was also a political image. Like the bronze *David* housed in the main courtyard of the palace, Donatello's *Judith and Holofernes* received patriotic inscriptions, which directly addressed the citizens of Florence. What

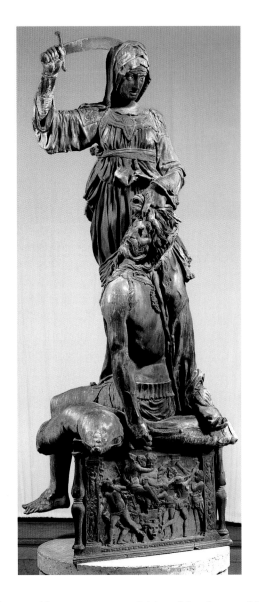

Figure 6.1
Donatello, *Judith and Holofernes,*
c. 1455. Bronze. Palazzo Vecchio,
Florence

is more, like the *David* it, too, was requisitioned by the republic in 1495 and transported to the Palazzo Vecchio. Set on the *ringhiera,* to the left of the main portal of the city hall, Donatello's bronze group supplanted the fourteenth-century *Marzocco* at the northwest corner of the palace as the most visible embodiment of the state. Armed with a new inscription, the *Judith and Holofernes* symbolized, as booty, the defeat of the Medici, and touted the firm morality and Judaic justice of the new Savonarolan republican regime. The statue also paved the way for the subsequent transformation of the piazza della Signoria into a stage for the projection of ideological and aesthetic ideals via monumental, agonistic sculpture. Indeed, the prominence of the bronze

group in the piazza della Signoria has tended to obliterate the work's earlier political role in the Palazzo Medici.

Scholars have already recognized and discussed the political dimension of the sculpture in relation to issues of gender. In her influential article, "The Loggia dei Lanzi: A Showcase of Female Subjugation," Yael Even interprets Florentine political statuary as exhibiting "men's longed-for control over women."[3] Emphasizing the pivotal role of Donatello's *Judith and Holofernes*, Even draws on Mary Garrard's important account of the apocryphal heroine in the work of Artemisia Gentileschi, to read the statue as an unequivocally positive rendition of female heroism. Even argues that the statue's demotion from its prominent position outside the west portal of the Palazzo Vecchio in 1504 represented a "relentless attempt all but to dispose of the *Judith and Holofernes*."[4] The decisive moment of the sculpture's removal from the center to the margins of the political stage, and its replacement with Michelangelo's marble *David*, reflects in Even's analysis "a blatant manifestation of misogynous attitudes." Later, when the *Judith and Holofernes* was lodged under the west arch of the Loggia dei Lanzi, its promotion of feminine virtue was drowned out amidst the trumpeting of male dominance by the sculpture that subsequently joined it there. Donatello's group was not—as previous scholarship would have it—simply complemented by Cellini's *Perseus and Medusa*. Rather, Even argues convincingly that Cellini's bronze was "designed to downplay the symbolism of the *Judith and Holofernes*, which had come to represent the struggles against tyranny of the now-defunct Florentine republic." In 1582, Giambologna's *Rape of the Sabines*, with its display of female subjugation and male sexual domination, replaced the "female hero" altogether. Erected in the west arch of the Loggia dei Lanzi, which does not face the public square, Donatello's "displaced female hero" was, as Even puts it, conspicuous only by her absence.

Although Even does not present any social historical data, her analysis rests on the assumption that the successive (dis-)placements of the *Judith and Holofernes*, and the display of statuary showing female subjugation in the sixteenth century, parallels the suppression of women, or at very least echoes "misogynist attitudes."[5] In her reading, art becomes a direct mirror of society, reflecting social realities back to the viewer.

Following the general thrust of Even's argument, Geraldine Johnson has established an even broader picture of the development of Florentine public sculpture representing female protagonists.[6] Johnson argues, analogously, that from the fifteenth century to the seventeenth century heroic women were progressively excluded from representation in major public stat-

uary. Without adducing social-historical data, Johnson also seems to assume that this development reflects the lived experiences of Florentine women.

Both Even and Johnson stress the status of Judith as a heroine in Donatello's statue, and read the sculpture's removal, and its replacement by Michelangelo's *David*, Cellini's *Perseus*, and Giambologna's *Rape of the Sabines*, as reflecting a long-term shift in civic symbolism away from positive representations of women and toward more masculine and misogynist civic embodiments in Florentine public art.

While I certainly agree with Even and Johnson that Italian Renaissance culture was, *grosso modo*, patriarchal, and that the history of Donatello's *Judith and Holofernes* does reveal misogynist attitudes, I cannot share their view that art operates as a direct reflection of actual circumstances.[7] Art in general and representations of gender in particular, rather than reflecting social-historical realities, exist in a complicated mobile pattern of exchange, linking production, reception, and circulation within particular contexts. In the case of Donatello's *Judith and Holofernes*, the elemental dialectic between "man" and "woman," the relation of the group to the biblical narrative, and the symbolic reading of the image cannot be taken as fixed, determinate meanings within a static system. While, following Stuart Hall, it is possible to understand these discourses as "structured in dominance"—in this instance perhaps suggesting the dominant norms and privileges of the Renaissance male viewer—it is also possible and imperative to reconstruct oppositional interpretations.[8] This requires, specifically, the abandonment of two things: the a priori status of Donatello's representation of Judith as a paragon of female virtue; and a teleological paradigm for understanding the sculpture's relation to its social and political context.

While the ambitious proposals of Even and Johnson concerning the development of social attitudes and public sculpture in Renaissance Florence are broad and stimulating, I would like to complement these useful interventions with a more focused account of the sculpture on which both their hypotheses pivot, Donatello's *Judith and Holofernes*. In so doing, I take into consideration the complicated dialogism of reception, and I frame interpretation as a process of negotiation, yielding multiple and dynamic meanings. Within this analytic frame, the displacement of the work, rather than necessarily mirroring women's progressive erasure from the public sphere, might instead register a response to a situation of perceived threat. The "visual logic" linking the object to its contexts might, therefore, be seen not as reflective, but as symptomatic. For the *Judith and Holofernes* appears to carry with it all the fear and desire associated with the familiar, yet eternally disruptive, topos of the "woman-on-top."[9]

To give ample rein both to the statue's potential multivalency, and to an analysis of the specific circumstances of its display and reception, I shall now concentrate on two major issues. First, I reconsider the sculpture's early political and symbolic significance in the Medici palace garden, complicating existing interpretations. Expanding on Michael Looper's suggestive essay, which provides a subtle political reading of the multiple symbolic references played out between the garden setting and Donatello's bronze, I reexamine the sculpture within this rich physical and social context. I then turn to the reception of the work and its provocative subject matter in print culture. To describe the performativity afforded by the Medici palace, in which visual interactions produced various possibilities for reception and, therefore, meaning, my analysis embraces the symbolic reciprocity between the sculptures in the Medici palace garden—especially the two figures of *Marsyas* flanking the garden portal toward via de' Ginori, and the antique representation of *Priapus*, possibly located at the north end of the garden—and Donatello's *David* in the adjacent courtyard.[10] Moreover, reading the iconographic transformation of Donatello's empowered, violent woman in a set of artistic responses, I attempt to take both male and female spectators into account while reconstructing the manner in which the figure of Judith was understood within the frame of courtly and poetic love. I argue that in the Medici garden the political message conveyed by Donatello's *Judith and Holofernes* gained power from and was simultaneously problematized by the statue's distinctively tense staging of gender relations, relations structured around particular, gendered points of view.

The second issue I address in detail is the relocation of these tensions into the more fully public arena of the piazza della Signoria. I focus on the most important event in the Florentine civic and religious calendar, the annual festivities held in honor of Florence's patron saint, John the Baptist. I reconsider the dramatic events that transpired at the celebrations held in 1500 as bringing to light the potential instability of Donatello's work as a Florentine political symbol; I link this vacillation to contemporary concerns with the increasing visibility of women at the center of the republic—in the Palazzo Vecchio. I argue that the removal of Donatello's bronze in 1504 emerged not only from misogynist attitudes, but also from anxieties concerning the perceived effeminization of "masculine" republicanism and from the formal and iconographic character of the statue itself.

This chapter aims to bridge the gap between the statue's two very different physical and political contexts. In order to do so I wish to introduce the issue of gender not only as an assumed social-historical backdrop against which to set the analysis of art, but also as a formative component in the pro-

duction of visual and, in this case, political meanings. I have chosen to use not a teleological frame in which gender relations are reflected in a trajectory of deterioration, or improvement, but rather the trope of the "woman-on-top," that is, the textual or visual inversion of traditional, patriarchal gender relations. By considering the statue within the operations of the "woman-on-top" topos and by following the statue's reception within contemporary print culture, I would like to suggest that the political instability of the work derived from both the formal and gendered structure of the object and the contemporary discourses of power and disempowerment within which such structures could have been interpreted. Before, however, dealing with issues of contextualization or reception, I would like to turn to the relation between the bronze and its textual shadows.

The Statue and Its Story

Part of the Apocrypha, the story of Judith was probably composed in the second century B.C.E. It was, at its inception, political and allegorical, figuring the salvation of Judea. For Judith—whose name is connected etymologically to Judea—symbolized the morality and courage not only of her city, but also of her people.[11]

The story tells how the widow Judith managed to raise the Assyrian siege of Bethulia. Adorning herself, she brazenly crossed to the enemy camp, offering to serve the Assyrian king. Accepted by the Assyrians, she was permitted to bring her own meat to the table in a bag, and, every night, she was allowed to exit the encampment with her servant to pray. On the fourth day of her visit, she plied Holofernes, the general of the Assyrian army, with wine, and while he slept she sliced off his head.[12] With the severed head in her food bag and accompanied by her maid, Abra, Judith left the camp as usual. Returning to her city, she displayed the head to her compatriots.[13] The Assyrians, literally headless, were disheartened and lifted their siege. Following her dramatic act of patriotism, Judith of Bethulia remained a chaste widow and a civic heroine.[14]

The apocryphal text emphasizes the political nature of Judith's actions. Patristic and then theological interpretation of the story saw a gradual shift in emphasis from the public actions of Judith toward her private virtues.[15] This shift occurred over a typological assumption that linked Judith to Mary and, by extension, to the Church.[16] By the fifteenth century, Judith's victory over Holofernes was increasingly framed as a sexual triumph. The chaste widow, gambling with her most precious virtue, managed to defeat eroticism.[17]

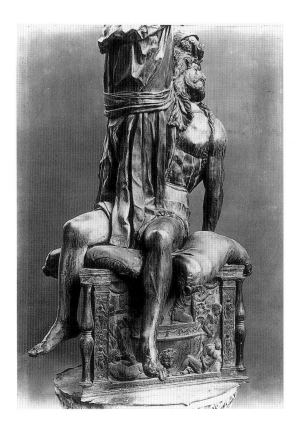

Figure 6.2
Donatello, *Judith and Holofernes*,
c. 1455. Bronze. Palazzo Vecchio,
Florence, detail

Donatello has his Judith stand on the defeated but not yet decapitated Holofernes (fig. 6.1). The heroine, raising with her right hand a curved sword above and behind her head, strikes a triumphant pose. Modest robes envelop Judith's slender body; a decorous hood shrouds her head. Judith's fully clothed body contrasts, strikingly, with that of her victim. His fleshy, senseless body appears naked but for a meager suggestion of shorts. The general's limp legs hang passively over the edge of the large, apparently soft rectangular cushion into which he seems, palpably, to sink. But Holofernes is not recumbent, Judith draws up his wine-soaked body, readying it for execution. With the index finger of her left hand, Judith grasps a large lock of Holofernes' abundant, long hair. But Judith also supports Holofernes' torso with her legs; his right shoulder appears to be pinned between Judith's thighs. Indeed, the boundaries between their two bodies are left, startlingly, undefined. The general's tumbling tresses mingle with the folds of her garment, while her left leg merges with Holofernes' right arm. Judith's left foot rests, uncomfortably for the viewer, on his twisted wrist. Her other foot is pointedly placed over Holofernes' groin (fig. 6.2).[18] Judith stands poised to execute her

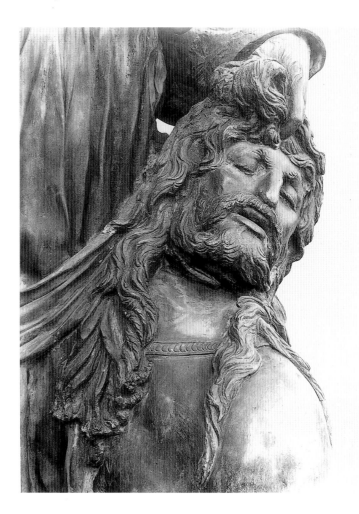

Figure 6.3
Donatello, *Judith and Holofernes*,
c. 1455. Bronze. Palazzo Vecchio,
Florence, detail of Holofernes'
head

enemy. On the cusp of narrativity, the statue implies—by the raised sword and the open gash visible on the general's neck—both past and future action. But for all this drama and suggested action Judith's body remains still, calm, and almost contemplative. Her face is impassive, her demeanor ceremonial in its seriousness.[19]

The relations between this crafted mass of metal and the apocryphal text it represents are complex. Later we shall see what happens when the image is considered autonomously from the apocryphal narrative. For the moment, however, I would like to point out some moments of harmony and dissonance between these two cultural "texts."

At a basic level, Donatello's *Judith and Holofernes,* like so much narrative art, is a condensed synecdoche of a text. The key action of the textual account run thus: "She went to the pillar that was at his bed's head, and loosed his sword that hung tied upon it. And when she had drawn it out, she took him

by the hair of his head, and said: Strengthen me, O Lord God, at this hour. And she struck twice upon his neck, and cut off his head, and took off his canopy from the pillars, and rolled away his headless body."[20]

The implication of narrative is unavoidable in the sculpture. The pillow and the sleeping Holofernes suggest that we are witnessing the moment of execution. Furthermore, the viewer is enjoined to decondense the static sign and imagine a series of actions. Particularly enticing in this regard is the existing slice in Holofernes' neck. This, whether or not it was the result of a casting flaw, suggests to the keen beholder that Judith has already struck one of the two blows that are mentioned in the Apocrypha (fig. 6.3).[21] The gash implies a past action, and the poised arm a future one. Narration, though not actual in the sense that it is, diachronically, represented, is virtual.

The retelling of successive events that the statue seeks to prompt in the informed viewer's mind must overcome, or circumvent, visual aspects that are blatantly, even daringly nonnarrative. Poised, Judith's swing is impossible, not only in a banal physical sense (the metal will not move), but also virtually: to cut through the neck of Holofernes would be to risk cutting into her own leg (fig. 6.1).[22] The implausibility of the execution underscores the condensed, symbolic nature of the representation; it stands for the biblical narrative without correlating to a precise moment in the text. The symbolic reading of the bronze finds further support in Judith's very odd position, standing *on* Holofernes. This visual arrangement would have opened the image to a visual and symbolic, rather than a textual and narrative, type of reading: the psychomachia.

In art, the psychomachia became disassociated from the rhetorical device developed by Tertullian, Prudentius, and Statius, which pictured abstract ideas in physical battle.[23] Although retaining some of its allegorical baggage, the psychomachia in the visual arts became associated with a particular figural disposition—one figure standing atop another. It signified, therefore, in a manner slightly different from traditional definitions of textual psychomachiata. The visual psychomachia leaps to the end of the story, denoting the victory of one figure over another, either on a literal or allegorical level, and frequently on both. In Florence, this figural disposition possessed particular visual resonances. Religious images of triumph often set Saint John the Baptist over Avarice, Saint Thomas Aquinas over heretics, or Saint Barbara, Saint Michael, Saint Philip, and Saint Margaret over the devil in various zoomorphic guises. Most well known, however, would have been the civic symbol of the lion— the *Marzocco*—standing over its prey.[24] In the trecento, at least four crowned lions guarded the Palazzo Vecchio, each conquering a smaller animal and holding it beneath its paws.[25] Florentines were prepared to read such images

of triumph, and this visual literacy, or horizon of expectations, spanned both the symbolic and the political: the lions were not simply victors but also allegorical guardians of the political core of the city. Given this local familiarity with religious and political psychomachiata, it is understandable that the Medici would, in the inscriptions appended to Donatello's work, blaze allegorical trails which the curious citizen-viewer might follow.

The original inscriptions on the pedestal of the *Judith and Holofernes* are known to us only indirectly. In a letter dated 5 August 1464 Francesco Micheli, called "del Padovano," related his condolences to Piero de' Medici, whose father, Cosimo, had recently died. In his letter, Francesco included the following distych: "Regna cadunt luxu surgunt virtutibus urbes / caesa vides humili colla superba manu" (Realms fall through luxury, cities rise through their virtues. You see the proud neck cut by humility's hand).[26] Before 1492 Bartolomeo Fonzio copied this letter in one of his *Zibaldoni*, glossing in the margin that the inscription could be found "on the columns beneath the Judith in the courtyard of the Medici."[27] Furthermore, since the bronze was standing in the garden of the Medici palace when it was removed in 1495 to the Palazzo Vecchio, this was likely its intended setting.[28] It is possible that the statue was conceived of as a fountain, although it apparently never served this function.[29]

A second inscription, which was visible while the statue was still in the Medici palace garden, records Piero di Cosimo de' Medici's dedication of the work to "civic virtue": "Salus Publica / Petrus Medices Cos[mi] fi[lius] libertati simul et fortitudini hanc mulieres statuam quo cives invicto / constantique animo ad rem publicam tuendam redderentur dedicavit" (Public Health. Piero de' Medici, son of Cosimo, dedicated this statue of a woman to union of strength and liberty, so that the citizens might be led back via an invincible and constant spirit to the defense of the republic).[30] Although not subtle, the political messages conveyed by the inscriptions are hardly direct. The first inscription explicitly points viewers toward an allegorical reading: the apocryphal story and its characters are symbolically transposed. Holofernes is cast as Luxury, whose "proud neck" is "cut" by the hand of Judith, who is cast as Humility. Through such virtuous acts, "cities" like Florence, we are to surmise, "rise." The second inscription grounds this allegory in immediate political circumstances. The body of the inscription suggests an obvious parallel between the virtues of the citizens of Florence (fortune, liberty, courage, and constancy) and the civic virtue of Judith-Humility.

But two aspects of the second inscription are less apparent. First, Piero's dedication focuses attention on the gender of the represented victor: *hanc mulieris statuam*. Like the decondensations of Marbod and Warburg

reviewed above, this imprecision (the group consists of a woman and a man) frees the statue from its biblical narrative and opens the way for multiple readings—especially the allegorical reading suggested by the other inscription. Thus, in a double gesture the Medici marginalized the voice of a normative, narrative reading and filled the acoustic void with their own propagandistic noise. Establishing an equation between Judith-Humility and the citizens of Florence, the Medici inserted themselves into this moral algebra so as to underscore their reluctant, humble, and efficacious service to the state. The other less obvious point of interest deriving from the second inscription is Piero's use of the stock Roman, republican expression "salus publica." Referring to the Roman health-goddess Salus, the inscription draws the statue into an antique context. But it also plays wittily on the name of the owner(s): the Medici as the "doctors" of their public.[31] The phrase crops up again on the medals cast as memorials after the Pazzi conspiracy of 1478. Giuliano, killed, was called LUCTUS PUBLICA, while Lorenzo retained for himself the epithet SALUS PUBLICA (fig. 6.4).[32] Curious also is the use of the word "public."

A family palace was hardly a traditional space for expensive bronze statues or the civic posturing apparent in the inscriptions. From various accounts, we know that the Medici palace was notably porous, admitting folk from all walks of life in a quasi-public manner. Most famously, we hear of a number of occasions when the Medici received in their palace foreign dignitaries. The building operated, therefore, as a public venue.[33] More telling, I believe, are the inscriptions that dedicate the statue to the public well-being of Florence, positing, therefore, a civic and suggestively broad spectatorship for the statue. It is through the inscriptions they received that the *Judith and Holofernes*, along with the bronze *David*, blatantly coded the Medici palace as a public and political space. The inscriptions on the *Judith and Holofernes* can be seen to blunt the potentially dangerous self-aggrandizement of this pointed gesture by setting private magnificence at the service of the state. In bestowing the statue upon the people of Florence and supplying a reading of the image as an allegory against Luxury, the Medici capitalized upon the possible public meanings that could accrue to such an object while simultaneously downplaying their appropriation of the visual means of representing the state and its authority.

Judging Judith

Although attempts to determine with accuracy the patronage and original site of the *Judith and Holofernes* have proven problematic and have spawned endless controversy, few have doubted the allegorical status of the statue. There

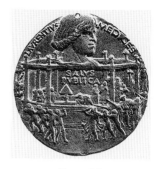

Figure 6.4
Bertoldo di Giovanni, *Lorenzo de' Medici/Salus Publica*, 1478–79. Bronze medal. British Museum, London

has never been any doubt that the bronze is a rendition of the apocryphal narrative of Judith and Holofernes, but it is equally clear that the sculpture, like the text, goes beyond an explicit act of retelling. Since Hans Kauffmann linked the *Judith and Holofernes* to the psychomachia, most interpretations have pursued the path of allegory, so congenial to iconographic investigation.[34] Fleshing out the elliptical identifications suggested by the Medicean inscriptions, scholars have read in the statue various agonistic values. H. W. Janson, in his monograph on Donatello, interpreted the statue politically, as figuring the struggle between republican values and luxury; in this he was largely followed by Laurie Schneider.[35] Kauffmann, Hans von Erffa, and Michael Looper sought theological contexts for the statue, seeing it, respectively, as typologically representing Humilitas defeating Superbia, Mary combatting the devil, and the ethical opposition of the *arbor bona* to the *arbor mala* in a symbolic garden of paradise.[36] All these readings highlight the statue's equivocality. Positing antinomies, the *Judith and Holofernes* possesses a certain ambivalence, and therefore a certain disquieting power.

The most convincing and fundamental of these allegorical readings continues to be Edgar Wind's, which, remaining close to the spirit of the inscriptions, sees in the statue the defeat of Luxuria by Sanctimonia.[37] Building on the typological identification of Holofernes as Satan, Wind forges this link between allegorical registers through etymology: "The name Holofernes is translated in medieval textbooks as *enervans vitulutm saginatum* (he who weakens the fatted calf). In the allegories of the *Biblia Pauperum* and the *Speculum humanae salvationis*, Holofernes stands for the Devil, as does Goliath, Haman, or any other vicious fiend. By virtue of his name, however, he often signifies that particular power of the Devil by which Man was first tempted and seduced: Incontinence, or, by her Latin name, Luxuria."[38]

Finally, Wind recalls that Durandus equates the suppression of Luxuria with decapitation in general and the decapitation of Holofernes in particular: "So the Church directs that we should slay Holofernes, i.e. the devil, who weakens and slays the lascivious in the world, which is to be achieved through sanctimony by cutting off his head. For the head of the devil is luxury, because it is, as it were, first with this that he begins to tempt men."[39] Thus, in religious commentary, Holofernes slips from the apocryphal narrative and into abstraction, no longer representing a particular character, but rather a primeval form of sin. The word *luxuria* in the late Middle Ages possessed inescapably sexual connotations.[40]

In patristic commentary, the term *luxuria* could be used to describe any number of corporeal sins, but by the fifteenth century the term's meaning had been honed. Albert the Great defined *luxuria* as "an experience of pleasure ac-

cording to the reproductive power that does not comply with law."[41] Thomas Aquinas made this equation even stronger, claiming that *luxuria* is a vice deriving from an excess in "venereal pleasures" (*voluptas venerei*).[42] If Holofernes, then, can be equated with Luxury etymologically and theologically, Judith's conquering of the general naturally becomes a triumph of chastity. The visual psychomachia—one figure atop another—leads, then, back to the literary trope of the psychomachia—allegorical figures in battle. For in the founding text of this type of rhetoric, Prudentius's *Psychomachia*, a violent battle takes place between the "maiden Chastity" and "Lust the Sodomite," in which the former is equated with Judith and the latter with Holofernes:

> Next to step forth ready to engage on the grassy field is the maiden Chastity, shining in beauteous armour. On her falls Lust the Sodomite, girt with the fire-brands of her country, and thrusts into her face a torch of pinewood blazing murkily with pitch and burning sulphur, attacking her modest eyes with smoke. But the maiden undismayed smites with a stone the inflamed fiend's hand and the cursed whore's burning weapon, striking the brand away from her holy face. Then with a sword-thrust she pierces the disarmed harlot's throat. . . . "A hit!" cries the triumphant princess. "This shall be thy last end; for ever shalt thou lie prostrate; no longer shalt thou dare to cast thy deadly flames against God's man-servants or his maid-servants."

Although Lust the Sodomite is a woman, Prudentius calls attention to the parallel story of Judith and Holofernes. Chastity continues her triumphant diatribe:

> "Shalt thou, O troubler of mankind, have been able to resume thy strength and grow warm again with that breath of life that was extinguished in thee, after the severed head of Holofernes and the unbending Judith, spurning the lecherous captain's jewelled couch, checked his unclean passion with the sword, and woman as she was, won a famous victory over the foe with no trembling hand, maintaining my cause with boldness heaven-inspired?"[43]

Prudentius links this sword-wielding representative of Chastity explicitly to Judith and the vice she decapitates, to the luxurious Lust the Sodomite.

Prudentius's allegory, along with the patristic and theological coding of Judith's victory as sexual, provides a backdrop against which to understand Donatello's rendition of the narrative as representing the triumph of Chastity.

Indeed, Donatello provides the viewer with several important visual clues that seem to bring such issues to the fore. In placing Judith's foot squarely on Holofernes' genitalia, Donatello has her visually and allegorically stamp out the luxurious, equated with the erotic (fig. 6.2). Donatello reinforces the exorbitant sexuality of Holofernes by emphasizing the general's shaggy hair, including his beard. As Joan Cadden, discussing medieval sexual symbolism, has indicated, "male hairiness was specifically associated with sexual virility. Hair was directly proportional to libido in men, and the quantity and location of hair was therefore one of the features which distinguished men of different temperaments from each other."[44] Moreover, the placement of Holofernes' hairy head, emerging from between Judith's legs, suggests that Donatello's heroine triumphs not only over her explicit victim, but also an implicit, inner force, "the devilish power of sin." As mentioned above, Judith could not, within this figural composition, cut off Holofernes' head without cutting into her own thigh (fig. 6.1).[45] The intimate opposition of virtue and vice takes place within a visual configuration where corporeal boundaries melt: the two figures are physically and psychologically interlocked. Indeed, it is not difficult to interpret the "group" as indicating an internal, psychic conflict. What we witness is not only the execution of an enemy, but a struggle and repression of an evil from within. The symbolic significance of the victory of Judith over Holofernes is, therefore, not only an allegorical psychomachia representing Chastity's victory over Luxury, but also the rejection of rough lust represented as an internal moral struggle.

The Medici Courts of Justice

During the second half of the fifteenth century, until the *Judith and Holofernes* was appropriated by the republican government, this symbolic repression of lust took place in the garden courtyard of the Medici palace on the via Larga. Although not inconceivable that the statue was originally intended for another location, it appears increasingly likely that it was made, specifically, for this site.[46] It was probably commissioned by the Medici for the garden of their recently completed palace sometime between 1457 and 1464.[47] With its completion in the late 1450s, the Medici palace became an unofficial center of public policy; its robust rustication and orderly disposition of windows sensitively echoing the architecture of the real city hall. Especially after the constitutional coup of 1458, when the Medici faction managed to shore up their regime by tightening their grasp on electoral procedures, Cosimo's role as the guiding intellect behind Florentine politics became more public, as did the issue of what would happen after Cosimo's death. The new palace served as a

carefully coded frame for the enhancement of Medici civic power, guided by a cultural policy that might be labeled "moral magnificence."[48] Despite Vasari's tale that Cosimo rejected Brunelleschi's extravagant design for the palace since, as the patron is reputed to have said, "envy is a plant one ought not to water," the magnificence of the Medici palace is self-evident. No Florentine private palace could compare with the enormous building and its luxurious appointment. The novel *all'antica* atrium of the palace speaks in a refined and learned architectural language. The garden, with its separate portal giving onto the via de' Ginori, a family loggia to the south, and fruit trees to the north, though not unique, was an exceptional space in the crowded city. The garden was extraordinary, also, for the several pieces of antique and modern sculpture it contained, including Donatello's *Judith and Holofernes*. It was, above all, the statuary that coded the palace's patently magnificent spaces as moral. Dotting the open spaces of the palace with monumental sculpture and hortatory inscriptions, the Medici transformed their private home into a public forum, producing a spatial hybridity that defies simple definition. The moral magnificence of the Medici palace collapsed the boundaries between the Medici and the state; the luxurious objects within their elegant home, demonstrating and defining contemporary artistic taste, certainly served to elevate the status of the family. But set within the unofficial center of public policy, such personal expense was set at the service of the state.[49] The public visual propaganda conveyed by the palace depended mightily on the stern justice meted out by the protagonists of the two courtyards. Nonetheless, the political coding of the garden court and the interactions between the sculpture within it were ambivalent, hinging on the volatile iconography of a woman conquering a man.

Stripped of narrative, the statue's juxtaposition of a sword-bearing woman and male decapitation became an unstable iconography, careening from positive to negative moral poles. Dangerous, an armed, empowered woman could lead to the misogynist generalities of Marbod, but to Tuscans a woman with a sword would have also possessed very positive connotations. For in fourteenth- and fifteenth-century central Italian art, a woman with a sword personified Justice.

One of the most familiar and public works of art in Florence, Andrea Pisano's south doors of the baptistery, display just such a personification (fig. 6.5). Here a regal woman sitting on a throne, like her virtuous companions at the base of the door, holds up her sword as an attribute and a warning; an inscription identifies the figure as *Iustitia*. A related image of Justice appears, famously, in Ambrogio Lorenzetti's *Good Government* mural in Siena, where on

Figure 6.5
Andrea Pisano, *Justice*, c. 1336.
Bronze. Baptistery, Florence

Figure 6.6
Ambrogio Lorenzetti, *Justice*
(from the *Allegory of Good
Government*), c. 1340. Fresco. Sala
dei Nove, Palazzo Pubblico, Siena

the far right Justice is shown balancing on her knee a decapitated head with the butt of her large sword (fig. 6.6).[50] The Sala dei Nove, where this mural can be found, functioned as a real court of justice, and the rather literal interpretation of this personification clearly operates as a caveat to transgressors and as a reminder of the punitive measures necessary to maintain stability within a republic. A similar set of issues inform our understanding of Piero Pollaiuolo's seated, sword-bearing *Justice* (fig. 6.7), commissioned in 1469 for the Sala del Consiglio of the *Mercanzia*, or merchant's court, in Florence. That this civilian court did not preside over capital cases might explain its less vivid and less gory character. Horst Bredekamp reminds us that Donatello might very well have been familiar with Pietro Lamberti's *Justitia* of about 1430 on the tomb of Raffaello Fulgosi in the Santo of Padua; triumphantly holding an enormous sword and a relatively small head, Lamberti's virtue does gaze off in a manner that seems to have intrigued Donatello.[51] Sword raised, Donatello's Judith, while not a personification of Justice per se, did

Figure 6.7
Piero Pollaiuolo, *Justice*, 1469.
Tempera on panel. Galleria degli
Uffizi, Florence

operate within a visual tradition that linked a woman with a sword to notions of equity and fairness. Donatello's statue acts out the form and consequences of divine and human justice. This enactment took place within a spatial configuration that emphasized the symbolism of justice in particular ways.

Spatially, the *Judith and Holofernes* was juxtaposed to another image thematizing justice and execution: Donatello's bronze *David* in the main courtyard of the Palazzo Medici (fig. 4.1). Judith's iconographic and symbolic relationship to David is a complex one, for it traverses many levels.[52] In the first instance they represent a typological—that is, a metaphoric—parallelism: in medieval religious thinking David was thought to relate symbolically to Christ, as Judith does to Mary.[53] As such, David and Judith analogously prefigure the divine yet human couple at the heart of Christianity. On a different level, they offer a narrative parallelism: both save their people from external threat. They are not, as is often said, tyrannicides; neither Goliath nor Holofernes was an absolute ruler, although they may have represented the

threat of absolute rule. The most striking narrative analogy between the two—David and Judith—is their just decapitation of an enemy; moreover, they performed this act against all odds. Both were perceived as underdogs—boy-woman against giant-man—and, as such, their battles, in representing exceptions, buttressed norms. What makes Judith extraordinary is not her strength, but that, despite her supposed "innate" weakness, she could accomplish a political and violent action. But whereas David's weakness is a transitory stage (boyhood), hers is immutable, attributable to her sex.[54] What is more, the moral valence of the story of David is coherent. While David overcomes his opponent with a single act of skill, Judith overcomes Holofernes by adorning herself, capturing Holofernes' eye in the "net" of her appearance: having disempowered the general through deceit, she lops off his head.[55]

The iconographic potential offered by these Judaic stories had already been explored by Florentine artists. In the vaults of the oratory of Orsanmichele, painted about 1400, one finds Judith and David paired in the iconographic scheme linking the male Old Testament figures in the southern bays to their female counterparts to the north.[56] The symbolic relation is underscored, again, on Ghiberti's *Gates of Paradise,* in which the narrative panel showing David's heroic feat on the battlefield is flanked by an iconic representation of Judith in the frame of the left valve (fig. 6.12). Carrying the head of Holofernes and wielding a sword triumphantly, this image of Judith's just victory is aligned with David's directly.[57]

Whether the analogous iconographic pairing in the Palazzo Medici was "originally intended" or was developed as a strategy of display, it certainly constructed a visual and spatial relationship made rich by the narrative and symbolic parallels outlined above. In the Florentine context, moreover, this sculptural dialogue pulled the *Judith and Holofernes* into the realm of civic meanings. For, in Florence, David's conquering of a dangerous enemy possessed clear civic and political implications.[58] Judith's status as a civic savior echoed David's heroic defense of the Israelites. But the statues also respond to one another at a nonnarrative, allegorical level.

I have already argued that Donatello's bronze *David* would have elicited a conflicted response—mingling the erotic and the chaste—from, especially, male viewers.[59] Its ultimate message, however, is clear. Transgression is punished, swiftly, mercilessly, justly, and with divine sanction. In the garden courtyard Donatello's *Judith and Holofernes* recapitulated this theme of abrupt and deadly Judaic justice.[60] Again this moral-political warning was figured as a sexual allegory, in which viewers were confronted with the rejection of masculine sexual presumption. The civic heroine Judith triumphs over

Figure 6.8
Zanobi Lastricati, *Design for the
Catafalque of Michelangelo
Buonarroti*, 1564. Drawing.
Biblioteca Ambrosiana,
Milan, detail

the military predator Holofernes; symbolically, she overcomes his, and her, lust. The just curtailing of male power links Donatello's two monumental bronzes and the spaces they helped symbolically to define. In the garden courtyard, two restored antique marble statues of *Marsyas*, which flanked the portal giving onto the via de' Ginori, underscored this theme.

The display of sculpture in the Medici palace garden has recently become far clearer, owing to the researches of Luigi Beschi, Francesco Caglioti, Cristina Acidini-Luchinat, and Shigetoshi Osano.[61] Nevertheless, the meaning of the monumental statuary in the garden remains unclear. Certainly it is unwise to speak of an iconographic program governing the decoration of the garden. The monumental sculpture within its walls can, however, be considered an iconographic complex, in which objects interacted with one another, producing meanings. Especially important in this regard are the two *Marsyas* statues and another, rarely discussed sculpture of *Priapus*.

Although he may have been wrong, Vasari tells us that Cosimo de' Medici had Donatello repair an antique statue of Marsyas, which was then put in the palatine garden.[62] Later, Cosimo's grandson, Lorenzo, commissioned Andrea del Verrocchio to perform a similar service and set a second antique Marsyas in the garden.[63] A swiftly executed drawing attributed to Zanobi Lastricati (for a relief panel to be set in the catafalque of Michelangelo) seems to show a space related to the Medici palatine garden (fig. 6.8). In the background we see an arched portal flanked by two figures: that on the left, with both hands raised above its head, in a pose readily associated with antique

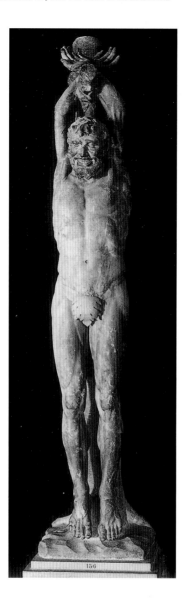

Figure 6.9

Anonymous, *Marsyas*. Roman
marble. Galleria degli Uffizi,
Florence

statues of Marsyas (fig. 6.9), and that on the right, seated and with its right
arm curled behind and above its head. Although it has proven difficult to con-
nect particular antique Marsyas statues with the antiquities in the palatine gar-
den, extant Roman sculptures do provide us with a good idea of how the two
Medici marbles must have appeared.[64]

Marsyas, the mortal musician who dared to challenge Apollo and, for
his presumption, was flayed at the god's request, often appeared in Roman
statuary as a tortured naked man, with his hands bound above his head. We
see him, therefore, as his skin is removed. Ancient sculptors capitalized on the
extreme pathos of the scene, representing Marsyas's often bearded face con-

torted into a grimace, expressing his unbearable suffering. Symbolically, Marsyas could be admired for his courage, but he was also a reminder of man's vanity and of the proper limits of man's ambition.[65]

The Medici statues of Marsyas, therefore, can be seen to underscore the theme of divine Justice activating both Donatello's *David* and his *Judith and Holofernes.*[66] In his moral treatise *Della vita civile,* the Florentine Matteo Palmieri called Justice the "queen and dominatrix of all the other virtues, which she contains in herself." Palmieri goes on to explain how Justice brought men together, for "this empress of the virtues fosters the unity and friendship between men, giving to each that which is his and sustaining faith concerning things promised."[67] The judicious Medicean Judith judged, condemned, and executed a culpably excessive masculinity in the name of justice, a virtue that, in turn, guaranteed the bonds of "unity and friendship between men."

Working with the *David* and the statues of *Marsyas,* Donatello's *Judith and Holofernes* emphasized the just chastity of its heroine. Male citizens saw in this complex of images the just chastisement of a predatory sexuality, an uncivil masculinity that threatened the public weal. Indeed, this image of moral and sexual victory was also directly political, for the apocryphal narrative played out within an allegory of sexual mores aligned Judith's triumph with that of Florence. Indeed, as I mentioned earlier Judith was *ab origine* a political embodiment of Judea; similarly, Donatello's Judith represented Florence. As an upright, Marian, chaste, and powerful Florentia, Judith the widow remained true to her one spouse, violently condemning others. I would like to propose, again, that the metaphysical bond between the Medici and Florence was inscribed within an amorous and/or marital symbolic register. This reading appears especially strong given the garden setting.

In the only study to have explored the symbolism of the Medici palatine garden in any depth, Michael Looper, confirming the earlier allegorical and theological readings of Wind and von Erffa, emphasizes the rather different, if not opposed, connotations of the enclosed space as a *hortus conclusus* or as an Edenic redaction.[68] Looper argues that while the former supports Judith's supreme moral position over Holofernes through her symbolic association with the purity and virginity of Mary, in the latter, the Garden of Eden, the dialectic between Sanctimonia and Luxuria is stressed. "The Judith group emphasizes not the temptation and fall of man," Looper concludes, "but the victory of virtue over *Luxuria,* the Medici garden is cast as a realm in which evil is vanquished."[69] By looking to religious symbolism, Looper attempts to stabilize the moral position of Judith in the garden. But as Looper himself admits without further discussion, "Lust and cupidity, too, were well-known

inhabitants of the gardens of fourteenth- and fifteenth-century Tuscan literature and pictorial art."[70] For it is also possible to see the garden neither as a *hortus conclusus* nor as a prelapsarian Eden, but rather as a "garden of love," which, as Paul Watson has amply and richly demonstrated, was a master trope in Renaissance Tuscan culture.[71]

"Lust and cupidity," in fact, could be found lurking in the Medici palatine garden. Donatello's *Judith and Holofernes* was not, as Looper's analysis might suggest, alone in the garden courtyard. Not only were the striking restored *Marsyas* statues close by, but the space was inhabited by other sculptures. Set into the loggia were several antique reliefs; here, too, could be found the famous and enormous antique bronze head of a horse. Also to be found in the garden—perhaps opposite the loggia at the north end of the garden, that is, in all likelihood behind the *Judith and Holofernes*—was a statue of Priapus, assumably antique. If Donatello's psychomachia gained a certain moral and political footing within the network of iconographic and textual signs stabilizing its public meaning, the lurking *Priapus* reminds us that this is a garden of love, where the image of a woman killing a man was an inherently unstable iconography. The dialogue between these two statues was not only visual, for the same source that recorded the inscriptions appended to the *Judith and Holofernes* also documents the Latin verses to be found under the *Priapus*. The transcription notes that one could find the verses "In the garden of Cosimo under the statue of a figure bearing fruit on his head while a robe conceals his extended phallus."[72] Through the recorded inscription, this rarely mentioned statue "spoke" directly to Donatello's heroine, addressing her somewhat informally:

> Quindam, quid rapis, o puella furax?
> Ne ramos traheres tibi hec feribam
> Sed posthac caveas feras quid orto.
> Obduxi licet arma: sum Priapus.
> (What in the world are you stealing, o thievish girl?
> Lest you should strip the branches of their fruit, I brought
> you these [*poma*].
> But henceforth be careful not to strike anything in this garden.
> For I have concealed my weapons: I am Priapus.)[73]

Comically hailing Judith as a "thievish girl," Priapus begs her to desist from stealing and to moderate her swordplay. The lines end with a punning reference to the garment which we must suppose covered (but also revealed the form of) Priapus's erect member. Telling is the inscription's total and conscious misprision of Donatello's statue; no longer anchored in its apoc-

ryphal narrative, it floats into the ludic and erotic. Judith, the stern champion of Bethulia, is recast as a wild, sword-wielding fury pilfering fruit from, and endangering the denizens of, the Medici palace garden. The lines establish an important parallel between *Priapus*'s "weapon" and Judith's, leading directly to the question: what exactly is she seen to have stolen? There is no simple answer, but it seems likely that the priapic inscription suggests that Judith is guilty of emasculating men, represented perhaps by the rather pitiful *Marsyas* statues; by offering his fruit, Priapus seeks to appease the "thievish girl." Should this gift fail, Priapus reminds Judith of his concealed weapon. For even if this chaste amazonic girl triumphs over a hairy and lustful representative of luxury, the hidden phallus, Priapus claims, can subdue her. In the Medici garden masculinity permits itself to be justly chastened by a powerful virtuous woman, but simultaneously reserves for itself a comic terminal refuge of sexual power.

Interpreting the Judith as a chaste Florentia within an amorous garden setting can be seen to sustain the political reading clearly intended by the Medici and encoded in the inscriptions at the foot of the statue; this symbolic framing also contains the seeds of a misunderstanding. For within the poetic universe of the Garden of Love, the powerful woman conquering an enemy could be read in an altogether different manner. The "puella furax," no longer a biblical heroine, might slide into the role of the *belle dame sans merci*, the beautiful woman without mercy. Indeed, within the albeit fragmentary print culture of late fifteenth-century Florence, it was precisely in this role that Donatello's Judith was cast.

Viewing Inversions

In her important article "Women on Top: Symbolic Inversion and Political Disorder in Early Modern Europe," Natalie Zemon Davis offered a paradigmatic analysis of how the reversal of gendered norms—although generally considered to reinforce social structures—could also unsettle political configurations. Zemon Davis opposed the traditional reading of such sexual inversions by anthropologists, who, she wrote, "generally agree that these reversals, like other rites and ceremonies of reversals, are ultimately sources of order and stability in a hierarchical society. They can clarify the structure by the process of reversing it. They can provide an expression of and a safety valve for conflicts within the system when it has become authoritarian. But, so it is argued, they do not question the basic order of the society itself. They can renew the system, but they cannot change it." Dispensing with this view, Zemon Davis presented a different claim: "The image of the disorderly

woman did not always function to keep women in their place. On the contrary, it was a multivalent image and could operate to widen behavioral options for women within and even outside of marriage, and to sanction riot and political disobedience for both men and women in a society that allowed the lower orders few formal means of protest."[74] Davis's linking of imagery, social protest, and anthropology has served to undo the recapitulation of sexual and political hegemonic positions in the analysis of early modernity, and her reminder of the provocative and dialogic nature of the topos of "woman-on-top" helps to reconceptualize the power of Donatello's *Judith and Holofernes* and to complicate its reception.

In the garden court of the Medici palace, Judith triumphed as a civic heroine, combating not only political subjection, but also male lust. This reading was stabilized through texts, collateral imagery, and the garden setting itself. Taken as reinforcing a patriarchal norm, the sexual inversion visible in the statue could, within narrative parameters, be added to the extraordinary feats of women who transcended their natural inferiority, catalogued in texts such as Boccaccio's *De claris mulieribus*. Identified with Florence, Judith could represent the, unexpected, power of the city; aligned with the Medici, she bodied forth their own political might: extraordinary, linked to particular and perilous circumstances, and operating under the auspices of an embracing sense of justice. Assuming a generalized male citizen-viewer, this set of responses seems quite natural, but, in the spirit of Zemon Davis's reminder of the potential subversive power of the "unruly" woman, I would also like to reimagine a female response to Donatello's "puella furax."

Focusing on the bronze *David*, Cristelle Baskins has reconstructed a viewing logic positing a female viewer, focusing in particular on the subject position of Clarice Orsini, the Roman bride of Lorenzo "il Magnifico."[75] This focus emerges from a curious document, already discussed in Chapter Four, recording the 1469 *nozze* the young couple and their families celebrated in the Medici palace. This text does not mention the *Judith and Holofernes*—as it does Donatello's bronze *David*—but it does reveal the spatial and sexual disposition of those participating in the festivities. The main courtyard, dominated by the bronze *David*, housed the banquet tables for the men. The older and married women ate upstairs in the *sala grande*. But the bride, accompanied by other young, unmarried women, celebrated in the garden courtyard, their tables set under the loggia to the south.[76] In the Medici *paradiso*, the young women gazed out from the arcade onto Donatello's striking image of gender inversion, the statue representing Judith killing Holofernes.[77] In this festive context, the image of a powerful woman, who adorned herself, at-

tracted a man, plied him with wine, and then killed him, would seem to fall squarely within the trope described by Zemon Davis as the "woman-on-top," and within the visual tradition described, and interpreted, by Anne Jacobsen Schutte in her seminal article treating the "Trionfo delle Donne."[78] Jacobsen Schutte describes the folkloric stories of Phyllis and Aristotle, and Virgil in the Basket as they appeared, especially, on Tuscan objects associated with the rituals of marriage and parturition, that is, on great-chest panels and on *deschi da parto*, the former originally used by patrician brides to transport elements of their trousseau, and subsequently as furniture in their new houses, and the latter symbolic trays associated with childbirth. On these objects, and on others connected to the bridal *camera*, artists included scenes of sexual inversion, often derived from Petrarch's influential *Triumphi*, specifically his "Triumph of Chastity."[79] Thus, in a series of five *deschi*, male figures like Aristotle, Samson, and Hercules, who all suffered at the hands of powerful women, are seen physically subjected. Jacobsen Schutte associates this visual topos with the ritual empowerment of patrician women at marriage and at childbirth. This imagery, she argues, offered to women a symbolic means of understanding their position within a set of social norms that had adolescent brides enter marital alliances with older spouses. Female power, elaborated visually, corresponded to a certain, if circumscribed, empowerment at important ritual moments in a bride's life. Moreover, this symbolic empowerment was fixed in representation, serving, perhaps, as a means through which women might continue to reformulate their position within a household, and society, that set severe limits on their behavior and comportment.

I would like to suggest that we reconsider the *Judith and Holofernes* within this carnivalesque iconographic tradition, within the gendered visuality this imagery posits, and within the Petrarchan and amorous literary conventions such images assume. It is, I believe, unlikely that the statue was made, literally, for a wedding—or a birth—but the symbolism of marriage and its attendant structures seems to offer a conceptual scaffold from which lost or undervalued readings of the object can be constructed. Judith and Holofernes did appear on painted works associated with marriage, and the story bears unavoidable iconographic affinities with those pictured on the *deschi* mentioned above. Indeed, although she does not appear on these trays, Judith was mentioned by Petrarch in his "Triumph of Chastity."

It is also telling that Lucrezia Tornabuoni, wife of Piero de' Medici and mother of Lorenzo "il Magnifico," authored an extended *sacra rappresentazione* devoted to the theme of Judith and Holofernes.[80] Probably composed after 1469, the play—*Ystoria di Iudith vedova hebrea . . .*—offers a relatively direct poetic rendition of the Old Testament text, emphasizing Judith's moral

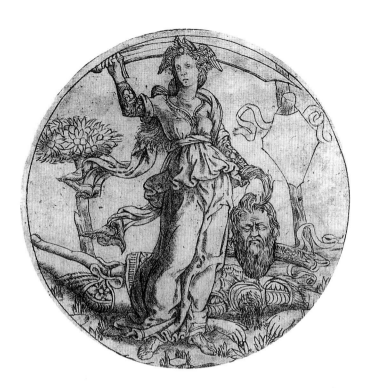

Figure 6.10
Anonymous (Florentine), *Judith as David*, c. 1469–78. Engraving (Hind, A. IV. 1). Petit Palais, Paris, Dutuit Collection

triumph. The text can clearly be seen as addressing Lucrezia's own widowhood, but it is difficult not to see her choice of subject matter in relation to Donatello's statue. Lucrezia's election to retell the story of Judith can be read, broadly, as a "proto-feminist" gesture, in that she sought with her words to emphasize a female moral example. The *sacra rappresentazione*, which we later hear Lucrezia's daughter could recite, serves to remind us how the iconography of female empowerment might very well have generated some pride within the minds of the female members of the Medici household. It helps us, in other words, to reimagine the empowerment of the female gazes cast upon Donatello's *Judith and Holofernes*.

As with the analyses of Zemon Davis and Jacobsen Schutte, within the female gaze the inversion of gender roles in Lucrezia's play and in Donatello's *Judith and Holofernes* can be seen both to buttress patriarchal norms and to offer the potential of destabilization. For if women were in the liminal moments of marriage and parturition granted a certain stature, an empowerment encoded symbolically in the images of inversion, the rarity of such moments speaks, negatively, of the less freighted moments of women's lives: the long years of disempowerment outside of ritual events. To women, the images of gender reversal might very well have served psychological functions, reminding them of their importance as brides and mothers. But as Zemon

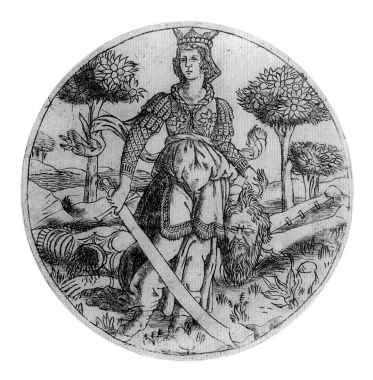

Davis suggests, the image of the "woman-on-top" cannot be tamed quite so easily. Especially in the public sphere representations of powerful women complicated the patriarchal norm they, on a primary level, seem to reproduce. The heady instability of the "woman-on-top" can be demonstrated, I believe, by turning to the reception and transformation of the figural disposition in Donatello's *Judith and Holofernes* by printmakers in the 1470s and 1480s, who, responding to the amorous implications of the garden and the narrative, removed "Judith" entirely from the apocryphal narrative and recontextualized "her" within poetic and amorous discourses.

Two of the so-called Otto prints—already linked to the Medici in the previous chapter—represent a woman, sword in her right hand and a bearded head in her left.[81] A decapitated body lies prone behind her (fig. 6.10 and fig. 6.11). Both female figures on the prints, therefore, conform in general to the "Judith" type and even directly echo in certain details the two most publicly visible renditions of the apocryphal heroine: Donatello's sculpture group and Ghiberti's *Judith* on the *Gates of Paradise*.

I shall focus on the larger, more accomplished, and more complex of the two prints (fig. 6.10).[82] The gentle contrapposto of the female figure's pose is, I would argue, drawn from Ghiberti (fig. 6.12); the connection is evident

when one compares the feet of the two figures. The gesture sweeping the sword above her head is also superficially similar to Ghiberti's *Judith*. Having said that, the figure responds as well to Donatello's *Judith and Holofernes*, a fact rendered evident when one compares the manner in which both protagonists draw up swords behind their heads; from a frontal view of Donatello's bronze, the square negative space defined by bent arm, head, and sword would seem to have borne upon the printmaker's similar figural construction. What is more, the "sculptural" treatment of drapery in the print—the clinging fabric and the veinlike folds—speak of a direct artistic response to Donatello's statue. Most strikingly, the crooked finger, wrapped about the forelock of the severed head in the print, echoes the distinctive manner in which Donatello has his Judith raise up Holofernes' similarly bearded head. Having touched upon these material particulars, it must be said that the most startling similarity between the print and Donatello's statue is a shared mood. Ghiberti's *Judith* twists in a vacuum of emotion, while Donatello's expresses somber and self-interrogating justice. The print, although not mimicking Donatello's rendition of Judith's physiognomy, nonetheless pictures her similarly, staring off in passive, prophetic triumph.

The protagonists pictured on both prints conform in general to the iconography of Judith Triumphant, as seen in Ghiberti's rendition: a woman with a sword in one hand and a severed head in the other. Be that as it may, we are dealing with an iconographic hybrid, a conflation of narratives and attributes. In one of the prints, Judith appears in armor (fig. 6.10); furthermore, in both, the decapitated body of her enemy is clad in clothes more appropriate to the battlefield than to the scene of seduction described in the Apocrypha. In fact, the battle between Judith and her foe is set outdoors—we see trees in the background and a groundplane spotted with grass.

It appears, at first, as if the narrative of David and Goliath has infected the iconography of Judith and Holofernes. In fact, the prostrate, decapitated, and relatively large figure appears to have been drawn from Ghiberti's Goliath in the narrative panel next to his figure of Judith on the *Gates of Paradise*—the squaring of the headless corpse's shoulders to the picture plane and elements of the figure's armor speak of an indirect connection. But the exterior setting and the hybridization of David and Judith also draw us back, again, to the garden of the Medici palace. Akin to the site of Donatello's monumental statue, the space on the prints would appear to pull these hybrid figures into the discourses of love, and transform them into a performance of an allegorical battle, not unlike Prudentius's psychomachia between Chastity and Lust.

Given the probable function of these prints—as decorations for boxes given to women by suitors—and the repeated emphasis on Chastity in imagery of this ilk, the appearance of the "woman-on-top" iconography is not surprising. Like the iconographies of inversion discussed by Jacobsen Schutte, these engravings, functioning within the liminal ceremonies of courtship and, perhaps, marriage, picture for a female audience a heroine conquering a man.[83]

As an aggressive representative of Chastity and recalling Prudentius's moral combat, "Judith as David" in the Otto prints battles physical love. Moreover, as "David," Judith might be seen to battle Goliath. In French misogynist literature Goliath could refer to female genitalia and signify the unbridled "nature" of female sexual appetite: "Her hairy Goliath so pricks and excites her and the fire burns so high in her that at last she succeeds in getting a man. . . . Goliath gapes too often. I can't satisfy him; I'm likely to die before I do."[84]

Such a mingling of Holofernes and Goliath might have informed Donatello's rather curious figural composition noted above, in which Judith's blow seems both to be directed at the foe emerging from between her legs and, perhaps, by extension at herself.[85] In the prints, "Judith as David" repudiates sexuality by executing Holofernes as "Goliath"; the designers of the prints not only emulate Donatello's figural disposition, but also drew, sensitively, on the meanings that accrued to the bronze statue in the Medici palace garden.

This visual interpretation indicates a potential moment of unease in the moral-political reading of the monumental sculpture. In battling against a political enemy and defeating him with questionable but justifiable means, the "public" Judith was morally unproblematic, a civic heroine easily equated with Justice and civic virtues. In battling against sex, however, the "private" Judith confronts the lover with a problem: a morally correct, hard, and empowered woman. Drawing both the narrative and iconic aspects of Ghiberti's and Donatello's Judiths into the discourse of love, these "Judith as David" prints signal a destabilization of any monologic, propagandistic interpretation of Donatello's *Judith and Holofernes*. Other misprisions seem similarly destabilizing.

One such response can be found in a print showing a young woman with a sword in right hand and in her left, the head of a "captive," held up by his hair (fig. 6.13). The scene evokes, without corresponding to, the Judith and Holofernes story. Undressed but for a pair of shorts, this "Holofernes"

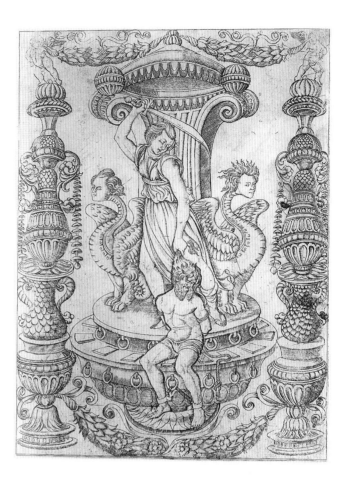

Figure 6.13
Anonymous (Florentine), *Woman
and a Captive*, c. 1469–78.
Engraving (Hind, A. II. 11).
Kunsthalle, Hamburg

sits—his arms bound and shackles around his ankles—at the feet of "Judith";
in comparison to her dynamic and much taller body, he appears small and cer-
tainly disempowered. Perhaps the artist intended to represent the male figure
also as unconscious, since his eyes are shut. But to the viewer, his firmly
closed eyes and his head, turned aside, seem to signal a shying away from the
anticipated blow of the sword.

The festive setting, complete with garland-bearing putti and a bal-
dachin, not to mention the distinctive construction upon which the figures are
set, call to mind both contemporary renditions of fountains and ephemeral
apparati for processions, specifically *trionfi*. Basins on pedestals with decora-
tive pendant rings repeatedly appear as fountains in contemporary paintings,
prints, and sculptures.[86] It is possible that the original pedestal for Donatello's
Judith and Holofernes possessed similar forms, and what we see in the print
might even resemble that lost base. But the festive construction also recalls
those ceremonial carts on which allegorical figures are often seen to perch in

272

representations of Petrarchan triumphs, like, for example, Jacopo del Sellaio's *Triumph of Chastity* (fig. 6.14). It is not, however, only such appurtenances that signal a connection to triumphal processions. In this print, "Judith" and "Holofernes" are transposed into the triumphal mode. The woman, lacking firm narrative identity, appears as an allegorical figure who triumphs over the doomed man at her feet. But if this is a triumph, it is, emphatically, not a straightforward triumph of Chastity. Two things make this clear: the sphinx-like creatures flanking the woman, and the pose of the captive.

Describing the famous Theban sphinx, Apollodorus reported that she had "the face of a woman, the breast and feet and tail of a lion and the wings of a bird."[87] Although the monstrous hybrids in our print, beyond wings and leonine paws, possess long reptilian necks, they still fall loosely within a Renaissance category of "sphinx."[88] As Janson and Chastel have asserted, the

Figure 6.14
Jacopo del Sellaio, *Triumph of Chastity*, c. 1490–93. Tempera on panel. Museo Bandini, Fiesole

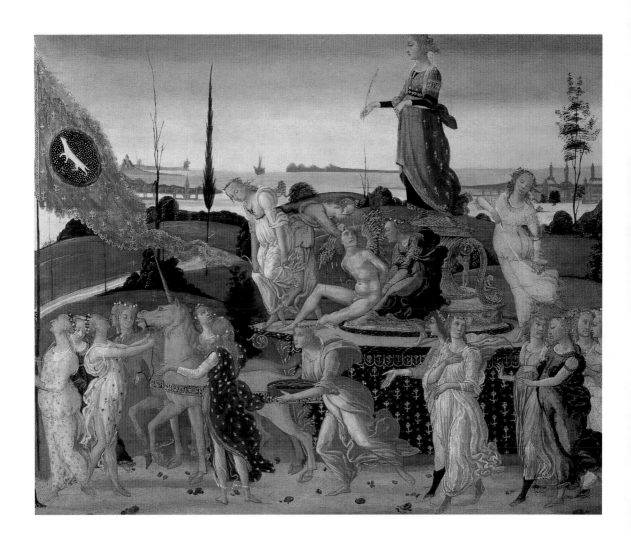

representation of sphinxes, especially paired, signified to the fifteenth-century viewer the presence of arcana.[89] This could indicate a positive moral reading. Thus sphinxlike creatures appear with Mercury Trismegistus on the Siena cathedral pavement, with *Philosophia* on the tomb of Sixtus IV in Rome, and flanking Donatello's Padua *Madonna*. Despite the availability of such readings, the "sphinxes" in the *Captive* print prompt a negative moral interpretation of the armed woman. Ancient writers saw the sphinx as an evil, hybrid compilation. Dio Chrysostom read this troublingly manifold body as symbolic of eclectic internal qualities: the feathers representing frivolity; the face of the girl, the deceptions of pleasure; and the leonine attributes, pride, arrogance, and cruelty.[90]

The riddling creatures bracket the violent protagonist of the print; indeed, they appear as three, evil "sisters." The face of the woman in the print appears, cloned and grafted onto the sphinxes' already spliced bodies; the hair of the beast to the left is in clear rapport with the protagonist's, while the snaky hair of the "sphinx" to the right curls to Medusan effect. In the print, the "sphinxes" speak silently of violence and sexual transgression, complementing the main figure, emphasizing her ambiguous moral stance. For she, preparing to execute her hapless captive, hardly seems to possess the moral footing of Judith or Chastity personified.

What, then, can one make of this bound man? Who is he? He has the beard of a Goliath, a Holofernes, or a Saint John. His state of undress, however, does not suggest a battlefield, nor do his shackled ankles and bound arms recall the scene in the Assyrian tent outside Bethulia, and the image hardly correlates to the execution of the Baptist. It is perhaps the juxtaposition of Donatello's *Judith and Holofernes* to the antique statues of *Marsyas* in the Medici palace garden that suggested the binding of the captive. In fact, his pose is derived from the figure of Marsyas in the famous engraved gem representing *Apollo, Olympos, and Marsyas*, set by Ghiberti in 1428 for Cosimo de' Medici (fig. 4.25).[91] Regardless of its source, the "captive" in the print seems to elicit our pity, rather than our revulsion. As the image is freed from the apocryphal narrative, there is no compelling reason to read the "woman-on-top" as a righteous assassin; to the contrary, flanked by wily sphinxlike creatures, the woman with the sword slips toward a negative moral position, while her captive seems defenseless and pitiful.

The moral coding of the woman in the *Captive* print is, I would suggest, problematic. In the discourse of love even her rejection of cupidity is tinged with the accusation of not taking pity on the lover's complaints. Thus, although the female captor still probably represents Chastity, her moral charge could be negative. It is precisely the semiotic and moral mobility

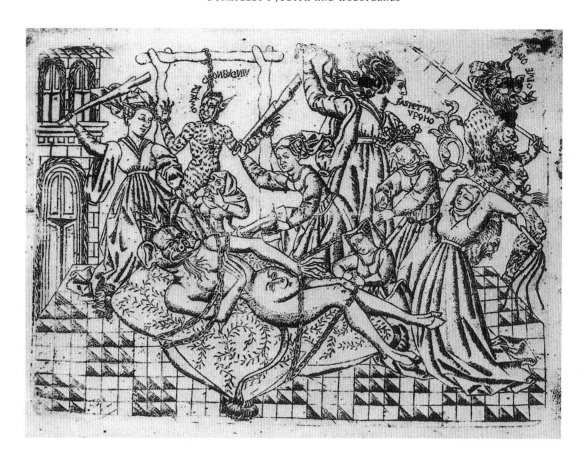

Figure 6.15
Anonymous (Florentine), *Women Punishing Devils*, c. 1469–78. Engraving (Hind, A. II. 6). Formerly in the Serai Museum, Istanbul

that Elena Ciletti identified more generally with certain representations of Holofernes, in which he was seen to "shed his traditional medieval identification with the devil and instead [to join] the ranks of saints and wise men, pathetic victims who have lost their heads (either literally or figuratively) to 'feminine wiles.'"[92]

One can trace this negative shift in other Florentine prints, which draw on the pose, iconography, and setting of Donatello's *Judith and Holofernes*, and which all operate within the frame of amatory imagery. The female figure with her right arm raised appears, albeit transformed, in the prints representing the punishment of Cupid, discussed in Chapter Five (figs. 5.11–12). The figure also surfaces in the odd early Florentine engraving, studied by Warburg, in which women combat one another in order to attain a pair of men's shorts, or hose.[93] But I would like to concentrate only on one further example in which six women—apparently from different social classes—band together to battle against and punish three large devils (fig. 6.15).[94]

The patterned ground and the palace façade inform us that the scene is set in a piazza. Public, the mise-en-scène bears traces of the theatric. The per-

formative quality is intensified by the costumes of the women and by the texts issuing from the mouths of the background figures, giving a sense of oral immediacy akin to drama; in this case we seem to attend a comedy.

In the background to the left we see a devil hanging from a makeshift gibbet. The words issuing from his mouth read O MALA CHONPAGNIA, as he bemoans the company into which he has fallen. To the right, a ferocious woman lurches forward, grasping the tail of a hairy monster; her right arm is drawn back ready to strike with her snaky cat-o'-nine-tails. While the assailant cries out for the devil to wait a moment (ASPETTA UPQHO), the "victim" seems to bemoan his situation, uttering OIME OIME in exasperation. Most attention, however, is paid to a grotesque devilish monster in the foreground. Conspicuously less hairy than his peers, this devil is rendered as fleshy. Its head, bracketed by enormous ears and capped by vegetal projections, seems to mingle porcine, canine, and human attributes. Instead of feet, the devil sports cloven hooves, and on its swollen belly a second, grinning face stares eerily upwards. The beast's long tail mingles with the vine-patterned cushion to which the women bind the creature with large chains. This immense, clearly symbolic pillow helps identify the fiendish devil's sin as Luxuria; the vine decoration might suggest overindulgence in wine, but it is more likely that the bestial devil, with its grinning and perhaps hungry "womb," represents raw animal lust and untamed sexuality. The women, however, seem to gain the upper hand over this symbolic beast; two women raise clubs, preparing to deliver blows, while another woman to the right, dressed like a nun, prepares to lash Luxuria with a large whip. Next to her a woman with a crown (a queen?), assisted by a kneeling woman, tie the devil with chains to its cushion.

The woman raising her club above her head in the left foreground seems to echo both the gesture and the significance of Donatello's Judith. What is more, the presence of the enormous, symbolic cushion seems more than coincidental. The print and the statue share a certain iconographic trajectory. Both represent the triumph of Chastity over Luxury, and the link between the two is preserved in an appropriated gesture. In the engraving, however, the austere moral allegory appended to the apocryphal narrative for political and propagandistic value, is recontextualized as a comic mock-dramatic psychomachia. The tenth figure—behind the supine devil and to the right of the woman in a pose similar to Donatello's Judith—appears to be a monkey dressed like a woman and reveals the print's mocking tone. Fingers distending its mouth, it purposefully sticks out its tongue, a grimace directed, it would seem, at the Judith-like figure with her club raised. This ludic smirk reframes heroic chastity as a farcical enterprise.

-w§ɔ

It seems to me odd, and irreconcilable, that interpretations of the *Judith and Holofernes* have narrowed the implied spectatorship for the work to a visual elite while broadening the alleged scope of its political impact. To my mind, in order to claim the latter, one must abandon the security of the esoteric implicit in the former. If a public for the statue is to be figured in the equation of its political significance, the symbolism of the image must be set in a broad frame and one in which the allegorical can be seen to have a certain contemporary relevance, a certain visual and social logic.[95]

Art historical interpretation always assumes a certain hermeneutic of spectatorship. Usually, it is based upon a synchronic view of meaning, reinserting auctorial or patronal intention through a stable, if often undefined, conception of the beholder. Visual analysis, for example, represents an important fusion of ocular and interpretative horizons. The art historian's visual perceptions, translated into data within modern categories of analysis, are set within a contextual structure established to explain why the artist and/or patron produced the object at hand. Linking the art historian's eye to what Norman Bryson has called the "founding perception" of the artist/patron is an assumed set of responses: visual analysis produces a temporal link with the past by aligning art historical and intentional gazes, brought together by invisible, but assumed, spectatorial sight lines. This collapse between the categories of intention, interpretation, and reception—one of art history's fundamental methodological operations—is often a pragmatic response to evidentiary lacks. Within modern art history, however, this assumed visual unity has occluded and marginalized historical reception: on the one hand by popular Romantic conceptions of artistic autonomy and genius; and on the other, by postmodern relativity and its promotion of the interpreter as a creative agent producing history. To those interested in the interpretation of political art, and a political interpretation of art, it is very attractive to mitigate the excesses of both these schemata by attempting to theorize and document historical reception.

In this spirit, the prints I have discussed are presented in order to offer one possible set of "public" reactions to Donatello's *Judith and Holofernes*.[96] I have not attempted to draw any firm conclusions concerning filiation or "influence." To the contrary, not only is the record too fragmentary to yield such results, but also the prints ought not to be interpreted as emerging from Donatello's work, but rather as active responses to it. In reusing and adapting the pose of Judith, the printmakers reacted to the form and meaning of the Medici *Judith and Holofernes*. In general, they capitalized upon the ambiguous morality of the protagonist, in the biblical narrative, in Donatello's bronze, and in its symbolic physical context. It is telling that all the adaptations speak of

love. This records a perception—conscious or unconscious—about what the Medici represented, and how they represented it, to the public of Florence. The imagery of the Medici palace courts—the *David*, the *Judith and Holofernes*, as well as the Marsyas statues—constructed the building as a moral place, in which presumptuous male eroticism was crushed. It was upon this morality that the Medici appended a political message. By promoting the chaste Judith they figured *their* actions as morally sanctioned, forced upon them by circumstance and their sense of duty.

But Donatello's statue was open to alternate interpretations. Not only was a woman with a sword an inherently multivalent iconograph, alternately buttressing and tearing down patriarchal norms, but within the loose narrative structure of the garden itself the moralizing psychomachia between virtue and vice, Sanctimonia and Luxuria, republicanism and tyranny could suffer inversion. If Judith as a "woman-on-top" could represent, within the female gaze, a moment of empowerment, within priapic male visuality she could also become the threatening "thievish girl." This ambivalence within amatory discourses marks the misprision of Donatello's sculpture in Florentine print culture of the 1470s. The meaning of the figural motif of the aggressive woman, recontextualized, shifted with successive decodings. Indeed, given the fundamental slipperiness of the image of an armed woman dominating a man, in playing with Judith as a symbol of Chastity the Medici ran the risk of the sign slipping out of a register of controlled meanings and into the dialogic. It was precisely this unpredictable dialogism that the Savonarolan republic inherited when, in 1495, it set the requisitioned Medici *Judith and Holofernes* outside the Palazzo Vecchio.

Topsy-Turvy Under the Republic

Placed on the ceremonial platform giving onto Florence's main civic space, the eminent symbol of Medicean moral magnificence and justice came to represent, somewhat ironically, the new republican regime. At this time a restrained, almost smug, inscribed gloss offered a response to the earlier inscriptions. The new tag figured the citizens of Florence as unambiguously active and concerned itself again with the "health" of the (re)public: "EXEMPLUM SAL[UTIS] PUB[LICAE] CIVES POS[UERUNT] MCCCCXCV" (The citizens placed [this here as] an example of the public weal).[97] In good health, the inscription perhaps implies, Florence no longer needs "doctors" (*medici*).

The decision to place Donatello's *Judith and Holofernes* before the Palazzo Vecchio in 1495 was epochal. The recontextualization of the expensive Medici icon surely served to emphasize the republic's victory over that family's "tyranny." Materially, as a luxury item, the statue functioned as

278

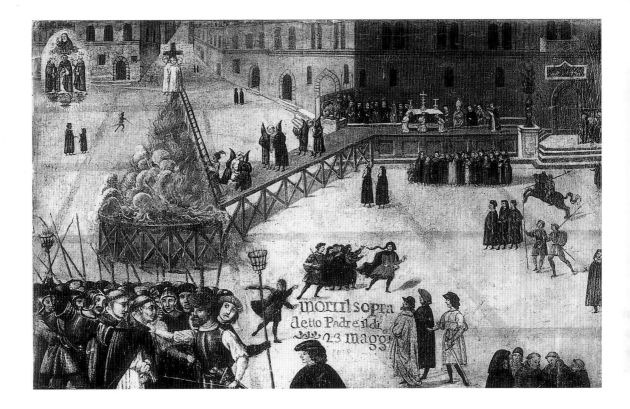

booty, triumphantly appropriated and displayed. What is more, both the Hebraic justice and the elemental psychomachia showing Virtue eliminating Vice surely appealed to Savonarola, who, mingling late medieval Christianity with the prophetic and ethically Manichean aspects of the Old Testament, railed against the Medici, decried Florentine moral laxity, and promoted the divine kingship of Christ. Judith's righteous execution suited this stringent and ascetic republicanism, and bodied forth an image of the state in tune with the political ethos of Savonarola. Despite Savonarola's enormous charisma and the fervent support he garnered, his authority imploded when, in 1498, the fiery Dominican friar met his end in the piazza della Signoria under the stern gaze and admonitory gesture of Donatello's Judith—an event vividly pictured in an anonymous, early sixteenth-century painting (fig. 6.16).[98]

Savonarola's failure led to a more secular republic and, following the example of Venice, to the 1502 election of Piero Soderini to an unprecedented life term as *gonfaloniere di giustizia,* the highest position in the government. It was under Soderini that, less than a decade after it was adopted by the republic as its most visible political image, Donatello's *Judith and Holofernes* was removed from its preeminent position outside the Palazzo Vecchio. This decision emerged from a committee comprising painters, sculptors, architects, as

Figure 6.16
Anonymous, *The Execution of Savonarola,* c. 1500 (Donatello's *Judith and Holofernes* is visible at top right). Tempera and oil on panel. Museo di San Marco, Florence, detail

well as other prominent Florentine professionals, convened explicitly to air opinions concerning the siting of Michelangelo's colossal marble *David*—called "il gigante," the giant (fig. 4.22). The minutes of these deliberations on 25 January 1504 reveal, however, that members of the committee understood their agenda in broader terms, for they addressed not only Michelangelo's work but also, especially, the two bronzes by Donatello requisitioned from the Medici palace: the *David* and the *Judith and Holofernes*. Proposals ranged from situating the statues in front of the cathedral to installing them all under the protective canopy of the Loggia dei Lanzi. It was finally decided to grant Michelangelo's *David* the position formerly held by Donatello's *Judith and Holofernes*.[99]

Seeking to fashion a political identity both novel enough to erase the bitter memories of Savonarola and the Medici, yet traditional enough to capitalize on ancient patriotic affections, the republic under Piero Soderini could easily dispense with the melancholic gravity of Donatello's sculpted execution, in favor of the vigorous, if ambivalent, masculinity of Michelangelo's giant. The outcome of the 1504 meeting, therefore, was hardly surprising. What remains shocking are the notorious opinions expressed by the herald of the Florentine Signoria, Francesco Filarete, while arguing for the removal of Donatello's *Judith and Holofernes* (fig. 6.1). His words can be seen within the traditional fears of powerful women: "The Judith is a deadly sign (*segno mortifero*) and does not befit us whose insignia are the cross and the lily, nor is it good to have a woman kill a man; moreover, the stars did not favor the erection of the Judith, for ever since then things have been going from bad to worse: [for] then we lost Pisa."[100]

Filarete's argument against the *Judith and Holofernes* is threefold: (a) the statue is a deadly symbol not consonant with the traditional republican signs of the cross and the lily; (b) it is not good to have a woman kill a man; and (c) the astrological formations under which the statue was erected were ill-omened. As to the latter, Antonio Natali has reported that astronomical evidence does not corroborate Filarete's astrological fears. It appears to have been a red herring, thrown out by the herald to support his rather subjective case.[101]

In the context of the meeting, Filarete's outburst is relatively bitter. One has the impression that the first two of his arguments are not disconnected and that the symbolic and primary iconological interpretations of this "deadly sign" for him are one. He could not, or did not, want to read around the face value—the primary iconological reading—of the group: a woman conquering, and killing, a man. To read his comments as just another set of broadly held misogynistic views, ratified by the committee of 1504, is overly mechanistic. I would like to argue that they emerged from the peculiar am-

bivalence of the statue itself, from the path of misprision already blazed in Florentine print culture, and from the particular fears concerning the "power of women" under the republic of the early sixteenth century.

During the early years of Piero Soderini's leadership, that is, just before the 1504 meeting, there was some anxiety in Florence concerning the role of women in the republic. Soderini was elected in 1502 and moved into the Palazzo Vecchio that year. In January 1503 his wife, Argentina Malaspina, joined him. The novel presence of women in the physical heart of the republic concerned Bartolommeo Cerretani. Since Argentina Malaspina moved into the palace, he wrote, one can see "something which until this time was unusual—many women going up and down the steps." He explains that this sight aroused great unrest in the people.[102] The presence of women in the Palazzo Vecchio was a novelty in Florence and ran against both custom and law: in the Statutes of 1415 women were explicitly barred from the city hall.[103] (Ironically, the only recorded contravention of this law of which I am aware was committed by the herald Francesco Filarete. In 1464 Cristoforo Landino, his boyhood friend, appealed to Lorenzo de' Medici to aid in getting Filarete out of trouble for having been discovered in the palace with a young woman.)[104]

Cerretani's vision of "many ladies" entering the palace and "going up and down the steps" seems to emerge from a fear that the (male) public seat of the government would be transformed into a domesticated site dominated by women. Unlike the Medici palace, where political authority was masked through symbolic tropes emphasizing the familial and the amorous, the governmental building of the republic was defined through the very absence of women from its spaces. The real presence of women in the palace, exacerbated by Donatello's domineering Judith, might very well have proved too blatant an inversion of masculine identification of public and civic enterprises as requiring for its city hall a sequestered, homosocial space, freed from heterosexual and private entanglements. The *Judith and Holofernes* could, within this distrustful outlook, falter from the sure footing of the apocryphal narrative, and from the decorous symbolism of the psychomachia, into the tropal unsteadiness of the "woman-on-top," communicating a topsy-turvy political message.

That the propagandistic messages shouldered by the *Judith and Holofernes* might slip with the statue's armed, female protagonist, who, as we have seen, could pitch from positive to negative moral positions, came to the fore during the festive, carnivalesque celebrations of Saint John's day 1500. Feting the chaste patron saint of the city who lost his head, the elaborate annual displays, processions, and performances were the most spectacular of the "sa-

cred cycle of civil feasts" defining Florentine public life.[105] The feast of Saint John was honored each year, not only to commemorate the Baptist, but—more importantly perhaps—to celebrate the city of Florence.[106] Originally organized by local groups, under the Medici the celebrations were increasingly centralized, planned, and realized under the auspices of the state, which regulated secular presentations and even appointed *festaioli* to coordinate the festive happenings. "The honor of the commune in the eyes of the world rested in [the *festaioli*'s] hands," writes Richard Trexler, "their carelessness could cause a scandal that would insult God and man."[107]

As opposed to the celebrations that fell earlier in the Florentine festive calendar in which "women and youth, groups outside the political body, had played a role," the participants at the feast of the Baptist were "mostly mature males."[108] As Trexler notes:

> [a]ll feasts reflected male domination of society and showed the liens and conflicts that defined a male political order. But though Carnival recognized the meliorative importance of women, youth, and even lower-class males as images permitting communication between families and groups of families, St. John's assigned these liminal groups to the audience, as devotees of the political process and order. In these festivities, it seemed that the city had been generated by male lineages married to each other and to the commune, and not by sexual copulation and daily work. Visitors to the patron's *festa* in this period marveled at a commune that could work endlessly at ritual at the expense of the shop, whose political males seemed able to generate life without women and without workers, a commune that with seeming ease produced genius and imagination from a seedbed of grave governors. Over it all stood the image, altar, and spirit of St. John the Baptist, the virginal male prophet of Christ and Christianity.

> Saint John's day provided a means for Florentine, politically enfranchised men to represent themselves within a mythical frame, bracketing out the unruly bodies that might disturb the image of an orderly, symbolic hierarchy, a harmonious body politic.

During the days preceding 24 June, artisans displayed wares, religious groups processed and reenacted religious stories, and secular festivities enlivened the streets of the city. The ritual climax, however, took place on the morning of 24 June, when the city's institutions and subjected territories delivered their symbolic tributes—heraldic standards and wax offerings—to the baptistery of San Giovanni. The symbolic gifts bestowed on the city's

patron saint served to represent the dominion of Florence over its "colonial" possessions in Tuscany. Recording victories over external and internal enemies, the economic and militaristic might of Florence was enacted in a hierarchical display.[109] Before concretization in the successive symbolic performances at the baptistery, the lavish procession formed in the piazza della Signoria.

The chronicler Giovanni Cambi recorded the strange occurrences that marred the feast of Saint John in 1500.[110] On the eve of 24 June a storm struck Florence, and violent winds caught the canvas "heaven" that, stretched between the baptistery and the façade of the cathedral, formed an enormous canopy over the piazza di San Giovanni.[111] This celestial canopy bore the arms of the city of Florence. It was under this material firmament, in which Florentines could see their city's most prestigious emblems, that the symbolic gifts to the Baptist were to be presented. In June of 1500, this awning, wrenched free from its anchors by the wind, wrought havoc, pulling down the cross that was fixed atop the pillar of San Zenobius, throwing a man into the air and breaking his leg. It also dislodged a piece of Arnolfo di Cambio's marble decorations above the main portal of the cathedral; a statue fell, killing a man. Cambi saw these phenomena as omens, speaking obliquely to the citizens of Florence of their own tumultuous political state. Expressing his discontent with the current Signoria, Cambi read the storm as political. Any disruption of such civic festivities, so central to the identity and hierarchy of the Florentine government, was subject to intense scrutiny. Cambi read the storm as a political omen. The next day, an epiphenomenal happening provided Cambi with more reading material. Another disruption took place while the participants in civic procession to the baptistery were assembling in the piazza della Signoria.

These processions often included men in costume and on stilts called, in Florence, *giganti* or *spiritelli*. These "giants" or "spirits" often represented biblical characters. In 1500 a giant dressed in the guise of Judith, bearing the "head" of Holofernes in one hand and a drawn sword in the other, took part in the celebrations.[112] The Judith on stilts clearly possessed religious significance, but her presence in this civic celebration—the religious processions traditionally took place on 23 June—was surely intended to evoke direct comparison with its bronze counterpart on the piazza della Signoria, the civic monument of the republic. Cambi describes what happened:

> And then, on the morning of St. John's day another thing happened
> that is no less notable than the others: while the Signoria was, as is

customary, on its way to make its offering, there was a *spiritello* on stilts, dressed as Judith with the head of Holofernes in one hand, and, in the other, a drawn sword. As this *spiritello* was walking, it encountered the Signoria, and, wishing to do reverance to them, fell, and in falling hit with its sword the head of the *Comandatore*, who carried the [ceremonial] sword with those caps in front of the Signoria, wounding him slightly. [This Judith] even struck the said sword, making it fall from the hand of the said *Comandatore*, which appeared to be an evil augur.

At the most sensitive place in the Florentine political body, the transvestite Judith, already a slippery iconographic inversion, faltered while paying homage to the lordly Signoria. Stumbling, her/his sword fell on the head of the *Comandatore*, or usher, who in turn let fall the ceremonial sword of the republic he was holding.[113] Such carnivalesque disruptions, as Cambi's interpretation informs, were read as portentous.

The almost comic succession of events could not but have struck the aged Filarete particularly. He had been the herald of the city since 1456, and in this capacity he was both the guardian of the traditions of public ritual and the master of ceremonies at civic festivities.[114] It was under Filarete that the *Libro cerimoniale*, a primer describing Florentine civic traditions, was composed.[115] Any slip would wound his pride. But in this instance more than his pride might have been hurt. For although the word used by Cambi to describe the recipient of the "giant's" blow, *Comandatore*, strictly refers to an usher, Filarete records in the *Libro cerimoniale* that it was the herald's function at other events to carry the ceremonial sword of the republic.[116]

The unseemly mistake, which had an armed woman unarm a man, and, moreover, relieve that man of a sword with civic symbolism, can be seen to reveal precisely what was most problematic about Donatello's *Judith and Holofernes* as a political image. The stumbling *spiritello* can be seen not only narrowly, as turning Filarete against the iconography of Judith, but can also be seen to expose the danger inherent in Donatello's *Judith and Holofernes*, the new "sign" of the republic under which the accident took place. As mentioned at the head of this chapter, Judith was a particularly odd heroine for Florentines. As Marbod of Rennes and Aby Warburg remind us, the image of a woman lopping off the head of a man parallels, dangerously, the story of the city's patron, Saint John the Baptist. Judith, as a Florentine symbol, stood on the edge of an iconographic precipice, ready to fall into Warburg's category of the "headhuntress," within which her moral fixity could dissolve.

In Cambi's text, for example, the "giant" Judith tumbled into a sinister pattern of omens. For Filarete, Donatello's bronze statue slipped in a similar direction, becoming a *segno mortifero*. Both interpreters chose to ignore the political monologues fed through the image; both, rather, recognized the fragility and mobility of meaning of this iconography. In tripping, the transvestite Judith of 1500 fell from the register of stable, state-controlled, dominant meaning, and into the dialogic. Cambi's and Filarete's words are remnants of this politically complex realm of multivocality.

Figures like the Judith on stilts performed at civic events in order to inspire the audience with awe and to reassure them on a symbolic level of the morality and stability of authority. This lurching "giant," a living impersonation of Judith and by extension the state, sought to make present to Florentines the real presence of abstract values like Justice, Fortitude, Chastity, Loyalty—virtues such as those represented in the fourteenth-century reliefs on the Loggia dei Lanzi. The ritual enactment of such virtuous behavior served to reconstruct the symbolic and moral order on which Florentine consent to authority was based. Similar to the carnivalesque, as described by Bakhtin, the civic performance, bringing to life an embodiment of the state, strove to reinscribe, perhaps subconsciously and in a mystical manner, the existing order of things. In this instance, the carnivalesque "giant" represented a "woman-on-top," the reversal of a gendered norm underscoring the extraordinary nature of the virtue needed to overcome vice. But the inversion of gender roles also rendered the iconography unstable, prone to tumble from a register of intended, narrative, or allegorical meaning into dialogism and potential misprision.

Notes

Introduction: Florence, Inc.

1. Walzer, "Symbolism in Political Thought,"
 194; Burckhardt, *Civilization*, part one.
2. Partridge and Starn, *Arts of Power,* 3 and 7.
 Two other studies that have suggested use-
 ful ways of interpreting the interpenetra-
 tion of art and politics are Woods-
 Marsden, "Art and Political Identity," and
 Welch, *Art and Authority.*
3. For a recent treatment of Medici patronage
 that argues strongly against political read-
 ings, see D. Kent, *Cosimo de' Medici.*
 Although I agree with Kent's distrust of
 loose political readings based on an assumed
 propagandistic scheme, I do not subscribe
 to her erasure of the political from Floren-
 tine visual culture.
4. Martines, "Politics of Love Poetry"; and his
 "Poetry as Politics."
5. Bal and Bryson, "Semiotics and Art
 History," 176–179.
6. For the former, see Pocock, *Machiavellian
 Moment.* For the latter, see, for example,
 Fubini, *Italia quattrocentesca.* For a distinc-
 tive evocation of these issues, see Jones,
 Italian City-State.
7. Najemy, *Corporatism and Concensus;* Fubini,
 "From Social to Political Representation."
8. Maier, "Il realismo letterario di Lorenzo il
 Magnifico"; and Germano, "Lorenzo de'
 Medici's Literary Versatility."
9. Chittolini, "The 'Private,' the 'Public,' the
 State," 35. For fifteenth-century meanings
 of the word "stato" (emphasizing its mean-
 ing "regime" rather than "state"), see
 Burckhardt, *Civilization,* 1: 4; Rubinstein,
 "Notes on the Word *stato*"; and Rubinstein,
 "*Stato* and Regime." On the sixteenth
 century, see Chabod, "Alcune questioni";
 and Hexter, "*Il Principe* and *lo stato.*"
10. Cassirer, *Myth of the State.*
11. See Bizzocchi, "Stato e/o potere," 57–58;
 and Petralia, "'Stato' e 'Moderno.'"
12. See especially Perrens, *Histoire de Florence;*
 and Chabod, "Y a-t-il un état de la Renais-
 sance?" The most eloquent proponent of
 the statist view of Florence's development
 has been Becker, *Florence in Transition;* and

"The Florentine Territorial State." The statist account of Florentine political history is now dominant; see, for example, D'Addario, *La formazione dello stato moderno;* Chittolini, ed., *La formazione dello stato;* Zorzi, *L'amministrazione della giustizia penale;* Chittolini, "Cities, 'City-States,' and Regional States"; Fubini, "From Social to Political Representation"; Fubini, *Italia quattrocentesca,* 19–39. For a very distinctive approach to the problem, see Cohn, *Creating the Florentine State.* Also see the essays collected in Chittolini, Molho, and Schiera, ed., *Origini dello stato;* in the abridged English version, Kirshner, ed., *Origins of the State;* and in Connell and Zorzi, *Florentine Tuscany.*

13. Baron, *Crisis.*

14. For a review of the response to Baron, see Hankins, "'Baron Thesis.'"

15. See, for example, Rubinstein, *Government of Florence;* Brucker, *Civic World;* D. Kent, *Rise of the Medici;* Najemy, *Corporatism and Consensus.* For broader, European developments, see Hintze, *Staat und Verfassung;* and Moraw, *Von offener Verfassung zu gestalteter Verdichtung.*

16. See, for example, the oeuvres of Richard Trexler, F. W. Kent, and Christiane Klapisch-Zuber. For a useful survey of the trends here discussed, see Najemy, "Linguaggi storiografici."

17. I am thinking here of Richard Goldthwaite and F. W. Kent's treatments of the Florentine palace (for example, see Goldthwaite's "The Florentine Palace as Domestic Architecture"; and F. W. Kent's "Palaces, Politics and Society"), of Nicolai Rubinstein's work on the Piazza della Signoria and the Palazzo Vecchio (*Palazzo Vecchio*), of Dale Kent's new opus on the patronage of Cosimo de' Medici (*Cosimo de' Medici*), and of the enormous outpouring of work on religious confraternities, *sacre rappresentazioni* and public festivities (see, for example, Richard Trexler, *Public Life;* Weissman, *Ritual Brotherhood*).

18. For cultural historical approaches to the interface between politics and art in fifteenth-century Florence, see Warman

Welliver's flawed but ambitious book *L'impero fiorentino;* Mary Bergstein's article "Marian Politics in Quattrocento Florence"; and Luca Gatti's dissertation, "The Art of Freedom."

19. Weinstein, "The Myth of Florence."

20. The manner in which Florentines referred to their town hall changed a number of times during the first two centuries of its history; for the sake of clarity, I shall refer to this building as the Palazzo Vecchio.

21. The *Marzocco* at the corner of the Palazzo Vecchio was, in this regard, a transitional work; see Randolph, "*Il Marzocco*"; Geraldine Johnson was kind enough to permit me to consult, before its publication, her essay "The Lion on the Piazza."

22. For a thought-provoking critique of recent historiographical trends toward dismissing the "state" as a critical concept in studying late medieval and Renaissance politics, see Chittolini, "The 'Private,' the 'Public,' the State"; and, for a challenge to integrate a discussion of gender into discussions concerning the formation of the state, see Chojnacki, "Daughters and Oligarchs."

23. White, *Metahistory.* For a useful overview of the problem of "public" and "private" in medieval and Renaissance Europe, see Duby, "Introduction: Private Power, Public Power," in *History of Private Life,* vol. 2; and Ariès, "Introduction," in *History of Private Life,* vol. 3; also useful is the collection of essays edited by Klapisch-Zuber, *Il pubblico, il privato, l'intimità.*

24. Habermas, *Structural Transformation of the Public Sphere.*

25. Habermas, *Structural Transformation of the Public Sphere,* 27.

26. Habermas, *Structural Transformation of the Public Sphere,* 1.

27. Landes, *Women and the Public Sphere,* 138, restates Habermas's position very clearly: "The 'representative' public sphere was not a sphere of political communication, nor did it require any permanent location. Rather, it was marked by the staged performance of authority, displayed before an audience, and embodied in the royal subject."

28. Landes, *Women and the Public Sphere*, 3. For some feminist appraisals of Habermasian terminology and theories, see Goodman, "Public Sphere and Private Life"; Nancy Fraser, "Rethinking the Public Sphere"; and Landes, ed., *Feminism, the Public and the Private;* especially Landes's own contributions, 1–17; 135–163.

29. Landes, *Women and the Public Sphere*, 3.

30. I am thinking here especially of Patricia Simons's article "Women in Frames"; and Cristelle Baskins's work on Tuscan domestic painting, above all her *Cassone Painting, Humanism, and Gender.*

31. Iverson, "Retrieving Warburg's Tradition"; for a recent bibliography of work addressing Warburg, see Rampley, "From Symbol to Allegory."

32. Baxandall, *Patterns of Intention;* and Shearman, *Only Connect.*

33. Rocke, *Forbidden Friendships.*

34. Kosofsky Sedgwick, *Between Men.*

35. Richard Trexler's entire scholarly production addressing Renaissance Florence could be adduced, but his vision of Florentine experience is most expansively presented in his *Public Life.*

Chapter One: Common Wealth: Donatello's *Ninfa Fiorentina*

Epigrams: Latini, *Il tesoretto*, 9 (lines 113–117); Cervellini, "I leonini delle città italiane," 257; and Debord, *Society of the Spectacle*, no. 34.

1. Cited in Herlihy and Klapisch-Zuber, *Tuscans and Their Families*, 1.

2. For an informative review of the literature addressing the Florentine oligarchy, and the transition from "corporate" to "elitist" politics in the late fourteenth and early fifteenth centuries, see Brucker, *Civic World*, 6ff. Also consult Baron, *Crisis;* Molho, "The Florentine Oligarchy," 23–25; Martines, "Political Conflict," 72–74; Martines, *Lawyers and Statecraft;* Tenenti, *Florence à l'époque des Médicis;* Guidi, *Il governo della città-repubblica;* and Najemy, *Corporatism and Concensus.* For a useful introduction to some of the problems concerning the development of the oligarchical

state in early fifteenth-century Florence, see Brown, "Florence, Renaissance, and Early Modern State." On the *catasto* see Karmin, *La legge del catasto;* Bayley, *War and Society*, 91–93; Molho, *Florentine Public Finances*, 39, 84–87; Herlihy and Klapisch-Zuber, *Les toscans et leurs familles* (and its abridged, English version, Herlihy and Klapisch-Zuber, *Tuscans and Their Families*). Two studies concerning the Brancacci chapel indicate some of the dangers in linking cultural phenomena to the introduction of the *catasto:* Procacci, "Sulla cronologia," 17–24; Molho, "The Brancacci Chapel."

3. As shall become apparent, we do not know precisely who commissioned this monument; lacking further evidence, one might, like Dale Kent, assume that the statue was commissioned by the commune. See *Cosimo de' Medici*, 120.

4. Kauffmann, *Donatello;* Haftmann, *Das italienische Säulenmonument:*, 139–141; Brunetti, "Una testa di Donatello," 81ff.; Wilkins, "Donatello's Lost *Dovizia*"; Bennett and Wilkins, *Donatello*, 71–73; Mori, "First Public Sculpture"; Wilk [McHam], "Donatello's *Dovizia*"; Haines, "La colonna della *Dovizia*." With the exception of Kauffmann's study, the *Dovizia* receives short shrift in most monographs devoted to Donatello. Nonetheless, see Janson, *Donatello*, 112, 204; Rosenauer, *Donatello*, 107, cat. no. 25; Pope-Hennessy, *Donatello*, 143–144. Two recent essays on Florentine public sculpture have remarked on the central importance of the *Dovizia* monument: Johnson, "Idol or Ideal?" 226–228; McHam, "Public Sculpture in Renaissance Florence," 151–152.

5. "Donatello's *Dovizia* may be cited as the sole recorded example of a statue erected in an open square [in fifteenth-century Florence]"; Wackernagel, *World*, 100.

6. Wilk [McHam], "Donatello's *Dovizia*," 17. For ideas similar to Panofsky's, see Goldschmidt, "Das Nachleben der antiken Formen," 40–50; and Seznec, *Survival of the Pagan Gods*, esp. 211.

7. For some very different attempts to link the *style* of early Renaissance art to politics, see

Antal, *Florentine Painting;* Frederick Hartt, "Art and Freedom"; Zervas, *Parte Guelfa;* and Gatti, "Art and Freedom."

8. The government requested the *David* on 2 July 1416. See Poggi, *Il duomo,* 1: LXXV–LXXVII, 75–78, docs. 406–413, 425. On the marble *David* see also Donato, "Hercules and David"; Rubinstein, *Palazzo Vecchio,* 55. Since the name of this building has often changed, I will conform to modern usage and refer to it consistently as the Palazzo Vecchio or the city hall.

9. Wundram, *Donatello und Nanni di Banco,* 7–10, 26–29, 62–69; Herzner, "David Florentinus I"; Pope-Hennessy, *Donatello,* 40–46.

10. Partridge and Starn, *Arts of Power.*

11. Haftmann, *Säulenmonument,* 136–137; Weinstein, "Myth of Florence"; Orlandi, *Palazzo Vecchio,* 49–52; Fader, "Sculpture in the Piazza della Signoria," 124–127, 284–287; Gatti, "The Art of Freedom," 69–76; for the dating of 1377 see Randolph, "*Il Marzocco*"; Johnson, "The Lion on the Piazza." And specifically on the Lion of St. Mark, Rudt de Collenberg, "Il leone di San Marco."

12. Bergstein, "Marian Politics." In "The Art of Freedom," Luca Gatti independently draws attention to the same project, and interprets its civic implications in a manner analogous to that essayed by Bergstein.

13. D. Kent, *Cosimo de' Medici,* 127–128, makes a similar suggestion.

14. Weinstein, "Myth of Florence."

15. Kauffmann, *Donatello,* 41–43. It was Émile Bertaux (*Donatello,* 128) who first recognized that a group of della Robbia glazed terracotta statuettes represented *Dovizia,* and referred to Donatello's lost monumental statue.

16. Wilkins, "Donatello's Lost *Dovizia*"; Mori, "First Public Sculpture"; Wilk [McHam], "Donatello's *Dovizia.*"

17. The literature on Civic Humanism is enormous. For purposes of navigation, consult Rabil, "The Significance of 'Civic Humanism'"; Hankins, "Baron Thesis"; Witt, "Hans Baron's Renaissance Humanism"; Najemy, "Baron's Machiavelli."

18. Although Cohn's hypotheses concerning class and urban space have been questioned, I think his basic formulation is strong; see Cohn, *Labouring Classes,* esp. 127: "While the patriciate had emerged from a neighborhood identification of themselves (at least insofar as the structuring of their consanguinal ties), the communities of the *popolo minuto* had become much more tightly focused around the large parish churches on the city's periphery. On the one hand, these networks of association isolated the artisan and laboring populations from the residual population; on the other hand, these large and well-defined parochial communities fragmented the *popolo minuto* as a whole. . . . The other side of the 'rational' formalistic city planning of the Quattrocento, the opening of space in the center city and the splendid palaces which branch out along strip developments such as the Via Maggio and Via Ghibelline through the city's inner ring, was the development of working class ghettos in S. Lorenzo, S. Maria in Verzaia, and S. Frediano."

19. In Chapter Five I return to this identification and, again following Warburg's discussion of *bewegtes Beiwerk,* I trace the transformation of the *Dovizia* in the spectacular world of Medicean political symbolism. Kauffmann, *Donatello,* 42, already mentioned the idea that: "Donatello hat das Thema mit einem antikischen Genius bewältigt." On Roman *genii* see Kunckel, *Der Römische Genius.* Wilkins, "Donatello's Lost *Dovizia,*" 415, hypothesizes that the "*Dovizia* is certainly no saint, but it is possible that for the humanists she might have represented the *tyche,* or symbol, of the city of Florence."

20. For Bruni's text, see Kohl and Witt, *Earthly Republic,* 135–178; esp. 144–145. The most eloquent proponent of the statist view of the development of Florence in the fourteenth and fifteenth centuries has been Becker. See his *Florence in Transition;*

Becker, "Economic Change"; Becker, "Problemi della finanza pubblica"; and Becker, "Florentine Territorial State." Also essential are the many studies of Giorgio Chittolini and Elena Fasano Guarini, including: Chittolini, "Alcune considerazioni"; Fasano Guarini, "Introduzione," in *Potere e società;* Chittolini, *La formazione dello stato,* 3–35; Fasano Guarini, "Gli stati dell'Italia centro-settentrionale." For a recent treatment of the development of the state Italy, see the contributions in Kirshner, *Origins of the State,* especially Kirshner's introductory essay, "The State Is 'Back In,'" 1–10. The statist view has recently been the subject of significant revision; see, for example, the essays collected in Connell and Zorzi, *Florentine Tuscany.* See, too, the critical "Comment" by Giorgio Chittolini at the end of this volume, in which a robust version of the "state" is defended.

21. Vatican, Urb. 491; Vatican, Urb. 277; Vatican, Latin 5699; Paris, Bibl. Nationale, Latin 4802, fol. 132v. The illustrations are sometimes attributed to Francesco di Lapacino and Domenico di Boninsegni, and the school of Piero del Massaio. See Hyman, *Fifteenth Century Florentine Studies,* 218–223; and Lago, *Imago mundi et Italiae,* 99ff. On cartography and civic imagery, see the interesting remarks of Crary, *Techniques of the Observer,* 52. On the *Chain Map,* see Boffito and Mori, *Piante e vedute,* 5–15 (with earlier bibliography); and Ettlinger, "View of Florence."

22. Cohn, *Labouring Classes,* 127.

23. Davidsohn, *Geschichte von Florenz,* 1: 137, records that the Mercato Nuovo was first mentioned in 1018.

24. The female figure, with a loose gown and holding a vessel and a cornucopia, in the right jamb of the Porta della Mandorla, would appear to be a response to an antique female "genius." See Bober and Rubinstein, *Renaissance Artists and Antique Sculpture,* cat. nos. 169 and 196.

25. See Davidsohn, *Geschichte von Florenz,* 1: 18; Kauffmann, *Donatello,* 42, citing

Migliore, *Firenze,* 515, discusses the *Dovizia* as referring to the city's original "genius"; Lopes-Pegna, *Firenze dalle origini,* 45 (fig. 10), 86 and 346 (cited by Wilk [McHam], "Donatello's *Dovizia,*" 18); Bargellini and Guarnieri, *Le strade,* 3: 226 (cited by Wilkins, "Donatello's Lost *Dovizia,*" 414). On the renewed interest in the columnar monument, see Haftmann, *Säulenmonument;* and Seymour, *Sculpture in Italy,* 6–7.

26. Wilkins, "Donatello's Lost *Dovizia,*" n. 74: "That *Dovizia* might have been a symbol of Florence is supported by a figure holding a cornucopia which was erected on a column in the market at Pisa; it was part of the 'renewal' of that city ordered by Duke Cosimo I. The placement of this Dovizia-like figure, in this position and in this setting, could be interpreted as an emblem of the Florentine presence in the conquered city."

27. Filarete, *Treatise on Architecture,* 1: 132; cited by Wilkins, "Donatello's Lost *Dovizia,*" 414.

28. One could also mention the column of St. Zenobius, erected in 1384 just to the north of the Baptistery. For Santa Felicita, see Haftmann, *Säulenmonument,* 134; for San Felice, see Haines, "La colonna della *Dovizia,*" 350, n. 11.

29. Looking to other communes, we see that the monumental column topped by a figure was quite popular during the late Middle Ages and early Renaissance. Columns of this sort were to be found in Venice, Milan, Siena, Pavia, and Ferrara, as well as in other centers (Haftmann, *Säulenmonument,* 120ff.) These often bore the city's patron saint or symbolic marker. For instance, in 1329 the Venetians set an effigy of Saint Theodore atop a column in the Piazzetta di San Marco, while the Sienese placed statues of their She-Wolf on columns throughout their city. What is more, the emerging powers of Venice and Florence set their symbolic lions—the winged Lion of Saint Mark and the *Marzocco,* respectively—on columns in the communes they subdued during their territorial expansion.

30. For a study examining the image of the toppled idol, see Camille, *Gothic Idol*. In his discussion of the statue-bearing column, Werner Haftmann (*Säulenmonument*, 92–93) notes the association with such columns and places of justice. The "Gerichtsäule," the column of justice, was to be seen in many late-medieval communes. This meaning was explicitly drawn upon, for example, in the Ferrarese monument to Borso d'Este. Here, Borso is portrayed with a symbolic baton, sitting in judgment as an exemplum of the good ruler. The column on which he was perched amplified the message transmitting Borso's qualities as just (see Rosenberg, *Este Monuments*, 50–82). The *Dovizia* column in Florence also spoke of justice; criminals were punished at its foot (see below).

31. Haines, "La colonna della *Dovizia*." Creighton Gilbert ("Earliest Guide," 35) has suggested that this column replaced another that was moved from the Mercato Vecchio to the Piazza di S. Felice and mentioned by Goro Dati in 1429. See Wilkins, "Donatello's Lost *Dovizia*," 414. For full bibliographical information see Haines, "La colonna della *Dovizia*," 350, n. 11. For the *sacra rappresentazione*, see Semper, *Donatello*, 321–322, who cites the play *Re di Babilonia*, in which a character called Donatello explains: "Donatello risponde: Io son mosso testè che vuole dire / Io ho fornire il pergamo di Prato / Et Siniscalco dice: E bisogna testè. / Donatello: Non vo disdire. / Et ho a fare la dovitia di mercato / La qual in sulla colonna s'ha a porre / Et hor più lavorio non posso torre." See also Janson, *Donatello*, 111–112.

32. This point has already been made by Wilkins, "Donatello's Lost *Dovizia*," 416. Some early sources called the stone *macigno forte*; Wilkins, "Donatello's Lost *Dovizia*," 403.

33. On the siting of the marble *David*, see Donato, "Hercules and David"; and Nicolai Rubinstein, *Palazzo Vecchio*, 55. Janson, *Donatello*, 45–56. For the basic information on the *Marzocco*, see Janson, *Donatello*, 41–43. On the political role of the Parte Guelfa in the fifteenth century, see Brown, "The Guelf Party."

34. See D. Kent, *Cosimo de' Medici*, 120, 127, and 344.

35. Baxandall, *Patterns of Intention*, esp. 58–62.

36. For further information and bibliography concerning these statuettes, see Randolph, "Renaissance Household Goddesses." I am aware of ten surviving examples, although it is likely others exist. The statuettes are attributed to various members of the della Robbia clan. Attributed to the workshop of Giovanni della Robbia: Minneapolis Institute of Arts (fig. 1.9); Florence, Private Collection; Fiorano (Modena), Collezione Carbonara; New York, Metropolitan Museum (fig. 1.10); Boston, Museum of Fine Arts (fig. 1.11); Florence, Museo Bardini; Dijon, Collection Grangier. Attributed to Fra Mattia della Robbia?: Florence, Casa Buonarroti (fig. 1.7); Cleveland, Museum of Art (fig. 1.8). Attributed to Benedetto and Santi Buglioni: Berlin, Kaiser Friedrich Museum. I have not seen the examples said to be in Fiorano and Dijon.

37. Minneapolis, Institute of Fine Arts; Florence, Private Collection; Collezione Carbonara, Fiorano [Modena]). The inscriptions are mentioned by Wilkins, "Donatello's Lost *Dovizia*," 409.

38. It is for this reason that Kauffmann's linking of the *Dovizia* to the angel on the left of Michelozzo's and Donatello's *Tomb of Rainaldo Brancacci* in Sant'Agostino in Nilo, Naples, convinces. The pose of the curtain-bearing angel is only superficially similar to that of *Dovizia;* nonetheless, the similarities between the garments of the two figures draw them closer together (see Kauffmann, *Donatello*, 68–71).

39. See the Casa Buonarroti version.

40. For example, see Warburg, *Gesammelte Schriften*, 1: 13 (*Renewal*, 97); and Janson, *Donatello*, 30. The female figure in the St. George relief was a civic personification, giving bodily form to the people of Cappadocia, whom St. George was liberating from the fiery threat of the dragon.

41. It is curious, in this regard, that Vasari mentions a *putto* cast by Verrocchio as a clapper for the bell of the clock in the Mercato Vecchio; see Wackernagel, *World*, 100, cites Giorgio Vasari, *Le vite,* 3: 375.

42. Wilkins, "Donatello's Lost *Dovizia,*" and Wilk [McHam], "Donatello's *Dovizia.*"

43. See Randolph, "Renaissance Household Goddesses."

44. Kauffmann, *Donatello,* 42: "Er [Donatello] gab das erste Beispiel der später so zahl-reichen 'Floren,' der bei den Quattro-centomalern von Fra Filippo Lippi bis Ghirlandajo und Botticelli beliebten eilen-den Korbträgerinnen mit wehendem Kleid, deren Attribute (Korb, Füllhorn und gegürteter Chiton) und Kontrast zwischen verhülltem und entblößtem Bein letzlich antiker Prägung entstammen." Recently, Patricia Rubin made a similar point: "Programmatically *all'antica, Dovizia* was the first and grandest of the nymphs grac-ing the city and doubtless did much to establish the norms or the expectations for the figure type" (see Rubin and Wright, ed., *Renaissance Florence,* 334; see also Caglioti, *Donatello e i Medici,* 1: 195.

45. Warburg, *Gesammelte Schriften,* 1: 21, 47, 66–67, 82–86, 157–158, 175–176, 182, 289–290, 311, 325, 336–337, 435 (*Renewal,* 65–66, 108, 112–114, 123–124, 134–135, 168, 381–382, 416, 465–466, 542). See also Gom-brich, *Aby Warburg,* 44, 57. See also Weise, "Spätgotisches Schreiten und andere Motive," 163ff.; Viani, "La 'ninfa,'" 265–269; and Forster, "Introduction," in Warburg, *Renewal,* 1–76; 15–21.

46. Winckelmann, *Geschichte,* 167–168.

47. See Contarini, "Botticelli ritrovato," 87–93; and Rampley, "From Symbol to Allegory," 41–55.

48. Wind, *Pagan Mysteries,* 100–120; see also Rubinstein, "Youth and Spring," 248–251.

49. Warburg linked his Florentine nymph to a Roman copy of a neo-Attic sculpture of "Pomona" (in fact, the *Hora of Autumn*) that is only proven to have been known to artists in the sixteenth century (although it could have been known earlier). On the Uffizi *Hora,* see Bober and Rubinstein, *Renaissance Artists and Antique Sculpture,* 94, cat. no. 58.

50. Warburg, *Gesammelte Schriften,* 1: 19: "dass es zwar einseitig, aber nicht unberechtigt ist, die Behandlung des bewegten Beiwerkes zum Kriterium des 'Einflusses der Antike' zu machen" (see *Renewal,* 104, for a slightly different translation).

51. Leon Battista Alberti, *On Painting,* 81. Gombrich, *Aby Warburg,* 57ff., mentions that Springer noted this in relation to the *Primavera* before Warburg.

52. *Leonardo On Painting,* 156–157.

53. He also linked the nymph to dramatic per-formances.

54. "Nympha," folder 118.1–2 of Section IV of Wuttke's listing of the Archives of the Institute; see Warburg, *Ausgewählte Schriften,* 593.

55. Gombrich, *Aby Warburg,* 108.

56. Gombrich, *Aby Warburg,* 123.

57. Ruda (*Fra Filippo Lippi,* cat. no. 55), dates this to the 1460s; more convincingly, Holmes (*Fra Filippo Lippi,* 141–45 and 169) dates it to 1452–53. I find it curious that in this *tondo* the figure next to the *Nympha* is a woman with a young child grasping at her dress. This configuration is very close to what we later see in the terracotta statuettes. Even more intriguing is the presence of a small animal just behind the child. Holmes (274, n. 18) suggests this is a piglet. Musac-chio (*Art and Ritual of Childbirth*) argues that similar creatures are martens. I still cannot but help thinking that this and other beasts like it are ungainly dogs; similar spry canines feature in the terracotta versions of *Dovizia.*

58. A similar figure appears in Lippi's *Birth and Infancy of St. Stephen* in the *cappella mag-giore* of the cathedral of Prato.

59. The *Nympha* appears a second time in the Tornabuoni chapel, again calling attention to fertility. Set just to the right of the embracing Mary and Elizabeth in the scene of the *Visitation,* the basket-bearing, strid-ing figure symbolically echoes the fresco's central theme of pregnancy.

60. On the rites of birthing, see Musacchio, *Art and Ritual of Childbirth.*

61. Gombrich, *Aby Warburg*, 123.

62. For some interesting comments on beauty and mobility, see Rogers, "Sonnets on Female Portraits," 296–7.

63. Bennett and Wilkins, *Donatello*, 71–73, draw attention to this drawing in relation to the *Dovizia*. On this drawing, see Patricia Rubin's entry in Rubin and Wright, *Renaissance Florence*, 334, cat. no. 87.

64. Randolph, "Performing the Bridal Body."

65. The drawing and the statuettes (and perhaps, therefore, the *Dovizia*) might also be understood as referring implicitly to seasonal fertility. A painting by an artist close to Botticelli represents Autumn as a female figure with a basket on her head and a child at her feet (Musée Condé, Chantilly; fig. 1.14); she steps forward with her bounty. Lightbown interprets this painting as an allegory warning against the dangers of inebriation. The abundance of grapes suggests that this is a symbolic rendition of Autumn, but as Lightbown observes (*Sandro Botticelli*, 2: 119–120) the presence of cherries, a Spring fruit, makes the painting's seasonal reference more complex. The female figure bearing a basket on her head could, however, represent Spring. Raphael would include a figure based on the *Dovizia* in his tapestry border of the four seasons, to the right of the Healing of the Lame Man. Here naked, the figure must be identified as "Spring"; see Langedijk, *Portraits of the Medici*, 47–49.

66. On this term, see Rubinstein, "Florentina Libertas."

67. Bober and Rubinstein, *Renaissance Artists and Antique Sculpture*, cat. nos. 169 and 169a.

68. Gramaccini, *Mirabilia*, 206–217, argues that the "Siena Venus" actually represented Diana and can be found today in the Palazzo Borghese in Rome. This means, of course, reading as hearsay Ghiberti's report that the statue was destroyed and buried in Florentine territory. Given that in 1357 Florence and Siena were not at war, this seems justified. For an alternate view, see Johnson, "Idol or Ideal?" 232–33. See also Hinz, "Statuenliebe."

69. For an analogous image, see the *Madonna Ferrara*, an *imagea clipeata* on the façade of that city's cathedral; Uggeri, "Il reimpiego di marmi antichi nelle cattedrali padane," *Nicholaus e l'arte del suo tempo*, 2: 607–36.

70. Cervellini, "I leonini," 251–252.

71. Uberti, *Il Dittamondo*, 2: 15: "Ahi, Verona, cittade ricca e nobile, / Donna e regina de le terre italice, / Formata sopra l'Adice, / Dove virtute e valore s'ingenera . . . / Non fra Tedeschi, né fra gente gallica, non credo che, / Cercando tutta Europia, / Donna si ritrovasse tanto angelica."

72. Cited by Scolari, "Le vicende," 200. See Gramaccini, *Mirabilia*, 248, n. 49.

73. Corna da Soncino, *Fioretto*, fol. 48; cited and discussed by Gramaccini, *Mirabilia*, 227.

74. Baskins, "Trecento Rome."

75. *Convivio*, 1.3. On the trope of Florence as the daughter of Rome, see Weinstein, *Savonarola and Florence*, 40.

76. Baron, *Crisis*, 47–78.

77. Giovanni Gherardo da Prato, in Lanza, ed., *Lirici toscani*, 1: 663.

78. For these views, see Wilkins, "Donatello's Lost *Dovizia*," 406–408.

79. Wilkins, "Donatello's Lost *Dovizia*," 414.

80. For the approximate height of the *Dovizia*, see Wilkins, "Donatello's Lost *Dovizia*," 406.

81. Pucci, "Le proprietà di Mercato Vecchio," 267–274.

82. *Annales Cerretani*, cited in Gutkind, *Cosimo de' Medici*, 53; Brucker, *Renaissance Florence*, 58: "Moneychangers who maintained their tables in the Mercato Vecchio were under the jurisdiction of the Cambio guild, but their fellows who lived and traded outside the city were exempt from the guild's control."

83. Brucker, *Renaissance Florence*, 23–24. Later, under the scions of Giovanni di Bicci, this center was to shift north toward San Lorenzo. But the Medici still patronized San Tommaso. It was probably they who hired Paolo Uccello to paint *The Incredulity of Saint Thomas* on its façade (see Borsi and Borsi, *Uccello*, 334–336. John Paoletti (". . . ha fatto Piero," esp. 233 and 247,

n. 57) mentions that the Medici owned "extensive property holdings in the area of the Mercato Vecchio throughout the Quattrocento," and that the 1395 wake of Vieri di Cambio de' Medici took place in the piazza.

84. Pucci, "Le proprietà di Mercato Vecchio," 269.

85. Pucci, "Le proprietà di Mercato Vecchio," 267–74; trans. and cited in Brucker, *Renaissance Florence*, 41; for a new translation see Dean, *Towns*, 121–124. Kauffmann, *Donatello*, 41, had already noted the connection between Pucci's verses and the *Dovizia*: "Antonio Pucci hat 1373 den Mercato Vecchio als das Herz, den Inbegriff von Floren, besungen, wo sich die Früchte häuften und die Blumen stapelten. Ein Wahrzeichen dieses blühenden Marktes und Marktes der Blüten, ein Sinnbild des Wohlstandes der ganzen Stadt errichtete Donatello gegen Ende der zwanziger Jahre in dem Steinbild der 'Dovizia,' mit einem Früchtefüllhorn im Arm und einem Blumenkorb auf dem Kopf." Migliore, *Firenze*, 514f., saw the *Dovizia* as a symbol of the market, and all the markets of the city. See too Bocchi and Cinelli Calvoli, *Le bellezze*, 215; and Wilkins, "Donatello's Lost *Dovizia*," 403.

86. Lanza, *Lirici toscani*, 1: 95–96: "Fra tanti gnaffi e mai frazzi trascorsi, / siamo en fatti con detti assai aguagliati, / e in Mercato Vecchio aviluppati / tra ceste e gabbie, uccellin, cosce e torsi. / In piazza istretti siam fra i calci e' morsi, / poi ringraziàn ch ci ha me' calpestati; / tutti gli andirivien si son provati, / né giova infine ai fatti contrapporsi. / E se già di memoria util fu l'arte, / oggi il dimenticar d'assai l'avanza, / posto che 'l Nici ai più lo 'nsegni in parte. / Chi non intende il suon non entri in danza, / perché chi non va a tempo, o nol comparte, / manca l'onore e perde ogni sustanza. / Vuolsi aver temperanza, / tirare accosto e guardar dalle colte, / perché non ci si torna poi due volte."

87. For the brothels, see Mazzi, *Prostitute e lenoni;* and Trexler, "Florentine Prostitution," 39–41. For the reputation of the via

de' Pellicciai, see Rocke, *Forbidden Friendships*, 154.

88. Beccadelli (Il Panormita), *Hermaphroditus*, book 2, chap. 37; cited by Trexler, "Florentine Prostitution," 39–40.

89. Habermas, *Structural Transformation of the Public Sphere*, 9.

90. Henri Lefebvre, *Production of Space*.

91. On the statue of Mars, which in the Middle Ages was to be found on, or near, the Ponte Vecchio, see Davidsohn, *Geschichte*, 1: 559–560 and 748–752; Haftmann, *Das italienische Säulenmonument*, 124–151; Davis, "Topographical and Historical Propoganda"; Gatti, "Il mito di Marte."

92. On the play between the body and the city see Grosz, "Bodies-Cities."

93. Lefebvre, *Production of Space*, 220.

94. Dati, *L'Istoria di Firenze*, 153: "Gli Uficiali della torre hanno a mantenere e migliorare ponti e mura della città e contado e fare racconciare i lastrichi delle vie quando sono guasti e provvedere per di fuori per lo contado le strade e i ponti istieno in modo si possino usare."

95. Brucker, *Renaissance Florence*, 30. For earlier interventions, see Wilkins, "Donatello's Lost *Dovizia*," 414.

96. Brucker, *Renaissance Florence*, 137.

97. Brucker, *Renaissance Florence*, 138.

98. Cited by Brucker, *Civic World*, 368.

99. See also Francesco Machiavelli (1425): "Quod omnes putant certo res esse quod pecunia nostra est defensio et in ea consistit nostra salus (Because they all think things to be stable, because our money is [our] defense and our weal depends on it.)" Cited by Brucker, *Civic World*, 463, n. 313.

100. Wilkins, "Donatello's Lost *Dovizia*," 422, does link the *Dovizia* to the general financial structure of the Florentine state in the first three decades of the fifteenth century, mentioning, specifically, the *catasto*.

101. On the Ciompi rebellion, see Scaramella, *Firenze;* Rodolico, *I Ciompi;* Brucker, "The Ciompi Revolt"; *Il tumulto dei Ciompi;* Cohn, *Labouring Classes;* Piper, *Der Aufstand der Ciompi;* and Stella, *La révolte des Ciompi*.

102. Baron, *Crisis*.

103. Robbia, "Valori."

104. On Florence's territorial expansion and its political ramifications see Becker, *Florence in Transition;* Becker, "The Florentine Territorial State"; Herde, "Politische Verhaltensweisen"; Molho, "Politics and the Ruling Class"; Molho, *Florentine Public Finances;* Witt, "Florentine Politics"; Brucker, *Civic World;* Guidi, *Il governo della città-repubblica;* Najemy, *Corporatism and Consensus.*

105. Cited in Brucker, *Renaissance Florence,* 168.

106. Gutkind, *Cosimo de' Medici,* 57–58.

107. On the definition of the *gente nuova,* or *novi cives,* see Becker, "An Essay on the 'Novi Cives.'"

108. Cavalcanti, *Istorie fiorentine,* bk. 3, ch. 2, 46–54. For commentary on Cavalcanti's report see D. Kent, *Rise of the Medici,* ch. 3; Brucker, *Civic World,* 473–481; Gutkind, *Cosimo de' Medici,* 56–57; Bayley, *War and Society,* 111–112; Brown, "The Guelf Party," 44. Rinaldo degli Albizzi had already aired the idea of a *catasto* in 1422. Legislation had been proposed and had been defeated a number of times before the meeting in Santo Stefano.

109. D. Kent, *Rise of the Medici,* 223–224.

110. Brucker, *Civic World,* 478.

111. Brucker, *Civic World,* 479.

112. Recent scholarship has questioned the profundity of Bruni's republicanism. See, especially, Herde, "Politik und Rhetorik"; see Seigel, "'Civic Humanism' or Ciceronian Rhetoric?" (and Baron's response, "Leonardo Bruni"); Herde, "Politische Verhaltensweisen"; Hankins, "'Baron Thesis'"; and Fubini, "La rivendicazione di Firenze."

113. On the *catasto* see above.

114. It is telling that this unity was also wrought through anti-Semitism; in 1427 the ban on Jews was renewed in the Florentine state. See Molho, *Florentine Public Finances,* 39.

115. Brucker, *Civic World,* 444.

116. Brucker, *Civic World,* 482.

117. Brucker, *Civic World,* 485, n. 57: "Cessabunt societates et simulaciones et potencium civium clientela et querele multorum qui ad hostium continue clamant."

118. Brucker, *Civic World,* 481.

119. D. Kent, *Rise of the Medici,* 241: "The series of major *pratiche* on unity held at frequent intervals throughout 1429–30 demonstrates that the party divisions within their ranks were increasingly becoming a cause of serious anxiety to the citizens of the *reggimento* concerned with the good of the commune."

120. *Consulte e Pratiche* 48, 51r; cited by D. Kent, *Rise of the Medici,* 242.

121. *Consulte e Pratiche* 48, 54v; cited by D. Kent, *Rise of the Medici,* 243.

122. D. Kent, *Rise of the Medici,* 244.

123. Brucker, *Civic World,* 482: "[The Signoria] desirous that those things which customarily were done for the magnificence of the people of Florence, not be lacking to the city on account of negligence."

124. Brucker, *Civic World,* 472.

125. *Humanism of Leonardo Bruni: Selected Texts,* ed. Griffiths, Hankins, and Thompson, 127.

126. Simmel, *Philosophie des Geldes,* 15.

127. On the personification of Florentia see Moseley, *"Lady";* Welliver, *L'impero fiorentino,* 41–52; Bergstein, "Marian Politics."

128. For some examples, see Flamini, *La lirica toscana,* 55, 85, 139, 161; and Lanza, *Lirici toscani,* 1: 116, 165, 651, 663; 2: 49, 83–87, 96, 131, 308–311, 338–339, 401, 409, 584, 598, 661–663. For a more detailed discussion of the personification of Florence, see Chapter Two.

129. For Latini, see *Raccolta di rime antiche toscane,* 1: 12. For Boccaccio, see Singleton, *Canti carnascialeschi,* 131–32. For Fazio, see Weinstein, "The Myth of Florence," 40 and 47.

130. See Martines, "The Politics of Love Poetry"; and his "Poetry as Politics."

131. *Rime di trecentisti minori,* ed. Volpi, 141–143.

132. MS Riccardiano 683, M.4.33, rubric 11, "Canzone in lode della Signoria di Firenze: canzone morale fatta a commendatione de' Signori priori e del gonfaloniere della giustizia e de' gonfalonieri di chompagnia e de' dodici buoni huomini loro collegi deputati al governo della gloriosa città di Firenze," 194v–198r: "Eccelenti signori e gloriosi /

padri e governator di questa donna, / è piena di virtù e d'eccelenza, / diritti guidatori a' suoi riposi, / e della libertà reina e donna, / a cui Italia porta reverenzia, / voi siete il frutto della sua semenza." Quoted and discussed by Flamini, *La lirica toscana*, 214–15. See also Guido del Palagio, "A Fiorenza," in *Rime di M. Cino da Pistoia*, ed. Carducci, 597–600: "O donna bella mia! O bel paese! / O soli, o gigli, o perli, o fiordaliso! / lo triemo tutto per la gelosia / Di te Madonna mia, / che tu non cresca sempre la tua insegna. / Ma colui ti sovvegna / Che tutto regge, e di te s'innamori / Si che Fiorenza sempre si rinfori."

133. MS Riccardiano 683, 195r and 195v.

134. The verses were published by Canestrini, ed., "Versi," 297–300; see also Lanza, *Lirici toscani*, 2: 661–63. For a discussion of the poem and its political context, see D. Kent, *Rise of the Medici*, 211–14; Brown, "The Guelf Party," 44–45; and Martelli, "La canzone di Francesco d'Altobianco degli Alberti." For an analysis of the poem's supposed latent homoerotic references, see Smith, "Fraudomy," 93–94.

135. Canestrini, "Versi," 297: "Antichi amanti della buona e bella, / Magnificata dalle vostre spese, / Tanto che tutto 'l mondo ne favella; / Lasciate omai passar vostra contese, / Che avete fatte per farvi maggiori / Della sua corte e del suo bel paese."

136. Canestrini, "Versi," 297: "Se non lo fate, tosto con dolori / Sarete spinti fuor della sua sala / Da genti nuove e vostri debitori."

137. Canestrini, "Versi," 297: "Adunque, antica e valorosa gente, / Ponete giù al tutto vostre gare, / E fate fra vo' pace prestamente. / E non lasciate più in alto montare / L'orogoglio dell'ingrate e nuove genti, / Che voglion vostra donna trasmutare."

138. Smith, "Fraudomy." See Chapter Four for a more detailed discussion of sodomy in Florentine fifteenth-century culture.

139. Canestrini, "Versi," 297: "Fate ogni legge sempre non sia vana . . . questa donna pia / Non sia baciata da gente villana." On "quella donna Veneziana," and her associations with Iustitia, see Wolters, *Bilderschmuck des Dogenpalastes*, 236–246;

Rosand, "*Venetia Figurata*," 177–196; and Goffen, *Piety and Patronage*, 138–141.

140. Bocchi and Cinelli Calvoli, *Le bellezze*, 215: "E quivi sopra una Colonna di granito situata una statua di pietra bigia maggiore del naturale rappresentante la Dovizia: E questa di mano di Donatello, vaghissima nella sua positura; ha in capo un cesto di frutta, et ha un ginocchio nudo la cui morbidezza è tale, che di vantaggio desiderar non si può. . . ." (cited in Wilkins, "Donatello's Lost *Dovizia*," 403). Wilkins (422) also uses language that suggests the statue's erotic content: "Donatello's *Dovizia*, with her invigorating movement and seductive beauty. . . ."

141. See Martelli, "La canzone."

142. Hind, *History of Woodcut*, 1: 555, fig. 313.

143. Palmieri, *Vita civile*, ed. Belloni, 157–58. Also published in Battaglia, ed., *Palmieri/Sacchi*.

144. See also Alberti, *Della famiglia*, 133.

145. See Fabbri, *Alleanza matrimoniale*.

146. Marvin Becker captures some of the ethos of this relation and its realization in the novel monumental art of Florence; see "The Florentine Territorial State," 138: "Myth and reality had blended, and while one could not be substituted for the other, each would lose meaning without its counterpart. Art and literature ministered to that twilight zone where ideal and real converged. It was in the area of this ambiguity that civic rhetoric gained cogency and the civic humanists acquired an audience. Patriot and egoist, the Florentine citizen desired to believe in the durability of the polis. His patrimony, the dowry of his daughter, and thus his progeny were hostages to the well-being of the state. Exactly at this time emerges the first great profusion of civic monumental art since the times of ancient Greece and Rome."

147. Trexler, *Public Life*, 379–80.

148. Rocke, *Forbidden Friendships*.

149. Trexler, *Public Life*, 380; citing Brucker, *Renaissance Florence*, 181.

150. Rocke, *Forbidden Friendships*, 78.

151. For some fascinating remarks on the "feminizing" of land, see McClintock, *Imperial*

Leather, 24: "As the visible trace of paranoia, feminizing the land is a compensatory gesture, disavowing male loss of boundary by reinscribing a ritual excess of boundary, accompanied, all too often, by an excess of military violence. The feminizing of the land represents a ritualistic moment in imperial discourse, as male intruders ward off fears of narcissistic disorder by reinscribing, as natural, an excess of gender hierarchy."

Chapter Two: Florentia Figurata
Epigraph: Cited in Gutkind, *Cosimo de' Medici*, 129.

1. Gierke, *Political Theories;* Lewis, "Organic Tendencies"; Chroust, "Corporate Idea"; Kantorowicz, *King's Two Bodies;* Hale, *Body Politic;* Struve, *Entwicklung;* Peil, *Untersuchungen*, 302–488. On the Renaissance in particular, see Archambault, "The Analogy of the Body." On Italy in particular, see Najemy, "The Republic's Two Bodies."

2. On the trope of personification, see Paxson, *Personification*.

3. Marks, "The Financial Oligarchy," 127: "il cuore di questo nostro corpo, che si chiama città . . . ogni membro picholo et grande contribuischa quanto commodamento ciaschuno può alla conservacione di tutto il corpo."

4. This, despite what would appear to be the opinion of those outside the field; see, for example, Mary Hollingsworth's eye-opening statement in the introduction to her *Patronage in Renaissance Italy*, 5: "To the modern art historian, concerned with tracing stylistic change in art and architecture, the prime importance of these works is aesthetic."

5. On the problem of patronage in general see Settis, "Artisti e committenti"; F. W. Kent and Simons, ed., *Patronage, Art, and Society;* Weissman, "Taking Patronage Seriously"; Haskell, *Patrons and Painters;* Gundersheimer, "Patronage in the Renaissance"; Burke, *Culture and Society*.

6. On clientelism see Kettering, "Political Clientelism"; Klapisch-Zuber, "Compérage et clientélisme"; Molho, "Patronage and the State"; see also Gellner and Waterbury, ed., *Patrons and Clients*.

7. Baxandall, *Painting and Experience*. For *some* commentary on Baxandall's contribution to the history of art, see the special issue of *Art History* 24, no. 4 (1998).

8. Three works that I have found particularly stimulating in this regard are: Baxandall, *Patterns of Intention;* Pollock, *Vision and Difference;* Clark, *Painting of Modern Life*.

9. Arasse, "L'art et l'illustration."

10. Francastel, *La réalité figurative;* and Francastel, *Études de sociologie*.

11. The title of this chapter derives from David Rosand's seminal article, "*Venetia Figurata*." In that essay, Rosand traces the lively tradition in the visual arts of personifying the most serene republic as a woman: Venetia. Moreover, he posits this visual personification as a central image of that state's iconographical "self"-presentation. Rosand's Venetia belongs, in fact, to an expansive pantheon of civic personifications. Rendered invisible by its ubiquity, this political trope was, for the most part, a literary phenomenon. Nonetheless, as Rosand's investigation reveals, visual renditions did exist and exerted a palpable influence on the imagery of statehood emerging in early modern Europe. See also Carroll, "Machiavelli's Veronese Prostitute," esp. 97–99.

12. Brucker, "The Medici in the Fourteenth Century."

13. On the Ciompi revolt, see Chapter One, n. 101.

14. Guicciardini, *Del reggimento di Firenze*, 34, 64, 97; quoted in Reumont, *Lorenzo de' Medici*, 1: 245.

15. Roover, *Medici Bank*, 35–52; and Holmes, "How the Medici Became the Pope's Bankers."

16. D. Kent, "Florentine *Reggimento*," 608, n. 150: Giovanni di Bicci de' Medici declared 79, 492 florins, Palla Strozzi, 101, 422.

17. Goldthwaite would have F. W. Kent place a little more stress on the economic relations that produced factions; see, for example, Goldthwaite, "Medici Bank." On the social

categories of "friends, relatives, and neighbors" see Klapisch-Zuber, "'Parenti, amici, vicini"; D. Kent, *Rise of the Medici;* F. W. Kent, *Household and Lineage,* 3–17 and 227–293. On Cosimo de' Medici's social "networking," see also Molho, "Cosimo de' Medici." Other useful accounts of Cosimo's cultural activities are: Brown, "Humanist Portrait"; Jenkins, "Cosimo de' Medici's Patronage"; Rubin, "Magnificence and the Medici"; Paoletti, "Cosimo de' Medici"; and, now especially, D. Kent, *Cosimo de' Medici.*

18. Padgett and Ansell, "Robust Action"; see also Rubinstein, "Florentine Constitutionalism."

19. In this they explicitly follow Samuel Cohn (*Labouring Classes*), who argues that during the late fourteenth and early fifteenth century the entire patriciate developed city-wide marital affines, disturbing the traditional structures provided by the neighborhood, parish, and quarter.

20. Cosimo was initially banished for only five years (11 September); a few days later this was increased to ten years.

21. Gutkind, *Cosimo de' Medici,* 79.

22. Gelli, "L'esilio di Cosimo de' Medici"; see also D. Kent, "I Medici in esilio."

23. Guicciardini, *Del governo di Firenze,* 262: "Così lo stato che nel 1434 venne in mano de' Medici, non parse tolto al popolo, ma a uno Messer Rinaldo degli Albizzi, a uno Messer Palla Strozzi et altri simili particulari, ed anche de' Medici non rimasono assolutamente padroni di ogni cosa, ma con qualche compagno."

24. Rubinstein, *Government of Florence;* see also Gutkind, *Cosimo de' Medici.*

25. Guicciardini, *Del reggimento di Firenze,* 34, 64, 97, quoted in Reumont, *Lorenzo de' Medici,* 1: 245.

26. The following description of the Medici ascendancy is indebted to Dale Kent's searching study, *Rise of the Medici.*

27. I am thinking here of the re-evaluation of Leonardo Bruni's literary works in light of recent debates about the nature of what Hans Baron labeled "Civic Humanism"; for some recent responses to Baron's argu-

ments, see Chapter One, n. 18. For an attempt to understand the function of Civic Humanism with the Medici ascendancy, see Mark Jurdevic, "Civic Humanism."

28. D. Kent (*Cosimo de' Medici*) seems to oppose Gombrich's method on this point, but her characterization of Cosimo's patronage as comprising an "oeuvre" seems to share some of Gombrich's fundamental assumptions.

29. For a critique of the earlier tradition of seeing patronage as an individual activity, see Bullard, "Heroes and Their Workshops."

30. Langedijk, *Portraits of the Medici,* 1: 38: "It has rightly been remarked that the absence of portraits on the tombs of the family evinces a reticence aimed at the avoidance of giving offence, but in the case of portraits meant as mementos in the family circle there was no reason for such reticence." See Bode, *Italienische Bildhauer der Renaissance,* 266.

31. For general overviews of Medicean patronage see Wackernagel, *World,* 220–251; E. H. Gombrich, "Early Medici," esp. 281ff.; Paoletti, "Fraternal Piety and Family Power"; and the same author's "Familiar Objects"; Francis Ames-Lewis, ed., *Early Medicean;* and D. Kent, *Cosimo de' Medici.* For a representative sampling of the recent flood of specific studies of Medici patronage, see Ames-Lewis, ed., *Cosimo "il Vecchio" de' Medici;* Beyer and Boucher, ed., *Piero de' Medici;* Gnocchi, "Le preferenze artistiche di Piero di Cosimo de' Medici"; Heintze, Staccioli, and Hesse, ed., *Lorenzo der Prächtige;* Mallett and Mann, ed., *Lorenzo the Magnificent;* and F. W. Kent, "Patron-Client Networks."

32. Bandmann, "Bermerkungen"; cited by Beyer, "Funktion und Repräsentation," 165, n. 19.

33. Pontano, *I trattati delle virtù sociali,* "De magnificentia," 101.

34. Gombrich ("Early Medici," 285–286) discusses Timoteo Maffei's Latin dialogue "In magnificentiae Cosmi Medicei Florentini detractores." See also Jenkins, "Cosimo de' Medici's Patronage"; and D. Kent, *Cosimo de' Medici.*

35. Janson, *Donatello*, 59–65; Rosenauer, *Studien zum frühen Donatello*, 53–68; and Lightbown, *Donatello and Michelozzo*, 24–51; Giusti, "Due interventi su marmi donatelliani"; and McHam, "Donatello's Tomb of John XXIII," 146–242.

36. The painted monuments of Sir John Hawkwood and of Niccolò da Tolentino commissioned decades later, from Paolo Uccello and Andrea del Castagno respectively, demonstrate a similar form of patronal strategy. The Medici stood in the reflected glory of these feted *condottieri*. See Wegener, "'That the Practice of Arms.'"

37. Hatfield, "Compagnia de' Magi"; Beyer, "Der Zug der Könige"; Acidini Luchinat, "La cappella Medicea"; Cardini, *I re magi*; Hatfield, "Cosimo de' Medici and the Chapel of His Palace"; Acidini Luchinat, *Chapel of the Magi*; Ahl, *Benozzo Gozzoli*; and D. Kent, *Cosimo de' Medici*, 305–328.

38. For a Neoplatonic reading of the magi, see Chastel, *Art et humanisme*, 245–248.

39. It is telling, however, that the Medici could appear as the Magi in an altarpiece commissioned by a supporter, Girolamo della Lama; see Hatfield, *Botticelli's Uffizi "Adoration."*

40. Piccolomini, *Comentarii*, 107.

41. Hyman, *Fifteenth-Century Florentine Studies*; Tönnesman, "Zwischen Bürgerhaus und Residenz"; Gombrich, "Early Medici," 287: "It is hardly fanciful to feel something of Cosimo's spirit in the buildings he founded, something of his reticence and lucidity, his seriousness and his restraint." See also, D. Kent, *Cosimo de' Medici*, 215–238.

42. Guicciardini, *Del reggimento di Firenze*, 34, 64, 97, quoted in von Reumont, *Lorenzo de' Medici*, 1: 245.

43. Graham Pollard aired the notion that, on account of the clumsiness of the reverse of Lorenzo's medal, it could not have been commissioned by the sitter; see Scher, ed., *Currency of Fame*, 132–134.

44. Filarete, *Treatise on Architecture*, 1: 316.

45. Friedlaender, *Schaumünzen*, 4. Although most medals were cast in bronze (or lead), the most prized versions were surely either cast in, or gilded with, precious metals. On the storage and display of medals, see Arne Flaten, "Identity and the Display of *Medaglie*."

46. Some medallists reused medal reverses. These therefore do possess a certain independence from their obverses.

47. Hill, *Corpus*, 1: 237, 236–238, cat. nos. 909 and 910; 910bis is probably an aftercast of a later version. For other treatments of these medals, see Supino, *Il medagliere mediceo*, n. 20–21; Friedlaender, *Schaumünzen*, 140–45; Middeldorf and Goetz, *Medals and Plaquettes*, n. 93; *Medaglie del Rinascimento*, n. 123; Hill and Pollard, *Renaissance Medals*, n. 245–47; Ciardi-Dupré dal Poggetto, "Un'ipotesi," 45, n. 17; Winner, "Cosimo il Vecchio als Cicero"; Kliemann, *Politische und humanistische Ideen*, 25–30; Hill and Pollard, *Medals of the Renaissance*, 316, 322, n. 90; Langedijk, *Portraits of the Medici*, 1: 15–17, 398–99, n. 26–9; Middeldorf and Striebral, *Renaissance Medals and Plaquettes*, n. XXXV; Pollard, *Medaglie italiane*, 16; Lorenzi, *Medaglie di Pisanello*, 70–3, cat. nos. 42 and 43; *Italian Renaissance Sculpture in the Time of Donatello*, 167, cat. no. 51; Börner, *Die italienische Medaillen*, 94, cat. no. 353–55. For recent assessments of the iconography, see Paoletti, "Familiar Objects," 99–100; D. Kent, *Cosimo de' Medici*, 375–376; and Leuker, "Numismatische Variationen." In a forthcoming article, Arne Flaten argues that Hill, no. 909, may be by Verrocchio.

48. See Hill, *Corpus*, 1: 237 quoting Müntz, *Histoire de l'art*, 1: 701; see also Heiss, *Les médailleurs*, 1: 21; *Italian Renaissance Sculpture in the Time of Donatello*, cat. no. 51 (attributed to an anonymous artist); Avery, *L'invenzione dell'umano*, 106–107 (ascribed to Donatello); Avery, *Donatello*, 146, cat. no. 83. Middeldorf thought it might have been by Bertoldo. Hill and Pollard, *Renaissance Medals*, no. 246 (close to Niccolò Fiorentino); Pollard, *Medaglie italiane*, 16, 27, no. 8 (close to Niccolò Fiorentino); Ciardi-Dupré dal Poggetto, "Un'ipotesi," 22–24, 29 (Niccolò

Fiorentino). Langedijk (*Portraits of the Medici*, 1: 15–17) questions whether the reverse is contemporary. Since Alison Brown ("Humanist Portrait") revealed that Cosimo was called *pater patriae* quite often already before his death, it is not impossible that the medal ought to be dated earlier; see also D. Kent, *Cosimo de' Medici*, 19. In this regard it is curious that Paolo Giovio, writing in the sixteenth century, seemed sure that the medal was cast immediately after Cosimo returned from exile in 1434 (*Dialogo dell'imprese*, 62).

49. Spallanzani and Gaeta Bertelà, ed., *Libro d'inventario*, 23v. The medal, with some other items, was appraised at 12 florins.

50. Hill, *Corpus*, 1: 238, remarks that both Heinrich Meyer and Goethe ascribed versions of the medal to Donatello. In the twentieth century, the medals are usually ascribed to Niccolò Fiorentino or to the "Florentine School."

51. Goethe wrote of Hill, no. 909, that this "work is quite extraordinarily masterly and bold; at the first glance, it is true, the portrait seems sketchy and hastily designed; on closer inspection, however, it is wonderfully ingenious, full of meaning, and complete in every part." Cited in Cornelius von Fabriczy, *Italian Medals*, 117.

52. Pope-Hennessy, *Portrait*, 64–84; Pope-Hennessy, *Introduction to Italian Sculpture*, part 2, 45–52; Lavin, "Portrait Bust"; Schuyler, "Florentine Busts"; Zuraw, "The Medici Portraits"; Marek, "'Virtus' und 'fama.'"

53. Trapesnikoff, *Porträtdarstellungen der Mediceer*, 15–16; Andrew Butterfield does not include it in his recent monograph on the artist; its attribution, therefore, would appear to be up for discussion.

54. Winner, "Cosimo il Vecchio"; and Marek, "'Virtus' und 'fama'"; see also her "Donatellos *Niccolò da Uzzano*."

55. A second, possibly earlier example possesses the inscription MAGNVS COSMVS MEDICES P P P.

56. Feo Belcari hailed Cosimo as the father of his country before 1464: "Padre della tua patria inclita e degna, / conservator de' templi e luoghi santi" (Lanza, *Lirici toscani*,

1: 227); Brown, "Humanist Portrait," 190, n. 20, quotes Antonio Pacini's 1440 funeral oration for Lorenzo di Giovanni de' Medici, Florence, Bibliotheca Riccardiana, MS 928, 4v: "Itaque si a romanis Camillus et M. Cicero patres patriae appellari meruerunt: quod alter armis hostes ab urbe propulsavit; alter consilio libertatem conservavit; quid est quod non eodem nomine Laurentium appellare debeamus qui hostes consilio et facultatibus suis iam libertate huis reip. fere labente ab ipsis portis expulit." Brown (n. 21) also cites Francesco Filelfo (1440) Florence, Biblioteca Laurenziana, MS Strozziane 105, 18v: "Sj malueris patriae exules cives restituere quam id pertinacius expectare ut patriam ipsi pristinae libertati dignitatique restituant, tum eris sane adversantibus nullis in republica princeps, tum pater patriae appellaberis. Tum omnes te colent, omnes admirabuntur." For the government decree bestowing the title *pater patriae* on Cosimo, see McKillop, "Dante and *Lumen Christi*," 291–301. See also McManamon, "Continuity and Change," esp. 76–77.

57. On the political significance of the title *pater patriae*, see Skard, "Pater Patriae"; and Alföldi, "Die Geburt der kaiserlichen Bildsymbolik." See also Winner, "Cosimo il Vecchio," 273. The appellation *pater patriae* was bestowed upon Cicero and Camillus; moreover, Luca de Penna discussed Lucan's description of Cato as *pater urbi*. See *Pharsalia*, 2. 326ff.

58. On the aptness of the "patriarchal" metaphor, see D. Kent, *Cosimo de' Medici*, 135.

59. In this sense the portrait medal is a type of *impresa*. See Klein, *Form and Meaning*.

60. Paoletti, "Familiar Objects," 99.

61. Tervarent, *Attributs et symboles*, 225. Giovio mentions that the yoke was a symbol of Cosimo "il Vecchio," basing this claim on a version of the medal reverse (*Dialogo dell'imprese*, 61–62).

62. Cox-Rearick, *Dynasty and Destiny*, 36–40.

63. For a later use of this topos, see Crum, "Cosmos, the World of Cosimo." For an alternate explanation of the object, see Leuker, "Numismatische Variationen."

64. The best surviving version in London (British Library MS Royal 6E IX) can be dated shortly after the accession of Benedict XII in 1334. Degenhart and Schmitt (*Corpus*, section 1, *Süd- und Mittelitalien*, 1: 55–56) proposed that the illustrations were the work of a Neapolitan artist; Bologna, *I pittori alla corte angioina*, 353. Offner (*Corpus of Florentine Painting*, section 3, 6: 213–16) thought that the painter was close to Pacino di Bonaguida; this is generally accepted today; see also Chelazzi Dini, "Osservazioni sui miniatori del Panegirico." For convenience, consult the facsimile edition: Convenevole da Prato, *Regia carmina*, 71: "Filia sum Rome: pro se loquor ac ego pro me, / et credor vere Florentia nomen habere. / Romani flores me construxere priores / menibus et mustis et me cinxere venustis: / nunc infelicis queror ex dampnis genitricis. . . . Io sono figlia di Roma: io parlo per esse come per me, / e si crede che con ragione io abbia nome Fiorenza. / I fiori romani me fondarono per primi / e me cinsero di mura e nuove e belle: / ora me lamento per le sciagure dell'infelice genitrice." See also the important contributions by Saenger, "Das Lobgedicht"; and Sonnay, "La politique artistique." The other manuscript versions are in Vienna (Nationalbibliothek, MS Ser. n. 2639) and Florence (BNCF, MS Codice rara no. 38, 13); for the latter see Frugoni, "Convenevole da Prato."

65. On Florence as "parva Roma" see Langedijk, *Portraits of the Medici*, 1: 49 (for Villani and Dante); Rubinstein, "The Beginnings of Political Thought," 201–217.

66. Bergstein, "Marian Politics."

67. Hinks, *Myth and Allegory*, 67–68. See also Gardner, "Cities and Countries"; Toynbee, *Hadrianic School*, 7ff.; Borromeo, "Tyche-Fortuna," 79–84; Dohrn, *Tyche von Antiocha;* and Hambdorf, *Griechische Kultpersonifikationen.*

68. Hinks, *Myth and Allegory*, 67: "To the ancient mind, cities were not mere conglomerations of buildings, inhabited by people who had come together for economic reasons; they were divine beings with an immortal conscious personality, capable of assuming a corporeal shape. It was therefore perfectly natural that they should appear in art, not only as isolated personifications, but also in a mythical context, associated with gods and heroes and even historical personages."

69. Shelton, "Imperial Tyches," 28–29.

70. On the personification of Rome and the appearance of Roma (*Thea* or *Dea Roma*) on Roman coinage see Vermeule, *Goddess Roma* and Stevenson, Smith, and Madden, ed., *Dictionary of Roman Coins*, s.v. "Roma," 692ff. On the worship of the civic personification see Fayer, *Il culto della dea Roma*, esp. 107–184; and Mellor, *Thea Rhome*, esp. 207–235.

71. Kunsthistorisches Museum, Vienna. For a recent study, see Pollini, "Gemma Augustea," 258–298.

72. Bober and Rubinstein, *Renaissance Artists and Antique Sculpture*, no. 168.

73. This type of personification was rampant. Roma appeared repeatedly on Roman coins and extended the Eastern tradition of the *tyche* into the iconography of the late Empire. In fact, the two traditions, of the Hellenistic *tyche* and the Roman cult of Roma, existed side by side, for the former never entirely died out. Still in the fourth, fifth, and sixth centuries, one finds small *tyches* representing city-states, and especially Constantinople. See Weitzmann, ed., *Age of Spirituality: Statuette of the Tyche of Constantinople*, Roman Gaul?, fourth–fifth century C.E., bronze (New York, Metropolitan Museum of Art); Roman and Constantinopolitan Diptych, late fifth–early sixth century C.E., ivory (Vienna, Kunsthistorisches Museum).

74. Warner, *Monuments and Maidens*. See also the collection of essays Schade, Wagner, and Weigel, ed., *Allegorien und Geschlechterdifferenz*, and particularly Weigel's contribution, "Von der 'anderen Rede.'"

75. The inscription on Polo's medal reads COSMVS . MED . FLORE . DVX . II. See Langedijk, *Portraits of the Medici*, 1: 500, cat. no. 27, 164.

76. SALVS PVBLICA appears on Bertoldo's medal

76. of Lorenzo commemorating his survival of the Pazzi Conspiracy. See Hill, *Corpus*, no. 915. The expression means both "health of the statue" or "public weal," while also referring to the public goods secured by the Roman health goddess Salus.

77. Ep. VII, 7; see Rubinstein, "The Beginnings of Political Thought."

78. The *Chronica de origine civitatis* claimed that Florence evolved "de flore hominum Romanorum" (see Weinstein, *Savonarola and Florence*, 36). The political bases for this imagery were discussed by Nicolai Rubinstein in "The Beginnings of Political Thought." The trope (of Florentia as the daughter of Roma) appears repeatedly in fifteenth-century Florentine poetry: for some examples, see Lanza, *Lirici toscani*, 1: 165 (Antonio da Castello San Niccolò); 1: 663 (Giovanni da Prato); 2: 84 (Antonio di Meglio); 2: 310 (Bonaccorso Pitti).

79. Giovio, *Dialogo dell'imprese*, 62: "Fiorenza assettata sopra una sedia col giogo sotto i piedi, per denotare quasi quel detto di Cicerone: *Roma patrem patriae Ciceronem libera dixit*." Gutkind's summation (*Cosimo de' Medici*, 123) is telling: "Florence was for Cosimo a somewhat larger family and home. Acording to the unwritten and incomprehensible laws which dignity, greatness, power, reticence, and, above all, love confer, Cosimo ruled in the house and family of Florence, just as he did in the microcosm of his private Medicean family, *as a respected patriarch*."

80. Poliziano, *Stanze*, bk. 2, 3.

81. Friedlaender (*Schaumünzen*, 5) mentions some examples of collectors committing their medals to the melting pot.

82. Florence, Galleria degli Uffizi, Inv. 1890, no. 1488. For a review of the literature on this painting, see Lightbown, *Botticelli*, 2: 33, cat. no. B22. On the related painting, see Stapleford, "Botticelli's Portrait"; and Christiansen, "Botticelli's Portrait," 744. See also Cahn, "Eine Münze und eine Medaille." The impression set into the painting is of Hill, *Corpus*, cat. no. 909, a medal closely related to fig. 2.1 (Hill, *Corpus*, cat. no. 910).

83. Bode, "Florentiner Medailleur."

84. On the problems of attribution see Hill, *Corpus*, 1: 237–8, nos. 909–910; and von Bode, "Florentiner Medailleur," 1–2.

85. Horne, *Botticelli*, suggested Giovanni di Cosimo. Recently, Susanne Kress ("Das autonome Porträt," 146–167) suggested that the portrait represents Lorenzo di Piero de' Medici. The only major difficulty in following this interpretation is the almost lack of resemblance between this portrait and others of Lorenzo.

86. Lightbown suggested that it might be a godson of Cosimo; on "baptismal patronage" see Louis Haas, "Il mio buono compare."

87. For a stimulating study on the medal as a charismatic marker of authority, see Marin, "The Inscription of the King's Memory."

88. Rubinstein, *Government*, 160–166; Brown, "Piero's Infirmity," 12–14.

89. Reumont, *Lorenzo de' Medici*, 1: 244, citing Lorenzo himself: "On the second day after my father's death . . . the most distinguished men of the State and of the ruling party came to our house to express their condolence, and at the same time to request me to undertake the conduct of affairs in the city and government, as my father and grandfather had done"; Tommaso Soderini addressed a gathering of more than six hundred citizens at Sant'Antonio, urging them to support Lorenzo (Reumont, *Lorenzo de' Medici*, 1: 246). See also Clarke, *Soderini and the Medici*.

90. *Canzone*. For a fascinating investigation linking Lorenzo's poetry to the cultural politics of its time, see Martelli, *Letteratura fiorentina*.

91. The medal is usually attributed to Niccolò Fiorentino, since the artist's signature (OP. NI. F.) can be found on the reverse of a version in the Bargello; see Friedlaender, *Schaumünzen*, 140; Warburg, *Gesammelte Schriften*, 1: 102, 115, 346, pl. 28 a–b (*Renewal*, 191, 203, fig. 28a–b); Trapesnikoff, *Porträtdarstellungen der Mediceer*, 48, pl. 16; Hill, *Corpus*, no. 926; Ciardi-Dupré dal Poggetto, "Un'ipotesi," 30, pls. 5–6; Winner, "Cosimo il Vecchio,"

179, pl. 8; Scher, *Currency of Fame*, 132–134, cat. no. 42; and Börner, *Die italienische Medaillen*, 96, cat. no. 363.

92. Although P P P does appear on his death mask in the Società Colombaria, Florence (with lines composed by Poliziano, "Morte crudele che'in quisto chorpo venne / Che dopo morte il mondo andò sotto sopra, / Mentre che tu visse tutto in pace tenne"). See Langedijk, *Portraits of the Medici*, 1: 154, cat. no. 74, 25. Rusconi ("The Medici Museum") interprets P P P on Lorenzo's death mask as signifying "Plato Pater Philosophiae."

93. Some commentators, noting the very different style of the reverse and slight variations in scale, have suggested that the reverse was made independently of the obverse (see Pollard in Scher, *Currency of Fame*, 134; Börner, *Die italienische Medaillen*, 96, cat. no. 363). Nonetheless, when Niccolò Fiorentino signs this medal, his signature appears on the reverse. Given that Niccolò's authorship of the obverse has never been questioned, doubts concerning the harmony between the two sides might simply reflect modern preconceptions about the unity of an artist's oeuvre and misunderstandings about the manner in which medals were produced and circulated. See also, James Draper's comments in Weil-Garris Brandt, et al., *Giovinezza di Michelangelo*, 240, cat. no. 19.

94. Cox-Rearick, *Dynasty and Destiny*, 17–19.

95. Bellincioni, *Le rime*, 224: "Co' fiori in grembo un'altra donna bella / Veggio, che nova Atene el mondo canta, / Lieta posarsi e l'umbra della pianta, / Che tanto amai in viva forma quella." Cox-Rearick, *Dynasty and Destiny*, 18–19. See also the sonnet, "Triunfo a l'ombra del mio santo alloro" (Cox-Rearick, *Dynasty and Destiny*, 35).

96. Poliziano, *Stanze*, ed. Pernicone, 1.4: "E tu, ben nato Laur, sotto il cui velo / Fiorenza lieta in pace si riposa, / né teme i venti o 'l minacciar del celo / o Giove irato in vista più crucciosa, / accogli all'ombra del tuo santo stelo / la voce umil, tremante e paurosa; / o causa, o fin di tutte le mie voglie, / che sol vivon d'odor delle tuo foglie."

97. Dati, *L'Istoria di Firenze*, 112: "E in poco tempo crebbe tanto e fue fatta sì bella cosa che qualunque persona l'avesse veduta e fussene domandato, rispondeva che ella era il fiore di tutte l'altre e che più ogni di fioriva; intanto che questo parlare fece che in poco tempo, abandonato il primo nome, da tutti era chiamata la città del fiore; e prendo che così fosse, prese per sua arme e insegna il giglio fiorito, che è sopra a tutti gli altri fiori; e era il giglio bianco naturale nel campo vermiglio; e così durò gran tempo insino alla raccomunazione che fu fatta co' Fiesolani quando la loro città fu disfatta e vennono in Firenze." See also, 133: "Il secondo segno si è il giglio il quale si porta nell'insegne o pennoni del Comune, che è il principe di tutti i fiori del mondo; questo si prese ab antico tempo e già se ne è parlato quando la città fue posta tanto bella che si diceva il fiore di tutte altre città." The trilobed and flowered *giglio fiorito*, called by some an iris (*gaggioli*), ought not to be confused with the French *fleur-de-lis* (which does not have the sprouting elements between its three lobes). The French *fleur-de-lis* (which may be based upon a lily or a white iris) was also an important sign in Florentine visual culture used first by Robert of Anjou, and later by the Medici (the French king gave Piero de' Medici the right to use it in 1465). On the medieval lily, see Cannart d'Hamale, *Monographie historique*.

98. On this legend see Villani, *Cronica* 1: 38. One finds frequent punning references to the city as "Fiorenza," and symbolic elaborations on its potential for "blooming" etc., in texts addressing the foundation and development of Florence.

99. Dempsey, *Portrayal of Love*, 82.

100. Dempsey, *Portrayal of Love*, 143; see also Lorenzo de' Medici, *Ambra*, octave 12: "Quel monte che s'oppone a Cauro fero, / che non molesti il gentil fior."

101. Hill, *Corpus*, no. 915.

102. On the erotic possibilities opened up by civic personification see Lynn Hunt's introduction to *Eroticism and the Body Politic*, 1: "Eroticism and the body politic might seem

to make an uncomfortable pair. We do not often think of representations of the political body as being erotic. . . . Yet the very fact that political orgnization can be imagined as a body leaves open the potential for erotic connotations."

103. See Machiavelli, *Prince*, 35–36.

Chapter Three: Engaging Symbols: Legitimacy, Consent, and the Medici Diamond Ring

Epigraph: Poliziano, *I detti piacevoli*, 57. See also Vespasiano da Bisticci, 2: 199: "Io vorrei che tu mi dicessi le cose chiare, sì che io t'intendessi—, gli rispuose: Appara il mio linguaggio!"

1. Brown, "Cosimo de' Medici's Wit and Wisdom."

2. Padgett and Ansell, "Robust Action." See also Weissman, "Importance of Being Ambiguous."

3. On the Medici ring, see Ames-Lewis, "Early Medicean Devices," esp. 131–136; Preyer, "Emblems," Appendix C, 198–207; Acidini Luchinat, "Lorenzo il Magnifico," esp. 1: 38; Cardini, "Le insegne Laurenziane," esp. 63–70; Borgia and Fumi Cambi Gado, "Insegne araldiche"; Böninger, "Diplomatie im Dienst der Köntinuität."

4. On Medici symbolism and the visual arts, see Settis, "Citarea"; Shearman, *Raphael's Cartoons*, 16–17, 50, 77–80; Cox-Rearick, *Dynasty and Destiny*, 12–40, 248; Perry, "'Candor Illaesvs'"; Ames-Lewis, *Library and Manuscripts*, 63ff.; Ames-Lewis, "Early Medicean Devices"; Preyer, "Emblems"; Acidini Luchinat, "L'immagine medicea," 125–142; Cardini, "Le insegne Laurenziane"; Borgia and Fumi Cambi Gado, "Insegne araldiche"; and Acidini Luchinat, "Lorenzo il Magnifico."

5. For examples of lists of diamond rings given or received at marriage, see Tommaso Guidetti, ASF, Carte Strozziane 4, 418, 4r; Luigi di Ugolino Martelli, Carte Strozziane 5, 1463, 116v; Francesco di Giuliano d'Averardo de' Medici, ASF, Mediceo avanti il principato 148, 31, 35r; Bartolomeo di Tommaso Sassetti, ASF, Carte Strozziane 5, 1749, 169r; Filippo e Lorenzo di Matteo di Simone degli Strozzi, ASF, Carte Strozziane 5, 17, 189r.

6. Giovio, *Dialogo dell'imprese*, 62–63: "Io non posso andar più alto de' tre diamanti che portò il gran Cosmo ["il Vecchio"], i quali voi vedete scoliti nella camera dov'io dormo e studio, ma, a dirvi il vero, con ogni diligenza cercandolo non potetti mai trovare precisamente quel che volessero significare."

7. On this painting, see Musacchio, "The Medici-Tornabuoni *Desco da Parto*"; Carli, *I deschi da parto*, 126–128, cat. no. 28. On the function of *deschi* see Klapisch-Zuber, "Les coffres de mariage et les plateaux d'accouchée à Florence," esp. 315–318; and especially Musacchio, *Art and Ritual of Childbirth*, ch. 3.

8. ASF, Mediceo avanti il principato 165, c. 14: "Uno descho tondo da parto, dipintovi il Trionfo della Fama f. 10." See Spallanzani and Gaeta Bertelà, *Libro d'inventario*, 27; and Carli, *I deschi da parto*, 126.

9. On this artist, see Bellosi and Haines, *Lo Scheggia*.

10. I see no reason to assume that the reverse was painted later than the obverse. Nonetheless, this possibility cannot presently be ruled out. Diamonds, naturally octohedronic, needed only to be cut in half to produce two pyramid-shaped gems. For references to the Medici inventories recording real ostrich feathers see Guidotti, "Gli aredi del palazzo."

11. It was Warburg ("Delle 'imprese amorose' nelle più antiche incisioni fiorentine [1905]," in *Gesammelte Schriften*, 1: 82; *Renewal*, 181) who demonstrated that this panel was in all probability commissioned for the birth of Lorenzo.

12. BNCF, MS Guardaroba mediceo 958, 6r; cited in Franco Cardini, "Le insegne Laurenziane," 61.

13. Ames-Lewis, "Early Medicean Devices," 122–124.

14. Thus, in 1513, when Giovanni de' Medici's accession to the papal throne was celebrated in Florence, two pageants were prepared by Andrea del Sarto, Jacopo Pontormo, and

others: one of the performing groups was called *il broncone* and another *il diamante*. See Cox-Rearick, *Dynasty and Destiny*, 16–17. On these groups, see also Butters, *Governors and Government*, 207–208. Giovio, *Dialogo dell'imprese*, 62, also calls the rings simply *diamanti*.

15. Giovio, *Dialogo dell'imprese*, 63. See also Dempsey, *Portrayal of Love*, 160: "The device of the diamond ring and feathers, for example, had been the *impresa* of Lorenzo's father Piero before it was adopted by Lorenzo as a youth, but the device is itself a cluster of metaphors for an idea of love that is not static but evolving. The white, green and red feathers in Piero's device were motivated by the conventional colors associated with the virtues of faith, hope, and charity, understood in the same, familiar sense in which Dante had also invoked them. The pledge of love these images signify as first adapted by Lorenzo in the 1460s, however, as expressed in his own early poems and in Pulci's *Giostra,* as well as in the Otto prints, links the concepts of faith, hope, and love (not charity) into a secularized troubadour's triad."

16. Elvira Garbero Zorzi, "Lo spettacolo," 204: "un'altro emblema mediceo, quello delle tre piume legate e l'anello con diamante (significante *Deo amante*) così composto: 'et in sul mazzocchio moveva tre penne d'oro filato suvi undici diamanti legati in castoni d'oro fine.'" See also Volkmann, "Hieroglyphik und Emblematik," 409–410, concerning Vasari's *Ragionamenti,* in which "Giorgio" interprets the Medici "diamante" as "Di amando."

17. Ferrara and Quinterio, *Michelozzo di Bartolomeo,* 243–245; and Finiello Zervas, "'Quos volent et eo modo quo volent.'" On Piero's circumspect use of his device, rather than the Medici *palle,* see Gombrich, "Early Medici," 299. Gombrich (290–291) also cites the stipulation that Cosimo could use at San Marco "his own coat of arms and devices."

18. Liebenwein, "Die 'Privatizierung' des Wunders." Also see Andrew Martindale, "Patrons and Minders."

19. See, for some examples, Perry, "'Candor Illaesvs.'"

20. Sculpture: Sciolla, *Mino da Fiesole,* 77, cat. no. 21; the maiolica: Wilson, "Some Medici Devices," 433; and Wilson, "Maioliche rinascimentali armoriate"; antique vases: Dacos et al., *Il tesoro,* 234–235, cat. no. 18. I have seen a diamond ring door knocker in the Museo Horne, Florence; another fine iron example is still to be seen in San Lorenzo (reproduced in Cardini, ed., *Lorenzo il Magnifico,* 139).

21. Based on the presence of rings, Scalini ("Divise e livree, araldica quotidiana," *Insegne araldiche* [Prato: 1992], cited by Cardini, "Le insegne Laurenziane," 73–74) proposes that two cassoni fronts in the Musée des Arts Decoratifs, Paris (battle of Zama and Triumph of Scipio) were for the marriage between Lucrezia (Nannina) de' Medici and Bernardo Rucellai in 1466. Interlocking rings are also to be found on a pair of marriage chest panels, now in the Staedel Institut, Frankfurt-am-Main. Rudolf Hiller pointed out to me that these rings probably refer to the Lanfredini family.

22. Erffa, "Meditationen"; Brogan, *Signature of Power;* Borgia, "L'insegna araldica medicea"; and Cardini, "Le insegne Laurenziane," 55–63.

23. Burroughs, *From Signs to Design.*

24. Giovio, *Dialogo dell'imprese*, 63. Vasari thought the ring with three feathers to be Cosimo's *impresa* and the ring-bearing falcon to be Lorenzo's; see Volkmann, "Hieroglyphik und Emblematik," 409–410.

25. Cardini proposes that the interlinked rings were Cosimo's device; this has been refuted by Borgia and Fumi Cambi Gado, "Insegne araldiche," 226. Ames-Lewis ("Early Medicean Devices") warned of the dangers of associating certain devices with particular members of the Medici clan. For a controversial attempt to read changes in the Medici coat of arms as an index of patronage, see Brogan, *Signature of Power.*

26. The dynastic implication of the application of devices can be perceived in Timoteo Maffei's Latin dialogue "In magnificentiae Cosmi Medicei Florentini detractores," in

which the author argues that Cosimo be permitted to affix "his device to his buildings so that those born after him may remember him in their prayers and that those who see his buildings are inspired to emulate them" (cited and discussed by Gombrich, "Early Medici," 285–286; and by Jenkins, "Cosimo de' Medici's Patronage").

27. It is telling that the interlocked diamond rings in Benozzo Gozzoli's fresco of the cavalcade of the Magi appear on the bridle of Piero's mount (fig. 3.6).

28. Lanza, *Lirici toscani*, 2: 378: "Tu se' el mio Petro e sopra questa petra / ho rinovato il tempio a libertate." See also Flamini, *La lirica toscana*, 145.

29. Cambini's sonnet can be found in Lanza, *Lirici toscani*, 1: 376: "Se la pace di fuor prodotta ha Dio, / fondala dentro in salda pietra, o Pietro, / di dïamante e non di fragil vetro . . . " See also Flamini, *La lirica toscana*, 145.

30. Lanza, *Lirici toscani*, 2: 311: "E tu, florida, bella, onesta e diva, / ogni mesto pensier da te disgombra, / po' che, felice giunta a quel che brami, / chi fia che non ti chiami / più ricca donna d'un sì car diamante, / pur che tu sia costante / di servar quel come tuo sommo bene, / non, come ispesso avviene, / nella mollizia, d'ogni ben nimica, / ché chi ben posa mal seme notrica?"

31. Poliziano, *Opere volgari*, 256.

32. Preyer, "Emblems," 198–207.

33. Borgia and Fumi Cambi Gado, "Insegne araldiche," 224: "È possibile che l'anello con il diamante e adorno di piume, che circonda lo scudo dell'arma qui esposta, e che, probabilmente dal 1438, si annovera tra le imprese di casa Medici, voglia alludere all'alleanza matrimoniale stretta con la famiglia dominante in Firenze e, congiuntamente, alla riconciliazione politica tra le due casate."

34. Preyer, "Emblems," 198–207.

35. Ames-Lewis, "Early Medicean Devices," 130 and 140–141.

36. Böninger, "Diplomatie im Dienst der Köntinuität." Ernst Gombrich made the plausible suggestion that the ring device may have originated in Burgundy ("Early Medici," 299: "This type of private heraldry was in itself in tune with the taste for chivalrous display which Piero may well have acquired in his contacts with his Burgundian customers").

37. Approaching the Medici ring as a quasi-heraldic gift helps to reflect upon the possible donations of family symbols and to postulate how the symbolic currency of the ring in northern Italian courts might have appealed to the bourgeois Rucellai and Medici. Certainly, in setting a ring with aristocratic connotations upon their public hands, these bourgeois Florentines capitalized upon the symbolism of nobility that inhered to the device.

38. Poliziano mentions, obliquely, the wide currency of the symbolism of the Medici diamond; see *Opere volgari*, 256: "Questo è 'l diamante, anzi il piropo ardente, / Che'e' gran proceri tua amavon tanto, / La plebe il vulgo e la patrizia gente."

39. On emblems and devices in early modern Europe, see Klein, "La théorie de l'expression figurée"; Pastoureau, "Aux origines de l'emblème"; Clements, *Picta Poesis;* Boureau, "État moderne et attribution symbolique."

40. For the general symbolism of the ring, see Kirchmann, *De annulis liber singularis;* Kornmann, *De annulo triplici;* Coldebach, *De annulis juris civilis;* Licetus, *De anulis antiquis;* Edwards, *History and Poetry of Rings;* Jones, *Finger-Ring Lore,* 297ff.; and McCarthy, *Rings Through the Ages,* 152–175. And on fifteenth- and sixteenth-century Italian rings, see *L'oreficeria nella Firenze,* 301–302; and Ciardi-Dupre dal Poggetto and dal Poggetto, ed., *Urbino e le Marche,* 233–236.

41. On the exchange and symbolism of the jewels exchanged at marriage, see Randolph, "Performing the Bridal Body."

42. Hoffmann, "Über den Verlobungs- und Trauerring"; Deloche, *Le port des anneaux.* See, too, Pliny, *Natural History,* 33.27.

43. Brucker, *Giovanni and Lusanna,* for a case study of the legality of the ring as a promise to marry. See, also, Boccaccio,

Decameron, 133 (day 2, novella 3), on the "female abbot": "She then sat up in bed, handed him a ring, and made him plight her his troth beneath a small picture of Our Lord, after which they fell into each other's arms, and for the rest of the night they disported themselves to their great and mutual pleasure." The bride, so Carlo Strozzi writes, follows the husband once the ring is put on her finger. The ring is perceived as marking a shift in legal possession of the bride. See Klapisch-Zuber, "Un salario o l'onore," 43: "Carlo Strozzi dice espressamente che, una volta messo l'anello al dito, la ragazza abbandona la dimore usuale per seguire il marito, il cui compito sarà quello di far fruttare gli attrezzi necesssari investandovi tempo e lavoro."

44. Klapisch-Zuber has also demonstrated that it served less obvious, yet similarly important, social functions that can be seen as undermining the Church's agenda. In another essay, scrutinizing records of the exchanges constituting marriage in fifteenth-century Italy ("The Griselda Complex"), she has described the role of rings in the marginal assigns made in Florence beyond the dowry. Rings, given to the bride by female members of the bridegroom's kin, drew the bride into a social network; obligated to the donors, she owed them a debt of obedience. Symbolically, Klapisch-Zuber argued, the rings served to integrate the bride into a new family network, redressing the imbalance of the dowry. Moreover, the passing of rings from members of one generation to those of the next produced intergenerational bonds among the women of the family. Symbolically, the rings functioned as beacons defining kinship. They served to establish the bride in "female roles," and they generated a group solidarity, especially between women.

45. On Florentine *ricordi* see Jones, "Florentine Families and Florentine Diaries"; Christian Bec, *Les marchands écrivains;* Anselmi and Pezzarossa, *La 'memoria' dei mercatores.*

46. Uguccione Capponi, ASF, Corporazioni religiose soppresse dal governo francese,

S. Piero a Monticelli 153, 5v.

47. Although the traffic in rings yielded and supported fresh family relations, and thus functioned positively, their circulation was, at least in theory, not unlimited. Sumptuary laws restricted the use of these rings. A law of 1439 limited women to wearing three rings; on their marriage day and fifteen days after it, however, brides could wear as many as they liked. See Morelli, ed., *Deliberazione suntuaria;* and Rainey, "Dressing Down the Dressed." In 1472 the bride was permitted to wear five rings; see Mazzi, *Due provvisioni suntuarie,* 5.

48. Klapisch-Zuber, "Zacharias, or the Ousted Father."

49. Goody's thesis has been the subject of much revision and commentary; see, for example, "Goody Revisited," special issue of *Continuity and Change* 6, no. 3 (1991).

50. Leclercq, "Anneaux"; Hoffmann, "Über den Verlobungs- und Trauerring"; Deloche, *Le port des anneaux.*

51. Gellius, *Attic Nights,* 10.10.2: "repertum est venam quendam tenuissimum ab eo uno digito . . . ad cor hominis pergere ac pervenire." See also Metz, *La consécration des vierges,* 404.

52. *Glossai Homerikai,* 3. 511; Pliny, *Natural History,* 33.24; Galen of Alexandria, *On the Usefulness of the Parts of the Body,* 14.704; Macrobius, *Saturnalia,* 7.13.7.

53. Metz (*La consécration des vierges,* 373) cites Isidore of Seville, *De ecclesiasticis officiis* (PL 83, col. 811–812); and Gratian, *Decretals,* c. XXX, q. 5, c. 7, § 3.

54. Bernardino, *Le predicazione,* 118: "Nel dito si mette che v'è la vena che va al cuore."

55. Bernardino, *Le predicazione,* 117–118: "Prima l'anello che sopra sta al dito; poi nel dito della vena al cuore; poi il dito della donna che avanza fuori dell'anello di sotto e di sopra: a dare a 'ntendere fede che si promette l'uno a l'altro, che fede che si promette non ha possanza del corpo d'altri. L'anello per marito, che sopra sta al dito, ha possanze sopra di lei; e il dito ch'avanva di lunghezza l'anello ha possanza lei sopra il marito."

56. Cherubino, *Regole,* 33–34.

57. Barberino, *Reggimento*, 59.

58. Ariosto, *Opera*, 3: 259–267: " . . . e trouva / Che 'l dito alla mogliera ha nella fica. / Questo anel tenga in dito, e non lo mova / Mai chi non vuol ricevere vergogna / Dalla sua donna. . . ." Bracciolini, *Facezie*, no. 133: "Franciscus Philelphus, zelotupus uxoris, summa torquebatur, ne com altero nem haberet, semper dies ac noctes ad ejus custodiam intentus. Huic dormienti, per somnium (fit in somniis saepius ocurrant), visus est Daemon queam uxoris securitatem polliceri, si, quae admoneret, vellet facere. Et cum per somnium ammisset, idque sibi pergratum fore diceret, simul praemium pollicitus: 'Cape hunc,' ille inquit, 'annulum et diligentur in digito serva. Nam in eo gestaveris hunc, nunquam uxor, te inscio, cum alio concumbet.' Prae gaudio excitatus a somno, sensit se digitum habere in uxoris cunno. Optimum quidem ejus annuli zelotypis remedium, ne uxores, ignorantibus viris, possint esse incontinentes." On this topos, see Bakhtin, *Rabelais and His World*, 243.

59. Within the similarly bawdy poetics of the "equivocal" tradition of Burchiellesque carnival songs, the signified ring appears as a "hidden" reference to the anus (Toscan, *Le carnaval du language*, 273–275; 334–345; 388–389; 689–690). Even Lorenzo "il Magnifico," adopting the voice of a perfume merchant, plays with this earthy significance in his *Canzona de' Profumi;* Lorenzo de' Medici, *Canti carnascialeschi*, 63–64: "Noi abbiamo un buon sapone, / che fa saponata assai: / frega un pezzo, ove si pone; / se piú meni, piú n'arai. / Evv'egli accaduto mai, / donne, aver l'anella strette? / Col sapon, che cava e mette, / cuoce un poco: pazienza!"

60. Gombrich, "Renaissance and Golden Age," 208.

61. On "civil principality," see Machiavelli, *Prince*, 35–36.

62. See Fabbri, *Alleanza matrimoniale;* and Molho, *Marriage Alliance.*

63. D. Kent, *Rise of the Medici;* Padgett and Ansell, "Robust Action."

64. For some of the numerous marriages arranged by Lorenzo de' Medici, see Niccolò Michelozzo, ASF, Notarile antecosimiano M 530.

65. Metz, *La consécration des vierges,* appendices, 208, and 305; and Lowe, "Secular Brides and Convent Brides."

66. Murphy, "Rings." See also Hoops, ed., "Ring." Cardinals also received rings; on Good Friday, they set these aside while mourning for their "spouse" (Jones, *Finger-Ring Lore,* 216).

67. Ambrose, Epistle 34; cited in Brandileone, "Contributo alla storia della *subarrhatio,*" 410: "cum anulo fidei suae subarravit me Dominus." On rings and episcopal investiture, see Jones, *Finger-Ring Lore,* 198ff. and Morgan, "Episcopal and Other Rings," 392–399. Episcopal rings were first mentioned in the seventh century at the Council of Toledo (633 C.E.) and by Isidore of Seville (d. 636 C.E.) in his *De ecclesiasticis officiis* 2.5. Durandus, in the thirteenth century, stresses the marital significance of the episcopal ring of investiture; see Morgan, "Episcopal and Other Rings of Investiture," 394.

68. Jones, *Finger-Ring Lore,* 234: "A platform was erected, surmounted by a rich baldaquin, near the high altar; a golden ring was brought to the prelate, which he placed on the finger of the abbess, whose hand was sustained by the oldest priest of the parish. The archbishop slept one night at the convent, and the next day was enthroned, with great ceremony, in the cathedral." Jones, *Finger-Ring Lore,* notes that similar ceremonies were performed in Pistoia, Milan, Bergamo, and Modena. Kate Lowe and Trevor Dean refer to this symbolic religious marriage in their introduction to *Marriage in Italy,* 4–5. I would like to thank Sharon Strocchia for a stimulating discussion concerning this ritual.

69. Honorius, "De annulo," *Gemma animae* 216 (PL 172.609). On the religious use of rings, see Leclercq, "Anneaux," 1282; and Metz, *La consécration des vierges.*

70. Waterton, "On the *Anulus Piscatoris*," 138. See too Scarisbrick, "Signet Ring," 294: "The *anulus piscatoris* is first referred to in a

letter from Clement IV written in 1265 to his brother Pietro Grossi of St. Gilles in these terms: 'Greet my mother and brothers: We do not write to you or your familiars under the bull, but under the seal of the Fisherman which the Roman pontiffs use for their private letters.'" On the distinction between the individual and his papal office, see Prodi, *Il sovrano pontefice,* 50ff.

71. On secular investiture "per annulum," see Twining, *European Regalia,* 265–268; Jones, *Finger-Ring Lore,* 177ff.; Hauk, "Der Ring als Herrschaftszeichen," esp. 190: "Im abendländischen Hochmittelalter erscheint der Fingerring immer wieder als eines der möglichen Sinnzeichen der Herrschaftsübertragung und auch der Herrscherweihe." Hauk cites the following studies by Schramm, "Die Krönung in Deutschland"; Schramm, *History of the English Coronation;* Schramm, *König von Frankreich,* 1: 9–10, 202, 238 and 2: 97ff. For some provocative thoughts on the political metaphor of marriage, see Kahn, "'The Duty to Love.'"

72. Huizinga, *Waning,* 234; cited in Muir, *Civic Ritual,* 126.

73. Godefroy, *Le cérémonial de France,* 348: "Anneau Royal: Parce qu'au jour du Sacre le Roy espousa somnellement son Royaume, et fut comme par le doux, gracieux, et amiable lien de mariage inseparablement uny avec ses subjects, pour mutuellement s'entraimer ainsi que sont les epoux, luy fut par le dit Evezque de Chartre présenté un anneau, pour marque de ceste reciproque conjonction . . . mit le dit anneau, duquel le Roy epousoit son royaume, au quatriesme doigt de sa main dextre, dont procede certaine veine attouchant au coeur." Cited in Kantorowicz, *King's Two Bodies,* 221–222. See Jones, *Finger-Ring Lore,* 179–180, states that the ring given to Louis XIII was "a symbol of love, whereby the King was wedded to his realm," and that the "typical meaning of the royal investiture by the ring is the union of the sovereign with his people, whom he is supposed to espouse at this solemnity."

74. Urban, "La festa della Sensa"; and Muir,

Civic Ritual, 119–134. See also Zenatti, "Il poemetto di Pietro de' Natali"; and Jaeger, "Der Ring des Meeres."

75. Muir, *Civic Ritual,* 120; citing in n. 45 Canal, *Les estoires de Venise,* 250: "Et li prestre qu'est aveuc monsignor li dus beneïst l'eive et monsignor li dus gete dedens la mer un anel d'or."

76. Salimbene de Adam, *Cronica,* 822–823: "Dux Veneciarum cum Venetis suis cum anulo aureo in die Ascenzionis Domini mare desponsat, partim causa solatii et deductionis, partim ex quadam ydolatri consuetudine motus, qua Neptuno sacrificant Veneti, partim ad ostendendum quod Veneti dominium maris habent. Postea piscatores qui volunt (quia aliter non coguntur) denudant se, et aleo [?] pleno ore, quod postea spargunt, descendunt in profundum maris ad anulum inquirendum. Et quicumque illum invenire potest, absque ulla contradictione possidet illum."

77. The story of Polycrates, who threw a ring into the sea and then had it returned to him by a fisherman who had caught the fish that had swallowed it, was widely diffused.

78. Although in Venice the meaning was more closely connected to the city's imperial relationship to the sea, the domestic reading of the Sensa ought not to be dismissed out of hand.

79. Kantorowicz, *King's Two Bodies,* 212: "Since Carolingian times, the mediaeval Prince received at his coronation, together with other symbols and insignia, a ring. The ecclesiastical writers, however, were careful to point out that this ring was conferred only as a *signaculum fidei* and to distinguish it from the episcopal ring by which the bishop, at his ordination, became the *sponsus,* the groom and the husband of his church, to which he was married, a simile on which the canonists sometimes expanded at great length." Kantorowicz cites Eichmann, *Kaiserkrönung,* 2: 94ff., and mentions that the ring was discussed during the Investiture Conflict, referring to the many tractates, *De anulo et baculo,* in Dümmler and Heinemann, ed. *Monumenta* 2: 508ff.; 3: 720ff., 723ff., 726ff.

80. *Cynipistoriensis . . .* , 446r, C.7.37.3. n. 5: "Quia ex electione Imperatoris et acceptione electionis Reipublicae iam praepositus negari non potest et eum ius consectutum esse, sicut consensu mutuo fit matrimonium. . . . Et bona est comparatio illius corporalis matrimonii ad istud intellectuale: quia sicut maritus defensor uxoris dicitur . . . ita et Imperator Reipublicae." See Kantorowicz, *King's Two Bodies*, 213.

81. Commentary of a law concerning "Occupation of Desert Land," C.11, 58, 7; cited in Kantorowicz, *King's Two Bodies*, 214. Luca also interprets the state's fisc as a dowry.

82. On the theology of marital consent, see Donahue, "The Policy"; Donahue, "Canon Law"; Laiou, ed., *Consent and Coercion*.

83. Medici, *Comento*. For commentaries on the text and the relevant bibliography, see Orvieto, *Lorenzo de' Medici*, 47–54; and Medici, *Opere*, 555–564. For fundamental studies on Lorenzo's writings in general, see also Martelli, *Studi laurenziani*, 51–133. See also Shapiro, "Poetry and Politics in the *Comento*." For an English translation, see Medici, *Autobiography*.

84. Ficino, *Commentary on Plato's "Symposium on Love"*; on Giovanni Pico della Mirandola's commentary on Benivieni, see Garin, *Giovanni Pico della Mirandola*, 29–30.

85. Fubini, "Nota sulla prosa di Lorenzo."

86. By October 1486, the text had reached the stage that Piero Bibbiena felt he could ask for a copy. On the dating of the various parts of the *Comento* see Zanato, "Sulla datazione del *Comento*," in Medici, *Comento*, 124–129.

87. Ady, *Lorenzo dei Medici*, 128–142; and Maier, "Il realismo letterario."

88. Orvieto, *Lorenzo*, 50: "È chiara la sua intenzione aristocratica di scrivere per una ristrettissima élite di intenditori: e proprio indirizzata ad una élite sempre più scelta di iniziati alla tematica d'amore sono i componimenti che possiamo chiamare filosofici di Lorenzo."

89. On this dynamic, see Martelli, *Letteratura fiorentina del Quattrocento*.

90. On the iconography of the removal of the heart, see Randolph, "Art for Heart's Sake."

91. Medici, *Comento*, 208–209; Medici, *Autobiography*, 119–121.

92. Medici, *Comento*, 210; Medici, *Autobiography*, 121. On Lorenzo's use of the topos of hands, see Paolo Orvieto's introduction to Lorenzo de' Medici, *Canzoniere*, xxxiv: "La mano di madonna che *tocca* il *gentile* animo di Lorenzo è, ancora, indice dell'amore intuitivo, *dell'idea* di Schopenhauer anteriore al *concetto* di Kant, disposizione sentimentale che differezia la poesia e la teologia mistica dalle altre attività *raziocinanti*: concezione *ermetica* (e, implicitamente, laurenziana) della poesia recuperata dai *simbolisti* francese e dai nostri *ermetici* (Montale, Luzi, ecc.). . . . Dopo la contemplazione, il godimento, la ficiniana voluptas: il ciclo teologico-umano di Ficino inizia da Bellezza e, tramite Amore, termina in Voluttà, alla quale siamo *rapiti* istintivamente dalla *bianca mano* di madonna. Quella miracolosa mano, però, non porta solo la morte, annientando ogni frammento di residua umanità, anzi trascinandoci sul *monte* dove risiede madonna, ci dà la vita immortale."

93. Medici, *Comento*, 211; Medici, *Autobiography*, 123.

94. Medici, *Comento*, 214; Medici, *Autobiography*, 127.

95. Medici, *Comento*, 219; Medici, *Autobiography*, 133.

96. Medici, *Comento*, 222; Medici, *Autobiography*, 135.

97. Gilbert, ed., *Italian Art*, 128–129; see also Medici, *Autobiography*, 137.

98. Medici, *Comento*, 225; Medici, *Autobiography*, 139.

99. Buck, *Der Platonismus*.

100. Lungo, *Gli amori*; Rochon, *La jeunesse*, 146–148.

101. I have adapted the translation offered in Boccaccio, *Amorosa visione*, 45.1–15. For the original Italian text, see Boccaccio, "Amorosa Visione," in *Tutte le opere*, 45. 1–15.

102. Dempsey, *Portrayal of Love*, 157, suggests that the diamond in the *Comento* might be read against the Medicean device: "The image of love is permanently painted on the

noble heart that has been transformed into *rigido diamante;* in this is the meaning of the device of the diamond (*diamante*) with the three feathers colored white, green, and red, the same traditional colors Dante had assigned to the three theological virutes, faith, hope, and charity."

103. Lanza, *Lirici toscani*, 2: 338.

104. Lanza, *Lirici toscani*, 2: 339.

105. Lanza, *Lirici toscani*, 2: 340.

106. For the imbrication of amorous and political imagery in Italian poetry, see Martines, "The Politics of Love Poetry"; and his "Poetry as Politics."

107. *Simposio*, 108; cited in F. W. Kent, "The Young Lorenzo," 5.

Chapter Four: Homosocial Desire and Donatello's Bronze *David*

Epigram: Francesco Filarete, in Gaye, ed., *Carteggio*, 2: 456. See Janson, *Donatello*, 78. For the best bibliography on the bronze *David*, see Caglioti, "Donatello, i Medici e Gentile de' Becchi," part 3, esp. 42, n. 3. Now amplified in Caglioti's book, *Donatello e i Medici*, 1:101–102.

1. Rubinstein, *Government of Florence*, 160–166; Brown, "Piero's Infirmity," 12–14.

2. Lanza, *Lirici toscani*, 2: 379: [Song in praise of Piero di Cosimo de' Medici] "Veggio dal tuo sinistro e destro lato / suger due laüretti e verdi rami, / e par che ciascun brami / con sue frondi adombrar la chioma mia, / in mezzo una colonna ed uno armato, / ch'asembra fare e tuoi nimici grami, / perché tu temi ed ami / quel che fé superare a lui Golia. / Questo fu che la setta iniqua e ria, / che tôr mi volle quel che meco nacque, / sì come al ciel sol piacque / si torse in fuga e la sua gran nequizia / ha ceduto a ragione ed a giustizia." For the laurel symbolism, see Cox-Rearick, *Dynasty and Destiny*, 17–19.

3. Excluding, that is, the inscription on the statue's pedestal; see below. Until now, the first document recording the statue's presence at this location appears in 1469; nevertheless, given Risorboli's lines, it seems sensible to assume that it gained this preeminent position at least by 1466, and probably

earlier when other important decorations for the palace—Benozzo Gozzoli's frescoes in the chapel, and Donatello's bronze *Judith and Holofernes*—were also reaching completion. Benozzo's letter to Piero de' Medici informs us that the chapel was nearing completion in July 1459 (Florence, ASF, Archivio Mediceo avanti il principato, 137, 96; see Gaye, *Carteggio*, 1: 191). On the dating of Donatello's *Judith and Holofernes*, see Chapter Six.

4. Although some think its political content has been overblown. See Sternweiler, *Lust der Götter*, 29–33; Butterfield, "New Evidence," esp. 115–116; and D. Kent, *Cosimo de' Medici*, 282–286. For a new political interpretation of the *David* and the *Judith and Holofernes* see McHam, "Donatello's Bronze *David* and *Judith*."

5. Paoletti ("Familiar Objects," 91–93) also draws these works together. One might even add to this geometry Donatello's *macigno Lion* or *Marzocco* (Museo Nazionale del Bargello, Florence), sculpted to decorate the stairs in the papal apartments in Santa Maria Novella in preparation for the visit of Martin V to Florence in 1419–20. It, too, was described as set upon a column.

6. Janson, *Donatello*, 77–78; see also Landucci, *Diario*, 119.

7. Janson, *Donatello*, 78; Gaye, *Carteggio*, 2: 52: Pier de Rohan, when requesting a copy of the bronze *David* by Donatello, mentions that it was "in the courtyard of the Palazzo Vecchio." See Janson, *Donatello*, 78–79, for references concerning the later history of the bronze *David* (including being struck by lightning). The *David* was moved from the courtyard by 1555; see Allegri and Cecchi, *Palazzo Vecchio*, 228–229.

8. See Doebler, "Donatello's Enigmatic *David*," 337–340.

9. Kosofsky Sedgwick, *Between Men*, 1–20. I have also found very useful Simons, "Homosociality and Erotics"; Bryson, "Géricault and Masculinity"; and Crow, "A Male Republic."

10. The study of male-male sex in the Middle Ages has profited from several serious

studies, most of which have addressed the condemnation and repression of the "unmentionable vice" by the Church. More focused studies will be cited as necessary, but for the most important contributions to the broader picture of medieval same-sex relations see Bailey, *Homosexuality;* Goodich, *Unmentionable Vice;* Foucault, *History of Sexuality,* vol. 1; Padgug, "Sexual Matters"; Boswell, *Christianity, Social Tolerance, and Homosexuality;* Gilbert, "Conceptions of Homosexuality." For the sometimes acrimonious debate between the Foucauldian "social-constructionists" and the "essentialists," see Boswell, "Towards the Long View"; Kuster and Cormier, "Old Views and New Trends"; Halperin, "Is There a History of Sexuality?"; Richlin, *Garden of Priapus;* Halperin, "Forgetting Foucault." On Foucault and representation, see Wolf, "Uses of Foucault's *History of Sexuality.*" See also Fradenburg and Freccero, ed., *Premodern Sexualities.*

11. Pollock, "The Politics of Theory."
12. In this chapter I focus on male sodomitical relationships and I use the term "homosexual," "homoerotic," and "homosocial" to speak about male-male relations. In other contexts it would make sense to broaden this analytical language to include female-female relations. For Renaissance "lesbianism," see Brown, "Lesbian Sexuality"; and Brown, *Immodest Acts.* For a theorization of female homoeroticism and visual culture, see Simons, "Lesbian (In) Visibility."
13. Davis, "Gender."
14. For a useful starting point, see Abel, ed., *Writing and Sexual Difference.*
15. See Shearman, *Only Connect,* 17–21; and Caglioti, "Donatello, i Medici e Gentile de' Becchi," part 3.
16. Sam. 17: 1–58.
17. For the most careful recent reading of the statue in terms of its religious content, see Butterfield, "New Evidence."
18. While the biblical account does have David stand on Goliath, this is before the scene of decapitation (1 Sam. 17: 51).
19. Not often represented, the helmet of

Goliath is mentioned in the biblical account (1 Sam. 17: 5). Although the biblical text does tell us that David picked up five stones, it does not really explain the presence of the stone in the hand of the statue, since David immediately put them in a bag (1 Sam. 17: 35). In any event, surely the boy needed both hands to wield Goliath's large sword? On the problem of David's stones, see Olszewski, "Prophesy and Prolepsis."

20. See Arasse, "L'art et l'illustration du pouvoir."
21. For a recent assertion of pictorial and imagistic power, see Mitchell, *Picture Theory.*
22. On the myth of meanings "behind" images, see Krauss, *Originality,* 293: "[the] notion that there is a work, x, behind which there stands a group of meanings, a, b, or c, which the hermeneutic task of the critic unpacks, reveals, by breaking through, peeling back the literal surface of the work."
23. Marco Parenti's 1469 description of the *David* in the Palazzo Medici is found in the BNCF, MS II, iv, 324, 108v; this has been published as Parenti, *Delle nozze;* for the translation, see Janson, *Donatello,* 77, and Ross, *Lives of the Early Medici,* 129–134. Today, it is generally held that the description was probably composed by Marco Parenti, not his son, Piero.
24. See Ames-Lewis, "Donatello's Bronze *David,*" 239–243 (who believes that the base was actually carried out by Donatello); and Caglioti, "Donatello, i Medici e Gentile de' Becchi," part 3. Caglioti (41), presents a stunning array of new information about the pedestal and concludes that it was indeed carved by Desiderio, probably during Donatello's extended stay in Siena (1457–61). This was also during the tenure of Gentile de' Becchi in the Medici household (1454–69); in an earlier study, Caglioti had proved that de' Becchi was the author of an inscription appended to the base of the *David.* It is not known what base, if any, the *David* had before Desiderio's. That Desiderio was the author of the pedestal is suggested by Antonio Benivieni, who wrote that "[Cosimo] bestowed both honours and countless rewards on Donatello and

Desiderio, two highly renowned sculptors" (Benivieni, *Egkomion*, 56; cited by Gombrich, "Early Medici," 288). This, incidentally, provides some support for seeing Cosimo as the patron of the bronze *David*. For a fascinating study on the form and significance of statue bases, see Weil-Garris Brandt, "On Pedestals." For a fanciful reconstruction of the pedestal, see Passavant, "Beobachtungen."

25. See Bulst, "Uso e trasformazione," esp. 111; Preyer, "L'archittetura del palazzo mediceo"; and D. Kent, *Cosimo de' Medici*, 231 (who also cites an unpublished paper by Simons, "Renaissance Palaces," as discussing the porousness of Florentine palaces). See also Rubinstein, "Palazzi pubblici e palazzi privati"; and Preyer, "Planning for Visitors." In his *Life* of Baccio Bandinelli, whose marble *Orpheus* replaced the *David* in the Medici palace courtyard in 1519 after the family had returned to power, Vasari praises the fifteenth-century pedestal again: "But because Baccio never cared for the art of architecture, he did not consider the ingenuity of Donatello, who made for his *David*, which was there before, a simple column on which it was placed as a base, open and split [*fesso*] beneath, so that those who passed by outside could see from the door on the via [Larga] the other door in the other courtyard opposite." For the Italian, see Vasari, *Le vite*, 6: 143–144: "Ma perchè Baccio non si curò mai dell'arte dell'architettura, non considerando lui l'ingegno di Donatello, il quale al Davitte, che v'era prima, aveva fatto una semplice colonna su la quale posava l'imbasamento di sotto fesso ed aperto, a fine che chi passava di fuora vedesse dalla porta da via l'altra porta di dentro dell'altro cortile al dirimpetto." My translation is slightly different from that offered by Ames-Lewis, "Donatello's Bronze *David*," 240. It is based, instead, on the rereading of Vasari offered by Caglioti ("Donatello, i Medici e Gentile de' Becchi," part 3, 18), who reports that Vasari actually wrote: "Una semplice colonna su la quale posava l'imbasamento, *fesso et aperto di sotto*" (empha-

sis added). Caglioti—bringing to light a number of early sixteenth-century descriptions—argues strongly that the pedestal consisted of an antique column, similar to the Bartolini-Salimbeni pedestal found in the Victoria and Albert Museum.

26. Hill, *Corpus*, no. 158, 1: 38; 2: pl. 29.

27. Pope-Hennessy, "Donatello's Bronze *David*," 125.

28. Spina Barelli, "Note iconografiche."

29. Francesco Caglioti recently restates the case for the dominant, proximate point of view. This supports his claim that the bronze *David* was originally made for the Sala Grande of the Medici *casa vecchia* on the via Larga; see Caglioti, *Donatello e i Medici*, 1: 189 and 214–218; see also his illustrations in vol. 2, fig. 96 and 97. Accounts that place too much weight on "optical corrections" in Renaissance art run the risk, I think, of short-circuiting the important "psychological corrections" and physical movements that characterize spectatorial activity, especially when it comes to sculpture in the round.

30. Vasari, *Le vite*, 2: 406; Janson, *Donatello*, 78. Vasari was repeating an opinion already expressed in the Codex Magliabecchiano of 1537–42; see Janson, *Donatello*, 78: "He [Donatello] did this [the bronze *David*] so well that it deserves to be ranked with the rare and beautiful works of the Ancients; if it were more lifelike [than it is], it would have been alive rather than a bronze figure."

31. See Freedberg, *Power of Images*.

32. For contributions to this field of investigation, see Rosenauer, *Studien zum frühen Donatello*, esp. 43–52; Munman, "Optical Corrections"; and Johnson, "Activating the Effigy," 445–459.

33. For an alternate version of the events, see Wundram, *Donatello und Nanni di Banco*, 7–10, 26–29, 62–69; Herzner, "David Florentinus I"; and Pope-Hennessy, *Donatello*, 40–43. See also Olszewski, "Prophecy and Prolepsis."

34. In this instance Hans Baron's thesis regarding the origins of Civic Humanism is useful. See Hans Baron, *Crisis*.

35. On the dating and attribution of the Gaddi,

see Ladis, *Taddeo Gaddi*, 31–33. Ames-Lewis, "Art History or Stilkritik?" 141, n. 12, refers to a manuscript illumination based on Gaddi's fresco (*Esposizione del Pater Noster*, BNCF, cod. II, VI, 16, f. 34v). He also refers his readers to d'Ancona, *La miniatura fiorentina*, no. 112. For the Orsanmichele frescoes, see Finiello Zervas, ed. *Orsanmichele*, 1: 326–337; 2: 170–171. See Battaglia Ricci, *Palazzo Vecchio e dintorni*.

36. See Norman, *Metamorphoses of an Allegory;* and Baldwin, "'I Slaughter Barbarians.'"

37. Also Nicola Pisano's *Fortitude* on the pulpit in Pisa's baptistery.

38. On Hercules as a Florentine symbol, see Ettlinger, "Hercules Florentinus"; Hessert, *Zum Bedeutungswandel der Herkules-Figur;* Donato, "Hercules and David"; and Wright, "Myth of Hercules."

39. Dante provided a strong foundation for analogies between the two heroes; *Monarchia*, 173 (II, 9): "Se poi si vorrà opporre alla verità che così abbiano messo in luce l'argomento volgere della impantà delle forze, basti contro batterlo la Vittoria di David su Golia; e se i Gentili non l'accontentan valga per loro la vittoria di Ercole su Anteo."

40. Butterfield, "Verrocchio's *David*"; and Butterfield, *Verrocchio*, 18–31.

41. Draper, "Bellano," 226–228.

42. A notable exception is the *David Triumphant* on the arms of Luca di Bertoldo Corsini (Pistoia, Palazzo del Podestà); fig. 12 in Borgia, "L'insegna araldica medicea."

43. See Ragghianti and dalli Regoli, *Firenze 1470–1480*.

44. For Michelangelo's bronze *David*, see Caglioti, "Il perduto *David medicea*"; and Weil-Garris Brandt et al., *Giovinezza di Michelangelo*, 414–415.

45. Sam. 17: 38–39. Olszewski, "Prophecy and Prolepsis," 72, sees the nudity of the bronze *David* as a "prefiguration of his [David's] dancing nude before the Ark of the Covenant on its return to the Israelites (2 Samuel 6:14–20)."

46. Barelli, "Note iconographiche," 37–40.

47. Schottmüller, *Donatello*, 83; Kauffmann, *Donatello*, 176; and especially Eisler, "The Athlete of Virtue."

48. Lányi, "Problemi"; Pope-Hennessy, "Donatello's Bronze *David*"; and Parronchi, "Mecurio e non David."

49. See Kurth, *Darstellung des nackten Menschen*, 34; Kauffmann, *Donatello*, 162; Morisani, *Studi su Donatello*, 61–83; Lisner, "Gedanken," 83ff.; Greenhalgh, *Donatello and His Sources*, 180: "The pose is a perversion of antique forms." Even if one accepts that there is a general reference to antiquity, no distinct antique model for the *David* has emerged; see, for example, Barelli, "Note iconografiche," 34: "E anche il Davide è 'all'antica,' per quanto, come Golia, non riferibile precisamente a nessun esemplare della statuaria classica."

50. Janson, *Donatello*, 85.

51. Manetti, writing in the second half of the fifteenth century, tells us that, after losing the competition for the baptistery doors, Brunelleschi went to Rome with Donatello (Manetti, *Brunelleschi*). See also Vasari, *Le vite*, 2: 337: "Fatta l'allogazione a Lorenzo Ghiberti, furono insieme Filippo e Donato, e risolverono insieme partirsi di Fiorenza, ed a Roma star qualche anno, per attender Filippo all'architettura e Donato alla scultura." The Roman sojourn cannot, however, be substantiated by independent documentation.

52. On this *querelle* concerning Brunelleschi's sources, see Howard Burns, "Quattrocento Architecture"; Onians, "Brunelleschi"; and Trachtenberg, "Brunelleschi, 'Giotto' and Rome."

53. Hahr, "Donatellos *Bronzedavid*." For Polykleitos's *Diadoumenos*, see the Roman copy in the Metropolitan Museum of Art, New York. See also Sirèn, "Donatello and the Antique."

54. It is uncertain whether large statues like the *Mercury* (Bober and Rubinstein, *Renaissance Artists and Antique Sculpture*, cat. no. 10) or the *Apollo* (Bober and Rubinstein, *Renaissance Artists and Antique Sculpture*, cat. no. 35) were displayed in Rome during Donatello's day. The former is first recorded in the sixteenth century, and the latter in the 1490s (in the delle Valle collection). I would

like to acknowledge Nanette Salomon's thought-provoking contribution to the Congrés internationale d'histoire d'art / International Congress of the History of Art (September 2000) in London on contrapposto as it appears in the *David* and in other works.

55. Greenhalgh, *Donatello and His Sources,* 172–174 (on coins and gems), and 180: "The most likely starting point would seem to be a bas-relief of a god or hero, probably a funerary stele showing the figure walking forward—which would account for the hand-on-the-hip motif."

56. Indeed, the Icarus roundel in the courtyard of the Palazzo Medici is based on the Roman relief on the Arch of Constantine.

57. Bober and Rubinstein, *Renaissance Artists and Antique Sculpture,* cat. no. 182d-vi. This relief was reinterpreted by a sculptor close to Donatello in one of the roundels of the Medici palace courtyard.

58. I find the first-century C.E. statuette said to represent *Veiovis* (Viterbo, Museo Civico) and found at Monterazzano to be a particularly compelling example of an Etruscan type that might have borne upon Donatello's vision of the male nude.

59. Dacos et al., *Il tesoro,* cat. no. 25; Greenhalgh, *Donatello and His Sources,* 173. On Trevisan's ownership see Caglioti and Gasparotto, "Lorenzo Ghiberti." Filarete mentions the cornelian and its owner; see *Treatise on Architecture,* 16: "Such as the cornelian of the Patriarch. In it [there were] three most noble figures, as noble as it is possible to make. [They were] a nude tied by his hands in front of a dry tree, another with a certain instrument in his hand and with a bit of drapery hanging from his waist, and another kneeling. . . . The afore-mentioned Patriarch sent the cardinal of San Marco to look for them in various parts of the world."

60. Spina Barelli, "Note iconografiche," 28–44; and Sternweiler, *Lust der Götter,* 29–97.

61. This reading was implied by Janson, *Donatello,* 81–86. It was, partially and iron-ically, given visual weight by Pope-Hennessy's observation that the head of the

David might have been inspired by an antique "portrait" of Antinoüs (*Italian Renaissance Sculpture,* 12). On Cosimo as a literary patron, see Hankins, "Cosimo de' Medici as a Patron."

62. This is the conclusion drawn by Spina Barelli, "Note iconografiche."

63. Garin, *Italian Humanism;* Chastel, *Art et humanisme.*

64. Kauffmann, *Donatello,* 159–165; Schneider, "Donatello's Bronze *David*"; and Ames-Lewis, "Donatello's Bronze *David.*"

65. On the roundels in the Palazzo Medici see Wester and Simon, "Die Reliefmedallions."

66. Ames-Lewis, "Art History or *Stilkritik?*"; Spina Barelli, "Note iconografiche."

67. Kauffmann, *Donatello,* 161: "Nächst der Ponderation hat die Proportion den Ruhm des David gerechtfertigt. Auch auf sie fällt Licht aus der Umgebug des Plastikers. Denn, wenn die Frage gestellt wird, ob der David wirklich eine Proportionsfigur heißen dürfe, wird man sie bejahen müssen, weil sie in der Hauptsache genau dem Kanon entspricht den Alberti in 'De statua' niedergelegt hat."

68. Aiken, "Alberti's System of Human Proportion"; Marco Collareta, "Considera-zioni"; and Caglioti, *Donatello e i Medici,* 1: 218–222.

69. Eisler, "The Athlete of Virtue"; Kauffmann, *Donatello,* 76–94, already noted the affini-ties visible between Donatello's *David,* and the canon described by Alberti in *De statua.* Although misdating the treatise, Janson also subscribed to this view (Janson, "The Image of Man," 122–123). See also Collareta, "Considerazioni," 178: "Quanto al *De statua,* il nesso col *David* è provato dal fatto ben noto che questo presenta lo stesso canone di proporzioni che è dato di leggere alla fine del trattatello albertiano."

70. Kauffmann, *Donatello,* 244, n. 509. On the ancient cap, see Schuppe, "Pétasos." I have heard it suggested that the hat is based on Etruscan antecedents. This sounds promis-ing; I, however, have failed to find a con-vincing parallel in Etruscan art.

71. Berger et al., *Ways of Seeing;* Nead, *Female Nude;* Adler and Pointon, *Body Imaged.*

72. Eleventh-century poem, cited in Roth, "Deal Gently with the Young Man," 31.

73. For a nonbinary theorization of gender as it pertains to art history, see Davis, "Gender."

74. Tschudi, "Donatello e la critica moderna"; Janson, *Donatello*, 85. For an early negative reaction to Janson's vocabulary, see Tolnay, "Two Frescoes," 241.

75. Foucault, *History of Sexuality*, vol. 1.

76. On this distinction, see the foundational texts: Cowie, "Woman as Sign"; and Rubin, "The Traffic in Women."

77. See Laqueur, *Making Sex*.

78. The arguments regarding Donatello's sexuality are based on a series of humorous tales, collected in the late fifteenth century, but only published in the sixteenth century. A sculptor called Donatello figures in seven stories; in three of these—numbers 230, 231, and 322—the character is portrayed as particularly fond of young boys. Janson, *Donatello*, 85, discusses the tales published by Albert Wesselsky as *Angelo Polizianos Tagebuch*. Sternweiler, *Lust der Götter,* has restated Janson's case in greater detail. Also see Panormita, *Hermaphroditus;* and for an English translation, see Panormita, *Antonio Beccadelli and the Hermaphrodite.*

79. Schneider, "Donatello's Bronze *David*"; Schneider, "Donatello and Caravaggio." See also Dixon's rebuttal of Schneider's claims, "The Drama of Donatello's *David*"; and Schneider's "Response"; and Schneider, "More on Donatello's Bronze *David*." Schneider's pseudo-Freudian interpretation spawned responses such as Camille Paglia's unguarded comments in *Sexual Personae*, 146–47: "Blatantly homosexual in inspiration. . . . The hand on hip and cocked knee create an air of sexual solicitation. From the side, one is struck by the peachy buttocks, bony shoulderblades, and petulantly protruding boy-belly. The combination of child's physique with female body language is perverse and pederastic. . . . David, plunging his massive sword to the center, has stolen the adult penis, as he has stolen hearts. . . . The *David*'s shimmery, slithery bronze is a frozen wet dream, an Apollonian petrification."

80. An example of the former may be found in Pope-Hennessy, "Donatello's Bronze *David*"; for the latter, see Shearman, *Only Connect*, 25.

81. Pope-Hennessy, "Donatello's Bronze *David*," 125.

82. Butterfield, "New Evidence," 116, n. 14: "It should be observed that David was an ancestor of Christ and the Beatus Vir of the Old Testament, and thus any erotic or homoerotic image of him would have been potentially blasphemous and heretical."

83. Janson, *Donatello*, 85; Sternweiler, *Lust der Götter,* 29–202, esp. 61–69.

84. Rocke, *Forbidden Friendships*, 43. Rocke also indicates that there is no evidence to substantiate the legend that Cosimo burnt the book. In fact, the text is recorded in a 1456 inventory of Piero de' Medici's library. See Ames-Lewis, *Library and Manuscripts*, 249.

85. There is, for that matter, no incontrovertible evidence that Donatello made the bronze. See Paoletti ("The Bargello *David*"), who argues against Donatello's authorship.

86. Fulton ("The Boy Stripped Bare by His Elders," esp. 35–36) reconsidered the homoeroticism of Donatello's *David* in light of a broader social and artistic interest in adolecent boys, equivocating that although "there can be little doubt that neither Donatello nor his Medici patrons intended to convey an overtly homosexual message," "[i]t is self-evident that the nude figure, so beautifully revealing of bodily charms, elicits a homoerotic response." Although his emphasis on an adolescent male audience is salutory, it is difficult to follow Fulton when he reconciles these very different responses to the *David* via Jacques Lacan's specular theory of *infantile* self-recognition and socialization at the "mirror stage."

87. Baskins, "Donatello's Bronze *David*."

88. Kaplan, "Is the Gaze Male?" in *Women and Film*.

89. The "horticultural fallacy" also disturbs Shearman, *Only Connect*, 26. See Foucault, "What Is an Author?"

90. For one of the more sensitive, and influential, accounts of this uncertainty, see Butler, *Gender Trouble.*

91. Foucault: "We must not forget that the psychological, psychiatric, medical category of homosexuality was constituted from the moment it was characterized . . . less by a type of sexual relations than by a certain quality of sexual sensibility, a certain way of inverting the masculine and the feminine in oneself. Homosexuality appeared as one of the forms of sexuality when it was transposed from the practice of sodomy onto a kind of interior androgyny, a hermaphroditism of the soul. The sodomite had been a temporary aberration; the homosexual was a new species." Cited in Solomon-Godeau, *Male Trouble,* 28.

92. For this phrasing, see Rich, "Compulsory Heterosexuality."

93. It is not, however, clear how visible this detail would have been when the statue was placed on its pedestal. For the ivy on Buggiano's Old Sacristy tomb, see Shearman, *Only Connect,* 15–17.

94. Czogalla, "David und Ganymedes." Unfortunately, to my thinking, he harnessed his insights to an unnecessary argument for the secondary identification of David *as* Ganymede; for a similar criticism, see Albentiis, "Per un riesame." See also John Shearman, *Only Connect,* 17–21.

95. It should be noted that Hercules was always a politically and morally equivocal figure (see Panofsky, *Hercules am Scheidewege*). Hercules could also thematize gender reversal. On many private representations of the *Triumph of Love,* Hercules appears dressed as a woman, signaling his submission to Omphale (see Jacobsen-Schutte, "'Trionfo delle donne'"). What is more, fifteenth-century Florentine and north Italian representations of Hercules and Antaeus are filled with homoerotic suggestions. Nonetheless, Hercules always plays the active role, and, in Renaissance terms, his "masculinity" is not threatened. Patricia Simons offered a stimulating paper on this topic—"Hercules and Antaeus"—at the College Art Association Annual Conference, Toronto, 1998.

96. For a study of fifteenth-century adolescence in representation that emphasizes the erotic ambivalence encoded in the *David,* see Fulton, "The Boy Stripped Bare."

97. See Rosenauer, *Studien,* 129: "Der David weist nur ganz wenige Ansichten auf, zwischen denen es keinen vermittelnden Übergang gibt: die Ansicht von vorne— eindeutig die Hauptansicht—die Rückenansicht und die beiden Seitenansichten . . . erweisen sich die einzelnen Körperteile als formal aufeinander bezogen."

98. Pope-Hennessy, "Donatello's Bronze *David,*" 125. On the similarities between wings and hands, see Leonardo, *Notebooks,* 1: 432.

99. See Hartt, *Donatello,* 209. Also curious, linguistically, is the link between *penne* (feathers) and *pene* (penis).

100. Albentiis, "Per un riesame," 123.

101. Hartt, "Art and Freedom," esp. 124–125. Hartt, interestingly, glosses over the bronze *David,* focusing instead on the far less problematic marble version. For the political bases of Hartt's argument, see Baron, *Crisis.* See also Hartt, *Donatello,* 210.

102. For a study taking Hartt's insights as a point of departure, see Leach, "Donatello's Marble *David.*" For a critique, see Butterfield, "New Evidence," 115–116.

103. For reassessments of Baron's bold hypothesis, see Chapter One, n. 18.

104. Hartt, "Art and Freedom," 130.

105. Lisner, "Gedanken"; and Levine, "'Tal Cosa.'"

106. Janson, "La signification politique," 33–38. See also Herzner, "David Florentinus II."

107. Sperling, "Donatello's Bronze *David.*"

108. Florence, Biblioteca Riccardiana MS 660, 85r; Sperling, "Donatello's Bronze 'David,'" 218, n. 3.

109. See Chapter Six.

110. See Sperling, "Donatello's Bronze 'David,'" 218: "Victor est quisquis patriam tuetur / Frangit immanis Deus hostis iras / En puer grandem domuit tiramnum / Vincite cives." To the patrician Florentine

viewer of about 1460, the inscription would have brought to mind another, well-known couplet. The lines on Donatello's marble *David* in the *sala grande* of the Palazzo Vecchio and attributed to Rosso Rossi: "To those struggling courageously for the fatherland, God grants help even against the most terrible enemies." (This inscription was recorded in the late sixteenth century: Schrader, *Monumentorum Italiae*, 78v: "Pro patria fortiter dimicantibus etiam adversus terribilissimos hostes Dii praestant auxilium"; cited by Donato, "Hercules and David," 83. Donato [91] presents a slightly different manuscript transcription "Pro patria fortiter dimicantibus etiam adversus terribilissimos hostes deus prestat victoriam.") On the marble *David* being in the *sala grande* of the Palazzo Vecchio see Janson, *Donatello*, 3–7; and Rubinstein, *Palazzo Vecchio*, 55–56, esp. n. 89. The Medicean inscription is a blatant evocation of this republican tag, appended to Donatello's marble *David* shortly after Florence had dodged disaster, when, in 1414, Ladislaus of Naples unexpectedly died (recapitulating the similarly fortuitous demise of Gian Galeazzo Visconti in 1402). Whether one reads the Medicean verse as a subtle imitation or as a co-optation of ideological tools, the fact remains that the thematic similarity between the two texts echoes the formal and iconographical resonance between Donatello's two statues. Like the bronze *David*, the Medicean inscription underscores the youthfulness of the protagonist (a point to which I shall later return). The inscription also adds the identificatory cue, "Conquer, o citizens!" unnecessary in the openly civic context of the Palazzo Vecchio, the public seat of government.

111. Caglioti, "Donatello, i Medici e Gentile de' Becchi," part 2.

112. Grayson, "Poesie latine di Gentile Becchi." See Caglioti, "Donatello, i Medici e Gentile de' Becchi," part 1; Caglioti, *Donatello e i Medici*, 1: 57–80.

113. Crum, "Donatello's Bronze *David*."

114. Butterfield, "New Evidence."

115. Czogalla ("David und Ganymedes," 120) was the first to remark on the importance of the psalm.

116. Butterfield, "New Evidence," 124.

117. Platina, "De optimo cive," 202.

118. See Lànyi, "Problemi"; Parronchi, "Mercurio non David"; Pope-Hennessy, "Donatello's Bronze *David*"; and Czogalla, "David und Ganymedes." See also Gombrich, "Early Medici," 294, who cites and discusses Avogadri, "De religione."

119. On ideal and real receivers see Iser, *Act of Reading*, 28–30.

120. Oxford, Bodleian, MS Lat. Misc. e 81. See Caglioti, "Donatello, i Medici e Gentile de' Becchi," part 1, 14.

121. Florence, Biblioteca Riccardiana, MS 660. See Sperling, "Donatello's Bronze 'David,'" 218; Caglioti, "Donatello, i Medici e Gentile de' Becchi," part 1, 14.

122. Florence, Biblioteca Laurenziana, Acquisti e Doni 82, 32r. See Sperling, "Donatello's bronze 'David,'" 219.

123. Rome, Biblioteca Corsiniana, Fondo Niccolò Rossi, 230 (36.E.19), 190v. See Caglioti, "Donatello, i Medici e Gentile de' Becchi," part 1, 15.

124. On the judging of material worth, see Michael Baxandall's canonical text *Painting and Experience*, ch. 1.

125. Virgil, *Aeneid*, 9: 311. See Curtius, *European Literature*, 98–101.

126. Trexler, *Public Life*, 367–418; and Trexler, *Power and Dependence*, 1: 54–112. See Fulton's comments on representations of adolescent males in fifteenth-century Florence, "The Boy Stripped Bare," 36–37. He, too, sees Donatello's *David* operating within the revolutionary shifts in Florentine public life studied, above all, by Trexler. See also Niccoli, "Compagnie di bambini"; and Konrad Eisenbichler, *Boys of the Archangel Raphael*, 1–71. For the performances of adolescent groups, see, in particular, Newbegin, *Nuovo corpus;* and Newbegin, "The Word Made Flesh."

127. Trexler, *Power and Dependence*, 1: 84–85, suggests that the emphasis on developing a notion of childhood via ritual groups devel-

oped as a response to a Florentine marriage market where very young brides married older men. One response to this was a burst in extramarital hetero- and homosexual activity. Moralists supported boys' confraternities as a way of chanelling adolescent energy into morally well-founded endeavors. Legislation restricting confraternal meetings was passed in 1419 and 1429; see Gutkind, *Cosimo de' Medici*, 57–58.

128. Trexler, *Public Life*, 383: "Adults first noticed the skills of children as actors in adult spectacles, and found the former better actors."

129. Trexler, *Public Life*, 374.

130. For the effect of such shifts on the arts, see Mode, "Adolescent *Confratelli*"; and Fulton, "The Boy Stripped Bare."

131. Trexler, *Public Life*, 387.

132. Banfi, *Sacre rappresentazione*, 113, cited in Trexler, *Power and Dependence*, 1: 97: "E farem quelle rappresentazioni / che si dice che fian nel detto giorno, / con certe contenzione tra' rei e' buoni / che faran più divoto e più adorno / quest'atto, e per le predette quistioni / potrá comprender che sarà da torno / el gaudio che procede da far bene, / e quanto è vizii sien cagion di pene."

133. Trexler, *Power and Dependence*, 1: 74.

134. This line of thought was already suggested by Fulton, "The Boy Stripped Bare."

135. Butterfield, "New Evidence," 127, cites Ricciardi, *Col senno, col tesoro e col lancia*, 97. See also Eisenbichler, "Confraternities and Carnival."

136. Trexler, *Public Life*, 435.

137. Adorno, "Rinuccini," 282; cited by Trexler, *Public Life*, 435.

138. In 1454, Lorenzo was sent to Milan; he also appeared in public for the reception of the duke of Anjou. See Trexler, *Public Life*, 249.

139. Cited by Garin, *L'educazione umanistica*, 61.

140. Butterfield, "New Evidence," 128.

141. Platina, "De optimo cive," 202.

142. Janson, *Donatello*, 85: "He is not a classical *ephebos* but the 'beautiful apprentice'; not an ideal but an object of desire, strangely androgynous in its combination of sinewy angularity with feminine softness and fullness."

143. Trexler, *Public Life*, 382.

144. On the period eye, see Baxandall, *Painting and Experience*, 29–108. See also Snow, "Theorizing the Male Gaze."

145. See Rocke, *Forbidden Friendships;* Rocke, "Sodomites in Fifteenth-Century Tuscany"; Marcello, "Società maschile e sodomia"; Poirier, "Sodomicques et bourgerons"; Poirier, *L'homosexualité;* and Mormando, *Preacher's Demons*, ch. 3. The word sodomy was used very broadly during the period, to encompass all manner of sexual acts; nonetheless, anal sex between male partners appears to have been the most paradigmatic form of sexual relation signified by this word.

146. In what follows I attempt to steer away from the problematic terms of "homosexual" and "homosexuality"; I shall, however, use the phrase "homosexual sex" and "homosexual relations" to indicate all manner of male-male sexual interactions (I do this explicitly to produce a certain discursive continuity between social historical studies like Rocke's and Ruggiero's); unless otherwise noted, these will not refer to female-female sexual relations. Similarly, unless otherwise indicated, I will use the word "sodomy" to refer to male-male anal sex. On the reasons for the latter distinction, see Jordan, *Invention of Sodomy*. Guido Ruggiero has also noted the frequency with which Florentines were prosecuted for sodomy in Venice; Ruggiero, *Boundaries of Eros*, 137–139.

147. Rocke, *Forbidden Friendships*, 36–42. Women bore equal blame for this problem. By demanding lavish gifts from their husbands-to-be, it was claimed, brides put men off marriage, turning them toward homosexuality.

148. Herlihy and Klapisch-Zuber, *Tuscans and Their Families*, 210.

149. On the Monte delle Doti, see Molho, *Marriage Alliance;* and, on the communal brothels, Mazzi, *Prostitute e lenoni*.

150. Rocke, *Forbidden Friendships*, 4.

151. Rocke, *Forbidden Friendships*, 5.

152. Rocke, *Forbidden Friendships*, 154, 186.

153. Rocke, *Forbidden Friendships*, 156.

154. Rocke, *Forbidden Friendships*, 95.

155. Francesco Filarete, in Gaye, *Carteggio*, 2: 456. See Janson, *Donatello*, 78; and Shearman, *Only Connect*, 22, note 17. Recently, Francesco Caglioti (*Donatello e i Medici*, 1: 310–319) has argued that Filarete was responding not to Donatello's bronze *David*, but to Verrocchio's bronze of the same subject. To do so, Caglioti must hypothesize that Verrocchio's statue— which was documented in the late fifteenth century and in 1510 as in the Sala dei Gigli of the Palazzo Vecchio—was moved. He bases this hypothesis on an uncharacteristically willful reading of the phrase "solo si mutò il David." While such movements are not impossible, in the absence of documentation demonstrating the contrary, it seems best to assume that Filarete was responding to Donatello's statue, which is documented as in the courtyard in 1495 and later.

156. Shearman, *Only Connect*, 22, n. 17 discusses the translation of the word, mentioning that it could mean "stupid," "dumb," "tasteless," or, better yet, "imprudent." "Schiocca" could also indicate that the leg is literally "lame," but this does not make much sense.

157. Gelli, "Vite d'artisti," 59; cited by Janson, *Donatello*, 78. Filarete would not, given his wording, appear to be referring to Donatello's *non finito*, later criticized by Michelangelo (as reported in Ascanio Condivi's biography; see Janson, *Donatello*, 78–79).

158. See Janson, *Donatello*, 77: [9 October 1495] "Two bronze statues, a David in the courtyard of the palace of Piero de' Medici and a Judith in the garden of the same palace, are to be turned over to the *operai* of the Palazzo Vecchio, together with their pedestals (*cum omnibus eorum pertinentiis*)."

159. Toscan, *Le carnaval du langage*, 371.

160. Only Fra Bartolomeo outdoes Donatello in this regard. His drawing of David shows a figure with an enormous, wide-brimmed hat.

161. Rocke, *Forbidden Friendships*, 155.

162. A similar case might be made for the sword.

Fencing academies were associated with male-male sexuality. See Rocke, *Forbidden Friendships*, 158–9.

163. For an analogous visual structure, see Colbum, "Desire and Discourse."

164. For two of her more recent contributions along these lines, see McKillop, "Dante and *Lumen Christi*"; and McKillop, "L'ampliamento dello stemma mediceo."

165. "Morte crudele che'in quisto chorpo venne / Che dopo morte il mondo andò sotto sopra, / Mentre che tu visse tutto in pace tenne"; see Langedijk, *Portraits of the Medici*, 1154, cat. no. 74, 25.

166. Trapesnikoff, *Porträtdarstellungen der Mediceer*, 45–56; Jurén, "'Civium Servator'"; Hill, *Corpus*, no. 916, 1: 241, 2: pl. 148; Langedijk, *Portraits of the Medici*, 1167–1168, cat. no. 74, 37.

167. Hill, "Classical Influence."

168. Rocke, *Forbidden Friendships*, 198.

169. Rocke, *Forbidden Friendships*, 198. There is even the suggestion that Lorenzo engaged in homosexual relations with Martelli. See Trexler, *Public Life*, 436, who cites Martelli in Rochon, *La jeunesse*, 125, n. 312. Most curious, and perhaps suggestive, regarding the original site and function of the bronze *David*, are the suspicions that seem to have surrounded Averardo de' Medici's relations with Micheletto degli Attendoli, the cousin of Francesco Sforza, and for a spell the Captain-General of Florentine in the early 1430s. The *condottiere* was, as Rocke put it, a man "suspected of sexual unorthodoxy" (Rocke, *Forbidden Friendships*, 43). Because of his early death in 1434, Averardo is not often given his due in discussions of the rise of the Medici to power. Through the 1420s he was, if not Cosimo's equal, at least the second most powerful member of their faction. The correspondence between Averardo and Micheletto is full of expressions of affection that go beyond, to my thinking, what Wendy Wegener called the "affectionate hyperbole common in the period" ("'That the Practice of Arms,'" 148, n. 56). A letter from Niccolò Tinucci to Averardo would seem to confirm this suspicion. Tinucci, concerned about the

potential political ramifications of Averardo's relations with Micheletto, warns him in no uncertain terms about the dangers of such a relationship: "It is deemed far too great a shortcoming that you have spent so much time with him, and yet you are unable to say whether he is a man or a woman; I would therefore do everything possible to clarify this, and may the smoke fly wherever it will!" (ASF, Mediceo avanti il principato 3n. 125 [13 March 1431–32]); excerpts are in Guasti, ed., *Commissioni*, 3: 523, n. 1; cited in Rocke, *Forbidden Friendships*, 43). It is worth noting that eventually all Averardo's possessions came under Cosimo's control. It is not impossible, therefore, that Averardo was the patron of Donatello's *David*. Were this to be the case, the statue's homoerotic content would take on another layer of meaning.

170. Cannarozzi was the first to suggest this reading. See Trexler, *Public Life*, 381 and Rocke, *Forbidden Friendships*, 42.

171. Machiavelli, *Prince*, 59.

172. Langedijk, "Baccio Bandinelli's *Orpheus*."

Chapter Five: Spectacular Allegory: Botticelli's *Pallas Medicea* and the Joust of 1475

For their lively responses and thoughts, I would like to thank the students who participated in the seminar I led at Harvard University in the fall of 1994 on Florentine public spectacles and art.

Epigram: Florence, Biblioteca Laurenziana, Pluteo 34, cod. 46, fols. 18r–18v: "In signis quare Medici sit, Bembe, requiris / Post tergum vinctis pictus Amor manibus, / Sub pedibusque tenens arcus fractamque pharetram, / Pendeat ex humeris nullaque penna suis; / Atque solo teneat fixos immotus ocellos, / Immeritam veluti sentiat ille crucem. / Horrida cui tereti Pallas supereminet hasta / Et galea et saeva gorgone terribilis. / Multi multa ferunt, eadem sententia nulli est: / Pulchrius est pictis istud imaginibus." See Truffi, *Giostre e cantori*, 134; and Ruggieri, "Letterati, poeti e pittori," 174.

1. On the painted memorials in the duomo, see Wegener, "'That the Practice of Arms.'" On the *pitture infammanti*, see Ortalli, *. . . pingatur in Palatio*, esp. 62 and 182; and Edgerton, *Pictures and Punishment*. On trecento political painting, see also Donato, "'Cose morali.'"

2. The numerous literary responses to the banners and the jousts attest to their importance in Florentine public consciousness. For the joust of 1469, see Pulci, *Opere minori;* Martelli, *Letteratura fiorentina*, 185–197; Davie, "Pulci's *Stanze*." The anonymous description can be found in the BNCF, MS Magliabechiano VIII, 1503; excerpts from this MS were published in Fanfani, ed., *Ricordo di una giostra;* for the banners, see Wackernagel, *World*, 199–201. For poetic responses to the joust, see Naldi, *Elegiarum*, 3: 18, 92–93. See Lanza, *Lirici toscani*, 1: 159–160 and 385 (for the sonnets of Bernardo Altoviti and by Giovanni Ciai; two of these had also already been published by Flamini in *La lirica toscana*, 376); Rochon, *La jeunesse*, 97–98 and notes. On the joust of 1475, see Lungo, *Florentia*, 393–397; Poggi, "La giostra medicea" (with excerpts from the anonymous report in BNCF, MS Magliabechiano II IV 324); Truffi, *Giostre*, 118–126; E. Tedeschi, *Alcune notizie fiorentine tratte dall'archivio Gonzaga di Mantova* (Badia Polesine, 1925), 13–25 (cited and discussed in Bessi, "Di due (o tre) giostre"; Kristeller, "Un documento sconosciuto," 438 and n. 4; Fumagalli, "Nuovi documenti," esp. 141–64; Augurelli, *Carmina nondum vulgata;* see also Pavanello, *Augurelli*, 237–240); Naldi, "Hastiludium"; Naldi, *Epigrammaton liber*, 5.

3. For the resurgence of interest in jousts in the late Middle Ages, see Truffi, *Giostre;* and Heers, *Fêtes, jeux et joutes*. On Tuscany in particular, see Christiani, "Sul valore politico del cavaliere"; Cardini, "Cavalleria e vita cavalleresca." See also Clough, "Chivalry and Magnificence."

4. See, for example, Ruggieri, "Letterati, poeti e pittori"; Settis, "Citarea"; Trexler, *Public Life*, 234ff.; Dempsey, *Portrayal of Love*,

esp. 114–139; Ventrone, ed., *Le tems revient;* and Dempsey, "Portraits and Masks."

5. Paola Ventrone has taken a contrary route, arguing for the fundamentally apolitical nature of the Medici jousts, and of spectacular culture in fifteenth-century Florence in general; see Ventrone, "Feste e spettacoli"; and Ventrone, "Lorenzo's *Politica festiva.*" While Ventrone's critique does raise the problematic issue of "intentionality," it is rather extreme in its desire to depoliticize Medici interventions in public life.

6. I shall usually refer to these figures as Pallas and Cupid, mingling Greek and Roman mythology.

7. Teskey, *Allegory and Violence*, 78–79.

8. Teskey, *Allegory and Violence*, 79.

9. Brown, "Guelf Party"; Finiello Zervas, *Parte Guelfa.*

10. Trexler, *Public Life*, 234.

11. Donatello's statue was moved sometime between 1451 and 1459; see Zervas, *Parte Guelfa*, 99ff.

12. In his rich article "Portraits and Masks," Charles Dempsey develops a reading of such staging, focusing on the metaphor of "masking."

13. See Dempsey, *Portrayal of Love*, esp. 114–139; Lungo, *Florentia*, 391–412; and Ventone, *Le tems revient*, 189–205. On the history of jousts, see Truffi, *Giostre;* Scalini, "Il 'ludus' equestre"; Trexler, *Public Life*, 234; and Carew-Reid, *Les fêtes florentines*, 28ff. On jousting weapons in particular see Scalini, "Weapons of Lorenzo de' Medici"; and Scalini "L'armatura fiorentina." The jousts (and the martial spectacles that accompanied them) also gave rise to a strong literary tradition; see, for example, Filippo Lapaccini, *Armeggiata of Bartolomeo Benci* (See Fanfani, *Ricordo di una giostra;* Lanza, *Lirici toscani*, 2: 1–16); Anon., *Giostra* (1410–19) (see Volpi, ed., "Un'altra giostra fiorentina"); Anon., *Giostra* for Giovanni de' Medici, uncle of Lorenzo, held in 1459 for Pius II and Galeazzo Maria Sforza (Volpi, ed., *Le feste di Firenze;* and Volpi, ed., *Ricordi di Firenze*). See also Anon., *Terze rime*, esp. fols. 73–76.

14. Truffi, *Giostre*, 119, 127; Rochon, *La jeunesse*, 97; Dempsey, *Portrayal of Love*, 80ff.

15. Roscoe, *La vita di Lorenzo de' Medici*, 103–104: "per seguire e fare come gli altri giostrai in sulla piazza di Santa Croce e, benché d'armi e di colpi non fussi molto strenuo, mi fu giudicato il primo onore, cioè un elmetto fornito d'ariento, con un Marte per cimiero." See Truffi, *Giostre*, 119; and Orvieto, "Introduzione," in Pulci, *Opere minori*, 55–56. Following his victory, Lorenzo received congratulations from many quarters; see Rochon, *La jeunesse*, 134, n. 417.

16. See Truffi, *Giostre*, 125. See also Doglio, "Laurent de Médicis."

17. Despite this heterosexual mythology, earlier in the century, in a *canzone* against sodomy, Domenico da Prato complained that "[n]on per le donne più si move a furia / le prove che solean maravigliose / schermir tornïamenti ed altre giostre: / chi più può per i garzoni or fa sue mostre (Those customary proofs—marvelous competitions of fencing, tournaments, and lofty jousts are no longer inspired by women; he who still can, now does his shows for boys)." See Lanza, *Lirici toscani*, 1: 570–571.

18. Lucrezia married Niccolò on 21 April 1465. On the relationship between Lucrezia and Lorenzo, see, inter alia, Lungo, *Gli amori;* Gori, *Firenze magnifica*, 90–92; Rochon, *La jeunesse*, 94–99; Dempsey, *Portrayal of Love*, 73–74; Ventrone, *Le tems revient*, 167–187; and Cardini, "Le insegne Laurenziani," 71–72.

19. On this relationship, see Ventrone, *Le tems revient*, 189–205; Dempsey, *Portrayal of Love*, 114–139.

20. Lungo, *Florentia*, 397: "E a' dì 28 di gennaio si fece una bella giostra in sulla piazza di Santa Croce; e furno 22 giostranti, molto ricchi di gioie e perle: e 'l magiore onore ebbe Giuliano di Piero de' Medici, e 'l secondo onore Iacopo Pitti."

21. That is not to say that such jousts could not be dangerous; in 1447 the patrician Alberto

d'Averardo degli Alberti died while taking part in such games. See Mario Martelli, "La canzone di Francesco d'Altobianco degli Alberti," *Interpres* 6 (1986): 42.

22. Lungo, *Florentia*, 399: "Ultimo tu entri nel campo, o mio Giulio, ma prima di bellezza, di forza, di ricchezza. Impossibile descrivere le gioie e perle in quantità, che risplendono sulla persona tua e de' tuoi compagni e sopra i destrieri: nè saprei raccontare delle schiere di cavalieri e pedoni ed araldi, io che, poveretta, mezza fuori di me, non distoglievo li occhi dalle tue forme divini, coperte di gemme e di diamanti: Marte nell'armi, Amore nel volto." See also Kristeller, "Un documento," 437–450, 446: "(Giuliano) cum magno egregioque pediatu inter duos veteranos equites sibi ad ludum adiunctos inclitus aderat ut quemvis Scipionem referre videtur, attalicis vero vestibus ita exornatus nempe auro argentoque solido contestis unionibus magnis atque rotundis gemmis innumeries fulgentibus coacervatim superimpositis, ut preteriens spectantis populi aciem suo splendore atque fulgore penitus perstringeret."

23. A similar description of Lorenzo in 1469 can be found in the poem by Giovanni di Bartolommeo d'Angiolo Ciai (See Flamini, *La lirica toscana*, 376): "Le palle e il giglio dentro al campo d'oro / oggi in giostra real mostran gran posse, / rendendo a molti molte alte percosse, / e si sonando in tutto el nome loro. / Negli ornamenti son d'assai tesoro, / zaffir rubin diamanti e perle grosse / onde le spraveste al vento mosse / donan talvolta altrui ricco lavoro. / Illustre è lor signiore e valoroso, / pien d'ardimento, e van con franco core / incontro a chi con lui colpir si brama, / e non dubita punto dell'onore, / rallegrandosi in sé vitorïoso, / or che vede fiorir suo' verde fama." See also the sonnet by Bernardo di Paolo Altoviti (Flamini, *La lirica toscana*, 375ff.): "Lauro gentil, quell'angelica luce, / che s'addornò del sole e delle stelle, / ha tinto in fiamme l'orate quadrelle, / per farvi sol beato ov'è piú luce. / Quest'è 'l trionfo ver di vostra luce, / onor fama dell'alte opere belle: / maraviglia che

n'ode, come in quelle / cose inaudite, uom della patria luce. / Dario Lucio Pompeo o Alessandro / ebbon mai spoglie fussi del bel lauro? / Le Muse e tutti e cigni di Meandro / non potrebbon cantar dell'ordin vostro, / che per virtute accede ogni tesauro." See also Vincenzo Borghini's response, cited in Truffi, *Giostre*, 125.

24. BNCF, MS Magliabechiano II IV 324.

25. Borghini, cited in Truffi, *Giostre*, 125; see also Rochon, *La jeunesse*, 98.

26. Wackernagel, *World*, 199–204, was the first to emphasize the role of important artists in producing ephemera for public displays of this kind and the cultural moment of these enterprises.

27. Florence, Biblioteca della Galleria degli Uffizi, Miscellanee Manoscritte, 1, fol. 3, no. 8: "Per lo stendardo per la giostra di Lorenzo." The inventory also refers to a second standard (with a "spiritello"), produced by Verrocchio for the joust of 1475: "Per dipintura duno stendardo ch uno spiritello per la giostra di Giuliano." See also Fabriczy, "Andrea Verrocchio"; Horne, *Botticelli*, 156–157; Barfucci, *Lorenzo de' Medici*, 175.

28. On Cosimo's tomb in San Lorenzo, for example. See Fabriczy, "Andrea Verrocchio"; Butterfield, *Verrocchio*, 33–55; and McKillop, "Dante and *Lumen* Christi."

29. Consider, also, the drawing for a banner by Verrocchio in the Uffizi, discussed by Wackernagel, *World*, 201; and Dempsey, *Portrayal of Love*, 136.

30. Fanfani, *Ricordo di una giostra*, 6: "i sternardo di taffetà bianco con frapponi intorno a lor divisa, che nella sommità era un sole che tutto il campo razzava di razzi d'oro, e nel messo v'era uno prato verdi suvi una dama ritta con vesta dommaschino chermisi la quale aveva preso il Dio d'amore, e toltogli l'arco e 'l turcasso, e legatogli le mani di dietro con catene d'oro, e dell'ale li traeva le penne, seminandone tutto il campo di penne e d'oro." See also Pulci, "La giostra," 55–120.

31. Fanfani, *Ricordo di una giostra*. On this text and on the standard it describes see Orvieto, "In margine." For Verrocchio's authorship

of the banner, see Fabriczy, "Andrea Ver-
rocchio"; Brown and Seymour, "Further
Observations"; and Brown, "Verrocchio
and Leonardo." On the symbolism of the
1475 tourney, see Ruggieri, "Letterati, poeti
e pittori"; Ruggieri, "Spiriti e forme"; Settis,
"Citarea"; and Moore, "Medici Myth-
Making"; and Dempsey, "Portraits and
Masks." For a modern reconstruction of
how the banner might have appeared, see
Ventrone, *Le tems revient,* 182–183, cat.
3.17.

32. Dante, *Divine Comedy,* 30, 16. 151–154:
"Con queste genti vid'io glorïoso / e gius-
to il popol suo, tanto che 'l giglio / non era
ad asta mai posto a ritroso, / né per
divisïon fatto vermiglio." See also Dati,
L'istoria, 11–12 and 133.

33. On the festive significance of such painted
dresses, see Dempsey, *Portrayal of Love,*
65–72.

34. See Cox-Rearick, *Dynasty and Destiny,*
17–19.

35. Pulci, *Opere minori,* 61–120; on the dating,
see Paolo Orvieto's introduction to the
poem: Pulci, *Opere minori,* 56. On the *gios-
tra* see Truffi, "Ancora sulla *Stanze*"; Volpi,
"Di nuovo delle *Stanze.*" As with Poliziano's
Stanze, it is impossible to ascertain the role
poets might have played in developing the
iconographic programs for the banners of
the tourneys. Nonetheless, given their con-
tent and uniformity, it seems likely that
someone like Pulci or Poliziano would have
had a hand in planning the imagery.

36. See Roscoe, *Life of Lorenzo de' Medici,* 55;
Truffi, *Giostre,* 118–119; Rochon, *La
jeunesse,* 89, 94–96; Dempsey, *Portrayal of
Love,* 82.

37. Pulci, *Opere minori,* 68.

38. Pulci, *Opere minori,* 65: "E perché egli
havea scritto in adamante / Quello atto
degno di celeste honore, / Si ricordò, come
gentile amante, / D'un detto antico: CHE
vuol' fede amore, / Et preparava già l'armi
leggiadre, / Ma nol consente il suo famoso
padre." For a slightly different translation,
see Dempsey, *Portrayal of Love,* 84.

39. See Ventrone, "Feste e spettacoli," 21.

40. For the Boccaccian roots of this expression,
see Watson, *Garden of Love,* 89, 156. On
the diamond as a Medicean symbol, see
Chapter Three.

41. Pulci, *Opere minori,* 86: "e nel suo bel vexil-
lo si vedea / di sopra un sole e poi l'ar-
cobaleno, / dove a lettere d'oro si leggea: /
'Le tems revient,' che può interpretarsi /
tornare il tempo e 'l secol rinnovarsi. / Il
campo è paonazzo d'una banda, / dall'altro
è bianco, e presso a uno alloro / colei che
per exemplo il ciel ci manda / delle bel-
lezze dello etterno coro / ch'avea tessuta
mezza una grillanda, / vestita tutta âzurro
e be' fior' d'oro; / e era questo alloro parte
verde, / e parte, secco, già suo valor
perde."

42. Pulci's poem begins with an invocation to
Apollo.

43. See the Gonzaga correspondence, in Truffi,
Giostre, 169–170; Bessi, "Di due (o tre)
giostre."

44. Lungo, *Florentia,* 391–412.

45. Poggi, "La Giostra Medicea," 72–73:
"Nella sommità era un sole; e nel mezo di
questo stendardo era una figura grande
similigliata a Pallas vestita d'una veste d'oro
fine in fino a mezo le gambe. Et disocto una
veste biancha onbreggiata d'oro macinato,
et uno paio di stivalecti azurri in gamba;
la quale teneva i piè in su due fiamme di
fuocho, et delle dette fiamme usciva fiamme
che ardevano rami d'ulivo che erano dal
mezo in giù dello stendardo, che dal mezo
in su erano rami senza fuocho. Haveva in
capo una celata brunita all'anticha, e suoi
capelli tucti atrecciati che ventolavano.
Teneva decta Pallas nella mano diricta una
lancia da giostra, et nella mano mancha lo
scudo di Medusa. Et apresso a decta figura
un prato adorno di fiori di varij colori, che
n'usciva uno ceppo d'ulivo con uno ramo
grande, al quale era legato uno dio
d'Amore cum le mani drieto cum cordoni
d'oro. Et a piedi aveva archo, turcasso et
saecte rocte. Era commesso nel ramo d'uli-
vo dove stava legato lo dio d'Amore uno
brieve di lectere alla franzese d'oro che
dicevano 'La sans par'; la sopradecta Pallas
guardava fisamente nel sole che era sopra a
llei." See also Poggi, "A proposito della

Pallade." For a Neoplatonic interpretation of the imagery of the 1475 joust see Martelli, "I Medici e le lettere." See also Dempsey, "Portraits and Masks."

46. Hulubei, "Naldo Naldi," 176: n. 2: "Cuius ut esse queas victricia dicere signa / Pallada conspicies spectantem in lumina solis: / Atque hastam manibus: scutumque insigne gerente / Gorgonis anguiferae: pedibus quae diva pudicis / Calcat: iter faciens tremulas castissima flammas / Hic tu non tenerum quicquam: necque molle videbis / Sed Veneris natum manibus post terga revinctis / Haerentem trunco teretis nisi fallor olivae, / Viribus effractum victricis in omnia divae."

47. Ruggieri, "Letterati, poeti e pittori," 178: n. 2: "uno idio d'amore assedere in sur uno ceppo d'ulivo et legato colle mani drieto a uno ramo d'ulivo."

48. Spallanzani and Gaeta Bertelà, *Libro d'inventario,* 81, c. 42v: "Un altro dono di giostra d'uno cimiere e uno elmetto, suvi uno chupido gnudo leghato le mani drieto a uno alloro. f.—." See Poggi, "La Giostra Medicea," 76. Ruggieri, "Letterati, poeti e pittori," 178, also mentions that "[i] Naldi accenna a un paggio di Giuliano, che 'nudum gerebat Amorem'—ad conum Medicis."

49. On the *broncone* see Giovio, *Dialogo dell'imprese,* 27–28: "i tronconi veri incavalcati i quali mostravano, fiamme, et vanpi di fuoco intrinseco"; Giovio associates the device particularly with Piero di Lorenzo de' Medici, and with his amorous fervor: "come giovane et innamorato . . . per significare che il suo ardor d'amore era incomparabile, poi ch'egli abbruciava le legna verdi." The device might have been invented by Poliziano (in reference to Virgil, *Aeneid,* 4: 66); see Settis, "Citarea," 136 and Langedijk, *Portraits of the Medici,* 1: 40. See also Cox-Rearick, *Dynasty and Destiny,* 12–31, esp. 17–23; Bausi, "Il broncone e la fenice," notes that the *broncone* derived from devices used by Lorenzo "il Magnifico."

50. See Dempsey, "Portraits and Masks." In this regard, it seems odd that the word "cominciate" in the full title of Poliziano's poem has not received more attention.

51. See Settis, "Citarea."

52. Poliziano, *Stanze,* ed. Pernicone, 1.46.

53. On the imagery surrounding Giuliano's joust see Ruggieri, "Letterati, poeti e pittori"; and Settis, "Citarea."

54. Dempsey, *Portrayal of Love,* 112.

55. In thinking about lost works of art and their afterlives, I have found particularly useful Ada Cohen's work on *The Alexander Mosaic,* esp. 13–23, 51–82.

56. Spallanzani and Gaeta Bertelà, *Libro d'inventario,* c. 42v, 80: "Nella camera di Piero . . . Uno panno in uno intavolato messo d'oro, alto br. 4 incircha e largo br. 2, entrovi una fighura di Pa[llade] et con uno schudo dandresse (sic) e una langia d'archo di mano di Sandro di Botticello. f. 10." The next entry: "Uno dono d'una giostra d'uno cimiere in sun un elmetto con una fighura di Pa[llade] di rilievo e d'ariento. f. 40." Soon after: "Un altro dono di giostra d'uno cimiere e uno elmetto, suvi uno chupido gnudo leghato le mani drietro a uno alloro."

57. Zorzi, "Lo spettacolo," 204: "Lo stendardo che fu opera del Botticelli rimase a lungo nel palazzo (lo ricorda ancora l'inventario del 1492) prima di andare disperso"; see also Caneva, *Botticelli;* and Dempsey, "Portraits and Masks," 28. These ideas derive from Poggi, "La giostra"; and Giovanni Poggi, "A proposito."

58. Vasari, *Le vite,* 3: 312. Although he was often confused on such matters, Vasari does mention specifically and suggestively that the work was made "for the elder Lorenzo."

59. Discussed by Warburg, *Gesammelte Schriften,* 1: 87 (*Renewal,* 144); Poggi, "La giostra"; and Settis, "Citarea."

60. The absence of the *bronconi* does not bear upon the problem of attribution; for another opinon, see Lightbown, *Botticelli,* 2: 214.

61. Lorenzi, *Medaglie di Pisanello,* exh. cat. , 86, cat. no. 53.

62. Colvin, ed., *Florentine Picture-Chronicle,* 39, no. XXXIX. See also Whitaker, "Maso Finiguerra, Baccio Baldini and The Florentine Picture Chronicle."

63. Ulmann, "Eine verschollene *Pallas Athena*"; and Müntz, *Les collections*, 86.

64. It is worthwhile recalling that Luigi Pulci has Lorenzo, after his joust, take his trophy to the Tempio d'amore. See Ruggieri, "Spiriti e forme," 12.

65. Lanza, *Lirici toscani*, 2: 360.

66. Warburg considered Agostino's agitated drapery style within the context of *bewegtes Beiwerk*, concentrating on a relief now in Milan; see "Sandro Botticellis 'Geburt der Venus' und 'Frühling' [1893]" in *Gesammelte Schriften*, 1: 12 (*Renewal*, 97).

67. Poliziano, *Opere volgari*, 251; Poliziano, *Rime*, 142, no. 10: "Dalla più alta stella / Discende a celebrar la tua letizia, / Glorïosa Fiorenza, / La dea Minerva agli'ingegni propizia: / Con le ogni scïenza / V'è, che di sua presenza / Vuole onorarti a ciò che sia più bella. / Poco ventura giova / A chi manca el favor di queste donne: / E tu, Fiorenza, el sai; / Chè queste son le tua ferme colonne: / La gloria che tu hai / D'altronde non la trai' / Che dall'ingegno di che ogn'or fai pruova. / Lo stelle sono stiave / Del senno, e lui governa le fortune / Or hai, Fiorenza, quello / Che desiam, è tante e tante lune, / Onorato cappello. / Verrà tempo novello / Ch'àrai le tre corone e le due chiave."

68. Rubinstein, "Youth and Spring."

69. For recent work stressing the patronage of Lorenzo di Pierfrancesco and usually subscribing to a marital interpretation, see Lightbown, *Botticelli*, 1: 69–81; Barolsky, "Botticelli's *Primavera*"; Levi d'Ancona, ed., *Botticelli's "Primavera"* (who has substantially revised her opinions in Levi d'Ancona, *Due quadri*, returning the painting to the main branch); Bredekamp, *Botticelli;* Zirpolo, "Botticelli's *Primavera*"; Rohlman, "Botticellis *Primavera*"; and Zöllner, *Botticelli*.

70. For the inventory see Shearman, "Collections"; and Smith, "On the Original Location."

71. Recently both Dempsey (*Portrayal of Love*) and Levi d'Ancona (*Due quadri*) have (re)promoted the idea the painting might have originally been produced for the main

72. Like the *Primavera*, the so-called *Pallas and the Centaur* appears to have been moved to the Medici villa at Castello during the sixteenth century.

73. Cox-Rearick, *Dynasty and Destiny*, 79. Despite the apparent similarity of Florentia to the Latin *florere*, or its gerundive *florens*, the city probably owes its name to the verb *fluere:* to flow, to spread, to spring, and, perhaps ironically given the Arno's propensity to swell unexpectedly, to overflow. Thus, although the name Florentia was determined by the city's site in a river valley, rather than by flowers, the link with blossoming, prospering, and fertility won out in the history of associations.

74. On the etymological and symbolic connections, see Dati, *L'Istoria*, 112: "Ella era il fiore di tutte l'altre e che più ogni di fioriva; intanto che questo parlare fece che in poco tempo, abandonato il primo nome, da tutti era chiamata la città del fiore; e prendo che così fosse, prese per sua arme e insegna il giglio fiorito, che è sopra a tutti gli altri fiori; e era il giglio bianco naturale nel campo vermiglio; e così durò gran tempo insino alla raccomunazione che fu fatta co' Fiesolani quando la loro città fu disfatta e vennono in Firenze."

75. On the name of Florence see Davidsohn, *Storia di Firenze*, 1: 12. Villani (*Cronica*, bk. 1, ch. 38, 1: 61–62) offered "Floria" as the city's first name, explaining that it referred both to Florence's founder, "Fiorino" (the Roman consul killed by the Fiesolans), and to Florence's foundation in a field where flowers bloom continually. On this legend, and the development of the trope, see Rubinstein, "The Beginnings of Political Thought"; Davis, "Il buon tempo antico"; Weinstein, "The Myth of Florence," 29, n. 3, 32; and Bruni, "Panegyric," 151, 154. Bruni claimed that the city had originally been called "Fluentia" and that either through corruption, or on account of Florence's "blooming," the name had become "Florentia." See Watkins, trans. and ed., *Humanism and Liberty*, 31.

76. *Stanze*, 1. 4. Bellincioni, *Le rime*, 224, son-

net 147. In the bottom right-hand corner of the painting, Botticelli painted an iris, related to Florence's heraldic flower (see Levi d'Ancona, *Botticelli's "Primavera,"* 43).

77. See Lightbown, *Botticelli;* and Salvini, *Botticelli.*

78. Ridolfi, "La *Pallade*"; Horne, *Botticelli.* Both Ridolfi and Horne see the *"Pallas and the Centaur"* as referring to Lorenzo's diplomatic success, either after his dramatic alliance with Naples, or after his pact with Innocent VIII in 1487. Bode (*Botticelli*) sees the painting as a general monument to Medici patronage of the arts.

79. Wittkower, "Transformations of Minerva"; and Gombrich, "Botticelli's Mythologies."

80. Lightbown, *Botticelli,* 1: 81. Given Dempsey's interpretations of the *Primavera,* stressing its thematic allusions to the main branch of the Medici family, it might also be wise to reassess the so-called *Pallas and the Centaur,* which, as noted, might very well have possessed a programmatic connection to the *Primavera.* Although it is fairly clear that both paintings could be found in the *casa vecchia* and thus belonged to the descendants of Pierfrancesco di Lorenzo de' Medici, this does not mean that they commissioned Botticelli to produce these works. In the early 1480s, after the death of Giuliano, Lorenzo reached a difficult settlement with his cousins regarding their legacy, of which he was the guardian. It would not be surprising if some inexpensive items, like paintings—especially perhaps if they had come to be associated with the tragedy of Giuliano and Simonetta—had changed hands and locations at this time. See also Noszlopy, "Botticelli's *Pallas and the Centaur*" (with earlier bibliography).

81. For this idea see Shearman, "Collections," 18–19.

82. For an earlier version of the ideas presented in the following section, see Randolph, *"Cupido cruciatur."*

83. Alberti, *Opere Volgari,* 5: 352: "Quel primo antico savio ch'Amor pinse / Nudo fanciullo con l'ale vezzose, / E con le mani sì maravigliose, / E ch'a begli occhi poi quel vel gli accinse; / Certo costui che Amore troppo ben finse, / Che vide amante mai potere ascose / Tener sue volglie fervide amorose, / Che 'l lume in lui mai di ragion non vinse. / Diedeli strali e face in mano ed arco, / Col qual da lunge e d'accosto ferisse / Con dolce piaga e al cor merore eterno. / Sforza chi 'l fugge, e chi 'l segue nutrisce / Di speme incerta, e mai lo soffre scarco / D'infiniti sospetti e nuovo scherno."

84. Warburg, "Delle 'imprese amorose' nelle più antiche incisioni fiorentine (1905)," in *Gesammelte Schriften,* 1: 77–88, 330–331 (*Renewal,* 169–183). See also Hind, *Early Italian Engraving;* and Zucker, ed., *Early Italian Masters,* 127–157, nos. 2403.010–.051. Zucker, assigning the majority of the group to Baccio Baldini and his workshop, points out that of the forty-two surviving prints that belong to this general type, only twenty-four actually belonged to Ernst Peter Otto.

85. Warburg (*Gesammelte Schriften,* 1: 81; *Renewal,* 172) by linking the print to Lorenzo's joust, seems to propose that it be dated to 1465. Kristeller (*Florentinische Zierstücke,* 11) proposed the 1470s, while Konrad Oberbuber (in Levenson, Oberhuber, and Sheehan, *Early Italian Engravings from the National Gallery of Art,* 14) has dated one of the prints to 1475. Hind, *Early Italian Engraving,* dated them generically to 1465–80 based, it would appear, upon stylistic evidence.

86. For the box in Boston, see Swarzenski, "Marriage Casket." For the Louvre box, consult Watson, *Garden of Love,* plates 68–69; and for the lost Berlin lid, see Toesca, "Una scatola dipinta," 107–108 and Schubring, *Cassoni,* 48–50.

87. See Hind, *Early Italian Engraving,* A.IV.1, A.IV.4, A.IV.11, A.IV.12, A.IV.15, A.IV.16, A.IV.25, A.IV.26, A.IV.27.

88. See Hind, *Early Italian Engraving,* A.IV.6, A.IV.10, A.IV.24, A.IV.28, A.IV.29.

89. Warburg (*Gesammelte Schriften,* 1: 79; *Renewal,* 169) mentions the inclusion of *bossoli da spezie* in the Medici inventory of 1492, citing Müntz, *Les collections,* 34. See also Bernardino, *Le prediche volgari,* 413.

On these small boxes see Schlosser, "Embriachi"; Kohlhaussen, *Minnekästchen;* Hildburgh, "Italian Renaissance Caskets"; Narkiss, "Niello Casket"; *Secular Spirit,* cat. no. 5 and cat. no. 8; Origo, *Il mercante di Prato,* 196; Witthoff, "Marriage Rituals"; Randall, "Gothic Ivory Boxes"; Lydecker, "The Domestic Setting," 69, no. 94, 128; Merlini, "La 'Bottega degli Embriachi'"; Thornton, *Italian Renaissance Interior,* 204; and Pommeranz, *Pastigliakaestchen.* For primary documents concerning the exchange of these boxes at marriage see *Giovanni Rucellai ed il suo Zibaldone,* 1: 28; and the following manuscript *ricordanze:* Bartolomeo di Tommaso, ASF, Carte Strozziane 5. 1749, 168v; Francesco di Giuliano d'Averardo de' Medici, ASF, Mediceo avanti il principato 148. 31, 39; Lucha di Matteo di Messer Lucha da Panzano, ASF, Carte Strozziane 2. 9, 139r; Alessandra Strozzi, ASF, Carte Strozziane 5. 15, 105r; Marco di Lorenzo di Marco del Burciolo, ASF, Corporazioni religiose soppresse dal governo francese 102. 87, 14r; Bernardo di Bartolomeo di Gherardo Gherardi, ASF, Gherardi Piccolomini D'Aragona 324, 6v; Luigi di Ugolino Martelli, ASF, Carte Strozziane 5. 1463, 119; 5. 1464, 117r–117v; 5. 1478. 114v; Uguccione Capponi, ASF, Conventi soppressi, San Piero a Monticelli 153, 12v; Marco Parenti, ASF, Carte Strozziane 2. 17bis, 72, 69, 4; 3v–23, 69r; Bartolomeo di Tommaso di Federigo Sassetti, ASF, Carte Strozziane 5. 1751, 135, 165v; Filippo e Lorenzo di Matteo di Simone degli Strozzi, ASF, Carte Strozziane 5. 17, 4r.

90. For a contrary view see Zucker, *Early Italian Masters,* 127–129, who attributes all the Otto prints to Baccio Baldini and his workshop.

91. Warburg ends his article on "amorous *imprese,*" promising to return to the connections between their imagery and that of the Medicean jousts (*Gesammelte Schriften,* 1: 87): "Per rendere credibile ed accetabile il mio modo di considerare queste 'scatoline d'amore' come l'anello di congiunzione con la pittura mitologica arcaicizzante, bisognerà analizzare stilisticamente anche gli altri ventitre tondini, ed ancora far soggetto di studio accurato un altro prodotto dell'arte 'erotica' applicata che fin qui è stato negletto; cioè gli stendardi che si portavano nelle Giostre, i quali, sebbene non conservati, possono ricostriursi in modo suffcente per una trattazione critica dalle descrizioni che ce ne rimangono. Bisognerà dunque considerare e studiare come fattore costitutivo dello stile nella storia della coltura artistica della Rinascità tutto ciò che si riferisce alle feste fiorentine. Questo vorrei tentare negli studi seguenti." See *Renewal,* 177.

92. There are a number of features of these prints that suggest a Medici connection. As mentioned, Warburg identified the Medici diamond ring impresa on the sleeve of one of the figures represented on one of the Otto prints. Furthermore, on another print, we find the Medici *palle* drawn into a central space. It has not been proven that these armorial markers were included in the fifteenth century, but there is no reason to assume they were not. Finally, the Otto prints include a number of representations that can be associated, directly, with Medicean symbolism. Here I will discuss the iconography of Cupid chastised; in Chapter Six I will return to the Otto prints representing Judith, which relate to Donatello's statue of *Judith and Holofernes* in the Medici garden courtyard.

93. See Chapter Six.

94. Warburg, *Gesammelte Schriften,* 1: 85; *Renewal,* 176.

95. See, inter alia, Callmann, "Growing Threat"; Olsen, "Gross Expenditure"; San Juan, "Mythology, Women, and Renaissance Private Life"; Christiane Klapisch-Zuber, "Les coffres de mariage et les plateaux d'accouchée"; and an important series of articles by Baskins: "'La festa di Susanna'"; "Griselda"; "Typology, Sexuality, and the Renaissance Esther"; "Corporeal Authority"; "Gender Trouble"; Baskins's articles are now supplemented by her *Cassone Painting, Humanism, and Gender.*

96. On the iconography of Cupid crucified, see Schizzerotto, *La commedia nuova.*

97. Petrarca, *Triumphi*, "Triumphis Pudicitie," 214–218, lines 118–147: "Ell'avea in dosso, il dí, candida gonna, / lo scudo in man che mal vide Medusa. / D'un bel diaspro er'ivi una colonna, / a la qual d'una in mezzo Lete infusa / catena di diamante e di topazio, / che s'usò fra le donne, oggi non s'usa, / legarlo vidi, e farne quello strazio / che bastò bene a mille altre vendette; / et io per me ne fui contento e sazio. / I' non poria le sacre e benedette / vergini ch'ivi fur chiudere in rima, / non Calliope e Clio con l'altre sette; / ma d'alquante dirò che 'n su la cima son di vera onestate; in fra le quali / Lucrezia da man destra era la prima, / l'altra Penelopè: queste gli strali / avean spezzato e la faretra a lato / a quel protervo, e spennachiate l'ali. / Verginia a presso e 'l fero padre armato / di disdegno e di ferro e di pietate, / ch'a sua figlia et a Roma cangiò stato, / l'una e l'altra ponendo in libertate; / poi le tedesche che con aspra morte / servaron lor barbarica onestate; / Iudit ebrea, la saggia, casta e forte, / e quella greca che saltò nel mare / per morir netta e fuggir dura sorte. / Con queste e con certe altre anime chiare / triumfar vidi di colui che pria / veduto avea del mondo triumfare." See now Dempsey, "Portraits and Masks," 3–16. On the representation of Petrarch's *Triumphs*, see Ortner, *Petrarcas "Trionfi."*

98. Boccaccio, *Genealogia deorum*, 9.4: "Eum [i.e. Cupidinem] cruci affixum si sappiimus, documentum est quod quidem sequimur, quotiens animo in vires revocato laudabili exercitio mollitiem superamus nostram et apertis oculis perspectamus quo trahebamur ignavia."

99. Furtwängler, *Die antiken Gemmen*, pl. 18, no. 40; pl. 27, nos. 4 and 5; pl. 29, no. 24; pl. 30, no. 32; pl. 57, no. 9, pl. 64, no. 60; see also 330, n. 4 for references to gems in St. Petersburg and Naples and 280, n. 5, for reference to a gem in the British Museum (no. 846). Such an image, probably copied from an antique gem, appears among the Otto prints: an infant Cupid, hands bound

behind his back and eyes blindfold, sits on a sea-surrounded rock. See Hind, *Early Italian Engraving*, A.IV.31.

100. *Greek Anthology*, no. 199, Crinogroas, L.

101. "Captors" are posited: "Whoever bound your hands to the pillar with inescapable knots?" (*Greek Anthology*, 194: Antipater of Thessalonica, LXXXIX).

102. Ausonius, "Cupido Cruciatus" in *Works*, ed. Green, 139: "Cupidinem cruci affigunt mulieres amatrices, non istae de nostro saeculo quae sponte peccant, sed illae heroicae quae sibi ignoscunt et plectunt deum"; for a translation see "Cupido Cruciatur" in *Works*, trans. White, 206–207. On the connection to Ausonius, see Warburg, *Gesammlte Schriften*, 1: 183; and Proto, "Il Petrarca ed Ausonio."

103. Ausonius, *Works*, ed. Green, 139–140; Ausonius, *Works*, trans. White, 208–209.

104. Ausonius, *Works*, ed. Green, 141; Ausonius, *Works*, trans. White, 210–213.

105. Ausonius, *Works*, ed. Green, 141–142; Ausonius, *Works*, trans. White, 206ff. Owing to the explicit reference to the cross, the iconography can justifiably be called "Cupid crucified," despite the fact that the Latin term *cruciatur* has a more general meaning.

106. Panofsky, *Studies in Iconology*, 95–128. See also Wickhoff, "Die Gestalt Amors"; Wind, *Pagan Mysteries*, 51–52; and Hyde, *Poetic Theology of Love.*

107. Panofsky, *Studies in Iconology*, 114.

108. Panofsky, *Studies in Iconology*, 121.

109. Panofsky, *Studies in Iconology*, 109.

110. Panofsky, *Studies in Iconology*, 125–126, Illustration, 95: "Disarmarment of Cupid," frontispiece (woodcut) from G. B. Fulgosus da Campo Fregoso (Milan: Anteros, 1496).

111. For another revision of Panofsky's binary, see Wind, *Pagan Mysteries*, 57–77.

112. Jacobsen-Schutte, "'Trionfo delle Donne'"; and Ortner, *Petrarcas "Trionfi."*

113. Benvenuto di Giovanni or Girolamo di Benvenuto, *Cupid Chastised*, c. 1490, Jarves Collection at Yale University, 1871.65. For a full bibliography, see Carli, *I deschi da parto*, 190–191, cat. 55. Modern criticism has given the panel to both Girolamo di

Benvenuto and to his father, Benvenuto di Girolamo. See also Sirén, *Pictures in the Jarves Collection*, 165, cat. 65; Seymour, *Early Italian Paintings*, 194–195, cat. 146. The reverse of the panel shows the Piccolomini arms, halved with those of another family, possibly the Griselli. See also Callmann, "Love Bound."

114. For a recent treatment of this iconography and its appearance on Tuscan domestic furniture, see Baskins, "*Il Trionfo della Pudicizia*."

115. Canuti, *Perugino*, doc. 316. This notoriously unsuccessful painting is now in the Louvre.

116. The painting, in the National Gallery, London (1196), is attributed to Gherardo di Giovanni.

117. Prudentius, *Psychomachia*, 1.40ff.

118. Boccaccio, *Book of Theseus*, 1.24.

119. Petrarca, *Triumphi*, 214–218, lines 118–47.

120. On the ritual use of *deschi da parto* see Musacchio, *Art and Ritual of Childbirth*.

121. On the melancholy of Petrarchan love see Enterlie, *Tears of Narcissus*.

122. Blum, *Les nielles*, 198. See also Hind, *Nielli;* and Levenson, Oberhuber, and Sheehan, *Early Italian Engravings*, Appendix B, 528–531.

123. In this regard, the visual trope of the removal of the heart is particularly important. For a discussion of this iconography, see Randolph, "Art for Heart's Sake," 67–72; and Camille, *Medieval Art of Love*. On the eating of the lover's heart, see also Hauvette, "La 39ème nouvelle du *Décaméron*"; Rossi, "Il cuore"; and Ceccione, "La leggenda."

124. Hind, *Early Italian Engraving*, A.IV.7.

125. Antonio del Pollaiuolo, *St. Sebastian*, 1475 (National Gallery, London); Sandro Botticelli, *St. Sebastian*, 1484 (Gemälde-galerie, Berlin); Antonio Rossellino, *St. Sebastian* (Collegiata, Empoli). See Hadeln, *Sebastian*.

126. Lorenzo de' Medici, *Comento*, 364–365; cited and translated by Dempsey, *Portrayal of Love*, 156, who adds: "At the outset Love is painted blind, for at this point the heart of the lover has been struck through the eyes by the accidents only of his particular

lady's physical beauty and bearing—*quell'apparente bellezza*—and he cannot yet know whether she feels compassion for him, nor whether she is truly worthy of his love."

127. Truffi, *Giostre*, 169–170; see also Bessi, "Di due (o tre) giostre," 305–308.

Chapter Six: "O Puella Furax": Donatello's *Judith and Holofernes* and the Politics of Misprision

This essay owes much to John Barrell's provocative essay, "The Dangerous Goddess."

Epigram: Gombrich, *Aby Warburg*, 287. Marbod, *Liber decem capiturlorum*, 101–102; bk. 3, ll. 25–31; or PL 171, 1698.

1. Mark 6.

2. The most important general modern studies addressing the *Judith and Holofernes* include the following: Kauffmann, *Donatello*, 165–176 (with references to the earlier literature); Morisani, *Studi su Donatello*, 161–71; Janson, *Donatello*, 198–205; Castelfranco, *Donatello*, 66–68; Reid, "The True Judith"; Liess, "Beobachtungen," 176–205; Erffa, "Judith-Virtus Virtutum-Maria"; Hartt, *Donatello*, 407–408; Fader, "Sculpture in the Piazza della Signoria," 128–192; Herzner, "Die *Judith* der Medici"; Parronchi, "Il significato"; Verspohl, "Michelangelo und Machiavelli"; Greenhalgh, *Donatello and His Sources*, 181–192; Bennett and Wilkins, *Donatello*, 82–89; Verspohl, "Der Platz"; Natali, "Exemplum salutis publicae"; White, "Personality, Text and Meaning"; Looper, "Political Messages"; Sperling, "Donatello's Bronze *David*"; Rosenauer, *Donatello*, 249–257, 283–286; Pope-Hennessy, *Donatello*, 279–286; Caglioti, "Donatello, i Medici e Gentile de' Becchi," parts 1–3; Bredekamp, *Repräsentation und Bildmagie;* and Caglioti, *Donatello e i Medici*.

3. Even, "Loggia dei Lanzi."

4. This, although the *Judith and Holofernes* was not disposed of; in 1504 it was moved to the center of the main courtyard of the Palazzo Vecchio.

5. It was Joan Kelly Gadol who, in her famous essay "Did Women Have a Renaissance?" first sketched out the deteriorating position of women during the Renaissance.

6. Johnson, "Idol or Ideal?"

7. The literature on the malleability of gender and its relation to the study of art history grows daily; for an early and influential theorization see Pollock and Parker, *Old Mistresses.*

8. Hall, *Culture, Media, Language.*

9. Davis, "Women on Top." See also Smith, *Power of Women.*

10. Caglioti (*Donatello e i Medici*, 1: 385–386) argues that the Priapus could be found over the portal leading into the main courtyard.

11. Dubarle, *Judith.* See also Stocker, *Judith, Sexual Warrior.*

12. Jth. 9–13.

13. Jth. 13: 19.

14. Jth. 16: 9.

15. See Capozzi, "Evolution and Transformation," 13–17.

16. Réau, *Iconographie,* 2: 1. 330. See also St. Ambrose, PL 56, 178–180; 225; 258–260; 1248.

17. See Pollock, *Differencing the Canon,* 116: "The sexual elements of of the story [of Judith] are subordinated to the larger cause and purpose of actions in a military context. . . . Yet the later mythic meanings of . . . the women created on that model overwhelmingly focus on sexuality, which is then endowed with a lethal danger to men. Sex, not politics, kills." Pollock's comments must be read in dialogue with Mieke Bal's *Death and Dissymmetry.* See also Ciletti, "Patriarchal Ideology"; Philpot, "Judith and Holofernes"; and Callahan, "Ambiguity and Appropriation."

18. See Liess, "Beobachtungen," 185; von Erffa, "Judith-Virtus Virtutum-Maria," 462; Herzner, "Die *Judith,*" 144, 149; Ciletti, "Patriarchal Ideology," 63; and Bredekamp, *Repräsentation und Bildmagie,* 23–24.

19. Bredekamp, *Repräsentation und Bildmagie,* 19.

20. Jth. 13: 8–10.

21. Donatello decided to leave the gash unrepaired. He thus invited the interpretation of the gap as the result of a first strike.

22. Herzner, "Die *Judith,*" 170; Bredekamp, *Repräsentation und Bildmagie,* 21.

23. See Norman, *Metamorphoses of an Allegory;* and Baldwin, "'I Slaughter Barbarians.'"

24. Florentines automatically turned to such civic symbols. Following a snowfall in 1409, snow-lions and a snow-Hercules were to be seen around the city. See Bartolomeo di Michele del Corazza, "Diario fiorentino," 246: "Fecionsi per Firenze grande quantità di lioni e begli: quasi in sun ogni canto ne era uno; e alle loggie, grandi e begli: e fessi in sulla piazza di San Michele Berteldi uno Hercole lungo ii braccia, e stette bene."

25. Randolph, "*Il Marzocco.*"

26. Ademollo, *Marietta de' Ricci,* 1: 758, no. 39; Wind, "Donatello's *Judith*"; Gombrich, review of Hauser, *Social History of Art,* 83, n. 4.

27. Bartolomeo Fonzio, *Zibaldone,* Florence, Biblioteca Riccardiana, 907, 143r: "in columnis sub iudith in area medicea." Sperling ("Donatello's Bronze *David,*" 219) has noted a second MS, datable to 1466–69, in which the inscription is preserved (Florence, Biblioteca Riccardiana, 660, 85r). This provides the earliest evidence that the statue was indeed in the Medici palace. On this, and other transcriptions of the inscription, see Caglioti, "Donatello, i Medici e Gentile de' Becchi," part 1, 14–16. Antonio Natali ("Exemplum salutis publicae") corrected Gombrich's reading of Fonzio from *aula* to *area* (suggesting the statue's placement in the garden courtyard of the Medici Palace; *area,* literally, means "threshing floor." In this case it probably means the "garden courtyard," rather than the palace's main courtyard). The other descriptions assembled by Caglioti usually refer to the *Judith and Holofernes* as "in orto," that is, in the garden of the palace.

28. Landucci, *Diario,* 121 (21 December 1495): "E a dì di dicembre 1495, si pose in sulla

ringhiera del Palagio de' Signori, a lato alla porta quella Giulietta di bronzo, ch'era in casa Piero de' Medici." For an English translation see Landucci, *Diary*, 99. See also Müntz, *Les collections*, 103.

29. Natali, "Exemplum salutis publicae," 27, notes that holes were not bored through the mouths of the masks on the three faces of the triangular base. Pope-Hennessy, *Donatello*, 286, still claims they are "bored through for the extrusion of water." Although it seems unlikely that the statue actually functioned as a fountain, it is difficult to rule out that such a plan was never considered.

30. For the various translations of these lines, and a convincing rereading of them, see Caglioti, "Donatello, i Medici e Gentile de' Becchi," part 1, 15–16.

31. Shearman, *Raphael's Cartoons*, 16–17, 50, 77–80. Given the congenital gout from which Piero suffered and from which he was to die in 1469, his "onomatopolitical" emphasis on health was apposite or ironic depending on one's point of view.

32. Langedijk, *Portraits of the Medici*, 1: 27; and Kress, "'Laurentius Medices-Salus Publica.'"

33. See Preyer, "Planning for Visitors"; and Chapter 4.

34. Kauffmann, *Donatello*, 165–176.

35. Janson, *Donatello*, 2: 198ff.; Schneider, "Some Neoplatonic Elements"; see also the response by Spina Barelli, "Donatello's *Judith and Holofernes*."

36. Kauffman, *Donatello*, 167ff.; Erffa, "Judith-Virtus Virtutum-Maria"; Herzner, "Die *Judith*"; Michael Looper, "Political Messages," follows Kauffman, *Donatello*, 168, in referring to Hugh of St. Victor's *De fructibus carnis et spiritus* (identifying Holofernes with the *arbor mala* and Judith with the *arbor bona*). For the critical history of the interpretation of the statue, see, especially, Herzner, "Die *Judith*."

37. Wind, "Donatello's *Judith*," 38, writes: "Holofernes lying half-naked on a soft cushion is the perfect embodiment of Luxuria; and Judith's long veils and heavy garments, which cover even her forehead and her arms down to the wrists, clearly emphasize her 'sanctimoniousness.'"

38. Wind, "Donatello's *Judith*," 37.

39. Wind ("Donatello's *Judith*") cites Durandus, *Rational divinorum officiorum*, 6: 128.1. Wind states that this widely distributed book "was printed in forty-four editions in the fifteenth-century alone."

40. It is, in this regard, curious that the name Bethulia can be related to an old Hebrew word for virgin, see Ciletti, "Patriarchal Ideology," 43, n. 16.

41. As paraphrased by Jordan, *Invention of Sodomy*, 126.

42. Jordan, *Invention of Sodomy*, 143. Aquinas does understand that the word could refer, secondarily, to other corporeal excesses. See also Ciletti, "Patriarchal Ideology," 43; citing Kosmer, "The 'noyous humoure,'" 4–5.

43. Prudentius, *Psychomachia*, 40ff. Prudentius' allegory is discussed by Herzner, "Die *Judith*," 145–146.

44. Cadden, *Meanings of Sex Difference*, 181.

45. Herzner, "Die *Judith*," 140.

46. Caglioti, "Donatello, i Medici e Gentile de' Becchi," part 1, 28.

47. Fader ("Sculpture in the Piazza della Signoria," 157–158) suggests that the "flying putti who hold a ring" on the neckline of Judith's dress might refer to the Medici ring device. She concludes that a "careful eye will find three bound feathers below the ring-bearing putti, which must assuredly claim *Judith* for Cosimo." While this observation, unique in the literature so far as I am aware, is suggestive, the ring held by the putti bears no resemblance to the diamond-set rings used by the Medici.

48. Jenkins, "Cosimo de' Medici's Patronage."For further information about the patronage of the Medici palace, see now Kent, *Cosimo de' Medici*.

49. Looper, "Political Messages," makes this point very effectively.

50. The mural actually pictures two figures of Justice, one on each end. On the allegorical scene, see Rubinstein, "Political Ideas in

Sienese Art"; Skinner, "Ambrogio Loren-
zetti"; Starn, "The Republican Regime";
Partridge and Starn, *Arts of Power,* 9–80;
and Donato, "Testi, contesti, immagini
politiche"; and Modersohn, "Lust auf
Frieden." For the iconography of Justice,
see Kantorowicz, *King's Two Bodies,*
107–108; Zdekauer, "Iustitia"; Ridevallus,
Fulgentius metaforali, 53. Bredekamp,
Repräsentation und Bildmagie, 14–17, also
discusses the iconographic cross-fertiliza-
tion of Donatello's Judith with Justice.

51. Bredekamp, *Repräsentation und Bildmagie,*
15–17. Martin Wackernagel draws attention
to the functional similarity between the
Judith and Holofernes and Benedetteo da
Maiano's 1475 *Justitia* for the Palazzo
Vecchio; see *World,* 100.

52. See Kauffmann, *Donatello,* 167–168, for
examples of the artistic pairing of David
and Judith. See also Thomas, "Classical
Reliefs," 128; and McHam, "Donatello's
Bronze *David* and *Judith.*"

53. See Herzner, "Die *Judith,*" 166.

54. Ciletti, "Patriarchal Ideology," 63 (citing
Capozzi, "Evolution and Transformation,"
13) refers to Saint Clement of Rome, of the
first century, the earliest patristic on Judith,
numbering her among those exceptional
women who, "being strengthened by the
grace of God, have performed numerous
manly exploits."

55. Jth. 10: 17.

56. Cohn, "Franco Sacchetti." Judith and
David are also matched on Pinturricchio's
ceiling paintings in the Room of the Seven
Saints in the Appartamento Borgia in the
Vatican. See also Smith, "A Nude Judith."

57. On this Judith see Krautheimer and
Krautheimer-Hess, *Ghiberti,* 173ff.

58. See Chapter Four and Janson, *Donatello,*
3–7; Herzner, "David Florentinus I,"
43–115 (who believes that the marble *David*
was not intended for the *sproni* of the cathe-
dral); Barocchi, ed., *Omaggio a Donatello,*
124–141; Settesoldi, *Donatello e l'Opera del
Duomo,* 10–11; Donato, "Hercules and
David"; and Rubinstein, *Palazzo Vecchio,*
55–56, esp. n. 89.

59. See Chapter Four.

60. Prudentius' identification of the the figure
pitted against Chastity-Judith with sodomy
is curious. As reviewed in Chapter Four,
sodomy was a burning issue in fifteenth-
century sexual politics, and one perhaps not
irrelevant to Donatello.

61. On the Marsyas statues and on the garden
in general, see Chastel, *Art et Humanisme,*
50; Valentiner, "Der 'rote Marsyas'";
Holman, "Verrocchio's *Marsyas*"; Beschi,
"Le antichità di Lorenzo il Magnifico";
Acidini Luchinat, "La 'santa antichità,'"
148; Caglioti, "Due 'restauratori'"; and
Osano, "Due 'Marsia.'" It is also expected
that Laurie Fusco's forthcoming book
(*Lorenzo de' Medici, Collector*) will shed
light on these matters.

62. Francesco Caglioti has attempted to
attribute this restoration, instead, to Mino
da Fiesole; see his "Due 'restauratori,'"
part I.

63. Vasari, *Le vite,* 3: 218: "Ed oltre a questi, era
quel giardino tutto pieno di torsi di femine
e maschi . . . che una buona parte vi è oggi
nella Guardaroba del duca Cosimo, ed
un'altra nel medesimo luogo, come i dua
torse di Marsia, e le teste sopra le finestre, e
quelle degl'imperatori sopra le porte" (cf.
3: 237). On the two Marsyas statues to the
side of the door to Via dei Ginori see
Vasari, *Le vite,* 2: 18, 407: "Avendo dunque
Cosimo de' Medici avuto da Roma molte
anticaglie aveva dentro alla porta del suo
giardino, ovvero cortile, che riesce sulla via
De' Ginori, fatto porre un bellissimo
Marsia di marmo bianco, impiccato a un
tronco per dover essere scorticato: perché
volendo Lorenzo suo nipote, al quale era
venuto alle mani un torso con la testa di un
altro Marsia, antichissimo e molto più bello
che l'altro e di pietra rossa accompagnarlo
al primo; non poteva ciò fare, essendo
imperfettissimo. Onde datolo a finire ad
acconciare ad Andrea, egli fece le gambe, le
cosce e le braccia che mancavano a questa
figura, di pezzi di marmo rosso, tanto ben
che Lorenzo ne rimase soddisfattissimo; e
lo fece porre dirimpetto all'altra dall'altra
banda della porta." Frustratingly, the inven-
tory of the palace made after the death of

Lorenzo in 1492 does not record any of the statues in the courts. These statues were also removed in 1495 by the Signoria, but returned to the Medici palace in 1512. On the return of statues to the Palazzo Medici, see Luca Gatti, "Displacing Images." In 1536 the Marsyas statues were described by Fichard: the one to the left hanging by arms and to the right, red, and sitting with arms tied to tree.

64. For some recent proposals, see Beschi, "Le antichità di Lorenzo il Magnifico"; and Caglioti, "Due 'restauratori.'"

65. Wyss, *Myth of Apollo and Marsyas.*

66. It is perhaps telling that in composing his figure of Justice for the Sforza monument in Santa Maria del Popolo, Rome, Andrea Sansovino drew inspiration from Donatello's Judith. See Boucher, *Sansovino.* Cristina Acidini Luchinat ("La 'santa antichità,'" 148) interprets the antique statues of Marsyas as functioning to ward off those who might not live up to the divine quality of the music usually heard in the Palazzo Medici.

67. Palmieri, *Vita civile,* 64: "Justitia, come regina et dominatrice di tutte l'altre virtù in sé qualunche di queste contiene. Di questa imperadrice della virtù è proprio conservare le coniunctioni et amicitie degl'huomini, dare a ciascuno quello ch'è suo, et servare la fede nelle cose promesse."

68. Looper, "Political Messages," stresses the Medici palace garden as a civic space within a lively tradition of political gardens.

69. Looper, "Political Messages," 262.

70. Looper, "Political Messages," 260, n. 39.

71. Watson, *Garden of Love;* Looper, "Political Messages," 261.

72. "In ortis Cosmianis sub statua cuiusdam gerentis capite poma cum obducta circum pudibunda veste." See Caglioti, "Donatello, i Medici e Gentile de' Becchi," part 1, 14; citing a MS in the Bodleian Library, Lat. Misc. e 81.

73. Agosti and Carinella, "Stanza delle teste," 99; 141–142.

74. Davis, "Women on Top," 153–154. See also Smith, *Power of Women.*

75. Baskins, "Donatello's Bronze *David.*"

76. Parenti, *Delle nozze di Lorenzo de' Medici con Clarice Orsini.*

77. Given Vasari's claim that one could see "through" the base of Donatello's bronze *David* to the courtyard portal giving onto the via de' Ginori (Vasari, *Le vite,* 6: 143–144), it seems likely that the *Judith and Holofernes* was not on axis with the doorways of the palace. It seems plausible that the statue might have been on the central, north–south axis of the garden, but set north of the portal axis.

78. Jacobsen-Schutte, "'Trionfo delle donne.'"

79. Petrarca, *Triumphi,* 202–222. See also Caglioti's comments on Bastiano Foresi's *Trionfo delle virtù; Donatello e i Medici,* 1: 230.

80. Published in Tornabuoni, *I poemetti sacri.* The play has been cited and discussed by Kauffmann, *Donatello,* 170 and 248; and Caglioti, *Donatello e i Medici,* 1: 229.

81. See Chapter Five for a discussion of the form and function of the Otto prints.

82. Hind, *Early Italian Engraving,* A.IV.1 and A.IV.2.

83. Indeed, another Otto print contains a representation of Phyllis and Aristotle, on which Jacobsen-Schutte bases her article.

84. Gautier Le Leu, "The Widow." See also Cadden, *Meanings of Sex Difference,* 178: "The association of the womb with the penis suggests it is an active, sexual organ (as distinguished from a passive, reproductive organ) and is in tune with the view that the womb and therefore (by metonymy) the woman are dominated by an insatiable sexual appetite. The womb has an appetitive faculty in the Galenic sense that it draws to itself the male seed or the combined seed of the male and female; the woman is all appetite in the more colloquial sense that she craves all the pleasures of the flesh."

85. Herzner, "Die *Judith,*" 140.

86. See Zoan Andrea, *Engraving of a Fountain,* British Museum; Girolamo da Cremona(?), *Fresco with a Fountain,* Palazzo Venezia, Rome; Matteo dei Pasti, reverse of a medal of Guarino Veronese (see Hill, *Corpus,* 158).

87. Apollodorus, *Library,* 3: 5. 8. See also Ausonius, *Works,* trans. White, 1: 363, lines

38–41: "The Sphinx was of triple shape; part bird, part lioness, part maid [*puella*]; in wings, she was a bird; in paws, a beast; in face, a girl." Aelian, *Characteristics of Animals*, 12.7: "The Sphinx with her two-fold nature, as of a two-fold shape, making her awe-inspiring by fusing the body of a maiden with that of a lion." See Tervarent, *Attributs et symboles*, 363–364.

88. For a comprehensive account, consult Demisch, *Die Sphinx*. See, too, the sphinxes on the portrait bust of Lorenzo de' Medici (Museum of Fine Arts, Boston) and on the lavabo in Old Sacristy of San Lorenzo, Florence.

89. See Janson, *Donatello*, 185; Chastel, *Art et humanisme*, 56 and 336.

90. Dio Chrysostom, *Discourses*, 10. 31–32; Dio Chysostom, *Sämtliche Reden*, 172–173.

91. The gem is now in the Museo Archeologico Nazionale, Naples. Ghiberti, to confuse matters even more, used the lithe figure of Apollo on the gem as a model for his Judith on the Doors of Paradise. The gem appears in Botticelli's portrait of a woman in the Staedel Institute, Frankfurt-am-Main. See Caglioti and Gasparotto, "Lorenzo Ghiberti."

92. Ciletti, "Patriarchal Ideology," 52.

93. Warburg, *Gesammelte Schriften*, 1: 179–182 (*Renewal*, 275–276).

94. Hind, *Early Italian Engraving*, A.II.6; and Hind, "Italian Engravings in Constantinople."

95. I am borrowing this term from Spiegel, "History, Historicism, and the Social Logic of the Text."

96. Another intriguing set of responses can be found in a group of glazed terracotta renditions of *Judith and Holofernes* issuing from the della Robbia workshops in the early sixteenth century. Interpretation of these objects as a response to Donatello's bronze group is made complex, however, by their strong resemblance to the glazed terracotta figures of *Dovizia* discussed in Chapter One. What is more, Butterfield and Franklin ("'Terracruda' Sculpture") have proposed that the Bardini della Robbia

Judith and Holofernes reflects a documented but lost version of the subject by Andrea del Verrocchio. On the della Robbia statues, see Tschermak von Seysenegg, "Die *Judith*"; and, from the same author, "Nochmals die *Judith*."

97. Janson, *Donatello*, 2: 198–199. Greenhalgh, *Donatello and His Sources*, 181.

98. In this painting, the statue is represented as if it were gold. While there are traces of gold on the surface of the sculpture, it is not known if it was originally fully gilded.

99. For the minutes of the meeting, see Gaye, *Carteggio*, 2: 454–462. See also Neumann, "Die Wahl"; Levine, "Location of Michelangelo's *David*"; Parks, "Placement of Michelangelo's *David*"; and Verspohl, "Michelangelo und Machiavelli."

100. Gaye, *Carteggio inedito*, 2: 456f.: "Io ò rivolto per l'animo quello che mi possa dare el iuditio, havete dua luoghi dove può supportare tale statue, el primo dove è la Iuditta, el secondo el mezzo della corte del palazzo, dove è el Davit: primo perchè la Iuditta è segno mortifero, e' non sta bene, havendo noi la † per insegnia et el giglio, non sta bene che la donna uccida lhomo, et maxime essendo stata posta chon chattiva chonstellatione, perchè da poi in que siate iti de male in peggio: perdessi poi Pisa."

101. Natali, "Exemplum salutis publicae," 31, n. 58.

102. This information was brought to bear on the placement of the David by Verspohl, "Michelangelo und Machiavelli," 204; he cites Villari, *Niccolò Machiavelli*, 1: 371. For an English edition see *Life and Times of Niccolò Machiavelli*. On the correlate position of women in the religious reform see F. W. Kent, "A Proposal by Savonarola"; and Polizotto, "When Saints Fall Out."

103. Women *were* allowed in at night; during the day, women who had business at the palace were met at the door, later the location of the *Judith and Holofernes* statue. See *Statuta*, 314, rubric 107: "Nulla mulier audeat accedere, vel ingredi palatium de die alcuius rectoris forensis communis Florentiae, vel ad aliam curiam communis

Florentinae, vel coram iudice, aut milite, aut notario dictorum offitialium sub poena librarum centum. Et quod per ipsam factum fuerit aut litigatum non valeat ipso iure. Et rector qui passus fuerit puniatur in libris centum pro vice qualibet, quas camerarii de suo salario debeant retinere, quod si non fecerint debeant syndicari. Mulier tamen contra quam poceceretur criminaliter, vel vocaretur causa testimonii ferendi possit venire ad se excusandum, et testimonium ferendum. Et notarius ipsam examin et ab ea iuramentum recipiat extra ianuam palatii habitationis talis rectoris. Et si qua mulier deberet torqurei possit ingredi palatium cum prasentia praesbiteri stincharum, salvo statuto De modo examinandi mulieres in maleficiis. Et similter quaelibet mulier possit ad dictam ianuam accusationes quaslibet sibi permissas facere, & porrigere." See also Jean Bethke Elshtain's comments on Macchiavelli in *Public Man, Private Woman,* 94–96: "A 'good' woman makes a 'bad' citizen by definition. The woman who is a 'good' citizen cannot, in the private spere, be a 'good' woman. She is judged in each instance by standards of so-called private morality, Christian morality without teeth. She is not to share in public (im)morality. Women are morally superior because they are publically inferior. The private realm of feeling and sentiment is not subject to laws and not judged by public standards. If there is power in this sphere, it is power as covert manipulation, deceit, and cunning. This realm is not properly part of the public sphere but provides a base for it. Women are nonpolitical and so are men in their private capacities. . . . Machiavelli's armed virtue not only excluded women from politics, it deemphasized women's traditional private sphere."

104. Trexler, ed., *Libro ceremoniale,* 48.
105. Trexler, *Public Life,* 240. See also Mancini, "Il bel San Giovanni"; Guasti, *Le feste di San Giovanni Battista;* and Carew-Reid, *Les fêtes Florentines,* 48ff.
106. Trexler, *Public Life,* 222: "St. John's had evolved into a celebration of the whole city."
107. Trexler, *Public Life,* 247.
108. Trexler, *Public Life,* 240.
109. Trexler, *Public Life,* 222.
110. Cambi, "Istorie," 163–164.
111. The metal rings on the baptistry from which this canopy would have been hung are still visible.
112. Cross-dressing was explicitly prohibited in Florence. See *Statuta,* 151 and 271. The appearance of the giant Judith on St. John's Day was fitting; having slain Holofernes, the biblical Judith herself became a living monument: "on festival days she [Judith] came forth with great glory" (Jth. 16: 27).
113. Cambi, "Istorie," 164: "E dipoi la mattina di S. Gio. avenne un altro segnio non mancho da notare, che le primi: Che andando la Signoria a offerta, comè di consuetudine a S. Gio. ed essendo uno spiritello insulle Zanche, vestito a suo di Giudetta colla testa d'Oliferno da una mano, e dal altra una spada ingnuda, e andando, riscontrò la Magnifica Signoria di Firenze, e volendole fare riverenza chaschò, e nel cadere dette colla spada insul capo al Comandatore, che portava la spada con que' berettone inanzi alla Signoria, e fecieli poco male, ed etiam percosse insù detta spada, e feciela cadere di mano al detto Comandatore, che parve chattivo aghurio." The ceremonial sword might have been that given to the commune by Eugenius IV in the 1430s; see Gori, *Feste fiorentine,* 158; and Trexler, *Public Life,* 259. Goro Dati (*L'Istoria,* 145) describes the Comandatore in the following manner: "Hanno ancora appreso ai piedi della detta Signoria e a loro servigio sette Comandatori, uomini molto dotti e di buono sentimento; costoro sono deputati a stare sempre all'uscio della udienzia di detta Signoria e sono quelli che rapportano loro le imbasciate di chi volesse loro parlare, e hanno per loro salario e subsidio fior. 4 1/2 per ciascuno mese, che sono in tutto il mese fior. 29 3/4, e più hanno per la festa di santo Giovanni Battista fior. 10 per uno vestire, e questi così fatti Comandatori conviene che sempre vadano vestiti di pavonazzo; somma l'anno fior. 427."

114. Filarete was really the first herald of the Florentine Republic; in 1456 it was decided to add the title "Herald of the Signoria" to that of the *sindicus et referendarius*. See Trexler, *Public Life*, 260; Trexler, *Libro ceremoniale*, 43; and Branciforte, "Ars poetica rei publicae."

115. Trexler, *Libro ceremoniale*.

116. Trexler, *Public Life*, 259. Trexler, *Libro ceremoniale*, 91, cites Filarete as recording that the herald "goes in front of the Signoria carrying the sword and spurs as a sign that the Signoria goes to do something already ordered by the councils." See also the *Vocabulario degli accademici della Crusca*, 3: 185, s.v. "Comandatore": "Comandatore si disse in Firenze a uno della Famiglia di Palazzo, che recava gli ordini della Signoria." Goro Dati (*L'Istoria*, 145), it must be recorded, clearly separates the positions of *Comandatore* and *Araldo*. Also see Brucker, "Bureaucracy and Social Welfare," 19.

Bibliography

Abbreviations

AB *The Art Bulletin*

AH *Art History*

ASF Archivio di Stato di Firenze

ASI *Archivio storico italiano*

BM *The Burlington Magazine*

BNCF Biblioteca Nazionale
Centrale di Firenze

GBA *Gazette des beaux-arts*

JWCI *Journal of the Warburg and Courtauld
Institutes*

MKIF *Mitteilungen des
Kunsthistorischen Instituts in Florenz*

PL Patrologia cursus completus: Series
Latinae. 221 vols. Ed. Jacques-Paul
Migne. Paris: Garniere, 1844–64.

RQ *Renaissance Quarterly*

ABEL, Elizabeth, ed. *Writing and Sexual
Difference.* Chicago: University of
Chicago Press, 1982.

ACIDINI LUCHINAT, Cristina. "La cappella
Medicea attraverso cinque secoli." In *Il
Palazzo Medici Riccardi,* ed. Giovanni
Cherubini and Giovanni Fanelli, 82–91.
Florence: Giunti, 1990.

——. "La 'santa antichità,' la scuola, il gia-
rdino." In *"Per bellezza, per studio, per
piacere": Lorenzo il Magnifico e gli spazi del-
l'arte,* ed. Franco Borsi, 143–160. Florence:
Cassa di Risparmio di Firenze, 1991.

——. *The Chapel of the Magi: Benozzo
Gozzoli's Frescoes in the Palazzo Medici-
Riccardi Florence.* London and New York:
Thames and Hudson, 1994.

——. "Lorenzo il Magnifico: Divise e mes-
saggio morale." In *La Toscana al tempo di
Lorenzo il Magnifico: Politica, economia, cul-
tura, arte,* ed. Riccardo Fubini, 1: 37–46. 3
vols. Pisa: Pacini, 1996.

ADEMOLLO, Agostino. *Marietta de' Ricci ovvero
Firenze al tempo dell'assedio.* Ed. Luigi
Passerini. 2d ed. 6 vols. Florence:
Stabilimento Chiari, 1845.

ADLER, Kathleen and Marcia Pointon. *The Body
Imaged: The Human Form and Visual Culture
Since the Renaissance.* Cambridge and New
York: Cambridge University Press, 1993.

ADORNO, Francesco. "Alamanni Rinuccini *Dialogus de libertate.*" *Atti e memorie dell'Accademia Toscana di scienze e lettere "La Colombaria"* 22 (1957): 265–303.

ADORNO, Theodor W. and Max Horkheimer. "Odysseus of the Myth of Enlightenment." Trans. Robert Hullot-Kentor. *New German Critique* 56 (1992): 109–141.

———. *Dialectic of Enlightenment.* Trans. John Cumming. New York: Continuum, 1993.

ADY, Cecilia M. *Lorenzo dei Medici and Renaissance Italy.* London: English Universities Press, 1955.

AELIAN. *On the Characteristics of Animals.* Trans. A. F. Scholfield. Cambridge, Mass.: Harvard University Press; London: Heinemann, 1958.

AGOSTI, G. and V. Carinella. "Stanza delle teste." In *Il giardino di San Marco,* ed. Paola Barrocchi, 95–106. Cinisello Balsamo: Silvana, 1992.

AHL, Diane Cohl. *Benozzo Gozzoli.* New Haven and London: Yale University Press, 1996.

AIKEN, Jane Andrews. "Leon Battista Alberti's System of Human Proportion." *JWCI* 43 (1980): 68–96.

ALBERTI, Leon Battista. *Opere volgari.* Ed. Anicio Bonucci. 5 vols. Florence: Tipografia Galileiana, 1849.

———. *Della famiglia.* Ed. Ruggiero Romano and Alberto Tenenti. Turin: Einaudi, 1969.

———. *On Painting and On Sculpture.* Trans. and ed. Cecil Grayson. London: Phaidon, 1972.

ALFÖLDI, Andreas. "Die Geburt der kaiserlichen Bildsymbolik." *Museum Helveticum* 9 (1952): 204–243; 10 (1953): 103–124; and 11 (1954): 133–169.

ALIGHIERI, Dante. *The Divine Comedy of Dante Alighieri.* Trans. and ed. John D. Sinclair. Oxford and New York: Oxford University Press, 1961.

———. *Monarchia.* Ed. Gustavo Vinay. Florence: Sansoni, 1950.

———. *Convivio.* Ed. Gian Carlo Garfagnini. Rome: Salerno, 1997.

ALLEGRI, Ettore and Alessandro Cecchi. *Palazzo Vecchio e i Medici: Guida storica.* Florence: S.P.E.S., 1980.

AMES-LEWIS, Francis. "Early Medicean Devices." *JWCI* 42 (1979): 122–143.

———. "Art History or Stilkritik? Donatello's Bronze David Reconsidered," *AH* 2, no. 2 (1979): 137–155.

———. *The Library and Manuscripts of Piero di Cosimo de' Medici.* New York and London: Garland, 1984.

———. "Donatello's Bronze *David* and the Palazzo Medici Courtyard." *Renaissance Studies* 3, no. 3 (1989): 239–243.

———, ed. *Cosimo "il Vecchio" de' Medici, 1389–1464.* Oxford: Clarendon Press, 1994.

ANSELMI, Gian-Mario and Fulvio Pezzarossa. *La 'memoria' dei mercatores: Tendenze ideologiche, ricordanze, artigianato in versi nella Firenze del Quattrocento.* Bologna: Pàtron, 1980.

ANTAL, Frederick. *Florentine Painting and Its Social Background: The Bourgeois Republic Before Cosimo de' Medici's Advent to Power: XIV and Early XV centuries.* London: Kegan Paul, 1948.

APOLLODORUS. *The Library.* Trans. James G. Frazer. Cambridge, Mass.: Harvard University Press; London: Heinemann, 1928.

ARASSE, Daniel. "L'art et l'illustration du pouvoir." In *Culture et idéologie dans la genèse de l'état moderne,* 231–244. Rome: École française de Rome, 1985.

ARCHAMBAULT, Paul. "The Analogy of the Body in Renaissance Political Literature." *Bibliothèque d'humanisme et Renaissance* 29 (1967): 21–53.

ARIÈS, Philippe. "Introduction." In *A History of Private Life.* Vol. 3, *Passions of the Renaissance,* ed. Roger Chartier, trans. Arthur Goldhammer, 1–19. Cambridge, Mass., and London: The Belknap Press of Harvard University Press, 1989.

ARIOSTO, Ludovico. *Opera.* Trieste: Biblioteca classica italiana, 1857.

AUGURELLI, Giovanni Aurelio. *Carmina nondum vulgata.* Rimini: Marsoner et Grandi, 1718.

AUSONIUS, Decimus Magnus. *The Works of Ausonius.* Trans. Hugh G. Evelyn White. 2 vols. Cambridge, Mass.: Harvard University

Press; London: Heinemann, 1968.

———. *The Works of Ausonius.* Ed. R. P. H. Green. Oxford: Clarendon Press, 1991.

AVERY, Charles. *L'invenzione dell'umano: Introduzione a Donatello.* Florence: La casa Usher, 1986.

———. *Donatello: Catalogo completo dell'opere.* Florence: Cantini, 1991.

AVOGADRI, Alberto (Alberti Advogradii Vercellensis). "De religione et magnificentia . . . Cosmi Medicis." In *Deliciae eruditorum, seu, veterum anekdoton opusculorum collectanea,* ed. Giovanni Lami, 12: 117–149. 18 vols. Florence: Viviani, 1736–1769.

BAILEY, Derrick S. *Homosexuality and the Western Christian Tradition.* London: Longmans, Green, 1955; reprinted Hamden, Conn.: Archon/Shoestring Press, 1975.

BAKHTIN, Mikhail. *Rabelais and His World.* Trans. Helene Iswolsky. Cambridge, Mass.: MIT Press, 1968.

BAL, Mieke. *Death and Dissymmetry: The Politics of Coherence in the Book of Judges.* Chicago: University of Chicago Press, 1988.

BAL, Mieke and Norman Bryson. "Semiotics and Art History." *AB* 73 (1991): 174–208.

BALDWIN, Robert W. "'I Slaughter Barbarians' Triumph as a Mode in Medieval Christian Art." *Konsthistorisk Tidskrift* 59, no. 4 (1990): 225–242.

BANDMANN, Günter. "Bermerkungen zu einer Ikonologie des Materials." *Staedel-Jahrbuch,* n. s. 2 (1969): 75–100.

BANFI, Luigi. *Sacre rappresentazioni del Quattrocento.* Turin: U.T.E.T, 1963.

BARFUCCI, Enrico. *Lorenzo de' Medici e la società artistica del suo tempo.* Florence: L. Gonnelli, 1945.

BARGELLINI, Piero and Ennio Guarnieri, *Le strade di Firenze.* 7 vols. Florence: Bonechi, 1985–1987.

BAROCCHI, Paola, ed. *Omaggio a Donatello, 1386–1986: Donatello e la storia del museo.* Florence: S.P.E.S., 1985.

BAROLSKY, Paul. "Botticelli's *Primavera* and the Tradition of Dante." *Konsthistorisk Tidskrift* 52, no. 1 (1983): 1–6.

BARON, Hans. *The Crisis of the Early Italian Renaissance: Civic Humanism and Republican Liberty in an Age of Classicism and Tyranny.* 2d ed. Princeton: Princeton University Press, 1966.

———. "Leonardo Bruni: 'Professional Rhetorician' or 'Civic Humanist'?" *Past and Present* 36 (1967): 21–37.

BARRELL, John. "The Dangerous Goddess: Masculinity, Prestige, and the Aesthetic in Early Eighteenth-Century Britain." In *The Birth of Pandora and the Division of Knowledge,* 63–87. London: Macmillan, 1992.

BARTOLOMEO DI MICHELE DEL CORAZZA. "Diario Fiorentino." Ed. Giuseppe O. Corazzini. *ASI,* 5th ser., 14 (1894): 233–298.

BASKINS, Cristelle. "'La festa di Susanna': Virtue on Trial in Renaissance Sacred Drama and Painted Wedding Chests." *AH* 14, no. 3 (1991): 329–344.

———. "Griselda, or the Renaissance Bride Stripped Bare by Her Bachelor in Tuscan Cassone Painting." *Stanford Italian Review* 10, no. 2 (1991): 153–176.

———. "Donatello's Bronze *David:* Grillanda, Goliath, Groom?" *Studies in Iconography* 15 (1993): 113–134.

———. "Typology, Sexuality, and the Renaissance Esther." In *Sexuality and Gender in Early Modern Europe: Institutions, Texts, Images,* ed. James Grantham Turner, 31–54. Cambridge: Cambridge University Press, 1993.

———. "Corporeal Authority in the Speaking Picture: The Representation of Lucretia in Tuscan Domestic Painting." In *Gender Rhetorics: Postures of Dominance and Submission in History,* ed. Richard C. Trexler, 187–200. Binghamton, N.Y.: Medieval and Renaissance Texts and Studies, 1994.

———. "Gender Trouble in Italian Renaissance Art History: Two Case Studies." *Studies in Iconography* 16 (1994): 1–36.

———. *Cassone Painting, Humanism, and Gender in Early Modern Italy.* Cambridge and New York: Cambridge University Press, 1998.

———. "*Il Trionfo della Pudicizia:* Menacing Virgins in Italian Renaissance Domestic Painting." In *Menacing Virgins: Representing*

Virginity in the Middle Ages and Renaissance, ed. Kathleen Coyne Kelly and Marina Leslie, 117–131. Newark: University of Delaware Press; London: Associated University Press, 1998.

———. "Trecento Rome: The Poetics and Politics of Widowhood." Paper presented at The 11th Berkshire Conference on the History of Women, University of Rochester, Rochester, N.Y., 5 June 1999.

BATTAGLIA, Felice, ed. *Matteo Palmieri: Della vita civile; Bartolomeo Sacchi, detto il Platina: De optimo cive*. Bologna: Nicola Zanichelli, 1944.

BATTAGLIA RICCI, Lucia. *Palazzo Vecchio e dintorni: Studi su Franco Sacchetti e le fabbriche di Firenze*. Rome: Salerno, 1990.

BAUSI, Francesco. "Il broncone e la fenice (morte e rinascità di Lorenzo de' Medici)." *ASI* 150 (1992): 437–454.

BAXANDALL, Michael. *Painting and Experience in Fifteenth-Century Italy: A Primer in the Social History of Pictorial Style*. Oxford: Oxford University Press, 1972.

———. *Patterns of Intention: On the Historical Explanation of Pictures*. New Haven and London: Yale University Press, 1985.

BAYLEY, Charles Calvert. *War and Society in Renaissance Florence: The "De Militia" of Leonardo Bruni*. Toronto: University of Toronto Press, 1961.

BEC, Christian. *Les marchands écrivains: Affairs et humanisme à Florence 1375–1434*. Paris and the Hague: Mouton, 1967.

BECKER, Marvin. "An Essay on the 'Novi Cives' and Florentine Politics, 1343–1382." *Mediaeval Studies* 24 (1962): 35–82.

———. "Problemi della finanza pubblica fiorentina della seconda metà del Trecento e dei primi del Quattrocento." *ASI* 123 (1965): 433–466.

———. "Economic Change and the Emerging Florentine Territorial State." *Studies in the Renaissance* 13 (1966): 7–39.

———. *Florence in Transition*. 2 vols. Baltimore:

Johns Hopkins University Press, 1967–68.

———. "The Florentine Territorial State and Civic Humanism in the Early Renaissance." In *Florentine Studies: Politics and Society in Renaissance Florence*, ed. Nicolai Rubinstein, 109–139. Evanston, Ill.: Northwestern University Press, 1968.

BELLINCIONI, Bernardo. *Le rime*. Ed. Pietro Fanfani. Bologna: Forni, 1878; reprinted Bologna: Commissione per i testi di lingua, 1968.

BELLOSI, Luciano and Margaret Haines. *Lo Scheggia*. Florence: Maschietto and Musolino, 1999.

BENIVIENI, Antonio. *Egkomion Cosmi ad Laurentium Medice: Riproduzione dell'autografo con proemio e trascrizione*. Ed. Renato Piattoli Florence: L. Gonnelli, 1949.

BENNETT, Bonnie A. and David G. Wilkins. *Donatello*. Mt. Kisco, N.Y.: Moyer Bell, 1984.

BERGER, John et al., *Ways of Seeing*. London: BBC; Harmondsworth: Penguin, 1972.

BERGSTEIN, Mary. "Marian Politics in Quattrocento Florence: The Renewed Dedication of Santa Maria del Fiore in 1412." *RQ* 44 (1991): 673–719.

BERNARDINO DA SIENA. *Le prediche volgari inedite: Florence, 1424, 1425-Siena 1425*. Ed. P. Dionisio Pacetti. Siena: Ezio Cantagalli, 1935.

BERTAUX, Émile. *Donatello*. Paris: Plon-Nourrit, [1910].

BESCHI, Luigi. "Le antichità di Lorenzo il Magnifico: Caratteri e vicende." In *Gli Uffizi: Quattro secoli di una galleria: Atti del convegno internazionale di studi*, ed. Paola Barocchi and Giovanna Ragionieri, 161–176. Florence: Olschki, 1983.

BESSI, Rosella. "Di due (o tre) giostre che non si fecero." *ASI* 150, no. 552 (1992): 303–318.

BEYER, Andreas. "Der Zug der Könige: Studien zum Ausstattungsprogramm der Kapelle des Palazzo Medici Riccardi in Florenz." Ph.D. diss., Goethe-Universität, Frankfurt am Main, 1985.

———. "Funktion und Repräsentation: Die Porphyr-Rotae der Medici." In *Piero de' Medici "il Gottoso" (1416–1469): Kunst im Dieste der Mediceer/Art in the Service of the Medici*, ed. Andreas Beyer and Bruce Boucher, 151–168. Berlin: Akademie Verlag, 1993.

BEYER, Andreas and Bruce Boucher, ed. *Piero de' Medici "il Gottoso" (1416–1469): Kunst im Dieste der Mediceer/Art in the Service of the Medici.* Berlin: Akademie Verlag, 1993.

BIZZOCCHI, Roberto. "Stato e/o potere: Una lettera a Giorgio Chittolini." *Scienza e politica* 3 (1990): 57–58.

BLUM, André. *Les nielles du Quattrocento.* Paris: Compagnie des arts photomecaniques, 1950.

BOBER, Phyllis Pray and Ruth Rubinstein. *Renaissance Artists and Antique Sculpture: A Handbook of Sources.* London: Harvey Miller; Oxford: Oxford University Press, 1986.

BOCCACCIO, Giovanni. *Genealogia deorum gentilium libri.* Ed. Vincenzo Romano, 2 vols. Bari: Laterza, 1951.

———. *Decameron.* Trans. G. H. McWilliam. Harmondsworth: Penguin, 1972.

———. "Amorosa Visione." In *Tutte le opere.* Vol. 3. Ed. Vittore Branca. Florence: Mondadori, 1974.

———. *Book of Theseus.* Trans. Bernadette Marie McCoy. New York: Medieval Text Association, 1974.

———. *Amorosa visione.* Trans. Robert Hollander, Timothy Hampton, and Margherita Frankel. Hanover, N.H.: University Press of New England, 1986.

BOCCHI, Francesco and Giovanni Cinelli Calvoli. *Le bellezze della città di Firenze.* Florence: Gugliantini, 1677.

BODE, Wilhelm von. *Italienische Bildhauer der Renaissance: Studien zur Geschichte der italienischen Plastik und Malerei auf Grund der Bildwerke und Gemälde in den Königlichen Museen zu Berlin.* Berlin: W. Spemann, 1887.

———. *Sandro Botticelli.* Berlin: Propyläen, 1921.

———. "Der Florentiner Medailleur Niccolò di Forzore Spinelli." *Jahrbuch der Preussischen Kunstsammlungen* 25 (1904): 1–2; 42 (1921): 105–106; 47 (1926): 131, 142.

BOFFITO, Giuseppe and Attilio Mori. *Piante e vedute di Firenze: Studio storico e topografico cartegrafico.* Florence: Giunti, 1926.

BOLOGNA, Ferdinando. *I pittori alla corte angioina di Napoli, 1266–1414, e un riesame dell'arte nell'età fridericiana.* Rome: U. Bozzi, 1969.

BÖNINGER, Lorenz. "Diplomatie im Dienst der Köntinuität: Piero de' Medici zwischen Rom und Mailand (1447–1454)." In *Piero de' Medici "il Gottoso" (1416–1469): Kunst im Dieste der Mediceer/Art in the Service of the Medici,* ed. Andreas Beyer and Bruce Boucher, 39–54. Berlin: Akademie Verlag, 1993.

BORGIA, Luigi. "L'insegna araldica medicea: Origine ed evoluzione fino all'età laurenziana." *ASI* 150, no. 3 (1992): 609–639.

BORGIA, Luigi and Francesca Fumi Cambi Gado. "Insegne araldiche e imprese nella Firenze medicea del Quattrocento." In *Consorterie politiche e mutamenti istituzionali in età laurenziana,* ed. Maria Augusta Morelli Timpanaro, Rosalia Manno Tolu, and Paolo Viti, 213–238. Cinisello Balsamo: Silvana, 1992.

BÖRNER, Lore. *Die italienische Medaillen der Renaissance und des Barock (1450 bis 1750).* Berlin: Mann, 1997.

BORROMEO, Georgina E. "Tyche-Fortuna: The Personification of Chance and Imperial Cities." In *Survival of the Gods: Classical Mythology in Medieval Art.* Exh. cat., 79–84. Providence: Department of Art, Brown University, 1989.

BORSI, Franco and Stefano Borsi. *Paolo Uccello.* Trans. Elfreda Powell. New York: Abrams, 1994.

BOSWELL, John. *Christianity, Social Tolerance, and Homosexuality.* Chicago: University of Chicago Press, 1980.

———. "Towards the Long View: Revolutions, Universals, and Sexual Categories." *Salmagundi* 58–59 (1981–82): 89–113.

BOUCHER, Bruce. *The Sculpture of Jacopo Sansovino.* New Haven and London: Yale University Press, 1991.

BOUREAU, Alain. "État moderne et attribution symbolique: Emblèmes et devises dans l'Europe des XVIe et XVIIe siècles." In *Culture et idéologie dans la genèse de l'état moderne,* 155ff. Rome: École française de Rome, 1985.

BRACCIOLINI, Poggio. *Facezie.* Milan: Rizzoli, 1983.

BRANCIFORTE, Suzanne. *"Ars poetica rei publicae:* The Herald of the Florentine Signoria." Ph.D. diss., University of Michigan, 1990.

BRANDILEONE, Francesco. "Contributo alla storia della *subarrhatio.*" In *Saggi sulla storia della celebrazione del matrimonio in Italia.* Milan: Hoepli, 1906.

BREDEKAMP, Horst. *Botticelli: Florenz als Garten der Venus.* Frankfurt am Main: Fischer, 1988.

———. *Repräsentation und Bildmagie der Renaissance als Formproblem.* Munich: Carl Friedrich von Siemens Stiftung, 1995.

BROGAN, Roy. *A Signature of Power and Patronage: The Medici Coat of Arts, 1299–1492.* New York: Peter Lang, 1993.

BROWN, Alison. "The Humanist Portrait of Cosimo de' Medici Pater Patriae." *JWCI* 24 (1961): 186–221.

———. "The Guelf Party in Fifteenth-Century Florence: The Transition from Communal to Medicean State." *Rinascimento* 20 (1980): 41–86.

———. "Florence, Renaissance, and Early Modern State: Reappraisals." *Journal of Modern History* 56, no. 2 (1984): 285–300.

———. *The Medici in Florence: The Exercise and Language of Power.* Florence: Olschki; Perth: University of Western Australia Press, 1992.

———. "Piero's Infirmity and Political Power." In *Piero de' Medici "il Gottoso" (1416–1469): Kunst im Dieste der Mediceer/Art in the Service of the Medici,* ed. Andreas Beyer and Bruce Boucher, 9–19. Berlin: Akademie Verlag, 1993.

———. "Cosimo de' Medici's Wit and Wisdom." In *Cosimo "il Vecchio" de' Medici, 1389–1464,* ed. Francis Ames-Lewis, 95–113. Oxford: Clarendon Press, 1994.

———, ed. *Languages and Images of Renaissance Italy.* Oxford: Clarendon Press, 1995.

BROWN, David Alan. "Verrocchio and Leonardo: Studies for the *Giostra.*" In *Florentine Drawing at the Time of Lorenzo the Magnificent.* Ed. Elizabeth Cropper, 99–109. Bologna: Nuova Alfa, 1994.

BROWN, David Alan and Charles Seymour. "Further Observations on a Project for a Standard by Verrocchio and Leonardo." *Master Drawings,* 12, no. 2 (1974): 127–133.

BROWN, Judith C. "Lesbian Sexuality in Renaissance Italy: The Case of Sister Benedetta Carlini." *Signs* 9, no. 4 (Summer 1984): 751–758.

———. *Immodest Acts: The Life of a Lesbian Nun in Renaissance Italy.* New York: Oxford University Press, 1986.

BRUCKER, Gene. "The Medici in the Fourteenth Century." *Speculum* 32, no. 1 (1957): 1–26.

———. "The Ciompi Revolt." In *Florentine Studies: Politics and Society in Renaissance Florence,* ed. Nicolai Rubinstein, 314–356. Evanston, Ill.: Northwestern University Press, 1968.

———. *Renaissance Florence.* Berkeley and Los Angeles: University of California Press, 1969.

———. *The Civic World of Early Renaissance Florence.* Princeton: Princeton University Press, 1977.

———. "Bureaucracy and Social Welfare in the Renaissance: A Florentine Case Study." *Journal of Modern History* 55, no. 1 (1983): 1–21.

———. *Giovanni and Lusanna: Love and Marriage in Renaissance Florence.* Berkeley: University of California Press, 1986.

BRUNETTI, Giulia. "Una testa di Donatello." *L'arte* n. s. 5 (1969): 81–93.

BRUNI, Leonardo. "Panegyric to the City of Florence." In *The Earthly Republic: Italian Humanists on Government and Society,* ed. Benjamin G. Kohl and Ronald G. Witt, 135–178. Philadelphia: University of Pennsylvania Press, 1978.

———. *The Humanism of Leonardo Bruni: Selected Texts.* Ed. Gordon Griffiths, James Hankins, and David Thompson. Binghamton, N.Y.: State University of New York Press, 1987.

BRYSON, Norman. "Géricault and Masculinity." In *Visual Culture: Images and Interpretations,* ed. Michael Ann Holly, Keith Moxey, and Norman Bryson, 228–259. Hanover, N.H.:

University Press of New England, 1994.

BUCK, August. *Der Platonismus in den Dichtungen Lorenzo de' Medicis.* Berlin: Junker und Dünnhaupt, 1936.

BULLARD, Melissa Meriam. "Heroes and Their Workshops: Medici Patronage and the Problem of Shared Agency." *The Journal of Medieval and Renaissance Studies* 24, no. 2 (1994): 179–198.

BULST, Wolfger A. "Uso e trasformazione del palazzo mediceo fino ai Riccardi." In *Il Palazzo Medici Riccardi di Firenze,* ed. Giovanni Cherubini and Giovanni Fanelli, 98–129. Florence: Giunti, 1990.

BURCKHARDT, Jacob. *The Civilization of the Renaissance in Italy.* 2 vols. Trans. S. G. C. Middlemore. New York: Harper and Row, 1958.

BURKE, Peter. *Culture and Society in Renaissance Italy, 1420–1540.* New York: Scribner, 1972.

BURNS, Howard. "Quattrocento Architecture and the Antique: Some Problems." In *Classical Influences on European Culture, A.D. 500–1500,* ed. R. R. Bolgar, 269–287. Cambridge: Cambridge University Press, 1969.

BURROUGHS, Charles. *From Signs to Design: Environmental Process and Reform in Early Renaissance Rome.* Cambridge, Mass.: MIT Press, 1990.

BUTLER, Judith. *Gender Trouble.* London and New York: Routledge, 1990.

BUTTERFIELD, Andrew. "Verrocchio's *David.*" In *Verrocchio and Late Quattrocento Italian Sculpture,* ed. Steven Bule, Alan Phipps Darr, and Fiorella Superbi Gioffredi, 108–116. Florence: Le Lettere, 1992.

———. "New Evidence for the Iconography of David in Quattrocento Florence." *I Tatti Studies* 6 (1995): 114–133.

———. *The Sculptures of Andrea del Verrocchio.* New Haven and London: Yale University Press, 1997.

BUTTERFIELD, Andrew and David Franklin. "A Documented Episode in the History of Renaissance 'Terracruda' Sculpture." *BM* 140, no. 1149 (1998): 819–823.

BUTTERS, H. C. *Governors and Government in Early Sixteenth-Century Florence 1502–1519.* Oxford: Clarendon Press, 1985.

CADDEN, Joan. *Meanings of Sex Difference in the Middle Ages.* Cambridge: Cambridge University Press, 1993.

CAGLIOTI, Francesco. "Due 'restauratori' per le antichità dei primi Medici: Mino da Fiesole, Andrea del Verrocchio e il *Marsia rosso* degli Uffizi." Part 1, *Prospettiva* 72 (1993): 17–42.

———. "Donatello, i Medici e Gentile de' Becchi: Un po' d'ordine intorno alla *Giuditta* (e al *David*) di Via Larga." *Prospettiva,* part 1, 75–76 (1994): 14–49; part 2, 78 (1995): 22–55; part 3, 80 (1995): 15–58.

———. "Il perduto *David medicea* di Giovanfrancesco Rustici e il *David* Pulszky del Louvre." *Prospettiva* 83–84 (1996): 80–101.

———. *Donatello e i Medici: Storia del "David" e della "Giuditta."* 2 vols. Florence: Olschki, 2000.

CAGLIOTI, Francesco and Davide Gasparotto. "Lorenzo Ghiberti, il 'sogillo di Nerone' e le origini della placchetta 'antiquaria.'" *Prospettiva* 85 (1997): 2–38.

CAHN, Erich B. "Eine Münze und eine Medaille auf zwei Bildnisporträts des 15. Jahrhunderts," *Zeitschrift für Schweizerische Archäologie und Kunstgeschicte/Revue suisse d'art et archéologie/Rivista svizzera d'arte e d'archeologia* 22 (1962): 66–72.

CALLAHAN, Leslie Abend. "Ambiguity and Appropriation: The Story of Judith in Medieval Narrative and Iconographic Traditions." In *Telling Tales: Medieval Narratives and the Folk Tradition.* Ed. Francesca Canade Sautman, Diana Conchado, and Giuseppe Carlo, 79–93. New York: St. Martin's Press, 1998.

CALLMANN, Ellen. "The Growing Threat to Marital Bliss as Seen in Fifteenth-Century Florentine Painting." *Studies in Iconography* 5 (1979): 73–92.

———. "Love Bound, A Sienese Desco." In *Mosaics of Friendship: Studies in Art and History for Eve Borsook,* ed. Ornella Francisci Osti, 105–116. Florence: Centro Di, 1999.

CAMBI, Giovanni. "Istorie." In *Delizie degli eruditi toscani,* ed. Idelfonso di San Luigi,

vol. 21 (1785). 24 vols. Florence: Gaetano Cambiagi, 1770–1789.

CAMILLE, Michael. *The Gothic Idol: Ideology and Image-Making in Medieval Art.* Cambridge and New York: Cambridge University Press, 1989.

———. *The Medieval Art of Love: Objects and Subjects of Desire.* New York: Abrams, 1998.

CAMMERER, Monika. *Donatello-Studien.* Munich: Bruckmann, 1989.

CANESTRINI, Giuseppe, ed. "Versi fatti da Niccolò da Uzzano." *ASI* 4 (1843): 297–300.

CANEVA, Caterina. *Botticelli: Catalogo completo dei dipinti.* Florence: Cantini Editore, 1990.

CANNART D'HAMALE, Frederic de. *Monographie historique et littéraire des lis.* Malines: Imprimerie de J. Ryckmanns-Van Deuren, 1870.

CANUTI, Fiorenzo. *Il Perugino.* 2 vols. Siena: Editrice d'arte "La Diana," 1931.

Canzone per andare in maschera per carnesciale. Florence, n.d. [c. 1500].

CAPOZZI, Frank. "The Evolution and Transformation of the Judith and Holofernes Theme in Italian Drama and Art Before 1627." Ph.D. diss., University of Wisconsin-Madison, 1975.

CARDINI, Franco. "Cavalleria e vita cavalleresca." In *Guerra e guerrieri nella Toscana del Rinascimento,* ed. Franco Cardini and Marco Tangheroni, 37–54. Florence: Edifir, 1990.

———. *I re magi di Benozzo a Palazzo Medici.* Florence: Arnaud, 1991.

———. "Le insegne Laurenziane." In *Le tems revient, 'l tempo si rinuova: Feste e spettacoli nella Firenze di Lorenzo il Magnifico,* ed. Paola Ventrone, 55–74. Cinisello Balsamo: Silvana, 1992.

———, ed. *Lorenzo il Magnifico.* Rome: Editalia, 1992.

CAREW-REID, Nicole. *Les fêtes florentines au temps de Lorenzo il Magnifico.* Florence: Olschki, 1995.

CARLI, Cecilia de. *I deschi da parto e la pittura del primo Rinascimento toscano.* Turin: Umberto Allemandi, 1997.

CARROLL, Linda L. "Machiavelli's Veronese Prostitute: Venetia Figurata." In *Gender Rhetorics: Postures of Dominance and Submission in History,* ed. Richard C. Trexler, 93–106. Binghamton, N.Y.: Medieval and Renaissance Texts and Studies, 1994.

CASSIRER, Ernst. *The Myth of the State.* New Haven: Yale University Press, 1946.

CASTELFRANCO, Giorgio. *Donatello.* Milan: Aldo Martello, 1963.

CAVALCANTI, Giovanni. *Istorie fiorentine.* Ed. Guido di Pino. Milan: Aldo Martello, 1944.

CECCIONE, G. "La leggenda del cuore mangiato." *Rivista contemporanea* 1 (1888): 336ff.

CERVELLINI, Gian Battista. "I leonini delle città italiane." *Studi medievali* n. s. 6 (1933): 239–270.

CHABOD, Federico. "Alcune questioni di terminologia: stato, nazione, patria nel linguaggio del Cinquecento" [1957]. In *Scritti sul Rinascimento.* Turin: Einaudi, 1967.

———. "Y a-t-il un état de la Renaissance?" In *Actes du colloque sur la Renaissance,* 57–74. Paris: J. Vrin, 1958.

CHASTEL, André. *Art et humanisme à Florence au temps de Laurent le Magnifique: Études sur la Renaissance et l'humanisme platonicien.* 2d ed. Paris: Presses universitaires de France, 1961.

CHERUBINO DA SPOLETO. *Regole della vita matrimoniale.* Ed. Francesco Zambini. Bologna: Comissione per i testi di lingua, 1888.

CHITTOLINI, Giorgio. "Alcune considerazioni sulla storia politico-istituzionale del tardo Medioevo: Alle origini degli 'stati regionali.'" *Annali dell'istituto storico italo-germanico in Trento* 2 (1976): 401–419.

———. *La formazione dello stato regionale e le istituzioni del contado: Secoli XIV e XV,* 3–35. Turin: Einadi, 1979.

———. "Cities, 'City-States,' and Regional States in North-Central Italy." In *Cities and the Rise of States in Europe, A.D. 1000–1800,* ed. Charles Tilly and Wim P. Blockmans, 28–43. Boulder, San Francisco, and Oxford: Westview Press, 1989.

———. "The 'Private,' the 'Public,' the State." In *The Origins of the State in Italy 1300–1600,* ed. Julius Kirshner, 34–61. Chicago and London: University of Chicago Press, 1995.

CHITTOLINI, Giorgio, Anthony Molho, and Pierangelo Schiera, ed. *Origini dello stato: Processi di formazione statale in Italia fra medioevo ed età moderna.* Bologna: Il Mulino, 1994.

CHOJNACKI, Stanley. "Daughters and Oligarchs: Gender and the Early Renaissance State." In *Gender and Society in Renaissance Italy,* ed. Judith C. Brown and Robert C. Davis, 63–86. London and New York: Longman, 1998.

CHRISTIANI, Emilio. "Sul valore politico del cavaliere nella Firenze dei secoli XIII e XVI." *Studi medievali,* 3d ser., 3 (1962): 365–371.

CHRISTIANSEN, Keith. "Botticelli's Portrait of a Young Man with a Trecento Medallion." *BM* 129, no. 1016 (1987): 744.

CIAPPELLI, Giovanni and Patricia Lee Rubin, ed. *Art, Memory, and Family in Renaissance Florence.* Cambridge: Cambridge University Press, 2000.

CIARDI-DUPRÉ DAL POGGETTO, Maria Grazia. "Un'ipotesi su Niccolò Spinelli fiorentino." *Antichità viva* 1 (1967): 22–34.

CIARDI-DUPRÉ DAL POGGETTO, Maria Grazia, and Paolo dal Poggetto, ed. *Urbino e le Marche prima e dopo Raffaello.* Exh. cat. Florence: Salani, 1983.

CILETTI, Elena. "Patriarchal Ideology in the Renaissance Iconography of Judith." In *Refiguring Woman: Perspectives on Gender and the Italian Renaissance,* ed. Marilyn Migiel and Juliana Schiesari, 35–70. Ithaca and London: Cornell University Press, 1991.

CINO DA PISTOIA. *Cynipistoriensis, ivrisconsvlti praestantissimi, in codicem et aliquot titulos primi pandectorum tome, id est, digesti veteris doctissima commentaria.* Frankfurt am Main: Feyerabendt, 1578.

CLARK, T. J. *The Painting of Modern Life: Paris in the Art of Manet and His Followers.* Princeton: Princeton University Press, 1989.

CLARKE, Paula. *The Soderini and the Medici: Power and Patronage in Fifteenth-Century Florence.* Oxford: Clarendon Press, 1991.

CLEMENTS, Robert J. *Picta Poesis: Literary and Humanistic Theory in Renaissance Emblem Books.* Rome: Edizioni di storia e letteratura, 1960.

CLOUGH, Cecil H. "Chivalry and Magnificence in the Golden Age of the Italian Renaissance," in *Chivalry in the Renaissance,* ed. Sydney Anglo, 25–47. Woodbridge: Boydell Press, 1990.

COHEN, Ada. *The Alexander Mosaic: Stories of Victory and Defeat.* Cambridge: Cambridge University Press, 1997.

COHN, Samuel K. *The Labouring Classes in Renaissance Florence.* London and New York: Academic Press, 1980.

———. *Creating the Florentine State: Peasants and Rebellion, 1348–1434.* Cambridge: Cambridge University Press, 1999.

COHN, Werner. "Franco Sacchetti und das ikonographische Programm der Gewölbermalereien von Orsanmichele." *MKIF* 8 (1957–58): 65–77.

COLBUM, Kenneth. "Desire and Discourse in Foucault: The Sign of the Fig Leaf in Michelangelo's *David.*" *Human Studies* 10 (1987): 61–66.

COLDEBACH, Matthaeus. *De annulis juris civilis et canonici significativis.* Frankfurt an der Oder: Michael Koch, 1632.

COLLARETA, Marco. "Considerazioni in margine al *De statua* ed alla sua fortuna." *Annali della scuola normale superiore di Pisa,* classe di lettere e filosofia, 3d ser., 12 (1982): 171–187.

COLVIN, Sidney, ed. *A Florentine Picture-Chronicle Being a Series of Ninety-Nine Drawings Representing Scenes and Personages of Ancient History Sacred and Profane by Maso Finiguerra.* London: Bernard Quaritch, 1898.

CONNELL, William J. and Andrea Zorzi, ed. *Florentine Tuscany: Structures and Practices of Power.* Cambridge: Cambridge University Press, 2000.

CONTARINI, Silvia. "Botticelli ritrovato: Frammenti di dialogo tra Aby Warburg e Andre Jolles." *Prospettiva* 68 (1992): 87–93.

CONVENEVOLE DA PRATO. *Regia carmina: Dedicati a Roberto d'Angio re di Sicilia e di Gerusalemme.* Ed. Cesare Grassi. Cinisello Balsamo: Silvana, 1982.

CORNA DA SONCINO, Francesco. *Fioreto de le*

antiche croniche de Verona e de tutti i soi confini e de le reliquie che se trovano dentro in ditta citade. Ed. Gian Paolo Marchi and Pierpaolo Brugnoli. Verona: Valdonega, 1973.

COWIE, Elizabeth. "Woman as Sign." *m/f* 1 (1978): 49–63.

COX-REARICK, Janet. *Dynasty and Destiny in Medici Art: Pontormo, Leo X, and the Two Cosimos.* Princeton: Princeton University Press, 1984.

CRARY, Jonathan. *Techniques of the Observer: On Vision and Modernity in the Nineteenth Century.* Cambridge, Mass.: MIT Press, 1990.

CROW, Thomas. "A Male Republic: Bonds Between Men in the Art and Life of Jacques-Louis David." In *Femininity and Masculinity in Eighteenth-Century Art and Culture,* ed. Gill Perry and Michael Rossington, 204–218. Manchester and New York: Manchester University Press, 1992.

CRUM, Roger. "Cosmos, the World of Cosimo: The Iconography of the Uffizi Facade." *AB* 71 (1989): 237–253.

———. "Donatello's Bronze *David* and the Question of Foreign Versus Domestic Tyranny." *Renaissance Studies* 10, no. 4 (1996): 440–450.

CURTIUS, Ernst. *European Literature and the Latin Middle Ages.* Trans. Willard R. Trask. Princeton: Princeton University Press, 1990.

CZOGALLA, Albert. "David und Ganymedes: Beobachtungen und Fragen zu Donatellos Bronzeplastik 'David und Goliath.'" *Festschrift für Georg Scheja zum 70. Geburtstag,* 119–127. Sigmaringen: Thorbecke, 1975.

D'ADDARIO, Arnaldo. *La formazione dello stato moderno in Toscana: Da Cosimo il Vecchio a Cosimo I de' Medici.* Lecce: Adriatica editrice salentina, 1976.

———. *Due quadri del Botticelli eseguiti per nascite in Casa Medici: Nuova intepretazione della "Primavera" e della Nascita di Venere.* Florence: Olschki, 1992.

D'ANCONA, Paolo. *La miniatura fiorentina.* Florence: Olschki, 1914.

DACOS, Nicole, Andreas Grote, Antonio Giuliano, Detlef Heikamp, and Ulrico Pannuti. *Il tesoro di Lorenzo il Magnifico: Repertorio delle gemme e dei vasi.* 2d ed. Florence: Sansoni, 1980.

DATI, Goro. *L'Istoria di Firenze di Goro Dati dal 1380 al 1405.* Ed. Luigi Pratesi. Norcia: Tonto Cesare, 1902.

DAVIDSOHN, Robert. *Geschichte von Florenz.* 7 vols. Berlin: E. S. Mittler, 1896–1908.

———. *Storia di Firenze.* 5 vols. Florence: Sansoni, 1956.

DAVIE, Mark. "Luigi Pulci's *Stanze per la Giostra:* Verse and Prose Accounts of a Florentine Joust of 1469," *Italian Studies* 44 (1989): 41–58.

DAVIS, Charles T. "Il buon tempo antico." In *Florentine Studies: Politics and Society in Renaissance Florence,* ed. Nicolai Rubinstein. Evanston, Ill.: Northwestern University Press, 1968.

———. "Topographical and Historical Propoganda in Early Florentine Chronicles and in Villani." *Medioevo e Rinascimento* 2 (1988): 33–51.

DAVIS, Natalie Zemon. "Women on Top: Symbolic Inversion and Political Disorder in Early Modern Europe." In *The Reversible World,* ed. Barbara Babcock, 147–182. Ithaca: Cornell University Press, 1978.

DAVIS, Whitney. "Gender." In *Critical Terms for Art History,* ed. Richard Shiff and Robert Nelson, 220–233. Chicago: University of Chicago Press, 1996.

DE ALBENTIIS, Emidio. "Per un riesame dell' iconografia del *David* bronzeo di Donatello." *Annali della facoltà di lettere e filosofia dell'Università degli Studi di Perugia,* n.s. 10 (1986/1987): 107–132.

DEAN, Trevor. *The Towns of Italy in the Late Middle Ages.* Manchester and New York: Manchester University Press, 2000.

DEBORD, Guy. *Society of the Spectacle.* Detroit: Black and Red, 1983.

DEGENHART, Bernhard and Annegrit Schmitt. *Corpus der italienischen Zeichnungen 1300–1450.* Berlin: Mann, 1968–.

DELOCHE, Maximin. *Le port des anneaux dans l'antiquité romaine et dans les premiers siècles du moyen âge.* Paris: Imprimerie nationale, 1896.

DEMISCH, Heinz. *Die Sphinx: Geschichte ihrer Darstellung von den Anfängen bis zum Gegenwart.* Stuttgart: Urachhaus, 1977.

DEMPSEY, Charles. *The Portrayal of Love: Botticelli's "Primavera" and Humanist Culture at the Time of Lorenzo the Magnificent.* Princeton: Princeton University Press, 1992.

———. "Portraits and Masks in the Art of Lorenzo de' Medici, Botticelli, and Politian's *Stanze per la giostra.*" *RQ* 52 (1999): 1–42.

DIETMAR PEIL, *Untersuchungen zur Staats- und Herrschaftsmetaphorik in literarischen Zeugnissen von der Antike bis zur Gegenwart.* Munich: Wilhelm Fink, 1983.

DINI, Giulietta Chelazzi. "Osservazioni sui miniatori del panegirico di Roberto d'Angio nel British Museum." In *Scritti di storia dell'arte in onore di Ugo Procacci,* ed. Maria Grazia Ciardi-Dupré dal Poggetto and Paolo del Poggetto, 140–45. Milan: Electa, 1977.

DIO CHRYSOSTOM. *Discourses.* London: Heinemann; New York: Putnam, 1932–51.

———. *Sämtliche Reden.* Ed. Winfried Elliger. Zürich and Stuttgart: Artemis, 1967.

DIXON, John W. "The Drama of Donatello's *David.*" *GBA* 93 (1979): 6–12.

DOEBLER, John. "Donatello's Enigmatic *David.*" *Journal of European Studies* 1 (1971): 337–340.

DOGLIO, Federico. "Laurent de Médicis et la politique du spectacle." Trans. Marie José Hoyet. *Fifteenth-Century Studies* 13 (1988): 505–518.

DOHRN, Tobias. *Die Tyche von Antiocha.* Berlin: Mann, 1960.

DONAHUE, Charles. "The Policy of Alexander the Third's Consent Theory of Marriage." *Proceedings of the Fourth International Congress of Medieval Canon Law.* Ed. Stephan Kuttner. Vatican City: Biblioteca Apostolica Vaticana, 1976.

———. "The Canon Law of the Formation of Marriage and Social Practice in the Later Middle Ages." *Journal of Family History* 8 (1983): 144–158.

DONATO, Maria Monica. "Hercules and David in the Early Decoration of the Palazzo Vecchio: Manuscript Evidence." *JWCI* 54 (1991): 83–98.

———. "Testi, contesti, immagini politiche nel tardo medioevo: Esempi toscani: In margine a una discussione sul *Buon Governo.*" *Annali dell'istituto storico italo-germanico di Trento* 19 (1993).

———. "'Cose morali, e anche appartenenti secondo e' luoghi': Per lo studio della pittura politica nel tardo medioevo toscano." In *Forme della propaganda politica nel Due- e nel Trecento: Relazioni tenute al convegno internazionale organizzato dal comitato di studi storici di Trieste, 1993,* 491–517. Rome: École française de Rome, 1994.

DRAPER, James D. "Bartolomeo Bellano, *David with the Head of Goliath.*" In *Italian Renaissance Sculpture in the Time of Donatello.* Exh. cat., 226–228. Detroit: Detroit Institute of Arts, 1985.

DUBARLE, André-Marie. *Judith: Formes et senses des diverses traditions.* Rome: Institut Biblique Pontifical, 1966.

DUBY, Georges. "Introduction: Private Power, Public Power." In *A History of Private Life.* Vol. 3, *Revelations of the Medieval World,* ed. Georges Duby, 3–31. Trans. Arthur Goldhammer. Cambridge, Mass., and London: The Belknap Press of Harvard University Press, 1988.

DÜMMLER, Ernst and Lothar von Heinemann, ed. *Monumenta germaniae historica: Libelli de lite.* 3 vols. Hannover: Hahn, 1891.

EDGERTON, Samuel Y. *Pictures and Punishment: Art and Criminal Prosecution During the Florentine Renaissance.* Ithaca and London: Cornell University Press, 1985.

EDWARDS, Charles. *The History and Poetry of Rings.* New York: Redfield, 1855.

EICHMANN, Eduard. *Der Kaiserkrönung im Abendland.* 2 vols. Würzburg: Echter-Verlag, 1942.

EISENBICHLER, Konrad. "Confraternities and Carnival: The Context of Lorenzo de' Medici's *Rappresentazione di SS. Giovanni e Paolo.*" *Comparative Drama* 27, no. 1 (1993): 128–139.

———. *The Boys of the Archangel Raphael: A Youth Confraternity in Florence, 1411–1785*. Toronto, Buffalo, and London: University of Toronto Press, 1998.

EISLER, Colin. "The Athlete of Virtue: The Iconography of Asceticism." *De Artibus Opuscula XL: Essays in Honor of Erwin Panofsky*, 82–97. Princeton: Princeton University Press, 1961.

ELSHTAIN, Jean Bethke. *Public Man, Private Woman: Women in Social and Political Thought*. Princeton: Princeton University Press, 1981.

ENTERLIE, Lynn. *The Tears of Narcissus: Melancholia and Masculinity in Early Modern Writing*. Stanford: Stanford University Press, 1995.

ERFFA, Hans Martin von. "Meditationen über di Palla Medicea." In *Festschrift für Ulrich Middeldorf*. Ed. Antje Kosegarten and Peter Tigler, 392–401. Berlin: Walter de Gruyter, 1968.

———. "Judith-Virtus Virtutum-Maria." *MKIF* 40, no. 4 (1970): 460–465.

ETTLINGER, Leopold. "A Fifteenth-Century View of Florence." *BM* 94 (1952): 160–167.

———. "Hercules Florentinus." *MKIF* 26 (1972): 119–142.

EVEN, Yael. "The Loggia dei Lanzi: A Showcase of Female Subjugation." *Woman's Art Journal* 12, no. 1 (1991): 10–14; reprinted in *The Expanding Discourse: Feminism and Art History*, ed. Norma Broude and Mary Garrard, 127–138. New York: Harper and Row, 1992.

FABBRI, Lorenzo. *Alleanza matrimoniale e patriziato nella Firenze del '400: Studio sulla famiglia Strozzi*. Florence: Olschki, 1991.

FABRICZY, Cornelius von. "Andrea Verrocchio ai servizi de' Medici." *Archivio storico dell'arte*, 2d ser., 1 (1895): 163–176.

———. *Italian Medals*. Trans. Mrs. Gustavus W. Hamilton. New York: E. P. Dutton; London: Duckworth, 1904.

FADER, Martha A. A. "Sculpture in the Piazza della Signoria as Emblem of the Florentine Republic." Ph.D. diss., University of Michigan, 1977.

FANFANI, Pietro, ed. *Ricordo di una giostra fatta in Firenze a dì di febbraio del 1468 sulla piazza di Santa Croce*. Florence: Logge del Grano, 1864 (also published as "Ricordo d'una giostra fatta a Firenze a dì febbraio 1468 sulla piazza di Santa Croce . . . Notizia della festa fatta a Firenze la notte di carnevale da Bartolomeo Benci in onore della Marietta Strozzi." *Il Borghini* 2 (1864): 474–483, 530–542.

FASANO GUARINI, Elena. "Introduzione." In *Potere e società negli stati regionali italiani del '500 e '600*, ed. Elena Fasano Guarini, 7–47. Bologna: Il Mulino, 1978.

———. "Gli stati dell'Italia centro-settentrionale tra Quattro e Cinquecento: Continuità e trasformazioni." *Società e storia* 6 (1983): 617–639.

FAYER, Carla. *Il culto della dea Roma*. Pescara: Trimestre, 1976.

FERRARA, Miranda, and Francesco Quinterio. *Michelozzo di Bartolomeo*. Florence: Salimbeni, 1984.

FERRARI, Alessandro. "Il palazzo del Magnifico a Siena." *Bollettino senese di storia patria* 92 (1985): 107–153.

FICINO, Marsilio. *Commentary on Plato's "Symposium on Love."* Trans. Sears Jayne. Dallas: Spring, 1985.

FILARETE (Antonio di Piero Averlino). *Filarete's Treatise on Architecture*. Trans. John R. Spencer. New Haven and London: Yale University Press, 1965.

FLAMINI, Francesco. *La lirica toscana del Rinascimento anteriore ai tempi del Magnifico*. Pisa: T. Nistri, 1891.

FLATEN, Arne. "Identity and the Display of *Medaglie* in Renaissance and Baroque Europe." *Word & Image* (forthcoming).

FORSTER, Kurt. "Introduction." In Aby Warburg, *The Renewal of Pagan Antiquity: Contributions to the Cultural History of the European Renaissance*. Trans. David Britt, 1–76. Los Angeles: Getty Research Institute for the History of Art and the Humanities, 1999.

FOUCAULT, Michel. *The History of Sexuality*. Trans. Robert Hurley. Vol. 1. New York: Pantheon, 1978.

————. "What Is an Author?" In *Textual Strategies*, ed. Josue V. Harari, 141–160. Ithaca: Cornell University Press, 1979.

FRADENBURG, Louise and Carla Freccero, ed. *Premodern Sexualities*. New York: Routledge, 1996.

FRANCASTEL, Pierre. *La réalité figurative: Éléments structurels de sociologie de l'art*. Paris: Gonthier, 1965.

————. *Études de sociologie de l'art*. Paris: Denoel and Gonthier, 1970.

FRANCESCO da Barberino. *Reggimento e costumi di donna*. Ed. Giuseppe Sansone. Turin: Loescher-Chiantore, 1957.

FRASER, Nancy. "Rethinking the Public Sphere." In *Habermas and the Public Sphere*, ed. Craig Calhoun, 109–142. Cambridge, Mass.: MIT Press, 1992.

FREEDBERG, David. *The Power of Images*. Chicago: University of Chicago Press, 1989.

FRIEDLAENDER, Julius. *Die italienischen Schaumünzen des fünfzehnten Jahrhunderts 1430–1530: Ein Beitrag zur Kunstgeschichte*. Berlin: Wiedmann, 1882.

FRUGONI, Arsenio. "Convenevole da Prato e un libro figurato in onore di Roberto d'Angio." *Bulletino dell'istituto storico italiano per il medioevo e archivio Muratoriano* 81 (1969): 1–32.

FUBINI, Mario. "Nota sulla prosa di Lorenzo." *Studi sulla letteratura del Rinascimento*, 126–137. Florence: Sansoni, 1948.

FUBINI, Riccardo. "La rivendicazione di Firenze della sovranità statale e il contributo delle *Historiae* di Leonardo Bruni." In *Leonardo Bruni: Cancelliere della repubblica di Firenze*, ed. Paolo Viti, 29–62. Florence: Olschki, 1990.

————. "From Social to Political Representation in Renaissance Florence." In *City States in Classical Antiquity and Medieval Italy*, ed. Anthony Molho, Kurt Raaflaub, and Julia Emlen, 223–240. Ann Arbor: University of Michigan Press, 1991.

————. *Italia quattrocentesca: Politica e diplomazia nell'età di Lorenzo il Magnifico*. Milano: F. Angeli, 1994.

FULTON, Christopher. "The Boy Stripped Bare by His Elders: Art and Adolescence in Renaissance Florence." *Art Journal* 56, no. 2 (1997): 31–40.

FUMAGALLI, Edoardo. "Nuovi documenti su Lorenzo e Giuliano de' Medici." *Italia medioevale e umanistica* 23 (1980): 115–164.

FURTWÄNGLER, Adolf. *Die antiken Gemmen: Geschichte der Steinschneidekunst im klassischen Altertum*. 3 vols. Leipzig and Berlin: Giesecke and Devrient, 1900.

GADOL, Joan Kelly. "Did Women Have a Renaissance?" In *Becoming Visible: Women in European History*, ed. Renate Bridenthal and Claudia Koonz, 136–164. Boston: Houghton Mifflin, 1977.

GALEN OF ALEXANDRIA. *On the Usefulness of the Parts of the Body*. Trans. Margaret T. May. Ithaca, N.Y.: Cornell University Press, 1968.

GARDNER, Percy. "Cities and Countries in Ancient Art." *Journal of Historical Studies* 9 (1888): 47ff.

GARIN, Eugenio. *L'educazione umanistica in Italia*. Bari: Laterza, 1949.

————. *Giovanni Pico della Mirandola*. Padua: Sezione di arti grafiche dell'istituto Paolo Toschi, 1963.

————. *Italian Humanism: Philosophy and Civic Life in the Renaissance*. Trans. Peter Munz. New York: Harper and Row, 1965.

GATTI, Luca. "The Art of Freedom: Meaning, Civic Identity, and Devotion in Early Renaissance Florence." Ph.D. diss., Birkbeck College, University of London, 1992.

————. "Displacing Images and Devotion in Renaissance Florence: The Return of the Medici and an Order of 1513 for the 'Davit' and the 'Judit.'" *Annali della scuola normale superiore di Pisa*, classe di lettere e filosofia, 3d ser., 23, no. 2 (1993): 349–373.

————. "Il mito di Marte a Firenze e la 'Pietra Scema': Memorie, riti, ascendenze." *Rinascimento* 35 (1995): 201–230.

GAUTIER LE LEU. "The Widow." In *Fabliaux: Ribald Tales from the Old French*. Trans. Robert Hellman and Richard O'Gorman. New York: Crowell, 1965.

GAYE, Giovanni, ed. *Carteggio inedito d'artisti dei secoli XIV, XV, XVI*. 3 vols. Florence: G. Molini, 1839–40.

GELLI, Agenore. "L'esilio di Cosimo de' Medici." *ASI*, 4th ser., 10 (1882): 53–96; 149–169.

GELLI, Giovanni Battista. "Vite d'artisti." Ed. Girolamo Mancini. *ASI*, 5th ser., 17 (1896): 32–62.

GELLIUS, Aulus. *Attic Nights.* Trans. John C. Rolfe. 3 vols. London: Heinemann; Cambridge, Mass.: Harvard University Press, 1946–52.

GELLNER, Ernest and John Waterbury, ed. *Patrons and Clients in Mediterranean Societies.* London: Duckworth; Hanover, N.H.: Center for Mediterranean Studies of the American Universities Field Staff, 1977.

GERMANO, Joseph E. "Lorenzo de' Medici's Literary Versatility." *Acta* 12 (1988): 81–93.

GILBERT, Arthur N. "Conceptions of Homosexuality and Sodomy in Western History." *Journal of Homosexuality* 6, nos. 1–2 (1980): 57–68.

GILBERT, Creighton. "The Earliest Guide to Florentine Architecture, 1423." *MKIF* 14 (1969): 33–46.

———, ed. *Italian Art 1400–1500: Sources and Documents.* Evanston, Ill.: Northwestern University Press, 1992.

GIOVIO, Paolo. *Dialogo dell'imprese militari e amorose.* Ed. Maria Luisa Doglio. Rome: Bulzoni, 1978.

GIUSTI, Annamaria. "Due interventi su marmi donatelliani: Il San Marco e il sepolcro di Baldassare Cossa." In *Donatello-Studien*, ed. Monika Cammerer, 113–120. Munich: Bruckmann, 1989.

GLOSSAI HOMERIKAI. Ed. Susanne Neitzel. Berlin: Walter de Gruyter, 1977.

GNOCCHI, Lorenzo. "Le preferenze artistiche di Piero di Cosimo de' Medici." *Artibus et historiae* 9 (1988): 41–77.

GODEFROY, Thomas. *Le cérémonial de France.* Paris: Pacard, 1619.

GOFFEN, Rona. *Piety and Patronage in Renaissance Venice: Bellini, Titian, and the Franciscans.* New Haven and London: Yale University Press, 1986.

GOLDSCHMIDT, Adolf. "Das Nachleben der antiken Formen in Mittelalter." *Vorträge der Bibliothek Warburg* 1 (1921–22): 40–50.

GOLDTHWAITE, Richard. "The Florentine Palace as Domestic Architecture." *American Historical Review* 77 (1972): 977–1012.

———. "The Medici Bank and the World of Florentine Capitalism." *Past and Present* 114 (1987): 3–31.

GOMBRICH, E. H. "Botticelli's Mythologies: A Study in the Neoplatonic Symbolism of his Circle." *JWCI* 8 (1945): 7–60.

———. "Review of Arnold Hauser, *The Social History of Art* (2 vols. New York: Knopf, 1951)." *AB* 35 (1953): 79–84.

———. "Renaissance and Golden Age." *JWCI* 24 (1961): 206–209.

———. "The Early Medici as Patrons of Art: A Survey of Primary Sources." In *Italian Renaissance Studies: A Tribute to the Late Cecilia M. Ady*, ed. E. F. Jacob, 279–311. London: Faber and Faber, 1968.

———. *Aby Warburg: An Intellectual Biography.* London: Warburg Institute, 1970.

GOODICH, Michael. *The Unmentionable Vice: Homosexuality in the Late Medieval Period.* Santa Barbara: ABC-Clio, 1979.

GOODMAN, Dena. "Public Sphere and Private Life: Toward a Synthesis of Current Historiographical Approaches to the Old Regime." *History and Theory* 31, no. 1 (1992): 1–20.

GORI, Pietro. *Feste fiorentine attraverso i secoli: Le feste per San Giovanni.* Florence: R. Bemporad, 1926.

———. *Firenze magnifica: Le feste fiorentine attraverso i secoli.* Florence: R. Bemporad, 1926–30.

GRAMACCINI, Norberto. *Mirabilia: Das Nachleben antiker Statuen vor der Renaissance.* Mainz: Philipp von Zabern, 1996.

GRAYSON, Cecil. "Poesie latine di Gentile Becchi in un codice Bodleiano." In *Studi offerti a Roberto Ridolfi*, ed. Berta Maracchi Biagiarelli and Dennis E. Rhodes, 285–303. Florence: Olschki, 1973.

GREENHALGH, Michael. *Donatello and His Sources.* London: Duckworth; New York: Holmes and Maier, 1982.

GROSZ, Elizabeth. "Bodies-Cities." In *Sexuality and Space*, ed. Beatrice Colomina, 241–254. New York: Princeton Architectural Press, 1992.

GUASTI, Cesare, ed. *Commissioni di Rinaldo degli Albizzi per il comune di Firenze dal MCCCXCIX al MCCCXXXIII*. 3 vols. Florence: M. Cellini, 1867–73.

———. *Le feste di San Giovanni Battista in Firenze descritte in prosa e in rima da contemporanei*. Florence: G. Cirri, 1884.

GUICCIARDINI, Francesco. *Del governo di Firenze dopo la restaurazione de' Medici nel 1512*. Bari: Laterza, 1931.

GUIDI, Guidobaldo. *Il governo della città-repubblica di Firenze del primo Quattrocento*. Florence: Olschki, 1981.

GUIDO DEL PALAGIO. "A Fiorenza." In *Rime di M. Cino da Pistoia e d'altri del secolo XIV*, ed. Giosué Carducci, 597–600. Florence: Barbèra, 1862.

GUIDOTTI, Alessandro. "Gli aredi del palazzo nel tempo." In *Il Palazzo Medici Riccardi*, ed. Giovanni Cherubini and Giovanni Fanelli, 244–261. Florence: Giunti, 1990.

GUNDERSHEIMER, Werner L. "Patronage in the Renaissance: An Exploratory Approach." In *Patronage in the Renaissance*, ed. Guy Fitch Lytle and Stephen Orgel, 3–26. Princeton: Princeton University Press, 1981.

GUTKIND, Kurt. *Cosimo de' Medici, Pater Patriae 1389–1464*. Oxford: Clarendon Press, 1938.

HAAS, Louis. "'Il mio buono compare': Choosing Godparents and the Uses of Baptismal Kinship in Renaissance Florence." *Journal of Social History* 29 (1995): 341–356.

HABERMAS, Jürgen. *The Structural Transformation of the Public Sphere: An Inquiry into a Category of Bourgeois Society*. Trans. Thomas Burger. London: Polity Press; Oxford: Basil Blackwell, 1989.

HADELN, Detlev von. *Die wichtigsten Darstellungsformen des H. Sebastian in der italienischen Malerei bis zum Ausgang des Quattrocento*. Strasbourg: Heitz and Mündel, 1906.

HAFTMANN, Werner. *Das italienische Säulenmonument: Versuch zur Geschichte einer antiken Form des Denkmals und Kultmonumentes und ihrer Wirksamkeit für die Antikenvorstellung des Mittlealters und für die Ausbildung des öffentlichen Denkmals in der Frührenaissance*. Leipzig and Berlin: Teubner, 1939.

HAHR, August. "Donatellos *Bronzedavid* und das praxitelische Erosmotiv." *Monatsheft für Kunstwissenschaft* 5 (1912): 303–310.

HAINES, Margaret. "La colonna della *Dovizia* di Donatello." *Rivista d'arte* 37 (1984): 347–359.

HALE, David George. *The Body Politic: A Political Metaphor in Renaissance English Literature*. The Hague and Paris: Mouton, 1971.

HALL, Stuart. *Culture, Media, Language*. London: Unwin Hyman, 1990.

HALPERIN, David M. "Is There a History of Sexuality?" *History and Theory* 28, no. 3 (1989): 257–274.

———. "Forgetting Foucault: Acts, Identities, and the History of Sexuality." *Representations* 63 (Summer 1998): 93–120.

HAMBDORF, Friedrich Wilhelm. *Griechische Kultpersonifikationen der vorhellenistischen Zeit*. Mainz: Philipp von Zabern, 1964.

HANKINS, James. "Cosimo de' Medici as a Patron of Humanistic Literature." In *Cosimo "il Vecchio" de' Medici, 1389–1464*, ed. Francis Ames-Lewis, 81–90. Oxford: Clarendon Press, 1994.

———. "The 'Baron Thesis' after Forty Years and Some Recent Studies of Leonardo Bruni." *Journal of the History of Ideas* 56 (1995): 309–338.

HARTT, Frederick. "Art and Freedom in Quattrocento Florence." *Essays in Memory of Karl Lehmann*, 114–131. New York: Institute of Fine Arts, 1964.

———. *Donatello: Prophet of Modern Vision*. New York: Abrams, 1973; London: Thames and Hudson, 1974.

HASKELL, Francis. *Patrons and Painters: A Study in the Relations Between Italian Art and Society*

in the Age of the Baroque. 2d ed. New Haven and London: Yale University Press, 1980.

HATFIELD, Rab. "The Compagnia de' Magi." *JWCI* 33 (1970): 107–161.

———. *Botticelli's Uffizi "Adoration": A Study in Pictorial Content.* Princeton: Princeton University Press, 1976.

———. "Cosimo de' Medici and the Chapel of His Palace." In *Cosimo "il Vecchio" de' Medici, 1389–1464,* ed. Francis Ames-Lewis, 221–244. Oxford: Clarendon Press, 1994.

HAUK, Karl. "Der Ring als Herrschafts-zeichen." In *Herrschaftszeichen und Staatssymbolik,* ed. Percy Ernst Schramm. 2 vols. Stuttgart: Hiersemann, 1954–56.

HAUSER, Arnold. *The Social History of Art.* 2 vols. New York: Knopf, 1951.

HAUVETTE, Henri. "La 39ème nouvelle du *Décaméron* e la légende du coeur mangé." *Romania* 40 (1912): 184–205.

HEERS, Jacques. *Fêtes, jeux et joutes dans les sociétés d'occident à la fin du Moyen-Âge.* Montreal: Institute d'études médiévales; Paris: J. Vrin, 1971.

HEINTZE, Horst, Giuliano Staccioli, and Babette Hesse, ed. *Lorenzo der Prächtige und die Kultur im Florenz des 15. Jahrhunderts.* Berlin: Duncker und Humblot, 1995.

HEISS, Aloïss. *Les médailleurs de la Renaissance.* Paris: J. Rothschild, 1881–1892.

HERDE, Peter. "Politik und Rhetorik in Florenz am Vorabend der Renaissance." *Archiv für Kulturgeschichte* 47 (1965): 141–220.

———. "Politische Verhaltensweisen der Florentiner Oligarchie, 1382–1402." In *Geschichte und Verfassungsgefüge: Frankfurter Festgabe für Walter Schlessinger,* 156–249. Wiesbaden: Steiner, 1973.

HERLIHY, David and Christiane Klapisch-Zuber. *Les toscans et leurs familles: Une étude du catasto florentin de 1427.* Paris: Editions de l'école des hautes études en science sociales et presses de la fondation nationale des sciences politiques, 1978.

———. *Tuscans and Their Families: A Study of the Florentine Catasto of 1427.* New Haven and London: Yale University Press, 1985.

HERZNER, Volker. "David Florentinus I." *Jahrbuch der Berliner Museen* 20 (1978): 43–115.

———. "Die *Judith* der Medici." *Zeitschrift für Kunstgeschichte* 43, no. 2 (1980): 139–180.

———. "David Florentinus II: Der Bronze-*David* Donatellos im Bargello." *Jahrbuch der Berliner Museen* 24 (1982): 436–443.

HESSERT, Marlis von. *Zum Bedeutungswandel der Herkules-Figur in Florenz: Von den Anfängen der Republik bis zum Prinzipät Cosimos I.* Vienna: Böhlau, 1991.

HEXTER, Jack H. "*Il Principe* and *lo stato.*" In *The Vision of Politics on the Eve of the Reformation: More, Machiavelli, and Seyssel,* 150–178. New York: Basic Books, 1973.

HILDBURGH, Walter L. "On Some Italian Renaissance Caskets with *Pastiglia* Decoration." *Antiquaries Journal* 26, nos. 3–4 (1946): 123–137.

HILL, George. "Classical Influence on the Italian Medal." *BM* 18 (1911): 259–268.

———. *A Corpus of Italian Medals of the Renaissance before Cellini.* 2 vols. London: Trustees of the British Museum, 1930.

HILL, George and Graham Pollard. *Renaissance Medals from the Samuel H. Kress Collection at the National Gallery of Art [Washington, D.C.].* London: Phaidon, 1967.

———. *Medals of the Renaissance.* London: British Museum Publications, 1978.

HIND, Arthur M. "Fifteenth-Century Italian Engravings in Constantinople." *The Print Collector's Quarterly* 20, no. 4 (1933): 279–296.

———. *Nielli, Chiefly Italian of the XV Century: Plates, Sulphur Casts, and Prints Preserved in the British Museum.* London: Trustees of the British Museum, 1936.

———. *Early Italian Engraving: A Critical Catalogue with Complete Reproduction of All the Prints Described.* London: M. Knoedler, 1938.

———. *An Introduction to a History of Woodcut.* 2 vols. New York: Dover, 1963.

HINKS, Roger. *Myth and Allegory in Ancient Art*. London: Warburg Institute, 1939.

HINTZE, Otto. *Staat und Verfassung: Gesammelte Abhandlungen zur allgemeinen Verfassungsgeschicte*. Ed. Gerhard Oestreich. 2d ed. Göttingen: Vandenhoeck und Ruprecht, 1962.

HINZ, Berthold. "Statuenliebe: Antiker Skandal und mittelalterliches Trauma." *Marburger Jahrbuch für Kunstwissenschaft* 22 (1989): 135–142.

HOFFMANN, F. "Über den Verlobungs- und Trauerring." *Sitzungsberichte der Königlichen Akademie der Wissenschaften, philosophisch-historische Klasse* 65 (Vienna, 1870): 849ff.

HOLLINGSWORTH, Mary. *Patronage in Renaissance Italy: From 1400 to the Early Sixteenth Century*. London: John Murray, 1994.

HOLMAN, Beth. "Verrocchio's *Marsyas* and Renaissance Anatomy." *Marsyas* 19 (1977–1978): 1–9.

HOLMES, George. "How the Medici Became the Pope's Bankers." In *Florentine Studies: Politics and Society in Renaissance Florence*, ed. Nicolai Rubinstein, 357–380. Evanston, Ill.: Northwestern University Press, 1968.

HOLMES, Megan. *Fra Filippo Lippi: The Carmelite Painter*. New Haven and London: Yale University Press, 1999.

HOOPS, Johannes. "Ring." In *Reallexikon der germanischen Altertumskunde*. Berlin: Walter de Gruyter, 1968.

HORNE, Herbert P. *Alessandro Filipepi Commonly Called Sandro Botticelli, Painter of Florence*. London: Bell, 1908; reprinted Princeton: Princeton University Press, 1980.

HUIZINGA, Johan. *The Waning of the Middle Ages*. Garden City, N.J.: Doubleday, 1954.

HULUBEI, Alice. "Naldo Naldi: Étude sur la joute de Julien et sur les bucoliques dediés à Laurent de Médicis." *Humanisme et Renaissance* 3 (1936): 169–186.

HUNT, Lynn, ed. *Eroticism and the Body Politic*. Baltimore and London: Johns Hopkins University Press, 1991.

HYDE, Thomas. *The Poetic Theology of Love: Cupid in Renaissance Literature*. Newark: University of Delaware Press, 1986.

HYMAN, Isabelle. *Fifteenth-Century Florentine Studies: The Palazzo Medici and a Ledger for the Church of San Lorenzo*. Ann Arbor: Garland, 1977.

Il tumulto dei Ciompi: Un momento di storia fiorentina ed europea. Florence: Olschki, 1981.

ISER, Wolfgang. *The Act of Reading: A Theory of Aesthetic Response*. Baltimore and London: Johns Hopkins University Press, 1978.

Italian Renaissance Sculpture in the Time of Donatello. Exh. cat. Detroit: Detroit Institute of Arts, 1985.

IVERSON, Margaret. "Retrieving Warburg's Tradition." *AH* 16, no. 4 (1993): 541–553.

JACOBSEN-SCHUTTE, Anne. "'Trionfo delle donne': Tematiche di rovesciamento dei ruoli nella Firenze Rinascimentale." *Quaderni storici* 44, no. 2 (1980): 474–496.

JAEGER, Roland. "Der Ring des Meeres." *Repertorium für Kunstwissenschaft* 51 (1930): 232–244.

JANSON, H. W. *The Sculpture of Donatello*. 2d ed. Princeton: Princeton University Press, 1963.

———. "The Image of Man in Renaissance Art [1966]." In *Sixteen Studies*, 122–123. New York: Abrams, 1973.

———. "La signification politique du *David* en bronze de Donatello." *Revue de l'art* 39 (1978): 33–38.

JENKINS, A. Fraser. "Cosimo de' Medici's Patronage of Architecture and the Theory of Magnificence." *JWCI* 33 (1979): 162–170.

JOHNSON, Geraldine A. "Activating the Effigy: Donatello's Pecci Tomb in Siena Cathedral." *AB* 77 (1995): 445–459.

———. "Idol or Ideal? The Power and Potency of Female Public Sculpture." In *Picturing Women in Renaissance and Baroque Italy*, ed. Geraldine A. Johnson and Sara F. Matthews Grieco, 222–245. Cambridge: Cambridge University Press, 1997.

———. "The Lion on the Piazza: Patrician Politics and Public Statuary in Central Florence." In *Secular Sculpture 1350–1550*, ed.

Thomas Frangenberg and Phillip Lindley. Stamford: Shaun Tyas, 2000.

JONES, Philip J. "Florentine Families and Florentine Diaries in the Fourteenth Century." *Papers of the British School at Rome* 24 (1956): 183–205.

———. *The Italian City-State: From Commune to Signoria.* Oxford: Clarendon Press, 1997.

JONES, William. *Finger-Ring Lore: Historical, Legendary, and Anectotal.* London: Chatto and Windus, 1898.

JORDAN, Mark J. *The Invention of Sodomy in Christian Theology.* Chicago and London: University of Chicago Press, 1997.

JURDEVIC, Mark. "Civic Humanism and the Rise of the Medici." *RQ* 52 (1999): 994–1020.

JURÉN, Vladimír. "'Civium Servator' Bertoldos Medaille auf Lorenzo il Magnifico." *Umění* 19 (1971): 75–82.

KAHN, Victoria. "'The Duty to Love': Passion and Obligation in Early Modern Political Theory." *Representations* 68 (1999): 84–107.

KANTOROWICZ, Ernst H. *The King's Two Bodies: A Study in Mediaeval Political Theology.* Princeton: Princeton University Press, 1957.

KAPLAN, E. Ann. "Is the Gaze Male?" In *Women and Film: Both Sides of the Camera,* 23–35. New York and London: Methuen, 1983.

KARMIN, Otto. *La legge del catasto fiorentino del 1427.* Florence: Vallechi, 1906.

KAUFFMAN, Hans. *Donatello: Eine Einführung in sein Bilden und Denken.* Berlin: Grote, 1934.

KENSETH, Joy. "Bernini's Borghese Sculptures: Another View." *AB* 63, no. 2 (1981): 191–210.

KENT, Dale. "I Medici in esilio: Una vittoria di famiglia ed una disfatta personale." *ASI* 132 (1974): 3–63.

———. "The Florentine *Reggimento* in the Fifteenth Century" *RQ* 28, no. 4 (1975): 575–638.

———. *The Rise of the Medici: Faction in Florence, 1426–1434.* Oxford: Oxford University Press, 1978.

———. *Cosimo de' Medici and the Florentine Renaissance: The Patron's Oeuvre.* New Haven and London: Yale University Press, 2000.

KENT, F. W. *Household and Lineage in Renaissance Florence: The Family Life of the Capponi, Ginori, and Rucellai.* Princeton: Princeton University Press, 1977.

———. "A Proposal by Savonarola for the Self-Reform of Florentine Women (March 1496)." *Memorie Domenicane* 14 (1983): 335–341.

———. "Palaces, Politics and Society in Fifteenth-Century Florence." *I Tatti Studies* 2 (1987): 41–70.

———. "Patron-Client Networks in Renaissance Florence and the Emergence of Lorenzo as 'Maestro' della Bottega." In *Lorenzo de' Medici: New Perspectives,* ed. Bernard Toscani, 279–314. New York: Peter Lang, 1994.

———. "The Young Lorenzo, 1449–69." In *Lorenzo the Magnificent: Culture and Politics,* ed. Michael Mallett and Nicholas Mann, 1–22. London: Warburg Institute, 1996.

KENT, F. W. and Patricia Simons, ed. *Patronage, Art, and Society in Renaissance Italy.* Canberra: Humanities Research Centre; Oxford: Clarendon Press, 1987.

KETTERING, Sharon. "The Historical Development of Political Clientelism." *Journal of Interdisciplinary History* 18 (1988): 419–447.

KIRCHMANN, Johannes. *De annulis liber singularis.* Leyden: Hackios, 1627.

KIRSHNER, Julius. *The Origins of the State in Italy 1300–1600.* Chicago: University of Chicago Press, 1995.

———. "The State Is Back In." In *The Origins of the State in Italy, 1300–1600,* ed. Julius Kirshner. Special supplementary volume of *The Journal of Modern History* 67 (1995): 1–10.

KLAPISCH-ZUBER, Christiane. "'Parenti, amici, vicini': Il territorio urbano d'una famiglia mercantile nel XV secolo." *Quaderni storici* 33 (1976): 953–982; translated as "Kin, Friends, and Neighbors': The Urban Territory of Merchant Family in 1400." In Christiane Klapisch-Zuber, *Women, Family and Ritual in Renaissance Italy,* 68–93. Chicago: University of Chicago Press, 1985.

———. "Zacharias, or the Ousted Father." In

Women, Family, and Ritual in Renaissance Italy, 178–212. Chicago: University of Chicago Press, 1985.

———. "The Griselda Complex: Dowry and Marriage Gifts in the Quattrocento." In *Women, Family, and Ritual in Renaissance Italy*, 213–246. Chicago: University of Chicago Press, 1985.

———. *Women, Family, and Ritual in Renaissance Italy*. Trans. Lydia Cochrane. Chicago: University of Chicago Press, 1985.

———. "Compérage et clientélisme à Florence (1360–1520)." *Ricerche storiche* 15 (1985): 61–76.

———. "Un salario o l'onore: Come valutare le donne fiorentine del XIV–XV secolo." *Quaderni storici* n. s. 79, no. 1 (1992): 41–50.

———. "Les coffres de mariage et les plateaux d'accouchée à Florence: Archive, ethnologie, iconographie." In *À travers l'image: Lecture iconographique et sense de l'oeuvre*, ed. Sylvie Deswaret-Rosa, 309–24. Paris: Klincksieck, 1994.

———, ed. *Il pubblico, il privato, l'intimità: Percezioni ed esperienze tra Medio Evo e Rinascimento*. Special Issue of *Ricerche storiche* 16, no. 3 (1986).

KLEIN, Robert. "La théorie de l'expression figurée dans les traités italiens sur les imprese (1555–1612)." *Bibliothèque d'humanisme et de Renaissance* 19 (1957): 320–342.

———. *Form and Meaning*. Trans. Madeline Jay and Simon Wieseltier. New York: Viking Press, 1979.

KLIEMANN, J. M. *Politische und humanistische Ideen der Medici in der Villa Poggio a Caiano: Untersuchungen zu den Fresken der Sala Grande*. Bamberg: Schadel and Wehle, 1976.

KNOTTS, Robert Marvin. "Judith in Florentine Renaissance Art, 1425–1512." Ph.D. diss., Ohio State University, 1995.

KOHL, Benjamin G. and Ronald G. Witt. *The Earthly Republic: Italian Humanists on Government and Society*. Philadelphia: University of Pennsylvania Press, 1978.

KOHLHAUSSEN, Heinrich. *Minnekästchen im*

Mittelalter. Berlin: Verlag für Kunstwissenschaft, 1928.

KORNMANN, Heinrich. *De annulo triplici: Usitato, sponsalitio, et signatorio*. Frankfurt: J. Fischer, 1629.

KOSMER, Ellen. "The 'noyous humoure of Lecherie.'" *AB* 7, no. 1 (1975): 1–8.

KRAUSS, Rosalind E. *The Originality of the Avant-Garde and Other Modernist Myths*. Cambridge, Mass.: MIT Press, 1985.

KRAUTHEIMER, Richard and Trude Krautheimer-Hess. *Lorenzo Ghiberti*. 5th ed. Princeton: Princeton University Press, 1982.

KRESS, Susanne. "'Laurentius Medices-Salus Publica': Zum Kontext eines Voto Lorenzo de' Medicis und seinem Bezug zur Thomas-Christus Gruppe." In *Die Christus-Thomas-Gruppe von Andrea del Verrocchio*, ed. Herbert Beck, Maraike Buckling, and Edgar Lein. Frankfurt am Main: Henrich, 1995.

———. "Das autonome Porträt in Florenz." Ph.D. diss., Gießen Universität, 1995.

KRISTELLER, Paul. *Florentinische Zierstücke in Kupferstich aus dem XV. Jahrhundert*. Berlin: B. Cassirer, 1909.

KRISTELLER, Paul. O. "Un documento sconosciuto sulla giostra di Giuliano de' Medici (1939)." In *Studies in Renaissance Thought and Letters*, 437–450. Rome: Edizioni di storia e letteratura, 1969.

KUNCKEL, Hille. *Der römische Genius*. Heidelberg: F. H. Kerle, 1974.

KURTH, Willy. *Die Darstellung des nackten Menschen in dem Quattrocento von Florenz*. Berlin: Hermann Blanke, 1912.

KUSTER, Harvey and Raymond J. Cormier. "Old Views and New Trends: Observations of the Problem of Homosexuality in the Middle Ages." *Studii medievali* 25, no. 2 (1985): 587–610.

LADIS, Andrew. *Taddeo Gaddi: Critical Reappraisal and Catalogue Raisonné*. Columbia and London: University of Missouri Press, 1982.

LAGO, Luciano. *Imago mundi et Italiae: La versione del mondo e la scoperta dell'Italia nella cartografia antica, secoli X–XVI*. Trieste: Università degli studi di Trieste, facoltà di magistero, dipartimento di scienze geografiche e storiche, 1992.

LAIOU, Angeliki E., ed. *Consent and Coercion to Sex and Marriage in Ancient and Medieval Societies.* Washington, D.C.: Dumbarton Oaks Research Library and Collection, 1993.

LANDES, Joan. *Women and the Public Sphere in the Age of the French Revolution.* Ithaca: Cornell University Press, 1998.

———, ed. *Feminism, the Public and the Private.* Oxford: Oxford University Press, 1998.

LANDUCCI, Luca. *Diario dal 1450 al 1516.* Ed. Iodoco del Badia. Florence: Sansoni, 1883.

———. *A Florentine Diary.* Trans. Alice de Rosen Jarvis. London: Dent; New York: Dutton, 1927.

LANGEDIJK, Karla. "Baccio Bandinelli's Orpheus: A Political Message." *MKIF* 20 (1976): 34–52.

———. *The Portraits of the Medici, 15th-18th Centuries.* Trans. Patricia Wardle. 2d ed. 3 vols. Florence: S.P.E.S., 1981–87.

LÀNYI, Jeno. "Problemi della critica Dona-telliana." *La critica d'arte* 19 (1939): 9–23.

LANZA, Antonio, ed. *Lirici toscani del Quattrocento.* 2 vols. Rome: Bulzoni, 1975.

LAQUEUR, Thomas. *Making Sex: Body and Gender from the Greeks to Freud.* Cambridge, Mass., and London: Harvard University Press, 1990.

LATINI, Brunetto. *Il tesoretto (The Little Treasure).* Ed. and trans. Julia Bolton Holloway. New York and London: Garland, 1981.

LAVIN, Irving. "On the Sources and Meaning of the Renaissance Portrait Bust." *Art Quarterly* 33 (1970): 207–226.

LEACH, Patricia. "Donatello's Marble *David:* Leonardo Bruni's Contribution." *Source* 12 (1993): 8–11.

LECLERCQ, Henri. "Anneaux." In *Dictionnaire d'archéologie chrétienne et de liturgie,* 1280. Paris: Letouzey et Ané, 1924.

LEFEBVRE, Henri. *The Production of Space.* Trans. Donald Nicholson-Smith. Oxford: Basil Blackwell, 1990.

LEONARDO DA VINCI. *The Notebooks of Leonardo da Vinci.* Ed. and trans.

Edward MacCurdy. 2 vols. New York: Reynal and Hitchcock, 1938.

———. *Leonardo On Painting.* Ed. Martin Kemp. Trans. Martin Kemp and Margaret Walker. New Haven and London: Yale University Press, 1989.

LEUKER, Tobias. "Numismatische Variationen über das Thema des Goldnen Apfels: Zu einer berühmten Medaille für Cosimo Pater Patriae." In *Florenz-Rom: Zwischen Kontinuität und Konkurrenz,* ed. Henry Keazor, 71–84. Münster: Lit, 1998.

LEVENSON, Jay A., Konrad Oberhuber, and Jacquelyn L. Sheehan. *Early Italian Engravings from the National Gallery of Art.* Washington, D.C.: National Gallery of Art, 1973.

LEVI D'ANCONA, Mirella, ed. *Botticelli's "Primavera": A Botanical Interpretation Including Astrology, Alchemy, and the Medici.* Florence: Olschki, 1983.

LEVINE, Saul. "'Tal Cosa': Michelangelo's *David:* Its Form, Site and Political Symbolism." Ph.D. diss., Columbia University, 1969.

———. "The Location of Michelangelo's *David:* The Meeting of January 25, 1504." *AB* 56 (1974): 31–49.

LICETUS, Fortunius. *De anulis antiquis.* Udine: Nicholai Schiratti, 1645.

LIEBENWEIN, Wolfgang. "Die 'Privatizierung' des Wunders: Piero de' Medici in SS. Annunziata und San Miniato." In *Piero de' Medici "il Gottoso" (1416–1469): Kunst im Dieste der Mediceer/Art in the Service of the Medici,* ed. Andreas Beyer and Bruce Boucher, 251–290. Berlin: Akademie Verlag, 1993.

LIESS, Reinhard. "Beobachtungen an der Judith-Holofernes-Gruppe des Donatello." In *Argo: Festschrift für Kurt Badt zu seinem 80. Geburtstag,* ed. Martin Gosebruch and Lorenz Dittmann, 176–205. Cologne: DuMont, 1970.

LIGHTBOWN, Ronald. *Sandro Botticelli: Life and Work.* 2 vols. Berkeley and Los Angeles: University of California Press, 1978.

———. *Donatello and Michelozzo: An Artistic Partnership and Its Patrons in the Early Renaissance.* London: Harvey Miller, 1980.

LIPPINCOTT, Kristen. "The Genesis and Significance of the Fifteenth-Century

'Impresa.'" In *Chivalry in the Renaissance*, ed. Sydney Anglo, 49–76. Woodbridge: The Boydell Press, 1990.

LISNER, Margrit. "Gedanken vor frühen Standbildern Donatellos." *Kunstgeschichtliche Studien für Kurt Bauch*, 77–92. Munich and Berlin: Deutsche Kunstverlag, 1967.

LOOPER, Michael. "Political Messages in the Medici Palace Garden." *Journal of Garden History* 12 (1992): 255–268.

LOPES-PEGNA, Mario. *Firenze dalle origini al medioevo*. 2d ed. Florence: Del Re, 1974.

L'OREFICERIA nella Firenze del Quattrocento. Exh. cat. Florence: S.P.E.S., 1977.

LORENZI, Giovanna de. *Medaglie di Pisanello e della sua cerchia*. Exh. cat. Florence: Museo Nazionale del Bargello, 1983.

LOWE, Kate. "Secular Brides and Convent Brides: Wedding Ceremonies in Italy During the Renaissance and Counter-Reformation." In *Marriage in Italy, 1300–1650*, ed. Trevor Dean and K. J. P. Lowe, 41–65. Cambridge: Cambridge University Press, 1998.

LUCAN. *Pharsalia*. Trans. J. D. Duff. Cambridge, Mass.: Harvard University Press; London: Heinemann, 1951.

LUNGO, Isidoro del. *Florentia: Uomini e cose del Quattrocento*. Florence: Barbèra, 1897.

———. *Gli amori del Magnifico Lorenzo*. Bologna: Zanichelli, 1923.

LYDECKER, John Kent. "The Domestic Setting of the Arts in Renaissance Florence." Ph.D. diss., Johns Hopkins University, 1987.

MACHIAVELLI, Niccolò. *The Prince*. Trans. and ed. Quentin Skinner and Russell Price. Cambridge: Cambridge University Press, 1988.

MACROBIUS. *Saturnalia*. Trans. Percival V. Davies. New York: Columbia University Press, 1969.

MAFFEI, Timoteo. "In magnificentiae Cosmi Medicei Florentini detractores." In *Deliciae eruditorum, seu, veterum anekdoton opusculorum collectanea*, ed. Giovanni Lami, 12: 150–168. 18 vols. Florence: Viviani, 1736–1769.

MAIER, Bruno. "Il realismo letterario di Lorenzo il Magnifico." In Lorenzo de' Medici, *Opere scelte*, ed. Bruno Maier, 1–49. Novara: Istituto geografico de Agostini, 1969.

MALLETT, Michael and Nicholas Mann, ed. *Lorenzo the Magnificent: Culture and Politics*. London: Warburg Institute, 1996.

MANCINI, Girolamo. "Il bel San Giovanni e le feste patronali di Firenze descritte nel 1475 da Piero Cennini." *Rivista d'arte* 6 (1909): 185–227.

MANETTI, Antonio di Tuccio. *The Life of Brunelleschi*. Ed. Howard Saalman. Trans. Catherine Enggass. University Park: Pennsylvania State University Press, 1970.

MARBOD OF RENNES. *Marbodi liber decem capitulorum*. Ed. Rosario Leotta. Rome: Herder, 1984.

MARCELLO, Luciano. "Società maschile e sodomia: Dal declino della 'polis' al Principato." *ASI* 150 (1992): 115–138.

MAREK, Michaela. "Donatellos *Niccolò da Uzzano*: 'Ritrarre dal naturale' und Bürgertugend." In *Donatello-Studien*, ed. Monika Cammerer, 263–277. Munich: Bruckmann, 1989.

———. "'Virtus' und 'fama': Zur Stilproblematik der Portraitbüsten." In *Piero de' Medici "il Gottoso" (1416–1469): Kunst im Dieste der Mediceer/Art in the Service of the Medici*, ed. Andreas Beyer and Bruce Boucher, 341–357. Berlin: Akademie Verlag, 1993.

MARIN, Louis. "The Inscription of the King's Memory: On the Metallic History of Louis XIV." Trans. Mark Franko. *Yale French Studies* 59 (1979): 17–36.

MARKS, L. F. "The Financial Oligarchy under Lorenzo." In *Italian Renaissance Studies*, ed. E. F. Jacob, 123–147. London: Faber and Faber, 1960.

MARTELLI, Mario. *Studi laurenziani*. Florence: Olschki, 1965.

———. "I Medici e le lettere." In *Idee, istituzioni, scienza ed arti nella Firenze dei Medici*, ed. Cesare Vasoli, 119–127. Florence: Giunti-Martello, 1980.

———. "La canzone di Francesco d'Altobianco degli Alberti." *Interpres* 6 (1986): 7–40.

———. *Letteratura fiorentina del Quattrocento: Il filtro degli anni sessanta*. Florence: Le Lettere, 1996.

MARTIN DA CANAL. *Les estoires de Venise: Cronaca veneziana in lingua francese dalle orgini al 1275*. Ed. Alberto Limentani. Florence: Olschki, 1972.

MARTINDALE, Andrew. "Patrons and Minders: The Intrusion of the Secular into Sacred Spaces in the Late Middle Ages." In *Church and the Arts*. Ed. Diana Wood, 143–178. Oxford and Cambridge, Mass.: Blackwell, 1992.

MARTINES, Lauro. *Lawyers and Statecraft in Renaissance Florence*. Princeton: Princeton University Press, 1968.

———. "Political Conflict in the Italian City States." *Government and Opposition* 3 (1968): 72–74.

———. "The Politics of Love Poetry in Renaissance Italy." In *Historical Criticism and the Challenge of Theory*, ed. Janet L. Smarr, 129–144. Urbana and Chicago: University of Illinois Press, 1993.

———. "Poetry as Politics and Memory in Renaissance Florence and Italy." In *Art, Memory, and Family in Renaissance Florence*, ed. Giovanni Ciappelli and Patricia Lee Rubin, 48–63. Cambridge: Cambridge University Press, 2000.

MAZZI, Corrado. *Due provvisioni suntuarie fiorentine (24 novembre 1464; 29 febbraio 1471 [1472])*. Florence: Nozze Olschki/Finzi, 1908.

MAZZI, Maria Serena. *Prostitute e lenoni nella Firenze del Quattrocento*. Milan: Saggiatore, 1991.

McCLINTOCK, Anne. *Imperial Leather: Race, Gender and Sexuality in the Colonial Contest*. New York and London: Routledge, 1995.

McHAM, Sarah Blake [Wilk]. "Donatello's *Dovizia* as an Image of Florentine Political Propoganda." *Artibus et historiae* 6 (1986): 9–28.

———. "Donatello's Tomb of John XXIII." In *Life and Death in Fifteenth-Century Florence*, ed. Marcel Tetel, Ronald G. Witt, and Rona Goffen, 146–242. Durham, N.C., and London: University of North Carolina Press, 1989.

———. "Public Sculpture in Renaissance Florence." In *Looking at Italian Renaissance Sculpture*, ed. Sarah Blake McHam, 149–188. Cambridge: Cambridge University Press, 1998.

———. "Donatello's Bronze *David* and *Judith* as Metaphors of Medici Rule in Florence." *Art Bulletin* 83, no. 1 (2001): 32–47.

McKILLOP, Susan. "Dante and *Lumen Christi*: A Proposal for the Meaning of the Tomb of Cosimo de' Medici." In *Cosimo "il Vecchio" de' Medici, 1389–1464*, ed. Ames-Lewis, 245–301. Oxford: Clarendon Press, 1994.

———. "L'ampliamento dello stemma mediceo e il suo contesto politico." *ASI* 150, no. 3 (1992): 641–713.

McMANAMON, John. "Continuity and Change in the Ideals of Humanism: The Evidence from Florentine Funeral Oratory." In *Life and Death in Fifteenth-Century Florence*, ed. Marcel Tetel, Ronald G. Witt, and Rona Goffen, 68–87. Durham, N.C., and London: University of North Carolina Press, 1989. *Medaglie del Rinascimento*. Bologna: Museo Civico, 1960.

MEDICI, Lorenzo de.' *Simposio*. Ed. Mario Martelli. Florence: Olschki, 1966.

———. *Canzoniere*. Ed. Paolo Orvieto. Milano: Mondadori, 1984.

———. *Ambra (Descriptio hiemis)*. Ed. Rosella Bessi. Florence: Sansoni, 1986.

———. *Canti carnascialieschi*. Ed. Paolo Orvieto. Rome: Salerno, 1991.

———. *Comento de' miei sonetti*. Ed. Tiziano Zanato. Florence: Olschki, 1991.

———. *Opere*. Ed. Tiziano Zanato. Turin: Einaudi, 1992.

———. *The Autobiography of Lorenzo de' Medici The Magnificent: A Commentary on My Sonnets*. Trans. James Wyatt Cook. Binghamton, N.Y.: Medieval and Renaissance Texts and Studies, 1995.

MELLOR, Ronald. *Thea Rhome: The Worship of the Goddess Roma in the Greek World*. Göttingen: Vandenhoeck und Ruprecht, 975.

MERLINI, Elena. "La 'Bottega degli Embriachi' e i cofanetti eburnei fra Trecento e Quattrocento: Una proposta di classificazione." *Arte cristiana* 727 (1988): 267–282.

METZ, René. *La consécration des vierges dans l'église Romaine: Étude d'histoire de la liturgie*. Paris: Presses universitaires de France, 1954.

MIDDELDORF, Ulrich and Dagmar Striebral. *Renaissance Medals and Plaquettes*. Florence: S.P.E.S., 1983.

MIDDELDORF, Ulrich and Oswald Goetz. *Medals and Plaquettes from the Sigmund Morgenroth Collection*. Chicago: Art Institute of Chicago, 1944.

MIGLIORE, Leopoldo del. *Firenze città nobilissima illustrata*. Florence: Stella, 1684.

MITCHELL, W. J. T. *Picture Theory*. Chicago: University of Chicago Press, 1994.

MODE, Robert L. "Adolescent *Confratelli* and the Cantoria of Luca della Robbia." *AB* 68 (1986): 67–71.

MODERSOHN, Mechthild. "Lust auf Frieden: Brunetto Latini und die Fresken von Ambrogio Lorenzetti im Rathaus zu Siena." In *Bildnis und Image: Das Portrait zwischen Intention und Rezeption*, ed. Andreas Köstler and Ernst Seidl, 85–118. Cologne, Weimar, and Vienna: Böhlau, 1998.

MOLHO, Anthony. "Politics and the Ruling Class in Early Renaissance Florence." *Nuova rivista storica* 52 (1968): 401–420.

————. "The Florentine Oligarchy and the Balìe of the Late Trecento." *Speculum* 43 (1968): 23–25.

————. *Florentine Public Finances in the Early Renaissance, 1400–1433*. Cambridge, Mass.: Harvard University Press, 1971.

————. "The Brancacci Chapel: Studies in its Iconography and History." *JWCI* 40 (1977): 50–98.

————. "Cosimo de' Medici: *Pater Patriae* or *Padrino?*" *Stanford Italian Review* 1, no. 1 (Spring 1979): 5–33.

————. "Patronage and the State in Early Modern Italy." In *Klientelsysteme im Europa der Fruehen Neuzeit*, ed. Antoni Maczak, 233–242. Munich: R. Oldenbourg, 1988.

————. *Marriage Alliance in Late Medieval Florence*. Cambridge, Mass., and London: Harvard University Press, 1994.

MOORE, Jeanie Grant. "Medici Myth-Making: Poliziano's *Stanze cominciate per la giostra del magnifico Giuliano de' Medici*."

Renaissance Papers (1989): 1–20.

MORAW, Peter. *Von offener Verfassung zu gestalteter Verdichtung: Das Reich im späten Mittelalter, 1250–1490*. Berlin: Propyläen, 1985.

MORELLI, Guido, ed. *Deliberazione suntuaria del comune di Firenze del XIII aprile MCCCCXXXIX*. Florence: Arte della stampa, 1881.

MORGAN, Octavius. "Episcopal and Other Rings of Investiture." *Archaeologia* 36 (1855): 392–399.

MORI, Masahiko. "First Public Sculpture in the Early Renaissance Florence: Donatello's Lost *Dovizia*" (in Japanese). *Bijutsu shigaku* 6 (1984): 39–71.

MORISANI, Ottavio. *Studi su Donatello*. Venice: Neri Pozza, 1952.

MORMANDO, Franco. *The Preacher's Demons: Bernardino of Siena and the Social Underworld of Early Renaissance Italy*. Chicago: University of Chicago Press, 1999.

MOSELEY, Thomas A. *The "Lady" in Comparisons from the Poetry of the "Dolce Stil Nuovo."* Menasha, Wis.: George Banta, 1916.

MUIR, Edward. *Civic Ritual in Renaissance Venice*. Princeton: Princeton University Press, 1981.

MUNMAN, Robert. "Optical Corrections in the Sculpture of Donatello." *Transactions of the American Philosophical Society* 75, no. 2 (1985): 1–96.

MÜNTZ, Eugène. *Les collections des Médicis au XVe siècle*. Paris and London: Rouam-Librairie de l'art, 1888.

————. *Histoire de l'art pendant la Renaissance*. 3 vols. Paris: Hachette, 1889–95.

MURPHY, F. X. "Rings." In *New Catholic Encyclopedia*, 12: 504–506. New York: McGraw-Hill, 1967.

MUSACCHIO, Jacqueline Marie. *The Art and Ritual of Childbirth in Renaissance Italy*. New Haven and London: Yale University Press, 1999.

NAJEMY, John M. *Corporatism and Consensus in Florentine Electoral Politics, 1280–1400*. Chapel Hill: University of North Carolina Press, 1982.

————. "Linguaggi storiografici sulla Firenze rinascimentale." *Rivista storica italiana* 97 (1985): 102–159.

———. "The Republic's Two Bodies: Body Metaphors in Italian Renaissance Political Thought." In *Languages and Images of Renaissance Italy*, ed. Alison Brown, 237–262. Oxford: Clarendon Press, 1995.

———. "Baron's Machiavelli and Renaissance Republicanism." *American Historical Review* 101 (1996): 119–129.

NALDI, Naldo. *Elegiarum libri III ad Laurentium Medicen*. Ed. Ladislaus Juhàsz. Leipzig: Teubner, 1934.

———. *Epigrammaton liber*. Ed. Alessandro Perosa. Budapest: K. M. Egyetemi Nyomda, 1943.

———. *Naldi Naldii Florentini, Bucolica, Volaterrais, Hastiludium, Carmina varia*. Ed. W. Leonard Grant. Florence: Olschki, 1974.

NARKISS, Mordechai. "An Italian Niello Casket of the Fifteenth Century." *JWCI* 21 (1958): 288–295.

NATALI, Antonio. "Exemplum salutis publicae." In *Donatello e il restauro della Giuditta*, ed. Loretta Dolcini, 19–33. Florence: Centro Di, 1988.

NEAD, Lynda. *The Female Nude: Art, Obscenity, and Sexuality*. London and New York: Routledge, 1992.

NEUMANN, Carl. "Die Wahl des Platzes für Michelangelos David in Florenz im Jahr 1504: Zur Geschichte eines Maßstabproblems." *Repertorium für Kunstwissenschaft* 38 (1915): 1–27.

NEWBEGIN, Nerida. *Nuovo corpus di sacre rappresentazioni fiorentine del Quattrocento edite e inedite tratte da manoscritti coevi o ricontrollate su di essi*. Bologna: Commissione per i testi di lingua, 1983.

———. "The Word Made Flesh: The *Rappresentazioni* of Mysteries and Miracles in Fifteenth-Century Florence." In *Christianity and the Renaissance: Image and Religious Imagination in the Quattrocento*, ed. Timothy Verdon and John Henderson, 361–375. Syracuse, N.Y.: Syracuse University Press, 1990.

NICCOLI, O. "Compagnie di bambini nell'Italia del Rinascimento." *Rivista storica italiana* 19 (1990): 346–374.

NORMAN, Joanne S. *Metamorphoses of an Allegory: The Iconography of the Psychomachia in Medieval Art*. New York, Frankfurt am Main, and Paris: Lang, 1988.

NOSZLOPY, George T. "Botticelli's *Pallas and the Centaur:* An Aspect of the Revival of Late-Antique and Trecento Exegetic Allegory in the Medici Circle." *Acta historiae artium academiae scientiarum hungaricae* 37 (1994–95): 113–133.

OFFNER, Richard. *A Critical Historical Corpus of Florentine Painting*. Section 3. New York: College of Fine Arts, 1956.

OLSEN, Christina. "Gross Expenditure: Botticelli's Nastagio degli Onesti Panels." *AH* 15, no. 2 (1992): 146–170.

OLSZEWSKI, Edward J. "Prophecy and Prolepsis in Donatello's Marble *David*," *Artibus et historiae* 36 (1997): 63–80.

ONIANS, John. "Brunelleschi: Humanist or Nationalist?" *AH* 5, no. 3 (1982): 259–272.

ORIGO, Iris. *Il mercante di Prato*. Trans. Nina Ruffini. 2d ed. Milan: Rizzoli, 1980.

ORLANDI, Giulio Lensi. *Il Palazzo Vecchio di Firenze*. Florence: Martello-Giunti, 1977.

ORTALLI, Gherardo. "*. . . Pingatur in Palatio . . .*": *La pittura infamante nei secoli XIII–XVI*. Rome: Jouvence, 1979.

ORTNER, Alexandra. *Petrarcas "Trionfi" in Malerei, Dichtung und Festkultur: Untersuchung zur Entstehung und Verbreitung eines florentinischen Bildmotivs auf Cassoni und Deschi da parto des 15. Jahrhunderts*. Weimar: VDG, 1998.

ORVIETO, Paolo. *Lorenzo de' Medici*. Florence: La nuova Italia, 1976.

———. "In margine all'edizione e commento delle opere minori di Luigi Pulci." *Interpres* 6 (1985–86): 91–123.

OSANO, Shigetoshi. "Due 'Marsia' nel giardino di Via Larga: La ricezione del *decor* dell'antichità romana nella collezione medicea di sculture antiche." *Artibus et historiae* 34 (1996): 95–120.

PADGETT, John F. and Christopher K. Ansell. "Robust Action and the Rise of the Medici, 1400–1434." *American Journal of Sociology* 98, no. 6 (1993): 1259–1319.

PADGUG, Robert. "Sexual Matters: On Conceptualizing Sexuality in History."

Radical History Review 20 (1979): 3–33.

PAGLIA, Camille. *Sexual Personae.* New Haven: Yale University Press, 1990.

PALMIERI, Matteo. *Vita civile.* Ed. Gino Belloni. Florence: Sansoni, 1982.

PANOFSKY, Erwin. *Studies in Iconology: Humanistic Themes in the Art of the Renaissance.* New York: Harper and Row, 1939.

———. *Hercules am Scheidewege und andere antike Bildstoffe in der neurern Kunst.* 2d. ed. Ed. Dieter Wuttke. Berlin: Mann, 1997.

PANORMITA (Antonio Beccadelli). *Hermaphroditus.* Ed. Friedrich Forberg. Coburg: sumptibus Meuseliorum, 1824.

———. *Antonio Beccadelli and the Hermaphrodite.* Trans. Michael de Cossart. Liverpool: Janus Press, 1984.

———. *Hermaphroditus.* Ed. Donatella Coppini. Rome: Bulzoni, 1990.

PAOLETTI, John. "The Bargello *David* and Public Sculpture in Fifteenth-Century Florence." In *Collaboration in Italian Renaissance Art.* Ed. John Paoletti and Wendy Stedman Sheard, 99–108. New Haven and London: Yale University Press, 1978.

———. "' . . . Ha fatto Piero con voluntà del padre . . . ': Piero de' Medici and Corporate Commissions of Art." In *Piero de' Medici "il Gottoso" (1416–1469): Kunst im Dieste der Mediceer/Art in the Service of the Medici,* ed. Andreas Beyer and Bruce Boucher, 221–250. Berlin: Akademie Verlag, 1993.

———. "Fraternal Piety and Family Power: The Artistic Patronage of Cosimo and Lorenzo de' Medici." In *Cosimo "il Vecchio" de' Medici, 1389–1464,* ed. Francis Ames-Lewis, 195–219. Oxford: Clarendon Press, 1994.

———. "Familiar Objects: Sculptural Types in the Collections of the Early Medici." In *Looking at Italian Renaissance Sculpture.* Ed. Sarah Blake McHam, 79–110. Cambridge: Cambridge University Press, 1998.

PARENTI, Marco. *Delle nozze di Lorenzo de' Medici con Clarice Orsini nel 1469:*

Informazione da Piero Parenti fiorentino. Florence: F. Bencini, 1870.

PARKS, N. Randolph. "The Placement of Michelangelo's *David:* A Review of the Documents." *AB* 57 (1975): 562–563.

PARRONCHI, Alessandro. "Il significato politico-religioso della *Giuditta.*" In *Donatello e il potere,* 237–243. Bologna: Il Portolano, 1980.

———. "Mecurio e non David." In *Donatello e il potere,* 101–126. Bologna: Cappelli; Florence: Il Portolano, 1980; reprinted in Alessandro Parronchi, *Donatello: Saggi e studi 1962–1997,* 78–89. Vicenza: Neri Pozza, 1998.

PARTRIDGE, Loren and Randolph Starn. *Arts of Power: Three Halls of State in Italy, 1300–1600.* Berkeley, Los Angeles, Oxford: University of California Press, 1992.

PASSAVANT, Günther. "Beobachtungen am Lavabo von San Lorenzo in Florenz." *Pantheon* 39 (1981): 33–50.

PASTOUREAU, Michel. "Aux origines de l'emblème: La crise de l'héraldique européenne aux XIVe–XVe siècles." In *Emblèmes et devises au temps de la Renaissance,* ed. M. T. Jones-Davies, 129–136. Paris: J. Touzot, 1981.

PAVANELLO, Giuseppe. *Un maestro del Quattrocento (Giovanni Aurelio Augurelli).* Venice: Tipografia Emiliana, 1905.

PAXSON, James J. *The Poetics of Personification.* Cambridge: Cambridge University Press, 1994.

PERRENS, François. *Histoire de Florence depuis la domination des Médicis jusqu'à la chute de la république (1434–1531).* 3 vols. Paris: Maison Quantin, 1888.

PERRY, Marilyn. "'Candor Illaesvs': The 'Impresa' of Clement VII and Other Medici Devices in the Vatican Stanze." *BM* 119, no. 895 (1977): 676–685.

PETRALIA, Giovanni. "'Stato' e 'moderno' in Italia e nel Rinascimento." In *Storica* 3 (1997): 7–48.

PETRARCA, Francesco. *Triumphi.* Ed. Marco Ariani. Milan: Mursia, 1988.

PHILPOT, Elizabeth. "Judith and Holofernes: Changing Images in the History of Art." In *Translating Religious Texts: Translation, Transgression, and Interpretation,* ed. David Jasper, 80–97. New York: St. Martin's Press, 1993.

PICCOLOMINI, Aeneas Silvius (Pius II). *Comentarii*. Trans. Florence A. Gragg as *Memoirs of a Renaissance Pope: The Commentaries of Pius II*. New York: G. P. Putnam's Sons, 1959.

PIPER, Ernst. *Der Aufstand der Ciompi: Über den "Tumult" den die Wollarbeiter im Florenz der Frührenaissance anzettelten*. Berlin: Wagenbach, 1990.

PLATINA (Bartolomeo Sacchi). "De optimo cive." In Matteo Palmieri and Bartolomeo Sacchi, *Della vita civile e De optimo cive*, ed. Felice Battaglia. Bologna: Nicola Zanichelli, 1944.

PLINY. *Natural History*. Trans. H. Rackham. 10 vols. Cambridge, Mass.: Harvard University Press; London: Heinemann, 1952.

POCOCK, J. G. A. *The Machiavellian Moment: Florentine Political Thought and the Atlantic Republican Tradition*. Princeton: Princeton University Press, 1975.

POGGI, Giovanni. "La giostra medicea del 1475 e la *Pallade* del Botticelli." *L'arte* 5 (1902): 71–77.

———. "A proposito della 'Pallade' del Botticelli." *L'arte* 5 (1902): 407–408.

———. *Il duomo di Firenze*. Ed. Margaret Haines. 2 vols. Florence: Medicea, 1988.

POIRIER, Guy. "Sodomicques et bourgerons: Imagologie homosexuelle a la Renaissance." Ph.D. diss., McGill University, 1992.

———. *L'homosexualité dans l'imaginaire de la Renaissance*. Paris: Champion, 1996.

POLIZIANO, Angelo [Ambrogini]. *Opere volgari*. Ed. Tommaso Casini. Florence: Sansoni, 1885.

———. *Stanze cominciate per la giostra di Giuliano de' Medici*. Ed. Vincenzo Pernicone. Turin: Loescher, 1954.

———. *The Stanze of Angelo Poliziano*. Trans. David Quint. University Park: Pennsylvania State University Press, 1979.

———. *I detti piacevoli*. Ed. Mariano Fresta. Siena: Editori del Grifo, 1985.

———. *Rime*. Ed. Daniela Delcorno Branca. Venice: Marsilio Editori, 1990.

POLIZOTTO, Lorenzo. "When Saints Fall Out: Women and the Savonarolan Reform in the Early Sixteenth Century." *RQ* 46, no. 3 (1993): 486–525.

POLLARD, Graham. *Medaglie italiane del Rinascimento*. Florence: Museo Nazionale del Bargello, 1983.

POLLINI, John. "The Gemma Augustea: Ideology, Rhetorical Imagery, and the Creation of a Dynastic Narrative." In *Narrative and Event in Ancient Art*, ed. Peter J. Holliday, 258–298. Cambridge: Cambridge University Press, 1995.

POLLOCK, Griselda. *Vision and Difference: Femininity, Feminism and the Histories of Art*. London and New York: Routledge, 1988.

———. "The Politics of Theory: Generations and Geographies: Feminist Theory and the Histories of Art Histories." *Genders* 17 (1993): 97–120.

———. *Differencing the Canon: Feminist Desire and the Writing of Art's Histories*. London: Routledge, 1999.

POLLOCK, Griselda and Roszika Parker. *Old Mistresses: Women, Art and Ideology*. New York: Pantheon Books, 1982.

POMMERANZ, Johannes. *Pastigliakaestchen: Ein Beitrag zur Kunst- und Kulturgeschichte der italienischen Renaissance*. Münster: Waxmann, 1999.

PONTANO, Giovanni. *I trattati delle virtù sociali: De liberalitate, De beneficentia, De magnificentia, De splendore, De conventia*. Trans. and ed. Francesco Tateo. Rome: Edizioni dell'Ateneo, 1965.

POPE-HENNESSY, John. *The Portrait in the Renaissance*. Princeton: Princeton University Press, 1966.

———. "Donatello's Bronze *David*." In *Scritti di storia dell'arte in onore di Federico Zeri*, 122–127. Milan: Electa, 1984.

———. *Italian Renaissance Sculpture*. Part 2 of *An Introduction to Italian Sculpture*. New York: Vintage, 1985.

———. *Donatello Sculptor*. New York: Abbeville, 1993.

PREYER, Brenda. "The Emblems." In *Giovanni Rucellai ed il suo zibaldone*. Vol. 2, *A Florentine Patrician and His Palace*, Appendix C, 198–207. London: Warburg Institute, 1960–81.

———. "L'archittetura del palazzo mediceo." In *Il Palazzo Medici Riccardi di Firenze*, ed. Giovanni Cherubini and Giovanni Fanelli, 58–75. Florence: Giunti, 1990.

———. "Planning for Visitors at Florentine Palaces." *Renaissance Studies* 12, no. 3 (1998): 357–374.

PROCACCI, Ugo. "Sulla cronologia delle opere di Masaccio e di Masolino." *Rivista d'arte* 28 (1953): 17–24.

PRODI, Paolo. *Il sovrano pontefice: Un corpo e due anime, la monarchia papale nella prima età moderna.* Bologna: Il Mulino, 1982.

PROTO, Enrico. "Il Petrarca ed Ausonio." *Rassegna critica della letteratura italiana* 10, no. 9 (1905): 218–227.

PRUDENTIUS. [Works]. Trans. H. J. Thomson. 2 vols. Cambridge, Mass.: Harvard University Press; London: Heinemann, 1949–53.

PUCCI, Antonio. "Le proprietà di Mercato Vecchio." In *Delizie degli eruditi toscani*, ed. Idelfonso di San Luigi. Vol. 4 (1775). Florence: Gaetano Cambiagi, 1770–89.

PULCI, Luigi. *Opere minori.* Ed. Paolo Orvieto. Milan: Mursia, 1986.

RABIL, Albert. "The Significance of 'Civic Humanism' in the Interpretation of the Italian Renaissance." In *Renaissance Humanism: Foundations, Forms, and Legacy*, ed. Albert Rabil, 141–174. Philadelphia: University of Pennsylvania Press, 1988.

Raccolta di rime antiche toscane. 4 vols. Palermo: G. Assenzio, 1817.

RAGGHIANTI, Carlo L. and Gigetta dalli Regoli. *Firenze 1470–1480 disegni dal modello: Pollaiolo, Leonardo, Botticelli, Filippino.* Exh. cat. Pisa: Istituto di storia dell'arte dell'Università di Pisa, 1975.

RAINEY, Ronald E. "Dressing Down the Dressed: Reproving Feminine Attire in Renaissance Florence." In *Renaissance Society and Culture: Essays in Honor of Eugene F. Rice, Jr.*, ed. John Monfasani and Ronald G. Musto, 217–237. New York: Ithaca Press, 1991.

RAMPLEY, Matthew. "From Symbol to Allegory: Aby Warburg's Theory of Art." *AB* 79, no. 1 (1997): 41–55.

RANDALL, Richard H. "A Group of Gothic Ivory Boxes." *BM* 128 (1985): 577–581.

RANDOLPH, Adrian. "Art for Heart's Sake: Configurations of Masculinity in Fifteenth-Century Florence." In *Mittelalter: Facetten der Genderforschung*, ed. Susan Marti and Daniela Mondini. Special issue of *Frauen Kunst Wissenschaft* 24 (1997): 67–72.

———. "Regarding Women in Sacred Space." In *Picturing Women in Renaissance and Baroque Italy*, ed. Geraldine Johnson and Sara Matthews Grieco, 17–41, 250–256. Cambridge: Cambridge University Press, 1998.

———. "Performing the Bridal Body in Fifteenth-Century Florence." *AH* 21, no. 2 (1998): 182–200.

———. "*Il Marzocco*: Lionizing the Florentine State." In *Coming About: A Festschrift for John Shearman*, ed. Lars Jones and Louisa C. Matthew, 11–18. Cambridge, Mass.: Harvard University Art Museums, 2002.

———. "Renaissance Household Goddesses: Fertility, Politics, and the Gendering of Spectatorship." In *The Material Culture of Sex, Procreation, and Marriage in Pre-Modern Europe*, ed. Karen R. Encarnacion and Anne L. McClanan, 163–190. New York: St. Martin's Press, 2002.

———. "*Cupido cruciatur* and the Medici." In *Le mariage à la Renaissance: Représentations et célébrations*, ed. Claudie Balavoine. Actes du colloque du centre d'études supérieures de la Renaissance, Tours, June 1995. Tours: C.E.S.R., forthcoming.

RÉAU, Louis. *Iconographie de l'art chrétien.* 3 vols. Paris: Presses universitaires de France, 1955–59.

REID, Jane Davidson. "The True Judith." *Art Journal* 28 (1968–69): 376–387.

REMINGTON MCCARTHY, James. *Rings Through the Ages.* New York: Harper, 1945.

REUMONT, Alfred von. *Lorenzo de' Medici, the Magnificent.* Trans. Robert Harrison. 2 vols. London: Smith, Elder, and Co., 1876.

RICCIARDI, Lucia. *Col senno, col tesoro e col lancia: Riti e giochi cavallereschi nella Firenze del Magnifico Lorenzo.* Florence: Le Lettere, 1992.

RICH, Adrienne. "Compulsory Heterosexuality

and Lesbian Experience." *The Lesbian and Gay Studies Reader*, ed. Henry Abelove, Michèle Aina Barale, and David M. Halperin, 227–254. New York and London: Routledge, 1993.

RICHLIN, Amy. *The Garden of Priapus: Sexuality and Aggression in Roman Humor*. Revised ed. New York: Oxford University Press, 1992.

RIDEVALLUS, Joannes. *Fulgentius metaforalis*. Ed. Hans Liebeschütz. Leipzig: Teubner, 1926.

RIDOLFI. Enrico. "La *Pallade* di Sandro Botticelli." *Archivio storico dell'arte* 2, no. 1 (1895): 1–5.

ROBBIA, Luca di Simone della. "Vita di Bartolomeo di Niccolò di Taldo Valori." *ASI* 4 (1843): 239–240.

ROCHON, André. *La jeunesse de Laurent de Médicis (1449–1478)*. Paris: Les belles lettres, 1963.

ROCKE, Michael. "Sodomites in Fifteenth-Century Tuscany: The Views of Bernardino of Siena." *Journal of Homosexuality* 16 (1988): 7–31.

———. *Forbidden Friendships: Homosexuality and Male Culture in Renaissance Florence*. New York and Oxford: Oxford University Press, 1996.

RODOLICO, Niccolò. *I Ciompi: Una pagina di storia del proletariato operaio*. Florence: Sansoni, 1945.

ROGERS, Mary. "Sonnets on Female Portraits from Renaissance North Italy." *Word and Image* 2, no. 4 (1986): 296–297.

ROHLMAN, Michael. "Botticellis *Primavera*: Zu Anlaß, Addressat und Funktion von mythologischen Gemälden im Florentiner Quattrocento." *Artibus et historiae* 17 (1996): 96–132.

ROOVER, Raymond de. *The Rise and Decline of the Medici Bank, 1397–1494*. Cambridge, Mass.: Harvard University Press, 1963.

ROSAND, David. "*Venetia Figurata:* The Iconography of a Myth." In *Interpretazioni veneziane: Studi di storia dell'arte in onore di Michelangelo Murano*, ed. David Rosand, 177–196. Venice: Arsenale Editrice, 1984.

ROSCOE, William. *La vita di Lorenzo de' Medici*. Pisa: Antonio Peverata, 1816.

———. *The Life of Lorenzo de' Medici*. London: Scott, Webster, and Geary, 1836.

ROSENAUER, Artur. *Studien zum frühen Donatello: Skulptur im projektiven Raum der Neuzeit*. Vienna: Adolf Holzhausens, 1975.

———. *Donatello*. Milan: Electa, 1993.

ROSENBERG, Charles. *The Este Monuments and Urban Development in Renaissance Ferrara*. Cambridge: Cambridge University Press, 1997.

ROSS, Janet. *Lives of the Early Medici as Told in Their Correspondence*. London: Chatto and Windus, 1910.

ROSSI, Luciano. "Il cuore, mistico pasto d'amore: Dal 'Lai Guirun' al Decameron." *Studi provenzali e francesi* 82 (1983): 28–128.

ROTH, Nicholas. "Deal Gently with the Young Man: Love of Boys in Medieval Hebrew Poetry of Spain." *Speculum* 57 (1982): 21–50.

RUBIN, Gayle. "The Traffic in Women: Notes on the 'Political Economy' of Sex." In *Toward an Anthropology of Women*, ed. Rayna Reiter, 157–210. New York: Monthly Review Press, 1975.

RUBIN, Patricia. "Magnificence and the Medici." In *The Early Medici and Their Artists*, ed. Francis Ames-Lewis, 37–50. London: Department of the History of Art, Birkbeck College, University of London, 1995.

RUBIN, Patricia and Alison Wright. *Renaissance Florence: The Art of the 1470s*. London: National Gallery Publications and Yale University Press, 1999.

RUBINSTEIN, Nicolai. "The Beginnings of Political Thought in Florence: A Study in Medieval Historiography." *JWCI* 5 (1942): 198–227.

———. "Political Ideas in Sienese Art: The Frescoes by Ambrogio Lorenzetti and Taddeo di Bartolo in the Palazzo Pubblico." *JWCI* 21 (1958): 179–207.

———. *The Government of Florence Under the Medici (1434–92)*. Oxford: Clarendon Press, 1966.

———. "Florentine Constitutionalism and Medici Ascendancy in the Fifteenth Century." In *Florentine Studies: Politics and Society in Renaissance Florence*, ed. Nicolai Rubinstein,

442–462. Evanston, Ill.: Northwestern University Press, 1968.

———. "Notes on the Word *stato* in Florence Before Machiavelli." In *Florilegium Historiale: Essays Presented to Wallace K. Ferguson,* ed. J. G. Rowe and W. H. Stockdale, 314–326. Toronto: University of Toronto Press, 1971.

———. "Palazzi pubblici e palazzi privati al tempo di Brunelleschi." In *Filippo Brunelleschi, la sua opera e il suo tempo,* ed. Franco Borsi et al., 1: 27–36. 2 vols. Florence: Centro Di, 1980.

———. "*Stato* and Regime in Fifteenth-Century Florence." In *Per Federico Chabod (1901–1960): I, Lo stato e il potere nel Rinascimento,* ed. Sergio Bertelli, 1: 137–146. 2 vols. Perugia: Università di Perugia, 1980–81.

———. "Florentina Libertas." *Rinascimento* 26 (1986): 3–26.

———. *The Palazzo Vecchio 1298–1532: Government, Architecture, and Imagery in the Civic Palace of the Florentine Republic.* Oxford: Clarendon Press, 1995.

———. *The Government of Florence Under the Medici (1434–1494).* 2d ed. Oxford: Clarendon Press, 1997.

———. "Youth and Spring in Botticelli's *Primavera.*" *JWCI* 60 (1997): 248–251.

———, ed. *Florentine Studies: Politics and Society in Renaissance Florence.* Evanston, Ill.: Northwestern University Press, 1968.

RUCELLAI, Giovanni. *Giovanni Rucellai ed il suo zibaldone.* Vol. 1, *Zibaldone Quaresimale.* Ed. Alessandro Perosa. London: Warburg Institute, 1960–81.

RUDA, Jeffrey. *Fra Filippo Lippi: Life and Work.* London: Phaidon, 1993.

RUDT DE COLLENBERG, W. H. "Il leone di San Marco: Aspetti storici e formali dell'emblema statale della Serenissima." *Ateneo veneto* (1989): 57–84.

RUGGIERI, Ruggero. "Letterati, poeti e pittori intorno alla giostra di Giuliano de' Medici." *Rinascimento* 10, no. 2 (1959): 165–196.

———. "Spiriti e forme epico-cavalleresche nella 'Giostra' del Poliziano." *Lettere italiane* 9, no. 1 (1959): 1–24.

RUGGIERO, Guido. *The Boundaries of Eros: Sex Crime and Sexuality in Renaissance Venice.* Oxford and New York: Oxford University Press, 1985.

RUSCONI, Arturo Jahn. "The Medici Museum at Florence." *The Connoisseur* 84, no. 339 (1929): 277–281.

SAENGER, Ernst. "Das Lobgedicht auf König Robert von Anjou: Ein Beitrag zur Kunst- und Geistesgeschichte des Trecento." *Jahrbuch der kunsthistorischen Sammlungen in Wien* 84 (1988): 7–92.

SALIMBENE DE ADAM. *Cronica.* Ed. Giuseppe Scalia. 2 vols. Bari: Laterza, 1966.

SALOMON, Nannette. "Contrapposto." Paper presented at the Congrès internationale d'histoire d'art/International Congress of the History of Art, London, September 2000.

SALVINI, Roberto. *Tutta la pittura del Botticelli.* Milan: Rizzoli, 1958.

SAN JUAN, Rose Marie. "Mythology, Women, and Renaissance Private Life: The Myth of Eurydice in Italian Furniture Painting." *AH* 15, no. 2 (1992): 127–145.

SCALINI, Mario. "The Weapons of Lorenzo de' Medici." *Arts, Arms and Armour* 1 (1979): 13–29.

———. "L'armatura fiorentina del Quattrocento e la produzione d'armi in Toscana." In *Guerra e guerrieri nella toscana del Rinascimento,* ed. Franco Cardini and Marco Tangheroni, 83–126. Florence: Edifir, 1990.

———. "Il 'ludus' equestre nell'età Laurenziana." In *Le tems revient/'I tempo si rinuova: Feste e spettacoli nella Firenze di Lorenzo il Magnifico,* ed. Paola Ventrone, 75–102. Cinisello Balsamo: Silvana, 1992.

SCARAMELLA, Gino. *Firenze allo scoppio del tumulto dei ciompi.* Pisa: Mariotti, 1914.

SCARISBRICK, Diana. "A Signet Ring of Pope Paul II." *BM* 127 (1985): 293–294.

SCHADE, Sigrid, Monika Wagner, and Sigrid Weigel, ed. *Allegorien und Geschlechterdifferenz.* Cologne: Böhlau, 1994.

SCHER, Stephen, ed. *The Currency of Fame: Portrait Medals of the Renaissance.* New York: Abrams and the Frick Collection, 1994.

SCHIZZEROTTO, Giancarlo. *La commedia nuova di*

Piero Francesco da Faenza. Ravenna: Edizioni della Rotonda, 1969.

SCHLOSSER, Julius von. "Embriachi." *Jahrbuch der Königlichen Sammlungen* 20 (1899): 220–282.

SCHNEIDER, Laurie. "Donatello's Bronze *David.*" *AB* 55 (1973): 213–216.

———. "Donatello and Caravaggio: The Iconography of Decapitation." *American Imago* 30 (1976): 76–91.

———. "Some Neoplatonic Elements in Donatello's *Gattamelata* and *Judith and Holofernes.*" *GBA*, 6th ser., 87 (1976): 41–48.

———. "Response." *GBA* 93 (1979): 18–19.

———. "More on Donatello's Bronze *David.*" *GBA* 94 (1979): 48.

SCHOTTMÜLLER, Frida. *Donatello.* Munich: F. Bruckman, 1904.

SCHRADER, Laurentio. *Monumentorum Italiae: Quae hoc nostro saeculo et a Christianis posita sunt, libri quattuor.* Helmstadt: Iacobi Lucii Transyluani, 1592.

SCHRAMM, Percy Ernst. "Die Krönung in Deutschland." *Zeitschrift der Savigny-Stiftung für Rechtsgeschichte,* Kan. Abt. 24 (1935): 202ff.

———. *History of the English Coronation.* Trans. Leopold G. Wickham Legg. Oxford: Clarendon Press, 1937.

———. *Der König von Frankreich.* 2d ed. 2 vols. Weimar: Böhlaus, 1939.

SCHUBRING, Paul. *Cassoni: Truhen und Truhenbilder der italienischen Frührenaissance: Ein Beitrag zur Profanmalerei im Quattrocento.* 2 vols. Leipzig: Karl W. Hiermann, 1923.

SCHUPPE, Ernst. "Pétasos." In *Paulys Real-encyclopadie der classischen Altertumswissenschaft,* ed. Georg Wissowa, 19: 1119–1124. 44 vols. Stuttgart: J. B. Metzler, 1894–1972.

SCHUYLER, Jane. "Florentine Busts: Sculpted Portraiture in the Fifteenth Century," Ph.D. diss., Columbia University, 1972.

SCIOLLA, Gianni Carlo. *La scultura di Mino da Fiesole.* Turin: Giappichelli, 1970.

SCOLARI, Antonio. "Le vicende di una statua e la resistenza pagana a Verona sul finire del sec. IV." *Atti dell'istituto veneto di scienze, lettere ed arti* 114 (1955/56): 199ff.

SEDGWICK, Eve Kosofsky. *Between Men: English Literature and Male Homosocial Desire.* New York: Columbia University Press, 1985.

SEIGEL, Jerrold E. "'Civic Humanism' or Ciceronian Rhetoric? The Culture of Petrarch and Bruni." *Past and Present* 33 (1966): 3–48.

SEMPER, Hans. *Donatello: Seine Zeit und Schule.* Vienna: W. Braumüller, 1875.

SETTESOLDI, Enzo. *Donatello e l'Opera del Duomo di Firenze.* Florence: Scala, 1986.

SETTIS, Salvatore. "Citarea 'su una impresa di bronconi.'" *JWCI* 34 (1971): 135–177.

———. "Artisti e committenti fra Quattro- e Cinquecento." In *Storia d'Italia. Annali, 4: Intellettuali e potere,* 701–761. Turin: Einaudi, 1981.

SEYMOUR, Charles. *Early Italian Paintings in the Yale University Art Gallery.* New Haven and London: Yale University Press, 1970.

———. *Sculpture in Italy 1400–1500.* Harmondsworth: Pelican, 1970.

SEZNEC, Jean. *The Survival of the Pagan Gods: The Mythological Tradition and Its Place in Renaissance Humanism and Art.* Trans. Barbara Sessions. New York: Pantheon, 1953.

SHAPIRO, Marianne. "Poetry and Politics in the *Comento* of Lorenzo de' Medici," *RQ* 26 (1973): 444–453.

SHEARMAN, John. *Raphael's Cartoons in the Collection of Her Majesty the Queen and the Tapestries for the Sistine Chapel.* London: Phaidon, 1972.

———. "The Collections of the Younger Branch of the Medici." *BM* 117 (1975): 12–27.

———. *Only Connect . . . Art and the Spectator in the Italian Renaisance.* Princeton: Princeton University Press, 1992.

SHELTON, Kathleen. "Imperial Tyches." *Gesta* 18, no. 1 (1979): 28–29.

SIMMEL, Georg. *Philosophie des Geldes.* Leipzig: Duncker und Humbolt, 1900.

SIMONS, Patricia. "Women in Frames: The Gaze, the Eye, the Profile in Renaissance Portraiture." *History Workshop: A Journal of Socialist and Feminist Historians* 25 (1988):

4–30; reprinted in *The Expanding Discourse: Feminism and Art History*, ed. Norma Broude and Mary Garrard, 39–57. New York: Harper and Row, 1992.

———. "Renaissance Palaces, Sex, and Gender: The 'Public' and 'Private' Spaces of an Urban Oligarchy." Paper delivered at the Courtauld Institute, 1989.

———. "Lesbian (In)Visibility in Italian Renaissance Culture: Diana and Other Cases of *Donna con Donna*." *Journal of Homosexuality* 27, nos. 1–2 (1994): 81–122.

———. "Homosociality and Erotics in Italian Renaissance Portraiture." In *Portraiture: Facing the Subject*, ed. Joanna Woodall, 29–51. Manchester and New York: Manchester University Press, 1997.

———. "Hercules and Antaeus: Gendered Oppositions, Homoerotic Encounters, and Unstable Masculinity in Italian Renaissance Art." Paper delivered at the College Art Association Annual Conference, Toronto, 1998.

SINGLETON, Charles S. *Canti carnascialeschi del Rinascimento*. Bari: Laterza, 1936.

SIRÉN, Osvald. *A Descriptive Catalogue of the Pictures in the Jarves Collection Belonging to Yale University*. New Haven: Yale University Press; London, Humphrey Milford; Oxford, Oxford University Press, 1916.

———. "Donatello and the Antique." *American Journal of Archaeology* 18 (1914): 303ff.

SKARD, Eiliv. "Pater Patriae." *Festskrift til Halvdan Koht*, 42–70. Oslo: Aschehoug, 1933.

SKINNER, Quentin. "Ambrogio Lorenzetti: The Artist as a Political Philosopher." *Proceedings of the British Academy* 72 (1987): 1–56.

SMITH, Alan K. "Fraudomy: Reading Sexuality and Politics in Burchiello." In *Queering the Renaissance*, ed. Jonathan Goldberg, 93–94. Durham: University of North Carolina Press, 1994.

SMITH, Susan L. "A Nude Judith from Padua and the Reception of Donatello's Bronze *David*." *Comitatus* 25 (1994): 59–80.

———. *The Power of Women: A Topos in Medieval Art and Literature*. Philadelphia: University of Pennsylvania Press, 1995.

SMITH, Webster. "On the Original Location of the *Primavera*." *AB* 57 (1975): 31–39.

SNOW, Edward. "Theorizing the Male Gaze: Some Problems." *Representations* 25 (1989): 30–41.

SOLOMON-GODEAU, Abigail. *Male Trouble*. London: Thames and Hudson, 1997.

SONNAY, Philippe. "La politique artistique de Cola di Rienzo (1313–1354)." *Revue de l'art* 55 (1982): 35–43.

SPALLANZANI, Marco and Giovanna Gaeta Bertelà, ed. *Libro d'inventario dei beni di Lorenzo il Magnifico*. Florence: Associazione "Amici del Bargello," 1992.

SPERLING, Christine. "Donatello's Bronze *David* and the Demands of Medici Politics." *BM* 134 (1992): 218–224.

SPIEGEL, Gabrielle. "History, Historicism, and the Social Logic of the Text in the Middle Ages." *Speculum* 65 (1990): 59–86.

SPINA BARELLI, Emma. "Note iconografiche in margine al *Davide* in bronzo di Donatello." *Italian Studies* 29 (1974): 28–44.

———. "Donatello's *Judith and Holofernes:* An Extreme Moral Instance." *GBA*, 6th ser., 91 (1978): 147–148.

STAPLEFORD, Richard. "Botticelli's Portrait of a Young Man Holding a Trecento Medallion." *BM* 129 (1987): 428–436.

STARN, Randolph. "The Republican Regime of the 'Room of Peace' in Siena." *Representations* 18 (1987): 1–32.

Statuta Popoli et communis Florentiae publica auctoritate collecta castigata et praeposita anno salutis MCCCCXV. 3 vols. Freiburg im Breisgau: Michael Kluch, 1778–1783.

STELLA, Alessandro. *La révolte des Ciompi: Les hommes, les lieux, le travail*. Paris: Éditions de l'école des hautes études en sciences sociales, 1993.

STERNWEILER, Andreas. *Die Lust der Götter: Homosexualität in der italienischen Kunst von Donatello zu Caravaggio*. Berlin: Rosa Winkel, 1993.

STEVENSON, Seth William, C. Roach Smith, and Frederic W. Madden, ed. *Dictionary of Roman Coins, Republican and Imperial.* London: B. A. Seaby, 1964.

STOCKER, Margarita. *Judith, Sexual Warrior: Women and Power in Western Culture.* New Haven and London: Yale University Press, 1998.

STRUVE, Tilman. *Die Entwicklung der orga- nologischen Staatsauffassung im Mittelalter.* Stuttgart: Hiersemann, 1978.

SUPINO, I. B. *Il medagliere mediceo del R. Museo Nazionale di Firenze.* Florence: Alinari, 1899.

SWARZENSKI, Georg. "A Small Marriage Casket and Its Moral." *Bulletin of the Museum of Fine Arts, Boston* 45 (1947): 55–62.

TENENTI, Alberto. *Florence à l'époque des Médicis, de la cité à l'état.* Paris: Flammarion, 1968.

TERVARENT, Guy de. *Attributs et symboles dans l'art profane, 1450–1600: Dictionnaire d'un langage perdu.* Geneva: Droz, 1958–64.

Terze rime in lode di Cosimo de' Medici e de figli e dell'honoranza fatta l'anno 1458 al figlo del Duca di Milano ed al Papa nella loro venuta a Firenze, Biblioteca Nazionale Centrale di Firenze, Magliabechiano VII 1121.

TESKEY, Gordon. *Allegory and Violence.* Ithaca and London: Cornell University Press, 1996.

The Greek Anthology: The Garland of Philip and Some Contemporary Epigrams. Ed. A. S. F. Gow and D. L. Page. 2 vols. Cambridge: Cambridge University Press, 1968.

The Secular Spirit: Life and Art at the End of the Middle Ages. Exh. cat. New York: Metropolitan Museum of Art, 1975.

THOMAS, T. M. "Classical Reliefs and Statues in Later Quattrocento Religious Paintings." Ph.D. diss., University of California, Berkeley, 1980.

THORNTON, Peter. *The Italian Renaissance Interior.* London: Weidenfeld and Nicolson, 1991.

TOESCA, Pietro. "Una scatola dipinta da Domenico di Bartolo." *Rassegna d'arte senesi* 13 (1920): 107–108.

TOLNAY, Charles de. "Two Frescoes by Domenico and David Ghirlandajo in Santa Trinita in Florence." *Wallraf-Richartz Jahrbuch* 23 (1961): 237–250.

TÖNNESMAN, Andreas. "Zwischen Bürgerhaus und Residenz: Zur sozialen Typik des Palazzo Medici." In *Piero de' Medici "il Gottoso" (1416–1469): Kunst im Dieste der Mediceer/Art in the Service of the Medici,* ed. Andreas Beyer and Bruce Boucher, 71–88. Berlin: Akademie Verlag, 1993.

TORNABUONI, Lucrezia. *I poemetti sacri di Lucrezia Tornabuoni.* Ed. Fulvio Pezzarossa. Florence: Olschki, 1978.

TOSCAN, Jean. *Le carnaval du langage: Le lexique érotique des poètes de l'équivoque de Burchiello à Mariano (XVe-XVIIe siècles).* 4 vols. Lille: Presses universitaires de Lille, 1981.

TOYNBEE, Jocelyn. *The Hadrianic School.* Cambridge: Cambridge University Press, 1934.

TRACHTENBERG, Marvin. "Brunelleschi, 'Giotto' and Rome." *Renaissance Studies in Honor of Craig Hugh Smyth,* 2: 675–697. 2 vols. Florence: Giunti-Barbèra, 1985.

TRAPESNIKOFF, Trifon. *Die Porträtdarstellungen der Mediceer des XV Jahrhunderts.* Strasbourg: Heitz, 1909.

TREXLER, Richard C. *Public Life in Renaissance Florence.* New York: Academic Press, 1980.

———. "Florentine Prostitution in the Fifteenth Century: Patrons and Clients." In *Power and Dependence in Renaissance Florence.* Vol. 2, *The Women of Florence,* 39–41. Binghamton, N.Y.: Medieval and Renaissance Texts and Studies, 1993.

———. *Power and Dependence in Renaissance Florence.* 3 vols. Binghamton, N.Y.: Medieval and Renaissance Texts and Studies, 1993.

———, ed. *The "Libro ceremoniale" of the Florentine Republic by Francesco Filarete and Angelo Manfredi.* Geneva: Droz, 1978.

TRUFFI, Riccardo. "Ancora sulla *Stanze per la giostra di Lorenzo de' Medici.*" *Giornale storico della letteratura italiana* 24 (1894): 187–201.

———. *Giostre e cantori di giostre: Studi e ricerche di storia e di letteratura.* Rocca San Casciano: Licinio Cappelli, [1911].

TSCHERMAK VON SEYSENEGG, W. "Die *Judith* von Giovanni della Robbia." *Keramos* 114 (1986): 27–36.

———. "Nochmals die *Judith* von Giovanni della Robbia, eine weitere Replik in Dresden." *Keramos* 123 (1989): 67–70.

TSCHUDI, Hugo von. "Donatello e la critica moderna." *Rivista storica italiana* 4 (1887): 1–36.

TWINING, Lord. *European Regalia*. London: Batsford, 1979.

UBERTI, Fazio degli. *Il Dittamondo e le rime*. Ed. Giuseppe Corsi. 2 vols. Bari: Laterza, 1952.

UGGERI, Giovanni. "Il reimpiego di marmi antichi nelle cattedrali padane." In *Nicholaus e l'arte del suo tempo: In memoria di Cesare Gnudi*, ed. Angiola Maria Rondanini. 2 vols. Ferrara: Corbo, 1989.

ULMANN, Hermann. "Eine verschollene *Pallas Athena* des Sandro Botticelli." *Bonner Studien: Aufsätze aus der Altertumswissenschaft, Reinhard Kekulé zur Erinnerung an seine Lehrtätigkeit in Bonn gewidmet von seinen Schülern*, 203–213. Berlin: W. Spemann, 1890.

URBAN, Lina Padoan. "La festa della Sensa nelle arti e nell'iconografia." *Studi veneziani* 10 (1968): 291–353.

VALENTINER, W. R. "Der 'rote Marsyas' des Verrocchio." *Pantheon* 20 (1937): 329–334.

VASARI, Giorgio. *Le vite de' più eccellenti pittori, scultori ed architettori*. Ed. Gaetano Milanesi, 9 vols. Florence: Sansoni, 1878–1906.

VENTRONE, Paola. "Feste e spettacoli nella Firenze di Lorenzo il Magnifico." In *Le tems revient/'I tempo si rinuova: Feste e spettacoli nella Firenze di Lorenzo il Magnifico*, ed. Paola Ventrone, 21–53. Cinisello Balsamo: Silvana, 1992.

———. "Lorenzo's *Politica festiva*." In *Lorenzo the Magnificent: Culture and Politics*, ed. Michael Mallett and Nicholas Mann, 105–116. London: Warburg Institute, 1996.

———, ed. *Le tems revient/'I tempo si rinuova: Feste e spettacoli nella Firenze di Lorenzo il Magnifico*. Cinisello Balsamo: Silvana, 1992.

VIRGIL. *Aeneid*. Trans. H. Rushton Fairclough. London: Heinemann; New York: G. P. Putnam's Sons, 1929–1930.

VERMEULE, Cornelius C. *The Goddess Roma in the Art of the Roman Empire*. Cambridge, Mass., and London: Spink and Son, 1959.

VERSPOHL, Franz-Joachim. "Michelangelo und Machiavelli: Der *David* auf der Piazza della Signoria in Florenz." *Städel Jahrbuch* n. s. 8 (1981): 204–246.

———. "Der Platz als politisches Gesamtkunstwerk." In *Kunst: Die Geschichte ihrer Funktionen*, ed. Werner Busch and Peter Schmook. Weinheim and Berlin: Quadriga, 1987.

VESPASIANO DA BISTICCI. *Le vite*. Ed. Aulo Greco, 2 vols. Florence: Istituto nazionale di studi sul Rinascimento, 1970–1976.

VIANI, Maria Cristina Bandera. "La 'ninfa': Continuità di rapporti tra antichità e Rinascimento nelle arte visive." In *Scritti di storia dell'arte in onore di Roberto Salvini*. Florence: Sansoni, 1984.

VILLANI, Giovanni. *Cronica*. Ed. Francesco Gherardi Dragomanni. 4 vols. Florence: Sansoni, 1845.

VILLARI, Pasquale. *Niccolò Machiavelli und seine Zeit*. Trans. B. Mangold. Leipzig: Teubner, 1877–1882.

———. *The Life and Times of Niccolò Machiavelli*. Trans. Linda Villari. London: E. Benn, 1929.

Vocabulario degli accademici della Crusca. 5th ed. 11 vols. Florence: Tipografia Galileiana di M. Cellini, 1863–1923.

VOLKMANN, Ludwig. "Hieroglyphik und Emblematik bei Giorgio Vasari." In *Werden und Wirken: Ein Festgruss Karl W. Hiersemann*, ed. Martin Breslauer and Kurt Koehler, 409ff. Leipzig: K. F. Koehler, 1924.

VOLPI, Guglielmo. "Di nuovo delle *Stanze per la giostra di Lorenzo de' Medici*." *Giornale storico della letteratura italiana* 32 (1898): 365–369.

———, ed. "Un'altra giostra fiorentina descritta in ottave." *Erudizione e belle arti* 4, no. 9 (1898).

———, ed. *Le feste di Firenze nel 1459: Notizia di un poemetto del secolo XV*. Pistoia, 1902.

———, ed. *Ricordi di Firenze dell'anno 1459 di autore anonimo*. Citta di Castello: Lapi, 1907.

————, ed. *Rime di trecentisti minori.* Florence: Sansoni, 1907.

WACKERNAGEL, Martin. *The World of the Florentine Renaissance Artist: Projects and Patrons, Workshop and Art Market.* Trans. Alison Luchs. Princeton: Princeton University Press, 1981.

WALZER, Michael. "On the Role of Symbolism in Political Thought." *Political Science Quarterly* 82, no. 2 (1967): 191–205.

WARBURG, Aby. *Gesammelte Schriften: Die Erneuerung der heidnischen Antike: Kulturwissenschaftliche Beiträge zur Geschichte der Europäischen Renaissance.* Ed. Gertrud Bing. 2 vols. Leipzig and Berlin: Teubner, 1932.

————. *Ausgewählte Schriften und Wurdigungen.* Ed. Dieter Wuttke. 2d ed. Baden-Baden: Koerner, 1992.

————. *The Renewal of Pagan Antiquity: Contributions to the Cultural History of the European Renaissance.* Trans. David Britt. Los Angeles: Getty Research Institute for the History of Art and the Humanities, 1999.

WARNER, Marina. *Monuments and Maidens: The Allegory of Female Form.* New York: Atheneum, 1985.

WATERTON, Edmund. "On the *Anulus Piscatoris,* or Ring of the Fisherman." *Archaeologia* 40 (1860): 138.

WATKINS, Renée Neu, trans. and ed. *Humanism and Liberty: Writings on Freedom from Fifteenth-Century Florence.* Columbia: University of South Carolina Press, 1978.

WATSON, Paul F. *The Garden of Love in Tuscan Art of the Early Renaissance.* Philadelphia: Art Alliance Press; London: Associated University Presses, 1979.

WEGENER, Wendy. "'That the Practice of Arms Is Most Excellent Declare the Statues of Valient Men': The Luccan War and Florentine Political Ideology in Paintings by Uccello and Castagno." *Renaissance Studies* 7, no. 2 (1993): 129–165.

WEIGEL, Sigrid. "Von der 'anderen Rede' zur Rede des Anderen: Zur Vorgeschichte der Allegorie der Moderne im Barock." In *Allegorien und Geschlechterdifferenz,* ed. Sigrid Schade, Monika Wagner, and Sigrid Weigel, 159–169. Cologne: Böhlau, 1994.

WEIL-GARRIS BRANDT, Kathleen. "On Pedestals: Michelangelo's *David,* Bandinelli's *Hercules and Cacus,* and the Sculpture of the Piazza della Signoria." *Römisches Jahrbuch für Kunstgeschichte* 20 (1983): 377–415.

WEIL-GARRIS BRANDT, Kathleen, Cristina Acidini Luchinat, James David Draper, Nicholas Penny. *Giovinezza di Michelangelo.* Exh. cat. Florence: Skira, 1999.

WEINSTEIN, Donald. "The Myth of Florence." In *Florentine Studies: Politics and Society in Renaissance Florence,* ed. Nicolai Rubinstein, 15–44. Evanston, Ill.: Northwestern University Press, 1968.

————. *Savonarola and Florence: Prophesy and Patriotism in the Renaissance.* Princeton: Princeton University Press, 1970.

WEISE, Georg. "Spätgotisches Schreiten und andere Motive spätgotischer Ausdrucks- und Bewegungs-stilisierung." *Marburger Jahrbuch für Kunstgeschichte* 14 (1949): 163–194.

WEISSMAN, Ronald F. E. *Ritual Brotherhood in Renaissance Florence.* New York: Academic Press, 1982.

————. "Taking Patronage Seriously: Mediterranean Values and Renaissance Society." In *Patronage, Art, and Society in Renaissance Italy,* ed. F. W. Kent and Patricia Simons, 25–45. Canberra: Humanities Research Centre; Oxford: Clarendon Press, 1987.

————. "The Importance of Being Ambiguous: Social Relations, Individualism, and Identity in Renaissance Florence." In *Urban Life in the Renaissance,* ed. Susan Zimmerman and Ronald Weissman, 269–280. Dover: University of Delaware Press, 1989.

WEITZMANN, Kurt, ed. *The Age of Spirituality: Late Antique and Early Christian Art, Third to Seventh Century.* Exh. cat. New York: Metropolitan Museum of Art, 1979.

WELCH, Evelyn. *Art and Authority in Renaissance Milan.* New Haven and London: Yale University Press, 1997.

WELLIVER, Warman. *L'impero fiorentino.* Florence: La nuova Italia, 1957.

WESSELSKY, Albert. *Angelo Polizianos Tagebuch.* Jena: Diederichs, 1929.

WESTER, Ursula and Erika Simon. "Die Reliefmedallions im Hofe des Palazzo Medici zu Florenz." *Jahrbuch der Berliner Museen* 7 (1965): 15–91.

WHITAKER, Lucy. "Maso Finiguerra, Baccio Baldini and The Florentine Picture Chronicle." In *Florentine Drawing at the Time of Lorenzo the Magnificent.* Ed. Elizabeth Cropper, 181–196. Bologna: Nuova Alfa, 1994.

———. "Maso Finiguerra and Early Florentine Printmaking." In *Drawing, 1400–1600: Invention and Innovation.* Ed. Stuart Currie, 45–71. Aldershot and Brookfield, Vt.: Ashgate, 1998.

WHITE, Hayden. *Metahistory: The Historical Imagination in the Nineteenth Century.* Baltimore: Johns Hopkins University Press, 1973.

WHITE, John. "Personality, Text and Meaning in Donatello's Single Figures." In *Donatello-Studien,* ed. Monika Cammerer, 170–182. Munich: Bruckmann, 1989.

WICKHOFF, Franz. "Die Gestalt Amors im Mittelalter." *Jahrbuch der Preussischen Kunstsammlungen* 11 (1890): 41–53.

WILKINS, David G. "Donatello's Lost *Dovizia* for the Mercato Vecchio: Wealth and Charity as Florentine Civic Virtues." *AB* 65 (1983): 401–423.

WILSON, Timothy. "Some Medici Devices on Pottery." *Faenza* 70 (1984): 433–440.

———. "Maioliche rinascimentali armoriate con stemmi fiorentini." In *L'araldica: Fonti e metodi,* 128–138. Florence: La Mandragora, 1989.

WINCKELMANN, Johann. *Geschichte der Kunst des Alterthums.* Dresden: Waltherischen Hof-Buchhandlung, 1764.

WIND, Edgar. *Pagan Mysteries in the Renaissance.* New Haven: Yale University Press, 1958.

———. "Donatello's *Judith:* A Symbol of Sanctimonia." *JWCI* 1 (1937): 62–63;

reprinted in *The Eloquence of Symbols: Studies in Humanist Art,* ed. Jaynie Anderson, 37–38. Oxford: Clarendon Press, 1983.

WINNER, Mattias. "Cosimo il Vecchio als Cicero: Humanistisches in Franciabigios Fresko zu Poggio a Caiano." *Zeitschrift für Kunstgeschichte* 33 (1970): 274–275.

WITT, Ronald G. "Florentine Politics and the Ruling Class, 1382–1407." *Journal of Medieval and Renaissance Studies* 6 (1976): 243–267.

———. "Introduction: Hans Baron's Renaissance Humanism," and *"The Crisis after Forty Years." American Historical Review* 101 (1996): 107–118.

WITTHOFF, Brucia. "Marriage Rituals and Marriage Chests in Quattrocento Florence." *Artibus et historiae* 14, no. 5 (1982): 43–59.

WITTKOWER, Rudolf. "Transformations of Minerva in Renaissance Imagery." *JWCI* 2 (1938–1939): 194–205.

WOLF, Reva. "The Uses of Foucault's *The History of Sexuality* in the Visual Arts." *Philosophy Today* 42, no. 1 (1998): 85–94.

WOLTERS, Wolfgang. *Der Bilderschmuck des Dogenpalastes: Untersuchungen zur Selbstdarstellung der Republik Venedig im 16. Jahrhundert.* Wiesbaden: Steiner, 1983.

WOODS-MARSDEN, Joanna. "Art and Political Identity in Fifteenth-Century Naples." In *Art and Politics in Late Medieval and Renaissance Italy, 1250–1500,* ed. Charles Rosenberg, 11–37. South Bend and London: Notre Dame University Press, 1990.

WRIGHT, Alison. "The Myth of Hercules." In *Lorenzo il Magnifico e il suo mondo,* ed. Gian Carlo Garfagnini, 323–339. Florence: Olschki, 1994.

WUNDRAM, Manfred. *Donatello und Nanni di Banco.* Berlin: Walter de Gruyter, 1969.

WYSS, Edith. *The Myth of Apollo and Marsyas in the Art of the Italian Renaissance: An Inquiry into the Meaning of Images.* Newark: University of Delaware Press; London and Cranberry, N.J.: Associated University Presses, 1996.

ZANATO, Tizano. "Sulla datazione del *Comento.*" In Lorenzo de' Medici, *Comento de' miei sonetti,* ed. Tiziano Zanato, 124–129. Florence: Olschki, 1991.

ZDEKAUER, Lodovico. "Iustitia: Immagine e idea." *Bollettino senese di storia patria* 20 (1913): 384–425.

ZENATTI, Oddone. "Il poemetto di Pietro de' Natali sulla pace di Venezia tra Alessandro III e Frederico Barbarossa." *Bolletino dell'istituto storico italiano* 26 (1905): 105–198.

ZERVAS, Diane Finiello. *The Parte Guelfa, Brunelleschi and Donatello.* Locust Valley, N.Y.: Augustin, 1987.

———. "'Quos volent et eo modo quo volent': Piero de' Medici and the *Operai* of SS. Annunziata, 1445–1455." In *Florence and Italy: Renaissance Studies in Honour of Nicolai Rubinstein,* ed. Peter Denley and Caroline Elam, 465–479. London: Committee for Mediaeval Studies, Westfield College, University of London, 1988.

———, ed. *Orsanmichele a Firenze/ Orsanmichele Florence.* 2 vols. Modena: Franco Cosimo Panini, 1996.

ZIRPOLO, Lilian. "Botticelli's *Primavera:* Lesson for a Bride." *Women's Art Journal* 12 (1991/1992): 24–28; reprinted as "Botticelli's *Primavera:* A Lesson for the Bride." In *The Expanding Discourse: Feminism and Art History,* ed. Norma Broude and Mary Garrard, 101–110. New York: Harper and Row, 1992.

ZÖLLNER, Frank. *Botticelli: Images of Love and Spring.* Munich, London, and New York: Prestel, 1998.

ZORZI, Andrea. *L'amministrazione della giustizia penale nella Repubblica fiorentina: Aspetti e problemi.* Florence: Olschki, 1988.

ZORZI, Elvira Garbero. "Lo spettacolo nel segno dei Medici." In *Il Palazzo Medici Riccardi di Firenze,* ed. Giovanni Cherubini and Giovanni Fanelli, 200–213. Florence: Giunti, 1990.

ZUCKER, Mark, ed. *Early Italian Masters.* Vols. 24 and 25 of *The Illustrated Bartsch.* New York: Abaris Books, 1980.

ZURAW, Shelley. "The Medici Portraits of Mino da Fiesole." In *Piero de' Medici "il Gottoso" (1416–1469): Kunst im Dieste der Mediceer/Art in the Service of the Medici,* ed. Andreas Beyer and Bruce Boucher, 317–339. Berlin: Akademie Verlag, 1993.

Index

Photo Credits